To Ursula:
This is to take
your mind off the
boo-boo! Love,
Iris
1/97

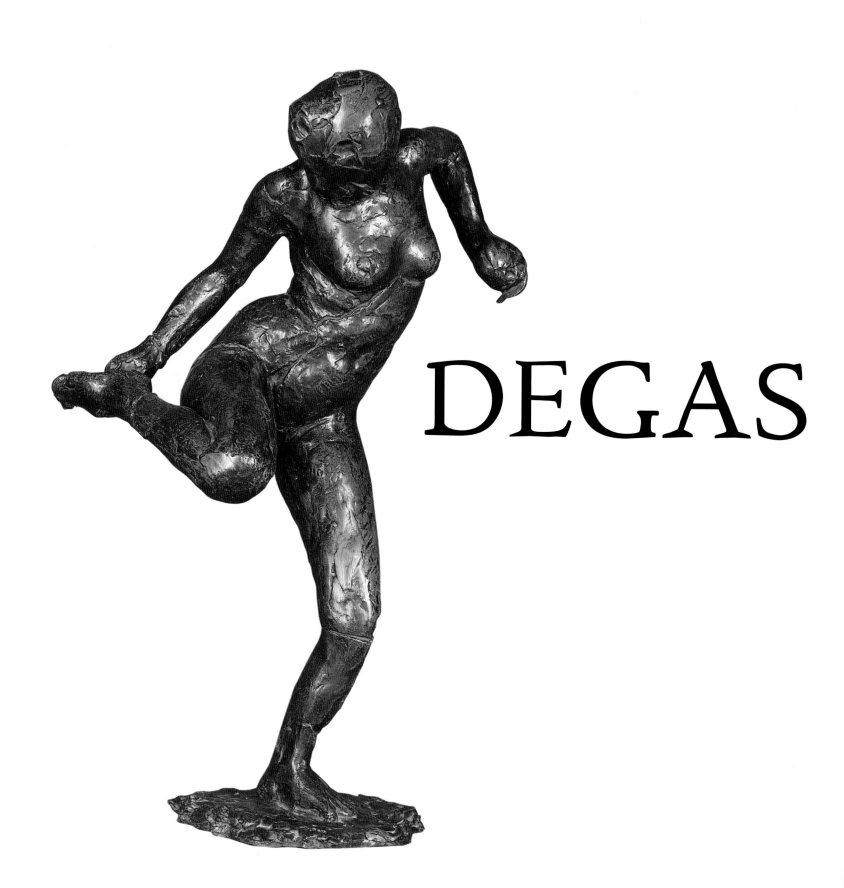

DEGAS

Richard Kendall

beyond Impressionism

NATIONAL GALLERY PUBLICATIONS, LONDON

IN ASSOCIATION WITH THE ART INSTITUTE OF CHICAGO

DISTRIBUTED BY YALE UNIVERSITY PRESS

First published in Great Britain in 1996 by
National Gallery Publications Limited
5/6 Pall Mall East, London SW1Y 5BA

Reprinted 1996

ISBN 1 85709 130 2 hardback
ISBN 1 85709 129 9 paperback

British Library Cataloguing-in-Publication Data.
A catalogue record is available from the British Library.
Library of Congress Catalog Card Number: 96–67918

Publisher *Felicity Luard*
Editor *Celia Jones*
Editorial Assistant *Katharine Eyston*

Art director *Andrew Gossett*
Design & typesetting *Studio Gossett, London*
Printed and bound in Italy by *Grafiche Milani*

Front cover (THE NATIONAL GALLERY)
Combing the hair (CAT. 42)
Front cover (THE ART INSTITUTE OF CHICAGO)
Two dancers (CAT. 77)
Back cover *Russian dancers* (CAT. 94)
Frontispiece *Dancer looking at the sole of her right foot* (CAT. 82)

This book was published to accompany an exhibition at:

THE NATIONAL GALLERY, LONDON
22 May – 26 August 1996

THE ART INSTITUTE OF CHICAGO
28 September 1996 – 5 January 1997

EXHIBITION CURATORS

Richard Kendall

THE NATIONAL GALLERY, LONDON
John Leighton, Curator of Nineteenth-Century Paintings

THE ART INSTITUTE OF CHICAGO
Douglas W. Druick, Searle Curator of European Painting,
Prince Trust Curator of Prints and Drawings

CONTENTS

CURATORS' ACKNOWLEDGEMENTS

THE PREPARATION of this exhibition has involved numerous colleagues in a variety of fields. Our greatest debt of gratitude is to the lenders. Several of the works in this show have not been subjected to the rigours of a long journey within living memory and we are grateful to the private collectors acknowledged by name in the List of Lenders, as well as those who wish to remain anonymous, who listened patiently to our pleas and responded with great generosity. We are similarly indebted to the responsiveness of our many colleagues in the lending institutions, including Glenny Alfsen, Maxwell Anderson, Adrienne Avery-Gray, Knut Berg, Robert P. Bergman, Peter Beye, Ernst Beyeler, Robert Boardingham, Helen Braham, Robert T. Buck, Dr Rainer Budde, Sara Campbell, Görel Cavalli-Björkman, Michael Clarke, Robert Clémentz, Timothy Clifford, Julia Collieu, Philip Conisbee, Malcolm Cormack, James Cuno, Dr Götz Czymmek, Alan Phipps Darr, James Demetrion, Lisa Dennison, Jane Farrington, Sarah Faunce, Peter Findlay, Hanne Finsen, Anne-Birgitte Fonsmark, Robert H. Frankel, Marianne Brunson Frisch, Jay Gates, Ulrike Gauss, Barbara K. Gibbs, Olle Graanath, Christopher Green, Vivien Hamilton, Anne d'Harnoncourt, Chieko Hasegawa, Laurence Kanter, Kimio Kawaguchi, Thomas Krens, Jan and Marie-Anne Krugier, Katharine C. Lee, Sara Lee Corporation, Irvin M. Lippman, Glenn D. Lowry, Henri Loyrette, Max Ludwig, Nannette Maciejunes, Peter C. Marzio, Tokuzo Mizushima, Philippe de Montebello, John Murdoch, Peter Nathan, Paul Perrot, Sherry Phillips, Edmund P. Pillsbury, Anne Pingeot, Joachim Pissarro, Earl A. Powell III, Fondation Rau pour le Tiers-Monde, Reader's Digest Corporation, Leslie Ridley-Tree, Joseph J. Rishel, Allen Rosenbaum, Phyllis Rosenzweig, Barbara T. Ross, Anne Röver-Kann, Samuel Sachs II, Siegfried Salzmann, Tim Schadla-Hall, Dieter Schwarz, Nicholas Serota, Tone Skedsmo, George Shackelford, Julian Spalding, Kristin Spangenberg, Shuji Takashina, Gary Tinterow, Julian Treuherz, Catherine Whistler, Christopher White, Mikael Wivel, Townsend Wolfe and Koji Yukiyama.

The special arrangements that have been made for the transport of pastels and other delicate works have created an added burden for collectors, museum staff and art handlers and we are conscious of the time and effort that the lenders and their representatives have devoted to this show. We have enjoyed enormous support from conservators who have willingly shared their research and expertise. Here a special mention is due to Harriet Stratis, whose research into pastels has underpinned this entire project. Harriet has worked closely with Patricia Goddard and the National Gallery's picture handling team to solve numerous problems relating to the transport and installation of the exhibits. Their research and planning have relied heavily on the cooperation of many colleagues, including Rod Bouc, Craigen Bowen,

Andrea Clark, Elizabeth Coombs Leslie, Jill DeVonyar-Zansky, Maureen Donovan, Kathleen Ecklund, Tom Hall, Anne Maheux, Maureen McCormick, Gillian McMillan, Cecile Mear and Paul Schwartzbaum.

Degas's later works are now scattered across the globe and in our efforts to track down particular works we have been assisted by many individuals on both sides of the Atlantic. We would like to thank in particular William Acquavella, Götz Adriani, Alexander Apsis, Janet Briner, Desmond Corcoran, William Darby, Melissa Dinger, Léonard Gianadda, Thomas Gibson, Franck Giraud, Laura Klar, David C. Norman, Martin Summers and Wolfgang Werner.

From the beginning, the collaboration between staff at the National Gallery and the Art Institute has been warm and enthusiastic. We hesitate to single out individual contributions since an exhibition of this complexity, and its catalogue, involves an extra effort from virtually everyone, but special thanks are due to Kathy Adler, Geri Banik, Karen Bath, Ann Berni, David Bomford, Gregory C. Cameron, Miranda Carroll, Rosalie Cass, Caesar Citraro, Jane Clarke, Christine Conniff-O'Shea, Maria Conroy, Sue Curnow, Chloe Dodwell, Katharine Eyston, Larry Feinberg, Sarah Frances, Daniel Frank, Penny Gibbons, Herb Gillman, Patricia Goddard, Sarah E. Guernsey, Eileen Harakal, Colin Harvey, Sara Hattrick, Mary Hersov, Michael Kaysen, Larry Keith, Joanna Kent, Denise King, Andrea Kusel, Joan Lane, Marcus Latham, Jean Liddiard, Felicity Luard, Robert E. Mars, Ian Martin, Geoffrey Matthews, Carol McFadyen, Colin McKenzie, Daniel Metcalf, John Molini, Julie Molloy, Tracie Nappi, Sandra Patterson, Gregory Perry, Razeetha Ram, Nick Rogers, Emily Romero, Steve Russell, David Saunders, Dorothy Schroeder, Clare Simpson, Mark Slattery, Mary Solt, Steve Starling, Larry Ter Molen, John Vinci, Kirk Vuillemot, Colin White, Patricia Williams, Michael Wilson and Frank Zuccari.

Finally, this exhibition has had at its heart the vision, drive and scholarship of Richard Kendall. We are indebted to him for the work that he has put into the preparation of this show and the accompanying publication.

John Leighton
Curator of Nineteenth-Century Paintings
THE NATIONAL GALLERY, LONDON

Douglas W. Druick
Searle Curator of European Painting and
Prince Trust Curator of Prints and Drawings
THE ART INSTITUTE OF CHICAGO

AUTHOR'S ACKNOWLEDGEMENTS

I HAVE BEEN GREATLY encouraged and generously assisted in the preparation of this catalogue by the Directors and members of staff of the National Gallery, London, and the Art Institute of Chicago, and by a number of colleagues and friends, notably Jean Sutherland Boggs, Lillian Browse, Isabelle Cahn, Douglas Druick, Caroline Durand-Ruel, Henri Loyrette, Anne Pingeot, Theodore Reff, George Shackelford and Richard Thomson.

Among the many other individuals who have helped with my enquiries, provided information and guided me through their archives, laboratories and collections, I offer my warmest thanks to Clifford Ackley, Gotz Adriani, William Agnew, Alex Apsis, Patrick Bade, Juliet Bareau, Wendy Baron, Martha Beck, Robert Bergman, Bruce Bernard, Robert Boardingham, Deborah Bogle, Malika Bouabdellah, Alan Bowness, Sophie Brame, Richard Brettell, Janet Briner, Peter and Angela Brookes, Robert Bruce-Gardner, James Burke, Barbara Butts, Sarah Campbell, Jaqueline Cartwright, David Chandler, Michael Clarke, Robert Clémentz, Philip Conisbee, Stephan Connery, Desmond Corcoran, Elizabeth Cowling, James Cuno, France Daguet, David Daniels, William Darby, Lisa Dennison, Jill DeVonyar-Zansky, Anne Distel, Barbara Divver, Roland Dorn, Manou Dufour, Anne and Charles Dumas, Elizabeth Easton, Sarah Faunce, Marianne Feilchenfeldt, Walter and Maria Feilchenfeldt, Clarice Finkelstein, Hanne Finsen, Shelley Fletcher, Anne-Birgitte Fonsmark, Francis Fowle, Robert Frankel, Marianne Frisch, Kate Garmeson, Léonard Gianadda, Thomas Gibson, Franck Giraud, Andrew and Annette Gossett, Gloria Groom, Charlotte Hale, Vivien Hamilton, Paul Haner, Jefferson Harrison, Françoise Heilbrun, Sabine Helms, Jack Hetherington, Anne Higgonet, Tom Hinton, Elizabeth Holland, Michael and Marianne Howard, Hans-Jurgen Imiela, Colta Ives, Stanley Johnson, Celia Jones, Paul and Ellen Josefowitz, Denis Kiel, James Kirkman, R.B. Kitaj, Irene Konefal, Olivia Lahs-Gonzales, Robert Lauer, Kate Lowry, Rhona Macbeth, Robert McNab, Anne Maheux, Caroline Matthieu, Cecile Mear, Charles Moffett, Ken Moser, John Murdoch, Christian Neffe, Anne Norton, Roy Perkinson, Joachim Pissarro, Jacqueline Ridge, Joseph Rishel, Anna Greutzner Robins, William Robinson, Anne Rocquebert, Millard Rogers, Susanne Ruf, Dieter Schwartz, Nicholas Serota, Arlette Serullaz, Marjorie Shelly, Richard Shone, Kristin Spangenberg, Martia Steele, Miriam Stewart, Annabel Stirling, Harriet Stratis, Charles Stuckey, Antoine Terrasse, Belinda Thomson, Gary Tinterow, Julian Treuherz, Caroline Villers, Jane Weber, Wolfgang Werner, William Weston, Catherine Whistler, Barry White, Jon Whiteley, Sarah Whitfield, Mikael Wivel, and Margaret Young-Sanchez. I would also like to add my thanks to the private collectors who wish to remain anonymous.

Above all, I have been sustained throughout the entire project by Mollie Sayer and my daughter Ruth.

Richard Kendall

Sponsor's Statement

J.P. Morgan takes great pleasure in sponsoring the first major exhibition to focus exclusively on the late work of Edgar Degas. We are proud to be associated for the first time through this project with The Art Institute of Chicago, one of our country's most distinguished museums.

Bringing together important works from both public and private collections throughout the world, the exhibition explores the innovative, multifaceted world of Degas's late period. The paintings, pastels, charcoals, and sculptures assembled here reveal new dimensions of his art. To experience a sense of surprise and discovery in viewing the work of so famous an artist is an unexpected delight.

We at J.P. Morgan feel privileged to have this opportunity to continue our longstanding commitment to the arts and to underscore our firm's close ties to Chicago and its business community.

Douglas A. Warner III
Chairman
J.P. Morgan & Co. Incorporated

FOREWORD

DEGAS, EIGHTY-ONE-YEARS OLD, frail, elegant and nearly blind, moves slowly along the boulevard de Clichy and towards the camera. Taken in 1915, it is one of the most poignant of all film stills. And it underlines the fact that this great artist of the 1860s and 1870s was also very much an artist of and for the twentieth century. He went on producing work which was seen and admired by contemporary artists until at least 1912, and it is this work of the later years, when Degas was middle-aged and old, that is the subject of the present book and the accompanying exhibition.

It is a period of his life and his art that is encrusted with myth, much of it of Degas's own making. Not for him the 'honour, love, obedience of troops of friends' that should accompany old age, but the studied presentation of self as an anti-social, obsessional curmudgeon. The myth was accepted. Contemporaries likened the solitary, increasingly sightless man to Lear and Homer. Later commentators lamented the dwindling and embittered twilight. In fact, we know that he remained attached to friends and keenly interested in the market for his works, and there can now be no doubt that the later years saw far-reaching innovations in technique and continuous re-negotiation – re-invention even – of long-worked subjects.

The sustained series of dancers and bathers produced in the later years have the quality of a private language, obsessional and irresoluble. Quite different from earlier treatments of the same themes, they lack narrative and spatial definition, any sense of audience and immediate charm. The lonely figures are rendered in colours that are frequently shrill and coarse, while the surface is attacked, scraped and reworked, often with the artist's fingers and thumbs.

In his techniques of these years, Degas is indeed a curmudgeon – at least as far as those organising exhibitions are concerned. Many of the key works are in charcoal on tracing paper or in pastel that is richly textured and layered. Had he set out to do so, he could hardly have chosen media more guaranteed to provide headaches for modern transporters. New techniques of safe travel have been devised and tested for this exhibition, but we are more than usually grateful to the many lenders who have entrusted their works to our care.

All late styles raise profound questions about the nature of artistic creation. In Degas's the freedom of handling offers evident parallels with the late style of Titian, whose slow reworking of canvases he frequently cited to justify his own practice, and with Poussin, whom he used familiarly and affectionately to refer to as 'le patron'. And in the compulsive, tragic investigation of the human figure is there not an endeavour that may be rightly compared with the late inventions of Michelangelo?

While Degas's late works may evoke comparisons with those of the great masters of the past, artists of his own time immediately valued them as pushing in new and fruitful directions, which they could themselves exploit. It will come as no surprise to learn, for example, that Matisse for many years owned the National Gallery's *Combing the hair*, that incomparable study of dissonance in red, where every note is sharp.

If the late works discussed here are often problematic, tough and harsh, it can happily be said that the preparations for this investigation of them have been entirely harmonious. The National Gallery and The Art Institute of Chicago have enjoyed working with Richard Kendall, whose invigorating and scholarly re-examination of 'Late Degas' is presented here. Above all, we are grateful for the support of our sponsors: in London, Evian and SBC Warburg; in Chicago, J.P. Morgan. Their generosity, together with the willing collaboration of the lenders, will allow the British and American publics to explore for the first time the many surprises and delights of Degas's late work.

Neil MacGregor
DIRECTOR, THE NATIONAL GALLERY, LONDON

James N. Wood
DIRECTOR AND PRESIDENT, THE ART INSTITUTE OF CHICAGO

INTRODUCTION

*If Degas had died at fifty, he would have been remembered as
an excellent painter, no more: it is after his fiftieth year that his
work broadened out and that he really becomes Degas.*

(Renoir, recorded by Vollard)

RENOIR'S CLAIM is almost as startling today as when it was first made.
In the late twentieth century, Degas is still pre-eminently the artist of the
ballet and the racetrack, the society portrait and the laundry scene,
subjects that derive essentially from his middle years and the era of
Impressionism. Created when Degas was in his thirties and forties, these
pictures have defined his identity and his achievement for several
generations; their incisive lines exemplify Degas's draughtsmanship,
their fine detail his remorseless urban vision; his figures in movement,
whether pirouetting on the stage or gesturing across a table, link Degas
with photography and the fleeting modern encounter; and his brightly
lit café and theatre compositions seem to encapsulate the contemporary
spectacle.

But Renoir, we are told, insisted that the maker of these pictures was
'an excellent painter, no more'. It was only *after* this phase and beyond
the period of Impressionism (Degas was fifty-one at the time of the last
group exhibition in 1886) that his work 'broadened out' and 'he really
became Degas'. How have we all been so wrong, at least in the terms
understood by Renoir? What is it that distinguishes Degas's later
pictures from those presented at the cycle of Impressionist shows? In
what practical, thematic or conceptual sense can they be said to have
'broadened out'? And how are we to understand Renoir's most
surprising claim, that it was in Degas's last works of art that he achieved
his greatest distinction, that 'he really becomes Degas'?

Most of these questions have rarely been asked, let alone answered,
and the radical implications of Renoir's view remain largely unexplored.
Significantly, a number of Renoir's contemporaries shared his opinion of
Degas at the turn of the century; Mary Cassatt saw him as 'the last great
artist' of their age, and Odilon Redon spoke of an 'absolute respect' for
his predecessor; Walter Sickert described how Degas, in later life, was
'surrounded by veneration, fear and affection'; Paul-André Lemoisne
noted in 1912 that Degas was the 'most revered name in the modern
school'; and Ambroise Vollard acknowledged him as 'the greatest of
living painters'. Knowingly or otherwise, however, this same generation
became complicit in the legend of the ageing artist, circulating tales of
his crusty behaviour and his hermit-like withdrawal from society,
hinting at a reluctance to exhibit and a terrible decline in his eyesight, a
violent misogyny and a dislike of all things modern. While none of these

stories is entirely without foundation, collectively they have muffled
and distorted a major phase of Degas's creativity, one that amounts to
more than a third of his entire working life. It is only by re-examining
these accounts, returning afresh to the art of his last decades and
re-establishing the context in which it was made that we can confront
Degas's art in all its diversity of form and meaning.

In 1890, at the age of fifty-five, Degas rented a large fourth-floor
studio at 37 rue Victor Massé, in an area on the lower slopes of
Montmartre that he had known since childhood. Here he worked
obsessively for more than twenty years (Daniel Halévy, who saw the artist
often at this time, described him as 'labour incarnate') until obliged by
the demolition of the property in 1912 to move to his final apartment on
the boulevard de Clichy. After his death in 1917, many of Degas's
contemporaries were astonished at the profusion of his output, much of
it still stored in his studio, ranging from sketches made as a teenager to
the intense and disparate products of his final years. Folders of drawings
and prints, stacks of paintings and pastels, youthful notebooks and
experimental photographs, and several dozen wax sculptures were then
catalogued, framed and restored, requiring more than six massive
auctions, the *Ventes* of 1918–19, for their eventual dispersal.

It is the imagery of these final decades, produced in the rue Victor
Massé studio from 1890 to 1912, that is principally addressed in *Degas:
Beyond Impressionism*. Given our previous lack of attention to these works,
so starkly illuminated by Renoir's remark, the project is both novel and
formidable. Except for the researches of Jean Sutherland Boggs, most
notably in the final section of the 1988 Degas retrospective catalogue,
hardly a single specialist article or essay, to say nothing of monographs or
exhibition catalogues, has been devoted to Degas's later oeuvre. Issues of
technique and iconography, of the artist's relations with his
contemporaries and with the society of the *fin de siècle*, even such
elementary questions as his exhibition history and contacts with dealers
and patrons, have lacked the detailed study they undoubtedly deserve.
More disturbingly, a surprising amount of the art of these years remains
unknown or unlocated, its spectacular excursions into line and colour,
its audacious restatements of the human figure and its sometimes reckless
experiments with materials, all hidden from view.

In these circumstances, the most fundamental characteristics of
Degas's later art and career have necessarily demanded attention.
Broadly speaking, the model proposed by Renoir has proved persuasive,
at least as far as the quantifiable factors in Degas's late career are
concerned. A study of Degas's pictures at the end of the 1880s, for
example, shows the systematic abandonment of much of the subject
matter of the Impressionist era and a new concentration on two or three
utterly distinct themes. Similarly, an analysis of Degas's craft reveals the

'broadening out' noted by Renoir, partly in a freer and less descriptive application of pastel, partly in an old-masterly engagement with oil paint. Other elements contribute to this pattern; a change in Degas's attitude to the art market, not as drastic as that of legend, but more subtle and instructive; and a modification of the artist's relationship with his visual surroundings, with the work of his contemporaries and with the processes of artistic invention.

Most crucially for our millennial audience, the new trajectory of Degas's career carries him to the heart of early modernism, to the visual and even geographical territory of the Nabis and the Fauves, and the young Cubists and Futurists who were often his Montmartre neighbours. It is here, perhaps, that the truly subversive nature of Renoir's statement becomes evident. If Degas is removed from the age of Impressionism and re-situated, at a time when he 'really becomes Degas', in the most tumultuous period of pictorial originality our culture has known, his later audacity finds a new resonance. When we discover that he was visited in his fourth-floor studio by the still unknown Georges Rouault and that he made the acquaintance of Pierre Bonnard in Vollard's gallery, Degas's pyrotechnic late colours take on an unexpected stridency; and when we find that, in 1902, the precocious Pablo Picasso exhibited some pastels at 25 rue Victor Massé, just five doors away from Degas's apartment, we sense a technical and pictorial dialogue that, in the words of Jacques-Emile Blanche, 'threw a bridge between two epochs'.

Central to Degas's lifelong project, and a vital point of contact with the rising generation, was the depiction of the human figure. Though he valued the landscape more than is generally realised, it was the body in a thousand states of repose and action that commanded his attention throughout the fifty years of his creative life; 'we were made in order to look at each other', the artist observed to Sickert in old age. In Degas's later images of the figure, we find the breadth described by Renoir at its most expressive and forceful. By the early 1890s, almost all the documentary functions of his earlier human subjects – the street entertainers, prostitutes, bourgeois strollers and silk-vested jockeys – had been left behind, replaced by elemental nudes and largely decontextualised dancers. Far from abstracting their forms and their dynamism, however, as some of his successors were to do, Degas returned to their bodily particularity, their weariness and their shared human predicament, 'defining a momentary pose of the body with the greatest precision', even as he gave it 'the greatest possible generalisation', in Paul Valéry's words.

For many, the most surprising feature of Degas's later production may be its purposefulness. Stripping down his technical range as well as his repertoire of subjects, Degas concentrated his energies with unprecedented deliberation, pursuing certain themes through dozens of works of art, from one medium to another, sometimes across many years. Clusters of imagery grew up around a single theme, such as the female toilette, and sequences of variants returned obsessively to the standing dancer, the nude drying her neck and the stooping bather, as if the artist was determined to explore his theme to its practical and interpretive limit, perhaps to the edges of representation itself. The technique of tracing, never before used in this way, became the generating mechanism of a transformed craft, challenging Degas's earlier dependence on the model and linking much of his later output in complex webs of resemblance and kinship. As the pictures and sculptures assembled in these pages show, Degas's last decades were endlessly inventive within their chosen limits, yet their unity and coherence have only just begun to be appreciated.

Degas: Beyond Impressionism offers a provisional map of certain features of this little-explored territory, gratefully acknowledging the incursions of others and anticipating the step-by-step surveys, dizzying aerial perspectives and speculative forays of its successors. By charting the material and documentary evidence, this study aims to remove a number of uncertainties that surround the terrain, such as the myths of the artist's reclusiveness and the inaccessibility of his late work. It also describes something of the distinctive topography of Degas's last decades: the serial nature of his imagery and the transformed significance of colour; the obsessive, endlessly reinvented depictions of the female form; the instrumental role of sculpture; and the relocation of the artist with respect to both tradition and the activities of the young. For once leaving behind the 'excellent painter' of Impressionism, we step into a more unfamiliar, even dangerous, arena where another of Degas's contemporaries, Camille Pissarro, could salute him as an 'anarchist in his art'.

Works illustrated are by Edgar Degas unless otherwise stated.

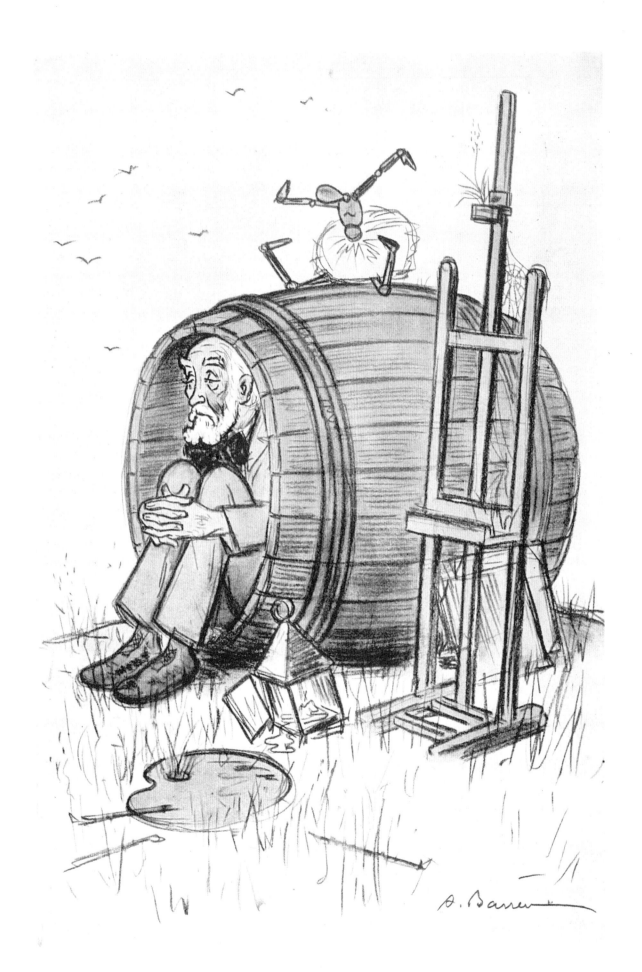

37 RUE VICTOR MASSÉ
Degas's Last Decades

IF A SINGLE MYTH can be said to dominate our perception of Degas's late career, it is surely that of his reclusiveness. The myth began early, finding stark expression in the writings of a number of Degas's younger contemporaries. According to his somewhat awestruck niece, Jeanne Fevre, Degas shut himself away in later life in his apartment on the edge of Montmartre, 'receiving almost nobody' as he 'withdrew into himself', toiling away in his 'voluntary prison'.[1] Here the artist lived in 'savage isolation', in the words of the portrait-painter Jacques-Emile Blanche, fierce in his 'hatred of publicity' and revered for his 'lofty and sullen modesty'.[2] In this 'premature retirement', his future biographer Paul-André Lemoisne wrote in 1912, Degas 'jealously guarded the mystery of his labour', 'adding a little misanthropy to his fine character' as he resigned himself grimly to the 'loneliness of old age'.[3] Like all such myths, that of Degas's remoteness is indiscriminate, allowing no distinction between his frenetic activity in the 1890s, for example, and the more sedate years preceding his death in 1917, between the social and the artistic spheres of his activity, or between Degas's carefully projected view of himself and the well-documented facts of his daily routine. But the romance of this hermit-like existence clearly gratified his peers and has clung stubbornly to his later achievement, generally with disastrous results. Degas's seclusion can seem perverse and arbitrary, especially at a time and in a city preoccupied with Symbolism and the emergence of the Nabis, and with the very public art of the Fauves and Cubists. By allowing himself to appear cut off from the present, Degas came close to writing himself out of the future.

In reality, most of the legends of Degas's reclusivity can be shown to be partial or flawed, if not mischievously generated by a range of individuals, not excluding the artist himself, with a vested interest in their currency. Journalists (described by one of their number as Degas's *bêtes noires*) who found themselves turned away from his door made the most of his truculence, invoking the 'prehistoric servant' Zoé Closier who denied access to her master and 'very brusquely' repelled even the most distinguished interlopers.[4] The writer in question, who signed himself 'Bing' in the popular magazine *Fantasio* in 1911, accompanied his article with a poignant representation of Degas as the philosopher Diogenes, the austere seeker after truth who lived apart from the customs of his times (fig. 1). But not only journalists suffered from Degas's asceticism. Jacques-Emile Blanche's image of the artist in 'savage isolation' was inevitably tainted by his exclusion from Degas's company after breaking a solemn agreement, and the Irish writer George Moore's account of Degas's 'solitude' was informed by his similar fate.[5] Many prospective purchasers and other visitors to his Montmartre premises, especially those who disturbed Degas's working routine, were likewise repulsed, and a number of them added to the tales of his remoteness,

FIG. 1
A. Barrère, *M. Degas: peintre Diogénial,* 1911
Colour print, 26 x 17 cm (10 x 6¾ in.)
Private Collection

while prospective organisers of exhibitions learnt for themselves of his fierce defensiveness. Friends protected his privacy by insisting that he was 'solitary in character, solitary in his . . . distinction, solitary above all in his art', as Paul Valéry, the writer and intimate of his old age, expressed it, knowing full well that this did not preclude extraordinary sociability on Degas's own terms.[6]

The most recent evidence of the letters, dealers' records, eye-witness accounts and photographic sources surrounding Degas's last decades shows that he was both active and visible in the cultural world of Paris for much of this period. In the years before 1917 there was undeniably a decline in health, morale and practical motivation, but in the 1890s and the early years of the new century Degas pursued his profession at large. Not only did he visit exhibitions in his native city, from the annual Salon to an occasional Cubist display, travel widely (as late as 1906, at the age of seventy-two, he journeyed alone to Naples) and familiarise himself with museums in Spain, Switzerland, Belgium and elsewhere, as well as those in provincial France; but in his Montmartre home he entertained generals and society hostesses, critics and poets, apprentice painters and favoured collectors, dining out himself several times a week at certain periods and maintaining a reputation as 'the soul of the evening; a constant, brilliant, unbearable guest'.[7] Capable of personal abrasiveness, he could be gentle with his models and surprisingly indulgent towards children, taking active pleasure in the company of young people. Anything but aloof from vulgar commerce, he wheeled and dealed aggressively in his own pictures and those of others, followed current shows, promoted his protégés and haunted the Paris salerooms. His art, too, was altogether more conspicuous than legend suggests, current works appearing in commercial galleries and mixed displays, in previously unnoticed solo shows in France, Europe and America, and in important illustrated publications. While there were certainly shifts of behaviour and a number of violent upheavals in his life, notably that of the Dreyfus affair in the late 1890s, the two decades following the 1886 Impressionist exhibition were marked by energetic and often public creative engagement, bearing comparison with any other period in Degas's professional history.

If Degas's reclusive status is set aside, a number of practical and historic consequences must follow. By removing his drawings, pastels, oil paintings and sculptures from the ivory tower of his Montmartre studio, we necessarily return them to the market-place beyond its walls, where they become part of the clamorous artistic exchange of the day. Quite apart from their commercial viability, expressed in rising prices, competitive acquisition and strategic location in exhibitions and on gallery walls, such works found their place in the more abstract currencies of Degas's cultural milieu. As our studies will show, these

were pictures and sculptures that were seen, if sporadically and somewhat arbitrarily, by his peers and by a curious cross-section of younger admirers – from Paul Gauguin to Maurice Denis, from the American Maurice Sterne to the Englishman William Rothenstein, from Max Liebermann to Pablo Picasso. In certain cases their visual trade took a literal form, with the purchase of examples from Degas's later oeuvre and his reciprocal acquisition of these artists' output. More importantly, their commerce was of a stylistic, technical and thematic kind, as Degas shared with his contemporaries in their hazardous visual speculations. Whether attending the opening of the Salon or joining one of Ambroise Vollard's dinners for Bonnard, Vuillard and Roussel, exhibiting his own recent photographs or avidly collecting the illustrated newspapers, Degas had a stake in the pictorial transactions of the day, and it is in this context that his later work must be evaluated. By the same token, his busy social life and restless peregrinations insist on Degas's participation in, rather than exclusion from, the intellectual and political currents of the *fin de siècle*. Mixing with such radical young writers as Paul Valéry and André Gide, as well with reactionary agitators such as Georges Jeanniot and Léon Daudet, Degas's sense of himself and his late art belonged to its times.

Three themes, distinct but overlapping, can be taken to exemplify the engagement of Degas and his art with his own era, and each will be explored in their turn in this and the following chapters: the patterns of his private world and public self-presentation; the character of Degas's studio and the accessibility of his current pictures and sculpture; and his relationship with the art market. A fourth line of enquiry, that of Degas's interchange with the artists of his own and successive generations, is pursued in chapter 6, while shared concerns of a practical or thematic nature are made explicit in several contexts. None of these enquiries will aspire to be exhaustive or erode the distinctive achievement of Degas's final decades. But all of them contain new documentary, technical or interpretive material that pins down this achievement in the 1890s and the early years of the twentieth century, not just among the endlessly debatable minutiae of his personal life but alongside the quotidian realities and proliferating visual languages of the modern age.

THE SOCIABLE RECLUSE

In its domestic detail and what Paul Valéry called its 'sentimental side', the last quarter century of Edgar Degas's long career might be described as one of heroic uneventfulness.[8] Indeed, the lack of personal drama may help to account for its comparative neglect, accustomed as we are to tales of poverty and tragic unfulfilment, Monet's later celebrity status and Gauguin's exotic obscurity. Throughout the period in question Degas lived quietly in Paris, remaining for two decades in the same apartment in an area he had known since youth. Significantly, this area bristled with studios, artists' suppliers and small galleries, satisfying most of his practical needs while throwing him into continual contact with fellow-professionals of all persuasions. Equally significantly, Degas's sedentary urban life emphasised his distance, not only from the rural haunts of such colleagues as Cézanne and Pissarro, and the more ambitious excursions of Monet and Gauguin, but also from the sometimes irregular modes of living of a number of his contemporaries. Degas remained pre-eminently an artist of the city, both as a painter of its intimate experience and an exemplar of its regularity. He followed routines and kept up appearances, dressing formally in public and observing the proprieties of his class. There was no metropolitan debauchery of the kind associated with Toulouse-Lautrec, despite the artistic and geographical proximity of their careers; no sudden crises of confidence, at least not in the eyes of the outer world; there was no public posturing such as that favoured by Rodin, nor were there institutional honours, of the kind achieved by the friends of Degas's youth, such as Léon Bonnat and Elie Delaunay. As a celibate man, Degas was largely proof against the marital shifts and scandals of his peers, preserving his innocence, equally, of the burdens and exhilarations of family life. Entanglements were resisted, financial stress shrewdly avoided and the extremes of both fame and obscurity kept at bay.

Detailed accounts of the events and non-events of Degas's last years have featured in three fine publications in recent years, each of which has contributed to the Chronology at the end of this volume (see pp. 294–5). All these studies have added flesh to the bare bones of Degas's metropolitan existence, though none would claim to have transformed its familiar physiognomy or discovered unsuspected blemishes. Roy McMullen's 1985 *Degas: His Life, Times and Works*, notable in its day for a lucid command of the documentary sources, has now been magisterially supplanted by Henri Loyrette's 1991 biography, as yet published only in French.[9] More widely accessible, the catalogue of the 1988 *Degas* retrospective edited by Jean Sutherland Boggs incorporates a sequence of exemplary chronologies, tabulating most of the principal evidence of the artist's later activity.[10] Selecting from this wealth of material and from documents published subsequently, from more than a century's output of Degas literature and from the voluminous studies of artists in his circle and recent scholarly research, it has been possible to distil a number of narratives with a direct bearing on our present theme.[11] Many of these sources, for example, provide evidence of Degas's persistent sociability at the turn of the century, identifying his dining companions, professional contacts and wider public acquaintance. Others bring together the artist's own thoughts, both in the form of letters and as reported conversations or acerbic asides. Some reiterate tales of his solitude, even as they recall exhibitions visited and pictures sold, artists encountered and journeys undertaken. And yet others have bravely tackled the man himself, confronting the misogynistic monster or the gentle, Lear-like old man according to taste.

As several of his contemporaries in later years forcefully observed, the complexities of Degas's personality resolved themselves into a kind of double life, the most visible being that of

> a cheerful and news-hungry passer-by, circulating with deceptive smiles and sparkling asides, at the centre of artistic and social events – the other . . . that of a recluse, shut away with his models and his sketches, intent upon conjunctions of tone and lines,

as Gustave Geffroy noted in 1890.[12] This bi-polar existence, with all its implicit tensions and continuous demands on those around him, does much to account for the starkly contradictory evidence of Degas's personal and professional activity. In the first instance, it encompasses the energetic round of dinners, social calls and cultural spectacles that Degas is known to have enjoyed for much of this period, as well as the descriptions of his 'bear-like sense of fun' and his 'brilliant and sparkling' company.[13] Equally, such a formulation fits plausibly with his severe reputation as a working painter, who rudely dismissed visitors at his studio door and turned violently on '*arrivistes* and charlatans', while expressing a 'disdain for the incomprehension of the crowd'.[14] With both modes of living, we are brought up against the extreme, even paranoid, self-consciousness of Degas's social behaviour, a characteristic that pervades much of his adult life. In his attire, his language and his forms of address, Degas rigorously defined the terms of his engagement with the world, adopting the pose of the monster who destroys his opponent with a witty barb, defending his right to intimacy and near-childishness, but always aware of his audience and not above dissimulation. He delighted in moulding other peoples' opinion of him, gleefully urging his model to circulate tales of his licentiousness and telling his niece 'I want people to believe me wicked'.[15] George Moore summarised this tactic perfectly when he wrote how Degas, who was 'the type and epitome of a French gentleman . . . *put himself forward* as an old curmudgeon'.[16]

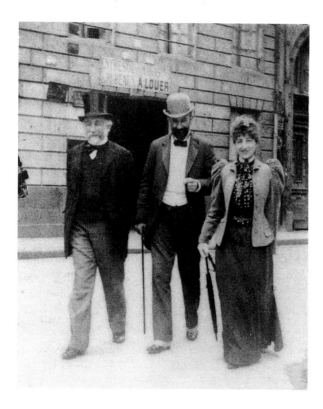

FIG. 3
Edgar Degas, *Degas in his studio, c.*1895
Photograph
Paris, Bibliothèque Nationale

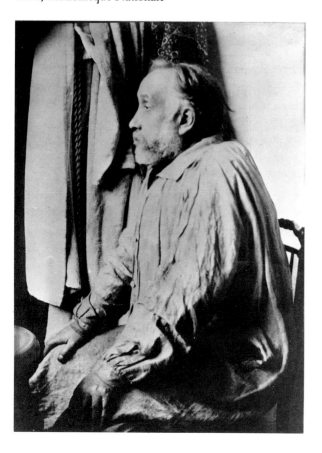

FIG. 2
Giuseppe Primoli, *Degas and friends*, 1889
Photograph
Rome, Fondazione Primoli

A pair of contemporary photographs brings us face-to-face with these two aspects of Degas's carefully compartmentalised existence; the first (fig. 2) dating from 1889, the second (fig. 3) from perhaps a decade later. In the earliest, taken by Count Giuseppe Primoli in 1889, the artist is shown accompanying two of his friends, one of whom may be the celebrated actress Réjane, as they walked through the Paris streets.[17] Here we see the Degas described by Geffroy, a man at ease in glamorous society, splendidly turned out in top-hat and black bow-tie, beaming all over his neatly clipped, but already silver-whiskered, fifty-five-year-old face. This is the man who could still enjoy a fun-fair in the place Pigalle, who attended more than thirty performances of his friend Ernest Reyer's opera *Sigurd* and who travelled by train to Brussels in 1890, principally to hear the voice of 'the divine' singer Rose Caron.[18] In the year of the photograph, Degas also visited the spa at Cauterets, mixing with 'aristocracy from the provinces', sharing a hotel with Sarah Bernhardt, and corresponding with the society portraitist Giovanni Boldini, with whom he planned a somewhat dissolute trip to Madrid.[19] On more familiar territory, Degas might busy himself with professional matters, quartering Paris to negotiate with dealers such as Théo van Gogh, Boussod et Valadon, Alphonse Portier and Durand-Ruel, exhibiting in 1889 a group of 'dancing girls, bathing women and jockeys . . . on the Boulevard Montmartre', and submitting his lithographs to the inaugural show of the Société des Peintres-Graveurs Français.[20] Other excursions took him to the enormous exhibition of Japanese prints at the Ecole des Beaux-Arts, which he visited with Mary Cassatt, and the opening of the 1891 Salon, where Berthe Morisot reported him 'scrutinising every picture';[21] and to Biarritz, where he encountered the painter Léon Bonnat 'on the outside of an omnibus'.[22]

In no meaningful sense, therefore, was Degas sequestered from his urban and convivial surroundings at the beginning of the 1890s. Rather, the peripatetic figure initially described by Geffroy and captured by the camera of Giuseppe Primoli seems to step from the world of the *flâneur*, detached from and yet parasitical upon his metropolitan milieu. As the decade progressed, this image continued to haunt the letters, photographs and first-hand accounts of painters and fellow-socialites, admirers of all ages, and of the artist himself. To illustrate these reports we might follow a year-by-year sampling of Degas's house-calls, ranging from casual visits to attendances at the grandest suppers and the most discreet family gatherings. Degas was a loyal friend and an inveterate diner-out, joining such intimates as the Rouarts at their table 'every Friday' and most Tuesdays, according to Paul Valéry and Jacques-Emile Blanche respectively; he also called for lunch 'two or three times a week' at the home of Ludovic Halévy, childhood friend and later writer and librettist, until he seemed to have 'definitively joined our family', in the

words of their son Daniel.[23] Degas met frequently, sometimes daily, with close acquaintances like the sculptor Paul-Albert Bartholomé and the painters Georges Jeanniot and Jean-Louis Forain, and was a regular at Henri Lerolle's soirées, along with Claude Debussy (who became 'fascinated' by the artist), Ernest Chausson and Pierre Louÿs.[24] In 1891, a typical meal united Degas with the Halévys, Blanche and the dramatist Meilhac;[25] the following year, Degas found himself enjoying the hospitality of his childhood friends, the Valpinçons, at their Normandy château;[26] in 1893, Berthe Morisot 'occasionally . . . went to dinner at Degas's where she usually met Forain and Bartholomé';[27] Julie Manet records entertaining evenings with Degas, Renoir and Mallarmé in 1894 and 1895;[28] on 17 December 1896 Degas fed and entertained a party of young friends at his apartment in the rue Victor Massé, where they talked of poetry, dance and music;[29] some time in 1897, the English painter William Rothenstein also went 'with Legros to dine at the rue Victor Massé';[30] the next year, Degas was present at a reception for Yvonne Lerolle, one of the daughters of the collector Henri Lerolle; and on 10 August 1899, we read of the artist spending the evening 'at Durand-Ruel's'.[31]

The mood of these occasions could vary from the solemn to the facetious, as when a male guest appeared for the benefit of Degas in the costume of a ballet dancer, to 'general hilarity' according to Jeanne Baudot.[32] But the socially mobile Degas was by no means all charm and affability. The same friends who relished his company knew him as 'nervous' and 'impulsive', prey to melancholy and deeply affected by the domestic tragedies of those around him.[33] Described by Mary Cassatt in 1893 as 'not an easy man to deal with', Degas was capable of reflecting on his own severity, writing to the elderly artist Evariste de Valernes:

I was or I seemed to be hard with everyone through a sort of passion for brutality, which came from my uncertainty and my bad humour. I felt myself so badly made, so badly equipped, so weak, whereas it seemed to me, that my calculations on art were so right. I brooded against the whole world and against myself. I ask your pardon sincerely if, beneath the pretext of this damned art, I have wounded your very intelligent and fine mind, perhaps even your heart.[34]

Unsurprisingly, his 'passion for brutality' was most evident in matters that concerned 'this damned art', and especially his right to professional and domestic privacy. Degas's fury against those who pried into his affairs was legendary, reinforcing the sense that his public bravado concealed a restless and uncertain self, 'so badly made, so badly equipped, so weak'. His eruptions of anger are those of a man under threat, whether sensing presumption in the approaches of the exhibition organiser Aglaus Bouvenne in 1891 or a public challenge in matters of

taste from Claude Monet, with whom he had a shouting match over the installation of Berthe Morisot's memorial exhibition in 1896.[35]

It is surely this second Degas, difficult and exacting, brooding 'against the whole world and against myself' that we see in the second photograph (fig. 3), which shows the artist seated in his Montmartre studio some time after 1895.[36] Apparently arranged by Degas himself, this composition reverses almost all the qualities of Primoli's image; here the subject appears alone and against a shadowy interior, his street attire replaced by a shapeless smock, his expression sullen and preoccupied. This is Geffroy's 'recluse, shut away with his models and his sketches', who told Vollard that he wanted 'people to think of him as hard-hearted'.[37] Above all, this is the man of iron will, who believed that his 'calculations on art were so right' and knew that long and sometimes barren hours in the studio, a rigorous routine and a grim commitment to his craft were his chosen lot. 'No one believed more than Degas in the need for discipline in every phase of life', wrote Vollard, adding that the artist's 'life was as ordered and arranged as a sheet of music'.[38] For Daniel Halévy, Degas was 'labour incarnate', a man who could explode with frustration at a dinner party when the talk turned to art, announcing 'what interests me is work, business, the army!'[39] It was this near-monastic dedication that defined the other half of Degas's self-image and, at a pedestrian level, confronted visitors to his rue Victor Massé rooms. Maurice Denis portrayed this absorbed figure in his *Portrait of Degas* (fig. 4), becoming one of many acquaintances who learnt to arrive 'at the end of the day, when it's *dark*', as Degas told a startled critic, or during his afternoon rest, when Suzanne Valadon seems to have paid her calls.[40] Outside these times he could be formidable, bellowing at a troop of strangers, who asked if their call inconvenienced him, the single word, 'Beaucoup!' But as Walter Sickert, who relayed the story, pointed out: 'If the greatest painter of the age, who happens not to keep a footman, may not, in broad daylight, say that he is occupied, when, in God's name, is it proposed that he should paint?'[41]

Degas's split behaviour was recognised by Paul Valéry, who described how the artist 'could be charming or frightful. He possessed – and affected – the worst possible disposition: yet there were days when he was quite unpredictably delightful'.[42] Again, Valéry described Degas's nature as 'uniting . . . an almost tragic sense of the difficulty and strictness of his art with a certain prankishness', stressing that, on his own visits to the studio, he was never sure which of the two personalities he would meet.[43] In another suggestive passage Valéry explored this bifurcation further, observing that Degas combined a 'passion for both romantic diversity and classical simplicity' and noting his 'taste for Italian music' as well as his 'horror for the Teutonic type of speculation'.[44] Music was immensely important to Degas and perhaps

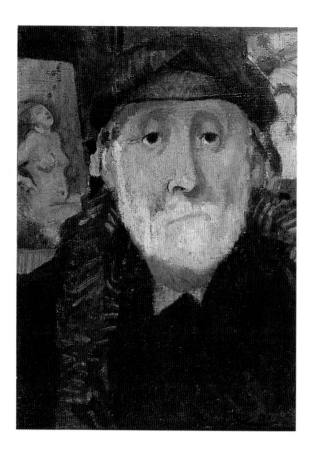

FIG. 5
Edgar Degas, *Young girl in a cloak*, c.1895
Photograph
Paris, Bibliothèque Nationale

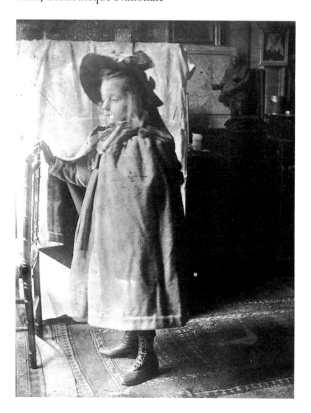

illuminates something of his character. It is found at every level of his career, from the remembered family concert that forms the subject of the late painting *Pagans and Degas's father* (cat. 3) to his continuing friendships with composers and practitioners, such as Reyer, Chausson, Chabrier and the Dihaus.[45] But Valéry's analogy is imperfect, since Degas's love for Neapolitan airs and the compositions of Cimarosa existed side-by-side, and quite characteristically, with a devotion to the Teutonic Gluck and the Austrian Mozart.[46] When the artist was working cheerfully, he would sing snatches of Italian opera and once completed one of these performances by dancing with his model around the studio, she naked but for a pair of slippers.[47] Conversely, the austere beauty of Gluck's *Orfeo ed Eurydice* haunted Degas throughout his life, linking youthful recitals by his sister to poignant renditions among friends, performances on the concert platform and even, in later years and at the artist's own instigation, in the open air.[48]

The almost unbridgeable divide between Gluck and the ditties of the café-concert, which Degas himself referred to wryly in a letter to Henri Lerolle, and between the Degas of his studio self portrait and the Primoli snapshot, echoes throughout the grandest and the most trivial aspects of his final years.[49] Artistically, it finds an equivalent in Degas's sombre draughtsmanship and frieze-like compositions on the one hand and the abrasive, brilliantly sensual colours of his pastels and oils on the other, while the endlessly elusive attempt to bridge the two might be seen as the animating force behind his entire creative project. In domestic terms, we shall also discover that Degas separated his life into two distinct enclaves, the one sober and comfortless, the other, in his own words, frankly 'bourgeois'.[50] Again and again, in his attitudes and habits during these last decades, paradoxical and sometimes violent contradiction seems to define, almost to motivate his being. Known for his persistent attachment to friends, Degas could nevertheless end a lifelong intimacy with a curt note, as in his ruptures with Renoir and the Halévy family in the late 1890s.[51] While some of his closest friendships were with women, including Louise Halévy, Hortense Valpinçon, Mary Cassatt, Berthe Morisot, Henriette Jeanniot, Julia Braquaval and Suzanne Valadon, he also mischievously encouraged a view of himself as a misogynist. Degas could show 'enormous patience' towards his models and help them in distress, or be randomly angry, even obnoxious, on certain occasions.[52] Though a confirmed bachelor, he found himself regretfully 'meditating on the state of celibacy', and showed a marked affection for children, recording several in his affectionately informal photographs (fig. 5).[53] Degas could regularly and scornfully dismiss all 'men of letters', even as he worked obsessively at a series of sonnets admired by Mallarmé and Valéry;[54] as the notorious scourge of landscapists, he could still choose landscape as the subject of his only

one-man show, in 1892;[55] and as an opponent of all things modern, he was fascinated by the camera, the telegram and even the aeroplane.[56]

If there is a context in which Degas's political views, and especially his response to the Dreyfus affair, can be given any coherence, it is surely in this bizarre private world of conflicting yet fiercely held beliefs. In October 1894, when the army captain Alfred Dreyfus, a Jew from the Alsace, was arrested on charges of spying for the German goverment, a train of events was set in motion that divided and traumatised the French nation. Although Dreyfus was later proved innocent, the *affaire* sundered friendships, provoked racial antagonism and seemed to politicise every aspect of society. Daniel Halévy, son of a Jewish family and much caught up in public affairs, rather surprisingly claimed that 'Degas never seemed to have any political opinions', a view partly justified by the scarcity of references to events of the day in the artist's letters and conversations. Where there are exceptions, as in an exchange about the progress of the Boer War in 1896, they are slight and conventional, or simply remind us of Degas's unswerving nationalism.[57] Of his emphatic and sometimes vociferous anti-Semitism, however, at least in his mature years, there can be not the slightest doubt. As early as December 1890, the eighteen-year-old Halévy innocently recorded a story told by Degas that hinged on the avarice of a member of the Rothschild family, while in 1898, the year preceding Zola's famous letter supporting Dreyfus, he noted with discomfort the artist's 'extremely anti-Semitic' remarks at their table.[58] Other witnesses document both the persistence and the crudeness of Degas's prejudice, his model Pauline remembering an ugly outburst in the artist's studio against the 'abominable race', the novelist Gyp recording his presence at her reactionary soirées, and both Julie Manet and Vollard noting his refusal to co-operate with Jews or Dreyfusards, whether real or imaginary.[59] We hear also of Zoé Closier, Degas's elderly maid, reading to him from the rabidly right-wing Edmond Drumont's newspaper *Libre Parole*, and in a little-cited passage from Léon Daudet's *Vers le roi*, of a visit by Degas 'a very great painter – the foremost of his generation – already very old and passionately anti-Dreyfusard', to a meeting of the Ligue d'Action Française at an unspecified date.[60]

But this is also the man of whom Linda Nochlin could write, 'the number of Degas's Jewish friends was unusually large', specifying two generations of the Halévy family, the Astrucs, Ernest Reyer, Charles Ephrussi, Charles Haas, Ernest May, Henri Michel-Lévy and Camille Pissarro, among others.[61] In her distinguished essay on Degas's anti-Semitism, Nochlin also reflects on his 'amazing feats of both irrationality and rationalization', which enabled him 'to keep different parts of his inner and outer life in separate compartments', as the artist sought to prolong his familiarity with Jewish acquaintances and simultaneously lend his voice to the anti-Dreyfus cause.[62] Until late in 1897 he appeared to manage this improbable balancing act, then painfully detached himself from 'my poor Halévys' and from fellow-artists in the other camp, like the Dreyfusard Monet and the Jewish Pissarro, the latter becoming the target of Degas's quite unreasonable abuse.[63] In one version of events, Daniel Halévy insisted that the break with his family was 'by common consent', followed by later contacts between them and, according to Rothenstein and Vollard, the expression of concern for alienated friends and colleagues.[64] Conversely, Degas's association with the like-minded Rouart family, with the militaristic Jeanniot and even the anti-Dreyfusard Cézanne were strengthened by the *affaire*. As Jeanne Baudot rather naïvely explained, Degas and Renoir were at one on the subject, wishing 'to make painting, not politics, but pained to see France divided, the army insulted'.[65] For Degas, the banker's son and witness to the horrors of the Franco-Prussian War, patriotism and the rule of order were cardinal principles, even though his own history and racial origins, as Nochlin points out, were characteristically at odds with his rhetoric.[66]

That Degas damaged himself severely in the course of the Dreyfus affair, both in his personal life and in the eyes of posterity, is today beyond question. For once obliged to confront his conflicting values and emotions, the painter took refuge in stridency and that 'passion for brutality' acknowledged several years earlier, clinging to his belief in 'work, business, the army', at whatever cost to his private world. Here, again, we find confidence masking insecurity, paradox raised to a governing principle, as Degas the man retreated into a system of values apparently at odds with Degas the artist – as Valéry noticed, Degas could be 'old fashioned compared with some of his own generation; whereas in the real boldness and precision of his mind he was ahead of many artists of his time'.[67] Linda Nochlin, too, insists that the importance for Degas's art of his anti-Semitism was 'little or none', though some of his admirers and critics will find this disentanglement awkward.[68] Whether as a symptom or cause, what Julie Manet called the 'interminable Dreyfus affair' coincided with the beginnings of a more general decline in Degas's well-being, evident in his health and correspondence, the declining fastidiousness of his craft and the decreasing breadth of his ambition. There was no sudden collapse, except occasionally in his spirits, but a determination to 'succeed in finishing my articles' and to 'finish with my damned sculpture', articulated as late as 1910.[69] And in the last years, as we shall see later in this chapter, there came an acceptance of the reality of that isolation he had so long contrived for his own amusement and protection.

DEGAS'S FINAL STUDIO

The regimentation of Degas's life in his last decades, and his relationship to the world at large, were powerfully expressed in his practical circumstances. Indeed, so clearly demarcated were his living and working arrangements, and so differentiated from each other, that it is hard not to see them as symbolic of his predicament. Artists have often treated their studios and their surroundings as extensions of themselves, preferring the cluttered yet calculated opulence of a Meissonier (fig. 6), for example, to the purpose-built tranquility of Cézanne at Les Lauves or the squalor of Picasso's Bateau-Lavoir, according to temperament and circumstances. Degas's case is distinct for a number of reasons, and characteristically shot through with that opposition of values and personal equivocation that became his hallmark. First and foremost, he adopted a new pattern of work and residence at the beginning of his later phase, effectively redefining his professional life at the end of the Impressionist era. Having made this move, and unlike many of his contemporaries, Degas then opted for stability, producing all his pictures and sculptures over the next twenty years, including most of the work discussed in these pages, in a single large room. Second, enough evidence survives for us to reconstruct this room and the regime that supported it, yielding original insights into Degas's late craft, his visual sources and the networks of his artistic and personal contacts. Finally, an analysis of Degas's practice helps to define his changed self-perception, in terms of his past career and the projects of his peers, as a member of a social class and as a resident of a particular urban milieu.

On 9 January 1890, Degas moved his studio from 21 rue Pigalle, the last of a series of premises occupied during the 1880s, to a building on an adjacent street, at 37 rue Victor Massé (fig. 7).[70] Here he established his easels and equipment on the fourth floor, in a 'long attic room, with a wide bay window', where he was to work continuously for the next twenty-two years.[71] At about the same time, he took over new living quarters at the nearby rue Ballu, formerly called rue de Boulogne (where Cézanne also rented premises at the turn of the century), necessitating a short walk each day from Degas's apartment to his place of work. By 1897, if not earlier, Degas had abandoned this arrangement and taken over the second and third floors of the rue Victor Massé building, combining residence and studio under one roof for the remainder of his professional life. Despite assiduous enquiries by a number of individuals, the precise details of these removals and of Degas's tenancy have remained elusive, though this broad description of his movements is beyond dispute.[72] Unremarkable in themselves, the bare facts of his relocation are surprisingly productive under further examination. The four-storey building in question was evidently substantial and Degas's occupation of three of its floors must be seen as an affirmation of both his status and his relative affluence. Remembered by Daniel Halévy as part of a 'block of houses of formidable appearance, a sort of cliff, a very high cliff, pierced with windows along its length of 150 metres and bristling with chimneys', the establishment was situated directly opposite the celebrated dance-hall of the Bal Tabarin (fig. 9).[73] Though no longer in

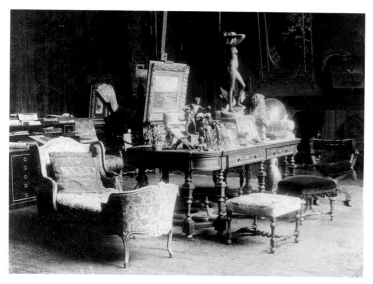

Anon., *Meissonier's studio-salon*, 1890. Photograph
Paris, Louvre, Département des Arts Graphiques (fonds Orsay)

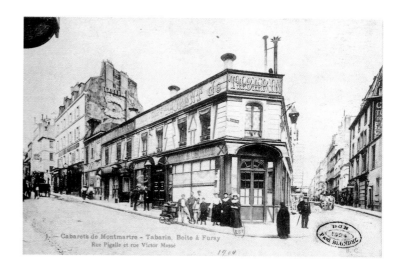

FIG. 7
Anon., *The Bal Tabarin and the rue Victor Massé*, Degas's apartment
and studio at the right. *c.*1904. Postcard. Paris, Bibliothèque Nationale

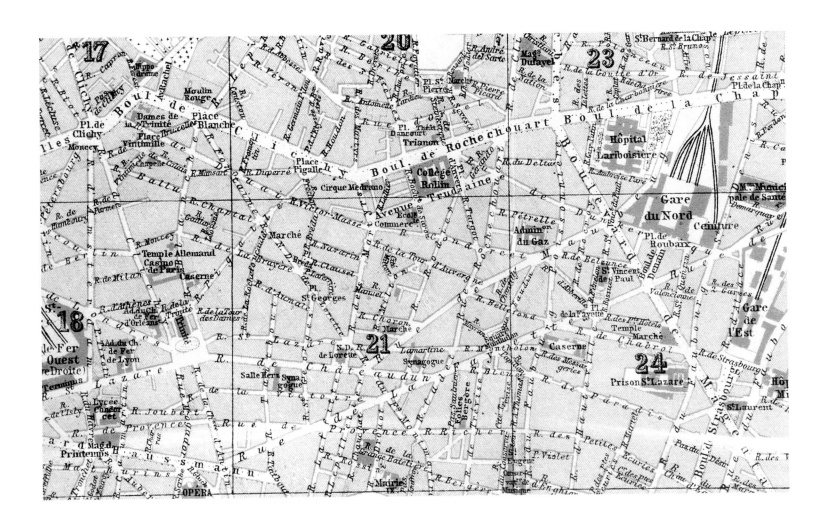

FIG. 8
*Paris, map of part of the 9th arrondissement, c.*1900

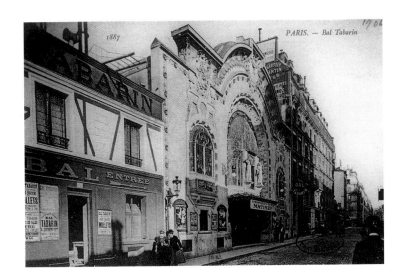

FIG. 9
Anon., *Rue Victor Massé and the Bal Tabarin, c.*1906. Postcard
Paris, Bibliothèque Nationale

FIG. 10
Anon., *Rue Victor Massé, Degas's apartment at the left, c.*1900. Postcard
Paris, Bibliothèque Nationale

existence, 37 rue Victor Massé can be seen clearly at the extreme right-hand side of a recently discovered postcard of about 1904 (fig. 7), in which the steep glass roof of the artist's roof is unmistakable.[74] Evident from all these accounts is the essentially traditional, not to say archaic, nature of the structure, with its carriage entrance from the street and stabling in the rear, its plain unadorned frontage and its floors 'served by a principal staircase and a private staircase'.[75]

The identity of the building and the area in which Degas chose to live out his days is of considerable importance. Degas's family home, where he was born in 1834, was in the rue Saint-Georges, a few hundred yards to the south. It was in the rue Victor Massé, then known as rue de Laval, that the twenty-five-year-old Degas had rented one of his earliest, perhaps his first, independent studio soon after his return from Italy in 1859.[76] Since then, Mary Cassatt had occupied a studio in this street and Degas had almost certainly visited his future premises when the same fourth-floor apartment was leased to Renoir between 1884 and 1887.[77] The location of his new rooms at the heart of an artistic quarter is emphasised by the number of suppliers and fellow-practitioners to be found within a few steps. The colour merchant and stretcher-maker Vielle et Troisgros had their shop next door, at 35 rue Victor Massé, while Berthe Weill's gallery, where Picasso had a precocious show in 1902, was just six doors away from Degas's apartment.[78] The Ottoz family, who sold canvases to both Monet and Degas (including that used for *Dancer with bouquets*, (cat. 6), were to be found at several establishments in the immediate vicinity, and Degas's source of photographic materials, Tasset et Lhote, where he exhibited his prints in 1896 and where van Gogh also bought his paints, was in the nearby rue Fontaine.[79] Père Tanguy, subject of van Gogh's celebrated portraits and an early exhibitor of Cézanne's paintings, operated in a street parallel to the rue Victor Massé, while Renoir obtained colours from Mulard on the rue Pigalle, and Puvis de Chavannes and Jean-Jacques Henner were based on the place Pigalle;[80] Jean-Louis Forain and Gustave Moreau lived in the rue Rochefoucauld, which ran close to the rue Victor Massé (as did rue Frochot, where Toulouse-Lautrec had a studio);[81] and in an extension of the same street, the rue Douai, the Halévy family resided, not far from their mutual friends Cavé, Reyer and Madame Howland.[82]

Degas's decision to settle in the rue Victor Massé, therefore, was in part nostalgic, in part a matter of professional convenience, but its wider resonance should not be overlooked. The street was also famed for its places of entertainment, of precisely the kind that Degas would once have frequented and made the subject of his art. During his residence, the exotic 'neo-medieval café' Le Chat Noir finally closed its doors, while the glamorous Bal Tabarin went from strength to strength, proclaiming itself to English and American customers as 'the greatest

attraction in Paris'.[83] Also offering 'French Cancan by the prettiest dancing women' in the city, such an establishment no longer attracted the mature artist, who claimed never to have crossed the threshold because of the intolerable brightness of the lights.[84] Its continuing significance for his admirers and successors, however, is evident in their memoirs and works of art. Georges Rouault's *At the Bal Tabarin (dancing the Chahut)* of 1905 (fig. 11) acknowledges both the location and the earlier subject matter of his mentor, while the Futurist Gino Severini's large canvas entitled *Dynamic hieroglyph of the Bal Tabarin* (New York, Museum of Modern Art) might be an aggressive farewell to Degas's world.[85] In another sense, Degas's commitment to this area was part of a long-standing identification with the artistic community, notably with its more modest craftsmen, obscure practitioners and the 'little active republic' of Montmartre, as Halévy called it.[86] This tangle of small streets just south of the place Pigalle survives today, its small merchants trading at addresses once visited by Degas, such as the former premises of Jerome Ottoz at 22 rue La Bruyère, and much of its village atmosphere intact. Several of Degas's contemporaries noted his rejection of the airs and graces of the successful *arriviste*, refusing to place the artist 'above other citizens', as Blanche reported, declining to be addressed as 'maître' and associating himself with artisans and 'the grace of the common people'.[87] Geographically and socially distinct from the modernised centre of Paris, the neighbourhood was a typical Degas paradox; rooted in the old city, yet populated by some of its freshest upstarts, allowing him to mix with fellow-toilers of all kinds, yet remain aloof behind his cliff-like façade.

The façade in question, along with the rest of the building, was demolished by developers in 1912, obliging the seventy-eight-year-old artist to move to his final residence on the nearby boulevard de Clichy. In contrast to his former colleagues Renoir, Cézanne, Monet, Moreau and Henner, therefore, whose wholly or partly surviving studios so vividly represent their later self-image, we must rely on circumstantial sources for our knowledge of Degas's surroundings. Perhaps for this reason, no previous attempt has been made to draw together the fragmentary documents, archival detail and local gossip that enable us to reconstruct both studio and living space with some confidence. If a major gap remains, it is that of photographs. Though the artist used his camera on several occasions in his apartment, inadvertently recording his possessions and domestic arrangements, we can only regret that this most passionate of photographers did nothing, haphazard or otherwise, to document his own studio. His resistance to such a project is in itself instructive. Unlike almost every painter and sculptor among Degas's acquaintance and the grandest and humblest practitioners of the day, Degas appears to have actively discouraged the depiction of his studio,

not just in his late phase but throughout his career. By contrast, it is difficult to find an individual of repute from Degas's circle who was not so immortalised, posed in mid-flourish in front of a manifestly completed picture; Forain, Henri Gervex, Eugène Carrière, Félix Bracquemond, Roll, Rodin, Toulouse-Lautrec and Fantin-Latour were photographed in their studios, some on numerous occasions, and Gérôme, Whistler, Meissonier and Chéret were the subject of paintings that showed them ostensibly at work.[88] Most of Degas's Impressionist friends were pictured as they toiled in the open air and indoors, while Renoir and Monet allowed themselves to be committed to moving film, brush in hand, in their last years.[89] Coincidence apart, Degas's reluctance to be depicted in action seems like part of his controlled presentation, a resistance to theatrics and a refusal to play out the artist's role for the benefit of the public.

As Degas compartmentalised his behaviour, so he divided his three-storey dwelling in the rue Victor Massé into solemnly distinct zones. On the second floor above street level, the artist maintained his 'museum', where his own earlier pictures and the bulk of his collection of works by friends and predecessors were stored. He also seems to have slept on this level and had his dressing room close by.[90] On the floor above was the apartment proper, with vestibule and corridors, kitchen and dining room, two 'enormous salons' hung with paintings, and a room reserved for his fierce housekeeper, Zoé Closier.[91] On the top storey was the studio, presumably running the length of the building, though apparently with some smaller rooms for more immediate storage of pictures and materials.[92] Complex though the arrangement sounds, it was shrewdly summed up for a visitor by the concierge, who serenely disregarded Degas's priceless horde and announced, 'couche au second, mange au troisième, travaille au quatrième'.[93] The advantages and disadvantages of this hierarchy are evident, with models free to come and go on the linking staircase without disturbing the household, elderly guests complaining of the stairs and the artist escaping at will to the isolation of the attic. Though initially a practical division, it is hardly an exaggeration to claim that each storey was different in appearance and meaning, that each had its own décor and code of conduct, and that each reflected a contrasting facet of Degas's contradictory world.

The lowest floor was the simplest, the most intimate and apparently the least accessible. It was always kept locked, although Degas would occasionally escort a favoured visitor into the 'vast bare room', as Paul Lafond remembered it, showing them his collection by the light of a candle or lamp.[94] Sickert recalled threading his way 'through the forest of easels standing so close to each other that we could hardly pass between them, each one groaning under a life sized portrait by Ingres, or holding early Corots and other things I cannot remember', while Julie

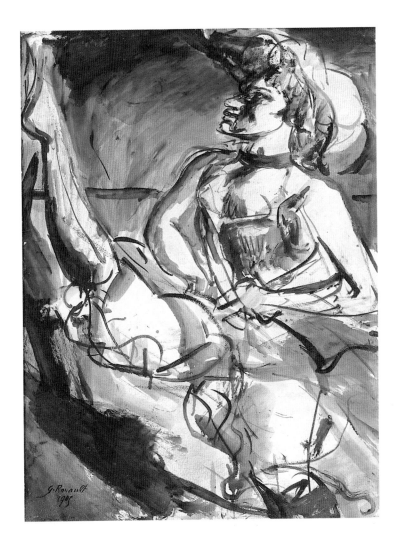

FIG. II
Georges Rouault, *At the Bal Tabarin (dancing the Chahut)*, 1905
Ink, watercolour and pastel on paper, 71 x 55 cm (28 x 21⅝ in.)
Musée d'Art Moderne de la Ville de Paris,
Legs de Docteur Girardin, 1953

FIG. 12
Edgar Degas, *Degas and Bartholomé*, c.1895
Photograph
Paris, Bibliothèque Nationale

FIG. 13
Edgar Degas, *Elie Halévy and Mme Ludovic Halévy*, c.1895
Photograph
Paris, Bibliothèque Nationale

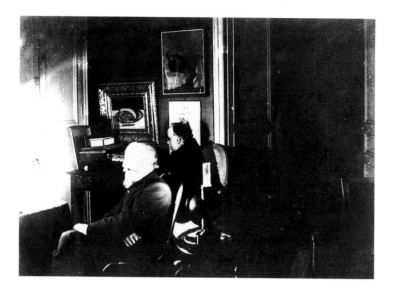

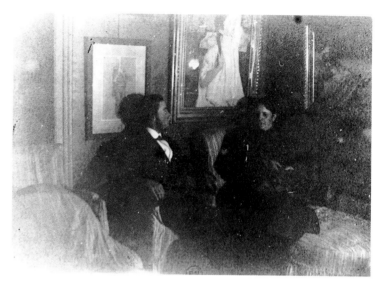

Manet confided to her journal a rather more romantic after-dinner descent to 'the museum' with the artist and her future fiancé, Ernest Rouart.[95] About 1901, Maurice Denis was invited by Degas to see his pictures by Ingres and was briefly entrusted with the precious key, while Degas 'finished a pastel' upstairs.[96] If relatively few guests were honoured in this way, a remarkable number seem to have been familiar with the pictures in Degas's bedroom, which was adjacent to the collection. Several accounts suggest that works of personal or sentimental value were hung here, including a pastel portrait of the artist as a child and one of the early paintings by Degas of his father with the guitarist Lorenzo Pagans (fig. 31).[97] Other pictures noted by his intimates were a drawing by Ingres and a small oil by Delacroix, studies by Manet and Corot, a silverpoint by Alphonse Legros and one of the 'wicked and supple' drawings of Suzanne Valadon.[98]

By contrast, the second storey of Degas's home represented his most public arena, where relatives and parties of friends were entertained, where dealers, critics and occasional collectors would come and go, and where the proprieties of middle-class life were respected to an extraordinary degree. The comfort and orthodoxy of his apartment can be imagined from a number of eye-witness accounts, and his taste

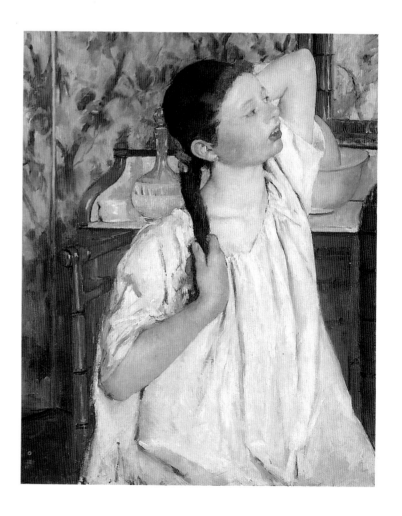

FIG. 14
Mary Cassatt, *Girl arranging her hair*, 1886
Oil, 75.1 x 62.5 cm (29⅝ x 24⅝ in.)
Washington, National Gallery of Art, Chester Dale Collection

inferred from some of the artist's own photographs, which show either his rue Ballu premises or, more probably, rooms in the rue Victor Massé.[99] On moving into the rue Ballu, Degas had thrown himself into the project of decoration, insisting that changes be made in the fabric, toying with expensive oriental rugs and confessing to Bartholomé that 'furnishing continues to preoccupy me'.[100] The results of this preoccupation are visible, if only hazily, in the well-known print of Degas and Bartholomé taken by lamplight (fig. 12) and in the less celebrated study of Louise Halévy (fig. 13), apparently in one of the artist's 'large salons'.[101] In both photographs, deeply moulded windows, shutters and doors can be seen, along with ornate tables and chairs, gilt-framed paintings and hints of rich carpeting and upholstery. Among the pictures are several works by Manet and Mary Cassatt's magnificent *Girl arranging her hair* (fig. 14), while in another photograph (fig. 5), showing a young girl posed on one of Degas's 'truly remarkable' rugs,

we glimpse the previously unidentified *Study of a woman* by Ingres (fig. 15), a reproduction of a van Eyck portrait and an oriental sculpture.[102] Other views reveal a silk-covered *chaise-longue* and a marble fireplace, a glass case containing leather-bound books and another holding Bartholomé's plaster *Weeping girl* (fig. 24), wall-hangings, ornaments and a bell-pull.[103] Whatever else they may signify, these are rooms to be seen and used, with possessions that speak of their owner's sophistication and the sedentary nature of his social being.

Described by Paul Lafond as the interior of a 'bon bourgeois' or a 'retired magistrate', whose 'old-fashioned furniture' was evidently handed down from the family, Degas's apartment was conventional and slightly grand. It must also have resembled a second private museum in its densely hung pictures, cabinets of sculpture, displays of Japanese books and neat piles of lithographs and illustrations by Degas's friends.[104] In many of these respects, Degas consciously perpetuated the ambience of his childhood home, where cultured formality rather than opulence are indicated by surviving descriptions and inventories.[105] By so doing, he again distanced himself from the erratic ways of life of many of his peers, and equally from the extreme ostentation of certain society painters. Just as he invariably dressed in top-hat and dark suit for social calls, so his reception rooms adopted the garb of his generation and class, prompting him to reprimand a visitor who expected bohemian surroundings by insisting, 'You are mistaken madame; you are in the home of a bourgeois!'[106] Clinging to such outward forms if not always to their maintenance, Degas continued his stratified existence into the early twentieth century, his clothes increasingly shabby for all their correctness, his apartment sombre and plagued by smoking chimneys.[107] When he described Gustave Moreau's nearby premises on the rue de La Rochefoucauld as 'truly sinister . . . it might be a family vault', Degas came close to summing up the surroundings of his own last years.[108]

Neither the sobriety of the 'museum' nor the sociable and splendid apartment prepares us in any way for Degas's top-storey studio. Once past the door, the visitor confronted a scene of 'indescribable disorder', according to Lafond, which Daniel Halévy remembered as 'sordid' and Georges Jeanniot as 'dusty'.[109] Here the artist, 'covered in pastel' and sometimes 'dressed like a pauper', held sway in a quite different universe, where almost all the conventions of the remainder of his dwelling, and of the rest of his existence, were systematically inverted. Though some of

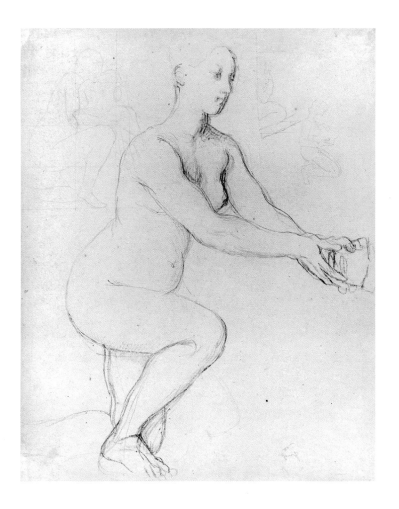

FIG. 15
Jean-Dominique Ingres, *Study of a woman*
Black chalk and pencil on paper, 36.4 x 29.5 cm (14⅜ x 11⅝ in.)
Copenhagen, Ordrupgaard

these descriptions date from the later years of Degas's occupancy, when a certain accumulation of materials and fixity of habit might be expected, they nevertheless have a consistency that is unmistakable. Perhaps the most vivid account is that of Degas's model 'Pauline', as related by Alice Michel, who tells us that her eyes would wander round the studio as she held her monotonous poses:

Although vast, it was gloomy, because the high north-facing windows which occupied a whole wall were almost obstructed by a linen curtain, falling very low; only a dim daylight filtered in, hardly reaching the end of the studio. This feeble light was interrupted everywhere by cupboards, numerous easels jumbled together, sculpture stands, tables, armchairs, stools, several screens and even a bathtub used for posing models as bathers.

The corners were no less cluttered; a quantity of picture-frames was arranged beside empty stretchers, rolls of canvas, rolls of paper. The only space left for Degas to work was very confined, at the front of the studio just under the windows. It was here, between the modelling dais surrounded by a screen, between the sculpture stand and the stove, that the mornings were spent.

But the most unpleasant thing, in Pauline's view, was the

dust that covered all the furniture. Old Zoé was only allowed to light the fire, sweep around the stand, the stove and the length of the route to the door, which ran down the middle of the studio. Apart from that, there was a strict ban on removing the dirt that had accumulated over the years. Degas, who was perhaps afraid of clumsiness, maintained that sweeping only moved dust around, that it would damage the frames and especially the canvases. No matter how much the models begged Zoé to clean at least the bench behind the screen on which they put their clothes, she always reminded them of Monsieur's ruling.

There was nothing, not the slighest ornament or drapery to brighten up this sombre interior. The brown doors and high walls were bare, without a single drawing or painting. Degas put away all his work in folders or cupboards, or piled them up in the little room at the end of the studio.[110]

Here we discover Degas the bohemian, Degas the master of chaos and, of course, Degas the egotistical monster. It was in these surroundings, at the same time bare and impossibly cluttered, that he spent his days 'shut away with his models and sketches', as Geffroy saw it, remote from the outside world and its protocols, even from his own norms of behaviour. No longer on duty or display, Degas abandoned the dress codes of his tribe, wearing the shapeless smock of his photographic self portrait or seen by Paul Valéry 'shuffling about in slippers, dressed like a pauper,

his trousers hanging, never buttoned'.[111] Behind his studio door he could sink into melancholic torpor, worrying about his eyesight or brooding on death, grumbling at his models or simply staring into the fire.[112] This was the artist who rudely turned away admirers or shunned prospective clients, or who equally whimsically charmed such visitors as Jeanne Baudot or Julie Manet, joking with them and patiently showing off his sculptures and pastels.[113] The testimonies of these varied individuals cover a period of more than two decades and naturally differ in their details (some of them, for example, describe certain of the artist's pictures on his studio walls), but they repeatedly turn to the themes of Pauline's vivid word-picture: the dimness of the light, the accumulation of the artist's recent works, the clutter of properties for use in his pictures and the sheer anarchy of his surroundings.[114]

Soon after moving to his new premises, Degas told Daniel Halévy how much he envied the soft, restful light in Jacques-Emile Blanche's studio, apparently achieved through the use of tinted glass; 'What light!', Degas exclaimed, 'my eyes immediately felt rested!'[115] Twenty years later, as his models and visitors emphasised, Degas still favoured a contrived gloom, partially covering his large windows with a curtain and, according to Valéry, insisting that the glass remained uncleaned to allow only a 'ghost of sunshine' through.[116] For a painter who specialised in brilliantly contrasted lights and shadows, to say nothing of the high-summer colours of his pastels and the autumnal hues of his canvases, such preferences must come as a surprise, though the artist himself explained to Halévy the errors of this simplistic response.[117] What is beyond doubt, however, is the deliberate adjustment of Degas's studio illumination to suit the damaged condition of his eyes, which had already been a source of anxiety for more than three decades.[118] Among the most pronounced of his symptoms was photophobia, or intolerance of bright light, manifested at one extreme in Degas's discomfort in the open air, at the other by his refusal to enter the Bal Tabarin, with its blazing globes and chandeliers.[119] On the street and while travelling, Degas habitually wore tinted spectacles to protect his eyes, though the controlled penumbra of his studio seems to have allowed him to work unaided.[120] While there is no question of colour blindness in the artist's condition, it cannot be sufficiently stressed that Degas's palette and the tonal range of his late compositions evolved in the most dismal of circumstances. Conceivably, the blazing corals and aquamarines of his last pastels were a specific response to these surroundings, as Degas adjusted to the constraints of his self-imposed obscurity. At the very least, we can be sure that his pictures seemed less incandescent than they appear under modern museum conditions, though the artist himself was to describe such late works as the *Russian dancer* series as 'orgies of colour'.[121]

FIG. 16
Maurice Denis, *Degas and his model*, c.1904–6
Oil, 38 x 46 cm (15 x 18⅛ in.)
Paris, Musée d'Orsay

Among the 'indescribable disorder' of cupboards, screens, tables and studio properties, many witnesses refer to the great number of easels in use by Degas at any one time, displaying past or current works of art or 'loaded with charcoal sketches of flat-nosed, twisted models', as Valéry bluntly recalled.[122] In addition, acquaintances such as Louisine Havemeyer describe the numerous portfolios of drawings stacked against the walls, on shelves and in the small rooms adjacent to the studio.[123] Instructive here is the image of Degas surrounded, almost immured, by his own production, with paintings, works on paper and, as we shall see, wax sculptures, visible at every turn or available for immediate reference. Many artists, of course, have been obliged to hoard their work through lack of patronage, but Degas's case is highly distinctive. Never short of customers, he had long been notorious for his reluctance to release pictures on to the market, especially those with a sentimental significance or a continuing role in his pictorial evolution. In effect, his drawings and studies provided a kind of visual retrieval system to be consulted at will, encouraging a symbiotic relationship between works in progress and works completed, as Degas compared one 'flat-nosed, twisted model' against another on a nearby easel, or a half-finished wax against its predecessor, or against a related pastel. As he laboured at his sequences of dancers, 'in one version the petticoats . . . yellow, in another purple', or made a *reprise* of a subject already a decade or more old, Degas was able to submerge himself in the self-contained continuities of his art.[124]

Two of the very few visual representations of the artist in his rue Victor Massé studio are the small paintings by Maurice Denis, *Portrait of Degas* (fig. 4) and *Degas and his model* (fig. 16). Both were executed in the early years of the twentieth century and both show Degas in his street clothes; in the former, preparing to leave the building, and in the latter making an appointment with Pauline or one of her colleagues.[125] In each case, stacks of pictures, some fanciful, others accurately remembered by Denis, provide an immediate background to the scene, blocking the space and framing the human protagonists.[126] Despite the curtness of Denis's manner, these pictures record a virtual hothouse of creativity, where proliferation and cross-fertilisation were endemic and exotic pictorial blooms could flourish. The analogy is extended by the essentially hermetic nature of Degas's chosen environment, with its carefully controlled access, its banks of reference material and its self-perpetuating routines. As the inventories of his visitors make clear, the studio was equipped with all the elements necessary for the propagation of Degas's art and the materials required for its nourishment. Apart from the furniture listed by Pauline, Lafond specified 'tables covered with lumps of clay and unfinished waxes', 'lithographic and etching presses' and 'boxes of colours, of pastels, of copper and zinc plates'; Vollard noted 'a little wooden horse' to help with equestrian scenes; and Valéry

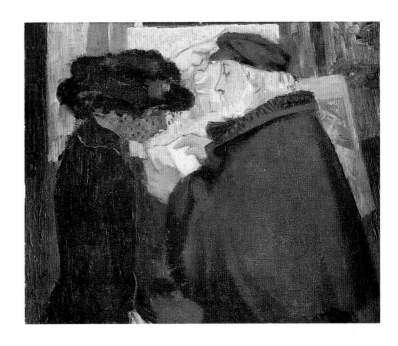

recalled a shelf 'piled with bottles, flasks, pencils, bits of pastel, etching needles . . .'[127] Surviving from other eras or still in use were 'double-basses, violins, baths, tubs, dancers' skirts and shoes, a life-cast of a woman, a conductor's podium, a piano, even a spiral staircase from a theatre'.[128]

Degas's fixation with several of these items is evident in many of the works under discussion. The 'dull zinc bathtub' noticed by Valéry must be the high-sided monster featuring prominently in the pastel *After the bath, woman drying herself* (cat. 47) and the charcoal *After the bath* (cat. 12), and one of the 'tubs' mentioned by various visitors occurs in the foreground of *Nude woman drying herself* (cat. 9).[129] Madeleine Zillhardt noted a 'divan', presumably the kind supporting the model in the Philadelphia oil *After the bath* (cat. 57), and two of the varieties of chair listed by Pauline appear in *Frieze of dancers* (cat. 16) and *Breakfast after the bath* (cat. 52).[130] The bench or *banquette* that Zoé was reluctant to clean is a standard fixture in Degas's ballet scenes, notably in *Group of dancers* (cat. 26) and *Study of four nude dancers* (cat. 36); in some of these variants, such as the repainted precursor of *Ballet dancers* in the Bührle collection (fig. 17), the bench supports a pair of pink satin shoes, perhaps those said to have been found in Degas's studio (fig. 18).[131] Moreau-Nélaton commented on the coloured fabrics on display in the studio, which must have inspired the backgrounds of *Woman at her bath* (cat. 49) and *The bath, woman seen from behind* (fig. 128), and even the improbable piano and spiral staircase mentioned by Lafond may lie behind such works as *Pagans and Degas's father* (cat. 3) and a painted version of *Three dancers* (cat. 70).

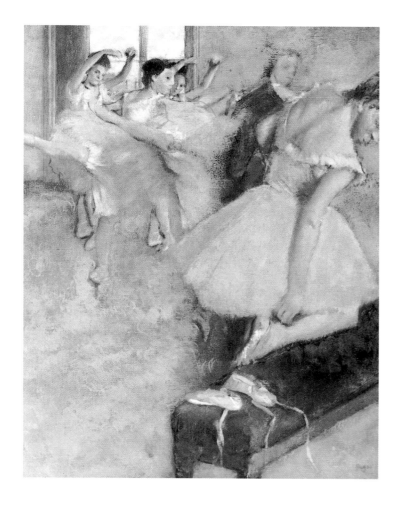

FIG. 17
*Ballet class, c.*1880–1900
Oil, 62 x 50.5 cm (24¾ x 19⅞ in.)
Zurich, Bührle Collection (L.587)

FIG. 18
Ballet shoe found in Degas's studio
Paris, Musée d'Orsay

Escaping from his 'bourgeois' third-storey apartment, Degas climbed the stairs to a confused, irrational world of make-believe that almost independently sustained his art. Within the four walls of his studio, the entire repertoire of furnishings, fittings and utensils in his later oeuvre could be found, needing only the animation of a model to create a semblance of life. By arranging a zinc tub, a chair, a screen and some drapery, Degas could conjure up a bathing scene; by posing his models in the muslin skirts recalled by Lafond, then seating them on his dusty bench, he could evoke a rehearsal room; and with a mirror and a wash-stand he could contrive another image of the toilette. Avoiding the inconvenience of real domestic locations, Degas cut himself off from the reality they represented, manipulating space and perspective, pattern and colour, human predicaments and narratives according to whim. In the accounts of Moreau-Nélaton, Pauline and others, and in the evidence of the pictures themselves, we can imagine entire areas of the studio cleared for each of these new settings. The barren arena of *After the bath, woman drying herself* (cat. 57), for example, must have been besieged on every side by the mountainous debris described by Degas's friends, heightening both its artificiality and the inconvenience of adjacent spaces. Pedantically detailed and outrageously bogus, these temporary locations would have turned parts of the studio into miniature stages or something close to a primitive film set. Stepping into this fiction, Degas's models briefly acted out their roles as ballerina or attentive maid, leaving their enchanted world at the end of the pose for ill-swept floors and the authentic warmth of the stove. And, once the picture or sequence was complete, the fragile walls could be knocked down and its components rearranged, its accessories recycled.

The few fragmentary glimpses of Degas's studio visible in his photographs offer tantalising confirmation of this impromptu state of affairs. In the self portrait already examined (fig. 3), the artist is posed against a portable screen of the kind listed by Pauline, its corner supporting one of the 'stale bathrobes' so fastidiously observed by Paul Valéry and familiar from a hundred Degas pastels. This print is also known is a less-cropped version, revealing more of its contrived, quasi-theatrical backdrop and the curve of the omnipresent zinc bathtub at bottom left.[132] The same tub can be seen in the most haunting of all Degas's photographs, *After the bath* (fig. 20), where its rim appears as a horizontal line beyond the model's thigh. Manifestly linked with the canvas of the same name (cat. 57), this image shows a screen, *chaise-longue* and bathrobe from the artist's motley collection, and two eruptions of oriental patterning that mitigate the scene's austerity.[133] In both pictures, Degas has positioned his subject with care, capitalising on the light from his tall windows, creating pools of shadow and intense, top-lit highlights. All the photographs associated with his studio repeat this

FIG. 19
Attributed to Edgar Degas, *Seated nude, c.*1895
Photograph, 17 x 12 cm (6¾ x 4¾ in.)
Malibu, California,
Collection of the J. Paul Getty Museum

FIG. 20
Edgar Degas, *After the bath, c.*1896
Photograph, 16.5 x 12 cm (6½ x 4¾ in.)
Malibu, California,
Collection of the J. Paul Getty Museum

FIG. 21
Edgar Degas, *Dancer of the corps de ballet, c.*1895
Photograph
Paris, Bibliothèque Nationale

pattern, while a print recently but not definitively linked with the artist, *Seated nude* (fig. 19), appears to show a bright rectangle behind the model's head designed to vary its effect.[134] Alarmingly, the sunshine falling on *Dancer of the corps de ballet* (fig. 21) seems to irradiate her figure, its solarised tones partially reversing the chiaroscuro of the studio. The result of a technical experiment, this and a number of related photographs again reveal the flimsy screens and hastily supported drapes of Degas's *mis-en-scène*, as well as poses that recur in several late drawings and pastels.[135]

None of these prints, of course, records the colours of Degas's surroundings, and it is left to us to imagine the 'salmon-pink' fabric arranged beside a bathtub, as recorded by Moreau-Nélaton, or the tinted tutus, bathrobes and hangings mentioned by other visitors.[136] In each case, no doubt, Degas gave himself considerable licence with his depicted hues and patterns, taking the cue from the stuffs to hand but freely inventing the stipples and streaks of such works as *Woman at her bath* (cat. 49). The one colour that is unequivocally documented, however, is that of his studio walls, described in Pauline's account as 'marron', or red-brown.[137] Varying in usage from mid-chestnut to the

dull purple of the English maroon, this surprising tint offered a tonally subdued if chromatically hot context for all Degas's visual activities, as well as providing a useful guide to the impact of his pictures on contemporary gallery walls. It may also survive in the dense, fiery atmosphere of certain paintings of the 1890s, notably the National Gallery's *Combing the hair* (cat. 42) and the Philadelphia *After the bath, woman drying herself* (cat. 57), both of them representing the kind of studio-corner stage-sets discussed above. The existence of alternatively coloured versions of such works, however, such as the cooler pastel variant of the London picture (cat. 41), returns us forcibly to the artifice of Degas's practice. Besieged in his studio with paints and coloured chalks, his zinc bathtub and cheap wash-stand, Degas had a God-like power to invent and destroy. Just as he could change the hue of a dancer's skirt with a few strokes, so he could add or subtract from the catalogue of properties that lay to hand, reliant only on the invigorating air of the streets supplied by his models. In this hermetic atmosphere Degas made his art, here it was seen by his visitors and from these autumnal walls it passed into the life of the city.

DEGAS AND THE MARKET-PLACE
The Accessibility of the Late Work

THOUGH DEGAS'S LIVING and working arrangements in the rue Victor Massé can be instructive in themselves, they have one overriding significance for his later reputation: that is their importance in the accessibility of his current works of art, both for his close friends and artistic intimates, and, beyond them, for the collectors, picture-dealers and exhibition promoters at the *fin de siècle*. Conventionally, we have been told that, as Degas 'concealed his life, he almost concealed his oeuvre', with the inevitable consequence that his art remained suspended, preserved in the vacuum of his studio and insulated from his immediate successors.[1] As with many other legends of Degas's old age, the roots of this misunderstanding can be traced back to their questionable source, to clients frustrated in their search for his pictures, to those with a commercial interest in their rarity, to others who were barred from his presence or too readily accepted his rhetoric, perhaps to our own unquenchable thirst for romance. Beneath them all, however, lie two sets of historical circumstances that have never been studied in detail and collectively undermine most of the retrospective mythology.

The first, discussed more fully towards the end of this chapter, concerns Degas's idiosyncratic manipulation of the Paris art market, not through the conspicuous solo shows preferred by such artists as Monet, Rodin, Cassatt, Renoir, Cézanne and others during this period, but by the selective release of batches of work to favoured outlets and individuals. Far from concealing his oeuvre, Degas regularly sold drawings, pastels and paintings to dealers in the 1890s and the early years of the twentieth century, parted with others in the form of exchanges and disposed of occasional items to colleagues. In addition, he seems to have co-operated in several hitherto overlooked displays of his pictures, and was undoubtedly aware of major showings of his work, including recently completed examples of drawings, pastels and paintings, in Paris, Berlin, New York, London and elsewhere. By a natural progression, many such pastels and oil paintings found their way on to the apartment and gallery walls of Europe, and into the auction houses and the dealers' stockrooms of the rue Laffitte, where we are told by a contemporary that they formed part of a 'second Louvre' for the next generation.[2] When we add to this Degas's ready participation in a number of publishing ventures, all calculated to promote his imagery in the form of black-and-white and colour reproductions, neither his alleged reticence nor the unavailability of his work sustain much of their former authority.

The second factor that disrupts the legend has already been touched upon in the catalogue of Degas's social engagements, professional encounters and casual visitors to his Montmartre premises. Not only did this stream of acquaintances have access to whatever pictures by the artist were visible in his apartment, but a substantial and well-documented proportion of them climbed the stairs from the third storey to the fourth,

FIG. 22
The Bath, c.1890–4
Charcoal and pastel on paper, 32.1 x 25.7 cm (12⅝ x 10⅛ in.)
New York, Metropolitan Museum of Art, H.O. Havemeyer
Collection, Bequest of Mrs H.O. Havemeyer, 1929 (L.1406)

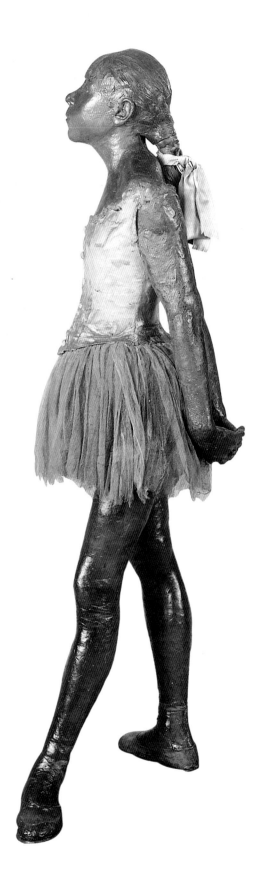

FIG. 23
Little dancer of fourteen years, 1878–81
Wax and other materials, 98 cm (39 in.) high
Upperville, Virginia, Collection of Mr and Mrs Paul Mellon (R.XX)

passing through the imaginary barrier in the artist's life to his studio beyond. In their diverse testimonies we are told of pastels and waxes seen in a state of incompletion, of excited invitations from Degas himself to see new work, and of certain images finished before their eyes. Among his guests were amateur artists and hardened fellow-practitioners, young bohemians from adjoining streets and high society gossips, dealers such as Joseph and Paul Durand-Ruel and the collectors Etienne Moreau-Nélaton and Louisine Havemeyer, all of whom might be expected to spread the word of his activities. As we approach Degas's final years, allowance must be made for the sad falling-off in the years before the war, when ill-health and morbidity seem to have preoccupied him to the exclusion of both art and affection. Nevertheless, surviving letters and the journals of friends all point to a measure of continued sociability up to his 1912 move to the boulevard de Clichy. By hazard or by design, therefore, Degas's output of his last decades was seen by his entourage and by his more determined admirers, whether in his own home, in the salerooms or in the galleries that clamoured for his output.

The neatest demonstration of this availability and of the distortion of the historical record concerns Degas's reputation as a sculptor. After the sensational appearance of the wax *Little dancer of fourteen years* (fig. 23) at the 1881 Impressionist exhibition, Degas never again included his statuettes in a public display, nor was the succession of smaller dancers, bathers and horses produced in his studio cast into bronze during his lifetime. Predictably then, we find Degas's biographers consigning his entire sculptural oeuvre to obscurity, François Fosca describing it in 1921 as 'unknown' and subsequent authorities perpetuating the formula, as in Rewald's 1944 claim: 'Few . . . were those who as much as knew that Degas did modelling; even fewer were those to whom the artist deigned to show some statuette.'[3] What is apparent from a detailed study of the period, however, is that awareness of Degas's three-dimensional experiments continued into his later years and attracted the most fulsome praise. Further, we find that many other examples of his sculpture were regularly, even casually available to visitors to Degas's apartment in the rue Victor Massé.

In 1886, for example, five years after the unveiling of the *Little dancer*, Félix Fénéon listed Degas's 'living painted waxes' among the artist's defining achievements;[4] in 1890, George Moore recalled an encounter with 'dancing girls modelled in red wax, some dressed in muslin skirts, strange dolls – dolls if you will, but dolls modelled by a man of genius';[5] while as late as 1897, Roger Marx still enthused about Degas's 'incomparable wax' and chose to illustrate several studies for the work in a contemporary article.[6] At an unspecified date, Renoir vividly remembered the 'ballet dancer in wax' in a discussion with Vollard, using it to advance Degas's claim to be 'equal to the ancients'. When

FIG. 24
Edgar Degas, *Degas looking at a statuette, c.1895*
Photograph
Paris, Bibliothèque Nationale

Vollard assumed that he was referring to Rodin, Renoir exclaimed, 'Who said anything about Rodin? Why, Degas is the greatest living sculptor!'[7] And more than three decades after the event, Louisine Havemeyer, who had tried unsuccessfully to buy the statuette from Degas in 1903, could still write of a time when 'artistic Paris was taken by storm . . . Was ever such a thing heard of! A ballerina with real hair and real draperies, and one of the greatest works of art since the dynasties of the Nile!'[8]

Degas's earlier achievement as a sculptor not only pursued him into his later years, but was continually reinforced by first-hand contact with his original works in three dimensions. Significantly, of the individuals quoted, Renoir and Fénéon were the only ones who certainly saw the *Little dancer of fourteen years* at the 1881 exhibition; George Moore remembered the 'strange doll' from visits to Degas's home, perhaps in his studio, where it was placed on view in its glass case and remained visible among the artist's possessions, despite several changes of address, for the next thirty years;[9] Mrs Havemeyer, who saw the work at the turn of the century, certainly encountered it in Degas's rue Victor Massé premises, apparently in the apartment rather than the studio, where she discovered 'a little vitrine containing the model of a horse and the remains of his celebrated statue of "La Danseuse"'.[10] Other intimates from these years, including Claudie Leouzon le Duc, Walter Sickert, Paul Valéry and Madame Jeanniot, confirmed the sculpture's continuing presence, while adding to the growing evidence that the *Little dancer* was not the only figurine on display.[11] Louisine Havemeyer's memory appears to be endorsed by William Rothenstein, who explicitly recalled 'a small wax model of a horse leaping to one side, which [Degas] made use of in a well-known composition of jockeys riding', and the English critic Charles Whibley used an emphatic plural when he wrote of the 'figures' he had seen.[12] Sickert also specified a multiplicity of works, noting 'the wax statuettes under their glass cases', and George Jeanniot's wife went further, describing a visit to the salon of Degas's apartment, where 'his essays in sculpture, nudes and clothed figures, were arranged'.[13]

The formal display of a number of pieces of Degas's own sculpture in his 'bourgeois' interior is of considerable practical and emblematic importance. Allowance must be made, of course, for alterations in his domestic arrangements and for the movement of waxes between studio and apartment, as well as for variations in witnesses' accounts.[14] But, in addition to the *Little dancer of fourteen years* and the 'model of a horse' described by Havemeyer and Rothenstein, at least three other figures were consistently visible in the later years, again in a glass case or vitrine. In her account of the artist's rooms, the model Pauline, who posed for several of Degas's sculptures, refers to a 'large display cabinet containing all sorts of charming trinkets, as well as several plaster statuettes that

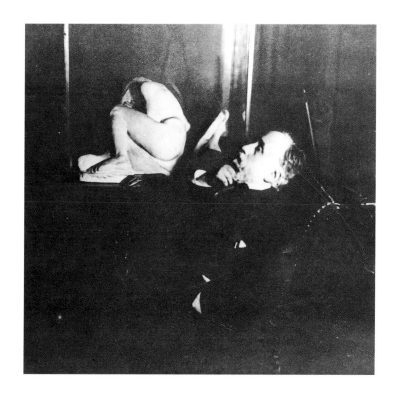

Degas had modelled himself'.[15] Though the unsystematic photographs of Degas's apartment omit this piece of furniture, one print shows the artist gazing at a display case containing a work in plaster by his sculptor-friend Albert Bartholomé (fig. 24), while a grandiose vitrine from Gustave Moreau's nearby studio evidently fulfilled a function similar to Degas's 'display cabinet'.[16] Some of Degas's 'trinkets', which included a plaster cast of the hand of Ingres and bronzes by Barye and Bartholomé, were itemised by Paul Lafond, while the identity of the 'plaster statuettes' can be deduced from circumstantial evidence.[17] In her description of a tiring and acrobatic pose she was required to hold for Degas, Pauline tells how she reminded the artist of an earlier sculpture based on the same position, now on show 'in the vitrine downstairs'.[18] A plaster cast corresponding to the pose in question still exists (fig. 25), one of only three plasters of Degas's smaller works to have survived and presumably identical with those remembered by Pauline, Madame Jeanniot and the many other visitors who passed through his salon.

Photographs of these three small plasters, *Spanish dance* (fig. 24), *Woman rubbing her back with a sponge, torso* (fig. 27) and *Dancer looking at the sole of her right foot* (fig. 25) have been preserved in the Vollard archives, though the history and significance of the works have been little explored.[19] It might be noted, for example, that Degas chose for the

FIG. 25
Dancer looking at the sole of her right foot,
c.1885–95
Plaster, 46.2 cm (18⅛ in.) high
Private Collection
Photograph Musée du Louvre,
Bibliothèque Centrale et Archives des Musées
Nationaux, Archives Vollard
(R.XLV)

FIG. 26
Spanish dance, c.1880–90
Plaster, 43.5 cm (17⅛ in.) high
Private Collection
Photograph Musée du Louvre,
Bibliothèque Centrale et Archives des Musées
Nationaux, Archives Vollard
(R.XLVII)

FIG. 27
Woman rubbing her back with a sponge, torso,
c.1890–5
Plaster, 43.7 cm (17¼ in.) high
Upperville, Virginia,
Collection of Mr and Mrs Paul Mellon
Photograph Musée du Louvre,
Bibliothèque Centrale et Archives des Musées
Nationaux, Archives Vollard (R.LI)

casting process a trio of images representing the most persistent themes of his maturity; the dance, the female nude and that curious hybrid, the 'nude dancer'. It is also noticeable that the three plasters were made from some of the most 'finished' of his sculptures, suggesting a self-consciousness about presentation and a relatively early date, perhaps around 1890, for the completion of the original waxes or clay models from which the plasters were cast.[20] There is also more to be said about the circumstances of the casting. Both Pauline and Paul-André Lemoisne date the event rather vaguely about 1900, without suggesting why Degas should have selected for immortality a group of studies that were already a decade or more old.[21] One justification, put forward in Lemoisne's seminal 1919 article 'Les Statuettes de Degas', is that his friends Bartholomé and Henri Rivière feared for the safety of the fragile figures and patiently coaxed the artist towards a more permanent material.[22] Degas's resistance, we are told, was due to his doubts about the fidelity of the casting process, though Vollard records an alternative explanation. Remembering the making of the plasters, the dealer claimed that Degas 'could not take the responsibility of leaving anything behind him in bronze; that metal, he felt, was for eternity'.[23]

Beyond the anecdotal record, what is most instructive about the set of plaster casts chosen for display is their reiteration of Degas's sculptural ambition. At some point in the *fin de siècle*, Degas singled out three of his wax or clay models from dozens already in existence, had them professionally translated into plaster (a standard preliminary to bronze casting), then installed the statuettes alongside his Barye bronzes and Bartholomé plasters for the benefit of himself and his visitors. Here, in the *Spanish dance*, was further evidence of the modelling skills that had produced the *Little dancer of fourteen years*; here again, in *Dancer looking at the sole of her right foot*, was his dexterity in capturing poise and movement; and here, in the deliberately fractured torso of *Woman rubbing her back with a sponge*, were signs of a new and self-conscious engagement with classicism. Though he stopped short of a bronze edition, these initiatives are hard to reconcile with the retiring and secretive artist depicted by Fosca, Rewald and others, suggesting, rather, a calculated retrenchment on Degas's part of his existing reputation as a sculptor. That this reputation was not solely dependent on remembered triumphs of the past or plaster casts glimpsed in the rue Victor Massé apartment, however, is amply demonstrated by successive generations of visitors. Not just Degas's formal collection, but the current sculptural exercises of his studio, his waxes, half-built armatures and mixed-media experiments, appear to have been regularly available to his peers.

In her journal entry for 29 November 1895, Julie Manet recorded one of many excursions to Degas's studio, on this occasion in the company of Renoir. Degas welcomed them and 'taking the dust sheets from a bust of M. Zandomeneghi' showed them his half-finished and later abandoned study of the Italian painter, 'an absolute marvel' with a 'big, slightly crooked nose' according to Julie.[24] Three years later, she recounted another such visit, when Degas 'received us very kindly in his studio where he had just been working on a delightful wax model of a nude woman'.[25] Her friend Jeanne Baudot also 'frequented this studio where cleaning-up was forbidden . . . I only had eyes for the admirable sculptures that Degas showed me . . .', she recalled.[26] Jeanne Fevre, the artist's niece, described how she watched as Degas modelled and ultimately destroyed two wax figurines, showing a frustration with the medium that was also witnessed and later immortalised in an anecdote by Ambroise Vollard.[27] Apart from his memories of the Zandomeneghi bust, Renoir spoke of 'a bas-relief' by Degas, claiming that the artist 'just let it crumble to pieces . . . it was beautiful as an antique'.[28] Another fellow-painter, Georges Jeanniot, surprised Degas at work on a 'small dancer in wax standing on one leg, the other thrown out behind, with an arm stretching forward' and discussed with him the problems of armatures.[29] As if to encapsulate these accounts, Joseph Durand-Ruel remembered in 1919 that 'whenever I called on Degas, I was almost as sure to find him modelling clay as painting'.[30]

The roll-call of those who either saw or knew about saw Degas's later sculpture is seemingly endless, laying to rest once and for all the legend of his secretive creativity. In her later years, Madeleine Zillhardt could still conjure up the 'maquettes representing horses' under their 'glass globes' that she had seen as a child;[31] the writer Daniel Halévy, intimate with the Degas household as a youth, recalled a studio where 'dried out waxes crumbled to dust and fell into powder';[32] Jacques-Emile Blanche remembered his first meeting with Bartholomé, whom he found helping Degas with one of his figures in 'red wax';[33] the singer Jeanne Raunay discovered the artist sitting alone with his statuettes, illuminated by the light of the fire;[34] and, even more dramatically, Sickert was shown a wax variant of the *Arabesque* motif by Degas, who 'held a candle up, and turned the statuette to show me the succession of shadows cast by its silhouettes on a white sheet'.[35] Degas himself spoke freely and at length about his 'attempts at modelling' to the writer Thiébault-Sisson in 1897, reporting on the progress of his 'little waxes' in a letter to Braquaval in 1901 and referring to his 'damned sculpture' in correspondence with Alexis Rouart.[36] So current were his activities in 'artistic Paris' that the young Paul-André Lemoisne, the most respectful of future biographers, felt bold enough to refer to them in print during the artist's lifetime, noting their 'power of expression' in a way that implied first-hand knowledge.[37] Such widespread familiarity demands a new approach to Degas's historic position as a sculptor, which sets aside the romance of the hermit-recluse and returns his wax and clay figures to the milieu that

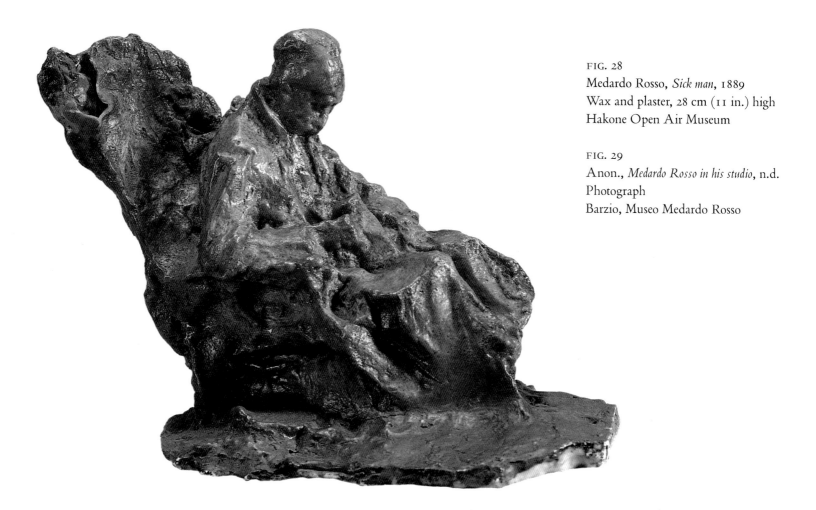

FIG. 28
Medardo Rosso, *Sick man*, 1889
Wax and plaster, 28 cm (11 in.) high
Hakone Open Air Museum

FIG. 29
Anon., *Medardo Rosso in his studio*, n.d.
Photograph
Barzio, Museo Medardo Rosso

both formed them and acknowledged their existence. Though they were not publicly exhibited, they clearly acquired a distinction and a following of their own, contributing in still partially understood ways to the medium of sculpture at a critical moment in its history.

Throughout this period, Degas sustained friendships with several prominent sculptors, ranging from a distant acquaintance with Rodin to a convivial, almost domestic relationship with the amateur modeller Paul Paulin. His principal contact with their world, however, must always have been through Bartholomé, his long-standing companion and practical adviser, who helped Degas with such technical matters as the making of armatures and preparations for casting. During these years, Bartholomé began to achieve considerable renown for his own waxes, marble carvings and bronze and plaster monuments, some of which, as we have seen, were represented in the collection in the rue Victor Massé apartment and stood beside Degas's own cast figurines. Almost equally celebrated in his day was François-Rupert Carabin, another modeller in wax and plaster who Degas knew and whose work he is said to have purchased (fig. 189).[38] As early as 1889, Degas made

the acquaintance of the highly original but irascible sculptor Medardo Rosso, who developed a distinctive technique involving the superimposition of wax on a plaster core, evident in such works as *Sick man* (fig. 28). Echoing certain of Degas's own experiments, these procedures were applied to figures in movement and a number of portraits, including one of Henri Rouart, which is just visible at lower right in a contemporary photograph of Rosso himself (fig. 29).[39] A letter of 1890 records Degas's contact with the sculptor Alfred Lenoir, and other sources tell of a conversation with Gérôme, painter and celebrated maker of polychrome figures, on the subject of Donatello.[40] Twice in his later career Degas became the subject of portrait busts by the dentist and part-time sculptor Paulin, who also immortalised Pissarro, Monet and Moreau-Nélaton in the same way. Letters from Degas to Paulin over more than two decades suggest the warmth of both their practical and social contact, not least in a specific invitation to the sculptor to visit Degas in his studio, where the evidence of his own modelling was continually on view.[41] Separated by temperament, politics and perhaps professional vanity, Degas and Rodin seem to have kept their distance,

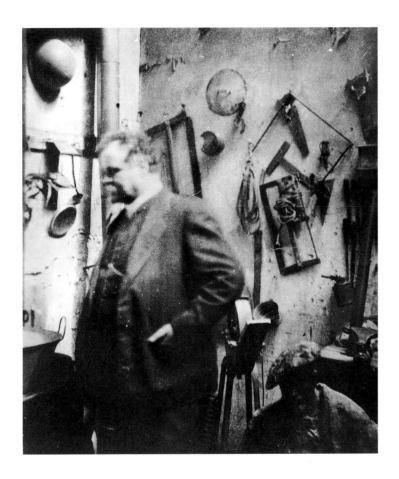

FIG. 30
Auguste Rodin, *Pas-de-deux*, c.1910–13
Bronze, 27.9 cm (11 in.) high
London, Courtauld Institute Galleries (Lillian Browse Collection)

a brief note from the former suggesting at least one social encounter, while Rodin's extraordinary late series of dancers, such as the *Pas-de-deux* (fig. 30) is surely inconceivable without some knowledge, perhaps vicarious, of Degas's wax figurines.[42]

Most challenging of all, however, are the hints that leading lights of the next generation of sculptors were aware of such works. As the brief survey in chapter 6 suggests, practitioners as varied as Picasso and Maillol, Derain and Matisse, Pavel Troubetzkoi and Henri Gaudier-Brzeska were likely to have known of Degas's waxes at first- or second-hand, while their reputation may have travelled even further. Certain modelled figures from Picasso's early years in Paris, such as his 1906 terracotta *Woman combing her hair* (private collection), were like acts of homage to his near-neighbour, while Degas's status as the major painter-sculptor of the Impressionist generation appears to have provided a more general model for both the young Spaniard and the slightly older Henri Matisse.[43] Details of links between these very different practitioners are only beginning to emerge, but their pattern is unmistakable. The presence of Louis Rouart's address in one of Picasso's sketchbooks

brings the subject of a Degas pastel portrait into the orbit of Cubism, while a visit by Fernande Olivier to Degas's studio in about 1904, when she found the elderly artist 'working on little statuettes', builds a modest but utterly enthralling bridge between two epochs.[44]

The case of Degas's sculpture is, of course, an extreme one, as he chose not to sell, publicly exhibit or make available for reproduction a single work from his later three-dimensional oeuvre during his lifetime. One under-acknowledged explanation for this reticence is explored elsewhere in this volume, where Degas's reliance on his wax statuettes as substitutes for living models is briefly assessed. But if it is true that his close friends and neighbours came into regular contact with these figurines, how much more familiar they must have been with his two-

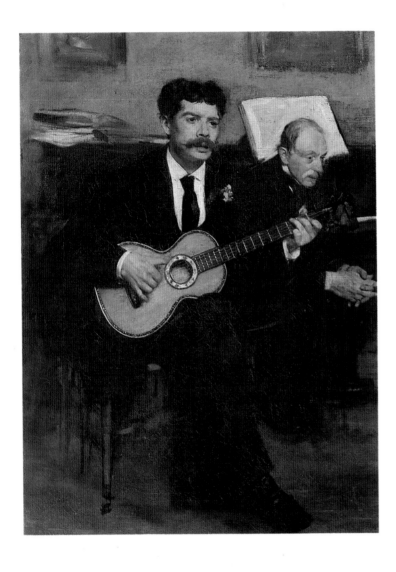

FIG. 31

*Lorenzo Pagans and Auguste De Gas, c.*1871–2

Oil, 54 x 40 cm (21¼ x 15¾ in.)

Paris, Musée d'Orsay (L.256)

dimensional work, to the drawings, pastels and oil paintings that were certainly not kept hidden or out of public circulation in these years. Most obviously, visitors to Degas's rue Victor Massé home who glimpsed the waxes would have seen whatever pictures were currently on view, among them earlier works hung in pride of place in the apartment, such as the *Lorenzo Pagans and Auguste De Gas* (fig. 31) in the artist's bedroom, the *Monsieur and Madame Edouard Manet* visible in the photograph of his salon (fig. 12) and what Paul Valéry described as 'a study of a *danseuse* which always made me covetous'.[45] Beyond these fixed artefacts was the endlessly shifting population of works in progress on the fourth floor, where recently drafted tracings, folders of drawings and abandoned compositions jostled for attention.

As with his sculptures, Degas again took pleasure in displaying certain of his current paintings and works on paper to the curious. When Vincent van Gogh's brother Théo, in his capacity as dealer for the Boussod et Valadon gallery, brought their sister Wil to inspect Degas's wares in 1890, the artist 'trotted out quite a number of things in order to find out which of them she liked best'.[46] Later in the decade, Julie Manet enthused about the 'lovely things in his studio' on one visit and was shown 'three pastels of women in Russian costumes' and 'some torsos and dancers' on another.[47] Jeanniot once waited with Degas 'for a celebrated picture dealer', while his mentor finished 'a pastel representing a woman leaving the bath . . . in a delicious harmony based on orange', and Moreau-Nélaton interrupted work on a bather study 'with a maid in the foreground', possibly *Breakfast after the bath* (cat. 52).[48] Another large picture of this period, *Four dancers* (fig. 125), was remembered in Degas's studio by Sickert, who suggested it was 'perhaps his masterpiece';[49] Valéry's encounters with 'charcoal sketches' of women combing their hair have already been noted;[50] and Mr and Mrs Havemeyer, who 'went several times to see Degas', recalled one occasion when, 'after we had looked at several pastels lately finished, Degas opened a portfolio to show us some of his drawings', which he 'tenderly lifted . . . one by one and showed them to us.'[51] Other tales are told of less welcome guests, including an American collector anxious to buy a picture with whom Degas haggled brutally, but, once again, those who did receive a warm welcome tended to stress their privileged access.[52]

As with any other artist, however, it is the pictures released into the outside world, and the manner of this release, that largely defines their immediate achievement. In this respect, Degas's history is unique among his peers, though the nature of this uniqueness has often been overstated or inaccurately defined. During the heyday of Impressionism, as we have often been told, Degas emerged as one of the principal exhibitors at the group events, participating in seven of their eight shows and contributing significantly to their organisation and promotion.[53] At the

same time, he became known as a difficult exhibitor, manipulative in his attitude to fellow-participants and pedantic over details of lighting, publicity and even terminology. Attracting both critical praise and patronage, Degas also joined his more successful colleagues in exploring other avenues for the promotion of his output – depositing pictures with dealers and selling direct from his studio, though not returning to the Salon, as did Monet and Renoir, nor yet favouring the one-man shows that seriously threatened the cohesion of the group. At the time of the last Impressionist show in 1886, Huysmans could write that Degas 'had voluntarily exiled himself from private exhibitions and public locations. At a time when every painter wallows in the trough of the common herd, he has completed, at a distance and in silence, some incomparable works of art'.[54] Quite distinct from commercial considerations, we already sense Degas's remoteness, perhaps his arrogance, as well as hints of the scarcity of his pictures and the high prices customers might expect.

After 1886 it was undoubtedly the case that Degas's public history as an artist departed radically from that of most of his colleagues, whose dominant aim seems to have been to present their recent work as advantageously, as profitably and as frequently as possible. For an artist such as Monet, the solo exhibition became a springboard to international stardom and considerable personal wealth, entailing formal agreements with leading galleries and the promotion of his work in several continents. With shows in Paris alone in 1888, 1889, 1891, 1892, 1895, 1898 and 1900, at such galleries as Boussod et Valadon, Durand-Ruel and Georges Petit, Monet pioneered a route that was followed, albeit less spectacularly, by Renoir, Cassatt, Pissarro and Cézanne. With the solitary exception of his 1892 display of landscapes, an idiosyncratic event in a number of ways, Degas stood aside from this cycle of regular exposure, refusing offers to exhibit in prestigious circumstances and mocking the commercialism of his acquaintances (he later told Mary Cassatt that Monet had 'done nothing worth doing for twenty years').[55] It is simply not the case, however, that Degas withdrew from exhibiting altogether in his later years or refused to release work from his studio, as we have so often been told. As with the supposed reclusivity of his person and the invisibility of his waxes, the reality is both more complex and ultimately more instructive.

Degas's equivocation in these matters is sharply captured in a note sent by Paul Durand-Ruel to Henry Roujon, the Superintendant of Fine Arts, at the time of the 1892 landscape show. Durand-Ruel hoped to entice Roujon to his gallery, presenting him with the following paradox: 'As you know, Degas never exhibits and it is quite an event to have persuaded him to show a group of new works.'[56] Modest though it is, this statement sets the tone for much of Degas's remaining career, juxtaposing a real aversion to publicity and self-promotion, which did

not exclude an acute sense of how such an aversion might be presented to his own advantage, with a need for sales and a wish to assert his presence in the current cultural milieu. Like the fiction of his solitude, Degas's carefully promoted reputation as an artist who 'never exhibits' distanced him from the harassment of dealers and the attentions of the press, and allowed him to control the time, place and circumstances in which his work would be released, if at all. Responding in 1891 to Aglaüs Bouvenne, who had included one of Degas's lithographs in an exhibition at the Ecole des Beaux-Arts without his permission, the artist wrote, 'I insist, on all occasions to appear, as far as possible, in the form and with the accessories that I like'.[57] As the 1892 show demonstrated, this fastidiousness extended to the most minute details of the mounting and framing of individual works, with highly original and sometimes bizarre results.[58] In subsequent years, Degas's passion for presentation seems to have diminished, though his tastes were sometimes respected by dealers and collectors and certain earlier works kept their former frames.[59] Several pictures included in these pages are recorded in archival photographs with plain white or tinted frames that follow the artist's known designs, and others have been mounted in ingenious modern reconstructions.[60]

But none of these factors truly justifies Degas's rejection of the path chosen by Monet and his colleagues, and we must look elsewhere for an explanation. As an artist whose work had attracted collectors for some years, the need to make money from sales was not paramount for Degas, as it was for Pissarro, Sisley and Monet for example; nor, on the other hand, did he show any desire to live ostentatiously or accumulate wealth. Equally, Degas did not enjoy the inherited affluence that has sometimes been associated with his middle-class banking family; for much of his life thinking of himself as a working artist who lived on the proceeds of his labour.[61] Several contemporaries tell us of the simplicity, even the meanness, of life at 37 rue Victor Massé, where small change was precisely counted out for his models and expenditure on new clothes and even food begrudged.[62] In the hundreds of letters Degas sent to Durand-Ruel, a significant number complain that he is out of funds and request small remittances to be paid to his maid, a tradesman or one of his suppliers of materials.[63] Durand-Ruel, it appears, acted as Degas's personal banker in later years, balancing such sums against the regular deposit of pictures at agreed prices, forwarding the artist's three-monthly rent of 2,000 francs and occasionally intervening on his behalf at auctions and in matters of insurance.[64] At times, Degas seemed to be leading a hand-to-mouth existence, surrendering a handful of pastels to increase his credit or cover his arrears – a situation confirmed by such intimates as Daniel Halévy and Jeanne Fevre, who wrote that he 'sold only out of necessity' or in order 'to allow him to acquire works by artists

he admired'.[65] Realistically, of course, Degas was sitting on a goldmine, the thousands of pictures, prints and items of sculpture by himself and others stored in his three-storey home representing 'great artistic riches', as Durand-Ruel rather pointedly described them in 1901.[66] Degas's instinct, however, was to keep these works under his roof, relishing past achievements, as in the 1860 painting of the *Young Spartans* (fig. 108) predominently displayed in his apartment through much of his later life, or endlessly embellishing and retouching, and sometimes ruining, recent productions.[67]

His retentiveness may have had other, deeper, origins. Perhaps derived from his privileged childhood and adolescence, Degas retained 'a horror of commerce', in the words of his niece, refusing to discuss financial matters in front of his models and lambasting the ostentation and competitiveness of galleries: 'Show in colour shops, restaurants,' he advised William Rothenstein, 'anywhere but at the brothels that picture shows are.'[68] He mocked the extravagant behaviour of people at exhibitions ('I see no need to lose consciousness in front of a lake', he said at a private view of a landscape painter's work[69]) and satirised a show with 'a catalogue, and a preface to this catalogue'.[70] For Degas it seems, public display and vulgarity went hand-in-hand, along with all the apparatus of Salons and juries, honours and decorations, criticism and 'art talk', the invasiveness of journalists and the excessive claims made for his fellow-professionals: 'Monsieur is not a genius,' he said of a colleague, 'he is a painter'.[71] Linked with this rhetoric are hints that Degas had been wounded by his own reception at earlier exhibitions, presumably the Impressionist shows of the 1870s and 1880s, or at least felt himself misrepresented and misunderstood. Huysmans' claim that Degas had 'exiled himself' from the public arena included the suggestion that the display of pastel nudes in 1886 was like 'an insulting farewell' to the throng, and in his 1912 monograph Lemoisne specifically blamed Degas's 'premature retirement' on the 'incomprehension of the crowd'.[72] This disdain became a repeated chorus in the artist's last years, echoing his deep social conservatism and his sense of the intractability, perhaps the ultimate elusiveness, of his enterprise. 'I don't give a damn about the public!', Vollard reports him saying;[73] 'All people talk about now is popular art. . . . What criminal folly it is!', the model Pauline was told.[74]

In his last decades, Degas's distaste for attention had a number of immediate effects on his career, limiting but not entirely preventing the circulation of his pictures. Writing in 1888 to Octave Maus, who had invited him to exhibit at the Libre Esthétique in Brussels, Degas admitted that, after a certain hesitation, he had decided 'to decline the proposition you put to me. I have too many reasons for staying away and I have a fancy that I cannot overcome to confine myself to this country'.[75]

Nationalism, then, played some part in Degas's behaviour, as it did in his later collecting habits, though not sufficient to persuade him to participate in the French pavilion at the 1889 Exposition Universelle, where he reputedly turned down an offer of a room for his own pictures.[76] In 1891 he had a serious quarrel with Durand-Ruel over a projected show, perhaps a revival of the Impressionist cycle, with Pissarro and Cassatt also threatening to abandon the dealer and 'exhibit with Degas' elsewhere.[77] This potentially historic event never materialised, nor did another proposed display of the artist's work at the Exposition of 1900, against which Degas vociferously campaigned, reminding the organisers 'not to think that you have any claim on my independence'.[78] Instead, the merest handful of pictures represented the artist on this millennial occasion, obtained without his co-operation and deriving exclusively from earlier periods.[79] Though he had no way of controlling the fate of the Caillebotte collection and the Camondo bequest, given to the French nation in 1896 and 1908 respectively, Degas again expressed reservations about their accessibility and once more found himself presented to the world as a painter of the Impressionist era.[80]

This situation would have been a bleak one indeed, amounting to an effective veto on all formal displays of Degas's post-1886 imagery in his lifetime, were it not for the substantial and well-documented indications of his alternative approaches to the market. In the first instance, as we have seen, Degas habitually sold individual 'articles', as he called them, to a variety of dealers, knowing full well that they would be exhibited in 'the brothels that picture shows are' and exposed to the 'incomprehension of the crowd'. In turn, such pictures would be bought and perhaps re-sold, making appearances at auctions and finding themselves legitimately gathered together, with or without the artist's consent, to form surveys of Degas's output. This, in effect, is what continued to happen, with literally hundreds of works leaving Degas's possession over the years, passing piecemeal into private collections or accumulating in the stockrooms of prominent galleries. The story is a complex one and still awaits patient reconstruction, but with each passing year the narrative becomes clearer. Using the Durand-Ruel ledgers and albums and the proliferating numbers of the artist's published letters, as well as the recently released Vollard archives and other documentary sources, such as the Cassirer papers, a tale of slow dissemination and vigorous currency has emerged, sometimes underscored by the detailed records of the pictures themselves.[81] In the present context, it is sufficient to establish the broad thrust of this saga, illustrating certain of its more piquant episodes and introducing its principal characters, before moving on to examine some of its previously unknown highlights, notably a group of exhibitions of work by the artist who 'never exhibits'.

FIG. 32
William Thornley (after Degas), *Woman leaving her bath,* 1888
Lithograph, 25 x 33 cm (9⅞ x 13 in.)
The Art Institute of Chicago, The Charles Deering Collection

FIG. 33
Paul Gauguin, *Page of sketches after Degas,* 1888
Black chalk on paper, 34 x 22.5 cm (13⅜ x 8⅞ in.)
Paris, Musée du Louvre

Around the time of the 1886 Impressionist show, Degas was doing regular business with a series of different dealers, apparently not yet overcome with his 'horror of commerce' and distributing work to Clauzet, Portier, Delorière and Boussod et Valadon, as well as Paul Durand-Ruel, his principal and long-standing agent. Degas's work was selling briskly and by playing off one gallery against another he found that he could increase this allure and raise his prices.[82] By 1888, Théo van Gogh had established a sufficient understanding with Degas to mount a small, informal display at Boussod et Valadon, where Michel Manzi was employed for his expertise in graphic matters. Van Gogh showed at least nine bather studies, all from the mid-1880s and all finished in pastel, most of them small and several worked over earlier monotypes, such as the *Woman leaving her bath,* later reproduced by William Thornley (fig. 32).[83] Félix Fénéon noticed the show in a wide-ranging article; Gauguin sketched many of the pictures on the premises, including *Woman leaving her bath* (fig. 33); while Berthe Morisot wrote to Monet that she had seen the 'the nudes of that fierce Degas, which are becoming more and more extraordinary'.[84] The following year, the artist could write of 'the fortune that Manzi places at my feet', even as he sold a handful of unidentified works to both van Gogh and Durand-Ruel, the former again displaying some in his gallery and the latter including two lithographs in the opening show of his Société des Peintres-Graveurs exhibition.[85] In 1890 this pattern of sales continued, though we can now

specify, on the one hand, that several pictures from earlier in Degas's career were among van Gogh's purchases and, on the other, that the very recent *Three dancers* (cat. 86) was bought in that year by Durand-Ruel for 800 francs.[86] 1891 was the year of Aglaüs Bouvenne's presumptuous showing of one of Degas's lithographs at the Ecole des Beaux-Arts, another event noted by Fénéon, and of the artist's quarrel with Durand-Ruel, followed shortly by their reconciliation at the time of the 1892 landscape exhibition.[87]

FIG. 34
Wheatfield and green hill, 1892
Monotype and pastel on paper, 26 x 34 cm (10¼ x 13⅜ in.)
Pasadena, California, Norton Simon Museum of Art (J.320)

'The event of the season', as it was called by one critic, the 1892 show at the Durand-Ruel gallery of two dozen pastels and heightened monotypes, such as *Landscape* (cat. 97), *Steep coast* (cat. 98) and *Wheatfield and green hill* (fig. 34), attracted a glittering company of critics, society figures and Degas's fellow-artists, despite the modest scale of the works and their baffling technical character.[88] In this sense, Degas was certainly successful in reasserting himself on the Parisian art scene and in boosting his fortunes, not least by selling the entire contents of the exhibition to Durand-Ruel for the considerable sum of 1,000 francs per picture.[89] The dealer, in his turn, soon disposed of about half his stock to collectors such as the Havemeyers, the Japanese importer Tadama Hayashi and the Bostonian Denman W. Ross, shipping several to his own New York gallery where they featured in a number of subsequent shows (figs. 38–40).[90] Another important purchase of Durand-Ruel's in 1892 was *Before the ballet* (cat. 8), significant not just as a freshly completed canvas from the artist's studio but as an expansive, and possibly repainted, variant of an earlier motif in Degas's new, broadly brushed manner. There is some evidence that in 1894 Durand-Ruel

FIG. 35
The Conversation, 1895
Pastel on paper, 65 x 50 cm (25⅝ x 19¾ in.)
Location unknown, photograph Archives Durand-Ruel, Paris
(L.1175)

again hung several of the landscape monotypes in his rue Laffitte premises, and in this same year a group of largely unidentified pictures by Degas also appeared in a mixed show at Camentron's gallery.[91] The next year, the artist's recent photographs were reputedly put on view at Tasset et Lhôte, one of Degas's suppliers in the rue Fontaine, a few steps from his studio.[92] Meanwhile, his relationship with Durand-Ruel seems to have been regularised. Théo van Gogh had died in 1891, soon after his brother's terrible end, thus leaving Durand-Ruel as the principal, if not the exclusive, channel of Degas's art into the wider world for some years to come. An unspecified understanding was evidently struck between artist and dealer, by which Degas ceased his business with other galleries in return for credit facilities, steady prices, occasional exchanges and the kind of banking arrangements already described.[93] During this period, from about 1894 to 1904, their often cordial correspondence and the artist's requests for money reached a peak, as did the dealer's recorded acquisitions of Degas's current and previous work.

Among the dozens of pictures bought directly by Durand-Ruel from Degas in these years was a scattering of identifiable pastels that had only recently left the artist's easel. These pictures would naturally have taken their place on the gallery walls or in the stockroom, where they were readily available to connoisseurs and practitioners alike: 'Old Monsieur Durand-Ruel, his son and assistants, would always allow us youngsters to enjoy their treasures,' wrote William Rothenstein, 'Their gallery, between the rue le Peletier and the rue Laffitte, was to me a kind of second Louvre,'[94] The vitality of this 'second Louvre' and Durand-Ruel's acumen as a salesman is apparent in the records; on 29 January 1895, for example, the dealer bought three works from Degas, all of which he had sold again within two years, one of them to Renoir;[95] four months later, on 29 May, he acquired the relatively small pastel of *The Bath* (fig. 22) at public auction, selling it for 600 francs to Mr and Mrs Havemeyer on 19 September the same year;[96] and on 16 December, he came away from the rue Victor Massé with the magnificent *Morning bath* (cat. 83), which was bought by Mrs Potter Palmer on 20 June 1896 for the considerable sum of 5,000 francs, passing directly from the collector to the Art Institute of Chicago in 1922.[97] Following his practice, Degas signed most of these works as they left his hands, though frustratingly dated very few. An exception is the handsome *Conversation* (fig. 35) of 1895, bought the following year along with several other pastels,

FIG. 36
In the rehearsal room, c.1891–8
Pastel on paper, 60 x 75 cm (23⅝ x 29½ in.)
Location unknown, photograph Archives Durand-Ruel, Paris (L.1294)

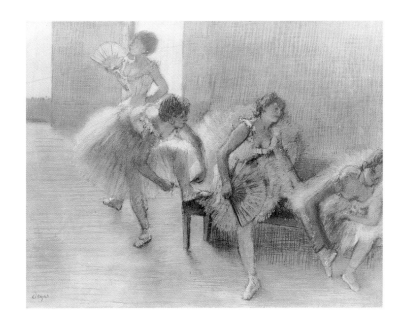

FIG. 37
Pink dancers, c.1895–8
Pastel on tracing paper, 84.1 x 58.1 cm (33⅛ x 22⅞ in.)
Boston, Museum of Fine Arts, Seth K. Sweetser Fund (L.1337)

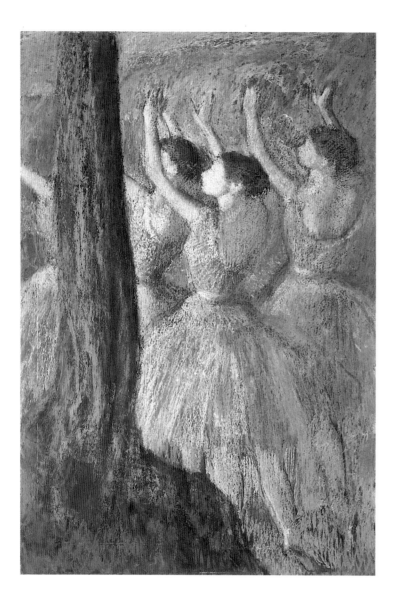

including *Three dancers in purple skirts* (cat. 73).[98] Tellingly, this work changed hands at least twice more in the next decade, passing through the galleries of Georges Petit and Bernheim-Jeune in the process, fetching 7,800 francs at the Tavernier sale of 1900 and suggesting a near-frantic interest in densely coloured and unproblematic subjects of this kind.[99] The Durand-Ruel archives indicate that *In the rehearsal room* (fig. 36), a work supposedly completed several years earlier, was bought in 1898 (from the Rouen collector Depeaux for 4,000 francs) and that a pastel bather of the late 1880s, *Nude woman drying her arm*, was acquired direct from the artist, to be sold on through no less than four collections before being donated to the Metropolitan Museum, New York, in 1929.[100]

At the turn of the century, then, a steady stream of finished pictures could be seen in the 'second Louvre' on the rue Laffitte, dominated by the output of recent years and representing most of the defining themes of the artist's maturity. Oil paintings and portraits were scarce and monochrome prints entirely absent, reflecting the transformed state of Degas's craft, while some of the subjects of the late decade, such as the Saint-Valéry landscapes and the *Russian dancers*, had yet to be unveiled. Almost as a marketing strategy, it seems, Degas contrived to release samples of each of his distinctive motifs into the public arena, sometimes as single items from a group, such as *Woman combing her hair* (cat. 41) sold to Durand-Ruel in 1899, *Dancers* sold in 1900, and *Dancers with fans* (fig. 155) and *Woman with a towel* (fig. 164), both sold in 1901, and sometimes as variants on a repeated image.[101] Among the latter are two portrayals of women washing over a basin, *Woman at her toilette* and *The Toilette*, and two clusters of ballerinas with raised arms, the *Three dancers with purple skirts*, already discussed, and the glorious *Pink dancers* (fig. 37), bought in by Durand-Ruel in 1901.[102] In parallel with these sales, Degas's pictures of the 1890s appeared with increasing frequency at Parisian auctions, such as the Vever, Goupil, Sisley, Tavernier, Abbé Gaugain and Lacroix sales held in successive years between 1897 and 1902, where such works as *The Toilette* and *Bathtime* passed before the public.[103] Such 'unplanned' sightings inevitably broadened the perception of Degas's activities and sustained the enthusiasm of collectors, even as they exemplified the rising prices of his 'articles'.

Two further mechanisms helped to disseminate Degas's later art at the turn of the century, both epitomised by initiatives of the Durand-Ruel gallery and both seemingly dependent on the co-operation of the artist. The first concerns the presentation of informal exhibitions of Degas's work, intended to draw attention to the stock of various dealers, and showing pictures of different periods or a new motif or series. Such shows were a regular feature of gallery life, as Théo van Gogh's activities at Boussod et Valadon illustrate, but were given little publicity and attracted meagre critical attention. That they also occurred under Durand-Ruel's management, and in the specific context of Degas's later art, is indicated by a note in the correspondence of the Pissarro family that has only recently come to light. Writing in 1896 to his brother Lucien about their father's current exhibition of Rouen canvases, Georges Pissarro added as a postscript, 'At Durand there is a new series of nudes by Degas, ah! the pig! it's admirable, pastels . . . as rich and solid as a tapestry'.[104] The identity of this 'new series of nudes' is unclear, though it may have included such recently acquired items as the Chicago *Morning bath* (cat. 83)[105] and *Leaving the bath* (fig. 166), as well as a range of other signed pastels dating from mid-decade.[106] A review by André Mellerio in *La Revue Artistique* explains that the display was 'one of these

FIGS. 38, 39, 40
Anon., *Degas exhibition at the Durand-Ruel Gallery, New York, c.*1901
Photographs Archives Durand-Ruel, Paris

discreet exhibitions, without announcements or fuss' that was appreciated by 'the élite among art-lovers', but makes clear that it had substantial retrospective ambitions. Beginning with *Sulking* of about 1870, the show surveyed 'paintings, many important pastels, drawings and unique prints', as well as a group of landscapes and a *Laundress*.[107] A display of this kind must surely have been mounted with Degas's blessing, if not his active participation, especially in the cordial and businesslike atmosphere that characterised the current exchanges between dealer and artist.[108] Though Degas seems to have regarded pictures acquired by commercial galleries as no longer subject to his control, it is difficult to imagine such amicable relations surviving any promotional project to which he was opposed.

These considerations apply crucially to Durand-Ruel's second initiative, that of promoting his stock of pictures and leading artists abroad. Almost from the beginning of his association with Impressionism, Paul Durand-Ruel had set his eye on foreign markets, but it was his vast 1886 exhibition of Impressionist and other works in New York that 'helped to turn the tide' of his fortunes, in John Rewald's phrase.[109] By 1888 he had opened his first branch in that city, arousing resentment in other dealers, and despite the reluctance of certain artists to allow their recent canvases to travel across the Atlantic, perhaps never to be seen again.[110] As we have discovered, a substantial group of Degas's landscape pastels from his 1892 exhibition were treated in this way and a marked taste for his art, pioneered by such imaginative collectors as Denman W. Ross, Mrs Potter Palmer, Mr and Mrs Havemeyer, Harris Whitemore and Oliver H. Payne became evident during this decade. A surprising number of Degas's pictures appeared in mixed shows across the United States, typically chosen from private holdings and showing the achievement of his Impressionist phase, notably in Cleveland in 1894 and at a series of remarkable annual exhibitions in Pittsburgh from 1896.[111] Durand-Ruel was both instrumental in and responsive towards this development, accumulating a number of attractive pictures in his lavish new Fifth Avenue premises and effectively dominating the American trade in Degas's work for some time. To his considerable credit he was not afraid to mix abrasive, freshly acquired images with more orthodox works from the artist's past. Most remarkable here is an exhibition staged at 389 Fifth Avenue, apparently in 1901, making it Degas's first show in the United States and one of the earliest exhibitions by an Impressionist artist to be recorded photographically.[112] Though no documentary account of the event survives in the Durand-Ruel archives, three prints (figs.38–40) of the installation reveal the elaborate hanging and framing arrangements, the number and stylistic range of the exhibits, and, with some help from an enlarging lens, the identity of each picture on display.[113]

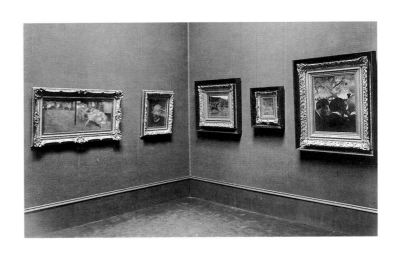

FIG. 41
*Dancers, c.*1895–8
Pastel on paper, 90 x 53 cm (35½ x 20⅞ in.)
Cambridge, Fitzwilliam Museum (L.1386)

FIG. 42
*After the bath, c.*1893–7
Pastel on paper, 70.8 x 57.2 cm (27⅞ x 22⅝ in.)
Cambridge, Mass., Courtesy of the Fogg Art Museum, Harvard
University Art Museums (L.1221)

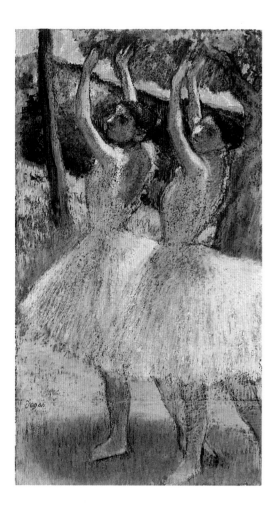

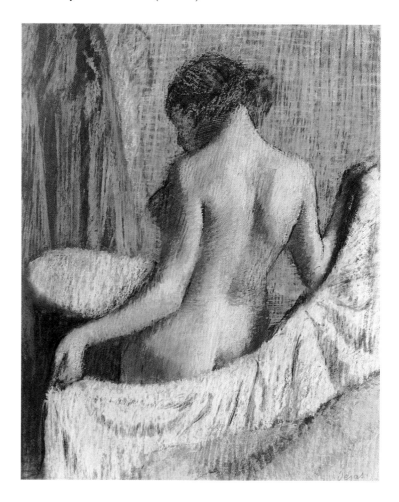

For our present purposes, the most encouraging evidence of this New York exhibition is that, of the twenty works visible, almost half were pictures from the 1890s, including studies from the beginning, middle and very end of that decade (the three large dance pastels, for example, are dated 1896, 1897 and 1900 by Lemoisne).[114] Along with five landscapes from the 1892 Paris show and the 1896 *Woman combing her hair* bought by Durand-Ruel in 1899 (cat. 41), visitors were exposed to such dramatic confections of colour as the pastel *Dancers* (fig. 41), completed only months before the New York exhibition and later bought by the intrepid Miss Anne Thomson of Philadelphia.[115] This work eventually found a home in the Fitzwilliam Museum, Cambridge, but a number of other exhibits were acquired at uncertain dates by private collectors and institutions across the United States. Perhaps reluctant to offend the susceptibilities of the host nation, Durand-Ruel excluded the subject of the female nude from his display, though in most other respects he attempted a survey of the artist's versatility and historical compass, as he had done in Paris in 1896.[116]

Durand-Ruel's proselytising ventures in the New World on Degas's behalf continued up to and beyond the artist's death in 1917. Despite the sparseness of records and the need for more detailed work on pictures, patrons and installations, it appears that the 1901 exhibition set an imaginative precedent that was emulated on several later occasions by a variety of galleries and individuals. In 1911, for example, the Fogg Art Museum staged a small retrospective and in 1913 three pastels appeared at the notorious Armory Show in New York, including *After the bath* (cat. 48).[117] Two years later, twenty-six Degas oil paintings and pastels of all periods were hung in the Knoedler Gallery in New York, beside work by Cassatt, Rembrandt and Rubens at Louisine Havemeyer's *Suffrage Exhibition*, this time featuring *Before the ballet* (cat. 8) of about 1890, *Woman with a towel* (fig. 164) of 1894 and *After the bath* (fig. 42) from the mid-1890s.[118] In April 1916, Durand-Ruel countered with a substantial dual display of *Manet and Degas*, where the recurrence of several works from 1901 hints at the difficulty of finding buyers for unfamiliar imagery and where the replacement of a number of frames

reflects changing fashions.[119] Following Degas's death, in January 1918 Durand-Ruel contrived an extensive memorial show for the artist, again including pictures seen earlier, to be followed two years later by a pioneering exhibition dedicated to Degas's draughtsmanship.[120] Comprising more than sixty studies of the human figure, apparently transported direct from the posthumous *Ventes* in Paris, this show revealed the artist in both formal and improvisatory modes, but predominantly through images chosen from the two previous decades.

Whatever else these under-examined events signify, they certainly do not constitute a neglect of Degas's output in the later phases of his career, nor a lack of interest among dealers and collectors in his work. When we discover that many of these exhibitions were paralleled and even anticipated in the major cities of Europe, we may conclude that the inaccessibility of Degas's art is one of the flimsiest artistic myths of the era. As with the American shows, Degas's representation in a series of mixed and sometimes ambitiously retrospective displays in London, Manchester, Glasgow, Dresden, Florence, Brussels, Berlin and elsewhere between 1890 and 1917 requires patient disentangling, if only to isolate the specific works that saw the light of day in his lifetime.[121] For the moment, we must content ourselves with one or two crucial and overlooked cases, notably those which initiated the cycle of European shows that brought Degas's new work to the attention of a wider public. Prominent here are two exhibitions held at the recently opened Berlin gallery of Bruno and Paul Cassirer, in 1898 and 1899 respectively.[122] Though little is currently known of the 1898 inaugural presentation of works by *Liebermann, Meunier and Degas*, its successor was a significant

milestone in the history of Degas's art. Devoted to *Manet, Degas, Puvis de Chavannes and Slevogt* (fig. 43) the 1899 exhibition's surviving but un-illustrated picture list shows that seventeen works by Degas had been gathered together, ranging from drawings to pastels and oil paintings. Many of the titles, such as *Dancer* and *Woman at her toilette,* are generic and of limited usefulness in tracing the works in question, though *Dancer at the photographer's* and *Laundresses* suggest the presence of pictures from the 1870s and 1880s, and *The Conversation* is perhaps the picture dated 1895 and bought by Durand-Ruel the following year (fig. 35).[123] More suggestively, several pastels and drawings carry the kind of broad denominations favoured in Degas's later career, such as *Three dancers* and *Yellow dancers*, indicating that the artist's current production was also offered to the Berlin audience.[124]

After the turn of the century, the sporadic and essentially haphazard pattern of Degas's exhibition history continued, marked by the artist's refusal to commit himself to solo shows or institutional retrospectives, such as those now regularly enjoyed by his former Impressionist colleagues, and a contradictory willingness to allow individual works on to the market. Conspicuous by their absence were major, formal exhibitions of Degas's art in Paris, where his truculence was now legendary and his angry rejection of the chance to show at the 1900 Exposition Universelle seems to have exhausted the patience of officialdom. Scatterings of his pictures appeared in such joint events as the 1903 and 1909 Bernheim-Jeune Impressionism exhibitions; at numerous private *ventes*, of which the 1912 Rouart sale is the most celebrated; and in unsung displays in countless boulevard and backstreet galleries. Abroad, Durand-Ruel's spectacular *Exhibition of French Impressionist Pictures* of 1905 at the Grafton Galleries in London included at least ten recent images, of which six were dated between 1896 and 1900 in the catalogue, while almost random appearances of such works as *Dancers* (cat. 23) at the 1904 Brussels *Libre Esthétique* maintained the visibility of his later output. Apart from his major initiatives in New York, Durand-Ruel continued to trade in isolated items from the rue Laffitte, several of which have a direct bearing on this catalogue. In 1902, for example, the glorious pastel *After the bath* (cat. 48), dated 1885 by a later hand but completed in the early 1890s, was bought from the artist for 6,000 francs, passing via the New York branch to Lillian Bliss for $9,000 in 1913.[125] Two years later, the dealer bought the *Frieze of dancers* (cat. 16), one of the most majestic images of Degas's later career, for 7,000 francs, selling it to Paul Cassirer for 10,000 francs the same day.[126] And between 1905 and 1909 variants of several images discussed in the present volume, including *Dancers in the wings* (fig. 86), *Pink dancers* (fig. 44) and *Woman combing her hair* (fig. 45) came and went, the latter to the Russian collector Ostroukoff.[127]

BRUNO UND PAUL CASSIRER
BERLIN W., VICTORIASTRASSE 35

II. JAHRGANG
DER KUNST-AUSSTELLUNGEN
WINTER 1899/1900

15. OKTOBER BIS 1. DEZEMBER 99

AUSSTELLUNG VON WERKEN
VON
ÉDOUARD MANET
H-G. E. DEGAS
P. PUVIS DE CHAVANNES
MAX SLEVOGT

FIG. 43
Title-page of *Manet, Degas, Puvis de Chavannes and Slevogt,* 1899
Photograph courtesy of Prof. Hans-Jurgen Imiela

FIG. 44
Pink dancers, 1897–1901
Pastel on paper, 62.2 x 70.5 cm (24½ x 27¾ in.)
Private Collection, photograph courtesy of the Lefevre Gallery,
London (L.942)

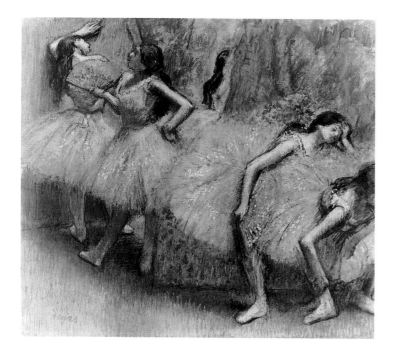

FIG. 45
Woman combing her hair, 1896–9
Pastel and charcoal on paper, 56 x 60 cm (22 x 23⅝ in.)
St Petersburg, Hermitage, photograph Archives Durand-Ruel,
Paris (L.976)

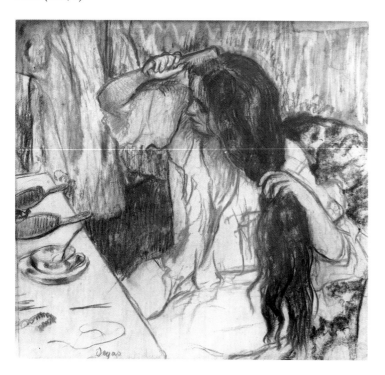

Some time before these transactions, however, a fascinating new factor had entered into Degas's marketing strategy, in the person of Ambroise Vollard, charismatic friend of the Nabis, brave promoter of the work of Paul Cézanne and for some years a leading dealer in pictures by Picasso (fig. 46). It was from Vollard's gallery, also in the rue Laffitte, that in 1895 Degas began to purchase his own collection of pictures by Cézanne, on one occasion excitedly drawing lots with Renoir for a watercolour they both coveted.[128] As the newly accessible Vollard archives show, most of Degas's varied and courageous acquisitions of Cézanne's still lifes, portraits and nudes took place between November of that year and June 1897.[129] What has not previously been noticed is that the artist came close to an even more dramatic coup, that of buying Cézanne's large, early *Déjeuner sur l'herbe* (private collection), described tersely but appropriately in Vollard's ledgers as 'manière noir', for 600 francs.[130] The same journals and account books show Vollard gradually winning favour with Degas during this period, selling several of his works on paper to private customers in 1896, probably including the pastel *After the bath* (fig. 47) acquired by the great Russian collector of Matisse and Picasso, Ivan Stchoukine.[131] At the same time, the seeds of a lifelong rapport between painter and dealer were sown, Vollard inviting Degas to some of the famous subterranean 'dinners' in his cellar, along with Forain, Bonnard, Vuillard, Rouault and others, and gradually eroding the monopoly of Durand-Ruel in his own favour. According to Mary Cassatt, the young dealer was able to build up his business when Durand-Ruel 'would not buy the things from Degas that Vollard gladly took and sold again at large profits. Vollard is a genius in his line, he seems to be able to sell *anything*'.[132]

Though the Vollard archives are incomplete and have still to be systematically published, there are clear signs of a historic shift of Degas's attentions away from Durand-Ruel and towards the representative of Picasso and his circle in the pre-war years. Not only do Vollard's records reveal the purchase of batches of five or six works from Degas at a time, sometimes in successive months or even weeks, they also reflect most vividly his 'genius' for the sale of such pictures to a wide variety of customers. Unfortunately, the same records use the vaguest titles for the works in question and are rarely accompanied by photographs, so the itemisation of specific pictures is unusually difficult.[133] Despite this, a knowledge of Degas's subject matter and the patterns of his titling leaves us in no doubt that Vollard was handling pastels and canvases from several decades, including the most recent, and that a steady, sometimes vertiginous, increase in prices was under way. In May 1906, for example, Vollard sold a pastel to the Havemeyers for 9,000 francs and appears to have interested them in two others, *Russian dancer* (cat. 92) and *Dancer with a fan* (cat. 24), within a month.[134] Three years later, after a series of

FIG. 46
Félix Vallotton, *Portrait of Ambroise Vollard,* 1902
Oil, 78.8 x 63 cm (31 x 24¾ in.)
Rotterdam, Museum Boymans-van Beuningen

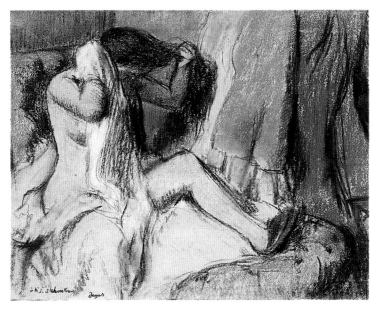

lesser sales and acquisitions, he bought no fewer than ten drawings retouched with pastel over a period of six weeks, paying Degas 24,000 francs in all.[135] One of at least fifteen works bought directly from the artist in 1911 was described as a 'Femme au tub et femme de chambre' (probably no.724 in Lemoisne's catalogue), acquired for the considerable sum of 20,000 francs for the single item.[136] Shrewdly, Vollard also realised the growing status of paintings from Degas's earlier career, persuading him to part with a youthful racecourse scene for 20,000 francs, which he then sold for 70,000 francs, and buying a trio of genre subjects in 1911 for 85,000 francs in total.[137] By this date, also, Vollard had established his own overseas links, most conspicuously with the Cassirer gallery, to whom he dispatched a consignment of more than twenty pictures in 1913, at a cost of over 700,000 francs, in preparation for an imminent exhibition.[138]

After the sensation of the Rouart sale in 1912, when Degas's *Dancers practising at the barre* of about 1877 was bought by Durand-Ruel on behalf of the Havemeyers for 478,500 francs, the prices of his pictures escalated dramatically. Vollard was able to charge Cassirer 125,000 francs for a single dancer pastel and 20,000 francs for a work described merely as a 'drawing',[139] cheerfully mixing large and small, exquisitely finished pastels and the most summarily coloured studies in the same batch. In this respect and many others, the catalogue of the 1913 Cassirer *Degas/Cézanne* exhibition in Berlin is a highly instructive document, containing as it does the titles of the twenty-nine Degas pictures on show and monochrome illustrations of twelve of them.[140] Of these, only three are mid-career works, the rest belonging emphatically to the 1890s and the early years of the new century, among them *Three dancers in red* (Kurashiki, Ohara Museum of Art) and *Dancers in the wings* (fig. 48). As with the Durand-Ruel New York show of 1901, images of the dance dominate the pictures in question, but Vollard and Cassirer now boldly included drawings, pastels and at least one late oil of the female nude, and including several charcoal studies as abrasive as *Woman in a tub*.[141] Such informal and even coarse works were perhaps the 'things' Durand-Ruel 'would not buy', but which Vollard, the admirer of Vlaminck, Rouault and Derain, felt naturally drawn to. There are few details more poignant in the Vollard records than this interweaving of his respect for the older generation, exemplified by studio visits and social calls to the elderly Degas, and his frequent contact in the rue Laffitte with the artist's young admirers and successors. In the pages of Vollard's diary, the

FIG. 47
*After the bath, c.*1893–8
Pastel and charcoal on paper, 48 x 63 cm (18¾ x 24¾ in.)
Munich, Bayerische Staatsgemäldesammlung (L.964)

FIG. 48
Dancers in the wings, c. 1897–1901
Pastel on tracing paper, 71.1 x 66 cm (28 x 26 in.)
Missouri, St Louis Art Museum (L.1066)

FIG. 49
Edgar Degas and William Thornley, *Young dancer with a fan,* 1888
Lithograph, 26.2 x 16.8 cm (10⅜ x 6¾ in.)
London, William Weston Gallery

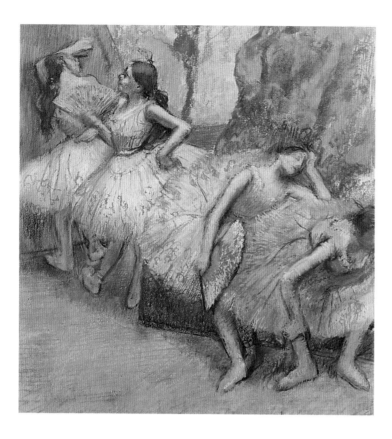

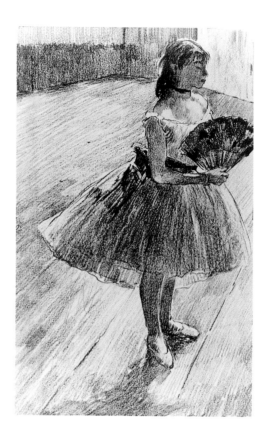

purchase of pictures from Degas is sometimes followed only days later by a payment to Picasso, raising the truly theatrical possibility of a meeting between the two painters – one internationally celebrated and approaching his seventies, the other an unknown twenty-year-old – in the dealer's legendary gallery.[142]

A final and largely neglected manifestation of Vollard's enthusiasm for Degas's late oeuvre, which also brings us back to the events of the artist's last years, is the dealer's involvement in publication. Combining modern technology, mass circulation and little-known works of contemporary art, and again presupposing the complicity of Degas in an act of commercial promotion, Vollard's 1914 album *Quarante-vingt-dix-huit reproductions signées par Degas (peintures, pastels, dessins et estampes)* was a milestone in the development of the genre (fig. 51). Historically speaking, it had been preceded by two important groups of reproductions of the artist's works, William Thornley's 1888 lithographs and Michel Manzi's 1897 volume of facsimiles, *Degas: vingt dessins, 1861-1896.* Thornley's lithographic renderings of Degas's oil paintings and pastels were necessarily based on works of the artist's middle years, such as the *Young dancer with a fan,* derived from a pastel of about 1879 (fig. 49), but they are illuminating in the present context for two reasons:[143] the

first is Degas's direct and sympathetic co-operation with the talented young draughtsman, perhaps extending to collaboration on the lithographic stone itself;[144] the second is the decision to exhibit the finished prints at the Boussod et Valadon gallery over a period of months in 1888, thus attracting even greater attention to both originals and transcriptions. Félix Fénéon enthused over the show, noting their 'laconic eloquence' and their 'liberal treatment' of the works in question, while their effectiveness in disseminating Degas's imagery is indicated by the English painter Philip Wilson Steer's acquisition of a complete set of prints, apparently in 1891.[145]

Degas's relationship with the mastermind behind the 1897 book, Michel Manzi, was of a different order, based on years of good-natured social and practical contact, summarised in the latter's skilful caricature of Bartholomé, Degas and Manzi himself inspecting a bust of their mutual friend Lafond (fig. 50). Manzi's publication, both grander and more literal than Thornley's, consisted of a large, richly bound volume of heliographic reproductions of the highest technical quality, the majority printed in more than one colour and strikingly true to Degas's touch and line.[146] Pissarro was astonished that Degas had been persuaded into the venture, describing the recently printed album as

FIG. 51
Title-page of *Quarante-vingt-dix-huit reproductions signées par Degas,*
1918 edition

'amazing . . . it's here we see that Degas is truly a master, it's as beautiful as Ingres, and dammit, it's modern!'[147] The link with Ingres, who greatly occupied Degas's thoughts at this time, seems to have been intentional, as was the inclusion of several up-to-the-minute examples of Degas's draughtsmanship and his explorations of pastel such as the 1895 *After the bath* (fig. 173).[148] Helpfully, several of these were dated, providing useful termini of 1887 for an early study for the Cleveland *Frieze of dancers* (cat. 16), and of 1896 for a draft of the Philadelphia *After the bath* (cat. 57).[149]

Vollard's 1914 album, then, extended a well-established practice of advertising Degas's past and current achievement to the world at large, while simutaneously advancing the interests of the participating dealer. More precisely, Vollard's publication can be seen as a cheaply produced and extensively illustrated catalogue of his present stock and of works recently sold, many of them recorded in his inscrutable ledgers and all appearing with Degas's explicit approval.[150] The proof of the artist's involvement is his signature on each photograph, written in Degas's wavering, elderly hand, and often resulting in doubly signed works, but in every case authorising the image as finished and fit for general consumption. This is critical, since it proves beyond doubt that the

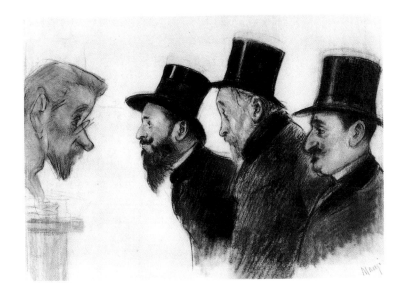

FIG. 50
Michel Manzi, *Bartholomé, Degas and Manzi with a bust of Lafond,* n.d.
Charcoal and pastel on paper
Paris, Musée du Louvre

eighty-year-old Degas was content to be represented by a mass of late work, including pictures as brutally unfinished and crudely gestural as anything that had emerged from his studio. Apart from a handful of prints and earlier pictures, the bulk of the ninety-eight Vollard plates can be dated to the late 1890s and the first years of the twentieth century, spanning such encrusted, rainbow-hued pastels as the Copenhagen *Three dancers* (cat. 20) and the dignified near-monochrome of *Woman combing her hair* (cat. 44). No fewer than eight pictures in the present volume were reproduced in Vollard's hazy grey pages, as well as numerous studies and compositional variants for works under discussion.[151] Produced in an age that had seen the beginnings of Expressionism and Futurism, and which was now coming to terms with the latest developments of Cubism, it is still almost shocking to see 'the last great artist of the nineteenth century', as Mary Cassatt was soon to call him, summarised by some of these plates. Especially radical in their violent graphism are charcoal studies such as *Group of dancers* (private collection) and *Study of a nude* (private collection), while the breadth of such works as *After the bath* (Paris, Musée des Arts Decoratifs) approaches the furthest extremes of primitivism in these turbulent years.[152]

DEGAS'S LAST YEARS

FIG. 52
Woman at her toilette, 1903
Charcoal and pastel on tracing paper, 61 x 51 cm (24⅛ x 20⅛ in.)
Collection Museu de Arte de São Paulo, Assis Châteaubriand (L.1421)

A more melancholy view of the 1914 Vollard publication brings us face-to-face with the octogenarian artist, evicted from his rue Victor Massé home and effectively at the end of his working life, now reduced to signing photographs of pictures already a decade or more old. Soon after his death in 1917, a variant edition of the album was released under the imprint of Bernheim-Jeune, with a few additional plates in sumptuous colour and a new title-page (fig. 51). This features one of the most haunting photographs of the artist's old age, showing Degas near his new boulevard de Clichy apartment in 1915, as he walks uncertainly and obliviously towards the camera of the pioneer film-maker Sacha Guitry. Guitry's rarely seen film *Ceux de chez nous,* which also preserves arresting footage of the elderly Renoir and Monet, captured Degas very briefly and against his explicit wishes, but its image of the frail, silver-bearded and still bowler-hatted artist remains irresistibly grand.[153] Seeing this now nearly blind figure on the streets of Paris, his contemporaries were moved to describe him as 'wandering like King Lear' or as a 'Homer with vacant eyes', even likening the 'long hair, long beard' of the artist on his death-bed to that of Christ.[154] Those close to Degas insisted on his quiet dignity, the faithful Daniel Halévy noting in 1913 'this presence, this energy, this clarity of eye and voice' in the 'half-absent' artist, and Bartholomé writing to Jeanniot of 'his fine figure. He had acquired a beauty that you cannot imagine'.[155] Even allowing for their deep-seated attachments, it is clear that this was a very different Degas from the busy socialite and the aggressive trader in his own 'articles' of the turn of the century, and some effort is needed to bridge the gap between them.

For the first half-dozen years of the twentieth century, the routines and protocols of Degas's previous decade seem to have continued without significant interruption. If there were changes, they merely extended the pattern of the later 1890s, narrowing the range of the artist's hospitality, for example, after the deaths of friends and the depredations of the Dreyfus affair, and further concentrating his mind on long-standing bodily ailments. But, once again, the letters and testimonies of Degas and his friends tell of a cycle of work and somewhat formal leisure, of interminable hours in the rue Victor Massé studio and sudden excursions to Normandy, Brie and Pontarlier on the Swiss border, which he visited for fifteen days in 1904, and as far as Naples in 1906, on 'family affairs'.[156] Writing to the young landscapist Braquaval in August 1902, Degas promised to travel soon to Saint-Valéry-sur-Somme, continuing, 'I cannot leave this studio, it pleases me, I work here obstinately'.[157] The following year, he told Alexis Rouart 'One is still here in this studio after doing some wax figures. With no work, what a sad old age!', and in 1904 he assured Durand-Ruel, 'I am working like a galley-slave, so as to be able to give you something

soon'.[158] After illness in February 1905 Degas informed the dealer that he would soon 'be allowed to ascend to the studio', while in August 1907 he again told Rouart, 'I am still here working. Here I am back at drawing and pastel. I should like to succeed in finishing my articles', but was able to add by this date 'journeys do not tempt me any more'.[159]

The evidence that Degas continued to labour at his 'drawing and pastel' until at least 1907 is, therefore, unequivocal, and is amplified and even extended by other reliable sources. Etienne Moreau-Nélaton's long, detailed account of the artist at work, specifically on an ambitious composition of a 'nude leaving the bath, with a maid in the foreground', is dated 26 December 1907, and the memories of Degas's model Pauline, which can be located around 1910, evoke a busy studio with several waxes and a variety of pictures in a constant state of readiness.[160] The nature of this engagement, however, is open to a variety of interpretations. The last dated work in Degas's oeuvre, *Woman at her toilette* (fig. 52), is clearly inscribed 1903, encouraging a view that his creativity declined and perhaps came to a halt soon after. Certainly Paul-André Lemoisne, the compiler of the four-volume Degas catalogue raisonné concurred with this view, listing fewer than thirty pictures in the pages devoted to 1904 and beyond, and dating none of them later

FIG. 53
*At the milliner's, c.*1905–10
Pastel on tracing paper, 91 x 75 cm (35⅞ x 29½ in.)
Paris, Musée d'Orsay (L.1318)

FIG. 54
*Seated bather drying her neck, c.*1905–10
Pastel on tracing paper, 68.7 x 58.1 cm (27⅛ x 22⅞ in.)
Fine Arts Museums of San Francisco, Gift of Mrs John J. Ide
(L.1172)

than 1908.[161] Though a group of ambitious pastels of the Rouart family can confidently be situated in 1904 on circumstantial grounds, Lemoisne, like most of his successors, was obliged to rely on instinct rather than documentation in defining this ultimate phase. The spare linearity of *Woman drying herself* (cat. 65) and the clamorous colours of *Woman at her toilette* (cat. 66), for example, suggested that both were extreme and therefore late statements, while the wild near-abstraction of *After the bath* (cat. 67) propelled it into the '1905–7' category.[162] More recently, specialists such as Jean Sutherland Boggs, Theodore Reff, Richard Thompson and George Shackelford have boldly added to the number of these ultimate images, proposing dates of 1905–10 for the tapestry-like *At the milliner's* (fig. 53), and re-locating works from the 1890s or even late 1880s in Lemoisne's listings to a decade or more later.[163]

Given Degas's description of himself 'working like a galley-slave', and his documented transactions with Vollard and Durand-Ruel during these years, there is every reason to believe that many more works tentatively attributed to the 1890s by Lemoisne now properly belong in the new century; it is surely inconceivable, for example, that the *Seated bather drying her neck* (fig. 54) assigned by Lemoisne to 1894 should pre-date an equally flamboyant and technically related pastel that Boggs

plausibly places in 1905.[164] But even a significant expansion of the late oeuvre of this kind does not fully explain the artist's professed activity around 1907, nor, conversely, does it tally with an undoubted lessening of his output towards the end of the decade. Several other factors must, therefore, be taken into account. The first is Degas's habit of reworking earlier images, either by adding further colours and forms to existing canvases or by superimposing new layers of pastel over works long-stored in his studio. This practice is considered in chapters 4 and 5, but it should be noted in passing that Lemoisne virtually disregarded it in his dating, locating many works on the basis of their subject-matter rather than their greatly modified surfaces.[165] A second factor in the equation has already been touched on – the passion for sculpture that manifestly occupied the artist until the end of his working life. In a letter to Braquaval written about 1901, Degas noted cryptically, 'I am still working at my little waxes', a refrain that echoes throughout the correspondence and eye-witness accounts of the period.[166] Alice Michel's text again reinforces this view, suggesting sustained and almost daily activity in 1910, while the artist's last dated letter, written in 1912 shortly before his move from the rue Victor Massé, ends with the plaintive cry, 'I do not finish with my damned sculpture.'[167]

Degas himself described sculpture as 'a blind man's trade', and most of his early biographers took up the refrain, one of them writing of the 'modelling which his failing eyesight had led him to substitute for painting as a means of expression'.[168] Given the difficulty of dating Degas's late wax and clay figures, it has been impossible to identify a clearly defined group of sculptures corresponding to this partially sighted phase, not least because of the extreme subtlety and inventiveness of even the most broadly drafted figures. But neither has the fundamental link between the artist's real and invasive eye problems and his gravitation towards sculpture been seriously challenged, though some confusion about its significance has been clarified. While Degas had sporadically made figures in wax, clay, plasticine and a variety of other materials since the 1860s, there is good reason to believe that proportionately more time was spent on his statuettes in the last decade of his active life; there are also grounds for accepting that reliance on touch compensated to some extent for his restricted vision. Attempts to justify his late manner in terms of his eyesight, however, have almost invariably been based on a simplistic understanding of events. Degas's eye problems began in his thirties, if not before, and by mid-life he was already obliged to wear dark glasses, visit doctors and specialists, and undergo courses of treatment that reduced him almost to despair. Among a complex of problems, he was effectively blind in one eye and suffered from photophobia (discomfort in bright light) and an irregular field of vision in the other, a condition that made him fear for his sight altogether. By the early 1890s Degas could write, 'My sight too is changing, for the worse . . . I am dreading a stay in my room, without work, without being able to read, staring into space', and it is evident that the difficulty of seeing rarely left his thoughts.[169] Against this must be set the extraordinary achievement of that decade, not just in its intense productivity but in the sheer refinement and precision of much of its imagery. Though Degas continued to struggle with his considerable infirmity, it evidently did not prevent him from working until the very last years of his professional life and may, contrarily, have increased his comprehension of the very visual processes on which he depended.

Prosaic confirmation of Degas's functional vision, as well as the continued accessibility of his art, is provided by diverse accounts of his life after the turn of the century. The catalogue of meals with friends and studio visits, encounters with artists young and old, attendances at auctions and trips to his dealers is a long one, but a sequence of isolated cases must paraphrase it here. Until at least 1905, it is clear that the relentless dining-out of earlier decades persisted: in 1902, for example, an imperious summons from Degas invited 'M and Mme Forain to come to dinner Tuesday 4th Feburary at 7.30 with General and Mme Mercier and the Rouarts';[170] the following year he told Braquaval,

'Yesterday I dined in the country at the home of the good Rouart. They are a family to me';[171] and in 1905 he was twice obliged to plead previous commitments when invited out.[172] One of these invitations came from the dentist and amateur sculptor Paul Paulin, a minor but appreciated figure who joined the celebrated artists regularly visiting Degas's studio.[173] Suzanne Valadon still made her calls, though apparently with less frequency;[174] Rouault saw Degas 'from time to time . . . tapping the ground with his pilgrim's stick', and persuaded him to talk about art;[175] a survivor from the Impressionist years, the painter Zacharian consoled the artist in 1903, during one of the latter's frequent bouts of illness, and the American, Maurice Sterne, met him at the Salon of 1905.[176] In 1906 there are documented encounters with Maurice Denis and the Spanish painter Sert;[177] Sickert saw him until 'shortly before the war' and Cassatt evidently kept in touch, describing Degas in 1913 as 'a mere wreck' from a lifetime of work;[178] and a number of documents remind us of the loyalty of Degas's fellow-practitioners Bartholomé, Jeanniot, Braquaval and Ernest Rouart in his final years.[179]

Likewise, Degas's attentions from his literary friends were sustained well into the new century, resulting in many of our most poignant accounts of the artist's demise. Paul Valéry left detailed notes of encounters in 1904 and 1905, when Degas reminisced about his adolescence and childhood, while a visitor at the Valéry house, André Gide, found the artist there in 1909 'just like himself; just a bit more obstinate . . . scratching the same spot in his brain where the itching becomes more and more localized'.[180] According to Gide and others, Degas increasingly relied on favourite stories and aphorisms, attacking landscapists ('impudent humbugs') and art criticism ('what an absurdity'), and insisting still that 'the Muses never talk among themselves . . . when they aren't working, they dance'.[181] His most faithful and eloquent visitor, however, was surely Daniel Halévy, who maintained watchfulness through the artist's illnesses and the aftermath of the Dreyfus affair, through the terrible preparations for the war and Degas's metamorphoses into a figure 'resigned, gentle, weary', as he described him in 1910.[182] Degas was plagued by 'gastritis' and trouble with his kidneys, by a weak stomach that occupied the doctors and sent him on rest-cures, and by approaching deafness and interminable trouble with his eyes. In 1904, Daniel was shocked to find Degas in his studio after an illness, 'dressed like a tramp, grown so thin', and the artist himself claimed in a letter of 1908, to his old friend Alexis Rouart, 'Soon one will be a blind man'.[183] But it is still erroneous to imagine Degas confined literally to his rue Victor Massé 'fortified enclosure', even with this catalogue of infirmities. As we have seen, around 1906 the artist could still drive a hard bargain with Durand-Ruel for a parcel of

FIG. 55
Anon., *Degas on his sick-bed, c.*1914–17
Photograph
Location unknown

pictures, and during 1911 and 1912 carried on a brisk trade with Vollard.[184] About this time, Degas was reputedly spotted at one of the first Cubist exhibitions;[185] in 1911, he closely examined the paintings at an Ingres show;[186] and in 1912 he was discovered by Daniel Halévy at the Rouart sale, besieged by journalists and admirers.[187]

Even more salutary, if not alarming, are the stories of Degas's mobility in the years preceding his death. He walked incessantly, crossing Paris on foot and finding in his ambulamania a solace for his eyes, his sleeplessness and perhaps for the 'immense indifference' that took hold of him.[188] Friends describe him striding oblivious through traffic, even as he thundered against his contemporaries' obsession with speed and the terrors of modern transport, maintaining to the end his obdurate contradictoriness.[189] In 1910 Degas was spotted in a motor car, the following year he saw an aeroplane at close quarters ('how small it is', he exclaimed) and Vollard tells us of endless trips on trams, or just 'wandering aimlessly about Paris'.[190] The most violent move, of course, was that in 1912 from his home of more than two decades at 37 rue Victor Massé, when developers saw fit to demolish the building. Transported just a few minutes walk away, to 6 boulevard de Clichy, Degas finally crossed the divide between declining professionalism and artistic inertia. Jeanne Fevre, who was encouraged by Mary Cassatt to move in and take care of her uncle in his last years, insisted that 'the new installation was never completed . . . we arranged the essentials, but my uncle's work was put in several unlit rooms and no-one was able to see it'.[191] Making an exception for some of the paintings from Degas's collection, which were hung 'within his reach', Fevre otherwise recounts the listlessness, sometimes the aggression, of the artist towards his former craft. Degas himself told Daniel Halévy, 'I no longer work since my move . . . it's astonishing, old age, how we become indifferent.'[192] On a later visit in 1916, Halévy found him in bed with bronchitis, but watched entranced as the eighty-two-year-old patriarch seized the arm of his niece and studied it with 'passionate attention', as if he were once more in his studio (fig. 55).[193]

On 29 September 1917, Mary Cassatt wrote from Paris to an American friend, 'Degas died at midnight not knowing his state. His death is a deliverance but I am sad, he was my oldest friend here, and the last great artist of the 19th Century – I see no one to replace him.' Three days later she confided to Louisine Havemeyer, 'We buried him on Saturday, a beautiful sunshine, a little crowd of friends and admirers, all very quiet and peaceful in the midst of this dreadful upheaval of which he was barely conscious.'[194] The upheaval of which Cassatt spoke had already claimed millions of lives (among them a scattering of bright and barely adult artists) even as it propelled the visual arts towards extremes of daring and self-doubt that still haunt us today. That Degas was aware

of some of these accelerations, communicated to him by younger Montmartre neighbours and glimpsed in nearby galleries, the record increasingly proves. That certain of them, in their turn, were fuelled by an awareness of Degas's own astringent radicalism, seen in pictures and sculptures in private collections and on gallery walls, we have more reason to suspect than ever. In the years immediately preceding the conflict there had been displays of Degas's work in Italy and Great Britain, as well as Berlin and Dresden, while during the Great War itself his pictures paradoxically appeared in the Dada capitals of New York and Zurich.[195] But these were fragmentary appearances and it was not until the posthumous sales of Degas's studio contents in 1918 and 1919, and the tidal wave of new publications that followed them, that the bulk of his late work became visible and the density of his achievement was encountered for the first time. In her 1917 letter describing Degas's funeral, the hard-headed Cassatt had already alerted Mrs Havemeyer to the situation, preparing her for the attempted purchase of the *Little dancer of fourteen years*; 'There will of course be a sale. The statue of the "danseuse" if in a good state you ought to have.'[196] The scramble for Degas's art and for his place in history had begun.

THE METAPHOR OF CRAFT
Tradition, Draughtsmanship and the Transformation of Degas's Technique

Mᴏʀᴇ ᴛʜᴀɴ ᴀɴʏ ᴏᴛʜᴇʀ painter of his era, and perhaps more than any artist before the generation of Picasso, Matisse and Duchamp, Degas made imagery that was inseparable from the means of its fabrication. His pictures are caught up in the business of picture-making, openly declaring their physicality and laying bare the processes of their contrivance, just as his subjects seem locked into the pastes and inks, the washes of colour and patterns of tone that give them form. In the same way, many of the artist's most celebrated themes are linked to a specific medium and are inconceivable beyond its confines: the brothel monotypes of the 1870s, for example, have no equivalent in oil on canvas, where their intimate scale and quasi-photographic tonality would lose much of their point; conversely, Degas's scenes of the racetrack are effectively absent from his prints, occurring only where bright colours and broad spaces allow them to flourish. Even with more ubiquitous subjects, such as the ballet and the toilette, each image finds its identity in the medium of the moment, whether pastel on tracing paper, gouache over monotype or distemper on silk, distancing itself from compositionally similar, but technically remote, equivalents in other materials.

In Degas's late years, this symbiosis of material and image became even more marked, as favoured themes were endlessly revisited and familiar techniques pursued to their limit. In a canonical work of his later career, such as *Combing the hair* (cat. 42), colour and form, gesture and ambience form a continuous, energised membrane, each element unimaginable without the other. Executed in oil paint on lightly primed linen canvas, this picture has taken on the status of a 'painter's painting', its sweeps of brushwork across coarse-grained fabric and accumulations of hue an inspiration to artists as different as Henri Matisse, who once owned the work, and Frank Auerbach, who has recently drawn it (fig. 56).[1] Its less well-known pastel variant, *Woman combing her hair* (cat. 41), presents much the same composition, though to fundamentally different effect. Here the brittleness of coloured chalks and their dry, linear contact with paper suggest agitation and urgency, in contrast to the expansiveness of the oil. Other variants of the image in charcoal, pastel and lithography offer further transformations, each material and change of format modifying the work's pictorial thrust (fig. 57). To disregard such attributes is to overlook not only the physical identities of these objects but also much of their meaning, and perhaps to fail to 'see' the pictures at all. Amongst his many late preoccupations, Degas was clearly fascinated by the materiality of his compositions, and by the way one set of tools and tinted powders directed a chosen motif towards amplitude, another towards refinement, yet another towards violence or abrasiveness. While it may be unreasonable to expect modern audiences to master the nuances of his craft, which even Degas's professional peers

Detail of cat. 42

FIG. 56
Frank Auerbach, *Study after Degas's 'Combing the hair'*, n.d.
Black felt pen and correction fluid on paper
25.2 x 32.5 cm (9⅞ x 12¾ in.)
London, James Kirkman Limited

sometimes misconstrued, some recognition of its constructive role in his mature iconography is surely inescapable.[2] And as we shall see, this is nowhere more true than in the artist's last decades, when his technical concerns took on a pervasive and perhaps symbolic significance for his art.

That Degas was a technical obsessive is amply documented in the records of fellow artists and younger admirers, some of whom watched him at work or collaborated with him on prints and paintings. The letters of Camille Pissarro describe recipes exchanged and materials shared, as well as joint attempts at printmaking and puzzled responses to new procedures.[3] In the 1880s, Walter Sickert visited Degas's studio frequently and later remembered conversations on draughtsmanship and colour, oil paint and pastel, sculpture and composition.[4] Georges Jeanniot, the illustrator and painter with whom the artist stayed in Burgundy 1892, recorded a vivid account of the creation of Degas's first colour monotypes and recalled the 'expression of pleasure and well-being' that suffused his face as he began his bizarre technical gymnastics.[5] Both Jeanniot and Ernest Rouart spent time under Degas's tuition and both left descriptions of his pedagogical methods and love of experiment. With each pupil, Degas seems to have used the opportunity to test his theories rather than pass on conventional wisdom, and each student reported his almost childish delight in the alchemy of their profession.[6] With Jacques-Emile Blanche he talked about lithography;[7] to William Rothenstein he showed his drawings, waxes and photographs;[8] in the company of Berthe Morisot he propounded his

theory of colours;[9] from Luigi Chialiva he received advice about fixatives and restoration;[10] on holiday with Louis Braquaval, he demonstrated perspective and composition;[11] to the young Georges Rouault he deplored the technical ignorance of his contemporaries;[12] and with Ambroise Vollard he talked of sculpture, tracing paper and even picture frames.[13] But it was another less-celebrated practitioner, Paul Valéry, who best summed up the artist's mania; a major part of Degas's vocation, he argued, was 'an endless meditation on the essentials and resources of his art'.[14]

Crucially, many of these testimonies come from the last decades of Degas's career, when the character of his oeuvre was seemingly established and his reputation secure. We should, however, be wary with this topic as with many others, of assuming that such documentation describes a fixed state of affairs. Degas's technical concerns were neither static nor seamlessly progressive throughout his working life, but subject to changes of emphasis, phases of abstinence and drastic shifts of direction. Too often, observations made by Jeanniot or Valéry are blithely cited in explanation of pictures executed two or three decades earlier, assuming continuity where none can be shown to exist. As the present study of Degas's later years demonstrates, nothing could be more misleading. Not only were his professional circumstances and his repertoire of images redefined during this time, but Degas's approach to the practice of his craft was transformed almost beyond recognition. Many, perhaps the majority, of the techniques used in earlier decades were summarily abandoned, often accompanied by the motifs which had brought them to prominence; other processes were substantially modified, both in application and in implicit meaning; and new priorities appeared, overturning long-held values and preparing the ground for the material anarchy of the next generation.

The most surprising shift in Degas's practice, not least because of his avowed fascination for 'the essentials and resources of his art', was the move from technical profligacy to a kind of penitent late austerity. In his early and middle years, Degas had excelled in the sheer diversity of his skills, ranging over almost every medium currently available and freely improvising variants of his own. His pride in this virtuosity is evident, both in the carefully orchestrated presentation of his work and in the use of public exhibitions to unveil his latest novelties. At the series of early Impressionist shows, for example, he pointedly hung works in all the orthodox media, including paintings in oil on canvas, pastels on paper, drawings, watercolours and a wide range of prints.[15] Hybrid processes of his own devising were also promoted, among them monotype, works in *essence* (or thinned oil paint), studies in colour superimposed on etchings and lithographs, portraits in distemper on linen and bravura displays such as *Rehearsal of the ballet on the stage* (New York,

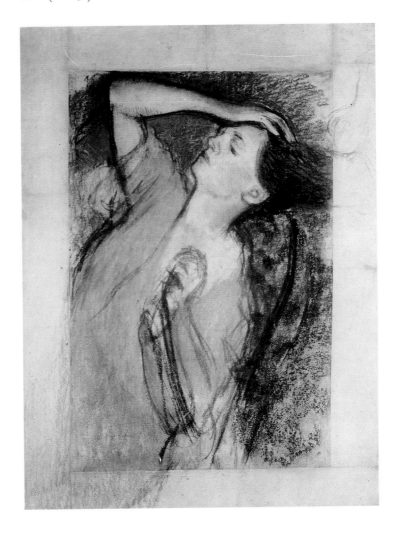

FIG. 57
*Study for 'Combing the hair', c.*1892–6
Charcoal and pastel on tracing paper, 75 x 52 cm (29½ x 20½ in.)
Location unknown, photograph Archives Durand‑Ruel,
Paris (L.1130)

Metropolitan Museum of Art), described less than accurately by George
Moore as 'begun in watercolour, continued in gouache, and afterwards
completed in oils', to which a 'finishing hand has been given with pen
and ink'.[16] Pedantic about his own versatility, Degas's catalogue entries
spelled out in detail the constituents of each work, specifying 'dessin à
l'essence', 'détrempe à pastel', 'Eaux‑fortes. Essais et états de planches'
and, in a much‑quoted attempt to avoid the word 'monotype', 'dessins
faites à l'encre grasse et imprimés'.[17] In later group shows, the
performance continued, augmented at the sixth Impressionist exhibition
by the triumphant appearance of Degas's first work in mixed‑media
sculpture, listed as 'Petit Danseuse de quatorze ans (statuette en cire)'.[18]

Hardly by coincidence, this decade of frantic and conspicuous
material experiment was also the period of the most wide‑ranging
thematic innovation in Degas's entire career. At the same pioneering
Impressionist shows, his name became associated with the ballet and the
laundry, the millinery shop and the café‑concert, the theatre and the
circus, the racetrack and the street scene, while such subjects as the
portrait and the nude continued to make their various presences felt. By
comparison with the 1860s, Degas's repertoire expanded beyond
recognition, not only in its self‑advertised originality, but in its
responsiveness to the spectacle of the modern city. And as George Moore
recalled, just as Degas 'sought for new subject matter, he sought for new
means by which he might reproduce his subject in an original and novel
manner'.[19] The urgency of many of these topics was intimately bound
up with the novelty of their physical expression, marrying the flat and
opaque colours of gouache over monotype, for example, with the bright
glare of the cabaret, using photographic plates as the basis for prints, or
dusting metallic pigment across semicircular fans.[20] This extraordinary
dialogue continued into the 1880s, in works shown publicly and in
documented prints and paintings sold or given to friends. A second
series of monotypes emerged, more ambitious in scale and technically
more audacious in their treatment of the female nude; works in oil,
distemper and pastel on a single canvas were included in group
exhibitions; and a family of somewhat earlier prints, newly worked with
colour, appeared at mid‑decade.[21]

Against this background, the attenuation of Degas's studio practice
as he approached his final decades can hardly be exaggerated. In
microcosm, it was summed up in the artist's contribution to the eighth
and final Impressionist exhibition of 1886, held at a time when the
group enterprise was foundering and the careers of many of its adherents
were undergoing profound reassessment. In contrast to Degas's earlier
submissions to such shows, only three subjects were represented: nudes,
portraits and milliners. Even more starkly, all ten of his pictures were
executed in a single medium, that of pastel.[22] Gone were the excursions

into printmaking and the hybrid techniques of *essence* and monotype;
gone were the novel materials and curiosities of finish; gone were the
sequences of near‑identical etching proofs, the half‑moon fans and the
be‑wigged and be‑ribboned sculpture; and gone too, at least temporarily,
was oil paint, the most tenacious and historically weighted of all Degas's
technical resources. Not only were all Degas's works in pastel, and listed
as such in the catalogue, but a study of the pictures in question shows
that each was carried out in the most orthodox application of the
technique, unmixed with other media and applied directly to standard
paper, rather than to an etching, lithograph or monotype. In works such
as *Woman in a Tub* (fig. 91) and *Woman bathing in a shallow tub* (fig. 58),
Degas's audiences found themselves back on familiar ground, at least as
far as his studio procedures were concerned.

FIG. 58
Woman bathing in a shallow tub, 1885
Pastel on wove paper, 81.3 x 55.9 cm (32 x 22 in.)
New York, Metropolitan Museum of Art, H.O. Havemeyer
Collection, Bequest of Mrs H.O. Havemeyer, 1929 (L.816)

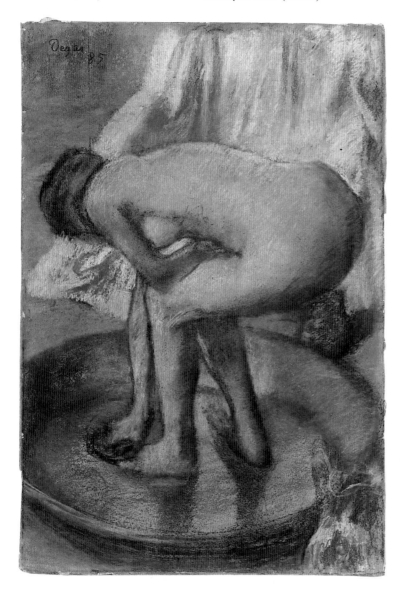

Some caution is necessary when drawing conclusions from such a singular and necessarily selective event, but a more detailed survey of Degas's output in the late 1880s, and of another display some two years later, confirms this dramatic and self-denying technical shift. Indeed, the roll-call of methods and materials discarded by the end of the decade, not just in public displays but in daily studio practice, reads like a catalogue of the artist's earlier achievement. *Essence* appeared for the last time in an Impressionist show in 1879; gouache and distemper survived to the beginning of the next decade, but not beyond; printmaking surfaced only fitfully in the 1880s, achieving a final flowering in the lithographs of nudes and the colour landscapes of 1890–92, then fading completely.

Other hybrid practices suffered a similar fate, even sculpture gravitating towards material simplicity after the *Little dancer of fourteen years* and the rather later, collage-like *Tub*.[23] Despite the drama of the 1886 presentation, Degas's retreat from virtuosity was gradual and evolutionary rather than sudden, but its effect was nonetheless decisive. By the early 1890s, his craft had been drastically circumscribed, reduced, in effect, to just two processes: charcoal and pastel on paper, and oil on canvas. We now confront an artist divested of his former glamour and determinedly, even wilfully, redirecting his craft, using materials at once more ancient and more radical in application than anything encountered in his earlier career.

In a conversation from Degas's later life recorded by Ambroise Vollard, the artist looked back nostalgically to the Impressionist era and claimed, 'I was very much interested in processes then, and had made countless experiments . . . but the trouble is that there are never enough buyers to encourage you to go on with it.'[24] Whatever the reasons for his change of heart, Degas clearly acknowledged the more restricted range of his late techniques and contrasted it with the licence of his earlier years. But the witnesses to Degas's late career leave us in no doubt that Degas's obsesssion with 'the resources of his art' continued to the very end, even increasing in its intensity in the final decades. Paradoxical though it may seem, this re-focusing of his pictorial energies from breadth into depth is consistent with many other shifts in his vocation, and was noted by some of his earliest critics. In his historic study of 1945, *Degas: à la recherche de sa technique*, one of the first book-length accounts of an artist's practice ever published, Denis Rouart stressed that Degas 'never ceased to investigate new methods of expression. This research lasted all his life, as a chronological study of his oeuvre would demonstrate'.[25] Deriving much of his material from the memories of his father, Ernest Rouart, who was taught by Degas in the 1890s, the author claims that 'of all the artists of the late nineteenth century, Degas is the one who was most disturbed by the question of craft'.[26] Referring more than once to Degas's 'artistic restlessness', Rouart presents even the final phases of his engagement with pastel and oil as a process of experimentation, at times hazardous and ill-conceived, more often productive of extraordinary originality. For Rouart and others, the relative austerity of Degas's late procedures represented not withdrawal and refinement, but a turning inward of his nervous energies, now directed at the fundamental concerns of his discipline.

The significance of Degas's technical obsessiveness is open to a number of interpretations, not least that of an excessive veneration for tradition of a kind that almost paralysed the craft of certain of his contemporaries. But the 'restlessness' recorded by Rouart and others was the opposite of complacency, finding its motivation in fierce self-

FIG. 59
Rape of the Sabines (after Poussin), *c.*1861–2
Oil, 149.8 x 201 cm (59 x 81½ in.)
Pasadena, California, Norton Simon Foundation,
Gift of Mr Norton Simon (L.273)

criticism and often leading to bizarre and unrealisable projects and even bouts of destructiveness. Several commentators remarked on the nervous urgency of Degas's relationship with his materials: 'Deep down, the painter loved nothing but difficulty', wrote his niece, Jeanne Fevre, a refrain taken up by Denis Rouart: 'He was not discouraged by the difficulties nor by the problems which he encountered. On the contrary, he loved to confront them and perhaps would have created them had they not existed.'[27] Paul Valéry argued that 'Degas rejected *facility* as he rejected all but the precise object of his researches', and went on to summarise his method as a combination of 'an almost tragic sense of the difficulty and strictness of his own art with a certain prankishness'.[28] If craft had once stood for security, in old age it became a metaphor for the unknown and the unachievable, and perhaps for the breakdown of that tradition which Degas continued, clamorously and insistently, to revere.

Even with his 'love of difficulty' and his 'prankishness', the drastic change in Degas's studio practice around 1890 is not easily explained. The artist's own reference to a lack of support from the market, made in the context of his printmaking, is hardly confirmed by the evidence of a brisk trade in pastel-over-monotypes and related works.[29] More plausible is the association of his novel artistic technology with the urban realism of earlier decades, and the desire felt by Degas and many of his colleagues to reappraise their late practice along with their imagery. If metallic pigments, daguerreotype plates and scenery-painters' colours were the currency of the 'Salon of Realists', as Degas once called it, they might well be devalued in the shifting, anti-naturalist 1890s.[30] Convenient though it appears to be, this explanation also poses problems. Broadly speaking, as quickly as Degas jettisoned the bravura attitudes of his middle years they were adopted by a younger generation of admirers, from such latter-day naturalists as Forain and Toulouse-Lautrec to the Symbolist-orientated Gauguin and the circle of the Nabis. Here, perhaps, we come closer to an answer; having pioneered so many departures in the Impressionist phase and passed on his expertise to the likes of Jeanniot, Forain and Gauguin, Degas may have chosen to retreat to metaphorically higher artistic ground, content and perhaps bemused to watch their technical antics from a position of seniority. Now an elder statesman, he was able to occupy himself with the consolidation and intensification of his craft, as distinguished now in his single-mindedness as he was once in his virtuosity.

A further factor in this complex equation is the relationship between Degas's art and that of the masters of the past, and our assumptions about the continuity of that relationship. In his important 1976 essay, 'The Artist as Technician', Theodore Reff defined the central paradox of the painter's attitude to his craft, arguing that 'Degas was at once more radical and more conservative than any major artist of his generation'.[31]

Ranging over the wide spectrum of the artist's techniques and most phases of his career, Reff surveys the subtle interaction of the old, represented by such elements as fresco painting, the copying of Renaissance art and the emulation of traditional draughtsmanship, with Degas's startling new experiments with tools, materials and the application of colour. Both Rouart and Reff's texts have been widely influential, few publications in recent years omitting some reference to Degas's practical concerns and their subtle exchanges with history. As with so many similar considerations, however, there has been little recognition of the rhythms and periodicity of these concerns in the long saga of Degas's working life. A reverence for the past is habitually taken to be a permanent feature of the artist's project, varying with the practical demands of the moment but offering an unchanging context for his imagery and his often-cited aphorisms.

Few aspects of Degas's career are as well documented as his youthful enthusiasm for the art of the past. Working in Paris and travelling through France and Italy in the 1850s, the fledgling artist accumulated notebook studies from engravings and statuary, copies of acclaimed paintings and canvases of his own made in transparent homage to Holbein and Leonardo, Raphael and Veronese, Ingres and Delacroix. His written asides encapsulate his progress: 'How can one forget that the antique, the strongest art is also the most charming?', he wrote in 1860; and soon after his return to urban France: 'Oh Giotto, let me see Paris, and you, Paris, let me see Giotto!'[32] Such enthusiasms, of course, were not uncommon among his peer group, but they became more surprising

when they persisted into the next decade, as Degas threw in his lot with the nascent Salon of Realists, among them Whistler, Tissot, Fantin-Latour and Manet. Though the pace of his copying slowed considerably, it lost none of its seriousness or ambition. In October 1865 Degas registered to study in the Louvre, where he drew and painted several versions of Sebastiano del Piombo's *Holy Family*; substantial copies were made from Mantegna, Veronese, Caroto, Mor and Le Sueur; and most spectacularly of all, Degas transcribed Poussin's large *Rape of the Sabines* in a full-size replica (fig. 59), considered by a contemporary to be 'as fine as the original', that was to be acquired by Henri Rouart and achieve some renown in the artist's later life.[33]

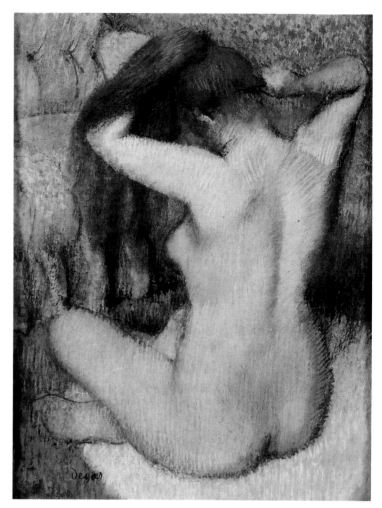

FIG. 61
*Nude combing her hair, c.*1888–90
Pastel on wove paper, 61.3 x 46 cm (24⅛ x 18⅛ in.)
New York, Metropolitan Museum of Art,
Gift of Mr and Mrs Nate B. Spingold, 1956 (BR.115)

FIG. 60
Jean-Dominique Ingres, *Valpinçon bather*, 1808
Oil, 146 x 97.5 cm (57½ x 38⅜ in.)
Paris, Musée du Louvre

Then, about 1870, all these activities come to an abrupt standstill. The notebooks of the Impressionist era, though admittedly fewer in number than in previous decades, show neither transcriptions from Degas's predecessors nor aphoristic reflections on their greatness, while not a single copy from the art of the past has been dated to this period.[34] Just as significantly, echoes of such works in Degas's own imagery fade almost completely, as if the rawness and topicality of shop-girls, jockeys and ballerinas precluded the resonance of history. One or two exceptions might be proposed, but in each case they are remote from the original or ironic, even irreverent in tone.[35] In itself, this distancing of Degas from tradition as his own career took flight might seem unremarkable, were it not for the evidence that, almost two decades later, the process was decisively reversed. It is in the 1890s that we hear once again of Degas's passion for the past, his fascination with Titian, Veronese and Poussin, and his preoccupation with their techniques. Asked by Vollard at this period how a young artist should train, Degas replied, 'He should copy the masters and recopy them, and after he has given evidence of being a good copyist, he might reasonably be allowed to do a radish, perhaps, from Nature'.[36] He told George Moore, 'What I do is the result of reflection and the study of the great masters'; and in the presence of Daniel Halévy exclaimed 'we are *tradition*, one can't say it often enough'.[37]

In the revived historicism of Degas's later years, the work of his illustrious forbears pervaded every aspect of his activity, from conversations with friends to advice for younger artists, from the pictures on his walls to the unformed projects in his imagination. When Degas undertook to instruct Ernest Rouart in the rudiments of painting, he took him to the Louvre to copy Mantegna, just as he directed the young Daniel Halévy towards Turner and Corot, and talked with him about his recent acquisitions of Ingres and Delacroix.[38] As the works in the present volume demonstrate, many of these same precedents had again seized his own art, less evidently in acts of homage than in former times, but arguably to more profound effect. The importance of Titian for his *After the bath, woman drying herself* (cat. 57) and Mantegna for his frieze-like late dancers, for example, or of Turner for the landscape monotypes and the Ingres of the *Valpinçon bather* (fig. 60) for the *Nude combing her hair* (fig. 61) is surely unarguable, as are other counterparts in Watteau, Delacroix and Poussin.[39] Most decisive and surprising of all, however, is Degas's return to his youthful practice of copying. In the late 1880s, he made a full-size paraphrase in oil on canvas of Delacroix's sketch for the *Battle of Poitiers* (Baltimore, Walters Art Gallery) and a large monotype based on a nude by Titian (fig. 62); several years later, he transcribed a second Delacroix composition in oil; and in 1897 made one of his most remarkable copies, the charcoal and pastel on canvas *Copy after Mantegna's 'Minerva chasing the Vices from the Garden of Virtue'* (fig. 121).[40]

This generalised outline of a career divided into three phases of engagement with past art, though broadly brushed and subject to local revision, is a useful corrective to the view of Degas's unvarying historicism. From this new vantage-point, the 1870s and 1880s can seem conspicuously anti-historical in many vital respects, as Degas endorsed the critic Edmond Duranty's call for the 'hustle and bustle' of contemporary life and finally relinquished his own commitment to Renaissance 'charm'.[41] The explosion of unorthodox techniques during these years took Degas as far away from 'the study of the great masters' as he was to travel, even though his draughtsmanship continued to

FIG. 62
*Torso of a woman, c.*1889–90
Monotype on paper, 50 x 39.3 cm (19¾ x 15½ in.)
Paris, Bibliothèque Nationale (J.158)

FIG. 63
The billiard room at Ménil-Hubert, 1892
Oil, 65 x 81 cm (25⅝ x 31⅞ in.)
Staatsgalerie Stuttgart (L.1115)

provide a linking thread. The relative scarcity of sketchbooks and eye-witness accounts during this middle phase should give us pause, but a resurgence of involvement with craft, and with pictorial precedent as he approached his final years is everywhere in evidence. Not the least persuasive of these developments is a kind of quasi-academic pose adopted by Degas with in his dealings with the past. Apart from regular sessions in the painting galleries and classical collections of the Louvre, he arranged a lengthy trip to Madrid to see the Prado, successive visits to the museum in Geneva, where he paid ritual homage to Corot's *Reclining nymph*, and a number of excursions to study Ingres at Montauban.[42] For Ingres he was willing to become almost scholarly, writing to the authorities at Montauban to suggest an exchange of photographs and paying calls on the artist's surviving sitters, while amassing a comprehensive collection of his drawings, cartoons and paintings.[43] As late as 1911 this studiousness persisted, when the Vollard archives reveal a glimpse of the aging painter soliciting a photograph of a work by Ingres from a Berlin collector who was about to buy one of his pictures.[44] Despite, or because of, his advancing years, Degas continued to interest himself in cataloguing and framing, relining and restoration, and would hold forth to whoever would listen on the state of the national collections and the desirability or otherwise of a personal museum.[45]

Degas's re-engagement with the history of his craft can be seen in a number of lights. At the personal level it suggests a nostalgia 'toward the art of the past . . . as he grew more disillusioned and conservative generally', as Theodore Reff has noted.[46] More critically, it might be viewed as the artistic equivalent of his notorious militarism and rabid nationalism in later decades, as well as a distrust of fashions and social innovation of all kinds. As such, it would appear to reverse the openness to both new practices and topical modes of behaviour that had distinguished the artist's middle years; when the elderly Degas mocked the telephone and the frantic speed of modern life, he might have been satirising his own preoccupations of the Impressionist era, when he had celebrated the latest technology and the collision of classes and visual conventions, and turned some of them into art. Such simple constructions, however, rarely fit the material evidence, and behind all the artist's final obsessions, not to say his ravings, lie the obstinate facts of his visual achievement. Though his art may have been made against a background of historical rhetoric, these pictures and sculptures do not look reactionary or conceptually tired. Such vibrant planes of colour and line, inextricably bound up with extreme depictions of the human body, belong with the most radical products of the *fin de siècle*, not with its fake medievalism and insipid classical revivals.

At the heart of Degas's renewed dedication to the past lay a crisis in his studio practice. His references to the paintings of the masters often express a yearning for their richness and subtlety, and a number make explicit reference to his own technical inadequacy. A vivid glimpse of this crisis is provided by the canvas *The billiard room at Ménil-Hubert* (fig. 63), one of a group of three oils associated with a little-known quasi-scholarly project of the 1890s, to produce an album of images and writings associated with billiards and their history.[47] With great poignancy, the picture displays Degas's affection not just for paintings of several periods, represented by the assorted collection of framed works on the billiard-room walls, but also for the traditional interior of a Normandy château belonging to some of his oldest friends. A letter written from Ménil-Hubert in 1892 alerts us to the work's painful beginnings: 'I wanted to paint and I set about doing billiard interiors', he wrote, 'I thought I knew a little about perspective, I know nothing at all, I thought that one could replace it by a process of perpendiculars and horizontals, measure angles in space by means of good will alone.'[48] The results of Degas's process of self-discovery are still visible in the lively conjunction of orthogonals in these oddly entrancing pictures, but almost as instructive are their complex membranes of paint. Brushed lines, thinly scrubbed colour and superimposed hues all point to a cumulative and extended facture, while patches of impasto and disc-like traces of the artist's fingers suggest revision and an engagement with

historical precedent. Put simply, these are signs of technical struggle, where Degas has pushed his craft to the limit and reached out for help to the expertise of the past.

The discovery of his ignorance of perspective is just one example of Degas's acceptance, as he entered his last decades, of his practical limitations. Jeanniot tells us that he, Degas and Luigi Chialiva, a North Italian painter and reputed authority on the materials of art, often discussed the lost expertise of their profession. On one such occasion, Degas reflected,

> *This painting in oils that we do, this difficult craft that we practice without having a real command of it! A similar inconsistency has doubtless never existed. There were tried and true methods that the artists of the seventeenth and eighteenth centuries practiced; methods still known to David . . . but the painters of the early nineteenth century were no longer acquainted with them.*[49]

Degas loved to repeat stories, many of doubtful authenticity, of the 'lost secrets' of the masters, telling Moreau-Nélaton of a chain of instruction that led from Titian to Van Dyck via an 'old maid in Genoa', and insisting to Valéry that painting would always remain 'a mystery'.[50] To Vollard, Degas protested,

> *'What a cursed medium oil is anyway! How is one to know the best canvas to use – rough, medium or fine? And as for the preparation, is white lead better, or glue? Should there be one layer, two or three?' He was equally perplexed by the minium preparation the old masters used. He would struggle with canvas for a while and then go back to pastel. 'I will never touch a brush again,' he would declare. Then, as if irresistibly lured by its very difficulties, he would return to oil once more.*[51]

Bluntly comparing the practices of his own day with that of the masters, Degas confessed to the young Georges Rouault, 'we paint like pigs'.[52]

This mixture of sentiment and perceived loss, of admitted incompetence and pure fantasy reminds us of the complexity of Degas's dilemma. Here is the celebrated traditionalist of the Impressionist generation in full maturity, bemoaning a lack of the most elementary skills in perspective, in the preparation of canvases and the application of paint; far from boasting of a continuity with his ancient predecessors, Degas was clearly appalled by the gulf that separated them and angered by his sense of helplessness. The contrast with the confidence and bravura of the artist's earlier years could hardly be more pronounced, nor that between the contested surface of *The billiard room at Ménil-Hubert* and the sparkling gouaches and *essence* paintings of the 1870s. Many of the works of Degas's last years seem to result from a kind of technical anarchy, innocent of the constraints of convention and the verities of the naturalist tradition, and blindly prefiguring the breakdown of orthodox skills in our own century. As countless letters and recorded conversations show, Degas's uncertainty echoed a more general technical self-consciousness among his generation, but one which must be approached with caution. Legends of declining standards, in art as elsewhere, can rarely be taken at face value and, as Reff observes, there was in reality 'no such dramatic breakdown of the studio tradition' in the early nineteenth century.[53] What is certain, however, is that many of his colleagues in later life *felt* this to be the case and allowed their practice to be governed by it, often echoing Degas's turns of phrase and encountering similar practical crises.

Personally remote but artistically akin to Degas, Paul Cézanne spoke longingly of the skills of Titian, Tintoretto, Rubens and Poussin, and of his wish 'to link up with all those great figures from the past two centuries. That fixed point rediscovered in the midst of all this modern chaos'.[54] Like Degas, he repeated Delacroix's claim that 'David killed painting', and repeatedly stressed the material difficulties of his calling: 'you can never fully know your craft' he told Joachim Gasquet.[55] Closer socially to Degas, the overtly historicist Renoir declared that, as a young painter who wanted 'to learn the traditional technique of painting', you would be merely 'left to your own resources'.[56] Renoir admitted that he had experienced his own technical crisis in the 1880s, deciding that he knew 'neither how to paint nor draw . . . Impressionism was a blind alley, as far as I was concerned'.[57] Turning to the Old Masters, he concluded that 'the ancients painted as well as the moderns . . . and their work is more permanent', and advised a young artist to 'strengthen and perfect his *métier*, untiringly, but he can only do that with the help of tradition'.[58]

These collisions between often ill-informed revivalism and radical innovation in the later work of Degas, Cézanne and Renoir could be both violent and productive of surprising new meanings. Renoir's discovery of Renaissance fresco painting brought a freshness and grandeur to his imagery, which was to resurface in Picasso's post-war classicism, while Cézanne's wish to 're-make Poussin entirely from Nature' energised his haunting series of late *Bathers*, so violently seized upon by the nascent Cubists.[59] In Degas's case, his obsession with past masters, techniques and works of art seemed to grow in proportion to his abandonment of the practices of his middle years, perhaps filling the vacuum left by their perceived limitations. Judging himself now against the monumental nudes of Titian and the lyrical nymphs of antiquity, Degas lived out his years in the centre of industrial Paris, obliged to reassess his most basic practical skills and reinvent his mastery of colour, form and line at the beginning of a new century.

THE CULT OF DRAWING

The most conspicuous thread running through Degas's long career, sustaining the tensions of new subject matter, shifts of attitude towards history and disruptions in technique, is surely that of his draughtsmanship. While the thread could be variously augmented and refined, and while it might be woven into a variety of pictorial fabrics, draughtsmanship brought resilience to his most extravagant designs and offered a direct line of communication with the past. As early as 1874, when the artist was still virtually unknown, one critic exclaimed, 'What precision there is to his drawing!', and soon afterwards another writer presciently linked him with one of the greatest draughtsmen of the century, predicting that 'Degas will take the place that Ingres holds now.'[60] By the following decade, his name was regularly paired with that of the Neo-Classical master, and occasionally with the linearity of 'the great Florentines, of Lorenzo di Credi and Ghirlandaio', while the 'astonishing power' of his drawing was almost routinely admired.[61] In the 1890s, Théodore Duret could still argue that Degas's 'strong point, his predominating faculty, is his draughtsmanship', an observation endorsed by the first substantial publication devoted to Degas's art, the luxurious *Vingt Dessins*, which appeared in 1897 and seemed explicitly to encourage the analogy with Ingres.[62] Significantly, this album of facsimile drawings was masterminded by Michel Manzi, himself an occasional draughtsman who caricatured Degas and his friends with skill (fig. 50). It also represented one of the first of many such tributes from fellow-painters to Degas's linear and observational skills. Sickert called him 'the greatest living draughtsman' and Renoir said of a charcoal study, 'I've never seen a finer drawing'; drawings and pastels by Degas were acquired by Claude Monet, Paul Gauguin, Mary Cassatt, Pierre Bonnard, Edouard Vuillard and Jacques-Emile Blanche, while a century later *Woman combing her hair* (cat. 44) and *Two nude dancers on a bench* (cat. 29), both in the present exhibition, were bought by Henry Moore, and R.B. Kitaj has written of Degas that 'no-one drew the figure better'.[63]

Beyond these pieties, few have understood both the continuity and the searching originality of Degas's late drawing as well as Paul Valéry, who singled him out as 'the most reflective, the most demanding, the most merciless draughtsman in the world'.[64] Valéry's testimony has at least three major claims on our attention. An amateur artist of some accomplishment, Valéry made sketches from life, such as the *Self portrait* (fig. 64), and imaginative compositions in a wide variety of media.[65] He also grew up in the same circles as Ernest Rouart and Julie Manet, surrounded by the paintings and drawings of Edouard Manet, Berthe Morisot (whose niece he married) and their intimates. More than most, Valéry felt the practical significance of lines on paper, even as he speculated widely and brilliantly on the processes of creativity. In the second place, Paul Valéry based his account on first-hand observation,

FIG. 64
Paul Valéry, *Self portrait*, n.d.
Black and red crayon on paper, 9.2 x 7.3 cm (3⅝ x 2⅞ in.)
Sète, Musée Paul Valéry

derived from a number of visits to Degas's studio and from lengthy discussions with the artist, as well as the intimate memories of Ernest Rouart.[66] Most crucial, however, is the historically-specific nature of Valéry's evidence, which coincides closely with the artist's late period. Arriving in Paris in the early 1890s, Valéry met Degas through the Rouart family in 1893.[67] Over the next decade, he wrote a story centred loosely on his conception of Degas's inner life, *La Soirée avec Monsieur Teste*, which he began to illustrate with his own, rather Degas-like drawings, teased the artist across the dinner-table about his theories and pronouncements, and was encouraged by Degas in the courting of his future wife.[68] As with so many of these friendships, that between Degas and the writer tailed off in the new century, though Valéry noted a long conversation that took place as late as October 1905, when they talked together about drawing and about Ingres.[69]

Valéry's discussions of Degas's draughtsmanship took place, therefore, sometimes quite literally, against a backcloth of works like those reproduced in these pages. When he evokes the series of 'easels loaded with charcoal sketches of flat-nosed, twisted models, with combs in their fists, held around thick hair gripped tight in the other hand', he might have been referring, however unflatteringly, to a drawing such as *Woman combing her hair* (cat. 38), just as the dance studies in which the artist seemed to be 'adding colours, mingling pastel with charcoal; in one version the petticoats may be yellow, in another purple' might be the variants of *Three dancers in yellow skirts* (cat. 18).[70] The authority of Valéry's account derives from his day-to-day familiarity with such pictures, as well as his knowledge of the combative role of line and tone in their evolution. Degas 'was particularly excitable where politics or drawing were concerned', he tells us, observing that,

The sheer labour of drawing had become a passion and a discipline to him, the object of a mystique and an ethic all-sufficient in themselves, a supreme preoccupation which abolished all other matters, a source of endless problems in precision which released him from any other form of inquiry.[71]

Beyond the 'labour' and 'precision' involved, Valéry was entranced by the interplay of the visual, the mental and the psychological in the act of draughtsmanship, and often tried to provoke Degas into elucidating these subjects. Facetiously, the writer once told him, 'You painters, you spend all day at your easel, but for a good part of the time your work is organised, short-circuited between hand and eye, leaving your mind disengaged.'[72] Degas's response is not recorded and it was left to Valéry to put the opposite case: 'The hand is very indirectly governed by the eye,' he notes, 'many "relays" come in between; notably that of memory. Every glance at the model, every line traced by the eye, at once becomes a recorded memory...'[73] He goes on to stress the functions of volition and the intellect in these processes: 'Every work by Degas was done in earnest . . . the will is all-powerful'; 'I know of no art that calls for the use of more *intelligence* than that of drawing.'[74]

It is perhaps in another context, in his reflections on the use of language in approaching works by Corot, Degas and Delacroix, that Valéry came closest to the heart of the matter. 'May not the prime motive of any work,' he asks, 'be the wish to give rise to discussion, if only between the mind and itself?'[75] This conception of art as a protean and endlessly reflective activity, a series of dialogues between the mechanical and the cerebral, coincides forcibly with Valéry's insights into Degas's draughtsmanship and with the fragmentary explanations of his activity elicited from the artist himself. Challenged by Valéry with 'What do you mean by *drawing*?', Degas replied 'Drawing is not the same as form,

it is a way of seeing form', leaving his apologist to explain, 'What Degas called a "way of seeing" must consequently bear a wide enough interpretation to include way of being, power, knowledge and will'.[76] For Degas and for Valéry, the author of *L'Introduction à la méthode de Leonard de Vinci*, drawing was among the most elemental as well as the highest forms of expression, offering a model not just for creativity but for the practical and intellectual life.

During his meeting with Valéry on 22 October 1905, Degas described a series of youthful visits, made just half a century earlier, to the studio of the elderly Ingres. Though Valéry and most of Degas's friends had heard this story countless times before, its salient features remained much the same, culminating in the advice given to the aspiring artist to 'Study line . . . draw lots of lines, either from memory or from nature'.[77] As we have seen, the spectre of Ingres haunted Degas through much of his career, but there are signs of a quickening of this influence in the last decades. Most of the anecdotal variants of his encounter with Ingres, such as those told to Walter Sickert, Georges Jeanniot, Daniel Halévy and Ambroise Vollard, were recorded in the 1890s or even later, and other accounts can be added to this list.[78] In January 1891, the artist jumped to his feet before Jacques-Emile Blanche and intoned some of the master's aphorisms from memory, while William Rothenstein recalled Degas's recent return from a pilgrimage to Montauban in 1896, when he 'was full of his visit, and of the surpassing beauty of the drawings' he had seen.[79] This was also the period of Degas's systematic study of Ingres's oeuvre, when the acquisition of twenty oil paintings and almost a hundred works on paper gave the most tangible expression to his awe.[80] Any analysis of Degas's late draughtsmanship must, therefore, take account of this presence, which was at the same time insistently literal and powerfully symbolic. As well as the reiterated articles of faith, there were portfolios of Ingres's drawings strategically placed in his apartment, framed paintings and works on paper in his salon (fig. 5) and his bedroom, and according to Moreau-Nélaton, a draft of a figure for Ingres's *L'Age d'Or* hung reverentially above the artist's bed.[81]

The drawing in question may well have been *Study for 'L'Age d'Or'* (fig. 65), known to have belonged to Degas's collection and now in the Clark Art Institute, Williamstown.[82] Economical, almost rudimentary though the study is, it is not difficult to understand how such a work might achieve emblematic status in Degas's life. Poignantly recalling the advice given by Ingres to his young disciple, this celebration of wiry, tremulous linearity encapsulates many of the practices of Degas's later years. As a drawn statement of a motif finding fuller expression in other forms, in this case one of the versions of Ingres's *L'Age d'Or* (fig. 160), it might be compared to Degas's closely twinned drawings and pastels, where line similarly precedes colour; as a drawing executed on tracing

FIG. 65
Jean-Dominique Ingres, *Study for 'L'Age d'Or'*, c.1862
Pen and ink on paper, 34.6 x 16.8 cm (13⅝ x 6⅝ in.)
Williamstown, Mass., Sterling and Francine Clark Art Institute

paper it has the closest technical ties with Degas's distinctive late materials; as an image of a standing female nude seen in three-quarter view it prepares us for many such subjects in Degas's oeuvre, among them *Nude woman drying herself* (cat. 65); and as a representation of a dancer, both classical in inspiration and manifestly naked, the *Study for 'L'Age d'Or'* prefigures much of Degas's mature subject matter.[83] Beyond these pervasive links, however, there lurks a fundamental challenge that is too often overlooked when Degas's affinities with his predecessor are ritually cited. When all these resemblances have been noted, Degas's late drawings are still profoundly *different* from those of Ingres, not just in their historically specific subjects but in their hesitations of touch, their coarseness of finish and their flirtations with, and frequent capitulations to, luxurious colour. Whatever his reasons for clinging to the art and life of Ingres, Degas's posturings clearly cannot be taken at face value.

Carole Armstrong has recently reflected on some of the differences, rather than the more familiar kinship, between the work of the two artists, though without casting doubt on Degas's wilful and self-conscious elevation of Ingres to cult status in his later years.[84] As we have seen, this beatification was part of Degas's new pattern of historicism, which in itself could be wide-ranging and thematically inconsistent. In the same room as Ingres's *Study for 'L'Age d'Or'*, Moreau-Nélaton tells us, were drawings by Delacroix and Suzanne Valadon, and other witnesses report that Degas spoke of the popular illustrators Gavarni, Forain and Charles Keene with a similar reverence, while adoring 'every line from the hand of Millet'.[85]

In theory if not in invariable practice, therefore, and regardless of the gross contradictions visible on his apartment walls and in his studio, Degas sided publicly with line against colour, with the disciples of Ingres against the motley followers of Delacroix, with Florentine *disegno* rather than Venetian *colore*. When he told Sickert 'I have always tried to urge my colleagues to seek for new combinations along the path of draughtsmanship, which I consider a more fruitful field than that of colour', he was pointedly aligning himself with respect to the past, even as he reformulated Ingres's belief that 'Drawing makes up more than three-quarters of that which constitutes painting'.[86] Implicitly, Degas also took over Ingres's association of line with austerity and control, both within and beyond the artistic vocation. Ingres's claim that 'Drawing is the probity of art' is an overtly moral statement, reflecting the rigour of the painter's professional life as well as the severity of most, if not all, his imagery.[87] But, just as Ingres's draughtsmanship and painting are today seen as more various and, in such pictures as *The Turkish bath* (fig. 66), more bizarrely sensuous, than the master perhaps wished his pupils to believe, so Degas honoured Ingres's precepts as much in the breach as in the observance.

FIG. 66
Jean-Dominique Ingres, *The Turkish bath*, 1862
Oil, diameter 108 cm (42½ in.)
Paris, Musée du Louvre

Ingres was not, of course, the lone representative of these views for Degas's generation. In his widely read and much-reprinted *Grammaire des arts du dessin*, for example, Charles Blanc propounded the centuries-old notion that drawing was the foundation of all the arts: for architecture it represented 'the generating principle', for sculpture, 'drawing is everything'.[88] Painting, he conceded, was a somewhat different case, where 'colour is essential, even though it occupies a secondary position' to that of draughtsmanship.[89] Blanc then went further, claiming even more extraordinary authority for his beliefs than Ingres himself. 'The superiority of drawing over colour is written in the very laws of nature' he explains, having already announced that 'Drawing is the masculine sex of art; colour the feminine sex.'[90] 'The union of drawing and colour is necessary to engender painting, just as the union of man and woman to engender humanity,' he continued, adding, 'it is necessary that drawing should retain its dominance over colour. If it is otherwise, painting hastens to its ruin: it will be betrayed, just as humanity was betrayed by Eve.'[91] Monstrous though these outpourings now seem, they undoubtedly formed part of the great debates and the studio small-talk of succeeding decades, for example when Huysmans observed the 'marriage and the adultery of colours' in a display of Degas's pastels.[92] But for all the echoes of this rhetoric in Degas's own language, in his public attachment to Ingres and to 'masculine' linearity, Degas's later years can be seen as a more complex and even compromising response to the values of his era. Just as his drawings rarely look like those of Ingres, and just as he promiscuously collected the works of Ingres's most notorious rivals, many of his finest late pictures seem wilfully dedicated to the fusion of line and colour, a conjunction of the 'masculine' and the 'feminine' that denies Blanc's 'necessary dominance' to either.

The practical reverberations of these historic issues can be seen to shift from decade to decade, preparing the way for the entirely distinct drawings of Degas's last phase. In a fine early study such as *Standing nude* (fig. 67), for example, made in about 1860, we see a masterly command of line and musculature that both Ingres and Blanc would surely have admired. The use of pencil, the soft internal shading of the body and even the langorous pose are explicitly Ingres-like, while the monochromatic image makes no concession to the 'betrayal' of colour.

FIG. 67
Standing nude, c.1860–5
Pencil on paper, 29.2 x 21.7 cm (11½ x 8½ in.)
Williamstown, Mass., Sterling and Francine Clark Art Institute
(IV, 109d)

FIG. 68
*Nude drying herself, c.*1876–80
Pencil and chalk on tracing paper, 44.6 x 27.9 cm (17⅞ x 11 in.)
Oxford, The Visitors of the Ashmolean Museum (III, 347)

Like many other studies of this period, the drawing emerged from Degas's long apprenticeship to the life room and the rituals of direct observation, as well as the preparation of his first large-scale paintings, such as *Young Spartans* (fig. 108).[93] Hundreds of works on paper were produced in advance of these elaborate canvases, establishing their panoramic compositions, fixing the poses of their participants and drafting out faces and gestures, vegetation and topography. In mundane terms and in the grander sense understood by Blanc, such drawings laid the foundation for the finished picture, determining most of its features and its meaning long before the first touch of paint was applied. By the same logic, as soon as the painting process was complete these studies had fulfilled their purpose and could be set aside or even destroyed with impunity.

Fifteen or twenty years later, the brisk silhouette of *Nude drying herself* (fig. 68) showed some of these assumptions retained, others long since abandoned. Though larger than its predecessor and still executed in pencil, the drawing has none of its predecessor's Ingres-like refinement, nor does its subject conform to the stock poses of the life class. Its purpose, however, remains that of a preparatory study, here hastily scribbled down from a studio model to assist in a pastel-over-monotype bedroom scene, *Woman at her toilette* (fig. 69).[94] At this date, speed was of the essence, as the artist kept pace with his new materials and the vigorous modernity of his subject, turning out a workmanlike but scarcely elegant sketch that Ingres would probably have despised. *Nude drying herself* is emphatically a drawing of the moment, one of many dozens of ink, pencil, charcoal and pastel studies of urban entertainers and audiences, the clothed and unclothed citizens of Degas's Paris. Into many of these works, colour had already made its insidious inroads, challenging and sometimes overwhelming 'the superiority of drawing', to use Blanc's phrase. As is evident in *Nude drying herself*, tinted papers and touches of chalk frequently animated such images, while in other cases, waves of pastel or gouache might swamp their carefully defined contours. By a natural progression, some of these drawings found themselves reclassified, no longer as preparatory drafts but as developed and marketable works of art.[95] Though *Nude drying herself* was stored away after use, it had already contributed to a *Woman at her toilette*, a work signed by the artist and sold in 1885 to one of his least graphically inclined colleagues, Claude Monet.[96] Such images now entered the mainstream of Degas's production, giving notice of a redefinition of his drawing practices and presaging further breaks with tradition.

FIG. 69
*Woman at her toilette, c.*1876–80
Pastel and monotype on paper, 45.7 x 60.3 cm (18 x 23¾ in.)
Pasadena, California, Norton Simon Museum of Art (L.890)

The new uses of draughtsmanship in Degas's late years are powerfully summarised in *Ballet dancer resting* (fig. 70 and cat. 21), made approximately two decades after *Nude drying herself* and some thirty or more years after *Standing nude*. Again a study of a standing female figure, *Ballet dancer resting* differs in almost every aspect of its facture, its purpose and its material history from the earlier drawings. Self-evidently remote from the exquisite handling of Ingres, it seems wilfully coarse, even hamfisted in comparison with the miniature-like *Standing nude*, yet equally distinct from the hastily-executed *Nude drying herself*, not least in its plausibility. Where the woman towelling her back acts out a mundane and universal ritual, as recognisable then as it is today, the dancer strikes a pose that defies explanation. Supposedly relaxed, the ballerina throws one arm upwards against the wall, the other outwards in an echoing triangle; her legs and feet mirror this contrast, again seeming tense rather than at ease; while the dome-like form of her tutu collides at the centre of the composition with her improbably conical torso. This is a posture that owes more to art than nature, revealing much about bodily tension and the occupation of space, almost nothing about backstage life or the *fin-de-siècle* theatre.

The further we enquire into *Ballet dancer resting*, the more radical its identity as a drawing, and that of hundreds of similar sheets from Degas's last years, becomes. Apart from distinctions in surface and pose, it departs from most of its predecessors in its technical origins, and specifically in its relationship to the subject perceived. Following the practice of these years, Degas almost certainly made *Ballet dancer resting* by a process of replication, not from the direct scrutiny of a living model but by tracing or duplicating an existing sheet. It is, in other words, a drawing of a drawing, not a study from the living model, like *Standing nude*, or a recorded fragment of modern experience, like *Nude drying herself*. Though certain practices of transfer and repetition had been used by Degas for many years, the transition from occasional to almost invariable use of this procedure had the profoundest consequences for his imagery. Not the least of these was the emergence of a new kind of seriality, analogous to some of the 'series' patterns of his peers but technically unique to himself, the intricacies of which will be examined below. More immediately, it affected both his studio practice and the implicit status of individual works yet. Where once a study such as *Ballet dancer resting* would have been a mere exercise or a provisional draft, it now became a self-conscious and self-contained statement, occupying the same scale and exhibiting many of the same properties as Degas's more intensely worked pictures. Considerable numbers of such drawings were signed by the artist, the clearest token of their completion and independence, and many were framed, exhibited and published during his lifetime, and according to his strict taste in such matters.[97] In

FIG. 70
Ballet dancer resting, 1897–1901
Charcoal on tracing paper, 50.5 x 31.1 cm (19⅞ x 12¼ in.)
California, Santa Barbara Museum of Art,
Gift of Wright S. Ludington (II, 274)

FIG. 71
*Nude study, two women standing, c.*1897–1901
Charcoal on tracing paper, 65 x 45 cm (25⅝ x 17¾ in.)
Location unknown, photograph Archives Durand-Ruel,
Paris (III, 239)

FIG. 72
*Dancer, c.*1897–1901
Pastel and charcoal on tracing paper, 45 x 23 cm (17¾ x 9⅛ in.)
Glasgow Museums, The Burrell Collection (L.944)

their new role as liberated images, unapologetically celebrating the qualities of line and tone, mass and human energy on a canvas-like scale, these drawings have no precedent in Degas's, and perhaps any other artist's, output.

A characteristic drawing from Degas's last years was made in a sequential process, beginning with a single study and fanning out to form a hierarchy or family tree, often including replicas, reversed variants and distant re-workings of the original image. A study such as *Ballet dancer resting* might emerge at any point from this branchwork, perhaps early, as an ancestral form that spawned many offspring, or as a late throwback to just such a primordial form. With this particular motif Degas seems to have delighted in its mutability, apparently beginning with one or more depictions of nude models, such as *Nude study, two women standing* (fig. 71), progressing to several clothed variants, including the monochromatic *Ballet dancer resting* and the lightly tinted *Dancer* (fig. 72), then adding the full panoply of colour, surface inflection and theatrical scenery in *Two dancers in the wings* (fig. 73). A collateral line involves the same pair of monumental figures, now reinforced by two seated and even more exhausted relatives who stretch and yawn in a dozen panoramic compositions, among them *Dancers* (cat. 23). Most

startling of all, perhaps, in this game of resemblances, is the twinning of *Ballet dancer resting* with its mirror reflection, *Dancer with right arm raised* (fig. 74). Such works, and the many others linked to this remarkable tribe, are manifestly not just preparatory studies leading towards a single finished picture, as the drawings for Degas's youthful *Young Spartans*, or even the later *Nude drying herself*, evidently were. Though some of them may have served this purpose, the sheer quantity of related drafts is far in excess of normal practice and their variation in both detail and structure demands other explanations.

The independent status of this new breed of drawings, bred from the art of draughtsmanship and from Valéry's 'discussion between the mind and itself', cannot be sufficiently stressed. Of the pictorial family discussed, one nude variant of *Ballet dancer resting* was signed by the artist, as were several sheets based on her regular companion, for example *Dancer with fan* (cat. 24). [98] Hardly the most polished example of Degas's draughtsmanship, this vivacious work was briefly heightened with pastel, authorised with the artist's signature and sold to the Havemeyer family, and later selected by Ambroise Vollard for his 1914 album *Quatre-vingt-dix-huit Reproductions signées par Degas*. Several other members of their sprawling company were likewise honoured, from the simplest

FIG. 73
Two dancers in the wings, c.1897–1901
Charcoal and pastel on paper, 59.5 x 46.5 cm (23¼ x 18¼ in.)
Boston, Museum of Fine Arts (L.944)

FIG. 74
Dancer with right arm raised, c.1897–1901
Charcoal on tracing paper, 58.2 x 46.5 cm (22⅞ x 18⅜ in.)
Molly and Walter Bareiss Family Collection (II, 384)

sketches to the most luxuriously coloured and finished pastels, and many found owners during the artist's lifetime.[99] In one sense, this practice can be seen as a continuation of Degas's advocacy of the exhibited and autonomous drawing, evident from the beginning of his professional career and pursued throughout the Impressionist era. In another, it continues his very public attachment to a stock of motifs that would be shamelessly repeated, modified or transposed from one composition to a subtly different one.[100] But there is no precedent for the proliferation of drawing in Degas's late studio practice, when it accounted for the great majority of his output and embraced not just charcoal studies but pictures in pastel and oil. Determining his studio routines and his iconography, his relations with the visual world and the market-place, Degas's sequential production is both the most decisive and most underestimated feature of his late draughtsmanship.

In re-evaluating the traditional usages of drawing, Degas was arguably in the vanguard of a historic progression that still unfolds today. The presence of draughtsmanship at the centre of an artist's creativity, generating not just supporting studies for major works but these major works themselves, is now familiar to us from the wall-size designs of Matisse and the graphic outpourings of Picasso, from the collaged

figures of Willem De Kooning and the drawn paintings and painted drawings of David Hockney. But as Richard Thomson has argued, Degas's radical attitudes grew out of a more general upheaval in drawing in the 1880s, affecting not just the Impressionist generation but the entire structure of exhibiting, collecting and evaluating works of art.[101] Many painters in Degas's immediate circle, conspicuous among them Pissarro, Gauguin, Morisot and Cassatt, worked extensively and productively on paper, and all shared his enthusiasm for the self-sufficient drawing. In rather different ways, both Seurat and Cézanne devised new roles for draughtsmanship in their practice, while artists as technically remote as Redon and Rodin promoted the public drawing and the expressive extremes of tone and line.[102] Other acquaintances of Degas, including such stalwarts of the Salon as Puvis de Chavannes, Gustave Moreau and Giovanni Boldini, produced substantial chalk, pastel and ink designs on paper, often framing and presenting them alongside their works on canvas. But for the majority of these individuals drawing remained a secondary activity that had been largely defined in previous centuries. Though they might display a pastel portrait or a polished sketch on a gallery wall, their actions did not reflect a deeper questioning of the mechanisms of their craft or the material basis of their draughtsmanship.

CHARCOAL

Literally fundamental to all Degas's late drawings, and to an understanding of his processes of replication, are two simple physical facts: the medium in which the drawings were made and the surface on which they were executed. Banal in themselves, these considerations determined much of the distinctiveness of his imagery, while each resounds with that clash of tradition and epic modernity that characterises Degas's late art. Almost every drawing made in the last quarter-century of Degas's career was carried out in a single medium; that of charcoal. His exclusive adoption of charcoal is remarkable in many ways, not least in the contrast between this late singularity and his earlier licence, and between the black, shadowy substance itself and the bewildering graphic palette of his middle years. As we have seen, the renown of Degas's draughtsmanship had partly depended on just such multiplicity, and on the outlandish combinations of media so pedantically described in the Impressionist catalogues. Now, when he began a drawing such as *Ballet dancer resting*, the artist turned automatically to his sticks of charcoal, endlessly drafting out ribbons of carbon and smudges of sooty brown and grey without recourse to other tools and materials, and often without proceeding to colour. Some of these drawings, it is true, formed the characteristic tonal foundation for Degas's brightly hued pastels, but as often they were left in their pristine, monochromatic state and unapologetically presented as such. Like the other renunciations of his late life, the transition to charcoal proceeded by degrees rather than by sudden upheaval, and, like them, lacks a single explanation. Was it prompted, as Jeanne Fevre, William Rothenstein and others suggested, by Degas's failing eyesight and the need to make bolder, more immediately visible lines?[103] Was it merely practical, offering a close technical affinity with his powdery, paper-based pastels? Or was it part of Degas's more general weariness with novelty, a return to the primary substances and gestures of his remote antecedents?

A drawing such as *Two dancers* (fig. 75) speaks eloquently of the appeal of charcoal in Degas's last decades. The soft, variable blackness of its lines enfolds the contours of the dancers' limbs and torsos at one extreme, their fluffy muslin skirts at the other, encompassing parallel striations, cross-hatching and a dense vocabulary of curls, blurs and serpentine flourishes. Where the charcoal stick has barely touched the paper, for example in the pale area of the left-hand tutu, the gentlest traces have been left behind, revealing the hazy form of the ballerina's leg beneath the fabric and hinting at her voluminous underwear. Where the charcoal, by contrast, has been firmly pressed into the surface, sometimes repeatedly and almost savagely along the same tracks, streaks of darkness have accumulated, engulfing both nuances of form and surrounding detail. In several areas Degas has returned to this network of blacks and greys, superimposing further hatchings and lightening or erasing others.

FIG. 75
*Two dancers, c.*1898–1903
Charcoal and pastel on tracing paper, 109.3 x 81.2 cm (43 x 32 in.)
New York, Museum of Modern Art,
The William S. Paley Collection (BR.149)

Beneath the bench, for instance, the still-mobile charcoal granules allowed him to sweep up lines into patches of mid-grey shadow, rubbing with his fingertips and smearing the loose powder to remodel forms and spaces, such as that around the right-hand dancer's leg. In these passages, the unfixed charcoal takes on a near-liquid quality, where light and darkness flow across the solidity of form and the coherence of a leg or profile is dissolved in adjoining tonalities. Finally, Degas added a few

FIG. 76
*Dancer, c.*1895–8
Pastel on paper, 53 x 39 cm (20⅞ x 15¼ in.)
Private Collection, photograph courtesy of Sotheby's (L.1367)

touches of pastel colour, paradoxically heightening the monochromatic nature of the image while setting off the ash blacks, carbon blacks and warm smoke blacks that remind us of the medium's elemental origin.

Two dancers was made at the turn of the century and subsequently signed by the artist, perhaps when it was reproduced in Ambroise Vollard's ambitious 1914 publication of Degas's work.[104] Regarded by both artist and dealer as a finished, representative work of art, *Two*

dancers also turns out to belong to an extended family of variants, in the same way as *Ballet dancer resting*, this time embracing such works as the brilliantly coloured *Dancer* (fig. 76) and *Dancers* (cat. 37). The medium of charcoal on paper, it would seem from these two cases, was considered by Degas to be appropriate to the grandest of public statements as well as the most convoluted extremes of private research. Almost infinitely flexible, charcoal could be both definitive and provisional, crisply linear and vaporously vague, complete in itself or receptive to extension and embellishment. On a modest scale, charcoal could register the finest detail, while on a full square metre of paper, such as that occupied by *Two dancers*, it could aspire to the sweeping gesture and the rhythmic pulse of a substantial canvas. In effect, charcoal subsumed in a single medium many of the functions associated in previous decades with Degas's famously varied range of techniques. As the tinted passages in *Two dancers* also show, the base elements of drawing might soon be transmuted into jewel-like pastel, fusing line with hue in a continuous, alchemical process.

No decision made by Degas, whether technical, thematic or conceptual, was entirely remote from the influence of tradition, though tradition was as likely to be inverted or misconstrued as blindly followed. His exclusive adoption of charcoal in later life is a case in point. Even as Degas brazenly transferred his allegiance to this material in the late 1880s and early 1890s, he was simultaneously engaged in propagating the cult of Ingres, the master of the lucid form, the razor-sharp contour and, above all, the needle-like pencil line. Though Degas emphatically continued to follow Ingres's advice to 'draw lots of lines', as he had done throughout his career, these lines were now fractured by erasure and swamped in vacillation, his slashes and scribblings of carbon at the opposite extreme from Ingres's 'dessin ferme'.[105] Admittedly, Ingres himself had often explored the multiple outline and, occasionally, the improvised sketch, but Degas's late charcoal manner is irreconcilable with his predecessor's call for 'purity' and 'perfection', for the removal of traces of labour and the evidence of 'facility', and for a draughtsmanship of 'grace' and 'extreme precision'.[106] Beneath Degas's most radical drawings, there lurks the unmistakable residue of a lifetime's study of his great predecessor, not only in the obsessive act of drawing itself, but in the networks of internal modelling of a study such as *Two dancers*, and in the characteristically dominant contour. But despite the endless recitations of his maxims and the sometimes embarrassing self-identification with the Montauban master, Degas daily contradicted him in the privacy of his studio.

The painterliness of charcoal leads us to other precedents for Degas's shift in taste. Widely used as a drafting medium in the nineteenth century, charcoal had been developed into a highly expressive tool by artists

admired in Degas's earlier decades, such as Honoré Daumier and Gustave Moreau, while always retaining its subsidiary character. To find charcoal at the centre of the painter's craft we must look back much further, to the collaborative studios of the Renaissance and the 'adorable fresco painters of the fifteenth century', as Degas's father had once called them, who composed their wall-size narratives with the material and used it to delineate figures, draperies and architecture.[107] More specifically,

in such early Renaissance treatises as Cennino Cennini's Libro dell' Arte, often cited in the nineteenth century and reputedly present in Degas's library, the versatility of charcoal is frequently invoked. Without making excessive claims for his erudition, we might reasonably find an affinity between Degas's dedication to such a historic medium and his rekindled passion for the past, at a time when at least one critic linked his drawings with the most ancient graphic art, that of cave painting.[108]

FIG. 77

Two dancers in repose, c.1895–1903
Charcoal and pastel on tracing paper, 57.2 x 44.8 cm (22½ x 17⅝ in.)
Philadelphia Museum of Art,
The Samuel S. White III and Vera White Collection (II, 294)

FIG. 78

Dancer in repose, c.1895–1903
Charcoal and pastel on tracing paper, 65 x 43 cm (25⅝ x 17 in.)
Portugal, Francisco da Cruz Martins (L.1331 bis)

THE GENESIS OF DEGAS'S PICTORIAL SEQUENCES

Coincidental to the sensuous and traditional pleasures of using this medium, a powdery black deposit is left on the surface of the paper when each charcoal line has been drawn. If these particles are lightly sprayed with a dilute varnish or adhesive, usually referred to as fixative, the charcoal is effectively glued or 'fixed' to the support and becomes essentially stable. For some centuries, however, it has been known that another sheet of paper laid over this initial drawing, before the fixing process, will pick up some of the vestigial charcoal powder, transferring a trace of the original design on to the second surface. This print, or 'counterproof' as it is known, is necessarily a mirror-image of the first drawing and is usually fainter and less precise, but is in every other sense its duplicate in scale and composition. The usefulness of the technique is self-evident, both for producing laterally reversed variants of a design and for replicating a unique composition, and examples survive of its application in a number of historic circumstances.[109] Denis Rouart tells us that the counterproof had fallen into disuse in the nineteenth century, but stresses its natural affinities with a number of Degas's late techniques, notably pastel.[110] Degas evidently explored its potential with enthusiasm in the last years of his life, producing numerous sets of paired drawings, such as *Ballet dancer resting* and *Dancer with right arm raised* (fig. 74), and generating a number of 'mirrored' motifs.[111]

Two dancers in repose (fig. 77) and *Dancer in repose* (fig. 78) show the counterproof relationship to perfection. The former is characterised by the dense black-greys and sharp detail of the directly applied charcoal, marking it out as the initial drawing from which the second proof was pulled. *Dancer in repose* is more silvery, showing breaks in areas of tone and passages of haziness where the paper has been unevenly handled or the transfer imperfectly carried out. For Degas the process must have recalled, even grown out of, his long acquaintance with conventional printmaking, where an etched plate or lithographic stone first carried the image and the printed sheet its reversed replica.[112] More than such prints, however, and more even than his largest monotypes, these charcoal counterproofs could take on the dimensions of a full-size pastel or oil painting, dependent only on the size of the original drawing. In this sense, counterproofing and its related practices held out the possibility of replication on the grandest scale, and of the propagation of multiple copies of fully resolved works of art. Even with relatively modest paired works such as *Dancer* (fig. 76) and *Dancer* (cat. 37), which show some immediate or slightly removed counterproof link, our assumptions about creativity are temporarily shaken as we move into a world of reflections and multiple identities where the uniqueness of the visual statement can no longer be taken for granted.

The central role of charcoal brings us to the second fundamental and practical quality of Degas's late drawings, as decisive in its way as his exclusive use of that medium; the surface on which the drawings were executed. Like charcoal, this surface decisively influenced the appearance and expressive potential of his draughtsmanship; even more than charcoal, it also determined the structural growth of his imagery. The overwhelming majority of Degas's drawings and pastels were made on paper, but not on the rag papers, hand-made papers, 'Ingres' papers or mass-produced papers used by his peers and widely available from artists' suppliers. Uniquely, Degas chose tracing paper, of a kind almost indistinguishable from the pale, lightweight material still found in the classroom and the draughtsman's office today. Then as now, tracing paper was commonplace, though largely confined to the most mundane tasks and almost never associated with the finished products of the artist's studio. What is exceptional about Degas is his use of this everyday material in elevated and highly unorthodox circumstances, specifically as the basis of a high proportion of his late pictures in charcoal and pastel. Most of the works on paper considered in the present catalogue were produced on this surface, for reasons both whimsical and ingeniously technical, which have only gradually begun to reveal themselves.

Most immediately, the character of tracing paper can be seen in Degas's less developed drawings, where additions of charcoal and pastel have not obscured areas of the original surface. In the lightly sketched *Three dancers* (cat. 70), for example, the milkily-translucent quality of the paper is apparent, as is its tendency to become slightly mottled and discoloured with use. On larger expanses, such as those of *Woman combing her hair* (cat. 43), the smoothness, even the blandness of the paper can be felt, encouraging the easy transition of charcoal or pastel across its surface. Other sheets show variation in colour, where the off-white appearance of the pristine paper has deteriorated in excessive light, fading to dull straw, deep caramel, or even grey-brown in extreme cases. This fragility and the lack of a distinctive 'tooth', or surface texture, go a long way to explain the unpopularity of tracing paper with other artists of his day, while illuminating something of its appeal for Degas. In his case, its evenness seems to have suited his flourishing, exploratory line and helped him to avoid the mannered touch associated with conventional, and more sumptuous, pastel papers. Equally, its flimsiness was linked to the paper's primary function, allowing another drawing to be laid underneath yet remain sufficiently visible to be copied, not just once but an indefinite number of times. Seizing on this property as no artist before him, Degas made tracing the central activity of his late draughtsmanship, allowing the humblest of tissues to determine and direct every aspect of his practice.

FIG. 79
*Study for 'Mademoiselle Fiocre in the ballet "La Source"', c.*1867–8
Charcoal and pastel on tracing paper, 62 x 42 cm (24⅜ x 16½ in.)
Location unknown, photograph Archives Durand-Ruel,
Paris (L.149)

Given its prevalence, remarkably little attention has been devoted to Degas's use of tracing paper. As with charcoal, it was the venerable character of the tracing process that may have recommended itself to the aging artist, as well as its paradoxical novelty and technical obtuseness. Tracing was ubiquitous in the studio procedures of the past, used for the transfer of designs from preliminary drawings to a canvas or wall painting, for example, or as a stage in the enlargement of draft compositions. Ancient treatises describe the oiling of papers and the manipulation of glue size to create translucent sheets, again in sources Degas appears to have known.[113] These practices continued throughout the nineteenth century, now dependant on manufactured tracing paper of various kinds, though noticeably it was the more traditionally orientated of Degas's colleagues, such as Puvis de Chavannes and Gustave Moreau, who were its most frequent exponents. Like their predecessors, however, these artists and many others used tracing in the preliminary stages of their picture making, as a mechanical means of transferring a design from one surface to another, and not as an end in itself. So familiar was it in this context, that the painter William Rothenstein was able to describe tracing at the end of the century as still 'common with artists in France'.[114] During his own academic training, Degas naturally encountered such techniques, making use of them not only in early studies but in the elaboration of his first major paintings, among them portraits, history pictures such as *Young Spartans* (fig. 109), and modern-life scenes, such as the *Self portrait with de Valernes* (Paris, Musée D'Orsay) and the seminal *Mademoiselle Fiocre in the ballet 'La Source'* (Brooklyn Museum).[115] A tracing for the last (fig. 79) shows Degas working in a manner almost unchanged since the Renaissance, transcribing a figure study from paper to canvas at natural scale. Emphasising the slow and methodical build-up of a work of art, such preliminaries also consign the traced drawing to oblivion, its usefulness exhausted and its flimsy character unsuited to preservation once the larger work was complete.

At about the time he finished *Mademoiselle Fiocre in the ballet 'La Source'*, in the late 1860s, Degas's youthful practice of using tracing paper disappeared suddenly and almost completely from his craft.[116] Challenged, perhaps, by the radicalism of his new colleagues in the 'Salon of Realists', and by their restless techniques and improvisatory facture, Degas set aside the tracing process itself and many of the preparatory rituals associated with it. This transformation was surely both practical and symbolic, as tracing paper was swept aside by a host of novel tools and materials, and as Degas temporarily turned his back on the 'adorable fresco painters of the fifteenth century' and their successors. During the Impressionist years, tracing paper featured little, if at all, among Degas's working surfaces and was never chosen as the

FIG. 80
Jean-Dominique Ingres, *Dancer with castanettes, tambourine player, c.*1862
Pencil on tracing paper, 42 x 15 cm (16½ x 5⅞ in.)
Montauban, Musée Ingres

basis of fully fledged drawings and pastels. This reversal became even more remarkable when, almost two decades later, it was once more inverted. At some point in the mid- or late 1880s, tracing once again entered the mainstream of Degas's practice, rapidly gaining momentum and soon dominating the tide of works flowing from his rue Victor Massé studio. Consistent with other fluctuations in his imagery and his technique, this revival of tracing in Degas's later career also confirmed the cyclical nature of his craft and the tendency to reassess ancient skills in his last years. The circumstances in which Degas took up tracing again, however, remain obscure. According to the artist Luigi Chialiva, it was he who accidentally introduced Degas to the medium, when Chialiva showed him some large and recently fixed plans by his architect son which had been completed on tracing paper.[117] Appealing though it is, Chialiva's story hardly explains Degas's youthful experience of the material, but may well mark a rediscovery of its versatility or an enlargement of his ambition in these last decades. It is certainly true that some of Degas's later traced drawings are among the largest works he ever produced, approaching the grandest designer's plans and his own most ambitious canvases, some reaching two metres in their largest dimension.[118]

Two habitual users of the tracing procedure, both important for Degas's practice in their different ways, may also have impinged on this development. As a young man in thrall to Ingres and an occasional visitor to his studio, Degas would certainly have been aware of the master's sketches and working drawings on *papier calque* or *végétal*, as tracing paper is variously known in France, such as *Dancer with castanettes, tambourine player* (fig. 80). Ingres often turned to tracing paper for the transcription of existing images, for preparing such works as his portraits and for the refinement of individual figures before their introduction into a painted scene, like the naked dancer who found a supporting role in his *Turkish bath* (fig. 66).[119] Here again, the workmanlike nature of orthodox tracing is signalled in the squaring-up, the annotation and the re-use of the sheet, and in the rough handling it has clearly experienced. Many of Degas's applications of tracing in his later career, therefore, have the clearest precedent in the techniques of Ingres and may have been retrospectively validated by them. Even the habit of pasting several sheets of tracing paper together, which becomes so characteristic of Degas's late craft, was anticipated in Ingres's drawings, as was the occasional use of reversal, presumably from a traced study.[120]

None of Degas's truly innovative applications of tracing, however, can be found in the work of Ingres and his generation, nor apparently among their precursors.[121] The multiplication of several identically sized works of art from a single sheet, the choice of tracing paper as the

FIG. 81
Gustave Moreau, *Study of a nude for 'Salomé', c.*1876
Pencil on tracing paper, 46.8 x 22.6 (18⅜ x 9 in.)
Paris, Musée Gustave Moreau

primary support for finished pastels and the taste for large-scale, exhibitable pictures on this distinctive surface are exclusive to Degas's final years. Closer to home, both geographically and historically, is the example of Gustave Moreau, who strongly influenced the young Degas's techniques when the two artists first met in Italy, and distantly haunted him in their later Montmartre-based careers.

Almost a thousand Moreau drawings on tracing paper survive, the earliest dating from the beginning of the 1850s, the last linked to some of Moreau's final and most elaborate compositions of the 1890s.[122] Significantly, a great flurry of traced studies from the Old Masters were dated by Moreau between 1857 and 1859, the years when he and Degas worked together in Florence and Rome, and the period of Degas's first tracings in his notebooks.[123] Like Ingres, Moreau relied on the tracing process for many routine tasks, working in ink or pencil on mainly small sheets of paper that would sometimes be collaged together into larger rectangles, as in his *Study of a nude for 'Salomé'* (fig. 81). Such drawings remind us again of the essentially craft-based nature of conventional tracing, as Moreau added rough patches of paper to his evolving compositions and casually included registration marks and splashes of ink on his design. In certain larger, grand format compositions on tracing paper, however, like the two-metre-wide *Les Sources* (Paris, Musée Gustave Moreau), Moreau came close to Degas's later expansiveness and perhaps offered him a prototype for his mature output.[124]

Even with its distinguished pedigree, Degas's fondness for tracing in his late years presented him with acute practical challenges. By its nature insubstantial and easily torn, tracing paper became unmanageable when used in large sheets, and had to be pinned or supported on another surface. Visitors to Degas's studio describe how he tacked his tracings to large pieces of cardboard as a temporary measure, inevitably weakening their corners and leaving pin-holes that are still clearly visible in such works as *Three dancers* (cat. 70).[125] On occasion, the artist seems also to have attached his drawings to rougher surfaces, such as the uneven wall of his studio, deliberately integrating the coarse textures of plaster or wood into his charcoal and pastel lines.[126]

Altogether more significant, however, was Degas's practice of arranging for the tracing paper to be glued to a sheet of lightweight card, apparently at some mid-point in the production of each drawing. The card chosen was typically faced with white paper, whose pale surface reflected light back through the tracing material and brightened its otherwise dull appearance.[127] When exposed to strong light over long periods, both elements of this layered arrangement can suffer discolouration, but it is crucial to remember that Degas evolved his drawn imagery against pale and largely neutral backgrounds.

Given its fragility, inconvenience and sheer eccentricity, why did Degas use tracing paper in this way? Its noble ancestry and smooth, unresisting surface hardly compensate for its drawbacks, and we must look to the original purpose of this material, as a medium for the reproduction and transference of a given design, for our answer. For Degas, the overriding attraction of tracing paper seems to have been its capacity for replication, for transcribing one drawing from another and for generating pairs or longer sequences of near-identical compositions. The evidence of his folios and the examination of hundreds of associated studies points inexorably to this conclusion, while a number of visitors to Degas's studio provide first-hand corroboration.

In different circumstances, both Jacques-Emile Blanche and Paul Lafond were advised by the artist to 'Make a drawing, begin it again, trace it; begin it again, and re-trace it.'[128] William Rothenstein remembered pictures of 'women tubbing or at their toilets', some of them 'redrawn again and again on tracing paper pinned over drawings already made';[129] Vollard and Jeanne Fevre offer their own variants of this story;[130] while the watchful model Pauline recalls how the artist would

retrace his drawing and copy the same tracing on to many sheets of pastel paper. Then he painted his subject in different hues, endlessly varying the colours, until one of the pastels satisfied him enough for him to complete it, leaving the others more or less finished.[131]

The use of tracing paper for the multiplication of his motifs, which provided the physical foundation not only for Degas's drawings but for the majority of his late pastels, appears to grow out of, but far exceed, certain predilections of his earlier years, famously summarised in a letter of 1886: 'it is essential to do the same subject over again, ten times, a hundred times,' Degas counselled his friend Bartholomé; 'Nothing in art must seem to be chance, not even movement.'[132] Virtually all his late works on paper have a family resemblance to other drawings or pastels, derived from their common origin in a single tracing, and most are further linked to parallel strains and distantly related clusters. Far from being a preparatory labour or a peripheral activity, as it had been with Ingres, Moreau and many of their contemporaries, tracing provided the generating force of Degas's late career.

A variety of justifications was offered by Degas's contemporaries for his bizarre addiction to tracing. Noting that the artist had been accused of 'repeating himself', Ambroise Vollard claimed in his defence, that it was Degas's 'passion for perfection' that led to this 'continual research'. According to the dealer, 'tracing paper proved to be one of the best means of "correcting" himself. He would usually make the correction by

beginning the new figure outside the original outlines, the drawing growing larger and larger until a nude no bigger than a hand became life-size – only to be abandoned in the end.'[133] Though this interpretation has passed into legend, there are few, if any, surviving drawings by Degas that endorse Vollard's vision of an ever-expanding study.[134]

The residual notion of a search for perfection, however, does find some support in other quarters, notably in Rothenstein's more prosaic sense of 'correction and simplification' and in Degas's own wish to 'do the same subject over again, ten times, a hundred times'.[135] Paul Valéry likened the serially minded Degas to a writer 'striving to attain the utmost precision of form, drafting and redrafting, cancelling, advancing by endless recapitulation, never admitting that his work has reached its *final* stage: from sheet to sheet, copy to copy, he continually revises his drawing, deepening, tightening, closing it up'.[136] Here it is a search for an elusive and ill-defined ideal that drives the artist, rather than an awareness of earlier failure, a quest for the 'utmost precision of form' that finally does justice to his pictorial challenge.

A more localised examination of his rituals of tracing helps to clarify Degas's motives. Any one of the late 'families' of dancers or bathing nudes might be instructively studied, as our earlier introduction to *Ballet dancer resting* has shown, but the distinctive cluster of three ballerinas at the side of the stage, a motif that haunts the drawings, pastels and certain oil paintings of this period, brings an unusual breadth to our enquiry. Characteristically, the artist established the dancers' poses at an early stage in a charcoal drawing on tracing paper, perhaps in the shimmering *Three nude dancers* (cat. 75), where revisions and linear second-thoughts hint at the direct interrogation of the model. This sheet is some sixty-three centimetres in height and the most prominent dancer approximately fifty-three centimetres tall, dimensions we should expect to find repeated in any subsequent tracings.[137]

At some point, hours, months or conceivably years later, a similar drawing was laid beneath a second sheet and *Three dancers in the wings* (cat. 78) traced from it, then lightly touched with pastel and signed. Though she has now acquired a ballet costume, the principal dancer's pose is almost unchanged and her height identical with the first study.[138] By proceeding from a nude figure to her clothed counterpart, Degas followed time-honoured practice; by colouring and signing the second study, and by propagating numerous other versions of the same motif through additional tracings, however, Degas moved beyond the simple logic of his predecessors. New dancers could now be overlaid on the scene or superfluous characters dismissed, single ballerinas extracted from the throng or fresh scenery invented, all on the same scale and each resulting in a separate sheet with its own subtle identity.

FIG. 82

*Three standing women, nude studies, c.*1893–8
Charcoal on tracing paper, 67 x 41 cm (26⅜ x 16¼ in.)
Location unknown, photograph archives Durand-Ruel,
Paris (III, 240)

The permutations of such traced networks are difficult to untangle,
but further examples from this series show the mechanics of proliferation
at work. Between the two cases already discussed, the artist evidently
chose to make a second hasty copy of *Three nude dancers*, tracing the broad
lines of *Three standing women, nude studies* (fig. 82) without lingering over
detail or internal modelling. At about the same time, he plucked the
foreground figure from the larger group to star in her own composition,
Study of a nude, hands on hips (fig. 83).[139] In the clothed sub-series, the most
distant dancer was omitted from a number of traced drawings, such as
Two standing dancers (fig. 84), which incorporate a curvaceous stage-flat
as well as further strips of paper attached to the sheet's edges. Tracing
from previous tracings as well as his original studies, sprouting offshoots
and hybrid visual cultures as he went, Degas continued to make virtual
replicas of earlier drawings, such as *Two dancers* (fig. 85), and dazzling
pastel variants, among them the *Two dancers* (cat. 77) and *Dancers in the
wings* (fig. 86). Almost twenty additional varieties of this versatile theme
can be identified and more than thirty compositions linked back to their
shared roots.[140] Many were left unfinished, the casualties, perhaps, of
Degas's search for 'the utmost precision of form', or his profligate studio
behaviour, but all owing their origin to a ballerina posed with hands on
hips, measuring some 53 or 54 centimetres in height.

As this cycle of drawings and pastels shows, and as dozens of similar
sequences of related nudes and dancers confirm, replication became the
governing principle of Degas's last decades. At times, it can appear
almost cynical, as if the artist was engaged in a Warhol-like mass
production of imagery that subverted the very tradition on which it
depended. At others, the fecundity of Degas's labour suggests a willing-
ness to supply a stream of familiar products to an increasingly avid circle
of collectors. Though there are elements of truth in both views, neither
takes account of a further, definitive characteristic of Degas's tracing
practice. Developed historically as a means of copying, tracing was never
used by Degas to make identical replicas of his pictures, but to
disseminate a suite of endlessly nuanced variations and some radical
transformations of his original subject. Degas traced freely rather than
pedantically, exploring the fluidity of the charcoal line to vary a pose or
heighten a contour, and following his pastels towards the decorative, the
starkly descriptive, or the chromatically grand. Despite their internal
diversity, however, we are left with an inescapable sense of art that breeds
from itself, of a process of self-reflection and contained, fissile energy that
turns to the outside world for nourishment but ultimately generates its
own motive force. Just as the organisation of his studio and apartment in
the rue Victor Massé allowed Degas to live, work and pursue his calling
under the same roof, so his daily craft, based on countless reformulations
of elemental motifs, made his late art almost self-contained.

FIG. 82

FIG. 83
*Study of a nude, hands on hips, c.*1893–8
Charcoal on tracing paper, 60 x 35 cm (23⅝ x 13¾ in.)
Location unknown, photograph Archives Durand-Ruel,
Paris (III, 255)

FIG. 84
*Two standing dancers, c.*1893–8
Charcoal on tracing paper, 63 x 54 cm (24¾ x 21¼ in.)
Location unknown, photograph Archives Durand-Ruel,
Paris (II, 275)

FIG. 85
*Two dancers, c.*1893–8
Charcoal and pastel on tracing paper, 69 x 57 cm (27⅛ x 22⅜ in.)
Location unknown, photograph Archives Durand-Ruel,
Paris (III, 316)

FIG. 86
*Dancers in the wings, c.*1893–8
Pastel and charcoal on tracing paper, 65 x 56 cm (25⅝ x 22 in.)
Location unknown, photograph Archives Durand-Ruel,
Paris (L.1015)

FIG. 83 FIG. 84

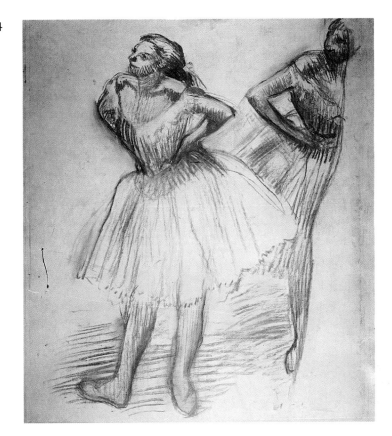

FIG. 85

FIG. 86

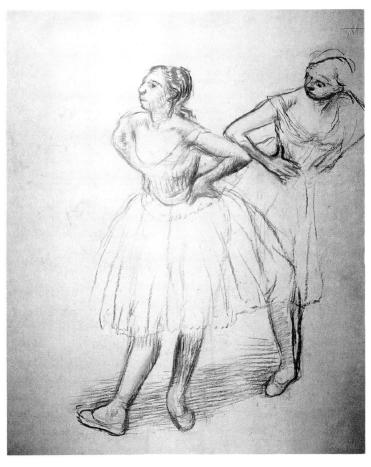

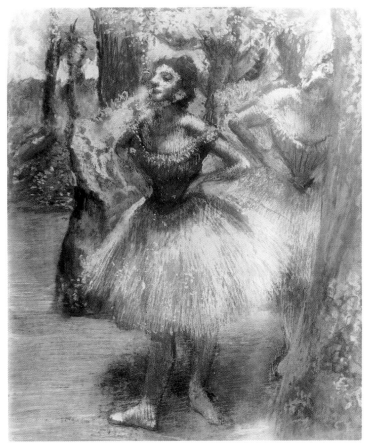

FIG. 87
After the bath, c.1900–5
Charcoal and pastel on tracing paper, 52 x 58.1 cm (20½ x 22⅞ in.)
Toronto, Art Gallery of Ontario, Private Collection (L.1382)

FIG. 88
After the bath, woman drying herself (with paper joins indicated), c.1890–5
Pastel and charcoal on tracing paper, 103.8 x 98.4 cm (40⅞ x 38¾ in.)
London, National Gallery (L.955)

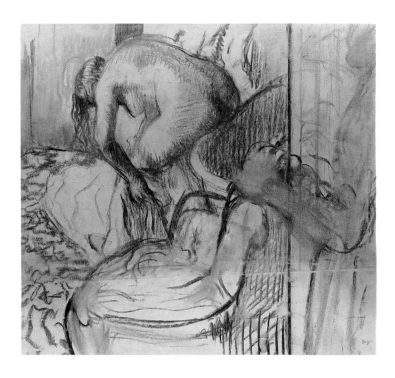

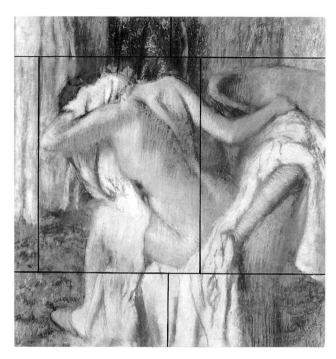

In practical terms, the tracing of a drawing enables an artist to work on the secondary or tertiary sheets in the secure knowledge that his starting-point remains intact, to be referred to at a later date or used for additional variants. As he built up his pastel sequences, therefore, Degas accumulated a kind of image-bank of primary charcoal studies, stored in the heaped-up folios of his studio and consulted as required, or shown to a few privileged visitors, such as Louisine Havemeyer and Piero Romanelli.[141] Many hundreds of these studies stayed with the artist until his death, only emerging from his folders for the 1918–19 *Ventes*, when the sheer quantity of near-identical drawings, counterproofs and tracings of single motifs first became apparent. Surprisingly, their significance has remained largely unexamined; were these the rough studies for more refined works and, if so, why were there so many of them? Were they failed drafts that should have been destroyed, as certain of Degas's contemporaries hinted? Or were they a new kind of serial object, descendants of the landscape sequences of Claude Monet, but now suggesting closer affinities with Marcel Duchamp's multiples or Warhol's silkscreens?

It is already apparent from our study of these pictorial clusters that Degas's linear production resulted in invention rather than repetition, in variations on a clearly stated theme rather than reiteration. This principle is further played out in his later modification of the shape and scale of his paper supports. Typically, this involved adding one or more strips of

tracing paper to the edges of his sheet, either to enlarge it or change its format from the horizontal to the vertical or square. Beginning by tacking such strips alongside his drawing as he worked, the artist then stuck these pieces in their final positions when the picture was fixed to card. At both stages, Degas could continue his charcoal or pastel strokes into the added areas, not only expanding his composition, but shifting its centre of gravity and introducing new structures or dramatis personae. Hundreds of works on paper were remodelled in this way, some showing only modest adjustment, others wholesale transformation from successive additions. A simple case is the charcoal *After the bath, woman drying her feet* (cat. 15), which reveals a single narrow strip of tracing paper added to its lower extremity, here left undeveloped. *After the bath* (fig. 87), was deepened by more than a third of its original height, a broad band of paper becoming incorporated into its narrative space. In *Two dancers in repose* (fig. 77) the scene has been extended on two sides, realigning a vertical rectangle into a near square, while enlargement on three or four sides can be found in such drawings as *Two standing dancers* (fig. 84) and *Study for 'Combing the hair'* (fig. 56), though several of these compositions were never extended into their new surroundings. Evidence of hesitation or over-ambition on Degas's part, these curiously arrested drawings have sometimes been cut down by unscrupulous owners, their original appearance often recorded in early photographs.[142]

FIG. 89
*Woman drying her hair, c.*1893–8
Pastel and charcoal on tracing paper, 83.8 x 104.8 cm (33 x 41¼ in.)
New York, Brooklyn Museum, Museum Collection Fund (L.953)

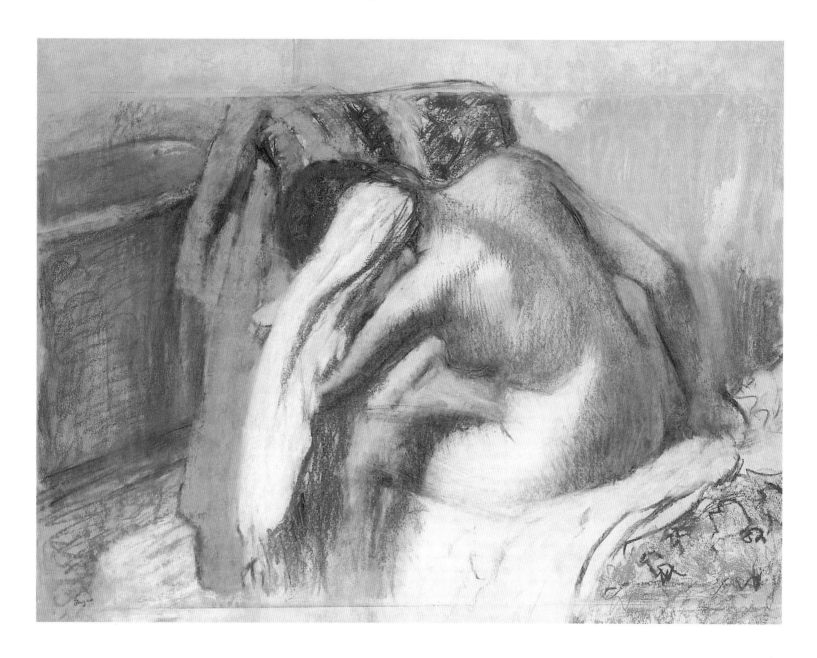

The practice of enlarging or reformulating his pictures in mid-production dates back to Degas's earlier decades, but nothing prepares us for either the extent or the sophistication of his late experiments.[143] By their nature, many of the surfaces in question have been camouflaged with colour, requiring a patient mapping of their hairline joints to plot their components. The modestly pastellised but large-scale *Bathers* (cat. 88), for example, reveals itself as a former horizontal scene, transformed into a square by the addition of wide strips of paper above and below the central sheet; *Breakfast after the bath* (cat. 52) was almost doubled in

height by a similar process; and *After the bath, woman drying herself* (cat. 47) was dramatically extended on all four sides. As the outlines of the constituent pieces indicate (fig. 88), here superimposed on a photograph but clearly visible to the naked eye, the latter was assembled from no fewer than seven elements, contributing to a metre-square collage of tracing paper that was trimmed, joined and stuck to card. The design appears to be based on a close-up study of the model, such as *Woman drying her hair* (fig. 89), drafted out as a long, low composition, then given added depth and leg-room as the monumentality of the image emerged.[144]

At first sight, these extraordinary patchworks of form and colour seem to preserve the logic of the artist's decision-making, as he engineered yet another complex rectangle from his fragile materials. On further reflection, the procedure raises as many questions as it resolves. Though Degas may have begun his drawing on a pattern of separate sheets loosely pinned together, the moment they were glued down no further adjustments were possible. At this point, which appears to have occurred quite early in the proceedings, the parameters of the scene were fixed and only by reversing the process, and cutting down the cardboard rectangle, could new changes be made; great flexibility seems to be followed, therefore, by sudden, almost arbitrary decisiveness. The puzzle deepens when we recall that large rolls of tracing paper, at least as wide as Degas's most ambitious drawings, were commercially available at this time and that he occasionally used such broad, continuous sheets for his pictures.[145] In other words, Degas could have started each work on a large expanse of paper had he so wished, trimming it to size once he had finalised the outlines of his picture. The existence of so many pasted-together rectangles, then, must derive from the rationale of his creative practice and most probably from tracing itself. By reproducing his initial drawing several times on identical sheets, Degas provided himself with a pattern or matrix that could be modified in a dozen different ways, by sticking each separate patchwork on to card, then moving forward to issues of colour and line, movement and tension, that further separated them from their common origin.

The presence on the surface of Degas's drawings and pastels of a rectilinear pattern of paper joins, evident as sharp incisions or clogged furrows of colour (see fig. 101 for a microphotograph of such a join), can be both disruptive and strangely invigorating. Very occasionally, these lines coincide with a pictorial element, such as a pillar in a rehearsal room or the back of a chair, but more typically they cut across and through the depicted forms.[146] As such, the grid-like joins set up a counterpoint to the major pictorial theme, opposing its rectilinearity to the curving rhythms of charcoal or pastel. The more numerous the joins the more insistent is their contribution, while the more urgently the spectator's attention is attracted towards tactile flatness and away from fictive depth. For a generation accustomed to Cubism and abstraction, to the formal scaffold of a Mondrian or the improvised geometry of a Richard Diebenkorn, this interplay between tactile marks and illusionistic space seems distinctly familiar. To a virtuoso maker of collaged drawings such as Degas, the notation of his paper networks became an inescapable part of his visual orchestration. At its most conspicuous, in a work such as *Bathers* (cat. 88), the sweeping horizontal structure of the dominant sheet both contains and counteracts the organic forms inscribed upon it. By emphasising the surface and echoing the frame, the relief-like nature of the image is further accentuated, as is the sheer physicality of the artist's performance.

A curious footnote to the story of Degas's pasted-together drawings is provided by contemporary accounts of their fabrication. The extreme precision of the cuts and joins in these picture suggests the work of a professional, rather than the enthusiastic but often slapdash nature of Degas's own technical practice. In addition, the presence of registration marks on adjoining sheets and of handwritten instructions on a number of drawings points to a collaboration between artist and technician.[147] Both Vollard and Halévy reveal that the craftsman in question was Père Lézin, a print specialist and *colleur*, or mounter of works on paper, from whose shop in the rue Guenegaud Degas also bought some of his picture-frames.[148] According to Halévy, Lézin was 'the most skilful handler of prints in Paris', as well as being notorious for his taciturnity, while Degas described him as 'a man astonishing as a *colleur*' and dedicated two drawings to him.[149] The collector Etienne Moreau-Nélaton, also portrayed by the sculptor Paul Paulin who made two busts of Degas, recorded a visit he made with the artist to Lézin's workshop on 26 December 1907. Arriving at Degas's studio, Moreau-Nélaton found him working on a pastel of 'a young woman leaving the bath, with a maid in the foreground', executed on *papier calque* pinned to a piece of card.[150] When darkness fell, the two men journeyed by carriage to the rue Guénégaud, south of the Seine and not far from the Institut, Degas holding the fixed and rolled-up drawing in his hand. At Lézin's, Degas unrolled the sheet and explained that a few centimetres were to be cut from the lower edge, then hesitated:

> *'Two centimetres, yes, no more.' He was anxious for my advice. I suggested he should leave it exactly as it was. 'Nevertheless, do it immediately. The head of the maid touches the upper edge. We must raise the lower edge a little. Without that the balance will be wrong.' I understood from these explanations that the drawing spread out before my eyes was just a preparation; once stuck down this study would be finished more easily.*[151]

It is still unclear what Lézin used as an adhesive, but the esteem of his contemporaries for his craftsmanship appears to have been well founded.[152] In most cases, Lézin managed the difficult operation of sticking the large sheets of tracing paper to card without creasing or tearing them, leaving only minor irregularities and occasional 'bubbles' that can still alarm conservators.[153]

Degas's recourse to the expertise of Père Lézin was another acknowledgement of his own limited technical skills and of a lingering dependance on the craftsmanship of others. More conventional was Degas's use of certain standard papers, requiring no special mount or

FIG. 90
*Nude, c.*1905–10
Charcoal on paper, 49.3 x 32.3 cm (19⅜ x 12¾ in.)
Oslo, Nasjonalgalleriet (IV, 287 b)

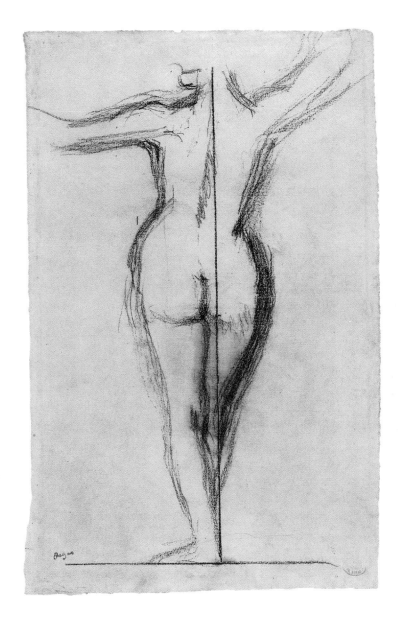

treatment, for a restricted number of late drawings. Isolated studies, such as figures drawn from the life or individual portraits, were as likely to be on the distinctively ribbed 'laid' paper, such as the widely used Ingres type, or the smoother and cheaper 'wove' varieties.[154] Straightforward examples of the former are *Nude* (fig. 90), and the St Louis Museum's *Madame Alexis Rouart*, both showing the unmistakeable parallel ridging of laid 'chain' marks on their tinted surfaces.[155] There is some indication that Degas chose such fine, watermarked or decoratively hued papers for occasional drawings that were never intended to be part of a sequence, perhaps intending some of them for immediate sale. Indeed an entire sub-group of 'presentation' drawings, lightly embellished in colour and exploiting the sumptuousness of their surfaces, can be located in the mid-1890s.[156]

Two highly finished works on paper appear to show Degas's choice of non-tracing material for just such solitary, finely coloured drawings. The glorious *Morning bath* (cat. 83) was executed on off-white laid paper, characterised by a regular, softly textured surface that both absorbs and heightens the strokes of pastel pulled across it. In contrast, the equally colourful *Two dancers* (cat. 77) was executed on heavier wove material, the paper lacking a distinctive grain or pattern and less obviously refined in appearance. As *Two dancers* reveals, the artist's practice of extending his initial sheet by the addition of peripheral strips was not restricted to tracing paper. With both wove and laid surfaces, Degas would freely modify his compositional rectangle, apparently in search of that 'balance' of pictorial forms he described to Père Lézin and Moreau-Nélaton.[157] Rather surprisingly, Degas seems to have felt no corresponding need to conceal these extensions, leaving a marked discontinuity of tone and texture in the foreground of *Two dancers*, for example, and later emphasising it further by the location of his signature. Whatever their individual histories, these drawings show the range and purposefulness of Degas's approach to the materials of his art, as well as the complex interchange between their technical genesis and surface glamour. When Vollard claimed that the artist 'took great pains with the composition of the paper he used', he was surely enjoying a rare moment of understatement.[158]

Moving from Paul Valéry's lofty speculations on draughtsmanship to a study of the tools of the artist's trade, this chapter has trespassed freely and impertinently in the little-explored territory of Degas's late drawing. Even in this brief incursion, we have discerned the unmistakable shape of a late career founded and embedded in line, clinging to its roots in tradition even as it branched upwards and outwards into seriality, pictorial artifice and the wildest extremes of colour. Partly as a result of his commitment to tracing, Degas's drawing can seem like a profligate and all-consuming passion, generating hundreds of studies that gathered dust in his portfolios or distracted him from other ambitions. Just as often, the vitality of his draughtsmanship is found at the heart of his inventiveness, animating an impasted canvas, conjuring up a variant on a well-tried composition or galvanising a relcalcitrant wax figure. Whether he drew 'for the sake of drawing', as George Moore claimed, or 'in search of endless problems in precision which released him from any other form of inquiry', as Valéry preferred, drawing continued to define and articulate Degas's artistic identity, often in the most radical ways, until the end of his working life.[159]

COLOUR
The Late Pastels and Oil Paintings

WHAT CHARCOAL IS TO Degas's line and structure, so pastel is to his colour. With pastel, Degas could work directly and sensuously at the surface of his designs, stroking ochres and violets into a bather's skin, smudging the cool tints of a dancer's tutu against the warmth of her surroundings or encrusting stage scenery with the most fanciful patterns. Pastel invites flamboyance where charcoal imposes restraint, tactility in place of flatness, the hues of sensation rather than the abstraction of form. In pastel, Degas found a medium that propelled him towards extravagance, using the patient tracings of his draughtsmanship as a springboard to the 'orgies of colour' of his final decades. Fusing tradition with violent innovation, Degas seized on pastel as the ultimate medium of his maturity, uniting in a single material the expressiveness of paint with the spareness and precision of drawing.

Though he was effusive on the subject of draughtsmanship, Degas was reticent and curiously self-deprecating when it came to his use of pastel. One of Degas's few references to the medium occurs in a letter of 1884, written soon after his fiftieth birthday, when he was experiencing some sort of personal and professional crisis. 'Where are the times when I thought myself strong?' he asked Bartholomé, 'When I was full of logic, full of plans. I am sliding rapidly down the slope and rolling I know not where, wrapped in many bad pastels, as if they were packing paper.'[1] Paradoxically, this letter coincides with one of the most assured and prolific phases of pastel-making in Degas's middle years, when he produced such definitive works as the 1884 *Woman in a tub* (fig. 91), soon to be included among the spectacular sequence of pastel nudes at the 1886 Impressionist exhibition. A further paradox is conveyed in a later aside, this time preserved in the memoirs of Walter Sickert: 'In oil painting, one should proceed as with pastel,' Degas announced, to which Sickert wisely added, 'It must be remembered that I am only recording what he said at a given date, and to a given person. It in no wise follows that, by advising a certain course, he was stating that he had himself refrained from ever taking another'.[2] And in one of Degas's last surviving notes, written by the septuagenarian artist in August 1907, he seemed surprised by the longevity of his own practice, exclaiming, 'Here I am back again at drawing and pastel'.[3]

The practical implications of Degas's remarks will be examined in due course, but his rather unexpected advice to Sickert, proposing a link between the two entirely different procedures of oil painting and pastel, offers an important first insight into his thinking. From an early date, observers had noted the cross-fertilisation of media in Degas's work, not only between oil and pastel, but in unexpected conjunctions of the materials with etchings, lithographs, monotypes and works in *essence* and distemper. Common to almost all these hybrid activities, however, was the medium of pastel, bringing iridescent colour to hundreds of

Detail of cat. 61

FIG. 91
Woman in a tub, 1884
Pastel on paper, 53.5 x 64 cm (21 x 25¼ in.)
Glasgow Museums, The Burrell Collection (L.765)

monochrome prints and line drawings, competing with full-size paintings and even invading the alien territory of the artist's canvases.[4] So characteristic was Degas's use of pastel that entire displays of his work in the 1880s were given over to the medium and by 1891, if not before, it was rumoured that Degas's adoption of pastel had entailed a complete abandonment of oil paint.[5] This gravitation towards pastel has become part of the Degas legend, repeated somewhat unquestioningly in the literature and resulting in a critical near-silence on his substantial late canvases.[6] But, whatever the historical circumstances and regardless of Degas's muteness on the matter, there can be no doubting his massive commitment to pastel in these final years. At its simplest, Lemoisne's

catalogue raisonné lists more than 600 pictures by Degas after 1886, of which a mere eighty are oil paintings; though they vary considerably in their physical constitution, almost ninety per cent of the works involving colour from Degas's last phase reveal the use of pastel.[7]

Because of its glamour and conspicuousness, Degas's pastel technique has become the most studied of all his studio practices. His earliest critics noted the artist's identification with the medium, gradually articulating the qualities of mattness, chromatic brilliance and surface friability that were to become its hallmarks. The most acute among them also detected a link between these qualities and the subjects Degas chose to depict, Charles Ephrussi writing of 'the most

FIG. 92
Maurice Quentin de la Tour, *Self portrait,* 1750
Pastel on paper, 64.5 x 53.5 cm (25½ x 21 in.)
Amiens, Musée de Picardie

unexpected and curious effects' of the 'relations of tone' in his ballet subjects, and Henri Fevre noting the appropriately 'pasty flesh' of certain of the 1886 pastel nudes.[8] Subsequent writers sensed the shift in the centre of gravity of Degas's art, associating his move from oil to pastel with a number of pragmatic factors: with the artist's uncertainty about traditional craft,[9] with his advancing age and declining eyesight,[10] and with the simple expediency of the medium, summarised in Sickert's remark that 'a pastel is always ready to be got on with'.[11] Denis Rouart devoted one of his most substantial essays to the subject, insisting on the essentially 'classic' nature of much of Degas's pastel application, while examining his idiosyncratic combination of the medium with gouache, *essence* and distemper.[12] Attempting to define the evolution of the artist's practice, Rouart also noted innovations in the build-up of pastel on the picture surface and new departures in his management of colour.[13] More recently, several authors have amplified or extended Rouart's approach in a series of articles, catalogue entries and specialist publications, while investigations by a new generation of scientifically trained conservators have brought the benefits of laboratory analysis to the ever-expanding project.[14]

Running through most of these studies is an acknowledgement of the polarity of Degas's pastel technique, at once conventional and utterly radical. On the one hand, he followed a practice that was widely used by his contemporaries, that would have been largely familiar to his predecessors and that involved orthodox materials handled in an essentially 'classic' manner. On the other, he transformed the expressive and chromatic possibilities of pastel in the modern context, so that 'he seemed to renew the medium', in Lemoisne's words, while becoming 'possibly the finest pastellist of all times' in Jean Sutherland Boggs's estimation.[15] In order to understand Degas's later adoption of pastel as his principal expressive vehicle, it is necessary to grasp both these principles, identifying the productive exchanges that took place between them and the continuous tensions they generated. Though little is known about the circumstances in which he began to use pastel, clues from Degas's youth remind us of its historical roots and its more orthodox application. As early as 1857, when the twenty-three-year-old artist was travelling in Italy, he had used a chalk-like material to heighten a landscape study made near Tivoli, touching in his colours over an essentially linear image.[16] Three years later, Degas noted of an antique mosaic in the Naples Museum, 'If I had my box of pastels I would learn a lesson from it which would last me a lifetime', again emphasising the mobile, supportive role of pastel in his early education.[17]

A more substantial grounding in pastel has been suggested by the researches of Jean Sutherland Boggs and Theodore Reff, both of whom have identified works by eighteenth-century portraitists in the collection

of Degas's father.[18] One of these, a study by the pastellist Perroneau of *Madame Miron de Portioux* (private collection), though in this case painted in oil on canvas, impinged directly on Degas's work in the form of a blurred but just recognisable smudge in the background of his 1869 pastel portrait *Madame Edmondo Morbilli, née Thérèse De Gas* (New York, private collection).[19] After Auguste De Gas's death, the Perroneau passed into the artist's collection and may have taken on other significances in his professional career. Jean-Baptiste Perroneau was famed in his own day for 'frequenting . . . the wings of the Opéra', making studies of notable entertainers and ballet-dancers of the era, such as *Mademoiselle Rosaline, dite Raton, artiste de l'Opéra-Comique* (location unknown), and perhaps offering an early role model for the aspiring young Degas.[20] Perroneau's art was also prominent in the revival of Rococo taste, visible on the walls of several of Auguste De Gas's friends and avidly collected by the circle around Degas in later adult life, among them Jacques Doucet, Georges Hoentshel, Emile Lévy, Alphonse Kahn and Camille Groult, the latter accumulating literally dozens of examples.[21] Just as important for Degas was Quentin de La Tour, widely regarded as the finest pastel portraitist of his generation and, again, represented in the family collection, perhaps, as Jean Sutherland Boggs has intriguingly proposed, by an image of Degas's favourite composer, Gluck.[22] Frankly admired by Degas (he is said to have regarded La Tour's *Self portrait* (fig. 92) as 'a masterpiece') and the

FIG. 93
Mademoiselle Bécat at the Café des Ambassadeurs, c.1877–8
Lithograph, 20.5 x 19.3 cm (8⅛ x 7⅝ in.)
The Art Institute of Chicago, William McCallin McKee Memorial
Collection (RS.31)

FIG. 94
Mademoiselle Bécat at the Café des Ambassadeurs, 1885
Pastel over lithograph, 22.8 x 20 cm (9 x 7⅞ in.)
New York, The Pierpont Morgan Library, The Thaw Collection
(BR.121)

subject of an attributed 1860 copy, La Tour joined with Chardin, Liotard, Perroneau and others as examplars of the high calling of pastellists in a former age.[23] More directly, they offered the fledgling Degas the guidance of their finished works, encouraging him to blend together the individual strokes of colour in his first pastel studies in the eighteenth-century manner and emulate the velvety and descriptive finish of his precursors.[24]

As these cautious beginnings suggest, Degas's emergence as a pastellist was both historically informed and fraught with potential conflict. Like so many of the quandaries of his career, the problem can be traced back to a primordial source in the teachings and example of Jean-Dominique Ingres. Trained in his shadow, Degas had learnt to revere Ingres's steely and supple line, stressing the constructive role of form and the fundamental sobriety of the pictorial vocation. Ingres had explicitly spelled out his disdain for colour, calling it 'the handmaiden' of art, which merely 'adds ornament to painting', and warning an entire generation of his followers away from its seductive charms.[25] Ingres himself never used pastel, scorning 'the mannerisms and conventions' of

the eighteenth century and the 'decadent taste' of the 'over-celebrated Boucher'.[26] Everything about the medium, from its brilliant hues to its gross physicality, would have provoked the antipathy of the master of Montauban. Superficially, pastel seems to subvert the functions of drawing, allowing the artist to work from the first stages of a composition directly in colour, without the laborious preparation of studies, tracings and tonal foundations. Even more confusingly, a stick of pastel can be seen as linear agent and colouring instrument combined, resulting in lines of explosive hue and tinted, spidery hatchings that defy *Ingresque* classification. While such qualities may have appealed directly to Degas, allowing him to resolve contrary drives toward the severe and the sensuous, pastel did nothing to mitigate his uncertain relationship with, almost his treachery towards, the hallowed doctrines of Ingres.

This perceived challenge of pastel to the precedence of draughtsmanship was exacerbated by a second characteristic of the medium; its palpable, undisguised sensuousness. Pastel is the most tactile of materials, its chalky softness leaving veils of colour on paper and hands alike (Jeanniot once described Degas at work, 'his fingers covered

FIG. 95
*Nude woman having her hair combed, c.*1886–8
Pastel on wove paper, 74 x 60.6 cm (29⅛ x 23⅞ in.)
New York, Metropolitan Museum of Art, H.O. Havemeyer
Collection, Bequest of Mrs H.O. Havemeyer, 1929 (L.847)

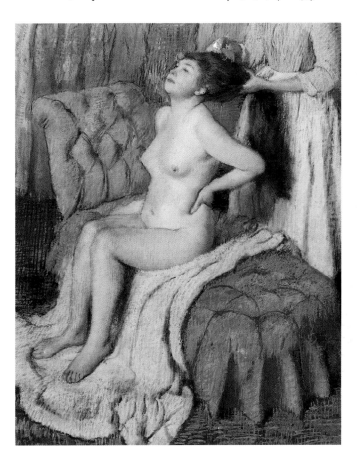

with pastel powder').[27] Its colours, too, can be gently suggestive or frankly vulgar, embracing not just the pale tints commonly associated with the material but the most strident concentrations of almost pure pigment, and offering the closest affinities with flesh, atmosphere and the brilliant profusion of nature. Nothing could be further from the vaunted ideals, if not the documented practice of Ingres, and nothing reminds us so forcibly of the independence of Degas's studio procedures, despite his rhetorical insistence to the contrary. While Degas's love of tradition, his reverence for the masters and even much of his late subject matter were undeniably Ingres-like, his attachment to pastel was unequivocally transgressive. Where draughtsmanship was timeless, the dusty particles of pastel were said to be unstable; where line was austere, pastel was notoriously decorative; and where drawing was seen as virile and male, colour, and especially the frivolities of tinted chalks, was considered irretrievably feminine. Though he avoids the word on this occasion, Charles Blanc makes clear his condescension in a brief discussion of the medium, suggesting that pastel is best suited to 'the brilliant tints of a young girl, the flesh of a child'.[28] Summarising a century or more of prejudice, Blanc argues that pastel lacks 'the depth of oil painting', recommending itself to artists who 'want to capture fleeting colours' without extensive preparation, while warning them of its 'inherent defect', which is a tendency 'to fall into dust'.[29]

In mid-career, when the bulk of his submissions to the Impressionist shows were large, finished pastels, Degas was able to strike a kind of bargain with the past, reconciling himself to Ingres in his vigorous draughtsmanship while exploring the dusty colours of pastel itself. Typically, an image was begun as a drawing, developed as a pattern of tone and only gradually transformed through the 'ornament' of local or descriptive hue. Degas also found that by adding pastel to his monochrome prints, such as the severely rectilinear *Mademoiselle Bécat at the Café des Ambassadeurs* (fig. 93), he could approximate to academic convention, progressing from the forms of the lithograph or etching to a multi-hued image of contemporary life, such as the pastellised variant of the same work (fig. 94). But nothing could disguise the exuberance and sheer visual glamour of these hybrid works, where the 'handmaiden of art' has shamelessly abandoned her subordinate role. In the mid-1880s, this radical transition seemed almost complete, with the production of a majestic series of pastel nudes that lack all but the most rudimentary drawn preparation.[30] Works such as *Woman in a tub* (fig. 91) and *Nude woman having her hair combed* (fig. 95), for example, were apparently initiated and completed on a single sheet, without preliminary sketches or separate, exploratory designs. Here, delineation and description have merged in a single membrane of colour, with contours and highlights, local tints and passages of detail all expressed in the language of pastel.

Compared to the pictorial models of Degas's youth, most notably the immaculately rehearsed *Valpinçon bather* of Ingres (fig. 60), these 'improvisations', to use Blanc's dismissive term, seem like acts of betrayal.[31]

The transition from a line-based to a purely colour-based art, which many have discerned in contemporaries as various as Gauguin, Cézanne and Redon, and certainly in the work of their younger retinue, never quite took place in Degas's pastels, nor in any but the most exceptional areas of his technical practice. For all the seductiveness of the pastel medium, Degas's youthful enthralment to draughtsmanship and to the precepts of Ingres continued, and may even have been intensified, in the revived adulation of his last years. However pyrotechnical their colours, and despite audacious exceptions, almost all the late pastels were stubbornly grounded in drawn or traced prototypes, some casual and barely more than outlines, the majority richly articulated with line, tone and anatomical detail. The persistence of these monochromatic underdrawings, with their echoes of Academicism and the tradition of *disegno*, deserves a more complete study, but it can be experienced in

FIG. 96
*The green dress, c.*1897–1901
Pastel on tracing paper, 45 x 37 cm (17½ x 14½ in.)
Glasgow Museums, The Burrell Collection (L.1236)

particularised form in these pages. Though much of the surface of the sumptuous *Dancers* (cat. 23), for example, is finely worked with pastel, several passages show the unmistakable substratum of its linear beginnings, like a skeletal structure beneath living skin; the fact that this picture was signed by Degas and released to Vollard in the artist's lifetime speaks eloquently of the artist's accommodation of both linear and colouristic traditions in his mature output. Even in more densely heightened examples, such as *Russian dancers* (cat. 90), where layers of exotic hue spread like a muffling blanket across the paper surface, glimpses of dark preliminary drawing can still be seen, reminding us of the ubiquity of Degas's draughtsmanship in even his most extravagantly coloured creations.

This co-existence of line and colour, charcoal and pastel, is one of the definitive characteristics of Degas's late oeuvre. On a practical level, it allowed the artist to take advantage of his system of traced drawings, producing cycles of near-identical monochrome images that became individualised with the progressive addition of pastel. On a more exalted plane, this marriage of opposing elements enabled Degas to make peace

with his past, reconciling the shadows of Delacroix and Ingres, as well as the personally competing claims of passion and discipline. In truth, it is less an idyllic marriage than a continuous series of disputes and reconciliations, now dominated by the intransigence of line, now by the vagaries of pastel. Frequently, the visual argument is acted out before our eyes, as waves of colour flow over and soften a scaffolding of form, while, conversely, a flurry of lines on an encrusted surface may bring last-minute articulation. In certain long-contested images this dialogue has clearly ebbed and flowed several times, leaving layers of colour and superimposed contours that inscribe their own technical histories. In *The green dress* (fig. 96), for example, a signed and therefore completed work, the subject was evidently begun as a pattern of light charcoal strokes across the picture rectangle. After the addition of passages of green, silver and pink pastel, further charcoal lines on the girl's arms were manifestly added over these flesh tints, reasserting form against luxurious hue. With more extensively worked surfaces this alternation might continue through several stages, until a final resolution was reached or the image abandoned.

When Degas claimed 'I always tried to urge my colleagues to seek for new combinations along the path of draughtsmanship, which I consider a more fruitful field than that of colour', he was dealing in mischief and characteristic overstatement, but also touching on the raw, central nerve of his career.[32] As Anne Maheux has pointed out, however, Degas's adoption of pastel cannot be understood outside the periodic revivals of the technique in the later nineteenth century, nor beyond the controversies that surrounded it. In his earlier career, Degas had mixed with a number of occasional pastellists, among them Fantin-Latour, Puvis de Chavannes, Boudin, Whistler, Tissot, Manet and Morisot, all of whom had tended to use the process in an essentially secondary capacity. With the passage of time, he became devoted to the work of Jean-François Millet, maker of canvas-size pastels and the object of a brief, and rather untypical, burst of technical imitation by Degas in the 1880s.[33] In later years, Degas in his turn stimulated the pastel experiments of a younger, often commercially minded generation, from the suave Edmond Aman-Jean and the saccharin Pierre Carrier-Belleuse to the austerely classical Emile-René Menard and the eclectic and plodding Georges Jeanniot. Many of these artists were swept up in a more general revival of pastel at this period, expressed in increased submissions of pastels to the Salon and culminating in the foundation in 1885 of the Société des Pastellistes Français, whose members exhibited regularly at the gallery of Georges Petit.[34] As Richard Thomson has pointed out, the Society openly associated itself with practitioners of early epochs, principally with the pastellists of the golden age of the eighteenth century who had so haunted Degas's youth.[35] Encouraged,

too, by such publications as the Goncourt brothers' *L'Art du XVIIIè siècle*, pastel not only boasted of its historical pedigree but aimed to prove itself as the vital medium of the new age.

Prominent in the legacy of the eighteenth century was the vast Salon-scale pastel, equal in its dimensions, its degree of finish and its pictorial ambition to oil paintings of comparable subjects. Quentin de La Tour's *Self portrait* (fig. 92), for example, which was singled out for admiration by Degas, is life-size, while the same artist's majestic portrait of the *Marquise de Pompadour* in the Louvre approaches two metres in height.[36] In the late 1880s and early 1890s, similarly grandiose pastels returned to the Paris Salon, exemplified by Carrier-Belleuse's even taller *Tender avowal. Mademoiselle Latini and Mademoiselle Bariaux, of the Opéra* (fig. 97), shown in 1894, and the sonorous pastel-on-canvas murals, some many metres across, of René Menard. Few of Degas's pastels approach either the monumentality or the surface refinement of the very largest of these pictures, but their claim to represent the artist's principal form of expression, and their status as self-sustaining, exhibitable works of art, is directly comparable. Following our earlier examination of his studio techniques, it is also clear that these large pastels were constructed from several pieces of paper joined together, as much through their haphazard origins as from a lack of suitable materials. Characteristic of Degas's practice though these features appear to be, the abutment of paper sheets is found in the eighteenth century, where a similar grid of joins and additions pervades the grandest portraits, such as those by La Tour that Degas admired.[37]

In both the centrality of pastel to his oeuvre and the scale of his aspirations, Degas stood apart from his Impressionist colleagues, most of whom used pastel in some capacity in their technically various careers. At their early group shows, Renoir, Morisot, Degas and even Monet submitted tentative forays in pastel on paper, though by the 1879 exhibition Degas's commitment to the medium was already apparent in his inclusion of at least ten pastel-dominated works.[38] In the displays of the 1880s, Degas's conversion was palpable, most obviously in an increase in the dimensions of his pictures and a marked advance in the distinctiveness of his pastel technique. Works such as *The dance examination* (Denver Art Museum), shown in 1880, and the 'suite of nudes' of 1886, vied with all but the most exceptional contributions to these events, not only in the density of their colours but in the painterly richness and sophistication of their facture. These were pictures that could never be mistaken for sketches or lightly tinted drawings, demanding parity with the canvases of his peers and conceding nothing to them in pictorial complexity or bravura. Not surprisingly, many of Degas's followers took up his initiative, Caillebotte, Forain, Raffaëlli and Zandomeneghi adding pastel to their public repertoire, and such

FIG. 97
Pierre Carrier-Belleuse, *Tender avowal, Mademoiselle Latini and Mademoiselle Bariaux of the Opéra*, 1894
Pastel on paper, 202 x 114 cm (79½ x 44⅞ in.)
Paris, Musée du Petit Palais

FIG. 98
Box of pastels found in Degas's studio
Paris, Musée d'Orsay

close collaborators as Pissarro, Cassatt and Gauguin making sustained experiments with the material.[39] With the important exception of Cassatt, arguably his closest disciple, however, none of Degas's fellow-Impressionists found in pastel such a sympathetic vehicle for their technical concerns and none chose the medium for continued, large-scale expression. By the time of the group's dispersal, most of his acquaintances had either abandoned pastel or subordinated it to other procedures, oppressed, perhaps, by Degas's dominance or content to leave him to his solitary virtuosity.

Whether practised by Perroneau or Carrier-Belleuse, Cassatt or Degas himself, pastel is essentially a simple medium. On a sheet of plain or tinted paper, a broad outline of the chosen subject is typically drawn in pencil, charcoal or a single pastel hue, locating its principal forms and establishing the intended composition. Then, using the 'marvellous coloured sticks', as Lemoisne called them, colour is stroked, touched or rubbed on to the paper surface, its chalky particles gradually tinting the initial drawing and building up the chromatic character of the scene. As the picture progresses, additional colour can be superimposed on this design, the new grains of pastel merging with those already present in a luxurious, velvety texture of powdered hues. Further softening and effects of form can be achieved by rubbing with the finger-tip or with a rolled-paper 'stump', both techniques widely used in the eighteenth and nineteenth centuries, while highlights or sharp contours can be added at the last moment with the edge of the pastel stick. According to taste or conviction, fixative is then sprayed across the picture to secure the particles to the support, followed, in traditional practice, by final flourishes of pastel on certain crucial areas to restore the 'bloom' of the material.

In principle, Degas's late pastels conform to this sequence of events, though with a number of idiosyncratic and revealing variations. We have already noted the oddity of Degas's chosen support, tracing paper, in the context of his drawing, but its consequences for pastel are even more far-reaching. Unlike the soft or elaborately textured papers beloved of pastellists past and present, the resilient surface of tracing paper does not 'absorb' the particles of colour so sympathetically, nor do its fibres break up as freely under the pastel's abrasion. Having no weave-pattern of its own, tracing paper allows the pastel sticks to wander and skid across its thin, neutral membrane, perhaps picking up the texture of the drawing-board beneath or 'skipping' over paper joins or marks already made. Again, without the delicate floral tints of commercial 'pastel paper', the dull beige of Degas's tracing material can seem brutal and unresponsive, flattening his image and diverting it from the notorious charms of the medium. For similar reasons, perhaps, in his mature technique Degas rarely exploited the 'sweetening' effect of pastel rubbed with the stump or finger, preferring to leave strokes of colour as assertive,

individual marks or, on occasion, to brush them with his hand or rub them violently with a cloth. Similarly, as we shall see, he stood out against the orthodox attitude to fixative, using this 'finishing' process several times during the making of a pastel and lacking any consistent attitude to the 'bloom' of the finished surface.[40]

Alternately 'classic' and heterodox in practice, it comes as something of a relief to find that Degas was entirely conventional in his choice of pastel sticks. Pastels are made, today as for centuries, by mixing appropriate combinations of coloured pigments with a 'filler', such as chalk, then usually adding a binder such as starch or gum and compressing the mixture into moulds.[41] The resulting cylinders of dry, compacted colour vary in their hardness according to the ingredients and processes used, ranging from dense, brittle wands that scratch the surface of the paper to more friable and easily crumbled crayons. Ann Maheux has uncovered evidence that Degas bought at least some of his pastels from the long-established Paris manufacturer Henri Roché, whose advertisements stressed the 'special softness' of their product and the 'solid and durable' qualities of the 'pastel paintings' that resulted.[42] A wooden box found in Degas's studio (fig. 98) bears the stamp of S. Macle, Roché's predecessor, the well-used fragments of pastel which it contains preserving a delicate spectrum of lilacs, purples and almond greens from the artist's last years.[43] Analysis of these fragments and of particles from a number of Degas's pictures shows the familiar constituents of the commercial pastel: fillers and a variety of white compounds predominate, with earth colours, traditional pigments and chemically synthesised hues making up the full range of his highly varied palette.[44]

FIG. 99
*The Bath, c.*1900–5
Pastel on paper, 46 x 59 cm (18 x 23¼ in.)
Ohio, Dayton Art Institute, Gift of Mr and Mrs Anthony Haswell
(L.917)

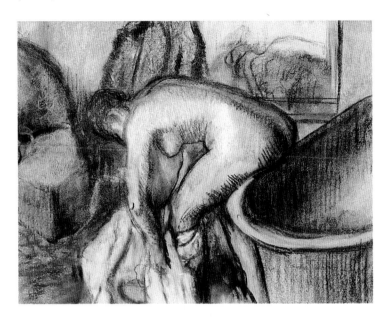

Though there is still more to learn, it seems that Degas purchased freely and sometimes recklessly from the pastel tints available to him, not excluding the most recently introduced varieties on the market.[45] The scintillating ultramarines, violets, yellow-greens and oranges of *Dancers* (cat. 23) might be an advertisement for Roche's latest products or for the achievements of modern chemistry, while the tangerine highlights of *Two dancers on a bench* (cat. 30) seem like a celebration of a new, electrically intense pigment. An anecdote told by Vollard, in which he claims that Degas deliberately soaked his pastel sticks in water and left them in the sun, suggests that the artist had learned to take precautions against the more fugitive pigments currently available.[46] Scandal had surrounded a number of organic dyestuffs, in particular a group of livid purples and violent pinks, that had proved unstable on exposure to light, prompting suppliers such as Roché to emphasise the 'durability' of their output.[47] It seems that Degas successfully avoided such hazards, becoming celebrated for the intensity of his hues among contemporaries and fellow-practitioners. In the same story, the dealer described how 'the brilliancy of his pastels had always been considered extraordinary. The painter B. said to me one day: "You know Degas, don't you? Won't you ask him for me where he buys his pastels? My wife is sure there is a trick in the way he gets a tone which is matt and luminous at the same time."'[48]

If a single remark by Degas helps to elucidate his techniques it is surely that recorded by Paul Valéry, when the artist claimed that a picture is 'the result of a *series of operations*'.[49] This is nowhere more evident than in Degas's pastels, each of which consists of layers or stratifications of colour, interleaved with charcoal and fixative according to a highly distinctive sequence of superimpositions. The first of these 'operations', as we have discovered, was the generation of a charcoal drawing, such as the gloriously subtle and muscular *Nude on the edge of a bath drying her legs* from Stuttgart (cat. 11), itself descended from a complex family of tracings. On this sheet, the artist would then use a handful of pastels to establish his principal hues, touching in the background of the closely related *Woman at her toilette* from São Paolo (fig. 52), for example, with strips of red, and blocking out other areas in blue, white and olive green. Rudimentary though this process might seem, the signature on the São Paolo picture reminds us that the 'series of operations' could be halted at any point, when the work was deemed to have acquired completeness or visual resolution, or simple marketability.[50] A more pondered approach to this stage is common, however, as in the broad harmonies of *Bather drying her legs* (cat. 14) and the rich swathes of gold and earth red in *After the bath, woman drying herself* (cat. 12), which here seem to have been laid down in anticipation of later, quasi-Venetian pastel scumblings.[51] Often carrying out this process with the side, rather than the tip, of his pastel stick, the artist

would continue to enrich his design with sweeps of colour and texture; in *The Bath* (fig. 99) both initial drawing and subsequent embellishment are clearly visible, while the cool colour of the paper (here a less typical laid type) still contributes to the overall tonality.

When Degas chose to pursue his 'series of operations' beyond such drawings as the Dayton *The Bath*, two broad possibilities lay open to him. The first was to continue the application of pastel over the still-fresh powder, rubbing colour into colour and imposing yet more streaks and hatchings on the dry bed of particles. Though a decisive pastel mark in these circumstances can still retain its identity, such additions tend to disturb earlier layers, mixing successive hues and softening their respective forms. Given the variation in density of his pastel sticks and the range of strokes in Degas's repertoire, all kinds of serendipitous effects could follow, from blurred outlines and dragged textures to clouded and variegated passages of colour. In much of his pastel oeuvre Degas exploited this diffuseness to deliberate pictorial ends, contrasting ill-focused distant forms with strongly delineated foregrounds and distinguishing between static and active elements. Already in *The Bath*, a purposeful haze can be seen at work, softening the background structure and hinting at the bather's mobility, while differentiating both from the precision of the metal tub. In later variants of the image, a kind of nebulous apotheosis is achieved, dissolving the forms of limbs and the solidity of furniture in veils of cascading colour.[52] More commonly, it brings animation to a contour or eases a spatial transition, as in *After the bath, woman drying herself* (cat. 47), where the blurred edge of the bather's forearm describes to perfection her muscular movement.

The second technical option presenting itself to Degas was the use of fixative. By spraying a dilute adhesive or varnish over his coloured ground, the artist could proceed with further additions of pastel without disturbing the layer beneath, effectively sealing or insulating each stage of the 'operation' from its predecessor. If he chose, the fixing process might be repeated on every level as the work progressed, until a stratified, sandwich-like accumulation of lines, colours and textures was built up. Some of those who knew Degas well insisted that this ritual was the defining feature of his pastel technique. Ambroise Vollard argued for the importance of a reliable fixative in Degas's practice 'because of the manner in which he did his pastels: they were worked over and over again, and hence it was imperative to obtain perfect adherence between each successive layer of colour'.[53] Closer to the realities of the studio, Denis Rouart claimed that 'Degas unquestionably invented this application of successive layers of pastel in which each one is fixed before it is covered with the next.'[54]

Degas's use of fixative has become one of the most unsettling and misunderstood issues of his craft. The historical record, on the other hand, backed up by carefully scrutinised pastels, presents us with an unequivocal picture of an artist who habitually, efficiently and often repeatedly fixed the majority of his later works on paper. In Degas's day it was widely appreciated that pastellists of the past had used fixative, standard textbooks offered a variety of recipes for amateur and professional alike and authorities such as Charles Blanc pronounced on their efficacy.[55] A decade before the artist's death, Moreau-Nélaton wrote down details of Degas's pastel technique from first-hand acquaintance, including the unhesitating claim that 'He fixed his pastels with a fixative which Chialiva had presented to him, to which he alone possessed the secret.'[56] Describing one of the works in question, the writer explained that 'the fixative had firmly attached to the paper the coloured powder with which it was covered. In order to convince me, a finger energetically rubbed the pastel, which survived the test'.[57] A brief article by Luigi Chialiva, the artist who had already influenced various aspects of Degas's painting practice, adds little to this account, but the importance of his role is again emphasised by the scholarly Ernest Rouart and the indefatigable Vollard.[58] Following Vollard, Degas 'would never use commercial fixatives, for he found that they gave a shine to the surface, and also attacked the colour. He used instead a fixative specially prepared for him by Chialiva, an Italian painter of sheep...'[59] The least cited and most explicit account of Degas's procedure, however, is that supplied by Sickert, who specified a pastel he had seen 'fixed and refixed, I beg you to believe, with a ball syringe'.[60] Attempts to identify this 'ball syringe', which may have resembled a pump-like garden spray or perfume dispenser, have not been

successful, but its effectiveness in producing fixed pastels with 'the surface appearance of a cork bath-mat' cannot be underestimated.[61]

That Degas 'fixed and refixed' many of his pastels, using solutions that allowed him to work over earlier layers without disturbing them, his contemporaries leave us in no doubt. That his pictures themselves show the traces of these 'secret' mixtures, as well as other marks of a fixative-based technique, modern examination of their surfaces has repeatedly confirmed. Signs of a 'glistening material' on two pastels from the Art Institute of Chicago, including the delicately worked *Morning bath* (cat. 83), have been recorded by David Chandler;[62] immunofluorescence analysis by Shelley Fletcher and Pia Desantis has identified a casein-based fixative in another pastel of a bathing nude;[63] and evidence of a resinous fixative has been found by Anne Maheux on *Dancers at the barre* of around 1900.[64] More simply, the naked eye can make out a variety of spattering and dotting effects on the surface of certain pastels, probably the result of coarse spraying with the 'ball syringe' seen by Sickert but conceivably due to the action of water.[65] Even more widespread is a distinctive dull sheen, visible on the exposed tracing paper and especially noticeable when viewed at an oblique angle, across the picture surface.[66] Whether this is the result of a single fixing of the initial drawing or repeated applications of the 'layers of heavy fixative' noted by Fletcher and Desantis, it is clear that such procedures were the rule rather than the exception in Degas's studio.[67]

As Sickert wryly observed, however, Degas was not the most systematic of technicians and it by no means follows that all his pastels were handled in the same way, or that some were not left partially or wholly untreated.[68] But the accumulated evidence suggests that the artist stabilised his work as he progressed, 'freezing' his initial charcoal drawing so that it was not disturbed by the application of colour, then fixing successive waves of pastel to control their juxtapositions and contrasts. At its extreme, this 'series of operations' could result in thick, crust-like deposits of particles, so dense that the paper was entirely covered and so chromatically complex that our normal vocabulary strains to express its subtlety. Additional techniques, such as the use of water or steam, brushing and scraping at the drifts of colour, and the deliberate generation of a 'pitted' or 'cratered' surface, compound this complexity, while reminding us of the central role of fixative in such accretions. Almost wilfully, the artist seems to have explored every permutation of his exotic craft, releasing on to the market the most casually heightened drawings as well as impasted and tapestry-hued sheets that defy description.

The combination of richness and lucidity in Degas's finest pastels can be studied in detail in the Courtauld Gallery's *After the bath, woman drying herself* (cat. 61).[69] Structurally, the picture was arrived at through

FIG. 100

After the bath, woman drying herself, cat. 61, detail

FIG. 101

After the bath, woman drying herself, cat. 61, detail

FIG. 102

After the bath, woman drying herself, cat. 61, detail

the characteristic sequence already described, involving tracing, drawing and progressive enhancement with colour. After a vigorous statement of the subject in charcoal on tracing paper and some laying-in of broad areas of pastel, the principal sheet was apparently trimmed, extended by the addition of a further strip at its lower edge and then stuck to cardboard.[70] The distinctive lamination of tracing paper and card, including some small 'bubbles' where the adhesion was imperfect, can be seen in fig. 100, while the neatly abutted join of the two sheets and the slight discontinuity of pastel is evident in fig. 101.[71] We know from Moreau-Nélaton's story of his visit with Degas to Père Lézin that the artist habitually used fixative on his drawings before they were mounted, a procedure evident in the Courtauld picture; several areas of developed pastel, for example, like that on the model's body and the chair, were clearly elaborated over previously fixed lines and colours, preserving the marks of the artist's design beneath. Equally, other superimposed passages were allowed to depart from this fixed substratum; the sand-coloured bath robe between woman and chair, for instance, manifestly began life as a differently shaped wedge of white, while the flurries of silver on the background wall were added over a stabilised mixture of golds and terracottas (fig. 102).

After the bath, woman drying herself is not signed and was never sold, and might therefore be defined as an unfinished work. Whatever the status of this magnificent study, it is vividly apparent that Degas's 'series of operations' and his use of fixative allow us privileged access to the technical history of such pastels. Physically, they exhibit a rare eloquence, a kind of densely coloured, lyrical shorthand that we can learn to read and articulate into our own exotic narratives. The Courtauld pastel is an unusually lucid case, offering a virtual thesaurus of Degas's graphic mannerisms and a palimpsest-like layering of gestures and flourishes, swirls and hatchings. Blunt, stabbing marks of dark pastel make up the patterned carpet to the left, contrasting with paler and more cursive zigzags in the model's back and shoulders. Across the chair, a meandering ribbon of colour defines the immediate foreground, echoing the awkward scribblings of white and orange on the distant wall. Elsewhere, repeated parallel scorings bring definition to a muscle or the rim of the bath; a pale, powdery cloud suggests the amorphousness of a towel; and drifts of grey and beige, laid on with the side of the pastel stick, float across more substantial forms.

Far from fracturing the composition, however, these graphic eruptions have an extraordinarily rhythmic and structuring effect. Most

FIG. 103

After the bath, woman drying herself, cat. 61, ultra-violet photograph

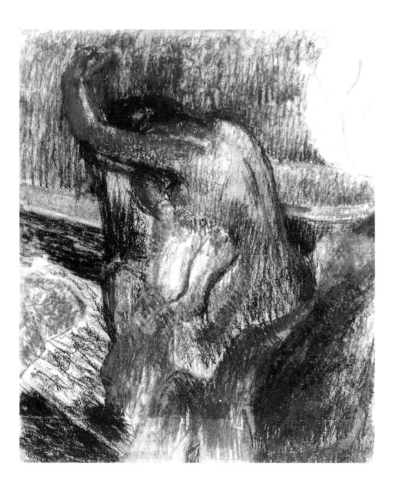

obviously, the diagonal stripes in carpet, rug and skirting-board are made to repeat the tangent of the bather's right arm and the edge of the tub, even as an opposing vertical thrust, running through the striations of the woman's back, the sides of the bath and the grain of the wallpaper, balances and opposes it. Other eddies of form flow around this polarity, enriching it and expanding its expressive potential. As much as colour or tonal modelling, it is this elemental direction of the pastel itself that articulates the bathing figure and her surroundings, creating a proto-Cubist sense of tectonics at play. When detached from its chromatic function, as in the ultra-violet photograph in fig. 103, this mesh of lines shows an exceptional cohesion, weaving together the forms of the composition in a web of contained energy. It is hardly surprising, in retrospect, that Degas treated the same subject in one of his wax sculptures (cat. 62), where literal planes and tangible masses take over and extend the graphic functions of hue and hatching. But throughout his late pastel oeuvre, whether in ballet scenes or views of the toilette, the dominant rhythm of the image depends on such orchestrated pattern and gesture, patiently and sometimes energetically built up on the paper.

As more than one commentator has noticed, the cumulative use of pastel also transforms many of our assumptions about colour. When we look at *After the bath, woman drying herself*, our response is not simply determined by the last strokes of pastel to be laid down, but also by the stratified marks that preceded them. Scrutinising the model's skin, for example, we peer through lattice-works of white, pale ochre, mushroom and salmon pink to the still-visible charcoal lines beneath, and beyond them to the dull beige of the tracing paper. Our optical impression is a heterogenous or cumulative one, simultaneously engaging a variety of hues, layered textures and competing directional strokes. As we have seen, a superficial pattern of white may partly conceal earlier sediments of yellow and burnt red, presenting the eye with a sensation of scattered, broken terracotta. Even more disparate are the elements of the zinc bath, moving from a transparent haze of grey over underlying ochre to the near-opposite, where stripes of gold and silver mask an earlier blackness. Each of these passages offers conflicting evidence to our senses, or a combination of tints and hues unknown to science and the colourman's catalogue. In other works of the period Degas extends the spectrum even more dramatically: *Three dancers in purple skirts* (cat. 73) presents a saturated gauze of pastel, combining warm rust and blue-violet in the dancers' legs and interwoven pinks and greens on the stage floor; *After the bath* (fig. 42) shows a startling tartan-like mesh of colour, here with a weft of lemon yellow and a warp of blue and orange;[72] and passages of the luminous *Pink dancer* (fig. 105) defy description, with apple greens fused into blossom pinks, purples melting into corals.

To the earlier claim made by Rouart and others, that the distinctiveness of Degas's pastel manner resides in his layering technique, we might now add this late, alchemical extension of the palette by intense juxtaposition. Resulting in both startling optical vibrations and a range of hybrid red-greens, orange-violets and ochre-blues that elude definition, such a historic departure deserves further study. Though it can be traced back to his more youthful, technically orthodox pastels, and beyond them to the minutely fractured colours of certain of his predecessors, such as Chardin and La Tour, Degas's new chromatic inventiveness reached its peak in his final decades.[73] In the 1880s, Joris-Karl Huysmans had presciently noted Degas's ability to 'invent neologisms of colour . . . by bringing together two others', observing memorably that 'No artist since Delacroix . . . has understood like M. Degas the marriage and the adultery of colours.'[74] When Degas's pastels were shown in 1886, Félix Fénéon was even more effusive, claiming that 'his colour has an artificial and personal mastery: he has shown this in the turbulent colour-schemes of jockeys and in the splendour of theatre décor: now he demonstrates it in muted, seemingly hidden effects, for which the pretext is a shock of ginger hair, the violet

folds of wet linen, the pink of a lost cloak, the acrobatic iridescence around the edge of a bowl'.[75] In subsequent years, the intensity of Degas's colours and the extravagance of his critics' responses reached a new pitch. Writing of the pastel-over-monotype landscapes shown in 1892, Arsène Alexandre spoke of 'fields the colour of pinkish heather', and Philip Hale described a 'blue not seen by vulgar eyes', while Geffroy exceeded them all with his 'colours burnt by the light, disappearing in passages of greenish flame, falling into embers and pink ashes'.[76] Revealingly, Degas's admirers would often refer to his later works by their dominant colour, as in Paul Valéry's 1898 note to André Gide recalling a 'vivid orange thing' he had seen recently and Maurice Denis's eulogy of 'the blue Degas' encountered in 1909, while on a visit to the Shchukin collection in Moscow.[77]

Despite this celebrity as a colourist, almost nothing is known about Degas's grasp of colour theory, nor of his interest in the many scientific and popular expositions of the subject current in his day. On the few occasions he spoke about the topic, Degas's remarks were commonplace or wilfully vague, Rouart explaining that 'he had a set of theories about colouring and its function in a picture which he would expound with great relish, but they were not always easy to grasp...'[78] When Degas told Sickert that 'the art of painting was so to surround a patch of, say, Venetian red, that it appeared to be a patch of vermilion', he was repeating an idea familiar to Delacroix, and when he announced that 'orange gives colour, green neutralises, violet gives shading', he may not have greatly enlightened those, like Berthe Morisot, who happened to be present.[79] As a young man, Degas had made notes of the colours of nature with great sensitivity, but there is no indication that he joined those of his contemporaries who engaged in a more thorough study of its theory and application. On the contrary, a previously unpublished and rather inaccurate drawing of an elementary colour wheel from one of Degas's notebooks of the early 1880s (fig. 104) suggests a delayed interest in such matters.[80] The evidence of Degas's art points to a pragmatic rather than a cerebral engagement with colour, combined with an opportunistic awareness of the researches of his peers and a curiosity about their immediate precursors. Versed in the art of Delacroix and intimate with several of the master's pupils, Degas acquired an early working knowledge of primary and secondary hues, contrasts and oppositions, that was common to most of the post-Romantic generation.[81] When Huysmans claimed that Delacroix was Degas's 'true master', whom he had 'studied at length', it was surely these chromatic rules of thumb he had in mind, though there is little evidence of Degas applying them with rigour.[82] Inspection of his pastels reveals that colour combinations were endlessly improvised, primaries juxtaposed with primaries, secondaries with secondaries, without preordained method.[83]

Further light can be shed on Degas's apprehension of colour from two contrasted sources; the distant past, in his rediscovered fascination with the techniques of the masters, and the immediate present, in his contacts with Neo-Impressionism. One of the obsessions of Degas's old age, as we have observed, was the colouring achieved by the painters of the Renaissance, prompting him to experiment with glazes, grounds, canvases and varnishes and to supervise even more bizarre trials among his followers. At the heart of this project was the idea of the coloured pictorial foundation, whether the 'apple green' demanded of Denis Rouart or the earth reds he preferred for himself, to be painted over with contrasting glazes at an appropriate time in the manner, as he believed, of Mantegna and Titian. As his remark to Sickert revealed, Degas considered that such procedures in oil painting were equally applicable to pastel; what is less well known is that these notions resulted in a series of curiously 'underpainted' and 'glazed' works in pastel on paper. Close examination of *Pink dancer* (fig. 105), for example, reveals an unexpected foundation of acid-green, apparently spread as a continuous layer of pastel across the entire composition in advance of the dominant strawberry pinks, offering an idiosyncratic variant of the painting system urged upon Rouart.[84] Conversely, *The morning bath* (cat. 83) was suffused with ochre-orange in its first phase, only to be developed in a later gamut of cool greens and china blues. Other examples can be cited, from the calculated layerings of the multicoloured 1892 landscapes to the verdant *Two bathers in the grass* (Paris, Musée d'Orsay), each allowing glimpses of their tinted foundation in a curious pastiche of traditional painterly technique.[85]

FIG. 104
Diagram of a colour wheel from one of Degas's notebooks, c.1880–4
Pencil on paper, 16.4 x 10.7 cm (6½ x 4¼ in.)
Paris, Bibliothèque Nationale. Notebook 34, page 9

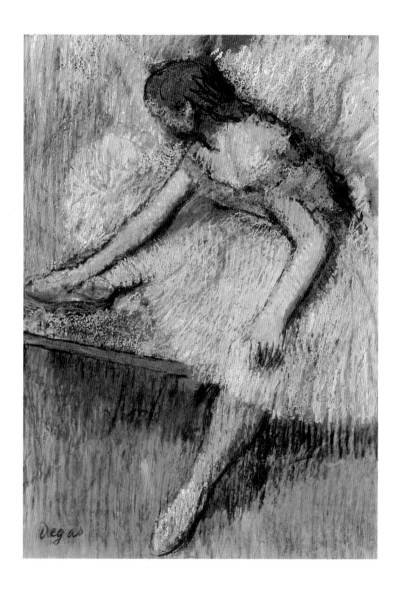

FIG. 105
Pink dancer, c.1897–1901
Pastel on paper, 41.2 x 29.9 cm (16¼ x 11⅞ in.)
New York, The Reader's Digest Association, Inc.,
Corporate Art Collection (L.1245)

Some time before these experiments, Fénéon's celebration of Degas as a colourist had formed part of an essay that concluded with the first of his many accounts of Neo-Impressionism.[86] Written in response to the 1886 Impressionist exhibition, which featured both Degas's 'suite of nudes' and substantial numbers of works by Signac and Seurat (including the latter's canonical *La Grande Jatte* (Art Institute of Chicago)), Fénéon's text ranged sympathetically across the old and new generations. After stressing the inventiveness of Degas's pastels, Fénéon explained in his influential, if simplistic, formulation that Impressionism was based on a 'decomposition' of colours that remained essentially 'arbitrary'. Seurat and his colleagues, by contrast, approached the matter in a way that was 'lucid and scientific', he argued, replacing the combination of hues on the palette with an 'optical mixture' and applying thousands of fine touches of colour that, when 'isolated on the canvas, recomposed themselves on the retina'.[87] Though it has long been understood that Seurat, in his formative years, was indebted to Degas for some of his subject matter and graphic techniques, the possibility of a reciprocal influence of certain other ideas, transmitted from the young man to the older in the manner of Seurat's impact on Pissarro, has hardly been considered. As fellow-exhibitors in 1886, the two artists necessarily encountered each other's work, though Degas's slighting response to *La Grande Jatte*, noting 'only that it is very big', is hardly promising.[88] Neither is Degas's disinclination to purchase works by members of the new faction, despite his reputation for encouraging the young by adding their pictures to his collection. More concrete is his willingness to exhibit with Seurat and his friends, at a time when he was almost unbearably fastidious about such matters, and his documented association with several leading members of the divisionist camp.[89]

Though their politics were poles apart, the radical Fénéon persisted for many years in his admiration for the art of the reactionary painter (optimistically, Pissarro called Degas an 'anarchist in art'),[90] enthusiastically reviewing his 1888 show at Boussod et Valadon and eventually adding several of Degas's works, including two challenging late charcoal and pastel studies, to his extensive collection.[91] Another recently discovered link with his world was between Degas and Edmond Cousturier, whose wife Lucie adhered to the new doctrines in her painting, wrote about Seurat's art and became the first owner of *La Grande Jatte*.[92] But it was surely the temporary convert to the cause, Camille Pissarro, who would have acted as the more substantial go-between, sharing his practical experiments with his colleague of many years and communicating the 'lucid and scientific' notions of the younger generation. Degas and Pissarro had often collaborated in the past, and both seem now to have explored applications of the new approach to colour in their works on paper. Towards the end of the

1880s, a number of Degas's studies show a more fragmentary and schematic application of pastel strokes, sometimes in the form of intense, scattered dots, that have no precedent in his oeuvre. In *Woman in a tub* (fig. 163) for instance, a rash of cherry-red spots has spread across the cool shadow on the model's upper thigh, as if added in retrospect or in imitation of a still-unfamiliar technique.[93] On a significant group of slightly later works, more confident dabs and stipples of contrasting hue appear, animating the background of *Nude combing her hair* (fig. 61), for example, and enriching a number of the 1892 landscapes, such as the shimmering *Steep coast* (cat. 98). By mid-decade, such dashes, specklings and scatterings of colour had become part of Degas's stock-in-trade, by no means observing the Neo-Impressionist protocols but broadly and rather haphazardly 'recomposing themselves on the retina' in the manner described by Fénéon. Even Degas's evocatively titled *zébrures*, or parallel pastel hatchings of bright colour, which are so conspicuous a part of his graphism at this period, offer a kind of informal divisionism, assaulting the eye with their 'ever-expanding science of light', as one critic wrote in 1912.[94]

The pragmatism of Degas's day-to-day handling of colour was encapsulated by his model Pauline, in her description of a sequence of pictures of ballet dancers arranged in the artist's studio. 'One of these figures, a dancer at the barre, reappeared in a number of pastels. In one, she was dressed in green and stood out against a background of violet; in another, the background was yellow and the costume red, and in a third she appeared in a pink tutu against a ground of green.'[95] Uniting Degas's practice of tracing and his commitment to serial imagery, and joining both with his serendipitous research into colour, this description brings us close to Degas's fundamental working method. As we have seen, Pauline continued by explaining that 'he painted his subject with different tones, endlessly varying the colours, until one of the pastels pleased him enough for it to be completed, leaving the others more or less unfinished.'[96] Though she was writing at the very end of Degas's pastel-making career, Pauline's account is broadly confirmed by dozens of surviving picture sequences, notably that surrounding the Burrell Collection's *Red ballet skirts* (cat. 17). In the Burrell work, all three dancers wear brilliant coral pink 'against a background of green'; in *Three dancers (green bodices)* (private collection), these colours are effectively reversed; extending his palette, *Three dancers (yellow dresses, red bodices)* (fig. 106) introduced blue and gold, while in *Three dancers in yellow skirts* (cat. 18) lemon tutus blaze out against a deep Prussian blue ground. Other variants add to this exotic spectrum, including the extended compositions of *Three dancers* (cat. 20) and *Dancers in the wings* (cat. 19), amounting to almost a dozen chromatic restatements of a single pictorial theme.[97]

FIG. 106

*Three dancers (yellow dresses, red bodices), c.*1897–1901
Pastel on paper, 65 x 52 cm (25⅝ x 20½ in.)
Private Collection, photograph courtesy of Christie's (L.1377)

What are we to make of this wilful, almost aleatory, distribution of intense colour in works that are otherwise so pondered and deliberate? Are we to take Pauline at her word, seeing it as a 'hit-and-miss' affair that resulted in a single study that 'pleased' the artist, leaving a folder full of 'rejects' in its wake? If there was nothing on which to base our judgement other than the cluster around the *Red ballet skirts*, from which only one work was signed and sold in Degas's lifetime, such an assessment might be plausible, irrespective of the profligate expenditure of time, energy and materials involved.[98] And it is certainly true that considerable numbers of unfinished drawings and pastels of this and other subjects, many linked in serial relationships, were found in Degas's studio after his death. But few 'families' of related images coincide so neatly with the model's testimony and few are so consistent with this quasi-Darwinian, survival-of-the-fittest approach. More common is the sequence of studies that includes three or four fully developed compositions, several of which may be signed, varying not just in their colouristic pitch but in subtle details of staffage and décor, in refinements of format and nuances of surface. The cycle around *Dancers* (cat. 23), for example, includes at least five near-identical representations of a group of resting ballerinas that almost exhaust the palette, from lavenders to sky blues, the fieriest of pinks to the most sonorous browns.[99] Far from offering a hierarchy of finish and marketability, however, we find that all these works were sumptuously enriched, all carry the artist's signature and all were sold to either Durand-Ruel or Vollard in Degas's lifetime.[100] Similarly, the populous family of *Russian dancers* (cat. 89–96) incorporates five or more signed works in its number, though here it is predominantly and surprisingly the less-developed specimens, such as the vibrant *Three Russian dancers* from Stockholm (cat. 83), that were surrendered to the market.[101] Conversely, a picture such as the magnificent *Russian dancers* (cat. 90) from the Lewyt collection, a masterpiece by any standards, remained unsold, revealing substantial flaws in Pauline's anecdotal account.

Not for the first time, our understanding of Degas's late craft may be advanced by a remark of Paul Valéry's, taken from an extended reflection on the painter's draughtsmanship, his willpower and his serialism. Valéry notes the reluctance of Degas to admit 'that his work has reached its *final* stage. . . . At times he turns back to those trial sketches, adding colours, mingling pastel with charcoal; in one version the petticoats may be yellow, in another purple'. As if to summarise his thoughts, the writer adds, 'Degas was one of that family of abstract artists who separate form from colour or from subject.'[102] Written in Paris in the 1930s, when the idea of a 'family of abstract artists' was both localised and historically specific, Valéry's text appears to appropriate Degas for one of the principal currents of modernism, even as he acknowledged the artist's

historic roots. As Valéry knew well, the separation of form and colour had a particular, even painful, resonance throughout Degas's career, echoing back to the doctrines of Ingres and the example of Delacroix, the rigour of Florence against the seductiveness of Venice. In these pastels, however, the time-honoured argument approaches a new and less-easily defined resolution. While the forms of Degas's late imagery may be swamped by waves of luxuriant colour, they were almost invariably founded on a deep-rooted sense of composition and sustained by the most buoyant of draughtsmanship. If these rainbow-hued scenes represent Degas's final liberation from Ingres, they are no more truly 'abstract' than their engagement with bodily movement, muscular exhaustion and corporeality allows.

Inverting Valéry's formulation, we might say that colour was never more purposeful nor instrumental in Degas's subject matter than in these last pastels. The closer that two renderings of *Russian dancers* become in their conformation, the more we respond to their finely nuanced hues, to the hints of dawn in one, of autumnal lassitude in another, to a wild eruption of pagan energy in a third. Colour is never arbitrary, but fiercely contested across every inch of the scene and inextricably bound up with the pattern of depicted form. In the *Russian dancers* series, entire planes of pastel have been shifted from russet to ochre or purple to white, while last-minute flourishes of charcoal impose order on impending chromatic chaos. Close scrutiny of such works exposes these tortuous processes at work, the principal dancer's dress in *Red ballet skirts*, for example, revealing itself as a vivid crocus yellow in a former incarnation and the face of the same ballerina disclosing an alternative, more anatomically precise, set of features. Georges Jeanniot confirmed this practice at first hand, writing of a picture begun in a range of cool blues and greens that he found transformed, a few days later, into one 'in the key of orange', echoing Valéry's account of the 'redrafting, cancelling and endless recapitulation' that went into such studies.[103]

In generating these extraordinary mutations, Degas separated form from colour only to fuse it together again in complex and utterly original ways. Seen as sequences, his groups of multi-hued pastels have the closest affinity with the suites of poplars and grainstacks of Monet, the urban landscapes of Pissarro and the obsessive Provençal scenes of Cézanne, while carrying the argument further, into the complex terrain of figuration. Like Monet and Pissarro, Degas would experiment with a shift of hue in a repeated form or explore a rise or fall in chromatic temperature; like Cézanne, he tightened intervals and masses or redistributed space with each successive alignment. More than any of these artists, however, Degas granted himself the right of invention, transforming a given pictorial challenge by changing a form, such as a prominent dancer's skirt, from yellow to scarlet, or, as Jeanniot tells us,

FIG. 107
Vincent van Gogh, *Still life with fruit, c.*1887
Oil, 46.5 x 55.2 cm (18⅜ x 21⅝ in.)
The Art Institute of Chicago, Gift of Kate L. Brewster

transposing the harmony of a picture from cool to hot. Running the gamut of the available palette, Degas toyed with 'increasingly violent . . . harsh colours', as the courageous Lemoisne wrote in 1912, or opted for elegiac, closely related brick reds or wintery silvers.[104] Certain pictures may even have been initiated by a cluster of such tones, as in the late variant of the *Modistes* theme (possibly *At the milliner's* (fig. 53) that Degas claimed to have based on an oriental carpet seen in the place Clichy.[105] Uniquely free to dispose of his coloured fabrics and scenery, pliant towels and angular furniture, Degas was more constrained by his human subjects, though even here his later transpositions vie with those of his most audacious peers. Local or descriptive hues were increasingly superseded by grander considerations, a complementary green invading the warm shadow of a face, for instance, or Fauve-like primary hues blocking out a limb.

Though we still know little about Degas's grasp of the science of colour, several of his contemporaries sensed the originality of these pastel sequences. When his densely hued landscapes were exhibited in 1892, their variations were compared to the abstract structures of music, in a way that may well have appealed to the opera-loving, Gluck-obsessed Degas.[106] Such sympathies may already have endeared him to the more theoretically minded Gauguin, who repeatedly associated the two art forms in his writings: 'One does not use colour to draw but always to give the musical sensations that flow from itself, from its own nature, from its mysterious and enigmatic interior force,' Gauguin declared, anticipating 'the musical role colour will henceforth play in modern painting'.[107] As Degas surrounded himself with examples of Gauguin's most evocative imagery in the 1890s, so he began to collect the paintings of other pioneers of this 'mysterious and enigmatic' colour, principally Vincent van Gogh and Paul Cézanne. Even braver, perhaps, than his purchase of certain of Gauguin's paintings was his acquisition from Vollard of van Gogh's 1887 *Still life* (fig. 107), a scintillating confection of slashed and hatched bars of paint that are curiously reminiscent of Degas's pastel *zébrures*.[108] At the other extreme, Degas's holdings of works by Cézanne reveal his appreciation of colour at its most both delicate and austere, as in the watercolour *Three pears* (New York, Metropolitan Museum of Art) and the handsome oil on canvas *Self Portrait* (Winterthur, Reinhardt Collection).[109]

In time, we shall learn more about the sympathies and the unconscious parallels between Degas and the younger colourists at the turn of the century. Some clues are offered, however, in the reflections of Henri Matisse, who outlined certain of his early views in the essay *Notes of a Painter*, published in Paris in 1908.[110] After dismissing the 'vibrating sensations' produced by a typical Impressionist rendering of a scene, which 'represents only one moment of its appearance', Matisse went on

to introduce his own method in terms that approximate rather startlingly to those of Degas. Beginning his picture by jotting down 'some sensations of blue, of green, of red', Matisse explained that he established a set of colour relationships that satisfied him, then developed it towards greater 'balance' and 'harmony'; 'a new combination of colours will succeed the first one . . . I am forced to transpose until finally my picture may seem completely changed when, after successive modifications, the red has succeeded the green as the dominant colour.'[111] Initially, it seems that Matisse has disregarded his subject matter, identifying himself with 'that family of abstract artists who separate form from colour or from subject', in Valéry's words. But the painter continues, 'What interests me most is neither still life nor landscape but the human figure', through which he aimed to express 'the nearly religious feeling that I have towards life'.[112] Whether the elderly Degas became aware of Matisse's text or not, he would surely have recognised in it a powerful summary of practices that had engaged him over the past two decades. By 1908, their careers had also become literally linked, with Degas's pastels hanging on the same walls as Matisse's paintings in Shchukin's Moscow apartment and Vollard's gallery, and mutual friends, such as Georges Rouault, establishing a bond between them. But by this date, Degas's activities as a pastellist were all but over, his Gauguinesque 'musical sensations', his Cézannian palpitations of colour, his Fauvist *zébrures* and his honorary membership of the 'family of abstract artists' in the hands of a new generation.

THE 'CURSED MEDIUM' OF OIL PAINT

FIG. 108
Young Spartans, 1860
Oil, 109 x 154 cm (43 x 60¾ in.)
London, National Gallery (L.70)

The contrast between the fluency of Degas's late pastels and his fitful, occasionally spectacular and sometimes disastrous engagement with oil painting could hardly be more complete. Pastel, in effect, had become Degas's vernacular, a highly personal idiom that expressed both his attachment to drawing and his love-affair with colour, his historicism and his 'anarchism', as Pissarro called it. Painting with oil on canvas, on the other hand, was fraught with ancient tensions and practical constraints, many of which Degas and his contemporaries failed to master to their satisfaction. Where pastel was relatively unencumbered by tradition, oil paint was almost inseparable from the past; where pastel 'lends itself to improvisation', in Charles Blanc's words, canvases required discipline, a knowledge of materials and a sustained physical engagement;[113] and where pastels were fresh and exhilarating, oil paintings threatened to discolour, their paint films to crack and their varnishes to decay. Degas was directly affected by all these issues, the paintings of his last decades amounting to a catalogue of challenges and exasperations with 'the cursed medium', as he described it in a fit of anger.[114] As the works here illustrate, however, the artist left behind sumptuous oil paintings in homage to Mantegna and Poussin, and others carried out with his thumbs, in the manner of late Titian; canvases begun in one decade and finished in another; and glorious exercises in underpainting and glazing, as well as encrustations of colour that approach incoherence. Each of these pictures has its own technical story to tell and each belongs with the evolving priorities and concerns of Degas's larger artistic project.

There are a number of reasons for identifying a practical crisis behind Degas's late oil painting. Before examining those particular to the artist, we should situate his difficulties in the broadest sense, not least in the stultifying approach to the medium that still dominated academies and teaching studios through much of the nineteenth century. Though Degas himself had little formal instruction in painting, such historic methods permeated his craft and undoubtedly provided the backdrop against which his technical performances took place.[115] Claiming a descent from the Renaissance and beyond, this orthodox procedure required that a painting be built up in a series of rigorously defined layers, each of which had purpose and meaning, and each of which had to be applied thinly, patiently and scrupulously. Over the centuries, different regional and material variants had emerged, but a typical sequence would involve the 'sizing' or sealing of the canvas, then the application of one or more coats of pale-tinted primer, to create the 'ground'. Next might come a coloured wash or preparation of beige, grey or ochre across the entire surface, on which the intended composition would be drafted out from prepared drawings. Allowing a considerable drying time between each painted layer, the principal forms

FIG. 109
Young Spartans, c.1860
Oil, 97.8 x 140 cm (38½ x 55⅛ in.)
The Art Institute of Chicago,
Charles H. and Mary F.S. Worcester Collection (L.71)

of the composition would then be developed in monochrome, and only as a final stage would 'local' or descriptive colour be added, along with fine detail and superficial 'glazes' on flesh and drapery.

After a period of several months, paintings produced in this way would be varnished and declared complete. According to conventional wisdom, and assuming the use of high-quality canvases, pigments and

FIG. IIO
*Lady with a parasol, c.*1870–2
Oil, 75.3 x 85 cm (29¾ x 33½ in.)
London, Courtauld Institute Galleries
(Samuel Courtauld Collection) (L.414)

oils, such works would be not only technically sound but expressive of the richness and subtlety of this complex medium. Superimposed membranes of colour conjured up fabrics that glowed in depth, skies that radiated light, and limbs and features with a skin-like translucency, while brushwork could be precise or vigorous, redolent of movement or suggestive of monumental form. As a young artist, Degas had been much in awe of such qualities and the venerated masters who created them, learning what he could of their techniques and making his own experiments in cumulative, multi-layered painting. Compensating in enthusiasm and application for his lack of historical knowledge, Degas executed first-hand copies from the canvases of Veronese, Titian, Rubens, Poussin and many others, often emulating their facture as eagerly as their imagery. Though some of these student attempts were misconceived, Degas's increasing confidence in his craft was soon noticeable, showing itself in grandiose canvases and ambitious projects of his own devising. When making the 1860 *Young Spartans* (fig. 108), for example, Degas produced an intricate series of drawings, compositional studies and a full-scale monochrome draft of the scene, the latter preserved in the Art Institute of Chicago (fig. 109), in a laborious sequence of preparatory stages.[116] Other pictures of these years show him experimenting with tinted grounds, underdrawing, glazes and a variety of mannered brushwork, as the historically minded apprentice pursued his own painterly education.[117]

That such a model of the artist's craft survived in Degas's mind until his last years, in spite of the technical and thematic upheavals of his middle life, is demonstrated by his stubborn insistence to Paul Valéry that a painting was the result of 'a series of operations'. Even more surprising, perhaps, is the discovery that this formulation persisted throughout the intervening Impressionist era, not just as a distant ideal but in the tangible and prosaic structures of Degas's pictures. His continuing use of monochromatic charcoal drawings beneath brightly tinted pastels and gouaches has already been discussed, as has the presence of black-and-white prints under coloured scenes of the café-concert and the dance (see figs. 93–4). What is less familiar is the pervasiveness of such tonal foundations under the most extravagant oil paintings of the 1870s and 1880s, like shadowy reminders of Degas's past lurking beneath the vulgar trappings of his modernity. Though it is in the nature of such underpaintings to be largely concealed by what follows, sufficient abandoned or half-completed canvases have survived to hint at the ubiquity of this method. The grey-green expanse of the early 1870s *Lady with a parasol* (fig. 110), for example, was brushed in like a broad chiaroscuro *ébauche*, or tonal preparation, and was undoubtedly intended for later embellishment with naturalistic colour, while the extraordinary sepias and silvers of the 1874 *Rehearsal of the ballet on stage* (fig. 111) recall

FIG. III
Rehearsal of the ballet on stage, 1874
Oil, 65 x 81 cm (25⅝ x 31⅞ in.)
Paris, Musée d'Orsay (L.340)

an eighteenth-century grisaille.[118] Countless other paintings show glimpses of blackish or umber surface washes and neutral statements of form, some almost concealed in the classic manner, many incorporated into the final image.[119]

It is in this confused technical ambition, to become an old-masterly painter of modern life, that the root of Degas's later problems surely lie. It is a confusion he shared with many of his Impressionist peers, though one which they variously resolved and redefined according to their skills and practical histories. But for all their diversity, and beyond all the lessons they learnt from their immediate precursors, a new and profoundly transformed approach to oil painting emerged in the circle of Monet, Renoir, Pissarro and Cézanne in the 1870s. Light tones were preferred to dark, bright colours to dull; directness and spontaneity of execution were admired, though not always achieved; canvases were begun with minimal drawing and sometimes finished in the same day; monochrome underpainting disappeared in most cases, as did the bituminous tones of shadows and the rituals of orthodox glazing, modelling and later varnishing. Far from preparing their imagery in a sequence of cautious stages, as Degas had done for his *Young Spartans*, his colleagues now collapsed this 'series of operations' into a continuous, sometimes reckless attack. Surprise was valued over doggedness, the raw encounter with actuality over the patient emulation of the past.

In such circumstances, Degas found his craft deeply compromised. On the one hand, the Degas who strode the streets of modern Paris delighted in their brash hues and light-bleached public spaces, finding equivalents for their new tonalities in his gouaches, distempers and pastels, as well as some of his most radical oil paintings. On the other, the reflective autodidact found himself clinging to the past, almost instinctively drafting out compositions in pencil or charcoal and habitually working from a tonal structure to a chromatic one. The story is a complex one, of course, mitigated by excursions into pastel and experiments with the kind of landscape subject favoured by his friends, but his path through these decades remains distinct and his output physically unmistakable.[120]

Degas was not alone, of course, in his restlessness or his sense of technical inadequacy. By the time the Impressionist painters had gone their separate ways, most had long-since compromised the innocence of their earlier practice or revisited the methods of the past: Monet had famously accepted the need to work indoors on his *plein-air* beginnings, piling colour on colour in distinctly unacademic layerings of paint;[121] Cézanne reportedly spent 115 sittings on his *Portrait of Vollard* (Paris, Musée du Petit-Palais) leaving an impasted, murky image that barely escaped his wrath;[122] and most brutally, Renoir claimed that 'he had wrung Impressionism dry', knowing 'neither how to paint nor draw'.[123]

Typical of their plight was Renoir's return to the fountain-head of their craft, in his case by travelling to the great museums of Italy and Spain, reading such treatises as Cennini's fifteenth-century *Libro dell'Arte* and even attempting a revival of fresco.[124] Other adherents of Renoir and Degas's circle, such as Julie Manet and Jeanne Baudot, admitted to a similar reliance on ancient texts, underlining once more the paucity of available guidance for contemporary practitioners.[125] For all these artists, as for Degas, their competence had been tried and found wanting, their command of canvases and oils unequal to their ambitious undertakings and their inadequacy beside 'the admirable works that have been handed down to us through the ages' of the Louvre, as Cézanne called them, woefully apparent.[126]

Seen in this light, Degas's perplexity with the 'cursed medium' merges into the more general frustration of his colleagues, while losing none of its gravity or its particularity of detail. For Degas, it was compounded by his parallel devotion to pastel, at once a rival for his attentions, a flexible modern medium, and a paradoxical expression of the 'series of operations' that properly belonged to oil paint. Pastel allowed Degas to advance by stages, building from line to tone, from tone to colour, in a stately re-enactment of painterly ritual. Able to control and understand his materials and, where necessary, add to their number, Degas the pastellist found success and fulfilment, even as his uncertainty as a painter became part of the gossip of Paris. Always alert to such stories, Vollard once interrogated Renoir on the subject; at first, Renoir deflected the question by admiring Degas's drawing, then eulogising the pastels he had exhibited in 1886, pointedly comparing their qualities to 'the freshness of a fresco'.[127] Finally, Vollard lost patience, exclaiming 'What I'm trying to get at is what you think of Degas as a painter in oils . . .', only to hear Renoir set off on another tangent, this time discussing Carpeaux, Rodin and Degas's sculpture. More substantially, Vollard remembered seeing in Degas's studio a number of easels 'with canvases half-finished on them, for after he had started an oil painting, he soon gave way to discouragement, not being able to fall back, as he did with his drawings, on tracing after tracing by way of correction'.[128]

The contested territory between Degas's oil painting and his later pastel technique is vividly described in two canvases, both begun in the 1880s and both symptomatic of his changing priorities. In their subject matter, *The millinery shop* (cat. 4) and *Hélène Rouart in her father's study* (cat. 2) still belong to the high-point of Degas's Impressionism, when the notions of Duranty's essay *The New Painting*, written a decade earlier, continued to hold sway. Here we see 'the special characteristics of the modern individual' defined by their 'physiognomy and clothing', the 'furniture, fireplaces, curtains and walls' that indicate their 'class and

FIG. 112
*Study of hands, c.*1886
Pencil on paper, 25 x 41 cm (9⅞ x 16¼ in.)
Mrs Henry Grunwald

profession', observed from a viewpoint that is perhaps 'very high, sometimes very low'.[129] Altogether less characteristic of this earlier moment of Impressionism for many of Degas's colleagues, however, is the fact that both works were preceded by a complex series of related studies, involving both drawings and discursive exercises in colour. Before embarking on *The millinery shop*, for example, Degas had generated a sequence of ambitious pastels on the same theme, two carrying the date 1882 and all taken to an intense, even exquisite, level of finish.[130] As he worked on the Chicago canvas, Degas again turned to pastel for a group of animated studies, exploring not just the pose but the broad chromatic character of the projected scene.[131]

Preparations for the slightly later *Hélène Rouart in her father's study* were equally extensive, again involving compositional drafts, pastel studies and line drawings of details, such as the hands (fig. 112).[132] Traditionally, such preliminaries were intended to resolve the problems of an oil painting in advance, leaving the artist free to complete his work with a minimum of hesitation. In neither picture, however, did this occur, both showing signs of editing and technical equivocation, and even perilous last-minute revision of their surfaces. At some point in the re-working of *The millinery shop*, in the area close to the woman's head, Degas 'scraped at the canvas with his palette knife', as Richard Brettell recounts, transforming an extravagantly hatted customer into a bare-headed shop assistant and similarly modifying her dress, her arms and the apricot *toque* she holds.[133] Recent examination of the *Hélène Rouart in her father's study* has revealed even more complex layers of paint, if rather less dramatic changes of pose.[134] Here attending to fine adjustments of contour and tonality, Degas overpainted several passages of colour with contrasting hues, redefined the outline of Hélène's shoulders in dark blue, and scumbled highlights and textures over existing forms. Whether his second thoughts came months or many years later, several features suggest both the passage of time and a transition to new pictorial concerns. The restatement of Hélène's hands (fig. 113), for example, covers a previously indicated engagement ring, visible in the preliminary drawing and still discernible in an X-ray photograph (fig. 114);[135] certain areas of repainting are based on red–green contrasts, another preoccupation of Degas's later 'Venetian' phase; and strokes of dry orange-brown paint of an almost pastel-like consistency have been added, notably in the contours of Hélène's dress and arms.[136]

The curious resemblance of such paint surfaces to the dry tactility of pastel draws attention to the occasional waywardness of Degas's technique, as well as the sometimes bizarre dialogue between the two media in his later years. At its best, this exchange mutually enhanced his chosen processes, bringing grandeur to Degas's pastel compositions and a kind of brittle vitality to his canvases. Both the paintings discussed have

FIG. 113
Hélène Rouart in her father's study, cat. 4, detail

FIG. 114
Hélène Rouart in her father's study, cat. 4, X-ray photograph of hands

FIG. 115
Nude woman drying herself, cat. 9, with drawn grid indicated

areas of colour that recall the dessicated tints of chalk, their fractured crusts allowing glimpses of earlier layers and textures. In the ripe, sonorous tones of the *Hélène Rouart in her father's study*, matt paint has been dragged across the canvas weave and already dried brushwork, while in the Chicago *Millinery shop* the decorated hats resemble their pastellised predecessors. Other canvases from this interregnum, such as *Woman ironing* (cat. 5) and *Pagans and Degas's father* (cat. 3), show parallel bars of paint in the manner of pastel hatchings, in places dissolving the gulf that separates the two materials. The ultimate hybrid, however, which perhaps speaks of desperation on Degas's part, was the application of pastel directly to canvas, without the mediation of oil paint. Using the fabric surface in place of a sheet of paper, the artist made a number of images in this way in his last years, including *Woman at her toilette* (Glasgow Museums, The Burrell Collection), perhaps intending them as colour beginnings for later embellishment in oil.[137] Though not unknown in the work of other artists, the application of pastel to canvas was likened by Sickert to laying powder on the surface of a vibrating drum, and fortunately for posterity Degas took his experiments no further.[138]

When Sickert recorded Degas's remark that 'In oil painting, one should proceed as with pastel', the English painter added, rather inscrutably, 'He meant by the juxtaposition of pastes considered in their opacity'.[139] Whether this was Sickert's way of describing the now familiar 'series of operations' is unclear, but there can be little doubt that Degas continued to approach his canvases in this sequential, historically sanctioned manner throughout his last years. In his most outlandish experiments as well as his greatest painterly achievements, the ageing Degas progressed from drawing to colour in an old-masterly sequence that still recalled the tentative trials of his youth. When these pictures achieved full resolution, as in the gorgeously hued *Woman at her bath* of the mid-1890s (cat. 49), colour, structure and subject came together with almost unprecedented force; when Degas's ambitions clashed with his practice, paint surfaces could become clogged and projects abandoned; and when some of these inspired essays were set aside, as perhaps were *Combing the hair* (cat. 42) and *After the Bath, woman drying herself* (cat. 57), we were inadvertently left with an insight into the thinking of the artist's final decades.

One such canvas 'frozen' in its dramatic, half-completed state is *Nude woman drying herself* (cat. 9), where the artist's studio procedures are revealed as frankly as the model's athletic form. Though executed at the beginning of the period under review, this enigmatic work summarises much of Degas's practice in his middle years and seems to mark a turning-point in his painterly fortunes. Close scrutiny of its surface has identified traces of a redrafted composition, apparently carried out with

FIG. 116
After the bath, woman drying herself, c.1890–4
Pastel and charcoal on paper, 33.5 x 50 cm (13⅛ x 19¾ in.)
Location unknown, photograph Archives Durand-Ruel, Paris (L.791)

a pencil or a piece of charcoal, as well as signs of the 'squared-up' transfer of at least one design.[140] When plotted schematically on to a photograph (fig. 115), this grid of lines recalls the practices of Ingres and the workshops of earlier centuries, even as its discontinuities show up the unevenness of Degas's craft.[141] More pointedly, it questions the evolution of the present image, already a contested topic through its links with earlier works, among them the pastel-over-monotype *Woman at her toilette*

FIG. 117
Nude woman drying herself, cat. 9, early state
Photograph Archives Durand-Ruel, Paris

FIG. 118
Study of a nude, c.1882–5
Pencil on paper, 27 x 21.7 cm (10⅝ x 8½ in.)
New York, Metropolitan Museum of Art. Notebook 36, page 34

34

(fig. 69).[142] In preparing the Brooklyn picture, Degas evidently used the squaring-up procedure to enlarge an existing drawing, marking out a study as he did with *After the bath, woman drying herself* (fig. 116) and drafting its forms on to his canvas. Equally clearly, other lines show that the first subject differed radically from that visible today, the bathtub being lower and more centrally placed and the woman herself kneeling or crouching towards the left; an early photograph in the Durand-Ruel archives shows the broadly sketched contours of many of these forms more vividly (fig. 117).[143] The resemblance of this last figure to such works as the Musée d'Orsay's pastel *Woman bathing in a shallow tub* raises the fascinating possibility that Degas contemplated a large oil painting of a bather in the mid-1880s, alongside the fabrication of the 'suite of nudes' shown at the eighth Impressionist exhibition.[144] Just as importantly, and for reasons that remain a mystery, Degas hesitated, reverting to a composition of the previous decade and the image of an entirely monocromatic *salle de bain*.[145]

If proof be needed of Degas's traditionalism, as well as his profound technical uncertainty in mid-career, it would be difficult to surpass the Brooklyn canvas. Having drawn and plotted his design, erased and then relocated his subject, the artist made further studies to revitalise this new conception, or possibly re-used a group of sketches completed for a recent ballet motif. One such sketch (fig. 118), found in a notebook datable to the early and mid-1880s, shows the closest consonance with the legs, feet and general deportment of the figure in *Nude woman drying herself*, largely resolving the picture's uncertain history.[146] After so much equivocation, Degas then became decisive, brushing in the outlines of

his figure with sweeps of liquid umber and splashing at shadows, the forms of wash-stand and bed, and the rock-like sponge in her tub. In a matter of minutes rather than hours, the artist conjured up one of the finest monochromes of his career, adjusting certain areas with wipes of a cloth and scrubbing out unwanted detail. Though its exuberance would have horrified him, this underpainting, or *camaieu,* effectively carried the doctrines of Ingres into the late nineteenth century and into the heart of late Impressionism, and with them the vestiges of an entire school of pictorial thought. Beyond this point, however, Degas was unable or unwillingly to proceed, perhaps enchanted by his own spontaneous creation or troubled by its implications, leaving the unfinished canvas in his studio, where it was copied or committed to memory before 1892 by Paul Gauguin.[147]

FIG. 119
Andrea Mantegna,
*Minerva chasing the Vices from the Garden of Virtue, c.*1500
Tempera and oil on canvas, 160 x 192 cm (63 x 75⅝ in.)
Paris, Musée du Louvre

FIG. 120
Copy after Mantegna's
'Minerva chasing the Vices from the Garden of Virtue', 1897
Charcoal and pastel on canvas, 73 x 92 cm (28¾ x 36¼ in.)
Paris, Musée d'Orsay (BR.144)

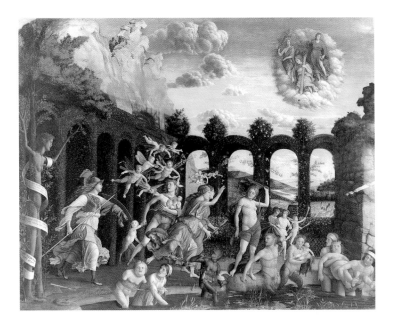

The pervasiveness of such monochrome underpaintings in Degas's mature work, though necessarily obscured by later colouring in the majority of cases, is widely evident in *Degas: Beyond Impressionism*. Canvases as different as the Cleveland *Frieze of dancers* (cat. 16) and the Liverpool *Woman ironing* (cat. 5) reveal preliminary tonal drafting under their abraded and richly worked surfaces, while other paint films show variations on the orthodox procedure. Degas's views on such matters are equally well documented. In 1893, for example, he took his young pupil Ernest Rouart aside and explained how to approach a canvas: 'You paint a monochrome ground, something absolutely unified: you put a little colour on it, a touch here, a touch there, and you will see how little it takes to make it come to life.'[148] Instructive here is the conviction that unity depends on the underlying *ébauche*, linking together the diverse elements of a composition through a single tone and establishing its dominant lights and shadows from the beginning. When he spoke about painting, Degas often stressed this 'ensemble', urging the importance of the 'sense of completeness' and the 'co-ordination of the various elements' in a scene, qualities that could be mapped out and fixed at a preliminary stage.[149] In *Nude woman drying herself* this unity has been emphatically achieved, allowing us to imagine the completion of the picture through the addition of colour, 'a touch here, a touch there',

without difficulty. In more finished and impasted canvases of the last years, such as the majestic *Four dancers* from Washington (fig. 125), this underlying coherence is sensed rather than seen at first hand, though the work was certainly drafted out in flourishing, single-hued brushstrokes like those of the Brooklyn picture.

Degas's obsession with the *ébauche* and the *camaieu* was partly practical, partly dependent on his reverence for historic precedent. In the texts of Cennini and Félibien, and the records of artists as distinct as Ingres and Delacroix, many of which Degas seems to have read, the advantages of a muted, monochromatic underlayer are taken for granted.[150] His indebtedness to this example is recorded in another sequence of events, this time surrounding Mantegna's monumental painting of *Minerva chasing the Vices from the Garden of Virtue* (fig. 119), then as now hanging in the galleries of the Louvre. In 1897, Degas instructed his pupil Ernest Rouart to make a full-size copy of the canvas and offered him practical guidance on Mantegna's techniques, at least as he understood them.[151] He also invited Rouart to visit him in his own studio, where Degas showed him a smaller-scale copy he had begun himself (fig. 120), 'a canvas on which he was doing an underdrawing in pastel in monochrome, after a photograph'.[152] Once again, Degas's curious experiment was left incomplete, though not entirely untinted as

FIG. 121
Ernest Rouart, *Copy after Mantegna's*
'Minerva chasing the Vices from the Garden of Virtue', 1897
Oil, 150 x 192 cm (59 x 75⅝ in.)
Paris, Musée d'Orsay

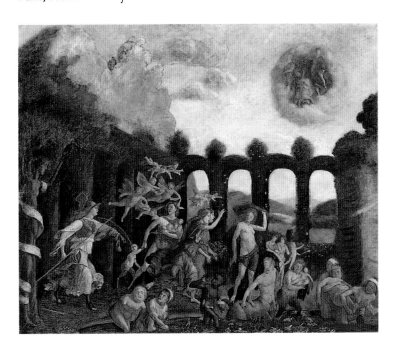

has sometimes been said, allowing us to share the artist's delight in black-and-white at first hand, now in the bizarre circumstances of a colour-painting lesson. Despite his own example, Degas was adamant that Rouart should start with the most violent hues:

> make a groundwork in green, and let it dry for a few months in the open air. Why, Titian himself would wait maybe a year before a picture was ready for more work! Then when the preparation is thoroughly dry, it can be glazed with red, and we'll have the right tone. While I was preparing my copy in terre-verte, Degas came to see me in the Louvre: 'But that isn't green! It's grey! Let me see you do it in apple green!' So I turned to the brightest shades to find a green that would suit him. Visitors at the Louvre thought I was crazy.[153]

In subsequent sessions and still under Degas's tuition, Rouart describes how he added the prescribed glazes, 'blue, red, yellow – very lightly, like watercolours, to let the ground show through', as the artist insisted.[154] Rouart was the first to admit that 'the result was not very good', and visitors to the Musée d'Orsay, to which the canvas was recently donated (fig. 121), can now confirm its heroic but confused technical history, including signs of a possible intervention by Degas himself.[155]

Though Degas's advice was neither true to Mantegna nor fully comprehensible to his pupil, it seems to have coincided with a dramatic departure in his own oil-painting technique. Rather than insisting that Rouart establish his design in browns or greys, as academic practice demanded and as Degas's photograph-based study still exemplified, the artist specified an 'apple green' underpainting, to be used throughout the canvas to define its, forms, rhythms and tonality. In the 1890s, Degas became fascinated by the application of this principle to his own works in oil, experimenting not just with green but with a variety of other canonical and uncanonical hues. Georges Jeanniot describes how he watched Degas embark on a genre scene at Diénay, where the landscape monotypes were also made, brushing a brilliant orange wash over a previously fixed drawing, then tempering it with touches of 'five or six' other colours.[156] Explaining that the process would strengthen the 'ensemble' and generate warmth throughout the final image, Degas also admitted to a certain levity in his approach on this occasion. But he was entirely in earnest in the majority of his trials, creating some of the boldest and most original canvases of the decade from such colour beginnings. Parallel in many ways to the group of 'old-masterly' pastels already discussed, in which brilliant pinks were worked over green bases or cool blues over orange ochre, these pictures initiated and finished in colour represent one of the most unexpected blossomings of Degas's late art.

In recent years, the two canvases *After the bath, woman drying herself* (cat. 57) and *Combing the hair* (cat. 42) have achieved unexpected celebrity, both acknowledged as incomplete and yet both admired for their chromatic and human drama.[157] Pervading each work is a glowing, richly inflected red, or rather a conspiracy of blood reds and near-oranges, caramels and ash purples, intensified as much as relieved by drifts of cream and white. Examination of their surfaces shows that these reds were brushed out in the early stages of preparation, not evenly across the priming like a true 'ground', but in differentiated passages that correspond to the tones and structures of their subjects. Some black was also used, but the pictorial character of the two works, and what might be called their visual temperature, found expression in a vividly suggestive hue at the opposite extreme from the cold, neutral tints of conventional grisaille.[158] Unsurprisingly, neither work was signed and there is every reason to include them among the 'half-finished' works described by Vollard, put aside to dry or from uncertainty as to how to proceed. But there is no doubt that Degas's original intention was to paint over both studies with glazes and touches of other colours, adding 'blue, red, yellow – very lightly, like watercolours, to let the ground show through', as he told Ernest Rouart, and perhaps finishing them with denser highlights and impasto. Ernest's son, Denis, in his published study of Degas's techniques, grouped *After the bath, woman*

FIG. 122
*Group of dancers, c.*1900–5
Oil, 46 x 61 cm (18⅛ x 24 in.)
Edinburgh, National Gallery of Scotland (L.770)

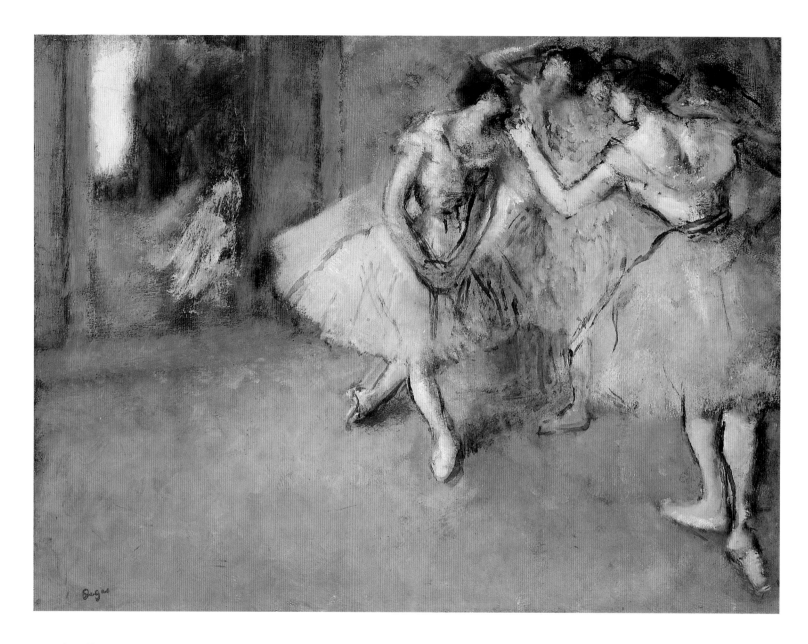

drying herself with works that 'dissatisfied' the artist, though more recently Jean Sutherland Boggs has recognised its enormous appeal to late twentieth-century viewers, plausibly suggesting that Degas may have felt it 'to be resolved' and left it deliberately in its present state.[159]

The survival of the Philadelphia and London canvases in their state of magnificent incompletion prompts us to look for other, similarly tinted *ébauches* beneath the finished oil paintings of Degas's last decades. Around 1890, the artist appears to have shifted his allegiances crucially, from the black or brown *camaieu* that had served him throughout his professional life, to preliminary drafts in a range of earth reds and

oranges, bright greens of the kind urged upon Rouart and a scattering of purples, pinks and gingers. Coinciding with the brilliant juxtapositions of hue in his pastel-over-monotype landscapes, this eruption of colour had similarly radical implications for his painting in oil, challenging the precedence of drawing, subverting form with hue and compromising a lifetime's fidelity to Degas's solemn idol, Jean-Dominique Ingres. The exoticism of some of the coloured drafts is almost shocking. When embarking on *Ballet dancers* (cat. 84), a pale cuprous green was brushed across the raw canvas; a bruised pink was used to prepare *Woman combing her hair* (cat. 39); and a mulberry purple lies beneath much of *View of*

Saint-Valéry-sur-Somme (cat. 99). Certain canvases, such as *The Bath* (Pittsburgh, Carnegie Museum of Art), show a calculated superimposition of hues from terracotta to blue, in a landscape-monotype-like sequence, while others emulate the sparkling crusts of Degas's recent pastels. Beneath the chalky intensity of *The bath, woman seen from behind* (fig. 128), for example, a crocus orange can been seen in the upper area of wallpaper, now almost obliterated by dabs and streaks of leaf green and blue grey, while *Woman at her bath* (cat. 49) overlays tints from throughout the spectrum. Dazzling in their variety, these canvases share a tendency towards warm reds, yellows and browns in their initial stages, followed by optically cooler hues in their subsequent embellishments.

This tendency is nowhere more apparent than in the scintillating *Group of dancers* (fig. 122), where a chestnut-red preparation is clearly visible under later brushwork, the latter carried out in peppermint green and silvery whites and greys. Though based on a rather confusing reversal of the procedure recommended to Ernest Rouart for his Mantegna copy, this progression from warmth to relative coldness, and specifically from earth reds to mineral greens, is highly characteristic of Degas's own later craft. Deriving its subject from a group of drawings and, like them, linked to a family of pastels, *Group of dancers* nevertheless originated and achieved full expression through colour; where draughtsmanship intervenes, it takes the form of fine lines of black and deep blue that have been painted *over* its chromatic foundation.[160] Here then, line follows colour, almost tidies up in its wake or finishes its task, rather than providing the 'foundation and condition of everything', as Ingres had demanded.[161] While such painted lines may still offer a vestigial link with Degas's past, there is no disguising their changed place in the scheme of things. *Group of dancers* has proceeded from breadth to refinement, from sensuously improvised colour to a final tightening of form, emphatically and symbolically reversing the procedures of Degas's youth.

Such a transformation is not easily explained and we must look for clues in a confluence of factors both within the artist's practice and beyond. One of these was undoubtedly the resurgence of interest in the colour theories and practices of Eugène Delacroix, who had anticipated many of the technical concerns of Degas and his colleagues. With the publication in 1893 of Delacroix's journal, a text widely known in Degas's circle, artists enjoyed unprecedented access to their predecessor's day-to-day studio practice.[162] Not only did Degas arrange for his servant Zoé to read the Journal to him, but Denis Rouart tells us that he acquired some of Delacroix's original paper 'palettes', or arrangements of colour mixtures, to analyse at first hand.[163] As we have seen, Degas had already returned to his practice of copying, making two ambitious

studies from Delacroix that concentrate on their colour harmonies and giving further encouragement to those who regarded him as Degas's 'true master'.[164] In 1897, Roger Marx reiterated this link, associating Degas's use of 'optical mixture' with that of Delacroix and favourably comparing their rich, painterly surfaces.[165] This was also the era of Degas's most intense acquisition of Delacroix's works, with oil paintings, watercolours, pastels and drawings entering his collection in unequalled profusion and certain pictures, such as an oil-on-canvas study for the *Battle of Nancy* (Zurich, Nathan Collection), hanging in pride of place in his bedroom.[166] Again pursuing his subject with quasi-scholarly vigour, as late as 1907 Degas arranged for Moreau-Nélaton to assemble a special photographic facsimile of a Delacroix notebook recently acquired by the Louvre.[167]

For Degas in the 1890s, Delacroix's writings on the technical challenge of oil painting must have seemed uncannily familiar, returning again and again to the question of successive grounds, underpaintings and glazes in works on canvas. Specific reference is made to the effectiveness of grisaille in the paintings of Correggio, Rubens, Prud'hon, Ingres and others, with Delacroix coming down emphatically on the side of the coloured laying-in. 'Unless you are deliberately setting out to do a monochrome or *camaieu* painting,' he writes, 'you must consider colour as one of the most essential factors . . . the colourists must establish everything that is proper and necessary to their art at once, from the start of the work . . . the colourist must mass-in colour.'[168] Referring to the practical aspects of his method, Delacroix also discusses the use of 'brown or red' canvas grounds, and records his experience of glazing with complementaries, such as 'earth green over red'.[169] Here we come remarkably close to Degas's own practical experiments in works such as the Edinburgh *Group of dancers*, as well as to a small canvas by Delacroix that was eventually added to his collection. The unfinished *Hercules rescuing Hesione* (fig. 123) was not acquired by Degas until 1899 and cannot therefore have been instrumental in the exercises already discussed, though his interest in such a half completed study is in itself instructive.[170] But, at the very least, the red-brown washes on the central figures and the answering blue-greens of the landscape must have brought Delacroix's text vividly to life and confirmed some of Degas's own explorations.

Influential though Delacroix clearly was in the chromatic about-turn of this period, few features of Degas's technical history have such unitary explanations at a time when he was 'haunted by the craftsmanship of the Old Masters'. Another underestimated source for Degas's later painting is the work of Poussin, richly represented in Parisian collections and the object of a pronounced vogue at the *fin de siècle*. Though long since recognised as a factor in Degas's youthful

FIG. 123
Eugène Delacroix, *Hercules rescuing Hesione*, 1852
Oil, 24.5 x 47.5 cm (9¾ x 18¾ in.)
Copenhagen, Ordrupgaard

development, as he had been for Ingres in his time, the resurgence of Degas's passion for Poussin in later life and the public acknowledgement of their affinity deserves further consideration. In the only substantial reference to Degas in the vast narrative of Marcel Proust's *A la Recherche du temps perdu*, Madame Cambremer is made to claim 'M. Degas affirms that he knows nothing more beautiful than the Poussins at Chantilly', adding that the artist also admired 'immensely' the works by the same painter in the Louvre.[171] Proust's friend Daniel Halévy remarked that the *Young Spartans* (fig. 108), reminded him of the 'dry and hard' lines of Poussin, while Jeanne Fevre tells us that Degas always referred to Poussin as 'le patron'.[172] Even more remarkably, perhaps, Théodore Duret began an article on Degas in 1894, one of the first of its kind, by recalling his copy of Poussin's *Rape of the Sabines* (fig. 59), owned by Henri Rouart and prominently displayed in his apartment.[173] Claiming that the copy was as fine as the original, Duret announced that Degas 'has revived among the French school of painters a peculiarly national phase of art, such as had previously been manifested by painters like Poussin and Ingres'.[174]

Less precisely documented but ultimately more helpful analogies are drawn elsewhere in the present catalogue, between Poussin and Degas's use of wax figures as models for their paintings; between Poussin's representations of the dance and Degas's late classicism; and between specific motifs, such as the seated pastoral bather, in the two painters' works.[175] To this list can be added the purely technical matter of Poussin's craft, discussed at several points in his letters (which were known to Degas) and anticipating certain features of Degas's late painting manner.[176] Of particular interest is Poussin's preparation of his canvases with a broadly brushed warm foundation, described by Anthony Blunt as 'dark brown or reddish,' or ranging from 'brown ochre mixed with white to give a pinkish grey ground, to almost red

ochre' in the words of Madeleine Hours.[177] We should not, however, confuse this flat, uninflected plane of colour, which imparts its warmth unselectively to the forms painted over it, with a true *ébauche* or underpainting. But in Poussin's paintings it is everywhere apparent that he added tints of 'blue, red, yellow' to his coloured ground, sometimes 'very lightly, like watercolours, to let the ground show through', offering yet another precedent for Degas's freshly revived craft.

The new priority of colour in Degas's painting naturally goes beyond the brightly hued underpainting, however fundamental, in every sense, that may have been. In traditional oil-based practice, it was the subsequent layerings of variously translucent or opaque paint that gave the picture its finished character, applied over the prepared ground but benefiting from its unifying properties. Central to this practice were the glazes, the oil-rich veils of paint brushed on as the work approached completion, bringing subtlety to its tints and refinement to its surface. Though no stranger to this procedure, we find Degas looking again in his last years at the great painterly exponents of the past, and especially those celebrated for their colour and exemplary technique. As we can tell from his conversations, it was to the painters of the sixteenth-century Venetian school that Degas turned instinctively at such moments, citing their authority ('Why, Titian himself would wait maybe a year!', he told Ernest Rouart) and attempting to learn from a scrutiny of their practical example. Despite warnings from teachers and parents, the Venetians had attracted Degas in his youth and it was they, according to Denis Rouart, who 'preoccupied him most particularly towards the end of his life'.[178] More than thirty years earlier, Degas had described a tint like a 'beautiful and vivid Veronese, grey as silver and coloured like blood'; now, in effect, he set about creating hues of a similar complexity in his own paintings on canvas.[179]

As with Mantegna and Poussin, the galleries of the Louvre offered Degas a generous catalogue of works by Titian, Tintoretto and Veronese for these studies, among them the latter's monumental *Marriage at Cana* and *Supper at Emmaus*, both of which had already featured in the artist's pictures.[180] But Degas's revived passion for these artists carried him further, to the Prado in Madrid in the late summer of 1889, where the Spanish royal collections of Venetian art had remained since the Renaissance.[181] Travelling with the painter Giovanni Boldini, Degas sent back characteristically inscrutable reports on what they saw ('nothing can give the right idea of Velázquez. We shall speak of it all the same on my return', he wrote to Bartholomé), but the journey may well have prompted a reassessment of his techniques.[182] In the months after their tour, the extraordinary multi-layered colour project of the Diénay landscapes took shape, many of them depending on the opposition of warm grounds and cooler pastel 'glazes'. Richard

FIG. 124
Titian, *Venus and Adonis*, 1553
Oil, 185 x 207 cm (72⅞ x 81⅞ in.)
Madrid, Prado

Thomson has suggested that Titian's *Temptation of Adam and Eve* in Madrid may have prompted Degas's monotype *Torso of a woman* (fig. 62), while the same artist's even more celebrated *Venus and Adonis* (fig. 124), also in the Prado, may prove to be the point of departure for the much-discussed Philadelphia *After the bath, woman drying herself* (cat. 57), conceivably via one of the photographs that Degas collected on these occasions.[183]. Seated on blood-red velvet, Titian's unforgettable figure of Venus twists her body away from us and bares the full expanse of her back, one thigh raised, the other tucked beneath her in unsettling anticipation of Degas's image. Though *After the bath, woman drying herself* restates the subject of Titian's canvas in the context of domestic Paris, its colouring, design and facture show that it does so in the Venetian manner, at least as understood by Degas and his contemporaries.

In Charles Blanc's 1868 study of the Venetian School, part of his widely read *Histoire des peintres de toutes les écoles*, the author stresses the technical and painterly virtues of Titian, Veronese and their followers.[184] Writing of their use of oil paint, Blanc notes the richness they achieved in the medium, its 'flexibility', its promotion of overall 'harmony' and its reliance on glazes, which permit the 'dessous', or underpainting, to remain partly visible.[185] Titian is saluted as 'the most painterly of all the painters', with Blanc emphasising the breadth of his craft and his reliance on a final effect that was 'calculated to be seen from a distance'.[186] Another contemporary authority, Mary Merrifield, known in France as well as Britain, covered the same topics in more detail and described Titian's materials and procedures with similar reservations. Observing that he sometimes 'used a red ground made of terra rossa with size', Mrs Merrifield continued:

> *When the subject was drawn, the local colours were laid in lightly and thinly with colours mixed with oil, the shades being left very cold. The picture was then exposed to the sun and the dew until perfectly dry and hard. . . . After many months, the dead or first colouring or abozzo, as it is called in Italian, was examined and corrected, and fresh colours were laid on ... Titian, it is said, frequently laid on the paint with his fingers.*[187]

In such texts, the roots of Degas's erudition can be found, as well as the source of certain of his misunderstandings. Here is the insistence on 'many months' left between layers of paint, the role of the *abozzo* or *ébauche* in generating 'harmony' and the importance of transparent glazes; and here, too, is the pervasive significance of densely applied colour.

In his introduction, Blanc notes that 'the Venetians oppose red against green, which is the true complementary of red'.[188] This red—green opposition, ubiquitous in nineteenth-century colour theory

and commonplace in studio practice, acquired an almost obsessive status in Degas's later painting. We have already found it sounding the key of the Edinburgh *Group of dancers* and its chromatic echo can be heard again and again throughout *Degas: Beyond Impressionism*. For Degas, like Blanc, this resonance appears to have been specifically Venetian. When he was planning his *Hélène Rouart in her father's study*, Degas wrote to Henri Rouart, then on holiday in Venice, recalling that his daughter Hélène's auburn hair and her complexion were famous in that city, itself renowned for Titian's red-headed courtesans. Indeed, Degas's determination to give most of his late models either orange or mahogany hair must partly be explained by this connection.[189] As the portrait advanced, the artist brushed a green underpainting beneath the girl's salmon-pink hands, introducing gingers and brick reds into almost every detail of her surroundings and streaks of sage and copper into chair, vitrine and piled-up papers. One of the pigments used in this harmony is undoubtedly Venetian red, a naturally occurring iron oxide known to artists for centuries and much used in Degas's circle.[190] Degas's remark to Sickert that 'the art of painting was so to surround a patch of . . . Venetian red, that it appeared to be a patch of vermilion' reflects this currency, while his observation to Berthe Morisot that 'orange gives colour, green neutralises', again associates such warm hues with cooler complementaries.[191]

FIG. 125
Four dancers, c.1895–1900
Oil, 151.1 x 180.2 cm (59½ x 71 in.)
Washington, National Gallery of Art, Chester Dale Collection
(L.1267)

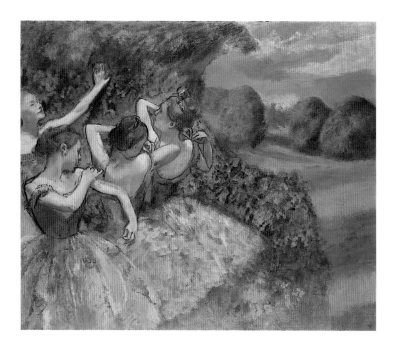

FIG. 126
Palette used by Degas
Paris, Musée d'Orsay

Juxtapositions of red-brown and blue-green, still visible on one of Degas's surviving palettes (fig. 126) and their derivatives pink and viridian, orange and almond, vibrate through many canvases in the present volume. In a barely sketched-out picture such as *Ballet Dancers* (cat. 84), a verdigris veil was washed over the distant wall and foreground bench, then answered by splashes of cinnamon in the ballerinas' hair. At the other extreme, the heavily worked *Frieze of dancers* (cat. 16) was apparently given its finishing touches with a range of similar hues, radiant against their predominantly monochrome setting. The small but delightful *Woman combing her hair* (cat. 39) lies between these two works, begun and completed in the gamut of red-brown and mineral green. Closely related to the National Gallery's *Combing the hair* in subject and facture, this study may also give a glimpse of Degas's intentions for the larger canvas, had he decided to continue with its quasi-Venetian beginnings. More complex still is the enormous *Dancer with bouquets* (cat. 6), initially brushed out on a muted coffee-salmon field in its lower areas, then overpainted with a range of greens, greys and purples in an approximation of the glazing process. Later additions introduced other hues, but a warm–cool polarity pervades its complex surface. It is arguably the vibrant *Dancers, pink and green* (cat. 31), however, apparently repainted in the early 1890s, that stands for many in its almost violent oppositions of hue. Its clamorous peppermints and notes of scarlet perfectly encapsulate Degas's new chromaticism.

Before exploring Degas's elaboration of his paint surfaces, whether inspired by Venetian precedent or his own impetuous craft, a brief glance at the supports of these pictures is necessary. One of the many tangible signs of Degas's enthusiasm for Titian and Veronese is his adoption of their heavy and coarsely textured canvases, in sharp contrast to the finely woven linen that typifies his earlier practice. The sheer scale of many Venetian altarpieces and murals had demanded strongly woven fabric, which in its turn encouraged tactility of brushwork and densely nuanced paint layers, allowing thin colour to sink into the weave and dry impasto to be scumbled across it. It was not until the mid-1880s that Degas made his first trials on such materials, using a rough, sack-like linen for the extraordinary *Woman ironing* in the Musée d'Orsay, and a substantial twill-weave canvas for the monumental Brooklyn *Nude woman drying herself*.[192] As we might expect, the Titianesque pair *Combing the hair* and *After the bath, woman drying herself* were both brushed over heavyweight fabrics and both exploit their supports to sensuous effect.[193] Sometime after he painted these works, Degas wrote to an artist friend, Julie Braquaval, telling her where she could buy lengths of especially coarse canvas.[194] Quite unhistorically, he also experimented with paint applied to such surfaces in their unprimed state, washing colour directly on to the raw, hemp-like support of *Ballet Dancers* (cat. 84).

FIG. 127
After the bath, woman drying herself, c.1894–8
Oil, 76.2 x 83.8 (30 x 33 in.)
Princeton University, The Art Museum,
Lent by the Henry and Rose Pearlman Foundation (L.1117)

FIG. 128
After the bath, woman seen from behind, c.1893–8
Oil, 65 x 81 cm (25⅝ x 31⅞ in.)
Private Collection (L.1104)

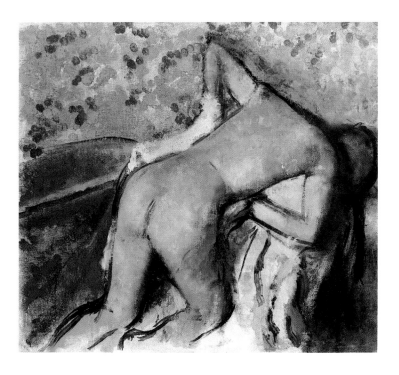

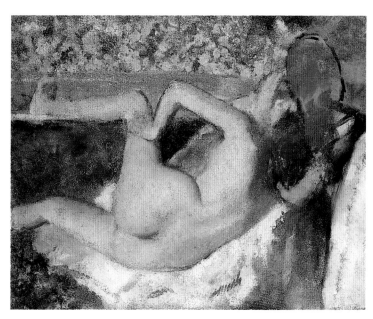

On such richly grained canvases and bright-hued grounds, Degas also found a new confidence in his brushwork, again apparently encouraged by his Venetian predecessors. As the accounts of Charles Blanc and Mrs Merrifield remind us, luxurious handling of paint and gestural, abandoned flourishes of the brush were widely associated with this school, often in tones of cautious disapproval. Such a view was given its classic formulation by the sixteenth-century painter and historian Giorgio Vasari, who asserted severely that Titian's works were 'done roughly . . . with strokes and blobs, to obtain the effect at a distance'.[195] Repeating this charge, Blanc also conceded the diversity of Titian's manner, his 'suave' brush and subtle mastery of light, the 'wild and harsh' touches that could result in broken surfaces that were confusing at close range.[196] We have already examined a number of Degas's late *ébauches* and seen his approximation of Titian's vigorously drafted underpainting; in such grand creations of the late 1890s as *Four dancers* (fig. 125), we surely confront his aspirations toward the celebrated brushwork of his predecessor. Pervaded by a palette of sombre oranges and deep blue-greens, almost every inch of this large canvas reveals successive accumulations of colour, applied in washes and stains, liquid ribbons and parched highlights, even what Vasari would have called 'strokes and blobs'. Over a fabric of pronounced weave and a warm, deep-tinted preparation, the artist has spread his complementary hues,

glazing pewter grey on earth-red sky, gold on aquamarine in the dancers' tutus, green on their pink flesh. Wristy flicks of dry paint indicate foliage and muslin, scraped contours hint at the movement of limbs, all ideally calculated to 'obtain the effect at a distance'.

Less apparent in the Washington canvas but conspicuous elsewhere is a further quality based on Titian, or perhaps on a misunderstanding of his legacy. In paintings such as *After the bath, woman drying herself* (fig. 127), the Cleveland *Frieze of dancers* (cat. 16) and *After the bath, woman seen from behind* (fig. 128), much of the surface is made up of disc-like patterns of colour, often arranged in regular formations. These are fingerprints or thumb-marks, applied by Degas with wet oil paint directly to the picture and, in many cases, leaving his finger-tip whorls still visible. Startling though this discovery can be, it is not without its historical precedent, most immediately in the tactile and richly manipulated plates of his 1892 colour monotypes.[197] But none of Degas's contemporaries shared this technique and we must once more look to the past for its origin. Denis Rouart was surely right in associating Degas's recourse to his hands with the documented practices of Titian, though he specifically and rather confusingly linked it with Titian's *spreading* of colour at an early stage of the *ébauche*.[198] Mary Merrifield, a source used by Rouart, describes a variety of contexts in which Titian abandoned his brushes, including work 'on the flesh and

FIG. 129
Paul Gauguin, *Tahitian woman*, 1898
Oil, 72.5 x 93.5 cm (28½ x 36⅞ in.)
Copenhagen, Ordrupgaard

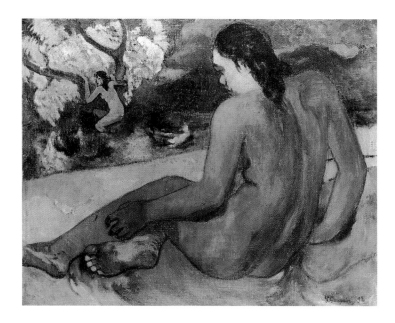

in the glazing', the use of 'all the fingers or the flat of the hand'; and a process by which he would 'dip the finger into the colour and draw it once along the surface to be painted'.[199] Closer still to Degas's practice was the sixteenth-century Palma Giovane's claim that, in the last stages of a work, Titian painted 'more with his fingers than with the brush', a description that would accurately account for Degas's rainbow-hued *View of Saint-Valéry-sur-Somme* (cat. 99), his mosaic-like *Woman at her bath* (cat. 49) and the shimmering *Blue dancers* (cat. 32).[200]

The courage, even the impertinence, of Degas in making pictures out of his own thumb-prints is a sharp reminder of the duality of his late craft. While his technique may ultimately derive from Titian, it equally invites comparison with the finger-paintings of Victor Hugo and the chance procedures of Surrealism, the *art brut* of Dubuffet and the tactile imagery of Abstract Expressionism.[201] Similarly with his colour, which on a single canvas might pay homage to the Venetians and assert Degas's place beside the most radical of his colleagues. In his last years, Paul Cézanne, too, had bowed his knee before 'the great Venetians', striving to emulate the 'great wave of colour' he saw in Veronese's *Marriage at Cana* in the Louvre.[202] Following his idol Delacroix, Cézanne also learnt to 'mass-in colour', laying paint directly on to the canvas with a minimum of drawing and frequently building up crust-like mosaics of hue that approach localised incoherence. Closer personally to Degas, Paul Gauguin had arguably influenced his development toward colour more than any of his peers. The period of Degas's late technical transition, from the late 1880s to the early 1890s, was also the phase of the

two artists' most intense mutual fascination ('Gauguin has again become very intimate with Degas and goes to see him often', wrote Pissarro in 1886), expressed in exchanged pictures and shared motifs, covert copying and public admiration.[203] If Degas's adoption of colour took place against the dramatic background of Gauguin's *La Belle Angèle* (Paris, Musée d'Orsay) and *Mehana no atua* (Art Institute of Chicago), both hanging in his rue Victor Massé premises, a more subtle traffic of materials was simultaneously taking place between them. From choice and necessity, Gauguin often turned to the roughest kinds of canvas for his paintings, perhaps preceding Degas in his later taste for 'toiles brutes'. In return, as Jean Sutherland Boggs has suggested, Degas appears to have adopted both the subject matter and palette of his admirer in pictures such as *The return of the herd* (cat. 100), a primitive-pastoral study in honey-browns and moss green.[204] Less familiar is the possibility that Gauguin espoused the signature colour of Degas's last years, Venetian red, in a series of canvases of this decade, such as *Tahitian woman* (fig. 129) and *Landscape in Tahiti* (Copenhagen, Ny Carlsberg Glyptotek) of 1898, paradoxically producing some of his most sombre and close-toned images.[205]

In pioneering the route of colour, Degas found himself not only in the same terrain as many of his peers and younger compatriots, but facing the same obstacles and uncertainties of procedure. Struggling with an imperfectly mastered craft, Degas would sometimes overpaint earlier canvases or build up dense crusts of colour, achieving both glamorous opulence and occasional incoherence. These reworked images must be approached with caution, requiring the skills of both scientist and conservator, the sensibilities of nineteenth- and of twentieth-century historians. The majority are undated, many showing signs of additions over a number of years, possibly as late as Degas's 1912 move from the rue Victor Massé.[206] Compounding the problem has been an uncertainty about their status, reflected in nervousness among collectors and the reluctance of major museums to acquire any but the most dramatic examples. Are these pictures a triumphant vindication of Degas's pursuit of colour and technical adventurousness? Are they, as some contemporaries suggested, just technical failures, the flotsam and jetsam of a tradition admitted to be in decline? And why were so few of these final late oil paintings, in comparison with the artist's pastels, surrendered to the market in his lifetime? Partial answers to these questions have been proposed in earlier chapters and continued scrutiny of the canvases in question can be expected to produce more. X-ray and ultra-violet examinations have helped to distinguish between pictures refined over time and those radically restructured, between localised adjustment and wholesale chromatic transformation, while several works have yielded up their secrets even as this volume has been in preparation.

FIG. 130
Woman combing her hair, cat. 39,
X-ray photograph with later image outlined

Such adjustments as those to the earlier *Millinery shop* were not uncommon, either in Degas's oeuvre or in the productions of his peers, though they would normally be accompanied by attempts to conceal the transformation, as in the Chicago example. A more extended campaign is implied by the complex surface of the *Hélène Rouart in her father's study,* begun in 1886 but arguably retouched and enriched as a colour harmony, and relined as a canvas, in the following decade. As we have seen, no major shifts in composition were involved, but the artist's new historically informed priorities are evident in broadly brushed additions of russet and gold, in complementary blue contours and viridian highlights. Similarly, the *Girl combing her hair* from Copenhagen (cat. 39) shows the sensuous manipulation of paint that characterises the mid-1890s, here augmented by dappled fingerprints and an even more pronounced 'Venetian' palette. None of these manoeuvres, however, has entirely obliterated an earlier design on the surface of the Copenhagen canvas, visible to the naked eye as a pattern of dry raised brushstrokes. Recent X-rays have confirmed the presence of a very different image from that seen today, shown in the photograph as a shadowy form beneath an outline of the later subject (fig. 130). Representing a broader, more static precursor of the toilette scene, with strong links to the Phillips Collection *Women combing their hair* of about 1869, this case suggests the re-use by the sixty-year-old Degas of a canvas from the beginning of his career.[207]

FIG. 131
Frieze of dancers, cat. 16, X-ray photograph

FIG. 132
Dancers, pink and green, cat. 31, X-ray photograph
New York, Metropolitan Museum of Art,
Sherman Fairchild Paintings Conservation Center

FIG. 133 FIG. 134

Dancers, pink and green, cat. 31, detail
New York, Metropolitan Museum of Art,
Sherman Fairchild Paintings Conservation Center

FIG. 134

Dancers, pink and green, cat. 31, detail
New York, Metropolitan Museum of Art,
Sherman Fairchild Paintings Conservation Center

Many other variations on these repainting procedures can be identified, some subtle and respectful of earlier stages, others more brutal. George Shackelford has published X-rays of the Washington *Before the ballet* (cat. 8) showing two extra figures at the centre of the scene, painted out by the artist in an early 1890s revision of the entire canvas.[208] Otherwise the initial composition remains intact, now augmented by drifts of violet and pink brushwork, suggesting an 'atmosphere of poignancy' and changing 'the tutu of the dancer on the right into some strange luminous flower', in Jean Sutherland Boggs's evocative phrase.[209] In *Frieze of dancers* (cat. 16) a comparable enchantment has taken place, transforming a series of matter-of-fact pastel drawings of the previous decade into one of the glories of the *fin de siècle*. The intricate paint layers of this picture discourage easy reading, but there is little doubt that Degas turned again to an earlier, largely monochrome canvas in the mid-1890s, infusing the ballerinas' skirts with soft greens and their surroundings with pale coffee and tourquoise, then tightening his composition with a few deft, brushed lines.[210] As before, X-rays (fig. 131) reveal the extent of the disc-like thumb-prints used in this reworking, while the presence of Degas's signature on an

overpainted shadow at lower right confirms the picture's finished status.[211] Both the Cleveland and Washington scenes were sold in the artist's lifetime, exemplifying Degas's confidence in his painterly powers and the successful, large-scale resolution of reworked canvases. It is difficult not to see in such works the exuberance of freshly discovered colour, of old habits thrown off and new departures eagerly seized upon. Far from being set aside in discouragement, as Vollard claimed of certain late studies, these ethereal exercises in colour, light and articulate form are among Degas's most profound achievements.

In a number of such canvases, the combination of a subject familiar from Degas's middle years with the colour and facture of his late manner, evident in a work such as *Dancers, pink and green* (cat. 31), should alert us to possible overpainting. Deriving its backstage setting and its detailed, slightly suggestive narrative from as far back as the 1870s, the 'densely worked' surfaces of the Metropolitan Museum's picture belong firmly in the mid-1890s.[212] Though it has previously been claimed that Degas 'made no substantial revisions to this painting', several inconsistencies of handling and detailed adjustments that are visible in X-rays suggest extensive, if localised, remodelling.[213] No major

FIG. 135
*Dancer adjusting the strap of her bodice, c.*1885–1905
Oil, 78.7 x 50.8 cm (31 x 20 in.)
The Art Institute of Chicago, anonymous loan (L.975)

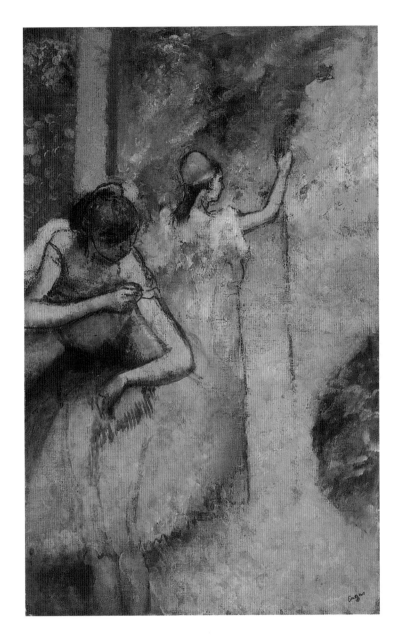

alterations of design or dramatis personae can be discerned, though an X-ray photograph (fig. 132) shows that the left-hand tree once had an angular branch; a diagonal 'prop' previously supported the scenery to the right of centre; and that the distant, central blur was formerly a pair of diminutive dancers.[214] Other modifications to limbs, tutus and surroundings betray the artist's revising hand, while certain encrustations of paint (fig. 133) hint at repeated superimpositions.[215] Some of this later painting is both dry and broad (fig. 134), allowing previous and contrasting hues to show through and encompassing the flourishing brushmarks and bold fingerprints of Degas's 'Venetian' phase. Even more extreme, perhaps, is the pervasive clash of peppermint green and tomato red across the scene, unprecedented in its sharpness for a picture of 1890, the date traditionally assigned to the canvas.[216]

More fundamental changes in the structure and meaning of a scene sometimes took place. When *Pagans and Degas's father* (cat. 3) was begun, probably in the 1880s, it implicitly looked back to a pair of oil paintings made a decade or more earlier, one of which hung in Degas's bedroom at the rue Victor Massé in his last years (fig. 31).[217] Despite this sentimental association, when Degas embarked on the later version he appears to have omitted the figure of his father altogether, only adding Auguste De Gas's distant, self-absorbed head in a final reworking.[218] *Dancer adjusting the strap of her bodice* (fig. 135) had a similarly protracted genesis, like *Dancers, pink and green* owing its origin to a composition of Degas's mid-career and even more than *Pagans and Degas's father* undergoing late modification.[219] X-rays expose its first appearance, with a second ballet-dancer at the right beneath the oval of dark-green foliage, the surviving dancer seated rather than standing, and a clearly defined chorus of legs in front of the orange backdrop.[220] One of half-a-dozen related pictures that were evidently reworked at some time in the 1890s, this contested surface shows a familiar repertoire of scumblings, thumb-marks and scraped-down passages, as well as the hot—cold harmonies of Degas's late craft. Other curiosities from this phase include a canvas of the 1870s spread with apricot and sky blue, *Ballet class* (fig. 17), a hasty transformation of a sombre rehearsal scene, and a number of thickly overpainted ballet subjects that still await decipherment.[221]

Faced with this bewildering array of canvases, from the dense to the chromatically majestic, how do we assess Degas's late achievement as a painter in oils? Sometime in the late 1880s, he had transformed the studio practice of an already long career, abandoning his solemn grisaille for the coloured *ébauche* and the delights of the prismatic palette. Stimulated by Gauguin and Seurat, instructed by the example of Delacroix and invigorated by the works of Veronese and Titian, Degas had experimented widely and sometimes to dramatically original effect. His experience of pastel undoubtedly provided a model of flexibility in his new enterprise, offering a 'series of operations' by which colour could be accumulated and texture enhanced. But even this advantage could not reinvent oil paint as an infinitely flexible medium, and some of Degas's endless revisions were bound to fail. If his later activities as a painter were sometimes compromised by eyesight problems, these did not prevent him working on some of the most arresting canvases of our era. When Max Liebermann hung Degas's *Frieze of dancers* in his Berlin apartment around 1910 and when Henri Matisse, after the 1914–18 war, acquired the National Gallery's *Combing the hair*, they said no less.

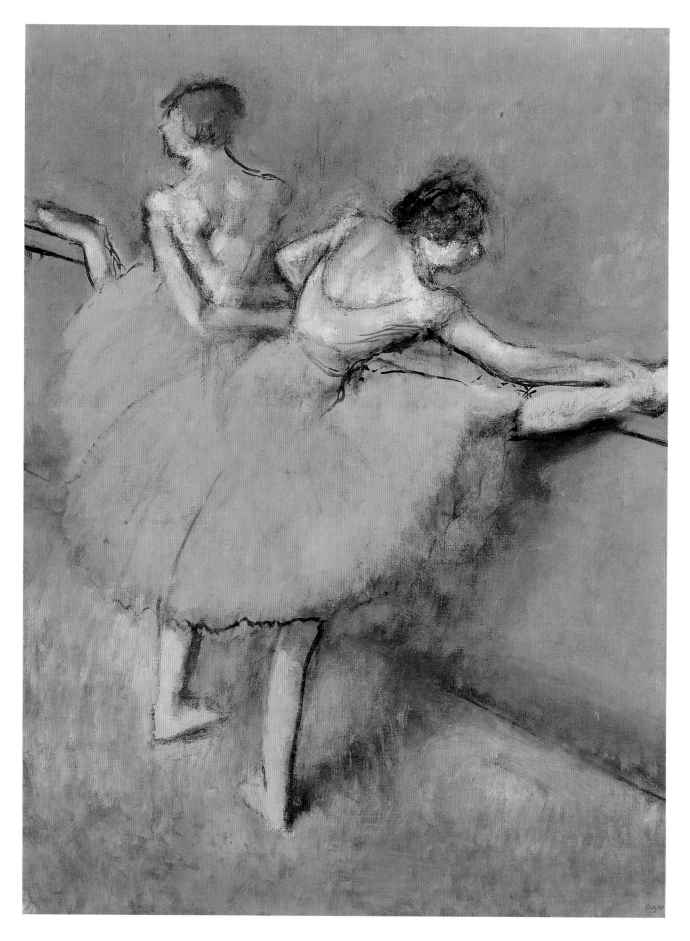

AN ART OF RENUNCIATION
Degas's Changing Subject Matter

THE THEMES OF Degas's art are unusually well-defined and almost excessively familiar. From the very beginning of his association with Impressionism, critics linked his name with a distinctive repertoire of motifs drawn from the urban spectacle, such as the dance, the genre portrait and the racetrack, until these subjects became inseparable from his burgeoning reputation. So fixed has this repertoire become that it has rarely been scrutinised or refined, nor set in the subtly evolving narrative of Degas's long working life. Most notably, the shifts in the thematic engagement of Degas's last decades have yet to be studied, along with their fundamental consequences for the meaning of his late art. In its simplest terms, the facts of this transformation are startling. By the time he reached his sixtieth year, Degas had effectively jettisoned most of the subject matter of his Impressionist phase, including the majority of categories that had initially brought him fame. Along with these subjects, many of the visual and stylistic preoccupations implicit in them had also disappeared, as had the materials on which they depended. Rather than exploring a fresh range of motifs in his later years, however, Degas turned fiercely and exclusively to the core of concerns that now remained, progressively narrowing his vocabulary and concentrating his technical resources on an art 'made of renunciations', and turning his back on much of his earlier achievement.

Writing in 1874, Jules Castagnary drafted out one of the first guides to Degas's visual territory, 'racehorses, ballerinas, laundresses, these are his favourite subjects', he explained to his readers.[1] Three years later Georges Rivière noted 'M. Degas is showing some new subjects, Café-concert singers, Women outside a café, Women at their toilette...', and Huysmans was soon to include 'theatre scenes' and 'effects of the boudoir' in this cumulative catalogue.[2] By about 1880, therefore, almost all the defining images of Degas's maturity had been spelt out in public, while some, it seems, were in danger of appearing laboured. In 1880, at the time of the fifth Impressionist exhibition, Emile Zola accused Degas of having 'shut himself up in his specialities', Paul Mantz adding that the artist tended to 'repeat the same subjects that have already inspired him'.[3] Certain critics, perhaps encouraged by Degas himself, were shrewd enough to link these repetitions with the idea of the 'series', a notion that became more commonplace as the 1880s advanced, George Moore recording Degas's belief that a painter should 'reiterate his thought twenty, fifty, yes, a hundred different' times.[4] From the beginning, the ballet emerged as a personal trademark, earning Degas the sobriquet of 'the painter of dancers' and obliging Huysmans to remind his readers of the versatility of 'this artist who is supposed to have painted nothing but dancers!'[5]

In the same article of 1880, Huysmans formulated a vivid account of Degas's purposes and achievements in such works of art: 'What truth!

FIG. 137
The changing patterns of Degas's principal subjects

what life!' he exclaimed of a dance composition, adding that Degas's powers of observation were 'so precise that . . . a physiologist could make a curious study of the organism from each study.'[6] In his eulogistic text, the critic returned repeatedly to the 'exactitude' of Degas's effects, admiring his mastery of light, colour and perspective in the service of a 'clearsighted' analysis, 'at once subtle and cruel'.[7] These studies of contemporary types might best be compared to the novels of Jules and Edmond Goncourt, he argued, aspiring to 'render visible, almost palpable, the exterior of the human animal'.[8] Huysmans's claim that Degas had become a pre-eminent 'painter of modern life' was echoed by many of his fraternity and repeated through much of the decade. At the 1881 exhibition, the 'extraordinary reality' of the artist's wax sculpture of the *Little dancer of fourteen years* was hailed by Paul de Charry, while Gustave Geffroy echoed the view of Degas as a 'penetrating observer' who was renowned for the 'psychological exactitude' of his portraits.[9] At the eighth and final Impressionist show of 1886, the majority of journalists still clung to this received wisdom, though one or two suspected a reformulation of the artist's priorities. The ever-acute Félix Fénéon, for example, praised the 'irrefutable truth' of the suite of pastel nudes submitted by Degas, even as he acknowledged that 'naive spontaneity' no longer accounted for them, accepting that such works offered something other than a 'direct vision' of the world.[10]

If Degas's career had been brought to a sudden and tragic halt in 1886, as van Gogh's was to be in 1890, he might be known today as no more than the social realist of the Impressionist camp, the historian of Paris street life and commerce, and the chronicler of the Opéra and the turf. What few of his contemporaries could have known, and what only the most assiduous excavation would have unearthed, was that Degas's iconography was already under drastic review. At the time of the last Impressionist exhibition, Degas had broken his connections with about half the subjects of the previous decade, including many of those listed by the earlier critics among his typical motifs. Of the remainder, several had been removed from public view, others were in terminal decline and only two or three might be considered in vigorous health. To add to the severity of this shift, it was precisely those motifs associated with the 'Salon of Realists', as Degas had called it, and with the novels of Zola, Huysmans and the Goncourt brothers, that had tended to disappear in mid-career. No new representations of the brothel, for example, a subject that inspired several of these writers and prompted dozens of Degas's black-and-white monotypes, had appeared for a number of years;[11] though the café-concert scenes had enjoyed a brief revival in the mid-1880s, they were now entirely defunct;[12] significantly, the two *Milliners* shown in 1886 had been executed four years earlier and were effectively the last of their kind;[13] and if the subject of the laundress was enjoying a

FIG. 138
*Dancers preparing for the ballet, c.*1872–6. Oil, 73.5 x 59.5 cm (29 x 23⅜ in.)
The Art Institute of Chicago, Gift of Mr and Mrs Gordon Palmer,
Mrs Bertha P. Thorne, Mr and Mrs Arthur M. Wood and Mrs Rose
M. Palmer (L.512)

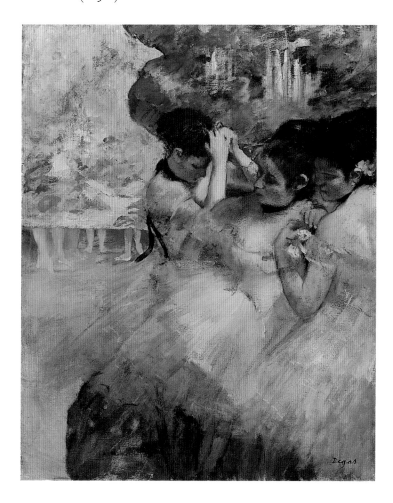

final, brief respite, it, too, was soon to move aside. Even some of the staples of Degas's repertoire were losing ground; the solitary *Portrait of Zacharian* (private collection) in the valedictory show was a poignant testimony to a genre that had occupied almost half the artist's energies in the 1860s; and no equestrian scene had been included in the last three group exhibitions.[14]

In order to express the simple drama of this mid-life pictorial crisis, we must resort to the very un-art-historical expedient of a graph (fig. 137). Using the standard catalogues of the artist's work, adjusted where necessary in the light of modern scholarship, it is possible to plot the trajectories of Degas's most prominent motifs through a series of broad historical phases, from the 1870s to the end of his working life.[15] Even allowing for the vagaries of such a method, the dominant pattern is unmistakable. In case after case, a topical theme of the Impressionist years reaches its peak in the mid-1880s, dipping towards the end of the decade and then fading into insignificance. Millinery and laundry scenes, café-concert and race subjects follow this pattern, while portraiture plunges from the near-equal of the nude in Degas's mid-career to vestigial status at the turn of the century. Though there are modest exceptions to the rule, notably landscape and the toilette, the thrust of Degas's iconographic development is emphatic, from diversity to concentration, from breadth to depth. While the majority of motifs declined as he approached his final decades, however, two rose to majestic prominence and entirely overshadowed his later oeuvre; the dancer and the female nude. Already in the ascendant half-way through the 1880s, by the end of the decade these subjects accounted for all the rest of Degas's themes put together. In the 1890s and beyond, the ballet and the nude virtually cleared the field of competition, occupying most of the artist's energies and radically redefining, if not rendering obsolete, his claims as a 'painter of modern life'.

Though such graphic claims for the restructuring of Degas's career in the late 1880s may be novel, preceding chapters of this catalogue offer endorsement for such a view from the technical, professional and domestic circumstances of the artist's life. But it might be argued that the two all-pervasive themes of Degas's last years, the ballet and the female bather, were themselves survivors of the naturalist era, and thus represent continuity rather than disruption. To some extent this is true; images of the dance form an unbroken series of threads through the complex fabric of Degas's work from the late 1860s to the end of his working life, while the female nude is even more deeply and variously woven into its textures. Extending the metaphor, the two subjects might be seen as the warp and weft of his art, beginning in scenes of historic athleticism and running through to muscular bathers, interlaced with the pastoral dance and the theatrical performance. But we have too often assumed that the long and complex tapestry of Degas's professional life is seamless, that a female figure has the same significance in one era as another, or that a ballerina carries an identical charge in the 1860s to that of some forty years later. Put in this way the proposition seems absurd, yet it is implicit in much that has been written about the artist and his slowly evolving iconography. A work made early in Degas's career, such as the mid-1870s *Dancers preparing for the ballet* (fig. 138), with its familiar catalogue of truncated limbs and clustered torsos, bold design and selective colour harmony, may appear to have much in common with the later ballet subjects in this volume. But almost every aspect of its material, visual and historical significance can be shown to contradict these later variants; where *Dancers preparing for the ballet* conforms to Huysmans's sense of documentary 'truth', works of the 1890s invariably sacrifice detail to breadth; where the earlier work presents a group of individuals, the dancers of Degas's later years become monumental and remote; in place of deep, wittily-articulated spaces, the artist adopted the ambiguous relief; and in preference to oil paint, he committed himself to the expressive hazards of pastel.

THE BALLET

FIG. 140
Louis Legrand, *La Rampe s'allume,* 1890
Lithograph, 24.5 x 21.6 cm (9⅝ x 8½ in.)
Private Collection

FIG. 139
Aubrey Beardsley, *Caricature of Queen Victoria,* n.d.
Ink on paper, diameter 10.3 cm (4 in.)
London, Victoria and Albert Museum

The dance is numerically the most significant subject of Degas's late career. In his 1984 catalogue, *Degas: The Dancers,* George Shackelford estimates that 'at least half of Degas's mature work was devoted to representations of dance subjects', accounting for 'approximately fifteen hundred paintings, pastels, prints and drawings'.[16] As our study of Degas's output has shown, this dominance steadily increased in the artist's middle years to reach a dizzying peak in the 1890s, when images of the dance exceeded all other categories by a factor of roughly three to one.[17] Not only quantity, but scale, range and a kind of promiscuous self-replication marked the spread of Degas's late ballet scenes. Most of the largest of his late canvases, such as *Dancer with bouquets* (cat. 6), *Frieze of dancers* (cat. 16) and *Four dancers* (fig. 125) were devoted to the theme, along with the most numerous 'families' of traced and reinterpreted motifs, such as those surrounding the *Red ballet skirts* (cat. 17) and *Two dancers* (cat. 77). During this same period, the ballet also pervaded his activities as a sculptor, his experiments with a camera and even his writing of poetry, while a sequence of photographs show the artist and friends pirouetting in the open air during a country weekend.[18] As early as 1880, the popular success of such pictures as the Chicago *Dancers preparing for the ballet* had obliged his admirers to refute the claim that Degas painted 'nothing but dancers', but by the end of his career this

reputation was both more deserved and more evident. Records of sales from the 1890s onwards show that ballet subjects exceeded all others in popularity, a gorgeously coloured work such as *Three dancers in purple skirts* (cat. 73), for example, changing hands at least three times before 1907.[19] Caricaturists seized gleefully on Degas's specialisation, Manzi showing him in the pose of the *Little dancer of fourteen years,* the caricaturist Barrère depicting him with a ballerina lay figure (fig. 1) and the British illustrator Aubrey Beardsley adopting the persona of the artist in his image of a prancing Queen Victoria (fig. 139).[20]

The identification of Degas with the dance is so complete that we tend to see it as natural and inevitable, despite the efforts of such scholars as Lillian Browse, Linda Muehlig and George Shackelford to locate it in time and place.[21] Degas's first ballet pictures, it is now widely acknowledged, grew out of a more general interest in the subject in the 1860s, deriving partly from the art of Honoré Daumier and other popular illustrators, but shared ambitiously and publicly with Manet and Renoir in the Impressionist circle.[22] Far from entering the mainstream repertoire, however, dance themes remained on the periphery and Degas's colleagues were apparently content to accept his monopoly, with only the more shameless of his imitators presuming to trespass on such well-marked territory. In Degas's middle and later years

FIG. 141
Gustave Leheutre, *Dancer beside a scenery wing*, 1897
Lithograph, 41.3 x 36.2 cm (16¼ x 14¼ in.)
London, William Weston Gallery

FIG. 142
J.-F.-F. Lematte, *The last veil, the end of the dance*, c.1891
From *Salon de 1891, catalogue illustré*

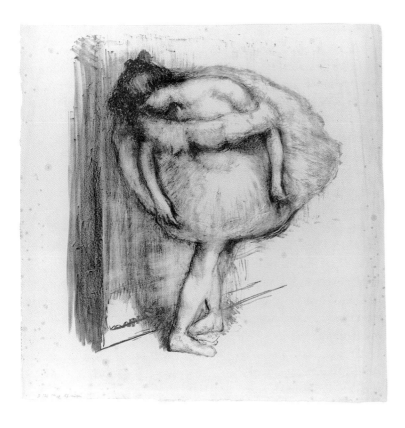

LEMATTE (J.-F.-F.). H. C. *Le dernier voile, fin de danse.*
The last veil, end of the dance.

however, a small army of illustrators, painters and printmakers followed him into the wings and the rehearsal rooms, ranging from the sardonic Toulouse-Lautrec to the ingratiating Paul Renouard, from such close friends as Forain to the eclectic Louis Legrand. Legrand's *La Rampe s'allume* (fig. 140), which appeared on the cover of *Le Courrier Français* of 21 September 1890, is characteristic of many of their outpourings in two respects: in its technical mastery, which encompasses the brilliance of theatrical lighting and the drama of the angular viewpoint, the nuanced graphic touch and the hint of caricature; more striking, perhaps, is its second quality: the manifest dependence of all these features on a visual language pioneered by Degas at least a decade earlier, at the height of his socially descriptive phase. Images such as Legrand's are inconceivable without a knowledge of, for example, Degas's *L'étoile* of 1876 (by this date in the Caillebotte donation) or one of the three variants of the 1874 *Ballet rehearsal on stage*, all of which passed through the market during these years.[23] The mannerisms of Legrand and his peers, therefore, were essentially *retardataire*, confronting Degas in the 1890s with a syntax he had largely abandoned. Only the most occasional and inspired efforts of his followers, such as Gustave Leheutre's 1897 lithograph *Dancer beside a scenery wing* (fig. 141) approached the master's later expressive density, avoiding sensationalism as well as pedantry.

Even more surprising is the extent to which ballet motifs were absent from officially sponsored exhibitions, such as the Salons, in Degas's last decades. In 1891, for example, the year when Berthe Morisot observed that Degas 'stayed in the Salon from morning till night, lunching there and thoroughly scrutinising every picture', the printed catalogue lists only a handful of exhibits with dance associations.[24] Among the three thousand or so listed images, works like Fantin-Latour's *Dances* and Gérôme's bronze *Dancer* were essentially timeless evocations of the subject;[25] the obscure Mademoiselle Itasse's marble relief of a *Young dancer*, Mademoiselle Conant's *Dancers* and Chevilliard's *Rehearsal* were unreproduced and remain unidentified;[26] while Lematte's *The last veil, the end of the dance* (fig. 142) was the sole illustration devoted to the theme.[27] In Lematte's preposterous vision, the dance is decontextualised and nullified, a mere pretext for an erotic encounter that is as shocking in its banality as in its frontal nudity. Confronted with this canvas on his Salon visit, Degas could only have reflected on its remoteness from his own practice, from the pedestrian settings and indolent ballet 'rats' he preferred to depict and the modesty, even the chastity, of their actions.

A second discovery is that a school of dance painting did co-exist with Degas's late career, combining elements of Salon glamour with strands of borrowed social realism, often to considerable commercial

FIG. 143
Jean Béraud, *Wings at the Opéra,* 1889
Oil, 38 x 54 cm (15 x 21¼ in.)
Paris, Musée Carnavalet

advantage. Capitalising on the celebrity of the stage and its popular stars, a host of now largely forgotten painters found a ready market for their portraits of prima ballerinas, their scenes of the Opéra foyer and their saucy glimpses of the dressing room. Like Degas, they tended to avoid the performance itself, but entirely contrary to his late manner they pursued all that was topical, sentimental and particularised in their subject. Jean Béraud's *Wings at the Opéra* of 1889 (fig. 143) exemplifies this mode, with its privileged view of pre-performance encounters, its frankly voyeuristic vignettes of dancers and their escorts, and its relentlessly focused setting. Béraud had trained with the eminent Salon portraitist and acquaintance of Degas's, Léon Bonnat, but moved easily in the company of the Impressionists and brought something of their rawness to his otherwise simplistic scenes. Though Degas gently mocked his obsession with detail, Béraud's formula assured his success as a painter of the theatre and the ballet, as it did with such artists as Clairin, Laurent-Desrousseaux, Palmaroli, Tavernier, Carrier-Belleuse, Renouard and Bertier.[28] Laurent-Desrousseaux's picture of *The dance class of Mademoiselle Théodore at the Opéra* (location unknown) was one of a host of such works exploiting the intimacy of the rehearsal room, while Carrier-Belleuse's *Tender avowal, Mademoiselle Latini and Mademoiselle Bariaux, of the Opéra* (fig. 97) offered a characteristic conjunction of sensuous pastel with a teasing balletic subject.[29]

Through engravings of such paintings, a diversity of prints in the popular press and the frenetically expanding medium of photography, illustration of the ballet reached a near-industrial level in Degas's lifetime.[30] His links with this phenomenon were strong, though often vicarious and typically shifting with the passage of time. In the 1880s,

Degas himself was swept up in the idol-worship of music-hall stars such as Thérèsa, singers like Rose Caron and the ballet dancer Rosita Mauri, the latter immortalised in *carte-de-visite* photographs, a painting by Bertier entitled *Rosita Mauri in the ballet 'La Korrigane',* and Degas's own contemporary pastel of the subject.[31] Degas's picture of 1887 shows Mauri in street clothes, a symptom perhaps of his slow withdrawal from the bright lights and from theatrical company even as his acolytes were capitalising on precisely such encounters. It was his close friends such as Forain and Jeanniot, using their acquaintance with Degas's earlier vocabulary and their own distinctive graphic skills, who effectively set about reworking their mentor's subject matter in the coarser idiom of the newspapers and periodicals. Cheaply reproduced sketches such as Jeanniot's *Folles Danseuses* (fig. 144) offered endless variations on themes of backstage flirtation and rapacity, the flimsily clad dancer and her gross male 'protector'.[32] Though this gave an unlooked-for currency to aspects of Degas's syntax, it again served to separate his art of 'renunciation' from that of his imitators; or, as the painter said on another occasion, to distinguish his role as 'a bourgeois artist' from those such as Jeanniot and Forain who made art for 'the people', though Degas conceded that the latter 'had their art as well'.[33]

This distinction between visual languages, as well as their audiences and means of transmission, became central to Degas's late enterprise. Though we should be wary of comparing like with unlike, we cannot sensibly study either his dance or bather themes as if they existed in a vacuum, not least in an age of massively proliferating imagery of every kind. Degas was actively conversant with most of these modes, from the Salon painting to the pornographic print, from Forain's weekly cartoon in *Le Figaro*, which he displayed on a special table in his rue Victor Massé apartment, to the latest work of the Montmartre studios.[34] His pictures of ballerinas and toilette scenes, therefore, must be seen against and beside such conventions, as responses to them, as knowing reversals of their signs and as conscious acts of identification or rejection. At the simplest level, an anonymous wood engraving of the ballet *La Chatte blanche* (fig. 145), typical of thousands of such images from the illustrated press, demonstrates one of the prevalent sets of codes with which Degas was confronted. In this paradigmatic scene, the entire corps de ballet is shown in fairyland, in a visual structure that heightens romance, spectacle and the distant experience of the theatre-goer. Despite the modest scale of the print, loving attention has been given to each dancer's costume and accessories, their peacock-eye fans and gossamer wings, their artful postures. Semi-tropical vegetation around and above them is rendered with equal precision, conforming to a continuous, hallucinatory focus that runs from foreground to depth, from prima ballerina to the humblest leaf. In their weightless world, the sordid

FIG. 144
Georges Jeanniot, *Folles danseuses,* n.d.
Reproduction of lithograph, 16 x 23 cm (6¼ x 9 in.)
Private Collection

FIG. 145
Anon., *La Chatte blanche,* n.d.
Wood engraving, 22 x 31 cm (8¾ x 12¼ in.)
Private Collection

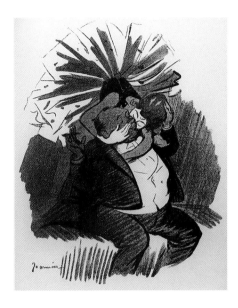

realities of the stage have no place, neither the mechanics of suspension and lighting on which it depends nor the urgent proximity of proscenium, orchestra and audience.

Lillian Browse has noted that, while Degas did make some pictures of dancers in performance, 'these were easily outnumbered by those behind stage . . . and those of the dancers in relaxation between their work'.[35] We can now go further, adding that his few frontal scenes of specific productions, such as that of *Robert le Diable* of 1876 or *Les Jumeaux de Bergame* of about 1885, were confined to the middle years of his career.[36] After the late 1880s, not one named ballet can be identified in any of his pastels or oils, while the move from performance to rehearsal, towards rest or peripheral activity, is almost complete. Of the hundreds of dance images of his last years, only the merest handful show the corps de ballet on stage and even these tend to be reworkings of earlier motifs.[37] Overwhelmingly, Degas adopted the group of two or three dancers as his vehicle of expression, typically shown waiting in the ill-defined space of the wings or recovering in some bleak and anonymous practice room. Intimately involved with this paring down of his subject was a change in structure and design, away from the remotely panoramic *La Chatte blanche* and towards the localised and the adjacent, away from selectivity and towards concentration. In one of his few late representations of the broader arena, *Dancers on stage* (fig. 146), Degas summed up the austerity of his vision, discovering a spartan but eloquent emptiness where his anonymous counterpart had found fairy-like glamour. An elaborated version of this composition exists, in the Washington *Ballet scene,* but both render superfluous any link with the contemporary ballet, both strip away details, and both speak in a new language of energy, mass and vibrant colour.[38]

The transformation of Degas's ballet vocabulary in later years was sensed by some of his more astute critics, who in turn struggled for language to articulate this change. His early dance pictures, as we have seen, were hailed as models of veracity, their sharp delineation and limelight colours expressive of 'an absolute reality', as Huysmans had claimed in 1876.[39] With few exceptions, this assumption prevailed throughout the 1880s, broadly in line with the naturalist formulation of the Impressionist project and, like much of that formulation, lingering beyond the point of its usefulness. Though no ballet scenes were shown by the artist at the 1886 exhibition, Octave Mirbeau could still pointedly include them in his celebration of Degas's pastel nudes, arguing that they shared 'the same bitter philosophy, the same superb vision', based on the artist's 'harsh observation' and 'unpitying draughtsmanship'.[40] More remarkably, such phraseology persisted into the next decade, despite the already discernible shifts in the technical and conceptual basis of Degas's dance subjects. In his wide-ranging essay on the artist in *La Vie Artistique* of 1894, Gustave Geffroy incorporated several sections of his earlier review of the 1886 show, again insisting that Degas was a true Parisian who personified all that was 'modern, essentially modern'.[41] Stressing Degas's first-hand familiarity with the world of the laundress, the milliner and the *chanteuse,* Geffroy concluded, as several observers had done before him, that the artist's pictures showed 'the taste of a zoologist for the physiology of the lower animals'.[42]

As he moved on to scenes of the ballet, however, Geffroy's rhetoric appeared to falter. After a ritual salute to their 'nervous life' and 'subtle and powerful grace', his staccato prose suggested that 'the girls of the Opéra, in his latest pastels, admirable for their mastery, of the most

FIG. 146

*Dancers on stage, c.*1900–5
Charcoal and pastel on tracing paper, 73.7 x 105.4 cm (29 x 41½ in.)
Pittsburgh, Carnegie Museum of Art, Acquired through the generosity
of the Sarah Mellon Scaife family (L.1460)

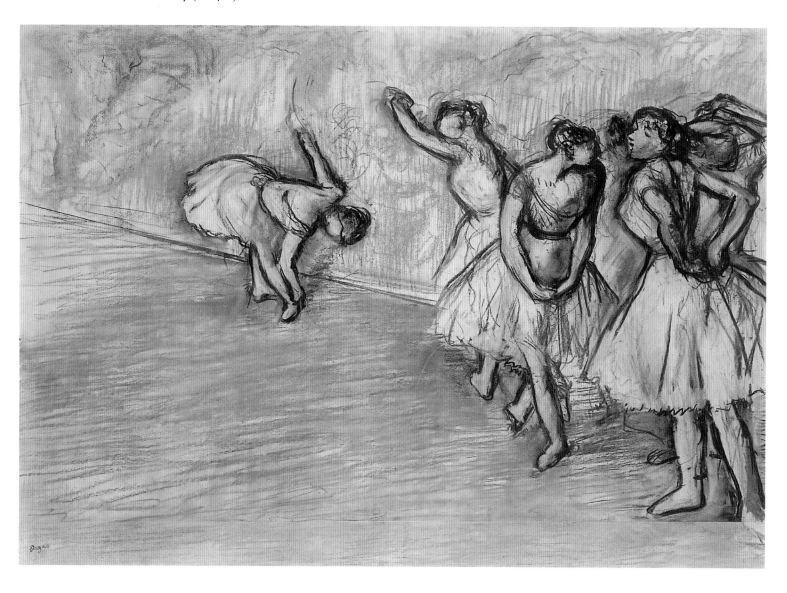

summary design, of the most harmonious colouring, brilliant like jewels in semi-darkness, take on the ways of the divinities of the dance'.[43] Continuing in quasi-Symbolist mode, Geffroy proposed that a study of this kind is a 'passage of colour and form, a magnificent drawing in movement', created from 'precision and memory, perspicacity and reverie'.[44] In the same year, Théodore Duret struggled towards a similar conception in an extended sketch of Degas's career for the *Art Journal*. Arguing that his first dancers were just 'young women in a particular costume who appeared with smiles on the stage, and conveyed to the eye, by means of graceful movements and studied poses, an effect of lightness, charm and pleasure', Duret stressed that, through Degas's practice of 'studying more and more closely the *being* apart from the ballet dancer, he

has ended by making his studies of "danseuses" convey a world of meaning to which they were at first strangers'.[45] Degas, he claimed, had penetrated beyond his subject, 'at first sight both frivolous and unprofitable' to the 'creatures agonised by their work, racked by the incessant effort to keep limbs and body supple. . . . He has proved once more that, with genius, subject is a secondary matter.'[46] 'From being merely a delicate and original painter of genre,' Duret announced with a flourish, Degas 'has gradually raised his point of view to something infinitely more powerful.'[47]

Geffroy's and Duret's words were necessarily based on random sightings of dance pictures in the late 1880s and early 1890s, at dealers' galleries and in private collections, in auction rooms and perhaps in the

FIG. 147
Gustave Leheutre, *Dancer at the barre, c.*1900
Drypoint, 19.8 x 27.5 cm (7¾ x 10¾ in.)
London, William Weston Gallery

artist's apartment.[48] But both writers had become aware of a new direction in Degas's art and both had begun to spell out, however haltingly, some of the preoccupations that would soon engulf his later ballet scenes. The right-hand figure in *Dancers on stage* (fig. 146) might well be 'racked by the incessant effort to keep limbs and body supple', just as she disdains the 'smiles' and 'graceful poses' of the artist's earlier manner. Similarly, the 'summary design' and heraldic colouring of this pastel find echoes in the critics' eulogies, as does the sense that it is these qualities, rather than the airy lightness of the performance or the sexuality of the ballerinas that should occupy our attention. As the years passed, Geffroy's intuition that the dynamics of 'colour and form' gave direction to such compositions, and Duret's that the ballet studies 'convey a world of meaning to which they were at first strangers' was amply justified. By the end of the decade, in a majestic canvas such as *Dancers at the barre* (fig. 136), hardly a trace is left of the tinsel and panoramic posturing of *La Chatte Blanche*, the suggestiveness of Legrand's *La Rampe s'allume* or even the 'graceful movements and studied poses' of Degas's own earlier iconography. In *Dancers at the barre*, the ballet is presented in its essence, almost its animality, the twisting sinews of the dancers energising space and colour, their massively outlined limbs expressive of nothing so much as 'creatures agonised by their work'. By contrast, a drypoint of about 1900 by Gustave Leheutre, *Dancer at the barre* (fig. 147), which seems to presuppose a knowledge of the Phillips picture, is stylish yet insubstantial, reminding us again of the fundamentally changed priorities of Degas himself.[49]

While the world-weary ballerinas in Degas's *Dancers at the barre* might trace their ancestry back to his earliest rehearsal pictures, to their fragile precursors, for example, in the background of the 1872 *Dance class at the Opéra* (Paris, Musée d'Orsay), their mature identity is that of the *fin de siècle*. Without excessive sentimentality, we can surely equate this late maturity with Degas's own, with his increasing and sometimes obsessive sense of physical frailty and of his own advancing years. Just as the Musée d'Orsay canvas was made by a dapper, confident young artist at the beginning of his career, so the Phillips picture was laboriously worked over by a near-seventy-year-old, now painting elderly models in a visceral, ponderously sensuous manner. *Dancers at the barre* confronts us with the swathes of colour and red–green palette of his 'Venetian' phase, the painted 'drawing' of contours that clings faintly to *Ingrisme*, the sculptural torsion of the late waxes. In a full-size variant on paper of the same subject, we also find the slashings of chalk and hatchings of contrasted hue of Degas's most developed pastels, themselves expressive of an extreme physicality.[50] The scale of both works summarises the ambition of this late imagery, stripped of detail and unconcerned with illusions of depth, no longer dealing with 'slim and elegant beings in

graceful motion', as Duret had put it, but with large-boned models who are past their prime. Though some sequences of works, such as the *Russian dancers*, still find a desperate, pantheistic energy, the prevailing mood is one of lassitude, the often expressionless faces of the ballerinas concerned with survival rather than display, seemingly resigned, perhaps bored beyond endurance.

Not only do these pictures reflect the new artistic concerns of his later years, but they seem to grow out of a pragmatically altered relationship between Degas and the dance itself. As the records of his attendance at Charles Garnier's Opéra have shown, Degas's first-hand contact with the ballet reached a peak in the late 1880s, declining rapidly thereafter.[51] Some links with the world of the dance continued: his taste for the music of the opera and for operettas is revealed in letters and memoirs;[52] the artist occasionally used ballerinas as hired models;[53] and he still considered himself capable, as late as 1897, of 'paying court to a dancer'.[54] But there can be no doubting Degas's increased remoteness from stage productions, just as he had long since abandoned the café-concert, the circus and the brothel salon. Even more than the works of his early and middle years, therefore, his ballet pictures were contrivances of the studio, executed away from the subjects they represented and without any but the most cursory reference to their notional origin. If these late scenes are lacking in theatrical detail, if they no longer seem to reflect the experience of an audience or a backstage voyeur, it is partly because Degas himself had withdrawn from their world, relying increasingly on 'memory, perspicacity and reverie', as Geffroy had shrewdly proposed. Pictures such as *Dancers at the barre* were posed by professional models in the rue Victor Massé attic, dressed in the

FIG. 148
Group of dancers, c.1890–5
Pastel on paper, 31.1 x 39.7 cm (12¼ x 15⅝ in.)
Dallas Museum of Art,
the Wendy and Emery Reeves Collection (Ex-L.)

stale tutus that Degas kept for the purpose and positioned against his sombre studio walls. His subjects seem deadened by fatigue, not from balletic exercise, but from many hours spent in the rigid and strenuous postures demanded by the artist, such as those held by Pauline and her dancer-friend Yvonne.[55] In the same circumstances, Degas's preference for the close viewpoint and the truncated composition fall into place, as does his predilection for bland or largely fanciful settings. These are images of the dance at the furthest remove from actuality, an art that 'gives the idea of the truth by means of the false', as he said about this time.[56]

When asked by his contemporaries why he had chosen to become the 'painter of dancers', Degas would offer a number of well-rehearsed axioms. To Vollard he suggested, 'my chief interest in dancers lies in rendering movement and painting pretty clothes', while George Moore was told, 'the dancer is only a pretext for drawing'.[57] His model Pauline noted with exasperation the artist's 'aversion for every gracious movement and his constant search for poses that expressed vigorous action', echoing Gustave Geffroy's proposal that the ballet was hardly a subject at all, but a convenient means of expressing 'power, rhythm and life'.[58] All these accounts date from the final decades of Degas's career and all share a sense of the contingent status of his theme; the dance in these pictures stands for something other than itself, for colour and movement, for energy or human exertion. There are no comparable records of the artist's views in earlier decades, but, as we have seen, admirers of his first ballet scenes were unanimous in saluting quite

different qualities, the 'truth' as seen by a 'penetrating observer', resulting in a 'clever and accurate satire' of theatre life.[59] Aware of his assiduous presence at performances, earlier writers had been content to see Degas as a kind of superior illustrator, an unofficial historian of the theatre who recorded its rituals and caprices in the language of art. Though such a view has its profound limitations, it provides another useful measure of the evolution of Degas's dance imagery. By comparison, the pastels and paintings of the later phase are of no conceivable value to the costume expert or the student of décor, telling us nothing about the buildings in which ballets took place, the crowds who attended or the individuals who starred in them. Still notionally linked to the Parisian stage, these scenes have become, in the artist's words, 'a pretext' for other explorations.

One of the first and most courageous patrons of Degas's late work, Louisine Havemeyer, enquired of the artist in his old age 'Why, monsieur, do you always do ballet dancers?', to be told, 'Because, madame, it is all that is left of the combined movement of the Greeks'.[60] Another version of the story concludes with Degas's claim that 'only there can I find again the movement of the Greeks', while a number of acquaintances record variations on the theme.[61] William Rothenstein understood that the dance allowed Degas 'the colour and movement of romantic art, yet provided the clear form dear to the classical spirit';[62] Henri Hertz argued that Degas 'followed purely and simply the Greek tradition, almost all antique statues representing the movement and poise of rhythmic dance';[63] and Paul Valéry and Etienne Moreau-Nélaton were among many who were told by Degas of the Muses, who 'work in solitude' during the daytime, then in the evening 'just dance'.[64] Again, all these testimonies come from the artist's last years and all find common ground in their phraseology and terms of reference. None mentions the grim realities of backstage life or the acuteness of the artist's perception and none, most noticeably, refers to the topicality of his dance scenes. In their place we find further invocations of 'movement' and 'colour', of 'clear form' and 'poise', now located in the timeless world of the Muses and in the setting of classical Greece.

Despite the artist's well-documented response to Mrs Havemeyer, the proposition that his late ballet imagery should be understood in terms of a revived interest in antiquity has never been pursued, nor its basis in his earlier years assessed. Even before he first travelled to Italy in 1856, Degas's youthful pencil had outlined Greek reliefs and Roman marble figures, terracottas in the Louvre and antique architecture in the French provinces.[65] Soon this was augmented by studies of gems and cameos, mosaics and bronzes, and the major monuments seen in Rome and its environs, as well as a lively interest in the literature and mythology of their era.[66] His fluency in the forms of antiquity, therefore, derived from

FIG. 149
Gaston Vuillier, title-page of *La Danse,* 1898

FIG. 150
Theory of Greek dance
Illustration from Vuillier's *La Danse,* 1898

THÉORIE DE DANSEURS GRECS
(*Les mouvements de jambes que font ces danseurs sont exactement les mêmes que ceux exécutés par un danseur moderne.*)

forms of Mediterranean culture with the 'movement and poise of rhythmic dance', as Hertz expressed it. What is remarkable about the majority of works by Degas from this late period, by contrast, is his resistance to such obvious historical trappings; there are no toga-clad senators or tunic-wearing maidens, arcadian shepherd-boys or athletic gods and goddesses; when columns and architraves put in a rare appearance, for example in *Seated dancer with raised leg* (private collection), they are manifestly made of wood and stage canvas, and when landscape can be seen it bears no resemblance to Sparta or Athens.[70] Even more emphatically, the characteristic figure groups of the last years, such as the solitary dancer with her hands on her hips (cats. 75, 77, 78), the ballerinas resting on their bench (cats. 25, 29) and the chorus clustered in the wings (cats. 17–20), have no antecedents in the classical vocabulary, either thematically or as pictorial forms. Whatever else Degas was trying to do, he was not attempting to 'find again the movement of the Greeks' in literal terms, nor pedantically 'quoting' its costumes, settings and mannerisms.

If we look at the literature of the dance in the late nineteenth century, some of it with direct links to Degas and his work, we find an altogether subtler and more deeply argued association between the ballet and antiquity. In the pages of Gaston Vuillier's *La Danse* of 1898, for example, a magisterial and extravagantly illustrated survey of the history of the discipline, Degas's sentiments are repeated in a dozen contexts.[71] Boldly using on its title-page a detail of the artist's *L'étoile* (fig. 149), a work that had been accepted by the Luxembourg only two years earlier, Vuillier's volume ranged fearlessly over the millennia and prominent cultures of past and present. Beginning with a juxtaposition of Abel Boye's *La Danse antique* and Gérôme's recent statue of a *Dancer*, the author argues relentlessly for the universality of the dance, expressed as a continuous tradition from the beginnings of human society to his own times. 'The history of the dance is also that of civilisation and of morals', Vuillier explains, 'in Greece, the dance was a veritable language, interpreter of all the sentiments and all the passion'.[72] Insisting on the survival of many ancient forms into his own era, the author illustrates a painting from an antique vase (fig. 150) with the caption, 'The dancer of today executes this movement just as it was done 2,000 years ago.'[73]

contact with original works of art and classical texts, is beyond question, as is his occasional appetite for introducing references to this tradition into his formative works. Charles Millard has gone further in the context of the artist's waxes, identifying case after case of such dependency and arguing that 'the iconographical basis of Degas's sculptural oeuvre is the repertoire of poses he knew from monuments of the past'.[67] Citing pastels and paintings as well as sculpture, Richard Thomson has proposed other visual citations from antique sources, ranging from a distinctive pose or disposition of a limb to an entire motif, such as the self-conscious reworking of the Roman *Spinario* in Degas's *The Thorn* (location unknown).[68] While such conjectures, by their nature, range from the forcefully persuasive to the frankly speculative, they remain concerned with only one aspect of an artist's interaction with the past. This might be called visual antiquarianism, a magpie appropriation of fragments that can be witty or erudite, privately coded or blatantly exhibitionistic. At its best, it belongs in the tradition of the respectful homage to past masters; at its most mechanical, as the work of dozens of his peers makes plain, it resulted in pastiche and anachronism of a sort that Degas openly derided.[69]

When Degas expressed his wish to 'find again the movement of the Greeks' in his later dance pictures, it was surely something other than this fragmentary eclecticism he had in mind. Where direct quotations continued to occur, as in the Acropolis-like background of *Group of dancers* (fig. 148), an unusual experiment in pastel on wood panel from the early 1890s, the effect is curiously touristic, juxtaposing the outward

FIG. 151
Tanagra sculptures in the Louvre
From Gustave Geffroy's *La sculpture au Louvre, c.*1900

FIG. 152
Paul Renouard, *Dance examination at the Opéra*, n.d.
Etching, from Gaston Vuillier's *La Danse*, 1898

Quoting several learned authorities, Vuillier describes the nature of many of these ancient steps, some of them directed by 'the gods themselves', stressing the 'rhythm and harmony' of their execution and the 'noble' and 'gracious' attitudes of the participants.[74] Accompanying his narrative with engravings after Poussin and Domenichino, Carpeaux and Collin, Bouguereau and, more bizarrely, Gustave Moreau, as well as a variety of works from antiquity, the author concedes that dance could take a number of diverse forms, though all were integrated into the patterns of Greek society.

One of Vuillier's chosen groups of reproductions is a series of Tanagra sculptures, all of them showing draped female figures in the act of animated but graceful dancing.[75] These small, late Hellenistic terracottas had enjoyed an extraordinary outburst of popularity after their discovery in the early 1870s, admired for their vivid depictions of contemporary life and their calm composure. By the 1890s, a representative selection had been acquired by the Louvre (fig. 151), a number were already owned by collectors in Degas's circle, such as Henri and Alexis Rouart, and forgeries had started to invade the market.[76] That Alexis Rouart kept some of his statuettes on his mantelpiece is suggested by a portrait of the collector by Paul Helleu. Degas clearly knew and admired these delicate figurines in several contexts, referring to them in conversation and making an unequivocal allusion to a Tanagra pose in one of his portraits of the Rouart family.[77] Another much-repeated Tanagra composition, that of two seated women who engage in flamboyant conversation, may also have encouraged one of Degas's distinctive late inventions, represented here by

Two dancers on a bench (cat. 30).[78] But as we have seen, such direct stimulus is the exception rather than the rule, and it is the combination of timeless poise and dynamism in the Tanagra repertoire, a combination specifically admired by Degas's contemporaries, that must surely have recommended these works to the artist.[79]

The lines of ancestry between the dancers of Tanagra and ancient Greece, on the one hand, and the glamorous ballerinas and avaricious 'rats' of Degas's time, on the other, may seem exceptionally tenuous, but they were insisted on at every turn. Though it was widely accepted that the ballet of the *fin de siècle* was in its decadence, every published study looked back to the glorious era of the mid-century, and beyond that to the spectacles and ceremonial dances of the French royal court. Following this logic, such rituals were traced to the Italian Renaissance and thence to the classical world, losing themselves in 'the first age of humanity and among the most savage peoples', as Henri de Soria wrote in 1897.[80] De Soria's book, *Histoire pittoresque de la danse*, appeared the year before Vuillier's but followed precisely the same pattern, if in a less opulent format. Introduced by the novelist, theatre director and critic Jules Claretie, who had reviewed Degas's contributions to several of the Impressionist exhibitions, this volume juxtaposed even more brazenly the 'ballroom' dancing of the author's own age with scenes from ancient, exotic and primitive dance. Had Degas read the book, he could only have been delighted by de Soria's references to the female youths of Sparta, who 'absolutely naked and in the presence of magistrates and citizens, exercised themselves through dance and wrestling; they learnt to the throw the javelin, exciting the young boys by their example and

FIG. 153

Andrea Mantegna, *Parnassus, c.*1500

Tempera on canvas, 159 x 192 cm (62⅝ x 75⅝ in.)

Paris, Musée du Louvre

FIG. 154

Jean-Léon Gérôme,

The antique pottery painter: Sculpturae vitam insufflat pictura, 1893

Oil, 50.2 x 68.9 cm (19¾ x 27⅛ in.). Toronto, Art Gallery of
Ontario, Gift from the Junior Women's Committee Fund, 1969

encouraging them with their praise'.[81] In conjunction with de Soria's description of a more amorous ritual encounter of Spartan youths, this text might have been written to accompany Degas's painting of the *Young Spartans* (fig. 108), a work the artist cherished in his later years and one which should perhaps be re-evaluated as a prototype for his dance compositions.[82]

Both Vuillier's and de Soria's narratives rely substantially on the visual history of the dance, incorporating engravings and photographs, reproductions of paintings, carvings, vases, illuminated manuscripts and sheet-music into their pages. In their different ways, however, each author is a little coy about contemporary art, confining it to the periphery of his opus or using undistinguished examples as illustrations. Despite placing Degas in pride of place on his title-page, Vuillier avoids his name in the text, though he comes close when he observes that the Greeks, in their traditional vase painters, 'also had their . . . Daumiers, their Chérets, their Caran d'Aches and their Forains'.[83] It was not until the following year, in a review of the English edition of the book, that Degas was added to this company.[84] Conscious, perhaps, of Degas's hypersensitivity in such matters, Vuillier settled for a solitary image of the Camondo *L'étoile*, preferring works by precursors such as Gavarni and followers like Renouard, including the latter's *Dance examination at the Opéra* in his introduction (fig. 152). More importantly, his argument relies on a sequence of images that often encapsulate Degas's formative history, from sculptures by Donatello to prints after Mantegna, a *Bacchantes dancing* by Poussin and several *fêtes-champêtres* by the eighteenth-century French school. The importance of Mantegna in this

respect can hardly be exaggerated. Vuillier illustrates a study for the exquisite group of rhythmic figures at the centre of Mantegna's *Parnassus* in the Louvre (fig. 153),[85] a painting that shows the Muses engaged in dance, accompanied by Orpheus, Mars and Venus, in a composition now believed to be based on Greek sculpture.[86] Degas had admired this work from his earliest days, copying some of its figures and presumably including it with its companion in the Louvre, *Minerva chasing the Vices from the Garden of Virtue* (fig. 119), when teaching his pupil Ernest Rouart; and it was surely *Parnassus* that Degas had in mind when he endlessly claimed that the Muses 'just dance'.

Other writers from Degas's circle drew on the same reservoir of imagery and made comparable claims for the classicism of the dance. Eugène Carrière, a painter publicly admired by Degas, prefaced his short appreciation of the dancer Isadora Duncan in 1901 with an account of Greek art, noting the 'power' and 'grace' of its rhythms and stressing the timelessness of its 'expressive mime'.[87] A year or two earlier, Duncan herself had performed an 'Idyll of Theocritus' in front of Rodin, clad only in an archaic tunic;[88] she became the subject of representations by Grandjean, dancing Gluck's *Orfeo*, and of a bas-relief by Bourdelle;[89] and later wrote her own texts on Greek dance and theatre.[90] In Paul Valéry's essay on the 'Philosophy of the Dance', which again contrives to avoid Degas's name, the writer reflects on dance's 'universality, its immemorial antiquity, the solemn uses to which it has been put', before holding forth on the expressive complexities of the art.[91] It is this grander and more abstracted conception of the dance, shared variously by Degas's contemporaries, that coincides with the

FIG. 155
*Dancers with fans, c.*1897–1901
Pastel on paper, 62.2 x 70 cm (24½ x 27½ in.)
Hartford, Wadsworth Atheneum, The Ella Gallup Sumner and Mary
Catlin Sumner Collection Fund (L.1321)

FIG. 156
The exaltation of the flower, Greek, first quarter of the fifth century BC
Marble, 60 x 67 cm (23⅝ x 26⅜ in.)
Paris, Musée du Louvre

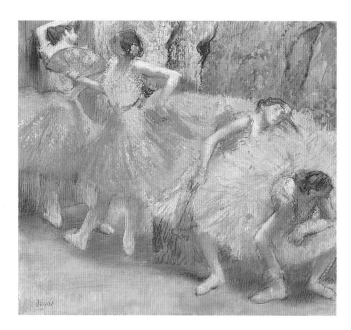

artist's views in later life, while contrasting sharply with the vocabulary of his youth. By aspiring to the almost disembodied 'movement of the Greeks', as he told Mrs Havemeyer, Degas was able to transcend the pageantry and fake archaicism of those contemporaries who also featured in Vuillier and de Soria's pages, the Bougeureaus and Gérômes whom the artist so frankly despised. A painting such as Gérôme's 1893 *The antique pottery painter: Sculpturae vitam insufflat pictura* (fig. 154) might be taken as the polar opposite of Degas's late classicism. Showing an improbable ancestor in the act of applying colour to a series of Tanagra-like figurines, here looking pointedly like one of Gérôme's own recent sculptures, the picture depends on a fancy-dress world of pun and pretence.[92] Mixing archaeological exactitude with the physiognomy of the late nineteenth century, Gérôme suggests the mannerisms of Art Nouveau as much as the 'movement of the Greeks'.

As understood by the scholars of Degas's day, the 'movement' of Greek dance was predominantly dignified, expressive of the deepest emotions and symptomatic of the values of ancient society. In another sense, therefore, Degas may have looked to classical dance as a model of order, of the stability of a mythical past when 'everyone stayed in his place and dressed according to his station', as he said about this time, if in another context.[93] Combining the measured structures of music with the athleticism of the body, the dance corresponded to Degas's personal stoicism as much as his sensuousness, while its representation made demands of his disciplined draughtsmanship and his barely containable delight in colour. It is finally in the products of these faculties and in the attitudes and tastes of Degas's last years that we must look for an

expression of his rediscovered classicism. Though few of his responses to classical works of art have been recorded, in later life Degas stopped Jeanniot in front of the Medici Venus and pointed out its slight imbalance: 'By this detail . . . the Greek sculptor gave his figure a splendid movement, while still retaining the calm which characterises masterpieces', he explained.[94] We can now see his earlier *Young Spartans* as a similar statement of contained energy in a proto-balletic context, while remembering that Degas once defended the painting in front of Gérôme himself: 'I suppose its not Turkish enough for you?', he enquired.[95]

But it is works such as *Three dancers* (cat. 20) and *Dancers with fans* (fig. 155) that show Degas's most deeply engaged yet non-illustrative reinvention of the antique. From first encounter, it is clear that both pastels speak the language of the sculpted relief, their bold forms spreading across the picture plane and their respective backgrounds defining the shallow spatial arena in which the action unfolds. In the former, the chalky quality of the dancers' arms and shoulders almost resembles carved stone, while their subtly interlinked limbs flow from side to side, like successions of notes on a stave. *Dancers with fans* and its associated 'family' of images comes even closer to the 'calm that characterises masterpieces'. Here, the dying fall of a wave of humanity carries the spectator from the top left-hand corner to the lower right, embracing the noble stance of the most prominent standing figure, the resignation of her neighbours and the tired despair of the dancer who clutches her ankles. As in the dances described by Vuillier, each individual is subsumed in a larger momentum, while each engages in

FIG. 157

Henri Matisse, *Study for 'The dance' (II)*, 1909–10
Charcoal on paper, 48 x 65 cm (18⅞ x 25⅝ in.)
Musée de Grenoble, Legs Agutte Sembat, 1929

FIG. 158

Group of dancers, c.1900–5
Charcoal and pastel on tracing paper, 57 x 70 cm (22⅜ x 27½ in.)
Location unknown, photograph Archives Durand-Ruel,
Paris (L.1374)

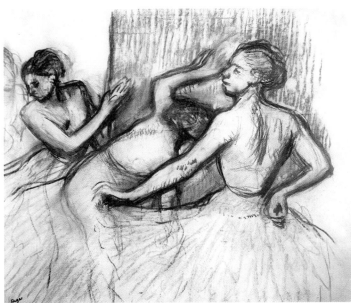

the 'expressive mime' that brings pathos to their exercises. Though they are resting rather than performing, these ballerinas are lost in the rituals of their profession, as every dancer 'encloses herself as it were in a time that she engenders, a time consisting of immediate energy', in Paul Valéry's words.[96] And, most importantly, they share this remoteness and gravity with many majestic works of past and present, without crassly imitating them. A celebrated Greek relief in the Louvre, known as the *Exaltation of the flower* (fig. 156), is pervaded with the same rhythmic dignity, expressed in a twining of arms and hands, a lateral rippling of form that energises the womens' stately encounter. Though it is ceremonial rather than balletic, Degas would certainly have known this work and must have had such icons of classicism in mind, along with Tanagra figurines, the paintings of Mantegna and much else, when he defined his oblique pursuit of the 'movement of the Greeks'.

The authors of Degas's day also acknowledged, though somewhat guardedly, that Greek dance could take on more energetic or even licentious forms, from the 'amorous comedies' mentioned by Vuillier to the 'profane dances' and 'celebrations of the seasons' discussed by de Soria.[97] By extension, many writers emphasised the survival of these forms in the peasant dances of their own day and their links with ancient symbolism. Both Vuillier and de Soria devote substantial chapters to country dance, in the living traditions of Spain, Sweden, Russia and Poland, as well as the distinctive customs of provincial France, notably such areas as Brittany. Taking the example of the *ronde*, or circular dance, Vuillier announced that it was 'the primitive dance, the true country dance', tracing its origins from prehistory to its appearance in the 'Celtic

Limousin', in Gallo-Roman culture and in a modern Breton *danse improvisée*, represented in his text by Derolle's painting of that name.[98] The same generic dance was the subject of Rodin's drypoint *La Ronde*, pictures by Pissarro and Gauguin, and the pantheistic, desperately rotating figures of Matisse's *The Dance* of 1909–10, here represented by a remarkably Degas-like charcoal drawing (fig. 157).[99] Remote from Degas though this may seem, it emphasises the broader understanding of ancient dance in his milieu and provides an overlooked context for some of his more idiosyncratic imagery. Degas's *La Danse grècque* (private collection) of 1881, a work included in several exhibitions during the artist's lifetime, appears to be an earlier, somewhat sanitised response to Mediterranean tradition, while the angular and occasionally wild ballerinas of later pastels, such as the group around *Two dancers* (fig. 75), may come closer to Tanagra figurines and Attic vase paintings.[100] It is the sensational *Russian dancers* sequence of the late 1890s, however, that most clearly benefit from this boisterous company. A Russian variant of the ronde is discussed by Vuillier and time-honoured peasant dances, such as the *khorovod* and the *trepak*, are described and illustrated by de Soria (fig. 161), offering both visual and historic precedents for Degas's iconography that await further investigation.[101]

A final reflection on Degas's late ballet subjects brings us to the curious nudity of many of his dancer figures. Most obviously in his sculptures, such as *Grand arabesque, second time* (cat. 71), but also in drawings and pastels related to these works, we appear to confront an anomaly; a ballerina engaged in the classic steps of her art, as if on stage, who is at the same time entirely naked. In literal terms, of course, such

FIG. 159
*Four dancers, c.*1891–8
Charcoal on paper, 61 x 75 cm (24 x 29⅓ in.)
Jerusalem, Israel Museum (II, 265)

FIG. 160
Jean-Dominique Ingres, *L'Age d'Or,* 1862
Oil, 46.5 x 61.9 cm (18¼ x 24⅜ in.)
Cambridge, Mass., Courtesy of the Fogg Art Museum, Harvard
University Art Museums, Bequest of Grenville L. Winthrop

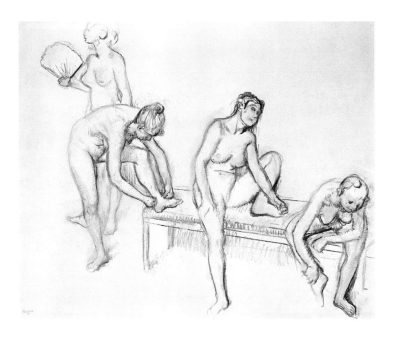

images had no counterpart in Degas's day, underlining yet again the remoteness of these pictures and waxes from the experience of the Parisian theatre. Their world is that of art, and specifically of Degas's studio practice, where the artifice of draughtsmanship and traditional routines of composition held sway. Typically, Degas began his figure studies with the nude form, whether for dancers or bathers, as our analysis of the sequence beginning with *Three nude dancers* (cat. 75) has made clear. In this respect he stayed close to academic procedure, exemplified in the two drawings by Ingres for his *Pindar* from Degas's own collection, the first showing the Greek poet naked, the other clothed.[102] With his waxes, Degas followed a similar pattern; later discussion in this catalogue shows how certain of his statuettes were used as miniature 'models' for drawings and pastels, taking the place of the nude figure in his studio and allowing the artist to refer back to underlying forms as his clothed compositions progressed. Whether using a live model or a wax figure, Degas could then add bodices and tutus in his pictures according to whim, or choose to leave his subjects unclothed. Curiously, some poses were developed in both forms, a woman with hands on hips appearing in a toilette scene as well as amongst a group of backstage dancers, transforming the significance of her gestures.[103] Yet others were begun as ballet configurations and left haphazardly nude, or allowed to retain vestiges of both contexts, as in the bare-chested and transparently clad *Group of dancers* (fig. 158).[104]

What is more remarkable, however, is the way that Degas increasingly and almost randomly conflated these two categories in his last years,

inventing a pagan dancer-nude that defies temporal logic. In a letter of 1891 he wrote of a suite of prints he was planning, 'a first series on nude women at their toilette and a second one on nude dancers', a project that resulted at this or a later date in the lithograph *Three nude dancers at rest*, related to such drawings as *Four dancers* (fig. 159).[105] The modelled *Dancer looking at the sole of her right foot* (cat. 82) is an even more developed expression of this new hybrid, here neither dancing nor resting, neither truly bathing nor attending meaningfully to her body. These explorations of athletic nakedness seem to take us, like so much of Degas's late imagery, both forwards and backwards in time. In one direction, we sense the uninhibited expressiveness of his younger Montmartre neighbours, of Matisse's charcoal nude drawings and animated bronzes, and Picasso's gymnastic whores; in the other, we return to the ethereal past, to the nymphs running naked in the primeval mist and the 'savage' origins of dance. Received opinion was unanimous in its view that certain of the earliest dances were performed nude, citing ancient literary texts, archaeological evidence and modern renderings of such scenes as their authority.[106] Ingres's *L'Age d'Or* (fig. 160) exemplifies this tradition, and Degas's acquisition of several studies for this painting, including at least one unclothed dancing figure (fig. 65), at the time he was working on his 'nude dancers', was hardly coincidental. Degas's indifference to the literal context of the ballet in these late works does much to summarise his final years. Not only do they mark his distance from mere illustration and banal historicism, but effectively acknowledge Degas's abandonment of the earlier modes of representation of his own career.

THE BATHERS

The paradox of Degas's late classicism was that it liberated him from the dogmatic contemporaneity of his middle years, not towards the antiquarianism of Gérôme or the pagan fantasies of Renoir, Roussel and Maillol, but towards a new freedom of expression, a kind of decontextualised language of form that was both personal and rooted in historic experience. As with his ballet subjects, so with the other pervasive theme of his last years, the female bather. Like the dance, the image of the nude had its origins in Degas's earliest decades, origins that are inseparable from his reverence for past art. During the years of Impressionism, both dancers and nudes found a fresh vitality in the vernacular, adopting the forms of the rehearsal room and the brothel, the stage and the bathtub, and only distantly recalling their ancient pedigree. With the all-embracing transformation of Degas's art in the late 1880s, such scenes lost their single-mindedness and particularity, separating themselves equally from his involvement with experimental technique and bizarre materials. And in parallel with Degas's studies of the ballet, the later generations of bathers presented a continuity with the works of his youth that was more apparent than real, exploring new kinds of spaces and harmonies of colour, new human predicaments and a new relationship with his peers.

In the mid-1870s, when they first appeared in his mature art, Degas's images of nudes were aggressively descriptive, his models clambering in and out of carefully detailed bathtubs, dressing or undressing in gaudy bedrooms and, in the brothel monotypes, vying for the attentions of top-hatted men. Their figures were often physically extreme, spanning the obese matron in the etching *Leaving the bath*, the animated sexual athletes of *The serious client* (fig. 161) and the gaunt, bird-like prostitutes of *Two young women* (private collection), just as their actions could be comical, mundane or grotesque.[107] By the following decade, his pastels of women 'bathing themselves, washing themselves, drying themselves, towelling themselves, combing their hair or having it combed', were less susceptible to definition, as Degas's rambling description in the 1886 Impressionist exhibition catalogue implied.[108] Certain critics clung to their grim, naturalistic terminology, seeing in such works as *Woman in a tub* (fig. 91) the 'streetwalker's modern, swollen, pasty flesh'.[109] Some evidently disagreed, noting that the *Girl drying herself* (fig. 162) was posed beside a rural stream, that one pastel showed a 'daughter of the bourgeoisie' and several revealed 'housewives who sponge themselves in tin baths'.[110] Yet other commentators sensed a new departure or a greater complexity in Degas's art, hinting that the figures represented were 'decidedly chaste', that they had 'the loveliness and power of a gothic statue' and that one model resembled 'a kneeling Venus'.[111]

The disarray of Degas's contemporaries and the extravagance of their language when confronted with the 1886 pastel nudes must form the

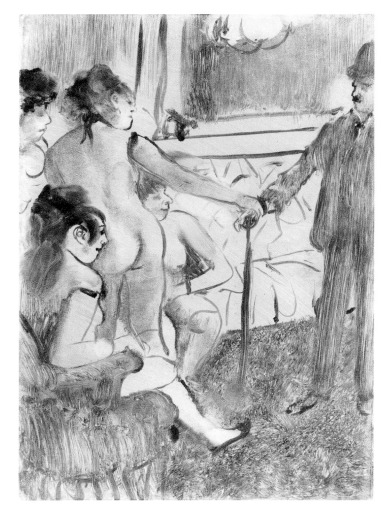

FIG. 161
*The serious client, c.*1876–8
Monotype on paper, 21 x 15.9 cm (8⅜ x 6¼ in.)
Ottawa, National Gallery of Canada (J.86)

starting point of our enquiry into the later bathers. Among its many significances, their confusion points to an art in transition, a set of visual codes transgressed and a subtler and more exacting role for the artist's audience. Many of the assumptions brought to these works, such as the determination to see the depicted women as prostitutes, were clearly survivals from earlier years, when a composition such as *The serious client* had spelled out the precise nature of the scene. In this monotype, Degas lingered over brothel furnishings and knowing looks, over ribbons, stockings and negligées, and the awkwardly clothed customer, drawing us in to his salacious narrative. In the 1886 pastels, such as *Girl drying herself*

FIG. 162
Girl drying herself, 1885
Pastel on paper, 80.1 x 51.2 cm (31½ x 20⅛ in.)
Washington, National Gallery of Art, Gift of the W. Averell
Harriman Foundation in memory of Marie N. Harriman (BR.113)

FIG. 163
*Woman in a tub, c.*1886–8
Pastel on paper, 69.8 x 69.8 cm (27⅜ x 27⅜ in.)
London, Tate Gallery (L.738)

So pervasive are the dislocations of meaning in Degas's late bather pictures that two features of these works, both previously overlooked, deserve a more detailed examination. The first is the presence or absence of male figures in the artist's pictorial repertory, whether in the dance rehearsals or in more intimate circumstances. In his middle years, Degas had unblinkingly portrayed the sexual market-place of the Parisian stage, illustrating the amorous intrigues in Ludovic Halévy's *Famille Cardinal* stories and frankly describing the voyeurism of audiences and male *abonnés,* or subscribers to the Opéra.[113] Symptomatic of this frankness is the presence of leering black-suited *abonnés* in Degas's depictions of the theatre wings, in moments of backstage flirtation and even in the shadows at the edge of a performance. Similarly insubstantial and often rather pathetic male figures appeared in his brothel studies, as *The serious client* demonstrates, heightening the confrontational nature of the scene and establishing its descriptive mode. By the same logic, when these figures suddenly disappeared from Degas's art, some time in the late 1880s, the sexual temperature of such subjects was transformed and implicitly lowered (the vestigial male survivor in the repainted *Dancers, pink and green* (cat. 31) is perhaps the last of his breed). After about 1890, men were entirely removed from Degas's dance and nude repertoire, as they were from almost every aspect of his art. Not just their blatant carnality in the ballet studies and brothel monotypes, but most of the

(fig. 162), *Woman in a tub* (fig. 91) and *Woman bathing in a shallow tub* (fig. 58), by contrast, none of these indicators was present and Degas's admirers had to invent their own narratives, perhaps question their most fundamental responses. If the brothel context was absent and the client banished, these naked figures might indeed be ordinary 'housewives' or 'fat bourgeoises', as one critic suggested, even the kind of women who visited art galleries;[112] far from being predatory, such figures might well suggest 'loveliness' and recall classical statuary; and rather than being clandestine objects, like the semi-pornographic monotypes, these pastels might reasonably take their place on the walls of respectable homes.

FIG. 164
Woman with a towel, 1894–8
Pastel on paper, 95.9 x 76.2 cm (37¾ x 30 in.)
New York, Metropolitan Museum of Art, The H.O. Havemeyer
Collection, Bequest of Mrs H.O. Havemeyer, 1929 (L.1148)

associated codes of display and narration went with them, leaving ambiguity in place of illustration, neutrality in place of spectacle. Here, conspicuously and quantifiably, Degas had elected to shift his pictorial ground, opting for the less precisely demarcated, though not necessarily more innocent, visual territory of the last decades.

Our second study concerns the documented response of the women in Degas's social milieu to his representations of the female nude. If the bather pastels were universally understood to depict 'streetwalker's flesh', as a number of commentators have continued to assume, they would hardly have been acceptable on the walls of bourgeois households and would certainly have been offensive to most women of Degas's acquaintance. That his nudes were not inevitably perceived in this way is demonstrated by a careful analysis of their purchasers and eventual locations. In the mid-1880s, for example, the industrialist Emile Boivin started to add works by Degas to his collection, but it was his *wife* who purchased the pastel *Woman having a bath* (cat. 10), a stark rear view of a naked bather.[114] Similarly, the boldly frontal *Woman in a tub* (fig. 163) was hung in the elegant family apartment of the Lerolles, a setting immortalised by Renoir in his paintings of the Lerolle daughters.[115] Another frank depiction of nudity, *After the bath* (Paris, Durand-Ruel Collection), was bought before 1895 by a certain Madame Aubry, from whom it passed to Madame Durand-Ruel.[116] Mary Cassatt's exchange of her own painting *Girl arranging her hair* (fig. 14) for Degas's pastel *Woman bathing in a shallow tub* (fig. 58), a work shown in 1886, is arguably a special case, but the same considerations do not apply to her suffragist friend Louisine Havemeyer. The Havemeyers acquired several pastel nudes by Degas for their elaborately installed New York collection from the 1890s onwards, including *Nude woman having her hair combed* (fig. 95), *The Bath* (fig. 22) and the voluptuous *Woman with a towel* (fig. 164), a policy continued by Louisine after her husband's death.[117] Other cases, such as the purchase by Mrs Potter Palmer of *The morning bath* (cat. 83), and Madame Ernest Chausson of *Nude woman combing her hair* (New York, private collection) add to a growing catalogue of works owned and displayed by contemporary women and undermine any simplistic reading of their significance.[118]

Both the removal of male figures and the neutralisation of the sexual context of the late bather are signs of a much wider reshaping of Degas's pictorial image. This language is one without fixed rules and standard primers, but none the less eloquent, sometimes lyrical and occasionally violent in its expressiveness. As in his ballet repertoire, Degas's awareness of the vocabularies and visual grammars of his day should never be underestimated, nor the endlessly renegotiated distinctions between one set of codes and another be allowed to lose their significance. Here was a painter conversant with the bohemian studios

of Montmartre and the galleries of the Louvre, fluent in the idioms of photographers and caricaturists, sculptors in wax and marble, artist's models and teachers of drawing, near-pornographers and pillars of the artistic establishment. His grounding in the syntax of the nude was second to none, while his alert response to the nuances and pitfalls of the genre are recorded in conversations and asides, and observations on Old Master canvases and newspaper cartoons. We misunderstand his parlance, however, if we assume that a single register was chosen for each of his pictures or group of studies, or, as we have seen in the 1886 criticism, that current audiences deciphered each work in a consensual fashion. On the contrary, Degas seems to have revelled in circumlocution, if not obfuscation, delighting in graphic puns and rhyming visual structures that teased his diverse admirers, in ambiguity and compositional licence throughout his proliferating nude repertoire.

The tabulation of Degas's mature artistic output (fig. 137) shows both the persistence and increasing dominance of bather subjects in the

FIG. 165
Paul Cézanne, *Venus and Cupid*, c.1873–5
Oil, 21 x 21 cm (8⅜ x 8⅜ in.)
Private Collection

course of his career, second only to the remarkable ascendancy of the dance. Between 1885 and the early years of the twentieth century, Degas made approximately 250 pastels and oil paintings of the female nude, quite apart from charcoal studies, prints, sculptures in wax and clay, and photographs.[119] A glance at his professional beginnings reveals that the nude represented one of Degas's most tenacious themes, appearing on the opening page of his first sketchbook, datable to 1853, and then recurring throughout his formative years, clinging on until the very last sculptures, such as *Dancer looking at the sole of her right foot* (cat. 82).[120] But as Richard Thomson's 1988 study of the subject, *Degas: The Nudes*, has shown, naked male and female figures occurred sporadically rather than continuously in the early decades, featuring in groups of life drawings and preparations for large paintings, then disappearing almost completely for years at a time.[121] By comparison, the resurgence of nude imagery in Degas's mid-career seems like a sustained statement of intent, while its survival through the thematic purges of the 1880s signals a new and unmistakable commitment to this most stubborn of motifs.

If we imagine the total number of bather pictures from Degas's last phase distributed evenly throughout this period, they would be equivalent to at least one substantial pastel or oil painting for each working month, quite apart from the monochrome drawings and tracings that accompanied them. Manifestly, the artist did not function in this systematic fashion, but such approximations bring to life Degas's massive and almost exclusive dedication to the female figure, not just in hundreds of concurrent ballet subjects but in cycle after cycle of bathers, toilette motifs and studies of the *coiffure*. It is this concentration of engagement, set against the collapse of his concern with portraiture, the racetrack and scenes of the street and café-concert, that most sharply characterises Degas's late project, while simultaneously prompting the unease of later generations. These are the pictorial routines of an obsessive, an artist fixated on the forms of the opposite sex, whether scantily clad in a muslin tutu or naked beside a tub, a bed or a mirror. In the late nudes, Degas returned again and again to poses he had depicted a dozen times before, sometimes reviving motifs of years or even decades earlier, often exploring the slightest inflection of gesture or deportment in a cycle of variants. Even when he turned to parallel activities such as sculpture, printmaking or photography, it was to the same set of visual challenges; a distracted bather drying her neck, a head of chestnut hair against pale flesh, a nude reaching for a comb or towel.

For those who consider the depiction by a male artist of the female nude as innately reprehensible, therefore, Degas stands a thousand times condemned. As a man in a patriarchal society, sharing many of the conventional attitudes of his caste and the mannerisms of a male-dominated cultural establishment, he was complicit in a system that denied fundamental rights and dignities to most of its women. That Degas expressed certain of these class and gender attitudes in his art is undeniable and inevitable, just as it is increasingly clear that other social structures were blurred or inverted by his visual strategies. It is only by setting his bather imagery against the multiple semaphores of the day and by scrupulously evaluating individual pictures, however, that we genuinely confront Degas's achievement. If he accepted certain pictorial conventions and their associated values uncritically, we must be prepared to spell these out in the context of his pastels and oils; and if he resisted or subverted others, we should again expect to find the evidence in the works themselves, as well as in their complex dialogue with the pictorial traditions of the day. Although his bather pictures have sometimes been compared with those of fellow-Impressionists, such as Renoir and Cézanne, it was from these broader traditions that Degas's work emerged and against their pictorial behaviour that he must be judged.

Within Degas's lifetime, the Italian Futurists were to call for the complete abolition of the nude in painting, 'as nauseous and as tedious as adultery in literature', as their manifesto claimed in 1910.[122] The Futurists' impatience marked the extraordinary survival of the heroic and sensuous nude into the early twentieth century, not just in the fine arts but in decoration and advertising, photography and popular

FIG. 166
Leaving the bath, c.1895.
Pastel on paper, 70 x 70 cm (27⅝ x 27⅝ in.)
Paris, Musée du Louvre (L.1335)

imagery. Despite the upheavals of Impressionism and its successors, the human figure still provided the staple of the academic curriculum and enjoyed a continuing, if anachronistic, prominence in official exhibitions and public commissions. Regulars of the Salon known personally to Degas, such as Henner, Puvis de Chavannnes, Bartholomé, Albert Besnard and Henri Gervex, frequently relied on nude subjects for their annual submissions, while similar themes were endlessly broadcast across ceilings and transepts, railway stations and public squares throughout Paris. At the opposite extreme, a very private and virtually untutored artist such as Paul Cézanne could place the nude at the centre of his art for reasons of his own, defying the establishment with scenes of repose and naked mayhem in the Provençal countryside. In the 1890s, Degas acquired two such paintings by Cézanne, including his *Venus and Cupid* (fig. 165), adding them to his collection of Tahitian nudes by Gauguin, studies of the body by Puvis de Chavannes and Berthe Morisot, a drawing for Manet's *Olympia* and several variants of the toilette by Mary Cassatt and Suzanne Valadon.[123] Alongside his groups of figure drawings by Ingres and Delacroix, these works unselfconsciously marked Degas's own place in the scheme of things, and his display of several such items in his apartment, including Bartholomé's naked *Weeping girl* (fig. 24), Gauguin's copy of *Olympia* (private collection) and Ingres's *Study of a woman* (fig. 15), merely reinforced the supremacy of this ubiquitous subject.[124]

At one level in this complex visual culture, therefore, Degas's devotion to the nude and the bather were hardly worthy of comment; at another, it might be seen as retrogressive, aligning him with the tradition of the Ecole des Beaux-Arts and its decreasingly valued teaching; and at a third, it embroiled the artist with some of the fiercest controversies of his day, both those concerning women and those concerned with their representation. So familiar were Degas's generic themes, however, that few of his contemporaries so much as noted the concentration of his repertoire. From Bouguereau to Picasso, by way of Maurice Denis and Pierre Bonnard, the elderly Renoir and the youthful André Derain, it was still taken for granted that the majority of painters would test themselves against the legacy of the nude. Certain of his colleagues, Henner and Rodin for example, even exceeded Degas in their commitment to the subject, while those who avoided the naked female form altogether, such as the single-minded Claude Monet, formed a tiny minority. But, as the Futurists' statement reminds us, representations of the nude had not lost their power to arouse passions and prejudices, even tedium. In Degas's case, as we shall see, suggestions of impropriety in his bather scenes faded markedly in the more informed criticism of the 1890s, though his approach to female subject matter might still demand tact. We have already encountered the suppression of nude subjects in his

1901 display in New York and a similar reticence is implicit in the submissions to the 1905 Grafton Galleries exhibition in London. To this might be added the subtly different example of the 1915 show organised by Louisine Havemeyer in New York, when Mary Cassatt noticed with amusement the inclusion of the supposedly misogynistic artist's work in an exhibition devoted to women's suffrage.[125]

To a significant extent, therefore, it is where, when and in what company a picture is seen that determines something of its meaning for a given audience. Beyond these circumstances, however, it is also the fundamental nature of the individual image, expressed in its lines and colours, its particular gestures and accessories, that distinguishes it from its companions and defines its visual identity. A succession of pastels of the female nude from Degas's last decades offer a number of case histories to be examined in this way; though each is entirely distinct, all derive from the serial procedures of Degas's tracing technique and all, as a result, are linked to sequences and clusters of related motifs. By studying each work in detail, we begin to compile a visual lexicon and a provisional terminology for the late nude repertoire, while differentiating this repertoire from that of earlier eras. *Leaving the bath* (fig. 170), for example, is one of several bather studies from the 1890s that revisited an image of the previous decade, in this case the exquisitely

FIG. 167

After the bath, woman drying her leg, c.1900–5
Charcoal and pastel on tracing paper, 62.5 x 51.5 cm (24⅝ x 20¼ in.)
Chicago, Ursula and R. Stanley Johnson Collection (L.1436)

authorial presence and the intrusiveness of the picture's audience. These issues will be considered in due course, but the seclusion, what might be called the visual celibacy of Degas's depicted nudes cannot be sufficiently stressed. By contrast, the prevalent modes of the artist's day seem committed to an improbable communal nakedness, from Bouguereau's groups of bucolic maidens to Puvis de Chavannes' hygienic family gatherings, from Toulouse-Lautrec's *filles*, with their consorts of both sexes, to Gauguin's parties of Tahitian youths. There are, of course, exceptions in Degas's late oeuvre, notably the female companions in works such as the Chicago *Bathers* (cat. 88) and the attendant maids in the series represented by *Breakfast after the bath* (cat. 52), but even in these cases the self-absorption of the individual bather remains largely undisturbed.

A more detailed scrutiny of *Leaving the bath*, and especially those features that distinguish it from the Tate variant, subtly reinforces this image of isolation. Where the background of the earlier *Woman in a tub* featured a half-open door, suggestive of the wider world and incomplete action, *Leaving the bath* is visually enclosed by a massive zinc tub and a contiguous wall. In common with many of Degas's later nudes, this enclosure is heightened by a tilting of the floor towards the picture plane, a tightening of the jigsaw of colour around the model and an intensification of the chalky pastel surface. Where the 1880s figure was surrounded by deep space, the later composition locks her into its design, the lines of her body inseparable from its rhythms and the colours of her flesh woven in to its textures. Her isolation, in other words, is less theatrical, more directly expressed in the pastes and patterns of the work of art itself. That this isolation could also be comforting is conveyed in the softness and warmth of the chosen hues, their peaches and ambers set off by the zinc grey of the tub. Combining stark simplicity with exceptional tactile richness, the picture soon found its admirers. Completed some time before 1895, when it was acquired from the artist by Durand-Ruel, it was bought by the Dresden collector Waldemar von Seidlitz in May of the following year.[127] One of the first pastels of this period to travel abroad, it established something of Degas's later syntax in the wider world, appearing as a reproduction in one of the first illustrated books on the artist, that of Georges Grappe in 1909.[128]

Less finished and much less well known, the pastel and charcoal *After the bath, woman drying her leg* (fig. 167) shares many qualities with *Leaving the bath*. Like that work, it presents the bather alone and at the centre of its field of energy, occupied exclusively with washing, drying or gently rubbing her body. Common to both is a sense of purposeful activity, neither flamboyant and calculated to attract attention, nor foolishly inert. Almost all Degas's late nudes are similarly occupied, brushing or combing their hair, stepping in or out of a tub, stretching

refined *Woman in a tub* (fig. 163) of 1886-8 that hung in the Lerolle household.[126] As a 'reprise', it differs little in design from its predecessor, though its very proximity encourages us to focus on subtle shifts of surface and pictorial incident. Before doing so, however, the magnificent *centrality* of both images demands acknowledgement, a quality emerging in the pastels of Degas's middle years but achieving dominance in his final phase. The composition of *Leaving the bath* is constructed, quite literally, around the model's figure, other possibilities fading into insignificance beside her palpable mass and her animated concentration. This is unquestionably a picture about a singular woman, or some aspects of her animal and human being, not about her possessions or the room she is in, her companions or the unfolding of a larger narrative. If there is a story, it is about her self and the preoccupations of her immediate present.

Linked with this centrality is the woman's solitude, not only in respect of other women, but of children, servants, lovers and intimates and intruders of all kinds. Absent from the scene, they also leave no trace in her surroundings, which suggest a private space devoted to her toilette, perhaps a dressing room, bedroom or bathroom. Such solitude is open to a number of interpretations, from blissful isolation to the vulnerable loneliness of the prostitute, raising also the spectre of the

FIG. 168
The Toilette, c.1896–1901
Pastel and charcoal on tracing paper, 62 x 83 cm (24⅜ x 32⅝ in.)
Private Collection (L.1289)

FIG. 169
The Toilette, c.1896–1901
Pastel and charcoal on paper, 58 x 56 cm (22⅞ x 22 in.)
Location unknown, photograph Archives Durand-Ruel, Paris (L.787)

their limbs or reaching for a sponge or towel. These are figures in viable movement, their actions sufficient to animate their muscular forms and locate them in the ordinary routines of life, in what Degas himself called 'natural' positions, but not to ingratiate themselves with the viewer.[129] The late nudes rarely balance or cavort for our gratification or 'freeze' in inexplicable postures, but echo the common experience of bathing or relaxation. As always with this most unsystematic of artists, there are important exceptions, not least the gymnastic nude in *After the bath, woman drying herself* (cat. 57), but the emphasis is on the mild and the mundane, if also the mobile. In many works, such as *After the bath, woman drying her leg*, this mobility is almost palpably inscribed in their shifting contours, where earlier statements of line have been partly erased or modified. Here again, the physical stuff of which the picture is made both defines and embodies its essence, the blurred pastel summarising the woman's agitation.[130] So distinctive, indeed, was Degas's engagement with dynamism that several contemporaries saw it as his main preoccupation, a heroic assertion of vitality over inertia.[131]

Energetic though they may be, the majority of Degas's late nudes contrive to be both anonymous and discreet. In both the examples discussed the models avert their faces, their physiognomies reduced to a shadowy silhouette or a mere blur. In the absence of eye contact, we register neither expression nor engagement, neither a seductive glance nor a look of alarm. Again, moving away from the almost caricatural figures of the brothel monotypes and the sporadically individualised subjects of his middle years, in works such as *After the bath, woman drying her leg*, Degas opted for detachment. Lacking a background, this drawing and many like it are left in an extraordinary state of suspension, without clothes to identify the sitter's class or profession and without those clues to personality that are found in the face. Even in more finished works, such as *Leaving the bath*, the simplicity of much of the setting reduces its instructiveness and the commonplace natures of towel, chair and carpet tell us little. Working habitually with paid models, Degas preserved their professional anonymity, neither dressing them in borrowed identities nor presuming to make portraits in their naked state. Uniquely, in these images the woman's body speaks on her behalf, the language of her limbs and deportment offering the only clues to her real or projected personality. Even here, Degas increasingly denies us information, generally avoiding extremes of obesity, attenuation or adolescent grace. Though he did sometimes explore these possibilities to dramatic effect, most of his models are of average weight and middling years, or rather of indeterminate stature and age. Consistent with this is his coyness about their sexual attributes, a highly distinctive but rarely

FIG. 170
After the bath, woman drying her hair, c.1900–10
Pastel on tracing paper, 85.6 x 73.9 cm (33¾ x 29⅛ in.)
Private Collection (L.1424)

FIG. 171
Bather beside the water, c.1900–5
Pastel and charcoal on paper, dimensions and location unknown
(L.1422)

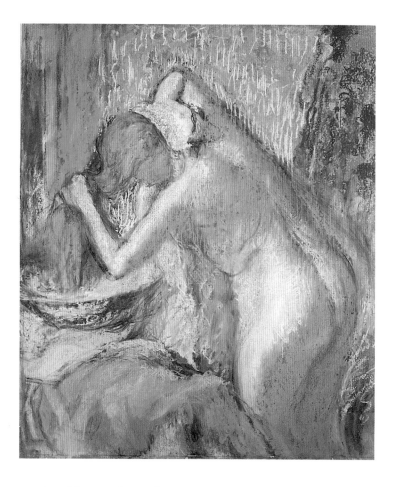

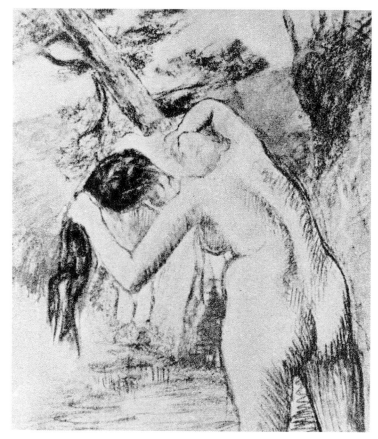

mentioned feature of Degas's late nudes. Where bathers depicted by his peers often stretch themselves voluptuously, their chests bared to the elements and their loins covered, if at all, with wisps of drapery or convenient foliage, Degas's nudes crouch and conceal themselves, their arms across their breasts and their thighs in shadow. Even more commonly positioned with their backs towards us, these are among the least flagrant and arguably most prudish nudes in Western art.

Among the exceptions to this general rule are a scattering of pastels and paintings that show a greater openness of pose, even a kind of exhibitionism. *The Toilette* (fig. 168) comes from a series of at least eight finished works made in the late 1890s, several of which were signed and released on to the market.[132] Varying only slightly in details of posture and setting, as a less heavily worked study demonstrates (fig. 169), all these pictures centre on the action of a woman drying or sponging her breast. In each case the model's face is shadowed or inclined, her identity signalled neither by her surroundings nor the nature of her banal ritual. She might be washing at daybreak or preparing for a lover, displaying her charms or towelling after a day's work; the point of Degas's

composition, however, is that all these readings are made possible but none is insisted upon. The washbowl and jug are virtually classless, as are the other items appearing in variant renderings, and without a knowing glance or a symbolic accessory, a meaningful picture on the wall or a suggestive human presence, we are once again denied a narrative.[133] Our attention is drawn to the woman herself, and specifically to her rhythmic movement and graphically realised musculature, expressing both the laboriousness and the practicality of her task.

In the early years of the twentieth century, a pastel such as *After the bath, woman drying her hair* (fig. 170) concentrated several themes from Degas's nude repertoire into a single resplendent image. Massively dominating the composition, the model is enclosed by light and colour, a riot of textures that evoke fabric and flesh, the sensuousness of her ablutions and the gravity of her form. Like her predecessors, she is anonymous and alone, indistinctly situated and occupied by her thoughts, and like a number of them she is almost sexless. Even more than the earlier works, however, this study is part of an extended family,

one of the largest and most inventively varied of Degas's late years. In dozens of charcoal drawings, pastels (for example *Breakfast after the bath* (cat. 52) and *Woman drying herself* (cat. 65) and even sculptures, this angular, averted figure towers over his pictorial repertory. Leaning forwards to attend to her hair and dry her neck, the woman twists her back so that the side of her thighs and the breadth of her shoulders are simultaneously visible. The curiously flattened shape that resulted clearly fascinated the artist, offering an oblique structure that energised a number of major compositions, as well as an unforgettable symbol of muscularity. So enthralled did Degas become that he restated the image in half-a-dozen different contexts, from the light-filled bedroom of *After the bath, woman drying her hair* to the claustrophobic *Woman at her toilette* (cat. 66), versions with tubs and those with attendant maids, even an extraordinary rendering set against rocks and pine-trees (fig. 171).[134] For proof of Degas's later preoccupation with the expressiveness of the figure, and his relative indifference to its setting, we need look no further.

A final feature of *After the bath, woman drying her hair* associates it with another element in the late nude vocabulary; Degas's revived historicism. In general terms, the motif of the model with her back turned towards us is inseparable from Ingres and the haunting, paradigmatic *Valpinçon bather* (fig. 60), a painting known and copied by Degas in his youth and venerated throughout his career.[135] Such a figure clutching her hair while leaning sharply to the side has also been linked to Ingres's rival, Eugène Delacroix, and specifically to the female captive in the foreground of his *Entry of the Crusaders into Constantinople* (Paris, Musée du Louvre).[136] This paradoxical conjunction is further complicated by the discovery that a similar action can be found in the Japanese tradition, for example in Utamaro's woodblock print *Woman combing her hair* (fig. 172). Aware of all these precedents, Degas transposed and absorbed them into his own idiom so successfully that they have remained undetected for almost a century, just as he digested the example of Tanagra figurines and Greek reliefs into his ballet repertoire. During these same years, a canvas by Titian seems to have supplied both the technical and thematic starting-point for his painting *After the bath, woman drying herself* (cat. 57), another inspired a black-and-white monotype *Torso of a woman* (fig. 62) and a number of classical sculptures may have prompted pastels and waxes of bather subjects.[137] These allusions range from acts of homage to moments of sly comedy, bridging the gap between his nude and dance imagery and recalling the antiquarianism of Degas's youth, even as they baffled those critics who could find a 'kneeling Venus' and a 'streetwalker's flesh' in the same pastel study.

This characterisation of a sequence of Degas's later nudes has focused on their visual signals, on forms that are present or absent, on the description of postures and the itemisation of accessories. At the simplest and most concrete level, therefore, we have established some of the patterns of the artist's enormous repertoire, noting anomalies where they exist, but identifying broad distinctions between works of the last decades and those of earlier phases. In contrast to the skittish brothel scenes of the 1870s, these late pastels are expansive and aloof, stripped of anecdotalism and the deep spaces that sustained it. By the mid-1880s, Degas had concentrated his forces on the central figure, strengthening his subtly modelled designs but still much engaged with the temporal and the descriptive. It is only in the last decade of the century, in works such as the Musée d'Orsay's *Leaving the bath*, that his priorities shifted unmistakably from the documentary to the expressive, embodying the textures of the woman's skin in his coloured chalks and her dignified mass in its tints and shadows. Much concerned now with technical and historical matters, Degas was able to propagate sequences of identical compositions, extending one with sheets of tracing paper, introducing the figure of a maid into another, embellishing some with rainbow hues, leaving others in near-monochrome. All these manoeuvres impinged not just on the appearance of the work, of course, but on its purpose and

resonance. One variant might present the bather in all her serenity, its near-twin exploit gloomy tonalities and frantic graphism, yet another recall the athleticism of antiquity. It is these transitions of significance that ultimately mark out the late nudes and it is in their response to such qualities that we most value the reports of Degas's peers.

After a visit to the Boussod et Valadon gallery in 1888, where a small exhibition of Degas's pastel bathers summarised some of the achievements of the decade, Berthe Morisot wrote of 'the nudes of that fierce Degas, which are becoming more and more extraordinary'.[138] Responding to the same display, Félix Fénéon lurched uneasily from the vocabulary of naturalism to that of Symbolism, saluting the 'authentic modernity' of Degas's vision and the animal-like quality of certain nudes, while sensing their elusiveness. Fénéon repeatedly praised the more abstract qualities of the pictures, singling out Degas's powers as a colourist and as a 'cold visionary dedicated to research into line', but hinting that the meanings of the pastels were enigmatic, perhaps unknowable; Degas, he claimed, 'takes pleasure in keeping his work from the understanding of the passer-by, in keeping secret its austere and flawless beauty'.[139] Gauguin's enthusiasm for the bathing scenes is evident in the drawings he made at the gallery (fig. 33), though his contemporary correspondence records little beyond his 'utmost confidence' in Degas in the same year.[140] As we now know, the 1888 installation was followed by other occasional shows, though critics were slow to articulate the evolving nature of Degas's nudes. In his broad survey of Degas's achievement in *The Art Journal* of 1894, Théodore Duret still spoke of him as a realist, concerned in his ballet-dancers, portraits and bathers to depict 'the character . . . of the modern Parisian woman'.[141] Echoing his colleagues at the 1886 exhibition, Duret argued that Degas

> has found new situations for the nude, in interiors, among rich fabrics and cushioned furniture. He has no goddesses to offer, none of the legendary heroines of tradition, but woman as she is, occupied with her ordinary habits of life or of the toilette, exhibiting all the pecularities – and one could say all the defects – of a body unhealthily paled by town life.[142]

Other writers at mid-decade either recycled their earlier prose or fumbled towards a new terminology for Degas's nudes. Gustave Geffroy fell into the first category, reminding his readers in 1894 of the acuity of Degas's vision and the modernity of his motifs, in a text little changed from 1886.[143] At the time of the 1896 show at Durand-Ruel's, however, Georges Pissarro responded more acutely, describing the 'new series of nudes by Degas's as 'admirable . . . as rich and solid as a tapestry'.[144] André Mellerio combined both approaches, summarising the modern-

life themes of the earlier work in the 1896 exhibition but then proposing that Degas was 'the artist who will represent *the classic*, in the highest meaning of the word, at the *fin de siècle*'.[145] Discussing a new 'suite of pastels' dedicated to the 'human gesture' and 'the intimate knowledge of movement', Mellerio made only passing reference to the significance of their subject matter. Of the group of nudes, 'chosen by preference from women at their toilette', he noted the 'play of muscles, these inclinations of the spine, these ungainly gestures that reveal in their accidental appearance a force that is general and immutable'.[146] The following year, Roger Marx ranged over similar territory, again moving effortlessly from comparisons with Poussin and Greek sculpture to a brief account of pictures where 'women secretly purify their flesh'.[147] It was not until the beginning of the new century that a more coherent consensus emerged, now based on a familiarity with some of the recent pictures Degas had released through the rue Laffitte. Camille Mauclair's essay of 1903 dutifully spelled out the artist's naturalist origins, but insisted (in a phrase that recalls Degas's own) that his bathers provided 'multiple pretexts for the modification of movement'.[148] It was the forms and volumes that excited the artist's talent, Mauclair claimed, not 'anecdote' or 'sentimental tenderness': 'These nudes by M. Degas symbolise nothing . . . they tell us nothing about his soul.' Referring explicitly to the later representations of women's backs, Mauclair announced that they were both 'austere' and 'classical', owing much to the example of Ingres but avoiding his bourgeois pomposity, and reaching to the 'foundation of things'.[149]

The visibility of Degas's bathers at the turn of the century and their perceived relationship with the wider nude repertoire offer further insights into the critical response. Comparatively few nudes were illustrated in the publications and articles already discussed, though examples in the 1888 lithographic suite by Thornley, such as *Woman leaving her bath* (fig. 32); in the Ingresque facsimiles published by Manzi in 1897, among them *After the bath* (fig. 173); and a single wood-engraving in the text of Roger Marx, provide illuminating exceptions.[150] Mauclair's 1903 inclusion of a photograph of *The Toilette* (St Petersburg, Hermitage), a dramatic pastel of a woman's torso seen from behind, was one of the first appearances of such works in an illustrated journal, chosen perhaps to encourage comparisons between Degas and Ingres.[151] Citing an anonymous 'Member of the Institute' who claimed that Degas was 'the leading draughtsman of the century', Mauclair argued that he had achieved an 'absolute art' superior in its 'perfection' and its 'implacable vision' to that of Ingres himself.[152] Such allusions were increasingly used to locate and justify Degas's imagery within a historic tradition, linking his work with the examples of Rembrandt, Poussin, Velázquez, Delacroix and other masters of the nude repertoire.[153]

FIG. 173
*After the bath, c.*1895–6
Pastel on paper, 82 x 71 cm (32¼ x 28 in.)
St Petersburg, Hermitage (L.1179)
(reproduced from Michel Manzi, *Vingt Dessins,* 1897)

FIG. 174
L. Perrault, *Venus, c.*1890
From *Salon de 1890, catalogue illustré*

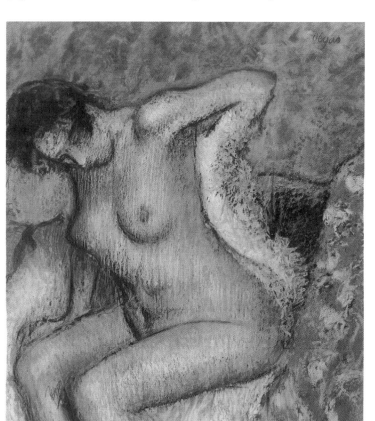

As early as 1901, Arsène Alexandre also made reference in print to Degas as a collector, again embedding his bathers and toilette scenes into a reassuring European heritage.[154]

Conversely, both Degas and his apologists found themselves defining his nude subjects with respect to popular stereotypes and the conventions of the Salon. As we have seen, Degas had many acquaintances in both camps, collecting Forain's interminable graphic satires on prostitution and marital discord on the one hand, and regularly attending the annual state-sponsored exhibitions on the other. In the same way that he differentiated his ballet vocabulary from what he saw around him, Degas dealt firmly with his fellow-painters of the female form. In front of a display of nudes, presumably at the Salon, he exclaimed to Jeanne Baudot 'what invertebrates!';[155] to Vollard he insisted 'nude models are all right at the Salon, but a *woman undressing* – never!';[156] and responding to a nude scene by the ever-popular Gérôme, Degas described it as 'pornographic'.[157] Echoing the same sentiments, a critic such as Geffroy could mock the 'nymphs, the naiads, the hamadryads, the Auroras' preferred by Degas's competitors and the

'strawberry, raspberry and redcurrant ice-cream' colours of their flesh.[158] In contrast to the self-consciousness of Salon models, who 'knew of old the gestures they were expected to adopt', Geffroy argued that Degas depicted women 'who did not know they were being watched'.[159]

The year after the revelation of Degas's 'suite of nudes' at the 1886 Impressionist exhibition, the catalogue of the Salon held at the Palais des Champs-Elysées shows that every type of nude derided by Geffroy and his colleagues was still much in evidence. A *Leda* by Tournier, a *Jeunesse et l'Amour* by Bourgeois, a *Juno* by Blanchard and a *Daphnis and Chloe* by Thomas spanned the mythological spectrum,[160] scenes of nakedness and debauchery lurked behind a number of oriental pretexts[161] and a scattering of pictures toyed with the macabre.[162] In subsequent years the pattern was largely repeated, underlining both the resilience of these pictorial modes and their remoteness from the evolution of Degas's nude subjects. A work shown in 1890, for example Perrault's *Venus* (fig. 174), is at the same time superficially similar to the Degas's *Woman combing her hair* (cat. 44), yet utterly alien in its facture, presentation and purpose.[163] Though Perrault's model is solitary, she directly and flirtatiously engages

the viewers' eyes, her raised arms exposing the nakedness of her breasts and her flimsy drapery accentuating, rather than concealing, her vulnerability. Ostensibly engaged with her toilette, the simpering figure clearly arranges herself for our benefit, attending to her hair without conviction and expressing passivity rather than meaningful action. It was against such works that critics found themselves emphasising Degas's 'austerity' and 'chastity', as well as the contemporary nature of his settings, and it was in the same context that the artist's resistance to allusiveness took shape. Degas would certainly have seen the 1890 show, in a year when colleagues such as Renoir, Whistler, Fantin-Latour, Henner, Braquaval and Maurin were represented, and it may well have been works such as Perrault's that provoked his famous outbursts of irony.

By choosing an extreme case like that of Perrault, we might seem to be overstating the distinctiveness of Degas's later nudes. But even the self-consciously 'modern' bathing and toilette scenes appearing at the Salon in modest but advancing numbers characterise themselves in much the same way. A canvas by J.-F. Ballavoine from the same installation, for example, shows a fashionably athletic young woman abandoning her cloak in unexplained rural circumstances, revealing a stark and open nakedness that derives further piquancy from its title, *The Indiscreet* (fig. 175). In 1891, a certain P. Quinsac fell back on the convenient device of the nude-in-a-studio, combining titillation and topicality in his *Still life* (fig. 176). In both cases the model is seen frontally, a vantage-point encouraging display and engagement rarely chosen by Degas, their allusive titles and evocative surroundings attracting our participation. Quinsac's image is perhaps the most intriguing in the present context, offering precise parallels with the cluttered studio setting in which Degas's own pastels and paintings of the nude were currently being made. Lacking the classical pretensions of Perrault and the theatricality of Ballavoine, *Still life* travels far in the direction of what Maurice Denis called 'the shabbiness of *trompe l'oeil*', towards an ingratiating and all-inclusive realism that Degas actively distanced himself from.[164] The antithesis of his 'art of renunciation', Quinsac's picture reminds us of the extraordinary visual austerity, combined with a resistance to the anecdotal and the technically facile, of Degas's treatment of an everyday artistic event.

Dismissive of the 'invertebrate' and 'pornographic' visual modes of the Salon, Degas evolved a range of pictorial manoeuvres that were neither opaque nor necessary benign, but his emphatic rejection, even his

FIG. 175
J.-F. Ballavoine, *The Indiscreet, c.*1890
From *Salon de 1890, catalogue illustré*

FIG. 176
P. Quinsac, *Still life, c.*1891
From *Salon de 1891, catalogue illustré*

negation, of many of the clichés of the day marked him out from the majority of his peers. When Degas turned his models away from our gaze, he registered a haughty indifference to commonplace eroticism; when he occupied them with believable, everyday tasks, he allowed them their own space and reality, largely independent of our own; and when he presented the 'woman as she is', in Duret's phrase, 'exhibiting all the peculiarities . . . of a body unhealthily paled by town life', Degas spurned the idealisation of the female body that still pervaded the salons and studios of Paris. This refutation of the easy reading was one of the most prodigious undertakings of Degas's last decades, provoking confusion among contemporary admirers and critics, but remaining widely unnoticed or misunderstood today. For some, his relentless depictions of the model and his insatiable curiosity about feminine washing, drying and hair-combing will always be suspect; for others, the acuteness of his later project has become increasingly apparent, allowing a writer such as Gill Saunders to propose that 'Degas's misogyny is actually a refusal to comply with the unwritten rule that the female nude be reduced to a sexual spectacle', and Wendy Lesser to suggest that his pastels of bathers 'give us the original moment of privacy, the first sense of being alone and yet entirely protected from danger'.[165]

We have already noted the systematic exclusion of male figures from Degas's later art, beginning in his bather scenes and extending, in the late 1880s, to the ballet. As with his dance subjects, Degas was able to watch an army of imitators continue the narrative manner of his earlier depictions of the nude in the 1890s. In his cartoons, Jeanniot returned repeatedly to the bather in her tub and the naked *fille* at her toilette, using captions, accessories or knowing glances to spell out her lascivious context or, in such drawings as *The Observer* (fig. 177), specifying the presence of a male client.[166] Forain was equally brash and unsubtle, while Félicien Rops, who was unfavourably compared to Degas by Huysmans in 1896, carried the same *frisson* into book illustration and the limited edition print.[167] Rops's *Le Maillot* of 1893 (fig. 178) features a female nude that steps directly from Degas's repertoire of the mid-1880s, for example the pastel *After the bath*, here transformed by its setting and questionable company.[168] Identified by the remnants of her costume as a dancer, the woman is caught in the act of intimate undressing, a salacious moment almost always avoided by Degas. Watched by a clothed, elderly man, she performs for his entertainment as Degas's monotype prostitutes had done in the mid-1870s, entirely remote from the self-absorbed, banally occupied bathers of the artist's last decades.

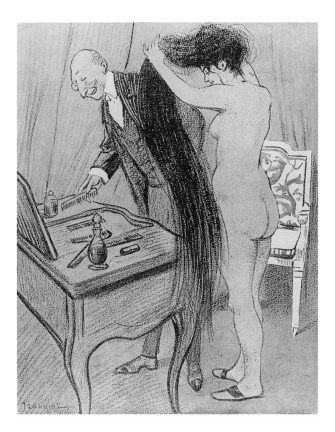

FIG. 177
Georges Jeanniot,
The Observer, n.d.
Reproduction of lithograph,
12 x 15 cm (4¾ x 6 in.)
Private Collection

FIG. 178
Félicien Rops, *Le maillot,* 1893
Etching
Paris, Bibliothèque Nationale

FIG. 179
*The Tub, c.*1896–1901
Pastel on wove paper, 60.6 x 84.2 cm (23⅞ x 33⅛ in.)
Glasgow Museums, The Burrell Collection (L.1098)

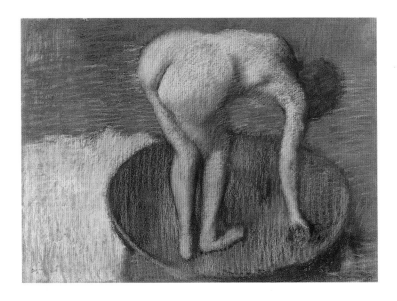

FIG. 180
Jean-Léon Gérôme, *Phryne before the Areopagus,* 1861
Oil, 80 x 128 cm (31.5 x 50.5 in.)
Hamburg, Kunsthalle

A pastel such as *The Tub* (fig. 179) shows the severity of Degas's vision at the turn of the century, divesting the scene of almost every intrusive and descriptive presence, making a virtue of the woman's solitude and a brave, heraldic emblem of her private action. Sensing this evolving austerity, and the distance travelled from the artist's middle period, Théodore Duret had earlier reassured his readers that 'in the art of Degas there is to be found no speck of lubricity, no subtle taste of the unclean'.[169] The same avoidance of display was acknowledged by the artist himself, when he told Jeanniot towards the end of his career, 'Women can never forgive me; they hate me, they feel that I am disarming them. I show them without their coquetry.'[170] The lack of anecdotal distraction in works such as *The Tub* obliged many commentators to confront the nude figure and the manner of its portrayal with an unusual directness. Geffroy's insistence that such scenes represented a 'real naked woman' expressed with 'sincerity and truth' was followed, in 1903, by Camille Mauclair's salute to Degas's honesty in 'seeing things as they are', then Georges Grappe's 1909 claim that the artist 'copied the truth as he saw it'.[171] Still coming to terms with Degas's changed priorities, the same writers were capable of dramatic contradiction, as in Mauclair's suggestion that the nudes were 'abstract' and Grappe's that 'in these later works of M. Degas the subject no longer exists', but their recognition of the altered sexual climate of these same pictures was unmistakable.[172]

This continued uncertainty of response to Degas's pastels was partly prompted by their increased physicality, itself an integral part of their complex pictorial semaphore. Works such as *The Tub* and *After the bath, woman drying her hair* are insistently tactile, their hatchings of colour and bright ribbons of chalk threatening to dominate the picture surface and almost justifying talk of 'abstraction' and the disappearance of the subject. More accurately, this graphic energy reminds us of the synthetic nature of Degas's imagery, directing our attention to the fictive planes of his works of art and constraining their propensity to illusion. In other words, these densely worked pastels are anti-naturalist by definition and design, their technical identity setting them apart from the more finished images of Degas's earlier decades, and at an unbridgeable distance from the refinement of a Carrier-Belleuse or the painterly slickness of a Gérôme. Not only their material density, but the spatial character generated by lines, textures and hues takes us into newly suggestive territory. In *The Tub*, a flat expanse of red-brown denies access to depth, appearing to compress the foreground figure and tilt her metallic tub sympathetically towards the plane of colour. *After the bath, woman drying her hair* is spatially more elaborate, though a comparable dialogue between foreground and imaginative distance, between the descriptive functions of pastel and its independent, granular life, is vividly in progress. As Lynda Nead has imaginatively argued, these practical

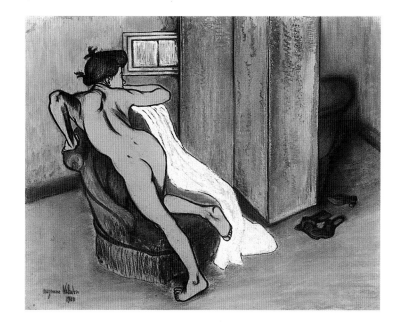

FIG. 181
Suzanne Valadon, *After the bath,* 1908
Pastel on paper, 52 x 64 cm (20⅜ x 25¼ in.)
Geneva, Musée du Petit Palais

considerations are often loaded with sexual significance, Degas's open facture restoring to the female body the 'faltering outlines and broken surface' denied by Western tradition. In this, as in so many respects, Degas undermined the practices and conventions of the nude, allowing the 'wayward' matter of the woman's body its undisciplined existence and giving expression to what Nead characterises as 'female formlessness'.[173]

Jeanniot records one of the few occasions when Degas held forth on the subject of nudity, in a series of observations on Gérôme's painting *Phryne before the Areopagus* (fig. 180):

'Phryne was one of the glories of her times because of the beauty of her body,'
he explained; 'What can one say of a painter who made of Phryne before the
Areopagus a figure of shame who hides her face? Phryne did not hide herself,
could not have hidden herself, because her nudity was precisely the cause of her
glory. Gérôme has not understood and has made of his painting, for this very
reason, a pornographic picture'.[174]

The offence of Gérôme's image was its association of nakedness with embarrassment, reminding us of the exceptional ease and obliviousness of most of Degas's portrayed models. In his chosen example, Degas confronts a scene of overt voyeurism, where a number of clothed men scrutinise a publicly isolated woman, admiring 'the beauty of her body' while reducing her to 'a figure of shame'. Degas's brothel monotypes of two decades earlier had briefly explored such confrontations, only to abandon them definitively, allowing us to see his reflections on Gérôme as a kind of retrospective self-criticism. By removing the male viewer and every trace of a masculine presence from his picture spaces, Degas took an important step in defusing this consciousness of shame and in defying the 'rule that the female nude be reduced to a sexual spectacle'. But it has sometimes been argued that Degas himself, in his role as the omnipresent male artist, fulfilled many of the functions of the pictured observer, implicitly taking the part of Rops's 'client' and vicariously invading the woman's privacy and security. Following the analogy of works such as Gérôme's, it has also been proposed that Degas's pastels presuppose a male audience, a notion that our earlier study of the patrons for such works has thrown into some disarray. When Mrs Potter Palmer gazed at *The morning bath* (cat. 83), when Mary Cassatt enjoyed her abrasive *Woman bathing in a shallow tub* (fig. 58) and when Louisine Havemeyer relished the energetic nudity of *The Bath* (fig. 22), voyeurism was hardly their principal concern. Under similar analysis, even the intrusive but disembodied presence of the male artist seems like sophistry, unavoidable by definition in Degas's case and not obviously distinct in its consequences from the female authorial presence in nude studies by Berthe Morisot, Mary Cassatt or Suzanne Valadon.

There is much work to be done on the sympathetic participation in these new pictorial codes of Degas and the group of female painters with whom he was closely associated, especially on the tempering influence such artists had over his visual behaviour. Mary Cassatt, who later described Degas as 'my oldest friend', included several female nudes and toilette scenes in her pioneering exhibition of colour prints in 1891, sharing with her mentor a preference for oblique viewpoints and the diffuse, unspecific moment in the daily round.[175] Quite distinct, however, in their incisive line and exquisite patterning, at least one of Cassatt's images, *La Coiffure*, presented a full-breasted woman frontally, a presumption that Degas almost invariaby avoided.[176] Suzanne Valadon borrowed even more freely from Degas's catalogue of poses, not just in such familiar scenes as her *Woman combing her hair* (fig. 200) and *Young girl kneeling in a tub* (private collection), but in reworkings of the artist's most violent postures, for example Valadon's 1908 pastel *After the bath* (fig. 181).[177] Both these artists, of course, brought their own exceptional sensibilites to the genre, from Cassatt's fine sense of colour to Valadon's willingness to tackle multiple nude groups and unsentimental scenes of naked children.[178] But it was perhaps Berthe Morisot's approach to the female figure, recently explored in an important book by Anne Higgonet, that most directly impinged on that of Degas himself.[179] In the years before her death in 1895, Morisot was close to Degas both personally and professionally, many of her strictures on the pictorial representation of her own sex appearing to reflect the consonance of their views. Morisot consistently excluded men from

FIG. 182
*Woman after her bath, c.*1900–5
Charcoal and pastel on paper, 61 x 47 cm (24 x 18½ in.)
Chicago, Ursula and R. Stanley Johnson Collection (II, 314)

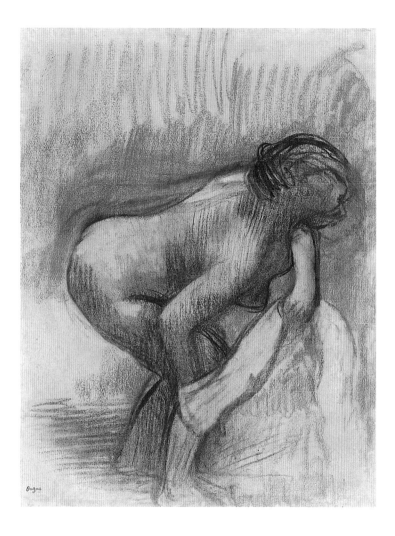

Degas's. As quotations from the texts of critics and colleagues have shown, a number of Degas's supporters struggled to claim his new nudes for the 'classic', and soon writers as various as Maurice Denis, Jacques-Emile Blanche and the American James Huneker shared in the litany.[181] While the shallow spaces and relief-like figure of the Burrell Collection's *The Tub* (fig. 179) might have encouraged them, the same individuals' insistence on Degas's visual 'truth' and their awareness of his technical idiosyncrasy often led them into contradiction. Despite efforts to link some of the later bathers with the antique, even the broadest understanding of classicism, such as that formulated by Denis at about the time *The Tub* was made, can hardly contain the tumbling multitudes of his late repertoire. Arguing for 'a system of subordination', 'an effort of the spirit against the facility of the imagination, the tyranny of the senses', Denis was able to identify with Degas's disciplined commitment and his vigorous mental grasp of his task. But his formulation does no justice to the sheer breadth of Degas's later vocabulary and the artist's continued invocation of observation as well as memory, of particularity and idealisation, of violent movement as much as tranquility. Even allowing for the extraordinary diversity of the classical canon, most of the bathers fail to align with ancient prototypes and many are frankly anti-classical in form and spirit.

The proliferation of Degas's bather images after 1890 might have been calculated to resist easy classification, extremes of both elegance and near-brutality coming within the artist's compass as the years passed. If a sumptuous scene such as the Norton Simon *After the bath* (cat. 48), now dated to the early 1890s, speaks of warmth and luxury, of a well-nourished model and a healthy regime, other pastels and oils exhibit the 'peculiarities' mentioned by Duret, and linger over bodies 'unhealthily paled by town life'. Georges Grappe recognised this breadth of response, suggesting that individual works might combine elements of 'chastity and lasciviousness, of modesty and vice' in a single image, and bravely reproducing *After the bath* in his popular 1909 publication along with ten other nudes from the two previous decades.[182] Such a selection emphasised the muscular and substantial physical types preferred by the artist, from the ample figure in *After the bath* to the more energetic model of *The Toilette* (fig. 169), though neglecting the near-comic obesity of such works as *Two bathers at the water's edge* (private collection).[183] Neither does Grappe deal with the exotic posture of a canvas such as the Philadelphia *After the bath, woman drying herself* (cat. 57), which is hardly consistent with everyday ablution, or the acrobatic presentation of *The bath, woman seen from behind* (fig. 128). These images seem to represent the ultimate and perhaps disquieting pursuit of bodily tension, an 'aversion from every gracious movement' and a 'search for poses that expressed vigorous action', such as those described by Alice Michel, requiring

scenes of nudity and the toilette, suppressing the sexual attributes of her models and averting their gaze from the spectator, 'refusing to provide the visual pleasure of direct access to the female body', as Higgonet puts it.[180] Though Morisot painted relatively few entirely nude figures, this refusal has a direct counterpart in Degas's patterns of renunciation and argues more generally for the ameliorative power of his female acquaintances over Degas's art.

Degas's response to the very different picturing of the female nude in Gérôme's *Phryne before the Areopagus* returns us to an earlier analogy, that between the latter's paintings and sculptures of the dance and Degas's late ballet imagery. Gérôme shared with Degas a commitment to classicism, yet their appropriation of antique forms and values took them in radically different directions, towards a superior type of pastiche in Gérôme's case, towards assimilation and occasional irreverence in

Degas's models to crouch, contort and suspend themselves in considerable discomfort as he explored their exertions from every angle.[184] His *Woman after her bath* (fig. 182), for example, takes us high above the bent figure, her limbs and torso forming angles and intersections that deny any sort of composure. Though still curiously prudish, such studies are among the least flattering depictions of the age, while offering undeniable if uncomfortable truths about the human form.

One of the most misreported of all Degas's observations on the visual language of the nudes is that recorded by George Moore: 'Hitherto the nude has always been represented in poses which presuppose an audience,' the artist remarked, 'but these women of mine are honest, simple folk, unconcerned by any other interests than those involved in their physical condition. . . . It is as if you looked through a keyhole.'[185] Made at the time of the 1886 Impressionist exhibition, this statement is habitually cited in truncated form, its final, seemingly voyeuristic, phrase separated from its earlier context and its sense thereby inverted. Sickert went out of his way to underline the innocence of Degas's meaning, but from the beginning, the press, the public and the critical fraternity has been determined to see it differently.[186] At the end of the present study, therefore, we might reassociate Degas's statement with the historical circumstances in which the pastels were made, or more precisely with the two hundred or so works that evolved in the rue Victor Massé studio in succeeding years. In remarkably literal terms, all these nude studies were posed by 'honest, simple folk' – Pauline, Yvonne and the other models who made their way to Degas's attic storey; apart from the necessary presence of the artist, there was no 'audience' and none was spelled out in the compositions that resulted; and as we know from Pauline's account, 'these women' were largely 'unconcerned by any other interests than those involved in their physical condition', whether it was the coldness of the studio or the dust under their feet, the rigour of their poses or the weariness of their limbs. In much the same way, we know that Degas surrounded his subjects with the furnishings of his own apartment, with screens and textiles like those visible in the photographs of his salon, with the turkey rugs and coloured walls he chose for himself. Predominantly domestic and often as 'bourgeois' as the building in which they were fabricated, these images form a paradoxical projection of the artist's quotidian world.

Degas's personal identification with his later figures of dancers and bathing nudes has already been hinted at, though the subject carries us into the most conjectural, not to say perilous, territory. The idea that Degas represented *himself* in these images of women seems initially absurd, even offensive, until it is set against their peculiarly intense and private genesis. It has often been noted that Degas established a rapport with the ballet and its performers, respecting the young 'rats' for their determination and the prima ballerinas for their control and grace. Sharing many of these commitments in his own craft, the artist watched as his balletic models grew old, recording their heavy limbs and increasingly lugubrious movements with his own ageing arms and through his blunted sight. Degas's bathers, too, seem to reflect his mortality, endlessly 'involved in their physical condition', like the ailing, hypochondriac artist, and often depicted on the very chairs and benches used for his recuperation. With his models, Degas discussed intimate details of health and compared recent symptoms, asking after their friends and relying on them for reassurance when blindness threatened.[187] Two floors below the studio, Degas washed himself every morning, as he told his friends, presumably relying on a tub or zinc bath of the kind that littered his pictures. In this primordial act, he and his models tended their common physicality, both reduced to 'the human animal occupied with itself', as the artist suggested on more than one occasion.[188] Even the prosaic acts of drawing and posing, of stretching to make a mark with the 'feminine' medium of pastel or reaching for a towel, modelling wax or grasping a sponge, have their irresistible analogies, merging the functions of portrayer and portrayed. Known for his propriety with models, Degas established an extraordinary and protracted intimacy with their clothed and unclothed forms, mirroring his own attentive rituals in their professionalism, his bodily consciousness in their vividly depicted carnality.

Perhaps we can never fully come to terms with the sixty- or seventy-year-old artist, living in celibacy and immured under his Montmartre roof, occupying his final days in drawing, painting and modelling a solitary member of the opposite sex. Determined to represent his subject in every state of repose and prostration, from every angle and in every predicament, Degas carried his curiosity and his inventiveness into all but the most private recesses of the woman's world. His pictures are acts of homage and sites of defiance, attempts to know the unknowable, a near-desperate circumvention of centuries of ritual that never entirely breaks with the past. Confronted with his monomania, we may feel awestruck or ill at ease, but it is clear that uncritical admiration and lofty scorn are equally out of place. In the most incisive and sometimes uncomfortable sense, the late bathers are portraits of human nakedness, not just the sentimental outpourings of an elderly man or records of a succession of particularised models. Both Edgar Snow and Wendy Lesser go further, arguing that Degas's pastels encapsulate 'the woman's intrinsic experience' and that, in the presence of one of his nude figures, 'looking at her body enables us, in part, to feel our own bodies'.[189] Whether male or female, these pictures bring us abruptly into the presence of the 'human animal', stripped of almost all ceremony and reminding us, in John Berger's words, that 'to be naked is to be oneself'.[190]

N° **18**. — 3 Mai 1919.

25ᵉ ANNÉE

	France et Colonies	Étranger
Trois mois...	5. »	6.50
Six mois.....	9.50	12.50
Un an.......	18. »	24. »

Les abonnements partent du 1ᵉʳ de chaque mois.

Le Rire

JOURNAL HUMORISTIQUE PARAISSANT LE SAMEDI

40 Centimes

F. JUVEN, éditeur
1, rue de Choiseul, 1
PARIS

Tout changement d'adresse doit être accompagné de 50 centimes.

Copyright 1919 by LE RIRE, Paris

PREMIER MAI

— Chez nous, Maître, pas de grèves...
— Non, mais c'est pis : vous pratiquez le sabotage.

Dessin de JEANNIOT.

THE STREET OF PICTURES

T HE RUE LAFFITTE IN PARIS, where both Degas's principal dealers in later life had their premises, 'was a kind of pilgrim's resort for all the young painters – Derain, Matisse, Picasso, Rouault, Vlaminck and the rest', according to the friend and advocate of many of these artists, Ambroise Vollard.[1] Running due north from the boulevard des Italiens to the lower slopes of Montmartre, this modest street was home to the galleries of Bernheim-Jeune, Vollard and Durand-Ruel, the latter known as the 'second Louvre' to William Rothenstein and his contemporaries. As we have seen, Vollard's diaries and ledgers at the turn of the century confirm the rue Laffitte's shrine-like status, recording visits by Renoir, Cassatt and Degas himself, modest sales to Julie Manet, Camille Pissarro and Emile Schuffenecker, and early purchases from Bonnard, Vlaminck and Picasso, among others.[2] These varied testimonies describe one of the most extraordinary cultural collisions of our era, a confrontation between the Impressionist old guard and the shock troops of the new order that remains largely unexplored to this day. Not just in personal encounters, but in the juxtaposition of their pictures on the walls and in the stock rooms of the rue Laffitte, two or three generations mingled promiscuously and to their mutual satisfaction. Walking the short distance from the rue Victor Massé, 'Degas liked going there when he had finished work for the day', Vollard tells us, perhaps to see exhibitions of protégées and followers, such as Charles Maurin, Henri Rivière, Georges Jeanniot, Henri de Toulouse-Lautrec and Georges Rouault, who in turn would note every appearance of the master's latest work.[3]

What was it that attracted these varied individuals to the 'Street of Pictures', as Vollard also called it?[4] Earlier chapters have shown how younger artists in Degas's entourage had sporadic access to his apartment and studio, even finding themselves present when he worked on current pastels and waxes. Some of them, such as Forain, Jeanniot, Cassatt and Sickert, had known Degas for a decade or more and had become discreet and protective friends, even as they translated his achievement into the idioms of the wider world. Degas's legendary remoteness, a reputation partly generated by the artist himself, kept away many more admirers and brought other relationships to an end, though it failed to discourage the dogged and the disingenuous. Painters as different as Maurice Denis and Suzanne Valadon, and visitors as varied as the critic Dougall S. MacColl and the future mistress of Picasso, Fernande Olivier, breached his defences around the turn of the century, carrying news of Degas's activities and aphorisms to the studios of Paris, London and beyond. By this date, a limited number of facsimiles of Degas's art were also in circulation, such as the copy of the Thornley album owned by the English painter Philip Wilson Steer, as well as a modest range of cheaper prints and photographs. Predominantly, however, such works

FIG. 183
Georges Jeanniot, cover of *Le Rire,* 3 May 1919
Private Collection

159

continued to represent the imagery of previous decades, and almost invariably in monochrome reproduction. Today it is hard to conceive of a time when not a single catalogue, monograph or sumptuous survey of the work of a major Impressionist existed, let alone colour postcards, posters and transparencies of their pictures. Yet this was precisely the situation faced by the young radicals of the day, whose knowledge of their predecessors was uneven at best, arbitrary and outdated at worst. With most of their seniors still unrepresented in institutional holdings, much energy was expended in searching out originals and gaining access to private collections: in order to study Cézanne, they haunted Vollard's gallery; to experience the colours of Gauguin, Rouault was shown a canvas in Degas's apartment; and to encounter the latest productions of Degas himself, these artists made their pilgrimages to the rue Laffitte.[5]

Over-impressed by tales of his reclusivity, we have tended to disregard the impact of Degas's art on subsequent generations. There was no moment of revelation, as with the first solo Cézanne exhibition in 1895 at Vollard's, nor was there a succession of major lifetime shows, like that preceding Cezanne's death in 1906, when the new generation was able to gather in homage. In Degas's case, the only comparable events were the series of massive posthumous *Ventes*, or studio sales, held in Paris in 1918 and 1919 while the effects of the war still paralysed the city.[6] In a sense, the *Ventes* were the great tragedy of Degas's career, too late to influence the generation of the *fin de siècle* and too remote from international events to attract the attention they undoubtedly deserved. Still under-researched as an influence on the 1920s, notably on the Neo-Classical revival in the work of Picasso, these sales sent more than a thousand examples of Degas's drawings, prints, pastels and oils across the globe, fuelling a delayed upsurge in scholarly activity and popular enthusiasm that has scarcely abated since. Before the Ventes, however, there were signs of a quiet and almost unconscious absorption of Degas's later achievement by those around him, whether at first hand, from an isolated picture seen on an apartment wall or, as in the earlier case of Mary Cassatt, through a gallery window;[7] at one remove, from a reproduction or a collection of photographs, like the 1914 Vollard album; or from hearsay and the debased currency of the plagiarist. But, overwhelmingly, it was the repertoire of the 1870s and 1880s that had entered the bloodstream of the capital and continued to flow, if variously adulterated, in the veins of native artists and temporary residents from Britain and the rest of Europe, from America and Japan. Defined by a previous generation, it was Degas the social realist who preoccupied his admirers, and it was his laundresses, café-concerts and scenes of backstage flirtation that most persistently resurfaced in their art.

Future research will unravel more of the complex exchanges between Degas, his immediate colleagues, younger acolytes and the legions of imitators who followed in his wake. Some of these encounters were technical, as in the brief flowering of colour monotypes after the 1892 Durand-Ruel landscape exhibition, the resurgence of pastel in the work of Valadon, Vuillard, Picasso and their peers, or Matisse's passing affection for Venetian red. Others appear to represent a meeting of minds, like that between the classically inclined Denis and the painter of the 'movement of the Greeks', or between Degas and the English master of irony and observation, Walter Sickert. But the most immediate legacy of the mature Degas to these artists was undoubtedly his subject matter, evident in the toilette scenes of Vallotton and Lautrec, the ballet dancers of Gustave Leheutre, Everitt Shinn and Laura Knight, in the women ironing of the Spaniard Pablo Picasso and the Irishman William Orpen, the nude in her tub by Rouault or Vanessa Bell and the *coiffures* of Max Pechstein and Ludwig Kirchner. Essentially superficial, this appropriation of Degas's iconography seems to have preceded a deeper understanding of his methods and purposes, and took little account of the artist's own late abandonment of precisely such themes. Neither does it follow that a laundress or a bathing nude derives directly from a work by Degas himself: it may depend on a motif shared with Renoir, for example, or a 'line stretching back from Bomberg to Sickert to Degas', as Frank Auerbach has said.[8] It is this pictorial inheritance that is the most conspicuous and identifiable pattern of influence, however, and it is this sometimes uncritical trade in motifs that first defines his following.

Degas was an artist's artist, surrounding himself with makers of images of all kinds and establishing many of his most long-standing friendships with fellow-practitioners. Far from aloof in his choice of company, he seems to have gravitated towards talents outside his chosen field or painters of modest accomplishment, keeping a professional distance from distinguished former colleagues, such as Monet, Cézanne and Rodin. Conversely, Degas was at ease with a variety of painters outside the Impressionist circle, from the elderly Puvis de Chavannes to the much-decorated Léon Bonnat, from the perpetrator of 'pornographic' pictures, Jean-Léon Gérôme, to popular image-makers such as Paul Renouard and Albert Besnard. But the diversity of Degas's artistic acquaintance and his familiarity with the young and the obscure, with photographers and illustrators, with the amateur landscapist Henri Rouart and the cartoonist Jean-Louis Forain, with the lugubrious sculptor Pierre-Albert Bartholomé and the artistic jack-of-all-trades Georges Jeanniot, remains exceptional in its breadth. Unsurprisingly, many of these individuals fell under his spell, adopting Degas's themes and graphic mannerisms in their own prints, designs and canvases, and transposing his visual syntax into the vernacular of the age. Forain was both the most successful and the most openly derivative of his intimates, bringing considerable powers of draughtsmanship and a day-to-day

FIG. 184
Jean-Louis Forain, *Painter and model, c.*1923
Pencil, watercolour and bodycolour on paper,
40.5 x 55.8 cm (16 x 22 in.)
London, Courtauld Institute Galleries (Samuel Courtauld Collection)

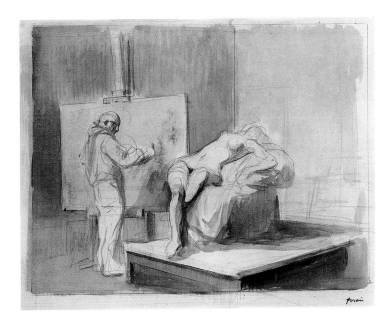

knowledge of Degas's repertoire to his prolific output of lithographs, etchings, gouaches, pastels and oil paintings, as well as his weekly drawings in Le Figaro. Unsure whether to be flattered or appalled, Degas encouraged him and collected his work, while claiming of Forain that 'he paints with his hands in my pockets'.[9]

A lithograph such as Forain's *Leaving the bath* highlights the strengths and weaknesses of his role. One of many hundreds of such prints produced for collectors or published albums, it exhibits the fluency, not to say the slickness, of Forain's mature manner, here applied to a transparently Degas-like motif. The motif in question, a standing nude who is offered a towel by her maid, is characteristic of Degas's art in the 1870s and 1880s, but by the time of Forain's drawing it had largely faded from the older artist's vocabulary.[10] In Forain's countless newspaper and magazine illustrations from the *fin de siècle*, this propensity towards outdated subjects and modes of representation became increasingly evident, as he exploited the salacious possibilities of his chosen genre and fell back on the descriptive codes and literary devices of a naturalism already thirty years old. Working from his studio in the nearby place Blanche, Forain called on his mentor frequently, Degas appearing to enjoy his companionship until the end. Their letters and the reports of contemporaries speak of family gatherings and country excursions in each other's company, of Degas's attention to Forain's children and friendship with his wife, whose remarkable skills as a puppet-maker he admired.[11] It was Forain who was asked to deliver the artist's funeral oration (Degas told him just to say no more than 'He greatly loved drawing') and it was Degas who continued to haunt the illustrator's oeuvre.[12] As late as the 1920s, a watercolour such as Forain's *Painter and model* (fig. 184) still combined painterly panache with a banal eroticism, even as it faintly recalls Degas's *After the bath, woman drying herself* (cat. 57), executed a quarter of a century earlier.

Both Forain and the ex-army officer Jeanniot shared Degas's reactionary views, joining with him against the Dreyfusards and expressing their rabid nationalism and anti-Semitism in a number of caricatures, Jeanniot most savagely in a suite of anti-German prints at the time of the 1914–18 war.[13] Like Forain, Jeanniot best understood the Degas of the brothel monotypes and café-concerts, producing dozens of his own billiard interiors and equestrian scenes, experiments in printmaking and illustrations for the novels of Daudet and the Goncourts.[14] Paradoxically, Jeanniot's greatest importance may have been as host to Degas at the time when the first landscape monotypes were made, during the excursion of Degas and Bartholomé to the Côte d'Or in 1890, and as the chronicler of the artist's last years, in his meandering but informative *Souvenirs sur Degas* of 1933.[15] Jeanniot was also one of the few artists in his entourage to emulate Degas's later

manner directly, producing a series of vividly coloured pastels of the nude that show a knowledge of his mentor's subject matter and studio technique, and some hints of his interpretive originality. Jeanniot's accomplished *Woman combing her hair* of 1890 (fig. 185) exploits the active poses and striated hues of Degas's contemporary bather studies, though his attempt to compete with Degas's fascination with hair appears heavy-handed. It was such pictures that presumably featured in Jeanniot's 1895 exhibition at Durand-Ruel's, about which Degas spoke tersely to Daniel Halévy, and the same gathering confidence that inspired his 1905 pastel *Woman drying herself* (Paris, Petit Palais) one of a select group that points to an awareness of Degas's expressive vigour in the late 1890s.[16]

A cover by Jeanniot for the magazine *Le Rire* of May 1919, executed in his most ponderous manner, sums up the clash of old and new in post-Cubist Paris (fig. 183). Seeking to identify with a venerable, white-bearded painter, surely based on Jeanniot's memories of the recently deceased Degas, a young artist is rebuffed, to be told that it is he and his kind who are 'practising sabotage' against their shared profession.[17] Degas had often reacted violently to the pretensions of *arrivistes*, to their habit of 'talking about art', to the 'young men in long frock-coats who converse with women with lilies in their hands'.[18] His preference was for the dedicated and the respectful: those like Ernest Rouart who were willing to be instructed in the Louvre; like Suzanne Valadon and William Rothenstein, who shared his love of draughtsmanship; or like Georges Rouault and Jacques-Emile Blanche, who delighted in talk of

FIG. 185
Georges Jeanniot, *Woman combing her hair*, 1890
Pastel on paper, 58 x 46 cm (22⅞ x 18⅛ in.)
Paris, Musée d'Orsay

FIG. 186
Eugène Carrière, *Figure seen from behind, combing her hair*, n.d.
Oil, 18 x 24 cm (7⅛ x 9½ in.)
Paris, Musée Rodin

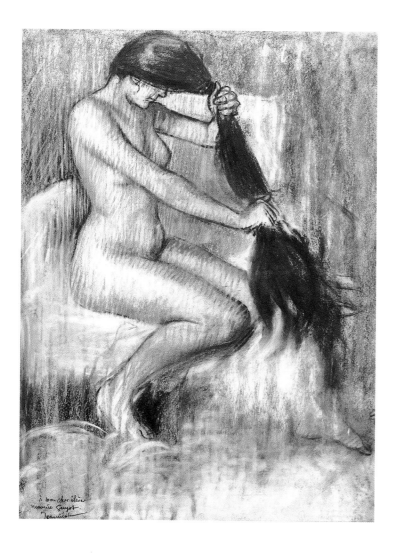

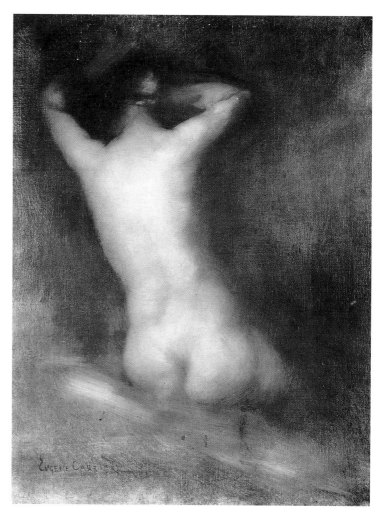

the Old Masters. During a dinner-party in 1891 at the Halévys', Degas was told by Blanche that 'in the history of painting, you will be a pupil of Ingres'.[19] Degas clearly enjoyed the conversation of Blanche, discussing matters of technique, dedicating a drawing to him, acquiring his canvas of *Francis Poictevin* (London, Tate Gallery) and granting him the rare privilege of a portrait sitting in 1901.[20] In his fashionable studies of high society, however, Blanche largely resisted the lure of Degas's example and it was his misjudgement of the artist's temperament, over the question of the 1901 portrait, that led to the rupture of their friendship.[21]

In another after-dinner conversation, Ludovic Halévy demanded Degas's opinion of 'this colour of Carrière's . . . does he see things in clouds?'[22] Eugène Carrière's vaporous and monochromatic paintings, such as *Figure seen from behind, combing her hair* (fig. 186) were widely

admired at the turn of the century, when he was fêted by the Symbolists and showered with official honours. Apparently attracted by Carrière's manipulations of light and shade, which approximated to his own obsession with the *ébauche* and the tonal underpainting, Degas 'never lost an opportunity to proclaim Carrière one of the great painters'.[23] What is equally apparent is Carrière's awareness of the recent work of Degas, not just in the monotype-like swirls of deep umber on his canvases but in the range of his favoured motifs. A succession of paintings of large, active female bathers, typically seen from behind, such as *The Toilette*, (Paris, Musée d'Orsay) and often attending to their hair, as in the *Figure seen from behind, combing her hair* formerly owned by Rodin, tell their own story, while Carrière's less well-known landscapes seem directly dependent on Degas's 1892 Durand-Ruel exhibition.[24] A number of such figurative artists benefited from Degas's growing celebrity, offering

Henri de Toulouse-Lautrec, *La Coiffure*, 1893
Lithograph, 31.5 x 23.9 cm (12⅜ x 9⅜ in.)
Paris, Bibliothèque Nationale

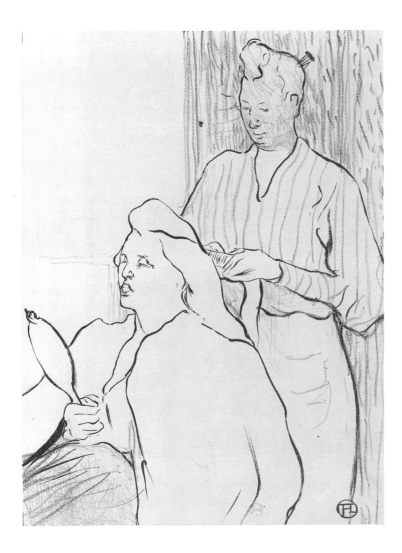

It is noticeable that these and many other popularisers of Degas's imagery were active makers of lithographs, aquatints, drypoints and easily reproduced designs of all kinds. Perhaps the most familar case is that of Henri de Toulouse-Lautrec, who 'regarded Degas as his master' and covered Paris in posters and music-hall programmes, illustrations and albums of prints that amounted to an extravagant public homage to his predecessor.[27] From his studio in the rue Fontaine, a few steps away from the rue Victor Massé, Lautrec's world overlapped with that of Degas and by the late 1880s they had met through a mutual acquaintance, the musician Desiré Dihau.[28] In 1891, Lautrec told his mother that 'Degas has encouraged me by saying my work this summer wasn't too bad', in subsequent years attempting to introduce other friends to the artist with the warning, 'he's quite unapproachable'.[29] A personal visit to Degas's studio may conceivably lie behind Lautrec's painting and lithograph *La Coiffure* (fig. 187), an image close to the National Gallery's *Combing the hair* (cat. 42), hinting at a date before 1893 for the latter canvas.[30] Degas told Rothenstein that he was 'interested' in his disciple's work, though he failed to acquire examples for himself and appears to have shared the doubts of his colleagues about Lautrec's importance.[31] A characteristic study of mid-decade such as *Woman fastening a corset, passing conquest* has all the 'facility, the manual skill, the charm' that Blanche identified in Lautrec's manner, while dealing bluntly and unpityingly with his chosen subject; comparing such works to Degas's monotypes, Renoir claimed 'Lautrec's prostitutes are vicious . . . Degas's never'.[32]

A robust charcoal and pastel drawing by a former friend of Lautrec's, Theo van Rysselberghe, *Woman leaving the bath* (fig. 188), reminds us of the persistence of Degas's motifs, materials and spatial structures in several European centres after the turn of the century. In this study of 1913, the Belgian artist recalled such works of Degas's as *The morning bath* (cat. 83) or *Woman taking a bath*, both of which had passed through Durand-Ruel's hands during these years, the latter also appearing as a reproduction in Grappe's 1909 monograph.[33] Other acquaintances of Lautrec and van Rysselberghe's emphasise the extraordinary breadth of Degas's appeal, not just to latter-day realists but to Symbolists and Nabis, divisionists and classicists, as well as decorators, photographers and sculptors. Another colleague of Lautrec's, François-Rupert Carabin, was one of few to tackle the ballet dancer in three dimensions, boldly choosing wax and producing a number of sequentially related statuettes that argue for an intimacy with Degas's sculptural oeuvre.[34] His *Ballerina* (fig. 189), shown at the Salon in 1898, exemplifies the uncomplicated and good-humoured naturalism of many of Carabin's designs, though revealing little of the eroticism of his carvings, photographs and certain other waxes.[35] Carabin's work

his motifs to the public in more palatable form or adding their own distinctive piquancy. We have already encountered Paul Renouard and Louis Legrand, both achieving considerable renown with their frankly eclectic prints and illustrations of the ballet. Degas was remarkably tolerant of Renouard, gently mocking his 'express draughtsmanship' that 'left nothing to the imagination' but respecting his professionalism.[25] Etchings such as Legrand's *Stretching* on the other hand, follow a now-familiar pattern, fusing the realism of the 1870s with a touch of *fin-de-siècle* abandon, though avoiding the blatant eroticism of his teacher Félicien Rops. The successful painter and etcher Albert Besnard, who Degas considered 'a true talent', specialised in dramatic and sometimes macabre studies of the female nude, rarely achieving the lightness of touch of his elders; 'He is a man who tries to dance with leaden soles', Degas remarked.[26]

FIG. 188
Theo van Rysselberghe, *Woman leaving the bath,* 1913
Pastel on paper, 66 x 51 cm (26 x 20⅛ in.)
Geneva, Musée du Petit Palais

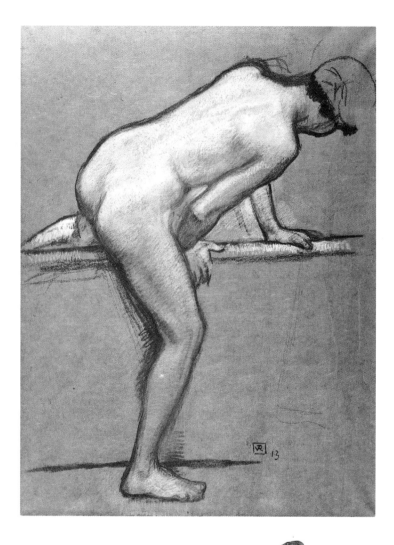

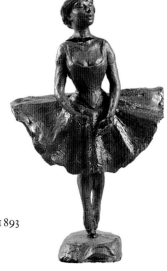

FIG. 189
François-Rupert Carabin, *Ballerina, c.*1893
Wax, 21.2 cm (8⅜ in.) high
Musée de la Ville de Strasbourg

was exhibited by both Durand-Ruel and Vollard, the latter also emerging as the champion of van Rysselberghe's painter-sculptor associate, Aristide Maillol.[36] In his small bronze *Kneeling bather*, Maillol encapsulates the subject of dozens of Degas's pastels, as well as crouching figures by Gauguin and Renoir, motifs from Puvis de Chavannes and canonical sculptures from the galleries of the Louvre. Though apparently unknown to him personally, Maillol was explicitly linked with Degas in the writings of their mutual friend Maurice Denis, who admired in both their 'art of synthesis' and their 'gift of classicism'.[37]

Maurice Denis's association with Degas and his attempts to claim the ageing painter for his new aesthetic have been touched on in previous chapters, though the importance of Degas's imagery for Denis's own still awaits an extended study. For more than a decade after their first meeting in the early 1890s, Denis frequented the studios and soirées of Degas's acquaintance, noting the pastel *Woman in the tub* (fig. 163) during evenings at the Lerolles' and familiarising himself with *Nude woman having her hair combed* (fig. 95), the picture that reappears in the background of his *Portrait of Degas* (fig. 4), at the critic Roger Marx's. Such images were openly quoted in Denis's own pastels and oil paintings of the period, though he seems to have attended equally to Degas's aphorisms;[38] in Denis's essays and journals, the emphasis on drawing, the reverence for Ingres and the invocation of the classical past are pervaded by Degas's known views, while the older artist's claim that 'a picture is above all an original combination of lines and colours that make themselves felt' anticipates Denis's more celebrated rhetoric.[39] To his lasting credit, Denis was one of the first to sense the changed priorities of Degas's later career, identifying with its rejection of the 'false theory' of naturalism and aspiring to a similar art of 'indefinable cohesion' that is 'made of sacrifices'.[40] Denis's early masterpiece, *The Muses* of 1893 (fig. 190), exemplifies the manner in which the most thoughtful of Degas's admirers responded to his maturing sensibility without merely reiterating his motifs. Instead of ballet dancers we see clusters of young women in a park, in place of scenery we find schematic trees, but the rhythmic orchestration of figures and their fusion with the 'flat surface covered with colours assembled in a certain order' offers the closest analogies with a contemporary work such as Degas's *Dancers, pink and green* (cat. 31).[41]

Apart from his cautious encouragement of Denis, we can only be baffled by Degas's apparent lack of interest in, even his violent distaste for, the art of the Nabis. According to Pissarro, Degas joined with Renoir, Monet and others in describing as 'hideous' Bonnard's first exhibition at Durand-Ruel's in 1896, and Sickert tells us of the artist's criticism of the 'school of Vuillard' in a haughty aside.[42] Our perplexity

FIG. 190
Maurice Denis, *The Muses,* 1893
Oil, 171.5 x 137 cm (67½ x 54 in.)
Paris, Musée d'Orsay

is deepened when Degas's personal tolerance of the individuals concerned is noted and when their pictorial tributes to his compositional skills, colour and earlier domestic themes are acknowledged. As artists of Vollard's 'stable', all were invited to dine in the notoriously damp 'cellar' of the dealer's rue Laffitte premises, where the very mixed company might include Redon and Rouault, Forain and Renoir, occasionally even Cézanne.[43] A painting by Bonnard shows Degas at a crowded table on one of these occasions, while a delightful drawing by the same artist (fig. 191) brings together Renoir, Pissarro, Degas and Vollard himself in the dealer's chaotic mezzanine, with Bonnard hovering nervously in the background.[44] This intimacy of contact with their predecessors is often palpable in Nabis works, where studies of the nude, informal portraits, lamp-lit interiors and vertiginous street scenes spell out the inheritance of the younger generation. Belinda Thomson has cited several cases from Vuillard's writings of his declared response to Degas's imagery, endorsed in the early twentieth century by Vuillard's acquisition of the pastel *Dancer with a fan* and the inclusion of Degas's *Woman seen from behind, drying her hair* (cat. 56) in the background of a family portrait.[45] Bonnard, who used a studio not far from Degas's, also owned one of his pastels, the highly unusual *Clothes on a* chair, while such drawings as his own *Bending female nude on sofa* are a clear response to Degas's mainstream vocabulary.[46] Works of this kind, however, were hardly calculated to please Degas himself, who seems to have deplored the triviality of much Nabis subject matter; when he mocked the 'school of Vuillard', it was the pretensions of their still lifes that he had in mind, while the only Nabi picture Degas is known to have admired was, significantly, a grandiose figurative canvas by the classicist Ker-Xavier Roussel, a *Triumph of Bacchus*.[47]

In stark contrast to his dealings with the Nabis, Degas was famed for the catholicity of his taste and his indulgence toward the young; 'Not that he showed any mercy for their pictures or their theories', Valéry tells us, 'but he carried out his demolitions with a sort of tenderness that blended very oddly with his ferocious irony. He went to their shows; took note of the smallest sign of talent; and if the artist was about, he would pay him his compliments and give him a few hints.'[48] Despite his support, some of Degas's protégés, such as Charles Guéroult, sank without trace; though Degas bought examples of their work, Phillipe-Charles Blache and Louis Braquaval went on to limited success; while among his youthful acquaintances Ernest Rouart, Julie Manet and Jeanne Baudot fared little better. In his 1912 monograph, however, Paul-André Lemoisne confirms the accessibility of the elderly painter to 'old friends and young artists' and the 'considerable influence' Degas still exercised over the practitioners of the day.[49] By this date, the commerce of the rue Laffitte had been transformed by escalating prices and radical

FIG. 191
Pierre Bonnard, *Vollard in his gallery,* detail, *c.*1910
Pencil and ink on paper. Private Collection

FIG. 192
Walter Sickert, *Interior with nude,* 1914
Oil, 50.8 x 40.8 cm (20 x 16 in.)
Manchester City Art Galleries

FIG. 193
William Rothenstein, *The Toilette,* 1924
Oil, 92 x 77 cm (36¼ x 30¼ in.)
Leicestershire Museums, Arts and Records Service

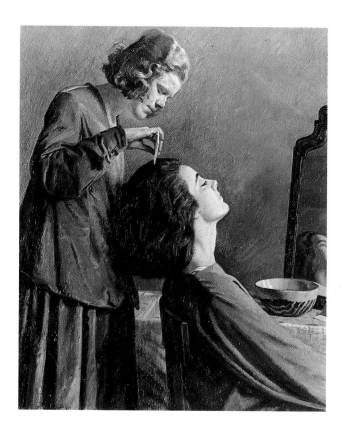

new talent, as well as by an unprecedented influx of collectors, entrepreneurs and visiting artists from abroad. The prospective purchasers now haunting Vollard's were as likely to be from America, like Leo and Gertrude Stein, John Quinn or Dr Barnes; from Germany, like Paul Cassirer and Count Harry Kessler; or from Scotland, like Alexander Reid and William Burrell; the fresh faces were soon to belong to painters like the American Edward Hopper, the Dutchman Piet Mondrian, the Italian Gino Severini or the Russian Marc Chagall, all of whom visited Paris before the war; and the painter making the short pilgrimage to the rue Victor Massé, or consulting the 'second Louvre' at Durand-Ruel's, was as likely to be from Britain, like William Rothenstein, Philip Wilson Steer or the artist-critic D.S. MacColl.

In no other country outside France did Degas's art have such a direct and turbulent effect as that which it produced in England, and in few other contexts did the transition between his early and late phases create such confusion. The story is a protracted one, but it can be summarised around the exhibition of Degas's picture *L'Absinthe* (Paris, Musée d'Orsay) at the Grafton Galleries in London in 1893.[50] The work had been painted in the mid-1870s and was one of a number to cross the channel during that decade on a wave of enthusiasm for Degas's scenes

of the racetrack, the ballet and the urban milieu. During the 1880s, *L'Absinthe* was in a private collection in Brighton, at a time when advocates of Impressionism such as Walter Sickert and George Moore were vigorously promoting the new art, often choosing Degas as their champion. When it re-emerged in 1893, the canvas caused howls of protest from those who described it as 'two rather sodden people drinking in a café', but prompted an answering chorus of support from painters and critics.[51] The irony of the situation, once again, was that Degas had long since rejected such subjects in his own art, a fact that only those conversant with his recent pastels and oils could have known. Here the testimonies of the English visitors to his Paris studio became crucial; George Moore, already banished from Degas's company for his indiscretion, sprang to the artist's defence, emphasising his disciplined draughtsmanship and reverence for Ingres;[52] D.S. MacColl, introduced to the rue Victor Massé apartment by Sickert in the early 1890s, wrote a series of lucid articles, arguing that 'it is the dignity of the performance that matters, not the subject';[53] and even the conservative, but remarkably well-informed, Charles Whibley spoke well of *L'Absinthe*'s 'impartiality' and 'severity'.[54]

A slightly earlier article by Whibley presented to his British readership one of the most acute accounts of Degas's mature art yet

FIG. 194
Philip Wilson Steer, *Bathsheba*, c.1919–21
Oil, 66 x 50.8 cm (26 x 20 in.)
London, Tate Gallery

FIG. 195
Laura Knight, *Three graces of the ballet. Dressing room*, 1926
Etching, 35.3 x 24.9 cm (13⅞ x 9¾ in.)
London, William Weston Gallery

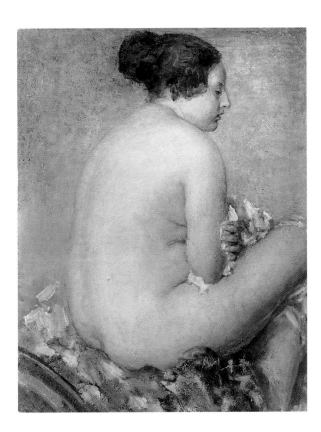

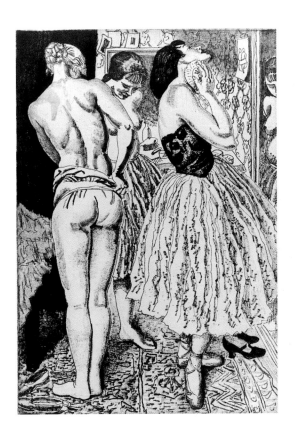

published, moving beyond a simplistic naturalism and towards a recognition of the artist's newly transformed ambition. Writing in 1891, the critic described how city themes 'suggest to Degas infinite combinations of line and colour. He sees half-a-dozen ballet-girls pirouetting down the stage, and straightway invents a new harmony . . . A nude woman, stooping in a tin bath to refill a sponge, is fashioned with an almost classic severity.'[55] Referring at this early date to Degas's production of 'tiny ballet-girls of wax', Whibley embodied the breadth of current awareness in London and summarised the challenges to the artist's many English followers. Like the published criticism, the responses of practical painters were sometimes informed by first-hand contact, as often outdated or contradictory. Able to claim a personal friendship of many years standing, Walter Sickert took it upon himself to propound and illustrate his mentor's greatness, both through his writings and through countless reworkings of Degas's motifs in the English idiom. For Sickert, the music hall stood in for the café-concert, the Big Top for the Cirque Medrano, and the bedrooms of Camden Town for the garrets of Montmartre. More than Degas, however, Sickert remained wedded to his metropolitan surroundings and it is only in later works, such as the 1914 *Interior with nude* (fig. 192), that a greater exapansiveness is evident, here combining elements of both the ballet

and bather strands of Degas's repertoire. Continuing to visit the rue Victor Massé until shortly before the Great War, Sickert recorded his memories of Degas in brilliant, idiosyncratic prose that brings us as close to the man as anything written.[56]

More ponderous are the recollections and acts of homage of William Rothenstein, whose 1924 painting of *The Toilette* (fig. 193) seems to be a delayed restatement of an image remembered from the Montmartre of twenty years earlier, perhaps stimulated by the illustrated catalogues of the Degas *Ventes*.[57] Almost as idiosyncratic are artists such as Wilson Steer and Laura Knight, the former's painting of *Bathsheba* (fig. 194) looking back to the nudes of the 1880s and the latter's spirited *Three graces of the ballet. Dressing room* (fig. 195), one of hundreds of dance pictures made by Knight, projecting Degas forward into the stylish 1920s. Other British followers include the intriguing John Copley, whose lithograph *Pas de ballet: Musicians No. 2* of 1911 recalls the multiple postures of the Cleveland *Frieze of dancers* (cat. 16), while anticipating the abstract dynamism of Futurism and Vorticism.[58] Though stepping into a new era, David Bomberg's Russian Ballet prints emerge from the same lineage, here invigorated by the Ballets Russes, as Bomberg acknowledged when he described his 'Degas–Sickert affinity' in 1909.[59] A similar affinity seems to lie behind much progressive British art of this

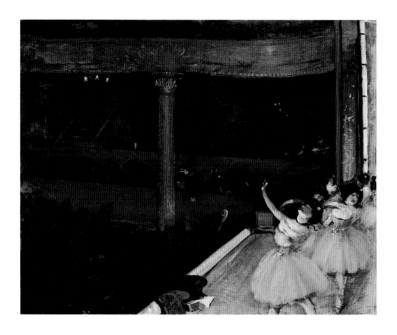

FIG. 196
Maurice Sterne, *Entrance of the ballet, c.*1904–5
Oil, 66 x 82.6 cm (26 x 32½ in.)
Detroit Institute of Arts, Gift of Ralph Harman Booth

FIG. 197
Max Pechstein, *Girl combing her hair,* 1910
Oil, 72.5 x 73.2 cm (28½ x 28¾ in.)
Philadelphia Museum of Art,
Purchased with the J. Stogdell Stokes Fund

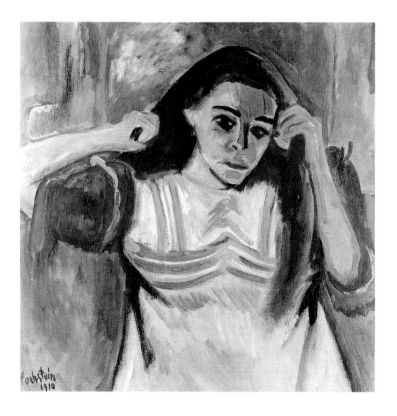

period, if merged inextricably with other continental enthusiasms. From Gaudier-Brzeska's sensuous early *Dancer* (London, Tate Gallery) to the nudes and portraits of the Bloomsbury circle, a more radical sense of Degas's significance makes itself felt in steep perspectives and bold design, as well as frankly eclectic subject matter. Vanessa Bell's audacious *The Tub* of 1917 (London, Tate Gallery) brings an awareness of Cubism and the innovations of Matisse to one of Degas's most distinctive themes, defusing the intimacy of his pastels in broad expanses of colour. Duncan Grant's respect was expressed in comparable canvases, as well as in a personal crusade to persuade the National Gallery to buy pictures for the nation at the Degas *Ventes*.[60] Though his art quickly absorbed these influences, the English Futurist C.W.R. Nevinson admitted that 'I had already devoured, by the age of fifteen, the books of Camille Mauclair on Renoir, Manet, Degas . . .'[61]

A similarly free-ranging approach to Degas's achievement can be found in the work of these artists' transatlantic peers, another group of enthusiasts who will repay further study. Conversant with Impressionism from sporadic shows in American cities and sojourns in Paris, London and Berlin, painters such as Edmund Tarbell, William Merritt Chase and Everett Shinn seized on Degas's techniques of composition and his still-provocative urban themes. Mary Cassatt's mediation can never be underestimated, nor can the aggressive marketing of Degas's pictures in the United States by Durand-Ruel and the evangelical efforts of such collectors as Louisine Havemeyer and Mrs Potter Palmer. Chase's pastel portraits, Tarbell's painting of a nude at her tub, *The Bath* of 1893 (location unknown), and Shinn's steep perspective views of the stage all testify to their new-found fluency in Degas's syntax, typically combining a quasi-academic craft with a fashionable or topical motif.[62] Like Sickert, Everett Shinn transposed Degas's café-concert designs to his native soil, in his case the music-halls of New York, producing the socially descriptive but visually abrupt *The orchestra pit, Old Proctor's Fifth Avenue Theatre* as late as 1906.[63] But it is in Maurice Sterne's *Entrance of the ballet* of 1904–5 (fig. 196) that some acknowledgement of Degas's later manner can perhaps be discerned. Sterne spent some years in Paris at this time, where he was baffled by Cézanne but clearly overwhelmed by Degas, whom he met dressed in a 'rather shabby old cape' at the Salon d'Automne of 1905.[64] Sterne's deeply defined space recalls the theatre scenes of the 1870s, while an explosion of blue dancers in the foreground proposes an awareness of Degas's luminous oils and pastels of recent years or even months.

At the beginning of the twentieth century, Degas's pictures often found their way into the enormous international exhibitions then in vogue, not infrequently beside works of younger and more clamorous colleagues. After the 1905 celebration of Impressionism at the Grafton

Galleries in London, organised by Durand-Ruel and described as 'overwhelming' by a contemporary British critic, London's artists could no longer plead ignorance of his later oeuvre.[65] Though few of Degas's thirty-five submissions have been firmly identified, about a dozen were dated in the catalogue to the 1890s or later, and a pastel such as *In the rehearsal room* (fig. 36) revealed the breadth of his later facture to British audiences.[66] Despite his following in England, Degas was perversely excluded from the seminal 1910 *Manet and the Post-Impressionists* exhibition by Roger Fry, who had yet to progress beyond a grasp of the artist's 'ironic vision of the factitious life of our cities', as he wrote at the time.[67] In 1913, however, three of Degas's pictures contributed to the sensational display of the New York *Armory Show*, where his *After the bath* (cat. 48) shared the walls with works by Gauguin and Cézanne, Picasso and Braque, Brancusi and Duchamp.[68] As we have seen, by this date several pastels from Degas's later years were also considered to be compatible with the major Matisse collection of Ivan Shchukin in Moscow, and the beginnings of a taste for his mature manner were discernible in other European capitals. The advocacy of Max Liebermann and Paul Cassirer in Germany had helped to alert their compatriots to Degas's later vocabulary, while first-hand contact with his work in Parisian galleries clearly impressed the emergent Expressionist generation. Liebermann's slim volume on the artist published in 1902, which includes several reproductions of pastels from the 1890s, is that rarest of things, a written celebration of one painter by his contemporary, and the drawings, pastels and oils of painters such as Kirchner and Max Pechstein (fig. 197) offer their more energetic tributes to Degas's later final achievement.[69]

At the time of the 1904 Salon d'Automne, Degas is reported to have said, 'Oh yes, they can all paint, these boys, not pictures, but stripes on a zebra'.[70] Typically paradoxical, Degas's remark coincided with his friendship with one of the most abrasive technicians in the group close to the Fauves, Georges Rouault. Like Matisse, Rouault had studied with Gustave Moreau, the friend of Degas's youth, and had later become curator of Moreau's studio-museum on the rue de la Rochefoucauld, a street or two away from the rue Victor Massé. Meeting Degas in 1903, Rouault discovered an unexpected rapport with the elderly artist and responded imaginatively to his practical guidance and pictorial history.[71] Though seemingly improvised, even barely controlled, Rouault's ink, gouache and pastel *Nude woman* of 1906 (fig. 198) proceeds from a monochrome draft to a coloured resolution, conforming to Degas's lifelong practice and the craft they discussed together at this time. Still obsessed by Ingres (his 'religion for Dominique' as Rouault called it), Degas was apparently able to see Rouault's circus, ballet and brothel scenes as an extension of his own earlier graphism, an 'informed

modernism' that could co-exist with his 'regretted classicism', and was to bequeath his printing press to the younger artist.[72] Works such as Rouault's *Nude woman* and *At the Bal Tabarin (Dancing the Chahut)* (fig. 11), bring a grittiness and desperation to Degas's long-abandoned urban motifs, not just wringing out their remaining vigour as Forain, Jeanniot and Legrand had done, but breathing new life into them from his own age. Like the most astute and informed of Degas's followers, Rouault soon progressed to subjects of his own, though always prepared to defend the reputation of his 'wicked' friend and, like him, aiming to 'amplify his style' and 'return to form through constant corrections'.[73]

As yet, little is known about the mutual estimation of Degas and Rouault's fellow-Fauve, Henri Matisse, though the contiguity of their social and professional lives is marked.[74] Apart from links with Moreau and Rouault, Matisse was familiar with Jeanne Baudot, a youthful visitor to Degas's studio, admiring her painted copy from Delacroix in 1900, and had contacts of various kinds with Degas's colleagues Pissarro, Carrière and Monet.[75] Matisse had been one of the exhibitors at the 1904 Salon d'Automne at the time of Degas's outburst, though by this date he had also shown at Berthe Weill's gallery in the rue Victor Massé and was soon to appear at Vollard's. Given Degas's acquaintance with his work we might expect a measure of sympathy between the two painters, in their shared veneration for draughtsmanship and for Ingres (Matisse had copied an *Odalisque*), for the female nude and for certain materials and practices. Matisse's 1907 study of bathers in a landscape for *Le Luxe I* (Paris, Musée National d'Art Moderne), executed in charcoal on tracing paper, might be a technical and thematic tribute to Degas, like Rouault both acknowledging and reformulating his earlier vocabulary. Even more dramatically polarised is a drawing such as *Study for 'The Dance (II)'* of 1909 (fig. 157), its endlessly erased outlines the result of 'constant corrections', its subject explosively liberating Degas's ballerinas from half a century of constraint. As if to recognise another debt and perhaps a visit to Degas's studio, Matisse was later to acquire the *Combing the hair* now in the National Gallery (cat. 42), a bravura exploration of reds and browns that anticipated several of the younger artist's canvases by a decade or more.[76] In *Harmony in red* (St Petersburg, Hermitage Museum), Matisse echoed the tonality of Degas's picture and introduced his distinctive figure of a standing maid; *The red studio* (New York, Museum of Modern Art) takes planarity several steps further; and in the so-called *Nude with a white scarf* of 1909 (fig. 199), which shows a model draped with a towel, Matisse appears to salute Degas's drawing, subject matter and chromaticism in a single brazen image.

'No sound artist ever looked except with scorn at these cubists and Matisse', wrote Mary Cassatt in 1913, explicitly comparing their current public reception to the moment when 'Degas and Monet, Renoir and I

FIG. 198
Georges Rouault, *Nude woman*, 1906
Ink, gouache and pastel on paper, 29 x 26 cm (11⅜ x 10¼ in.)
Copenhagen, Statens Museum for Kunst

FIG. 199
Henri Matisse, *Nude with a white scarf*, 1909
Oil, 116.5 x 89 cm (45⅞ x 35 in.)
Copenhagen, Statens Museum for Kunst

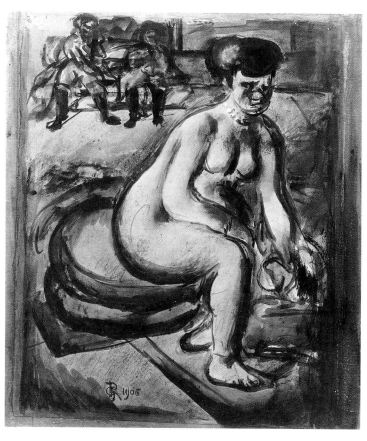

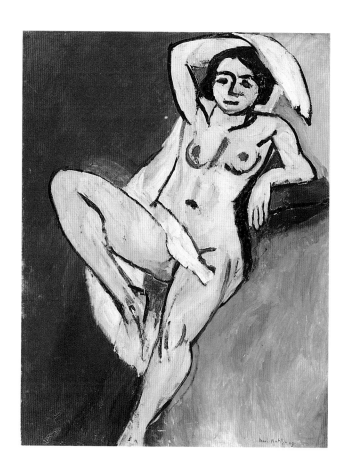

first exhibited'.[77] Jealous perhaps of her friendship with Degas, Cassatt seems to have been indifferent to the art of Suzanne Valadon, in many ways her successor and another figure who bridged the generations. Valadon worked as a model for Puvis de Chavannes, Renoir, Zandomeneghi and others, but her own forceful drawings, such as *Woman combing her hair* (fig. 200) soon brought her to the attention of Degas, who kept one of her works on his apartment wall.[78] Over many visits to the rue Victor Massé in the 1890s, Valadon was taught printmaking by Degas, assured of her 'rare talent' and often encouraged to arrive with 'a box of beautiful drawings'.[79] As she became a *habitué* of Old Montmartre, Valadon remained largely independent of the factions that came and went, while absorbing something of the linear and colouristic drama that unfolded around her. If her earlier studies of the toilette are indebted to the domestic side of Cassatt and Degas, her mature pictures, such as the remarkable pastel *After the bath* (fig. 181), show an unsentimental, almost a violent fascination with the nude that both derives from and sometimes exceeds Degas's own. In her paintings, Valadon applied the lessons of Cézanne and Gauguin, the harshness of Picasso and the lyricism of Matisse, typically containing them within her

distinctive, muscular outlines. Though never part of the Bateau-Lavoir circle, she knew and was admired by Apollinaire, Jacob and Derain; lived in the same building as Georges Braque around 1909;[80] and painted the critic Gustave Coquiot, who was portrayed in a portrait by Picasso and later wrote a book on Degas.[81]

There are many satisfying reasons for bringing this brief survey of Degas's influence to an end with the figure of Pablo Picasso. Protean as artists, prodigious in their mastery of line, tone and sculptural form, and both devoted to and tormented by the representation of women, Degas and Picasso stand back-to-back at the turn of the century, like two sides of the modernist coin. They knew each other's art but, tantalisingly, not each other, moving through the same streets and galleries, sharing acquaintances such as Louis Rouart, Ivan Tschoukine, Fernande Olivier and Suzanne Valadon, but never personally confronting their exceptional and historic affinity. One of Picasso's earliest exhibitions took place in 1902 at Berthe Weill's gallery, a few doors from Degas's apartment on the rue Victor Massé.[82] Though the anti-Semitic Degas avoided Weill's shows, he must have registered the event and heard of some of the exhibits, such as the pastel *At the café-concert* (Paris,

FIG. 200
Suzanne Valadon, *Woman combing her hair, c.*1905
Crayon on paper, 25.7 x 19.7 cm (10¼ x 7¾ in.)
Pittsburgh, Carnegie Museum of Art, Leisser Art Fund

FIG. 201
Pablo Picasso, *Woman ironing,* 1904
Oil, 116.2 x 73 cm (45¾ x 28¾ in.)
New York, Solomon R. Guggenheim Museum, Thannhauser
Collection, Gift of Justin K. Thannhauser 1978

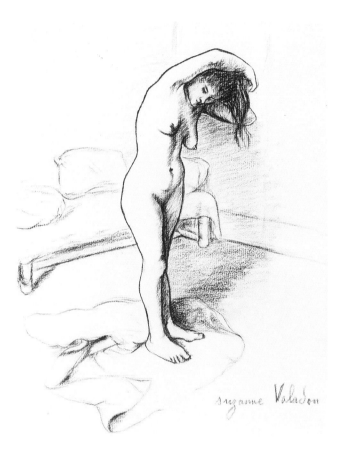

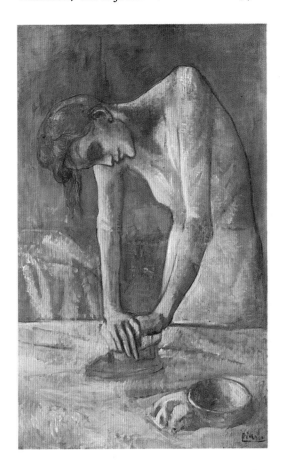

Berggruen Collection), with its high-kicking dancer in a setting not unlike *L'Absinthe*.[83] Throughout these formative years, Picasso feasted himself on Degas's subjects and draughtsmanship, whether consumed at first hand in the rue Laffitte, tasted in the work of imitators, like Forain, Steinlen and Toulouse-Lautrec, or sensed from afar through the mediation of Valadon, Olivier and others. Picasso's studies of girls at their toilette, his circus performers, dancers, bathers, prostitutes, singers, milliners and horsemen, show him determined to digest the achievement of his predecessor, just as he devoured the work of Cézanne and El Greco, Iberian art and African carving during these years. And as with Matisse, Degas's famed versatility provided a model for Picasso's emerging self-image, an elderly personification of the sculptor, draughtsman, printmaker and painter the young Spaniard was soon to become.

Dozens of seminal pictures from the pre-Cubist era bear witness to Picasso's absorption of the art of Degas, as well as his confident, often flagrant, attempts to defy his father-figure. His forlorn *Woman ironing* (fig. 201) unashamedly acknowledges its source in one of the many Degas laundress images currently in circulation, while announcing a new

talent and the taking of new visual liberties.[84] Just as Rouault had reinvented a Degas nude in the language of Montmartre, so Picasso claimed a laundry-girl for his own bleak, proletarian vision, wrenching her figure into the picture plane and blasting away the last trace of Impressionist colour. Beyond such direct acts of expiation, Picasso too learnt to value the formal originality and chromatic verve of Degas's last phase, pushing further the multiple perspectives of the *Frieze of dancers* (cat. 16) and *View of Saint-Valéry-sur-Somme* (cat. 99) and the anatomical latitude of the late bathers. The solemnity of his task was not invariable, however, as Picasso and the assorted misfits of the Bateau-Lavoir took refuge in caricature and irreverence, as well as their game of 'doing a Degas', when the grossest language was wrapped in 'the most exquisite courtesy'.[85] In later years, Picasso returned voraciously to the classicism of the pastel dancers and the eroticism of Degas's brothels, to the improvised sculptures and anarchic prints, accumulating a superb collection of monotypes and introducing the figure of Degas himself into a suite of etchings.[86] And the traffic in admiration and irony was not just one-way; going into an unspecified early exhibition of Cubist painting, Degas is said to have quipped, 'It's harder to do than painting'.[87]

THE CATALOGUE

THE YEARS OF TRANSITION

Between 1880 and 1890 – effectively the middle years of his life – Degas's art underwent a slow, deliberate and radical transformation. Not just the pictures themselves, but the circumstances in which they were made, the techniques involved in their fabrication and the means of their dispersal into the wider world were fundamentally recast, along with their relationship to the artist's visual surroundings. Though some of Degas's subjects remained familiar, notably his representations of the ballet and the female toilette, even these took on new meanings and shed those of the past. Most dramatically, in the course of this decade many of the definitive themes of the Impressionist years, such as the café-concert, the laundress, the milliner's shop and the race meeting, were effectively jettisoned, along with the idiosyncratic techniques and materials used for their expression. In their place, we find an extraordinary concentration on the two or three subjects that remained, a renewed enthusiasm for tradition and, paradoxically, a remarkable affinity with the forms and colours of the new century.

Many of the individual paintings and pastels produced by Degas in the 1880s bear witness to this transition, either in adjustments to their imagery or in their contested surfaces. Some canvases, for example, still show the meticulous brushwork of his earlier manner, alongside passages of gritty texture and strident colour that hint at things to come. Others have manifestly been overpainted, as Degas transformed a familiar theme or simplified an overcrowded composition according to his new priorities. In many works in pastel, the subjects of the dancer and the female nude went through a complex reformulation, taking on even greater prominence in his oeuvre and a new range of expressive roles. Like many of his themes, the nude linked past, present and future, recalling Degas's academic beginnings even as it prepared the way for the entirely original departures of his last years.

In July 1884, Degas reached the age of fifty and confided to his friends that he had reached some kind of mid-life crisis. Reflecting rather grimly on his celibacy, his damaged eyesight and his uncertain artistic achievement, he wrote to the sculptor Bartholomé that he felt 'heavy and disgusted' where once he had been 'full of logic, full of plans'. And with the painter and collector Henry Lerolle he went further, claiming, 'I have lost the thread of things . . . I am incapable of throwing off the state of coma into which I have fallen'.[1] Whatever its causes, Degas's lassitude did not last long and soon his letters were again describing projects for sculpture, drawing and portraiture, such as his plan to paint the ambitious *Hélène Rouart in her father's study* (cat. 2).[2] Some of his uncertainty may be traced to the doubtful status of the Impressionist enterprise itself, now weakened by defections and compromised by new recruits. *Woman having a bath* (cat. 10) was executed soon after the eighth and last Impressionist exhibition and gave notice of the simplicity, even

the austerity, of Degas's late bathers. Neither furniture nor drapery, domestic incident nor narrative structure disturbs the clarity of the scene, in which an anonymous woman calmly and prosaically sponges her leg. Action, setting and model are eloquent only in their spareness, but are made compelling through the bravura evocation of warm light and soft shadow, the dense but differentiated textures of skin and muscle, towel and carpet.

Characteristically, even at his most audacious Degas referred back to his past; the woman's naked back recalls vividly one of the icons of Degas's youth, Ingres's *Valpinçon bather* (fig. 60), as well as a figure from Degas's own *War scene in the Middle Ages* (Paris, Musée d'Orsay) of the mid-1860s, while simultaneously preparing the ground for his last excursions into lithography. By contrast, a large and vivacious oil painting carried out earlier in the decade, *Nude woman drying herself* (cat. 9), seems both technically unresolved and rooted in the descriptiveness of Impressionism. Glorious though its sweeping brushwork seems today, this canvas represents an abandoned *ébauche* or underpainting, intended for development in colour in the way that Degas had previously applied pastel to his own monochrome prints (figs. 93–4).

Degas's inability or unwillingness to proceed with *Nude woman drying herself* may well be a reflection of his crisis of confidence in the mid-1880s, while conforming to a wider pattern of technical re-evaluation during these years.[3] Returning to a canvas begun as early as 1879, *The millinery shop* (cat. 4), the artist had scraped away some of the initial paint and changed the female subject from a sumptuously hatted customer to a plain shop-girl, now locked into a bold pattern of gold, green and chestnut.[4] Even more unexpectedly, in *Woman ironing* (cat. 5) Degas revisited a subject first tackled twenty years earlier, as if taking farewell of one of his most distinctive Impressionist creations. Executed in the early 1890s, this resonant image joins a fascinating cluster of such *reprises*, including a horse-racing scene, a millinery subject and the portrait *Pagans and Degas's father* (cat. 3), made by Degas in his final years.[5] Identifiable as a late work by its autumnal colouring and rich paint surface, *Woman ironing* also reminds us of the rarity of such socially specific, genre-based subjects in Degas's oeuvre after the decline of Impressionism.

A similar progression from the documentary to the broadly expressive can be traced in Degas's later portraiture. Conspicuous in his output in the 1860s and 1870s, Degas's production of portraits lost its momentum in mid-career and came to a virtual halt before the turn of the century. The reasons for its demise are unclear; one of the last examples, the haunting *Self portrait* (cat. 1), of which Degas said 'I look like a dog',[6] shows that his skills were far from exhausted; his contemporary photographs of friends (figs. 5, 12–13, 24) reveal a

flourishing wit and inventiveness; and Degas's acquisition of portraits by his peers, such as Cézanne, Manet, Gauguin, Cassatt and Blanche, acknowledges the continuing viability of the genre.

Hélène Rouart in her father's study (cat. 2) formed part of Degas's final cycle of portraiture, a series of likenesses of the Rouart family that occupied him into the early twentieth century.[7] Formerly regarded as a work of 1886, recent study of this picture suggests that it was reworked by the artist, lined with fresh canvas and apparently restretched during his later years.[8] Its earth-red colouring and encrusted surface also link it with Degas's mid-1890s enthusiasm for Venetian techniques, adding to its role as a transitional statement. Such a role is explicit in the case of *Pagans and Degas's father*, a complex interweaving of early imagery with late explorations of colour and brushwork, private sentiment with public rhetoric. Referring back to a painting of the same subject made about 1871 (fig. 31), this moving image seems to recall not just a still-mourned parent but a lost and perhaps regretted era in the artist's own development.

Three images of the ballet mark the evolution of Degas's vocabulary in these intermediate years. The pastel *Ballet dancers on the stage* (cat. 7) exemplifies the high-point of Degas's Impressionism, when gorgeously hued scenes of the stage and the Paris streets confirmed his talents as draughtsman, colourist and observer of the contemporary spectacle. Here is the 'gamut of original points of view' advocated by the writer Edmond Duranty, the figures 'frequently cropped by the frame' of Joris-Karl Huysmans and the 'profound understanding of tones' noted by the critic Charles Ephrussi, virtual trademarks of Degas's middle phase.[9] A later work, *Dancer with bouquets* (cat. 6), shows the ballerina still engaging with her audience, but this image is among the last of its kind. By this date many of the pictorial devices that so appealed to Degas's early admirers have been stripped away, leaving the dancer centrally placed and visually intact, her figure viewed almost frontally and her angular, poignant pose the real subject of our attention. In common with the pastel, however, Degas clings to the luminous tints of the footlights, now rendered in washes and scumblings of oil paint on an unusually grand canvas. Both *Dancer with bouquets* and the much smaller *Before the ballet* (cat. 8) depend on compositions developed in earlier years, allowing us to assess the amplitude of Degas's handling and the depth of his late colour. With *Before the ballet* the artist literally reworked and simplified an existing canvas, painting out a dancer at the centre of the scene and unifying floor and walls with a newly evocative, sensuous palette.[10] The distant ballerinas now almost an irrelevance, we approach the final subject of Degas's art; a solitary individual or pair of figures in different states of ease or prostration, largely oblivious of their surroundings and mutely absorbed with their physicality.

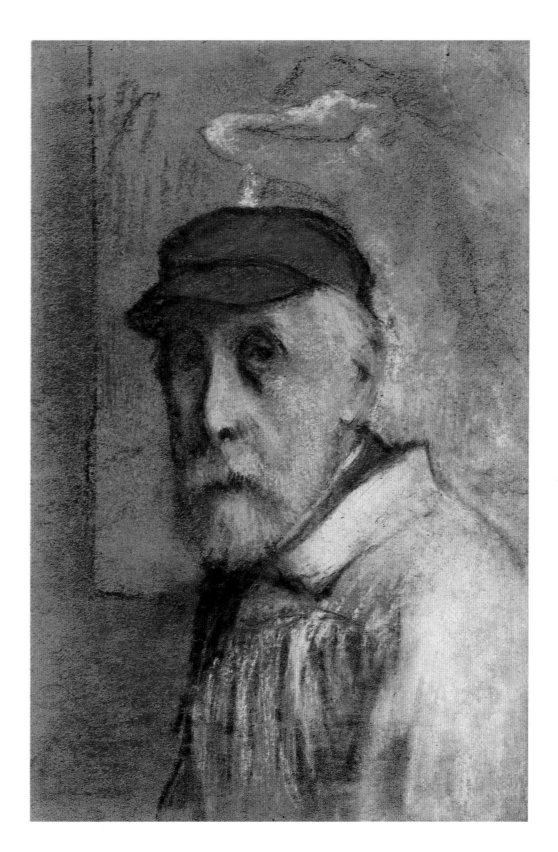

CAT. I
*Self portrait, c.*1895–1900
Pastel on paper
47.5 x 32.5 cm (18¾ x 12¾ in.)
Zurich, Fondation Rau
pour le Tiers-Monde

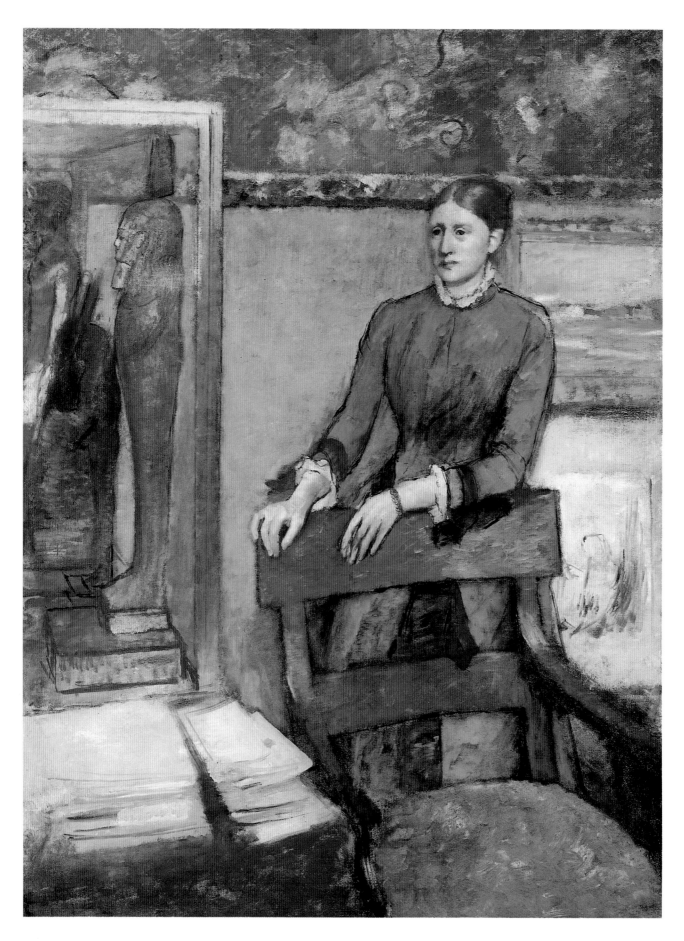

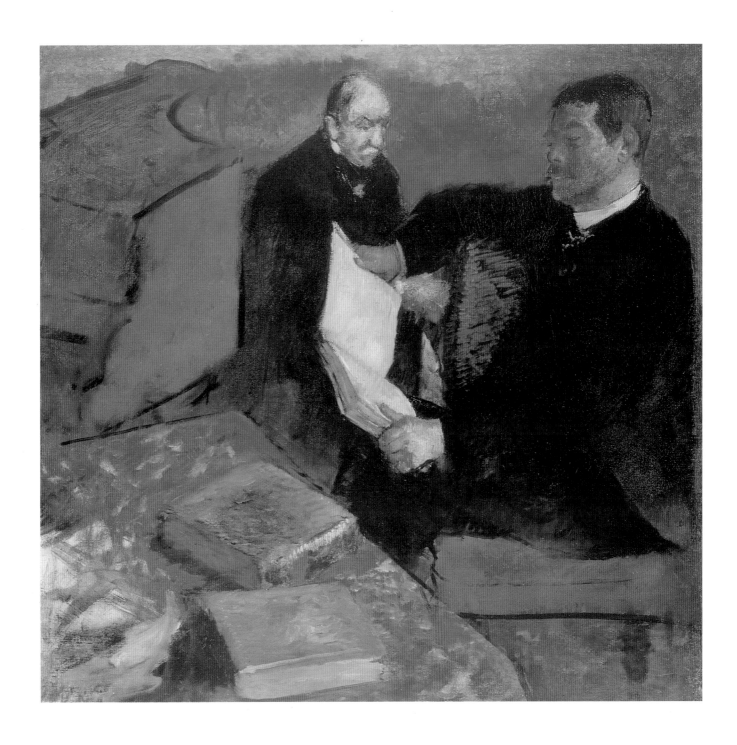

CAT. 2
Hélène Rouart in her father's study, c.1886–95
Oil, 161 x 120 cm (63⅜ x 47¼ in.)
London, National Gallery

CAT. 3
Pagans and Degas's father, c.1895
Oil, 82 x 84 cm (42¾ x 44 in.)
Scott M. Black Collection

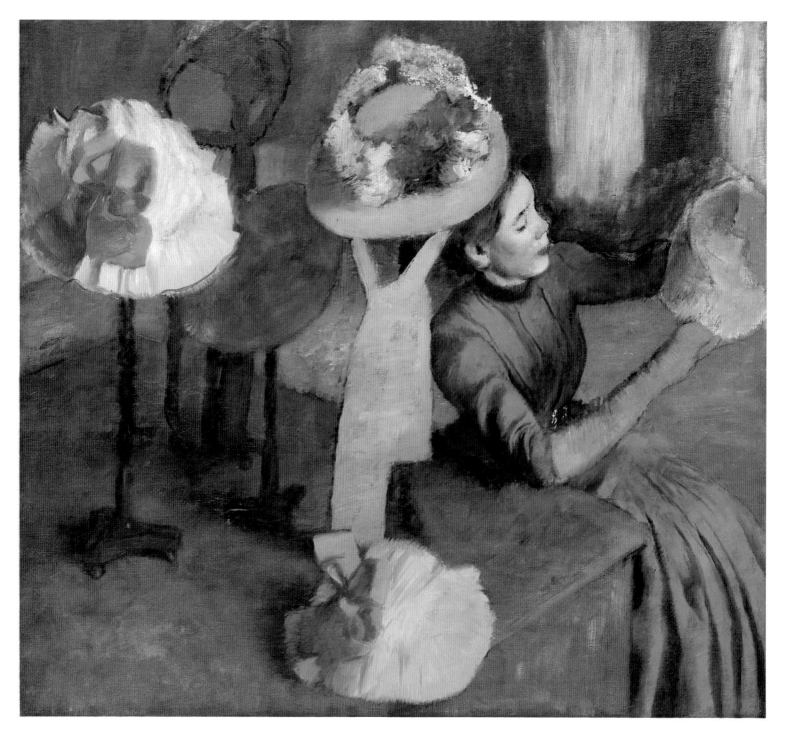

CAT. 4
The millinery shop, c.1879–84
Oil, 100 x 110.7 cm (39⅜ x 43⅝ in.)
The Art Institute of Chicago

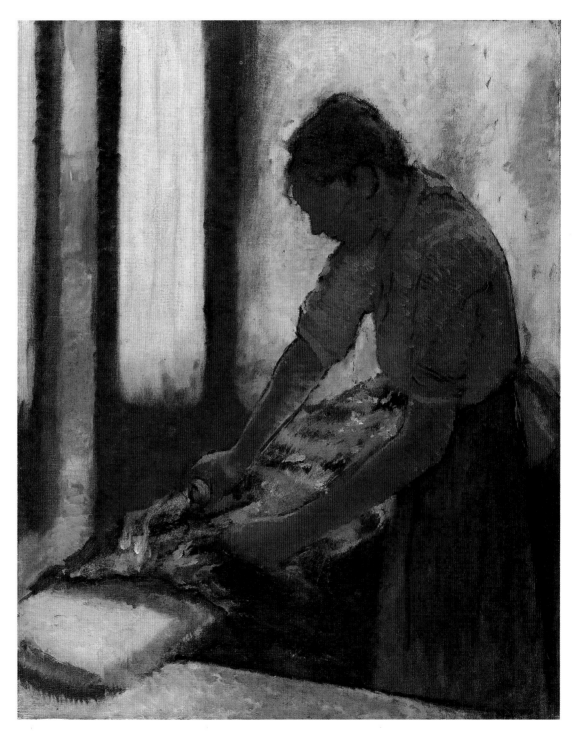

CAT. 5
*Woman ironing, c.*1892–5
Oil, 80 x 63.5 cm (31½ x 25 in.)
Liverpool, Walker Art Gallery

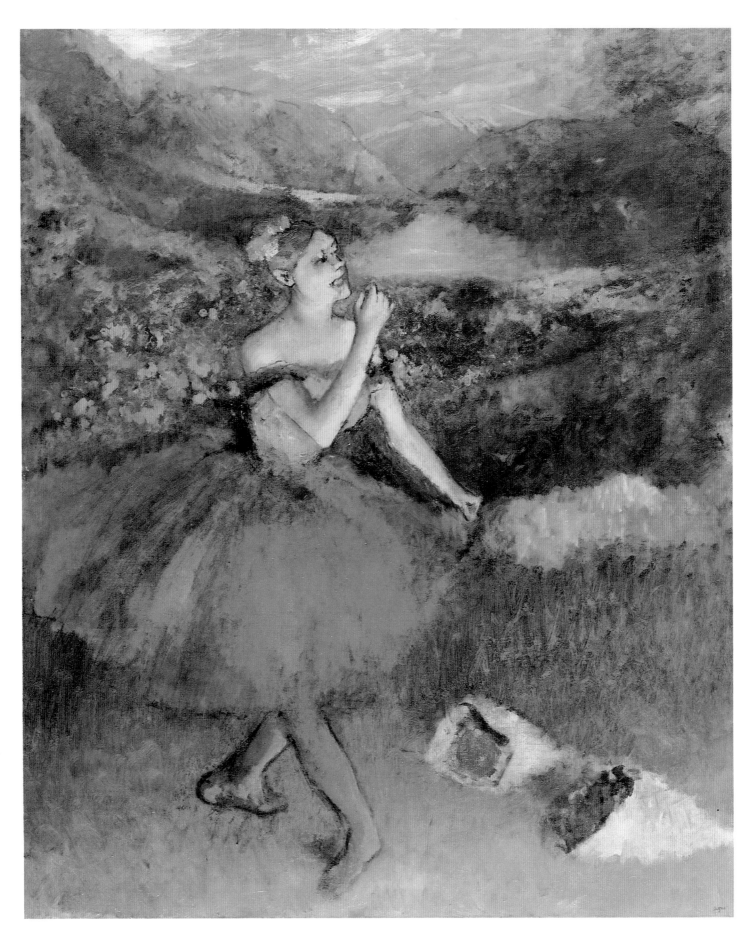

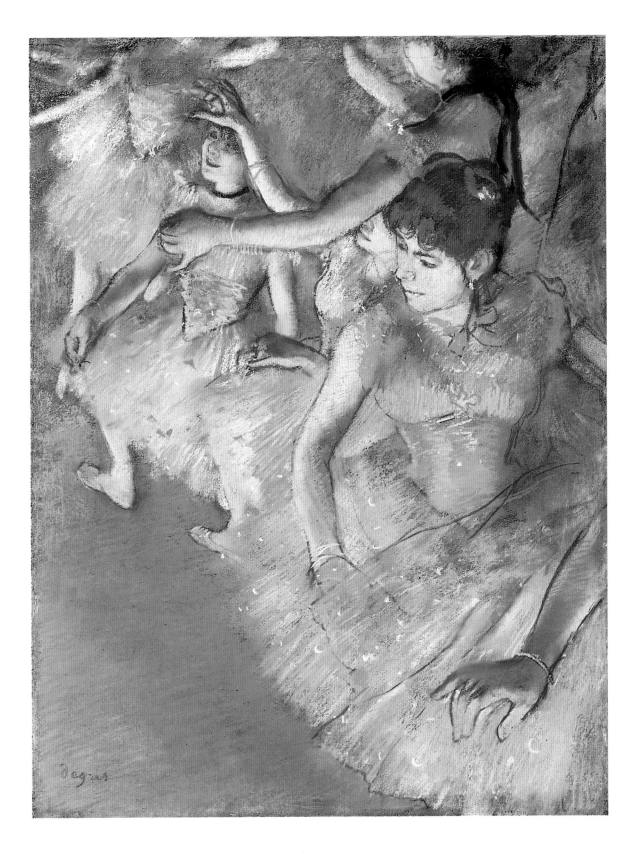

CAT. 6
Dancer with bouquets, c.1890–5
Oil, 180 x 151 cm (71 x 60 in.)
Norfolk, Virginia, Chrysler Museum of Art

CAT. 7
Ballet dancers on the stage, 1883
Pastel on paper, 62.2 x 47.3 cm (24½ x 18⅝ in.)
Dallas Museum of Art

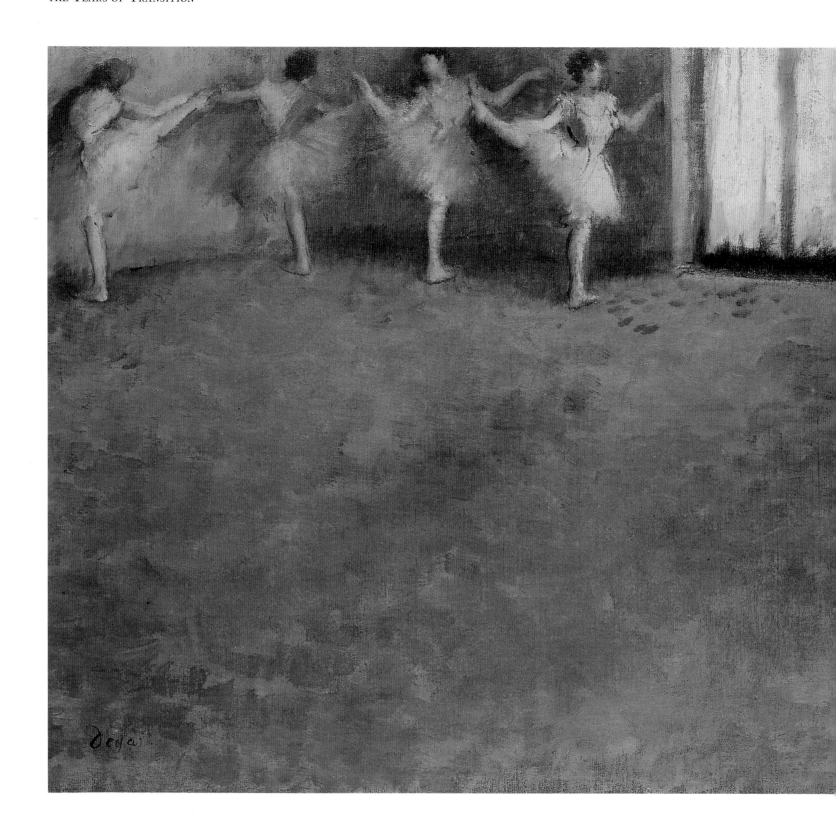

CAT. 8
*Before the ballet, c.*1890–2
Oil, 40 x 88.9 cm (15¾ x 35 in.)
Washington, National Gallery of Art

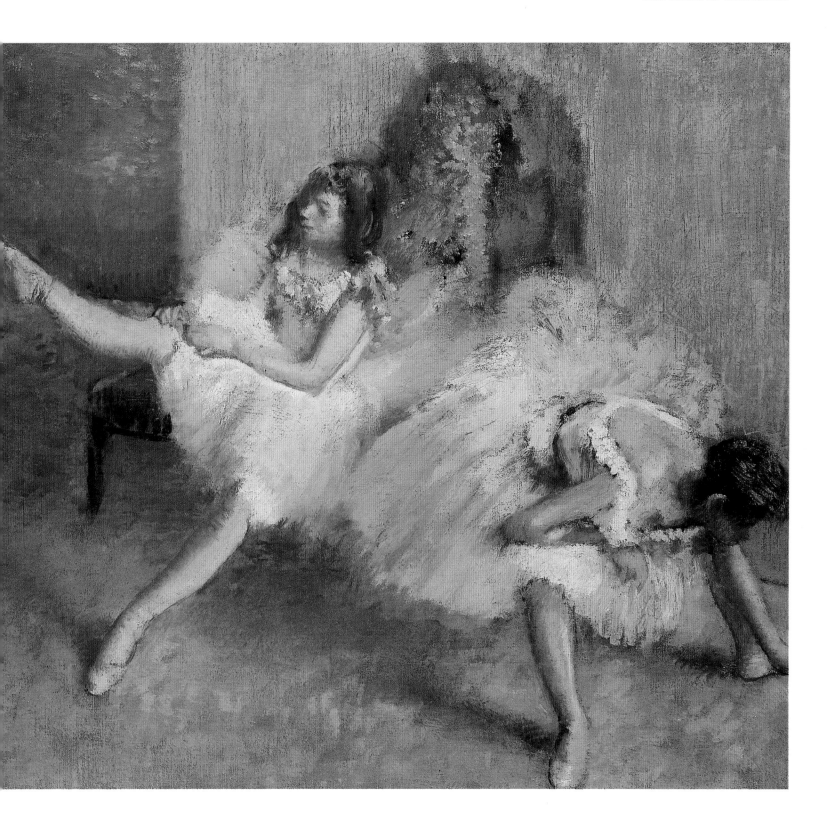

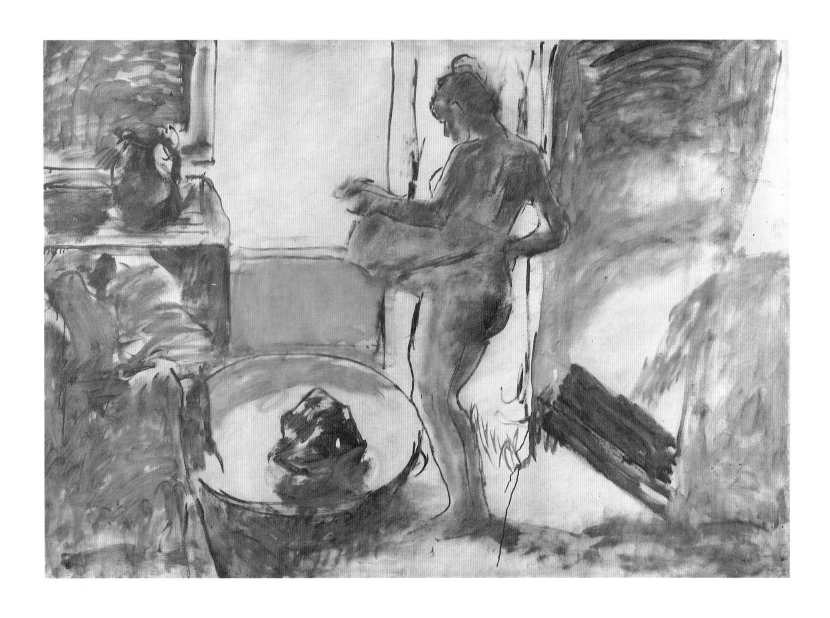

CAT. 9
*Nude woman drying herself, c.*1884–6
Oil, 150 x 214.5 cm (59 x 84⅜ in.)
New York, Brooklyn Museum

CAT. 10
*Woman having a bath, c.*1886–8
Pastel on paper, 72 x 56 cm (28⅜ x 22 in.)
New York, Metropolitan Museum of Art,
Private Collection

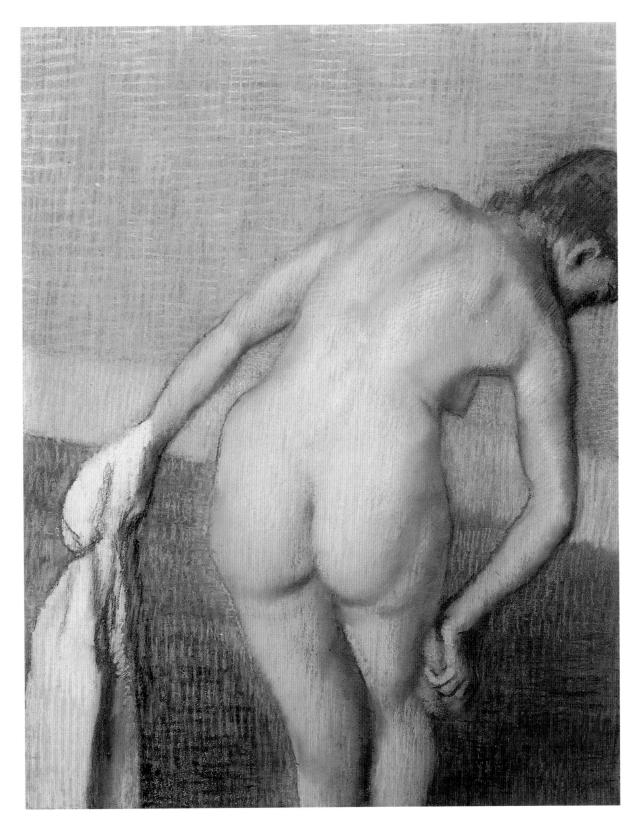

Drawing, Tracing and the Sequence

One of the most distinctive shifts in Degas's working practice in later life was towards the sequence or series. Rather than create a unique statement of his chosen subject, in the form of a single drawing, pastel or oil painting, he would generate a succession of near-identical variants that eventually formed a 'family' of compositions, some with just two or three members, others extending to twenty or thirty related works. Though some of his contemporaries have become celebrated for their sequential canvases, such as Monet's *Rouen Cathedral* cycle and Cézanne's repeated views of Mont Saint-Victoire, there is no precedent for the pervasiveness of Degas's later serial practice, which accounted in his last decades for the overwhelming majority of his pictures.

Like so many features of Degas's mature art, his seriality had its roots in earlier decades, perhaps at the very beginning of his career. As a student in the 1850s he had learnt to copy and trace from the works of the masters, graduating to etching, lithography and the lure of the multiple image, where a series of prints could each be subtly differentiated from the last.[11] In his Impressionist phase Degas earned a reputation for pictorial obsessiveness, returning repeatedly to such subjects as the racetrack and the rehearsal room and becoming accused of 'shutting himself up in his specialities'.[12] From their inception, these revisitations seem to have represented for Degas a measure of his professionalism, a determination to do justice to the complexities of the motif and to go beyond the merely superficial; 'It is essential to do the same subject over again, ten times, a hundred times', he told his younger admirer Bartholomé, and insisted to Paul Valéry that a picture is the result of 'a series of operations'.[13]

As early as 1859, the poet Charles Baudelaire had argued that 'a harmoniously conducted picture consists of a series of pictures superimposed on one another, each new layer conferring greater reality on the dream'.[14] Certain drawings and pastels from Degas's maturity come close to this ideal, the first linear expressions of their image followed by coloured responses, then by further drawn and painted reiterations on the same surface. As in Baudelaire's claim, such additions can also invoke the passage of time and the operations of memory, and by extension the continuity of the artist's experience as the work unfolds. Degas' well-known fascination with arrested movement has a natural affinity with these concerns, resulting in the topical immediacy of certain works from the Impressionist era and a grander, more ambitious synchronicity in his last years. Conspicuous here is the monumental *Frieze of dancers* (cat. 16), a richly developed canvas that was probably completed in the mid-1890s, but derived from countless drawings, pastels and associated studies from previous decades.[15] Incorporating line and luminous colour, the application of paint with fingers as well as brushes, and shifting, suggestive light, this rhythmic panorama is one of

the most spatially complex of all Degas's late pictures. As well as Baudelaire's 'superimpositions', here we are presented with apparent movement in time and space around a single model, a pre-cinematic sequence of stills that prepares the way for Cubism and Futurism.

Famously, Degas's art was based on draughtsmanship, 'a way of seeing form' as the artist described it to Valéry, and it was this process of drawing that formed the foundation for his series and replications.[16] All the pastels and paintings in these pages were built over a scaffolding of lines, some so literally that the drawn contours, hatchings or brushed outlines of the original design are still clearly visible beneath later applications of colour. In Degas's last phase, the role of draughtsmanship was intensified and many of its functions and significances transformed. Abandoning the pencils, pens, chalks and other tools of the Impressionist era, from the late 1880s Degas turned exclusively to the medium of charcoal, exploiting its versatility and sombre, expressive tones in many hundreds of studies of the human form. While some of these drawings might be regarded as preparatory works, examples such as *Torso of a dancer* (cat. 34), *Woman combing her hair* (cat. 44) and *Russian dancer* (cat. 92) were evidently seen by the artist as self-contained works of art, to be signed, sold and exhibited alongside his grandest creations. And, revealingly, such drawings were almost invariably executed on tracing paper, allowing the artist to repeat his compositions, in principle, an indefinite number of times.

The significance of the tracing process is immediately apparent in the surfaces of many of Degas's late drawings. Varying in colour from milky-grey to a rich honey-brown (see cats. 70 and 52) according to its condition and history of exposure to light, tracing paper presents a hard, unyielding face to the artist's charcoal line. In the sumptuous graphism of *Group of dancers* (cat. 26) this collision of forces brings life to the image, erupting into veils and ribbons of tone, scratches and flourishes of blackness on mellow parchment. By making a second tracing from this sheet, such as that used for *Dancers* (cat. 25), Degas could take his invention a stage further yet preserve his original sheet for replication. In *Dancers*, the blackness of charcoal has been overlaid with startling strokes of pastel and new features have been added, such as the dancers' peppermint-green tutus and the blue-shadowed scenery. In a further variant, the ballerinas were clad in yellow and the stage flats banished, while other tracings were variously ornamented and refined (fig. 202) introducing richer colour harmonies and new dramatis personae.[17]

This sequence of drawing, tracing and subsequent colouring became the central ritual of Degas's later craft. Eye-witnesses describe how the artist pinned sheets of tracing paper to pieces of cardboard as he worked, adding further strips to their edges to extend his compositions (clearly

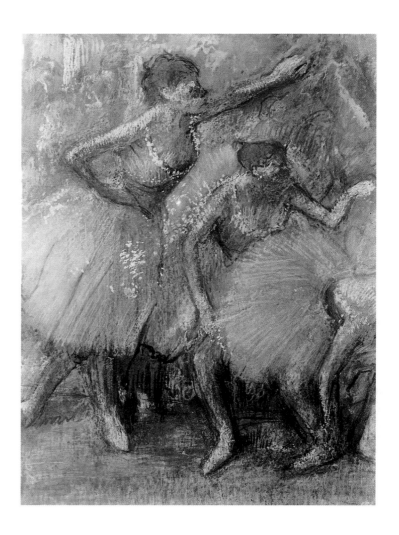

FIG. 202
Three dancers in yellow skirts, 1898
Pastel on tracing paper, 68 x 52.5 cm (26¾ x 20⅝ in.)
Location unknown,
photograph Archives Durand-Ruel, Paris

visible in cats. 12 and 15) before having them finally stuck down.[18] After more tracings and extensions, half-a-dozen variants of the same scene would be arranged on easels in his studio, allowing him to work on them in succession and 'adding colours, mingling pastel with charcoal; in one version the petticoats may be yellow, in another purple', as Valéry remembered.[19] Such a process must lie behind the pairing of *Three dancers in yellow skirts* (cat. 18) with *Red ballet skirts* (cat. 17), while the enlargement of the paper sheet and the introduction of new figures would explain *Dancers in the wings* (cat. 19) and *Three dancers* (cat. 20), all of which began life as charcoal drawings on tracing paper. Up to twenty other studies can be added to this hierarchy, some just black-and-white drafts used in the jigsaw-like assembly of different scenes, almost half of them fully-fledged works in a variety of tonalities.[20]

Characteristic of this procedure was the gradual build-up of complex compositions from simpler units, in which individual figures such as *Dancer with a fan* (cat. 24) or *Ballet dancer resting* (cat. 21), would be incorporated into a larger ensemble, such as the magnificent *Dancers* (cat. 23). Once used in this way the smaller drawings could be developed in their own right, re-traced to make further variants or exploited for yet more multi-figure scenes, among them *Pink dancers* (fig. 44) and *Dancers in the wings* (fig. 48). A character such as the dancer seated on a bench, her head in her hands, as in *Two dancers at rest* (cat. 22), or her leg akimbo, as in *Dancers* (cat. 37), might reappear in a wide range of guises, from solitary studies to rehearsal-room gatherings. Others exist in both clothed and nude versions, such as the *Study of four nude dancers* (cat. 36) which provided the foundation for a number of fully embellished pastels and a late lithograph.[21] Though habitual in Degas's later pastel technique, this transposition of figures from one format to another, presumably via the tracing process, can also be found in a number of sequentially related oil paintings. The two almost identical-size canvases, *Dancers, pink and green* (cat. 31) and *Blue dancers* (cat. 32), for example, appear to have a very close kinship of this kind, their variation due as much to progressive reworking and adjustment of their respective palettes as to fundamental differences in staffage.

Several of his contemporaries commented on Degas's serial creativity, putting forward a variety of explanations and reflecting on its significance. Vollard suggested that it was a means of correcting himself, while one of Degas's models observed that it encouraged experimentation, prompting the artist to render 'his subject in different hues, endlessly varying the colours, until one of the pastels satisfied him . . .'.[22] Others, like Octave Mirbeau in 1905, pointed out that seriality was a feature shared with many of the 'superior' artists of the age, comparing Degas's 'astonishing' variations 'on the same dancer, the same gaunt face, the same dry and angular bone-structure, the same long, thin arms, the same nervous legs' with Monet's sequential paintings of Rouen Cathedral and waterlilies.[23] Subsequent proposals have ranged from Valéry's belief that, in repeating his motifs, Degas was 'striving to attain the utmost precision of form', to Carol Armstrong's charge that such repetitions represented 'a kind of draughtsmanly impotence'.[24]

In the second half of the nineteenth century, the grouping together of a painter's works into 'series', either by subject matter or the circumstances of their creation, was a commonplace. Artists as different as Daubigny and Sisley, Cassatt and Whistler, Pissarro and Renoir specifically linked their images into 'sets' or had them so described by others, while Degas himself advertised a 'suite' of nudes in the catalogue of the 1886 Impressionist exhibition and spoke of his desire to make a 'series of landscapes' at the time of his 1892 Durand-Ruel exhibition.[25] Monet's installation of several near-identical compositions of grain-stacks (1891) and poplars (1892) in the same gallery brought a new deliberation to such displays, proposing a cumulative experience and a unity of achievement that to some admirers suggested music, to others poetry or the flux of being. Similar responses were expressed when Degas's landscapes were unveiled, perhaps as a result of their unity of scale and progressive exploration of related motifs, perhaps also in recognition of their 'pairing' of certain compositions, where two variants of a single scene offered a condensed serial experience to the viewer.

The artist's little-documented show of 1896 included 'a new series of nudes by Degas', again implying that the sum of the exhibition was greater than its constituent parts and inevitably inviting analogies with other art forms.[26] Although it is not known whether Degas chose to install such works side-by-side in chromatic or linear sequences, it is clear that he worked on them in this way and that they were seen together in his studio.[27] In the rhythmic relationships of certain charcoal drawings (cats. 11–15), all executed in charcoal on tracing paper, we might be moving through the frames of Eadweard Muybridge's high-speed exposures or Jules-Etienne Marey's time-lapse prints, both of which Degas had encountered and initially responded to in mid-career. Some of these studies seem to encourage such a reading, the multiple outlines of *After the bath, woman drying herself* (cat. 12), for example, suggesting a blurred, transitional form, and the charcoal penumbra around *Nude on the edge of the bath drying her legs* (cat. 11) evoking tremulous activity. Despite his active participation in photography in the later 1890s, however, Degas was rarely inclined to apply the lessons and forms of the medium directly to his pictures. By the turn of the century, the majority of his drawings, pastels and even sculptures were linked through tracing, replication and a shared dynamism, but their vitality was now internalised and contained within the structures of his art.

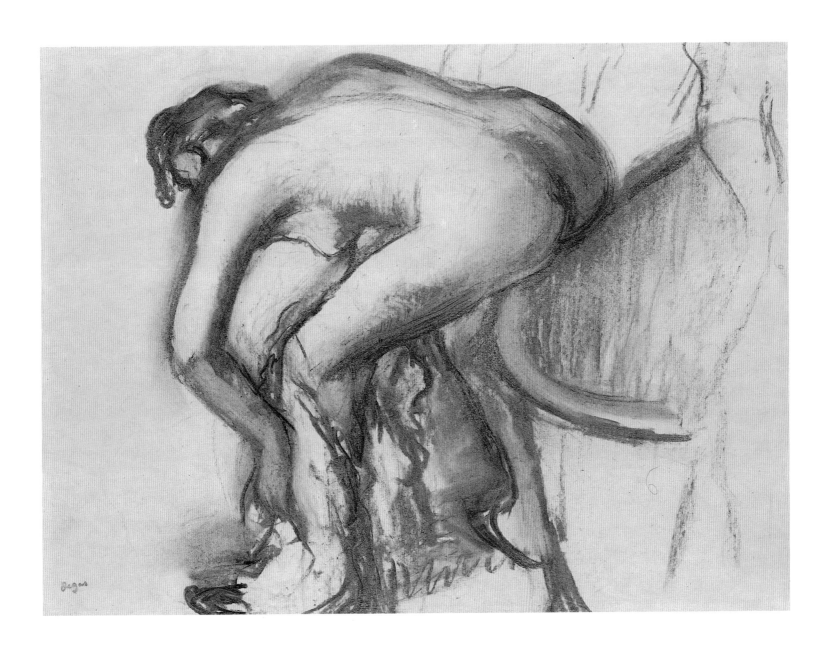

CAT. 11
Nude on the edge of the bath drying her legs, c.1900–5
Charcoal on tracing paper
40 x 54 cm (15¾ x 21¼ in.)
Stuttgart, Staatsgalerie

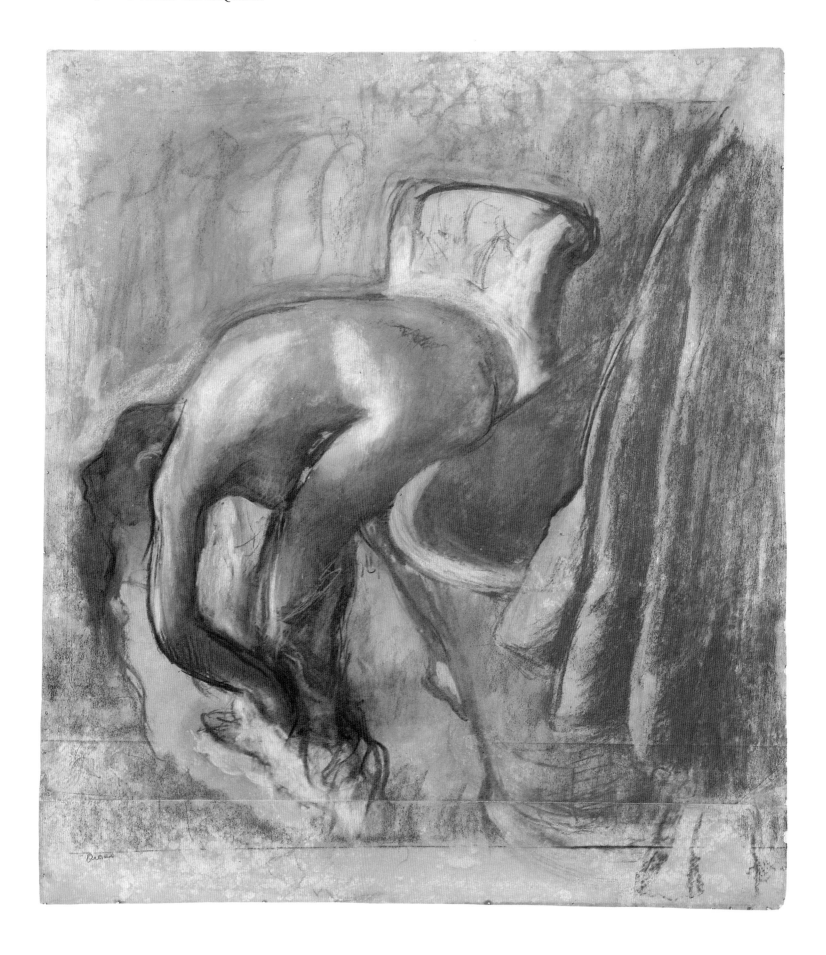

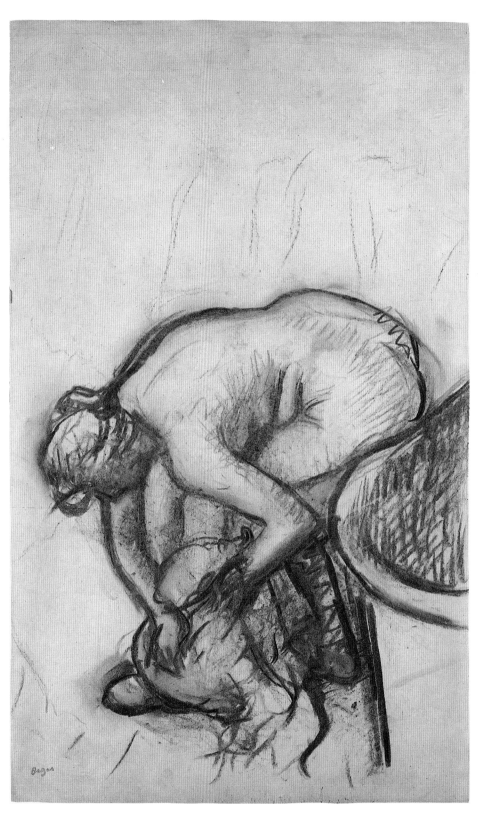

CAT. 12
After the bath, woman drying herself, c.1900–5
Charcoal and pastel on tracing paper
80 x 72 cm (31½ x 28¼ in.)
New York, Mr Gregory Callimanopulos

CAT. 13
After the bath, woman drying herself, c.1900–5
Charcoal on tracing paper
63.1 x 38.1 cm (24⅞ x 15 in.)
Private Collection

191

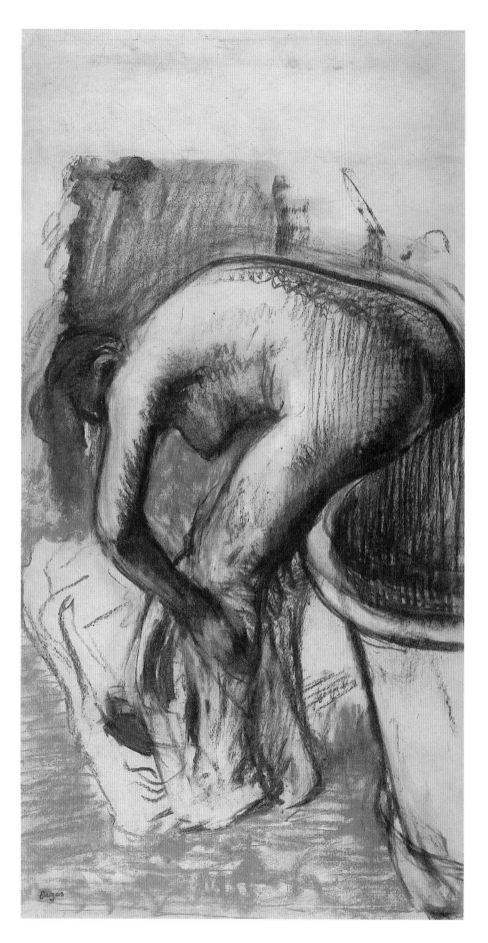

CAT. 14
*Bather drying her legs, c.*1900–5
Charcoal and pastel on tracing paper
69 x 36 cm (27⅛ x 14⅛ in.)
Switzerland, Private Collection

CAT. 15
*After the bath, woman drying her feet, c.*1900–5
Charcoal and pastel on tracing paper
57 x 40.8 cm (22½ x 16 in.)
The Art Institute of Chicago

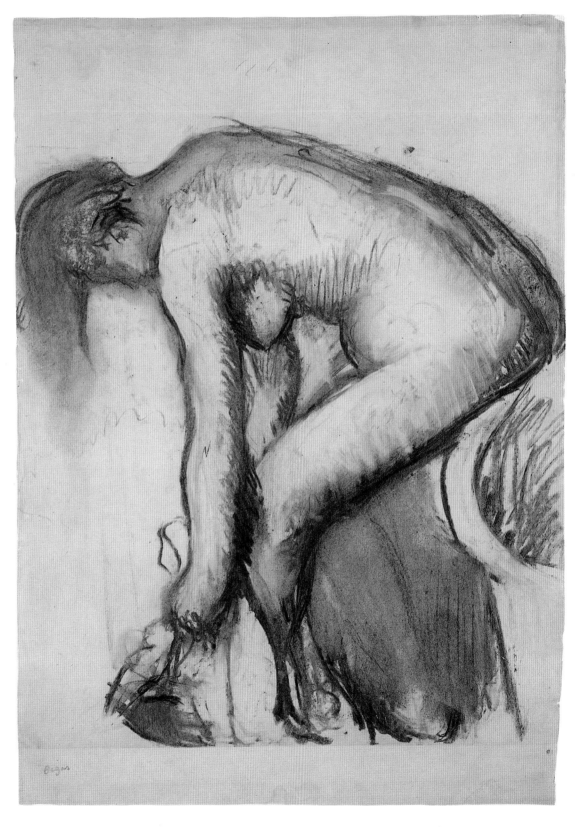

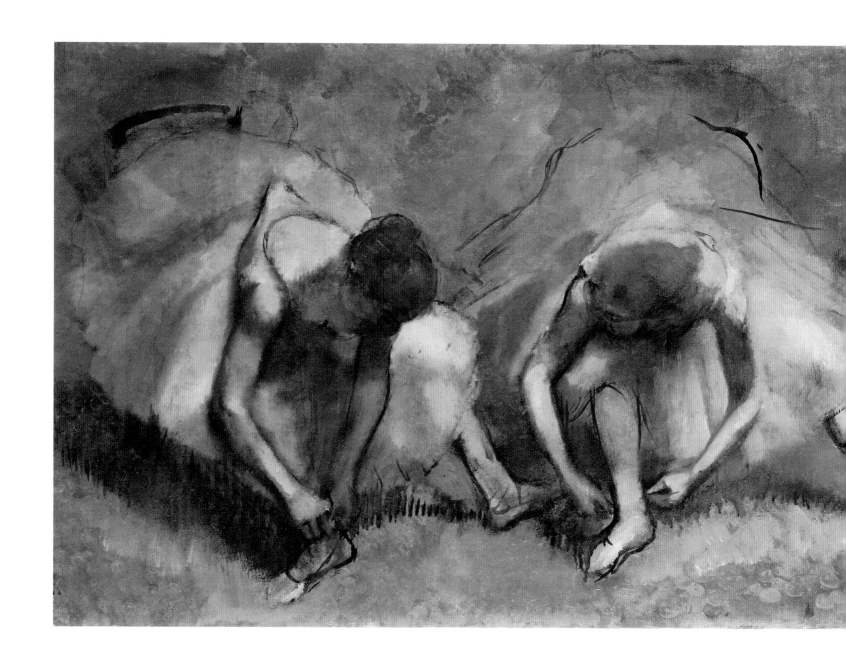

CAT. 16
*Frieze of dancers, c.*1893–8
Oil, 70 x 200.5 cm (27½ x 79 in.)
Ohio, Cleveland Museum of Art

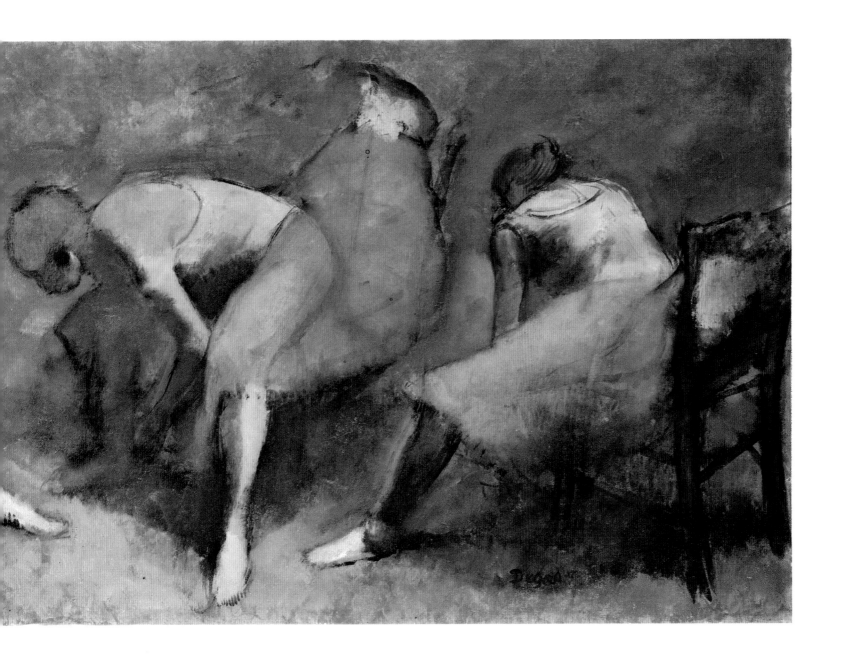

CAT. 17
Red ballet skirts, c.1897–1901
Pastel on tracing paper
81.3 x 62.2 cm (32 x 24½ in.)
Glasgow Museums, The Burrell Collection

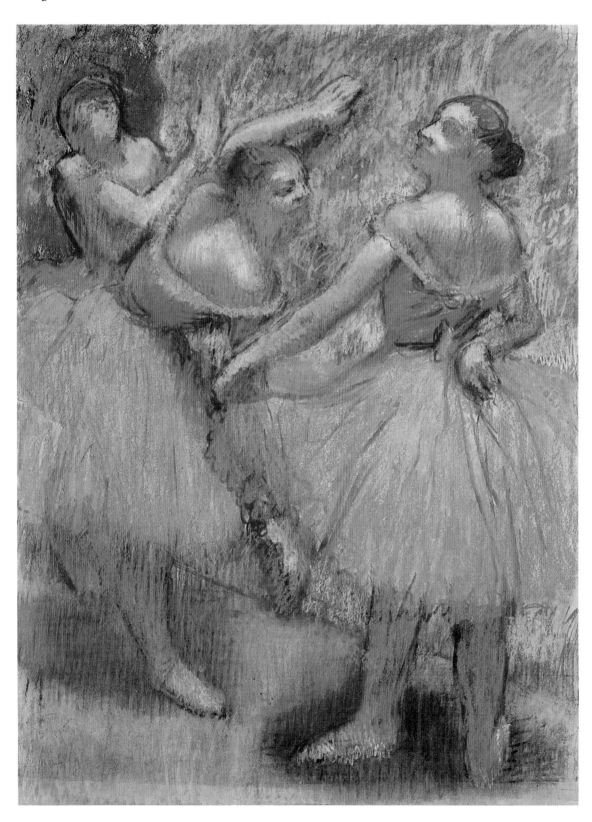

CAT. 18
*Three dancers in yellow skirts, c.*1899–1904
Charcoal and pastel on tracing paper
64.5 x 49.8 cm (25⅜ x 19⅝ in.)
Cincinnati Art Museum

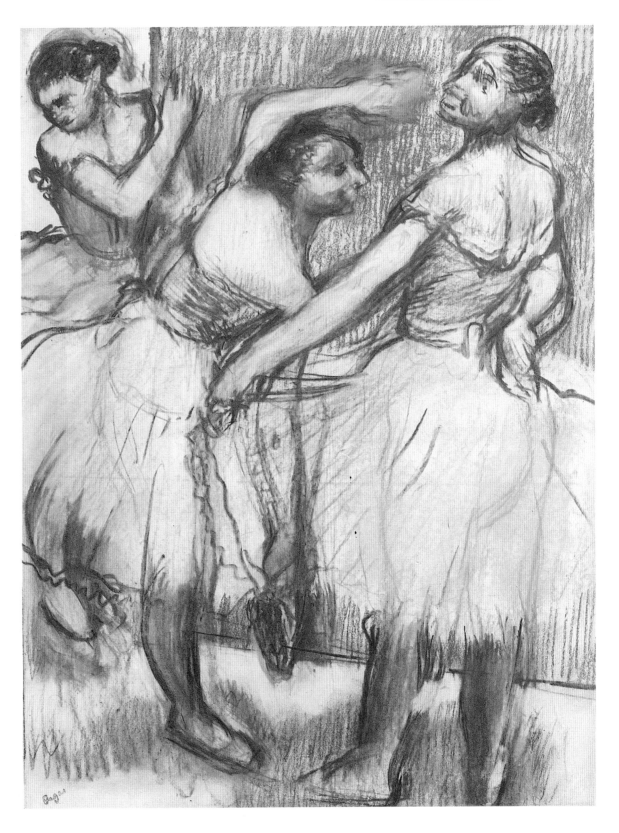

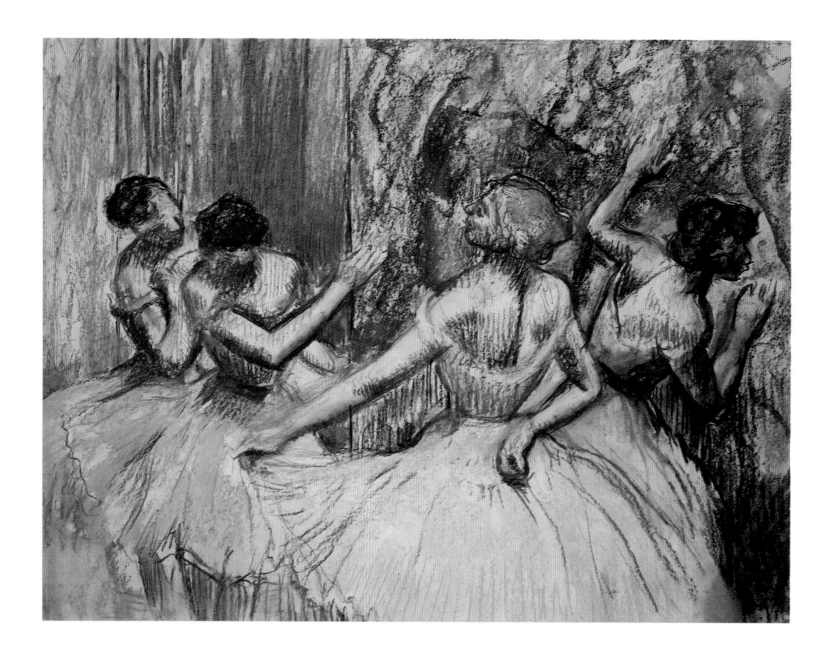

CAT. 19
Dancers in the wings, c.1897–1901
Charcoal and pastel on tracing paper
80 x 110 cm (31½ x 43¼ in.)
Tokyo, Kasama Nichido Museum of Art

CAT. 20
Three dancers, c.1897–1901
Pastel on tracing paper
90 x 85 cm (35½ x 33½ in.)
Copenhagen, Ordrupgaard

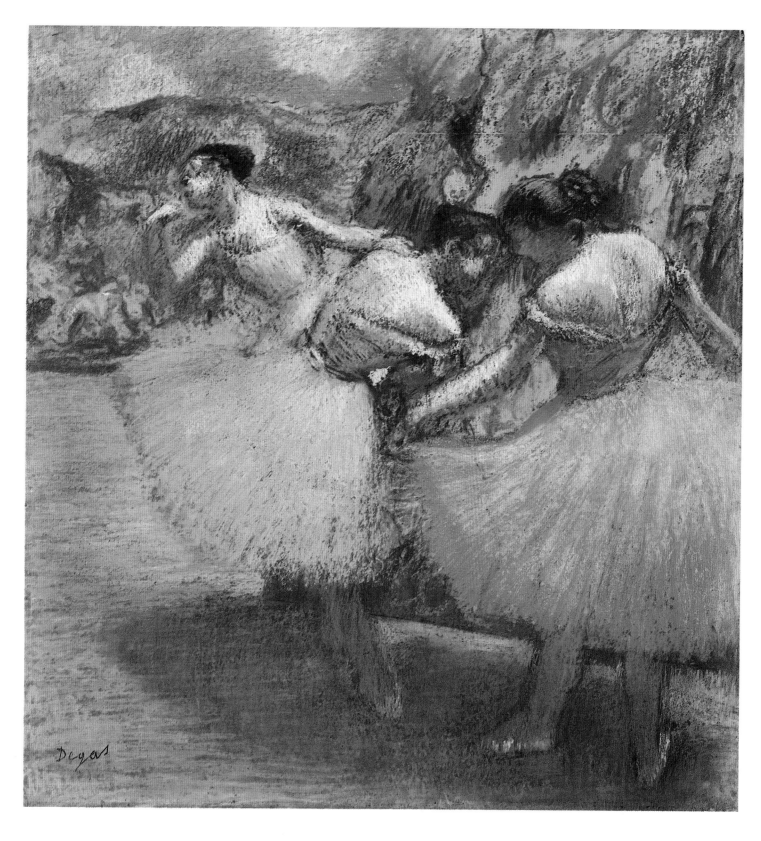

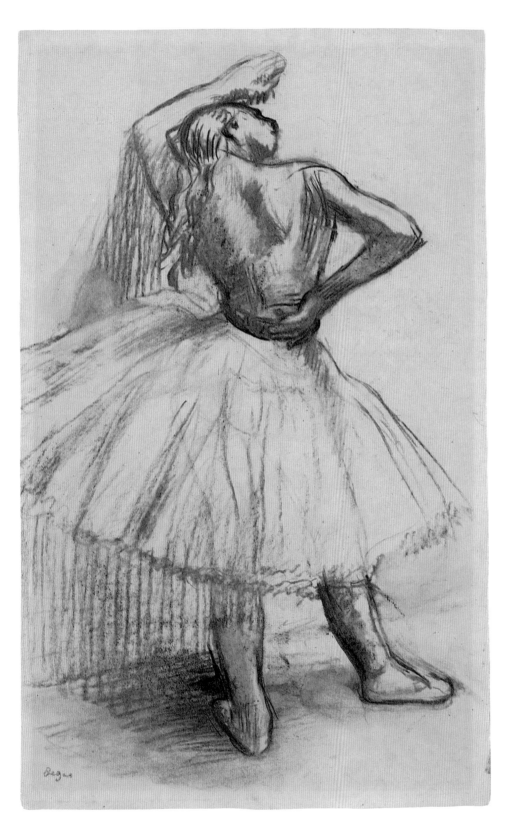

CAT. 21
*Ballet dancer resting, c.*1897–1901
Charcoal on tracing paper
49.8 x 31.1 cm (19⅝ x 12¼ in.)
California, Santa Barbara Museum of Art

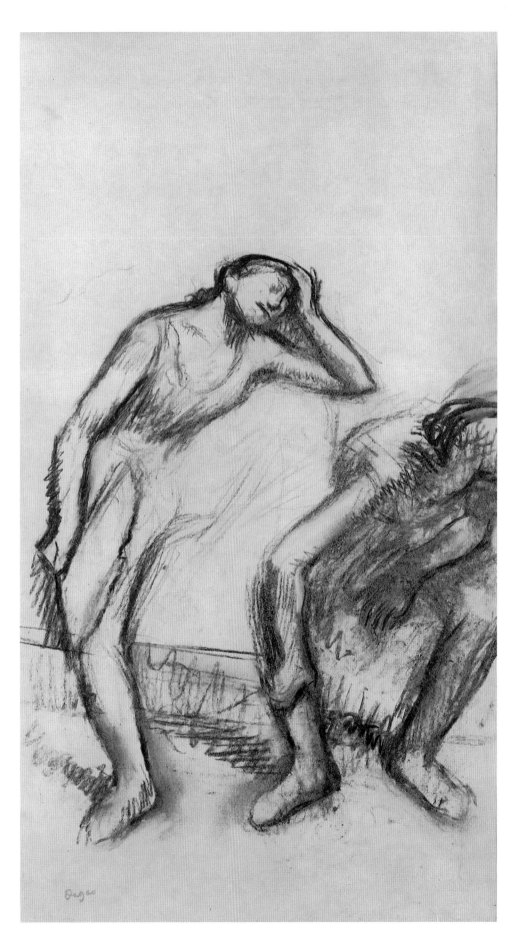

CAT. 22
Two dancers at rest, c.1897–1901
Charcoal on tracing paper
62 x 35 cm (24⅜ x 13¾ in.)
London, Courtauld Institute Galleries
(Lillian Browse Collection)

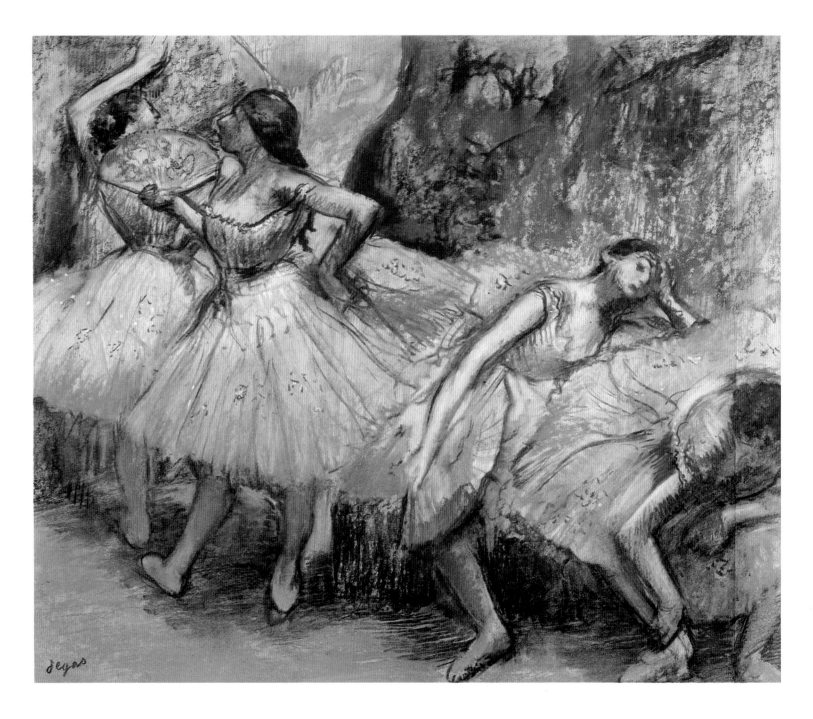

CAT. 23
Dancers, c.1897–1901
Pastel and charcoal on tracing paper
65.4 x 77.5 cm (25¾ x 30½ in.)
New York, The Reader's Digest Association Inc.,
Corporate Art Collection

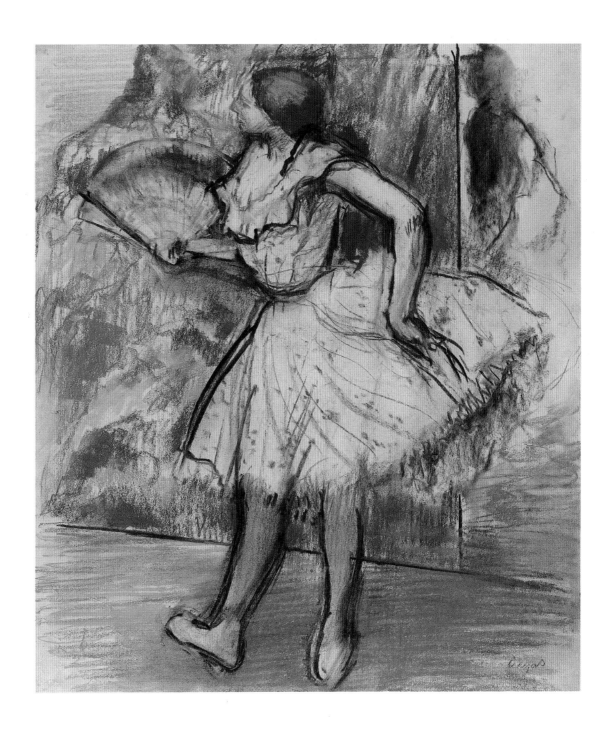

CAT. 24
Dancer with a fan, c.1897–1901
Pastel and charcoal on tracing paper
55.6 x 48.9 cm (21⅞ x 19¼ in.)
New York, Metropolitan Museum of Art

CAT. 25
Dancers, c.1897–1901
Pastel on tracing paper
73.5 x 61 cm (29 x 24 in.)
Basel, Galerie Beyeler

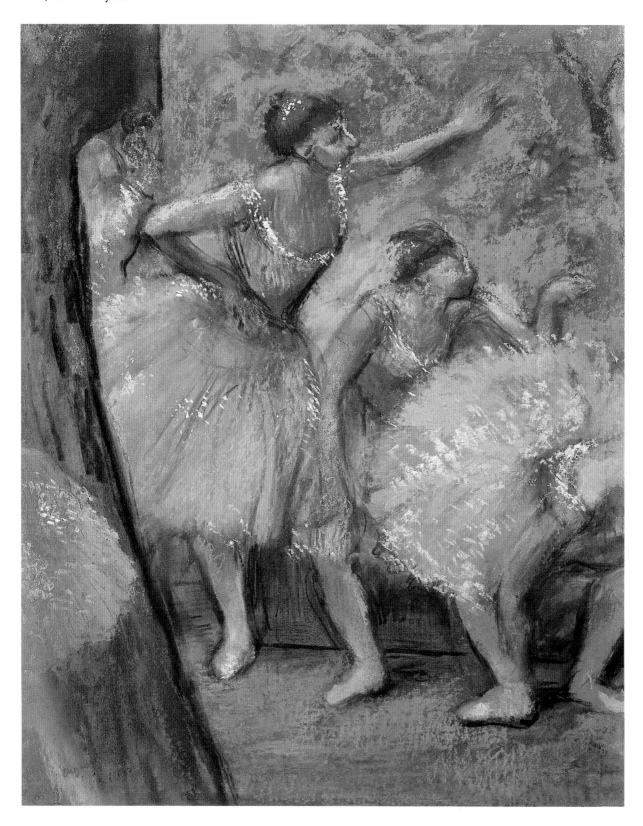

CAT. 26
*Group of dancers, c.*1897–1901
Charcoal on tracing paper
77.2 x 63.2 cm (30⅜ x 24⅞ in.)
Little Rock, Arkansas Arts Center

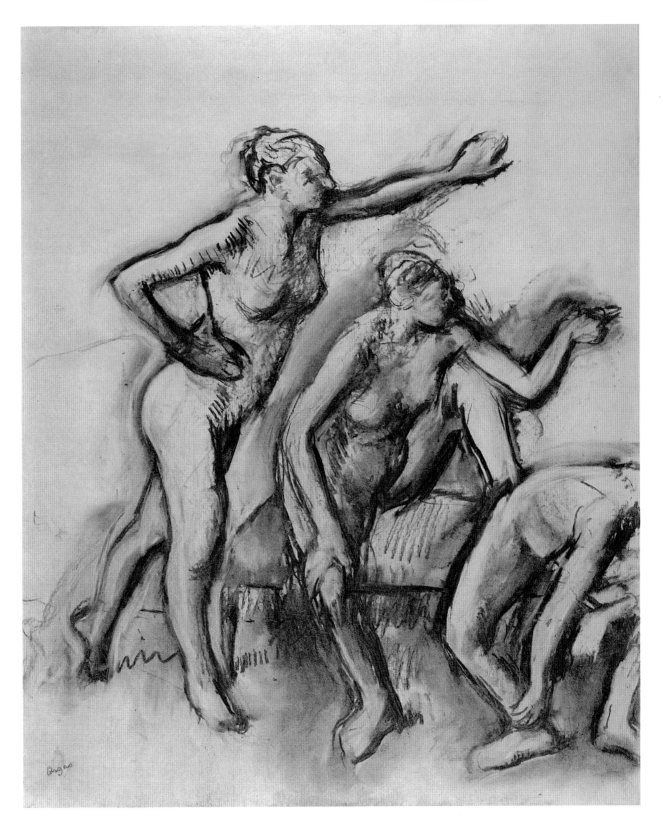

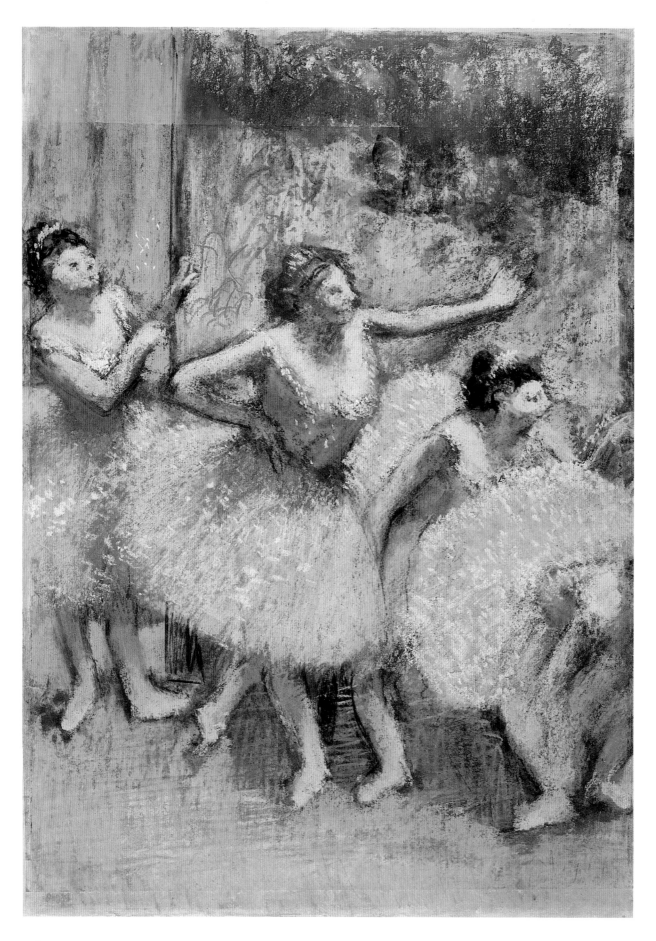

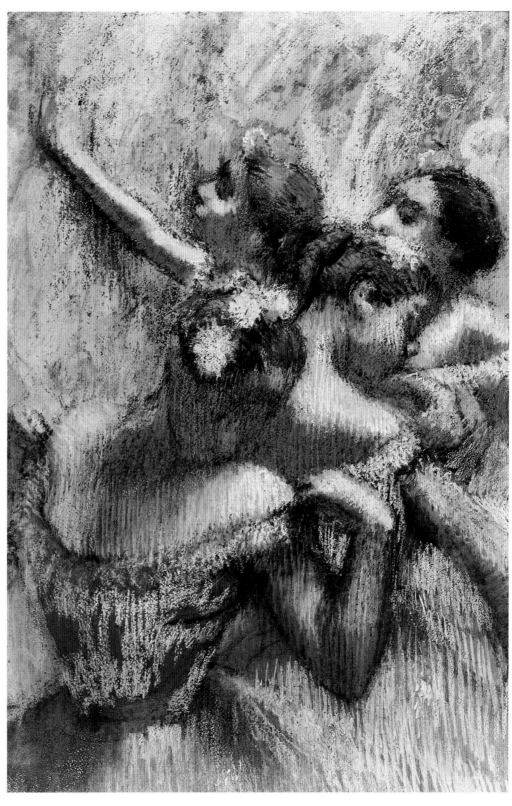

CAT. 27
*Dancers in green and yellow, c.*1899–1904
Pastel on tracing paper
98.8 x 71.5 cm (38⅞ x 28⅛ in.)
New York, Solomon R. Guggenheim Museum,
Thannhauser Collection

CAT. 28
*Four dancers, c.*1899–1904
Pastel on paper
64 x 42 cm (25¼ x 16½ in.)
Private Collection

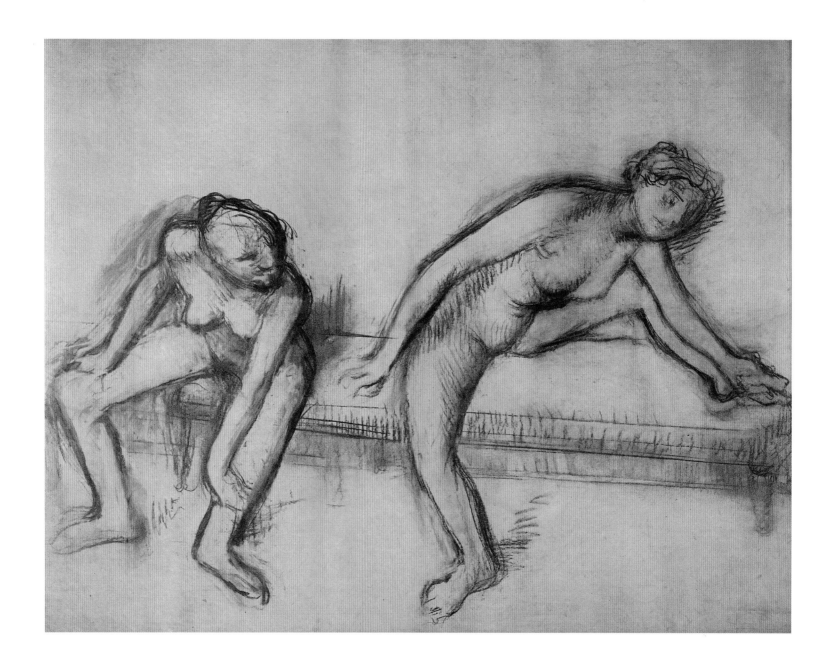

CAT. 29
Two nude dancers on a bench, c.1900–5
Charcoal on tracing paper
80 x 106 cm (31½ x 41⅞ in.)
Chicago, Private Collection

CAT. 30
Two dancers on a bench, c.1900–5
Pastel on tracing paper
83 x 107 cm (32⅝ x 42⅛ in.)
Private Collection

CAT. 31
Dancers, pink and green, c.1885–95
Oil, 82.2 x 75.6 cm (32⅜ x 29¾ in.)
New York, Metropolitan Museum of Art

CAT. 32
Blue dancers, c.1895
Oil, 85 x 75.5 cm (33½ x 29¾ in.)
Paris, Musée d'Orsay

CAT. 33
*Dancers, c.*1900–10
Pastel and charcoal on tracing paper, 45 x 93 cm (17¾ x 36⅝ in.)
Cologne, Wallraf-Richartz-Museum

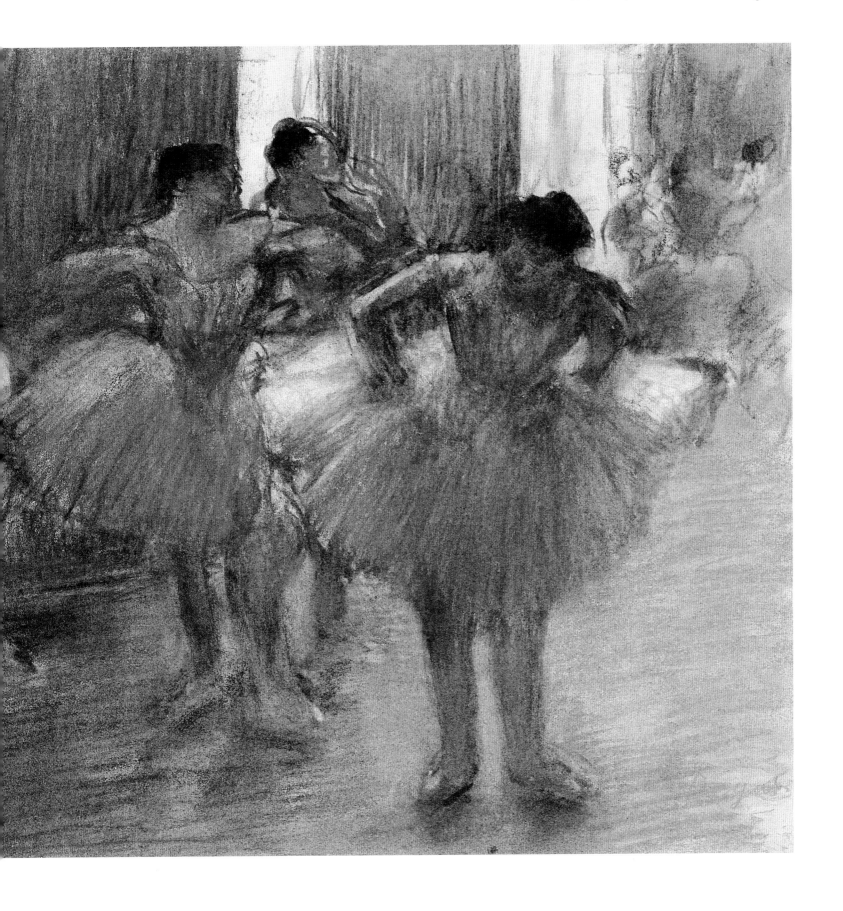

CAT. 34
Torso of a dancer, c.1899
Charcoal and pastel on tracing paper
47.5 x 37 cm (18¾ x 14½ in.)
Bremen, Kunsthalle

CAT. 35
Dancers, nude study, c.1899
Charcoal and pastel on wove paper
78.1 x 58.1 cm (30¾ x 22⅞ in.)
Private Collection

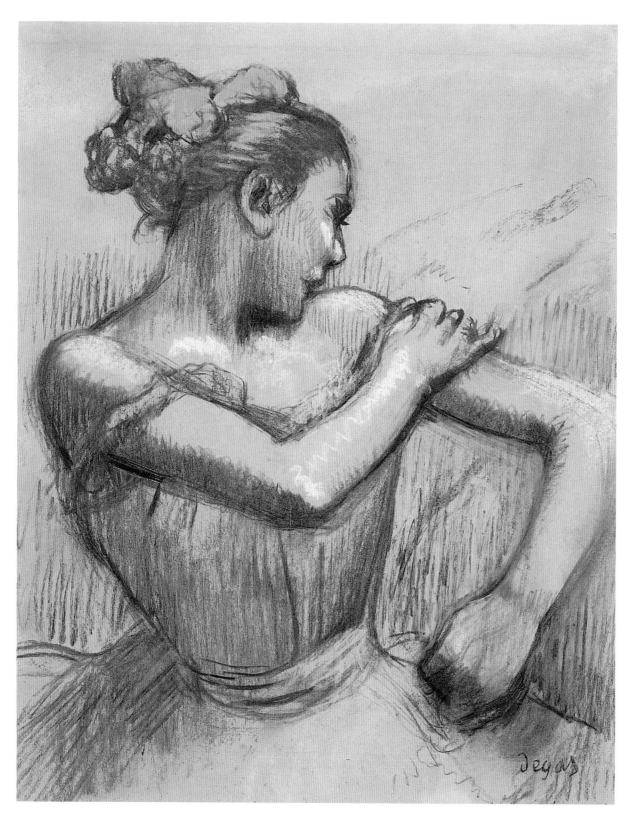

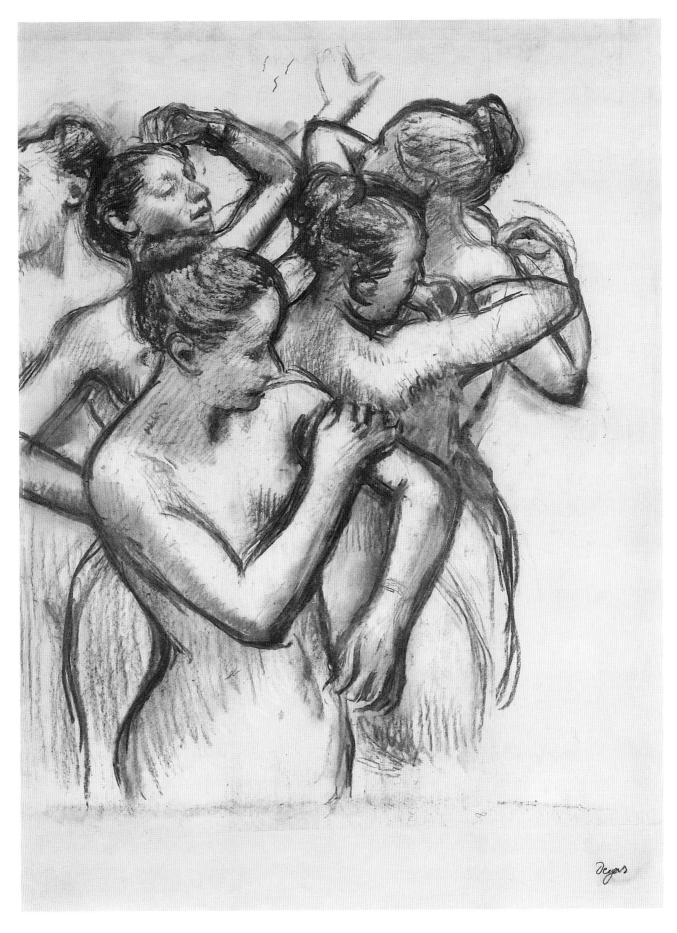

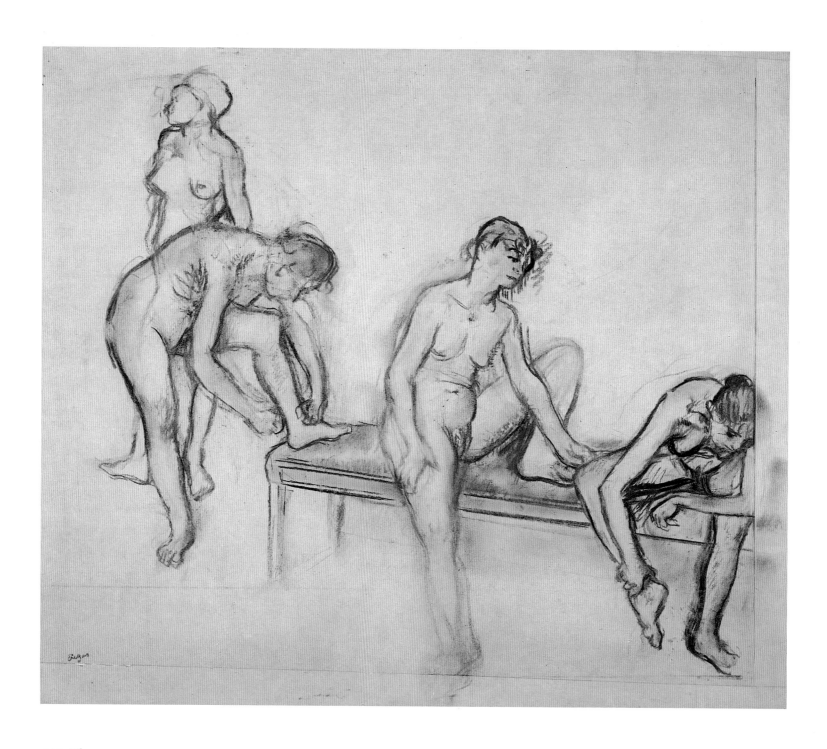

CAT. 36
*Study of four nude dancers, c.*1890–1900
Charcoal on tracing paper
56 x 66 cm (22 x 26 in.)
Collection Susan and Lewis Manilow

CAT. 37
*Dancers, c.*1895
Pastel on tracing paper
51 x 40 cm (20⅛ x 15¾ in.)
Tokyo, Fujikawa Galleries

Combing the Hair

THE SUBJECT OF THE COIFFURE, where a solitary woman combs her hair or has it brushed by a maid, inspired some of the finest pictorial inventions of Degas's last years. Though it had featured briefly in his earlier repertoire, the theme seized Degas's imagination afresh in the 1890s and prompted a profusion of drawings, pastels and oil paintings, even lithographs and wax sculptures. Many were linked by the process of tracing or serial extension, but all demonstrated the artist's extraordinary ability to find visual and psychological drama in the humblest incidents of everyday life. Some models appear in their domestic surroundings, others against stark, anonymous walls; some are seen close-to, others from a distance, from above or from an oblique angle; most are decorously clothed, but occasionally a figure appears naked (cat. 38); almost all are solemnly engaged with their toilette, but, again, this can seem serene or indolent, hasty or near-desperate in its intensity.

Two contrasted variants, *Woman combing her hair* (cat. 39) and *Combing the hair* (cat. 40), illustrate the range of Degas's creativity and something of the subject's complex history. On the surface, the pose and colouring of *Woman combing her hair* tie it closely to a dated pastel of 1894 and a larger canvas of about the same date, securely locating the work in the mid-1890s.[28] X-ray examination of the picture, however, has recently shown that it was executed over a much earlier depiction of a similar image (fig. 130), apparently close to a painting such as *Women combing their hair* of about 1869 in the Phillips Collection, Washington.[29] If traces of anecdotalism cling to the Copenhagen picture, the Oslo *Combing the hair* (cat. 40) appears timeless and tragic, its massively orchestrated forms recalling the cadences of Greek relief sculpture, its protagonists locked in some elemental exchange. Barely able to raise her head, the seated woman braces herself against the tug of her hair, her mute, hunched companion defying the gravitational pull of their surroundings. Suggesting to Jean Sutherland Boggs a time of illness, or of 'apathy and futility', the narrative finds its equivalent in the harsh textures and abrupt modelling of Degas's brushwork.[30] Though suffused with hopeful pinks, oranges and golds, it is the soiled white of shifts and bed-linen that establishes the picture's sobriety.

In many of these coiffure improvisations, as in so much of Degas's later work, it is this bonding of image and technique that brings us close to the artist's purposes. *Woman at her toilette* (cat. 45) relies on Degas's friable, chalky and rainbow-hued pastels to animate the composition, now hinting at nervous energy and fragmented light. Again, such pictures have their origins in the detailed interiors of earlier decades, their speckled wallpapers and vivid upholstery, even — in *Woman at her toilette* — the traces of a domestic pet, spelling out the comforts of what appears to be a bourgeois household. Here pastel is used both to describe and unify, its cascades of yellow, blue and ginger flowing across the disparate

components of the scene and conjuring up rhythms and incident, dignity for the maid and agitation for her mistress.

Common to all these depictions, and perhaps responsible for some of their poignancy, is a rudimentary paradox. On the one hand, the act of combing, brushing or attending to the hair is one of the most banal and wearisome of daily routines, associated with personal hygiene as much as glamour from the beginning of history. In Degas's day such rituals were still doubly oppressive for women, whose hair was typically kept long, yet was endlessly lifted and coiled, pinned and often kept out of sight for work or public presentation. Such demands required endless labour, either the repetitive, self-imposed effort implicit in the two versions of *Woman combing her hair* (cats. 43 and 44) or the mechanical toil expected of a servant. Just as significantly, attention to the hair was essentially classless, occurring out of doors in rural communities or on beach holidays, as Degas's earlier work illustrates, or behind closed doors in the middle-class homes of Paris.

In stark contrast to this banality, hair-combing has a rich and allusive history, intersected by allegorical, literary and sexual traditions, many of which were known to Degas. From the *vanitas* portraits of the Renaissance, such as Titian's *Lady at her toilet* (Paris, Musée du Louvre), where an anonymous beauty tends her chestnut locks while gazing into a mirror, to the public preenings of the modern prostitute, manipulation of the hair was identified with sensuality and its intimate life with eroticism. In the Goncourts' novel *La Fille Elisa*, for example, a work Degas illustrated in his sketchbooks around 1877, the authors describe two prostitutes brushing each other's hair in heightened language that leaves no doubt of the sexual frisson involved.[31] Hair-dressing scenes also appear in the parallel repertoire of the Japanese print, again in many images known to Degas (fig. 172) and set in the 'floating world' of the pleasure-houses of Edo.

The extent to which Degas's images of the coiffure make reference to, disregard or invert these systems of meaning is still a matter of debate. Though little is known of their origins, except that several works were sold during his lifetime, some points can be established with certainty.[32] Degas's first images of hairdressing, such as *Beach scene* (London, National Gallery), were set in the open air and in transparently innocent surroundings. His second suite, executed as monotypes in the late 1870s, brazenly tackled the opposite set of conventions, showing prostitutes surrounded by all the accoutrements of the brothel as they allow attendants to prepare their toilette or brush their hair in front of a client.[33] By the next phase, centred on such pastels of the mid-1880s as *Nude woman having her hair combed* (fig. 96), both of these explicit contexts had been abandoned, replaced by indoor settings, ill-defined spaces and the absence of accompanying narrative.

FIG. 203
Jean-Dominique Ingres, *Study for 'The Turkish bath'*, n.d.
Ink and crayon on paper
Paris, Louvre, Cabinet des Dessins

It is also evident that, like many of his male and female artist contemporaries, Degas continued to engage with the spectacle of hair dressing at first hand. Though excluded by his bachelor status from day-to-day contact with the toilette of women and children, the young Degas had made notes on hair colouring and styles, asked to watch a friend at work on her coiffure and, in later life, spent long hours in his studio as his models posed with brushes and combs.[34] Such poses were part of the common currency of the Paris art world, and their results could range from the near-pornographic to the sombre and the decorative. Acquaintances of Degas's as different as Puvis de Chavannes and Lorenz Frohlich, Berthe Morisot and Mary Cassatt (fig. 14), Federico Zandomeneghi and Georges Jeanniot (fig. 185) made images of hair-combing scenes, while younger colleagues such as William Rothenstein (fig. 193), Toulouse-Lautrec (fig. 187), Pablo Picasso and Henri Matisse contributed respectfully or mischievously to the genre.[35]

One of the most majestic of all Degas's responses to the theme, *Combing the hair* (cat. 42), echoes the fullness of this repertoire while achieving a radical simplicity and poise of its own. In this uncompromising tableau, a certain opulence may be intended in the heavy curtain and glimpse of a mirror or painting, the formally attired maid and the warmth and comfort of her setting. But the seated woman, who appears to be pregnant, expresses discomfort, even the extremes of exhaustion beside her statuesque companion, recalling the pathos of the Oslo canvas and Degas's fascination with women in all their predicaments.[36] Its glowing hues and sweeping brushmarks derive from Degas's late interest in the technique of the Venetian painters, notably Titian and Veronese, and his design also turns out to have historic roots. An almost identical group of two female figures, one seated while her hair is brushed by a friend, occurs in Ingres's *The Turkish bath* (fig. 66) and its preparatory drawings (fig. 80), as well as in Renaissance prototypes.[37] Even at his most aggressively experimental, Degas still took strength from tradition.

CAT. 38
*Woman combing her hair, c.*1896–9
Charcoal and pastel on tracing paper
108 x 75 cm (42½ x 29½ in.)
Private Collection

CAT. 39
*Woman combing her hair, c.*1894
Oil, 54 x 40 cm (21¼ x 15¾ in.)
Copenhagen, Ordrupgaard

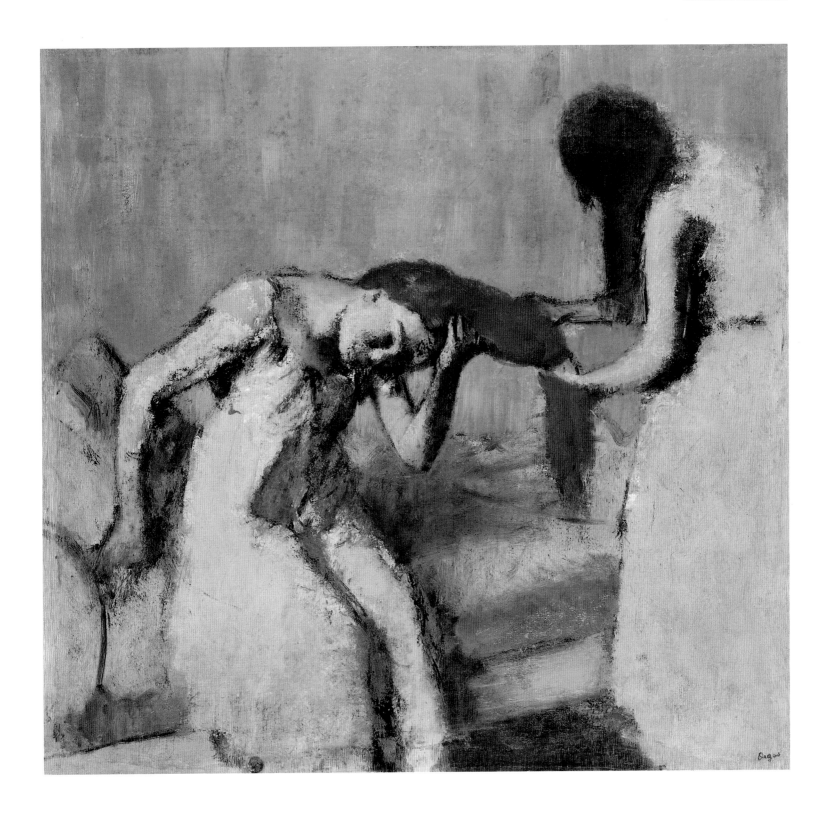

CAT. 40
*Combing the hair, c.*1896–1900
Oil, 82 x 87 cm (32¼ x 34¼ in.)
Oslo, Nasjonalgalleriet

CAT. 41
Woman combing her hair, c.1892–6
Pastel on tracing paper, 56 x 56 cm (22 x 22 in.)
Private Collection

CAT. **42**
*Combing the hair, c.*1892–6
Oil, 114.3 x 146.1 cm (45 x 57½ in.)
London, National Gallery

CAT. 43
Woman combing her hair, c.1896–9
Charcoal and pastel on tracing paper
58.5 x 81 cm (23 x 31⅞ in.)
London/Geneva, Private Collection

CAT. 44
Woman combing her hair, c.1896–9
Charcoal and pastel on tracing paper
89 x 89 cm (35 x 35 in.)
Private Collection

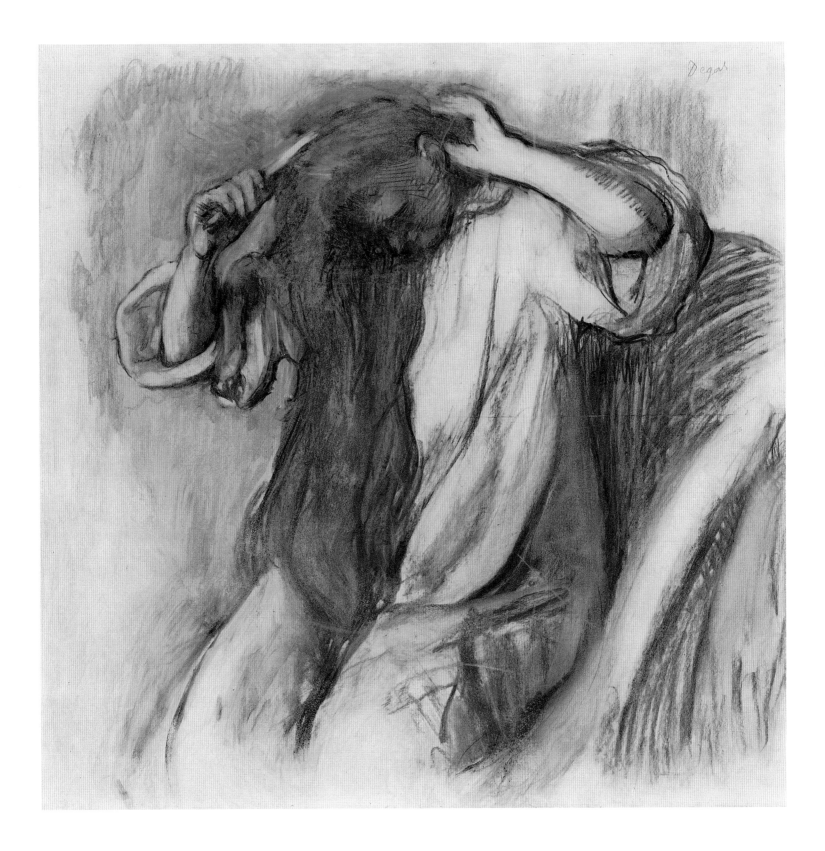

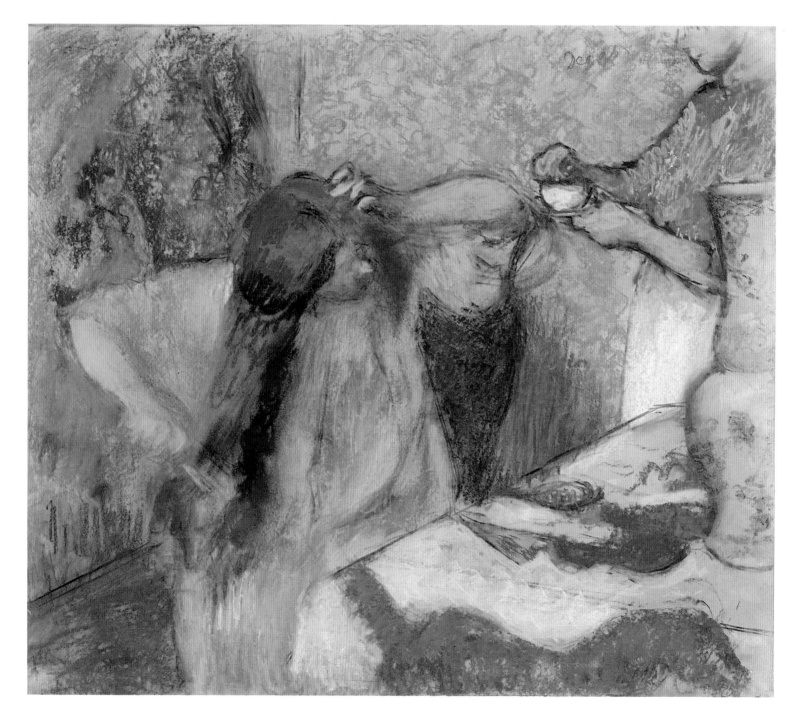

CAT. 45
Woman at her toilette, c.1896–9
Pastel on tracing paper
96 x 110 cm (37¾ x 43¼ in.)
London, Tate Gallery

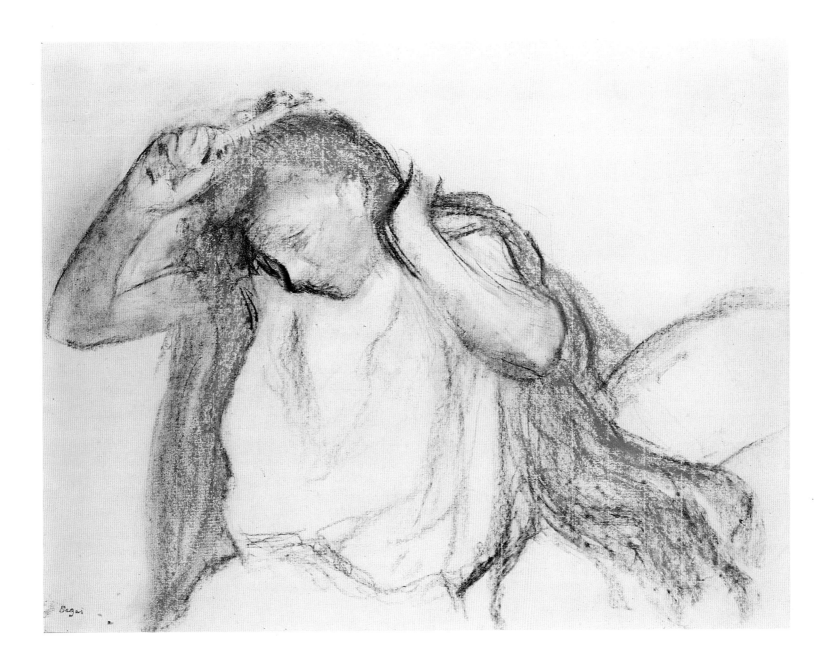

CAT. 46
*After the bath, c.*1896–9
Charcoal and pastel on paper
47.6 x 61.5 cm (18¾ x 24¼ in.)
Tokyo, National Museum of Western Art,
Matsukata Collection

WOMEN BATHING

In the last two decades of his working life, Degas made at least two hundred pastels representing female bathers, as well as substantial numbers of oil paintings, lithographs, sculptures and countless charcoal drawings on the same subject. Averaging at least one major statement of the theme each month, and exceeded only by depictions of the ballet during this period, the bather became one of the artist's driving obsessions, dominating several of his current displays, attracting enthusiastic patronage and often contradictory criticism, and threatening to supplant his reputation as 'the painter of dancers'. Curiously, these late nudes and toilette scenes have never been studied in their own right, despite their profusion and their manifest departure in appearance, ambition and technical engagement from Degas's earlier bather subjects. When they are mentioned at all, they tend to be uncritically grouped with the more well-known, and extensively analysed, pastel nudes of the mid-1880s and unquestioningly associated with the social and pictorial context of the Impressionist era.

An exploration of the distinctive features of Degas's late bather pictures, based on the precise scrutiny of individual images and the plotting of wider patterns of evolution, is included in chapter 5 of the present volume. This highlights the unusual spareness of most of these pictures; the solitude of the female model; the absence of narrative devices and the paraphernalia of eroticism; the depicted women's self-absorption, their sexual modesty and the general plausibility of their occupations; and their distinction from the classical athletes and insubstantial nymphs that still populated the works of former Impressionists and Salon favourites alike. Extending this attempt to situate Degas's nude repertoire in the visual currents of his day, new evidence is offered about the purchasers of his bather pictures, many of whom turn out to have been women, and the halting efforts of contemporary critics to give expression to their development. None of these investigations is intended to diffuse the compelling and vividly expressive character of these pastels and canvases, nor to spare them from the energetic attention they will undoubtedly receive as they become better known. On the contrary, by mapping routes and identifying hazards, by drafting contours and establishing points of reference it is hoped that a succession of productive excursions into this ill-explored terrain will follow.

How should modern audiences respond to a representative array of Degas's final studies of the female nude, such as that assembled in the following pages? To some viewers, these works are frankly disquieting, even repulsive, the outpourings of a man fixated on the opposite sex, who has invaded its privacy, exploited its vulnerability and given visual form to the oppressive gender relations of his times. Others have found these images less susceptible to categorisation, defiant in their assertion of

the model's unglamorous predicament and respectful of her muscular independence. Yet others continue to delight in their chromatic and linear extravagance, their powerful dispositions of form and the endlessly inventive interplay of mass and energy, nuance and texture that remind us of their essential artifice. Are these pictures merely reflections of their age, or knowing and distanced commentaries upon it? Are they exotic confections of colour, to be enjoyed irrespective of their subject? Or are they documents of neurosis, the records of perverse curiosity that invite our disapproval?

A densely worked pastel such as *After the bath* (cat. 48), which would surely occupy the high ground in any provisional mapping of Degas's achievement, summarises the extremes of sumptuousness of the late bathers. At the more sombre end of the same spectrum, the austere drawing from the Fogg Art Museum (cat. 50) and the near-monochrome canvas from Philadelphia (cat. 57) remind us of the rigour of Degas's practice, as well as the sheer diversity of his graphic imagination. It is this exceptional span, from the near-playful to the well-nigh desperate, via the monumental, the serene and the historically resonant, that is most often overlooked in considerations of Degas's female imagery and that least lends itself to broad generalisation. Even more than in his Impressionist years, when he had consorted with scientists and interested himself in methodical studies of his own species, Degas seemed determined to represent his models in all their moods and private circumstances. Conflating the language of the *flâneur* with that of the researcher, Degas claimed that 'women are our only concern' and that 'we are made to look at each other', describing his representations of 'the human animal occupied with itself' whose activities did not 'presuppose an audience'.[38] Some of the critics sensed his purpose, one writing in 1894 of Degas's images of 'the modern Parisian woman . . . woman as she is' and another, in 1909, describing his depictions of 'the female body in all the caprices of its nudity'.[39]

The exceptional range, both pictorial and psychological, of Degas's depictions of women seems essential to their collective and individual meaning. In *Woman at her bath* (cat. 49), the amplitude of the bather's pose, the reassuring presence of her maid and the cascades of light and pattern evoke domestic luxury; in the bronze *Seated woman wiping her left hip* (cat. 55), cast from Degas's original wax, the woman's pleasure in her own body is manifest; *After the bath* (cat. 59) can seem alternately placid and alarming, while *The Masseuse* (cat. 60) speaks of painful exercise and stoic resignation. Certain images developed in sequence appear to follow an emotional progression, from the reserved *Woman drying herself* (cat. 65) to the almost unbearably intense *Woman at her toilette* (cat. 66), for example, or between the fulsomeness of *Woman drying herself* (cat. 63) and the more agitated *After the bath* (cat. 64). Wilfully

revisiting certain gestures, such as the crooked elbow in *After the bath, woman drying herself* (cat. 53) and *Woman seen from behind, drying her hair* (cat. 56), Degas seemed determine to exhaust the language of the human body and the nuances of its representation.

In itself, Degas's preoccupation with the nude was unexceptional among the artists of his age. Studies of the naked model formed the staple of the painter's education and images of instructive, ornamental or notionally modern nudity were still favoured in civic buildings and public exhibitions. It was the bather that provided the strongest link, in their later years, between the work of Degas and that of Cézanne, Renoir, Gauguin, Toulouse-Lautrec and even Pissarro, as well as with such acquaintances of Degas as Henner, Besnard, Rodin, Carrière, Bouguereau and Gérôme. Common to all these contexts, though utterly disparate in its effects, was an awareness of the antiquity of the nude, suggestive of orthodoxy and erudite allusiveness to some, licensed voyeurism to others. Many commentators have noted the persistence of this tradition in Degas's nude compositions, citing his copies from Mantegna (fig. 120), Poussin (fig. 59) and Titian (fig. 62) and the exemplary role played throughout his career by such works as Ingres's *Valpinçon bather* (fig. 60). Though his reverence for these masters continued, perhaps intensified, in old age, the historicism of Degas's later nudes is easily misunderstood.

Alongside Degas's veneration for the works of the past, his 'bear-like sense of fun' (as Sickert described it) often led him to mock the solemnity that surrounded his precursors, posing a party of his friends in an absurdly inaccurate version of Ingres's *Apotheosis of Homer* and joking that 'If Veronese landed on the banks of the Seine it would not be to Bouguereau, but to me, that he gave his hand as he stepped out of his gondola'.[40] In a similar way, Degas derided those of his peers, like Gérôme, who leaned too heavily on historical sources and went to considerable lengths to avoid such quotations in his own work.[41] Compared to a bacchanale by Bouguereau, a Susannah by Henner or the *Phryne before the Areopagus* (fig. 180) by Gérôme, even to the bathers of Renoir, Cézanne and Gauguin, Degas's nudes are aggressively and uncompromisingly modern. Not only do they engage with 'woman as she is', without classical or biblical circumlocution, they tackle the awkwardness and disequilibrium of contemporary experience, its anxieties as well as its comforts. When Degas announced 'in former times, I would have painted *Susannah at her bath* . . .', he was emphatically *separating* himself from the images and assumptions of history, not urging continuity where it no longer existed.[42]

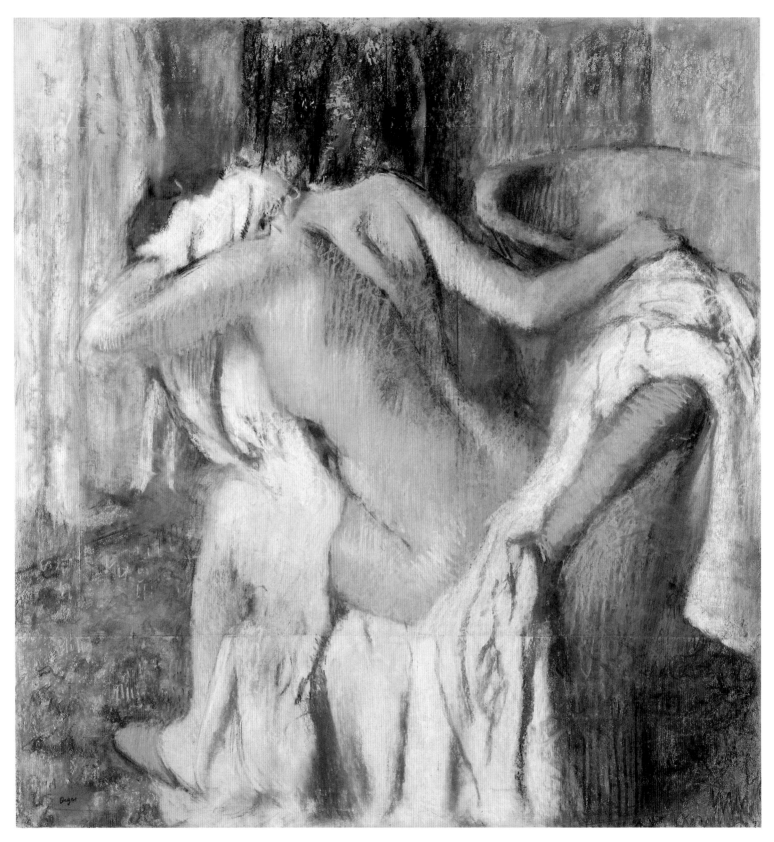

CAT. 47
After the bath, woman drying herself, c.1890–5
Pastel on tracing paper, 103.8 x 98.4 cm (40⅞ x 38¾ in.)
London, National Gallery

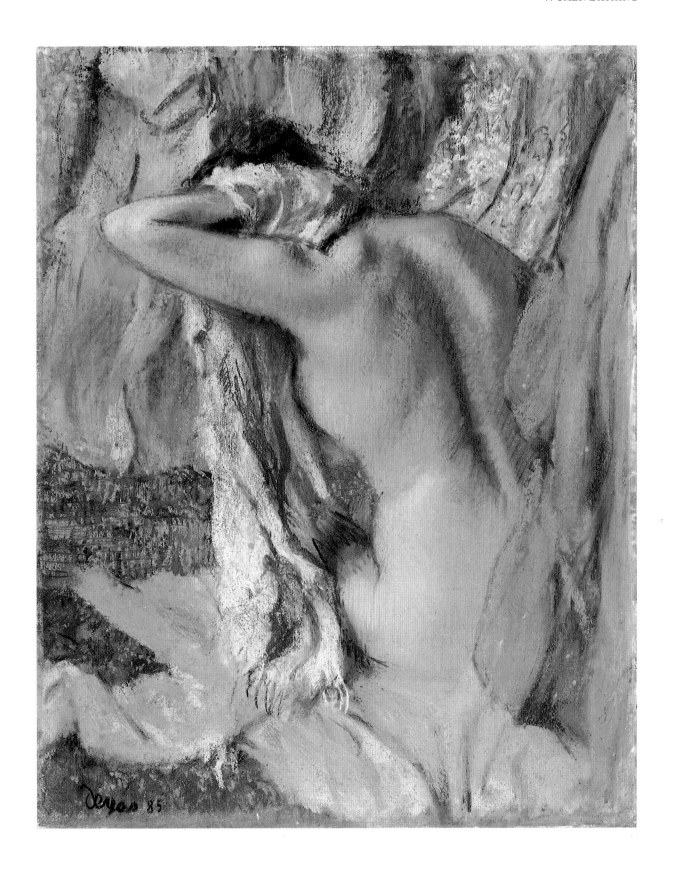

CAT. 48
*After the bath, c.*1890–3
Pastel on tracing paper, 66 x 52.7 cm (26 x 20¾ in.)
Pasadena, California, Norton Simon Foundation

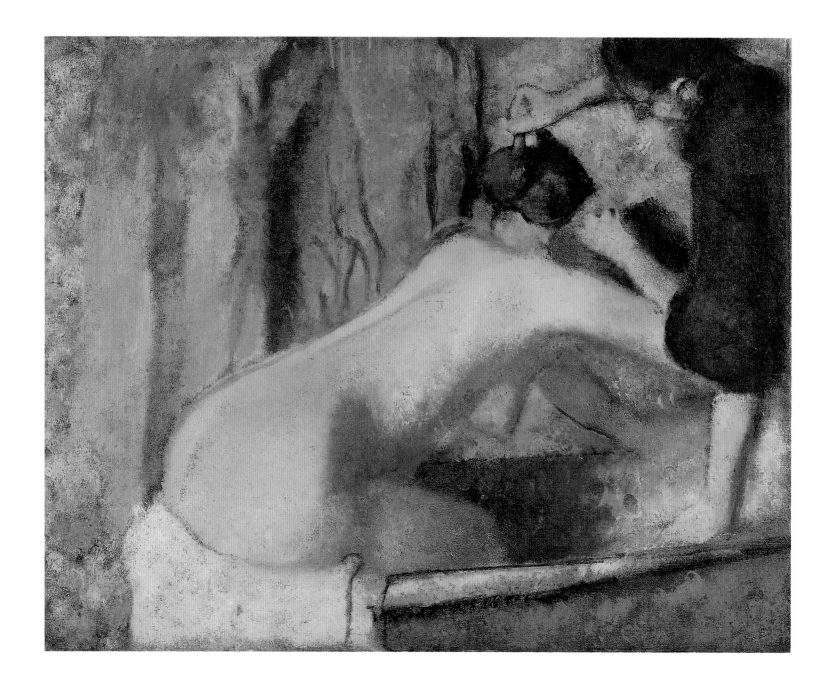

CAT. 49
*Woman at her bath, c.*1893–8
Oil, 71.1 x 88.9 cm (28 x 35 in.)
Toronto, Art Gallery of Ontario

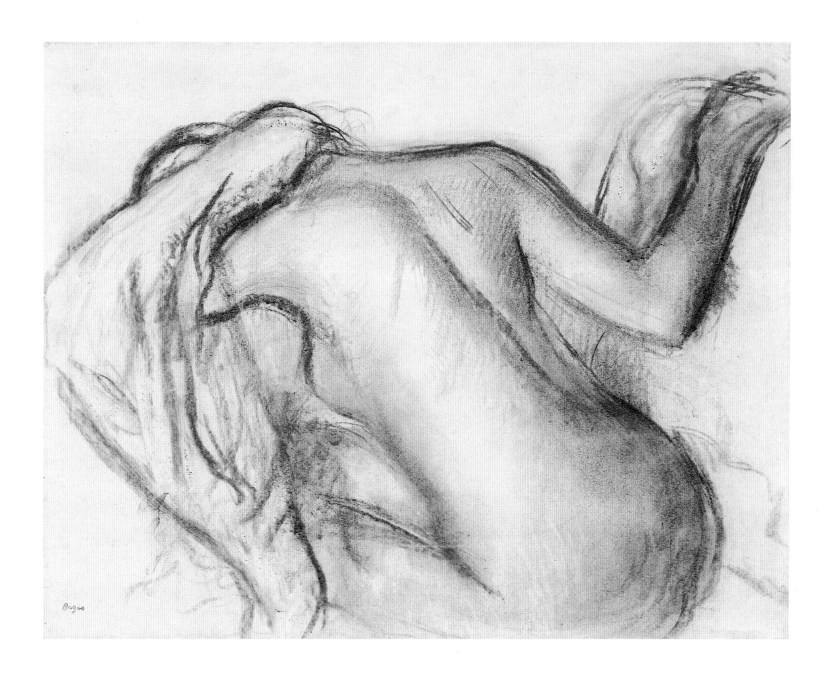

CAT. 50
*After the bath, c.*1893–8
Charcoal on tracing paper
49.7 x 64.4 cm (19½ x 25⅜ in.)
Cambridge, Mass., Fogg Art Museum,
Harvard University Art Museums

CAT. 51
*After the bath, woman drying her hair, c.*1893–8
Charcoal on tracing paper
62 x 69.3 cm (24⅜ x 27¼ in.)
Fort Worth, Texas, Kimbell Art Museum

CAT. 52
*Breakfast after the bath, c.*1893–8
Pastel on tracing paper
119.5 x 105.5 cm (47 x 41½ in.)
Winterthur, Kunstmuseum

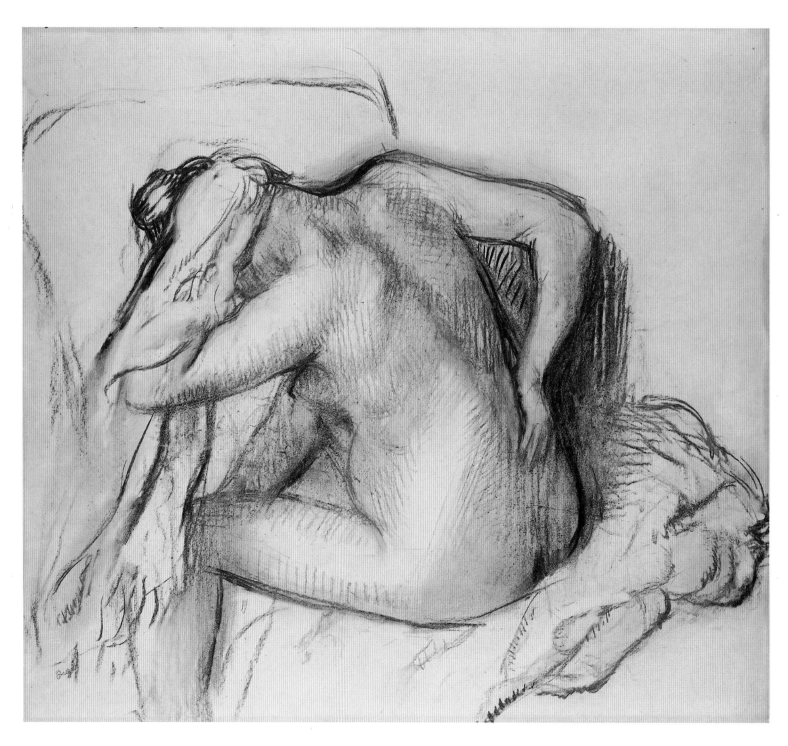

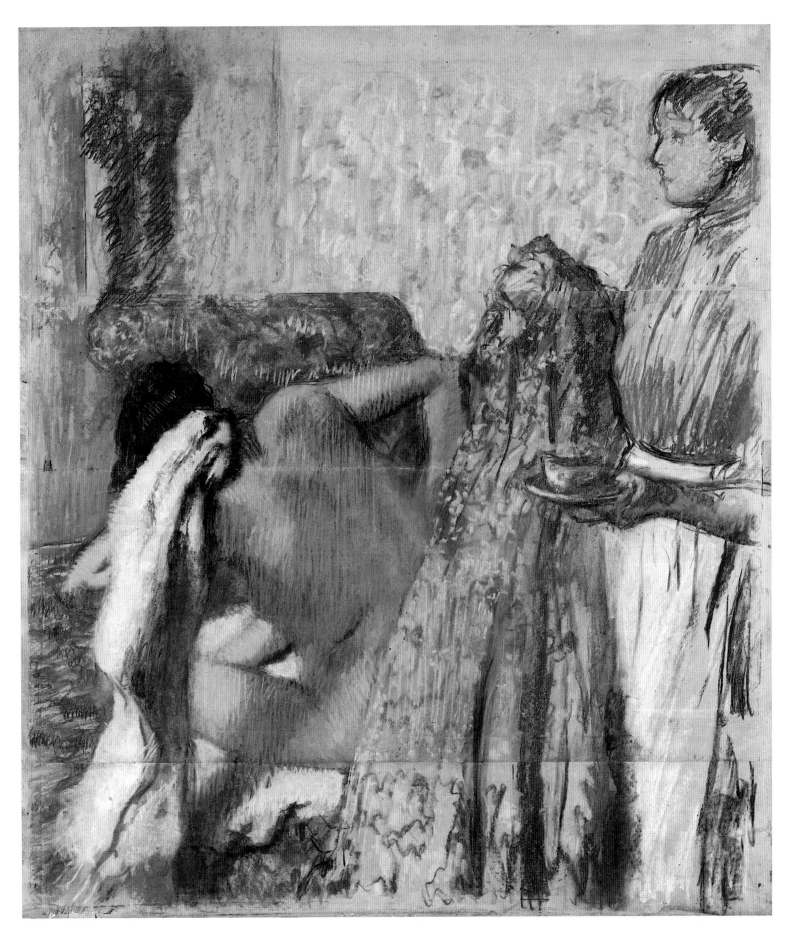

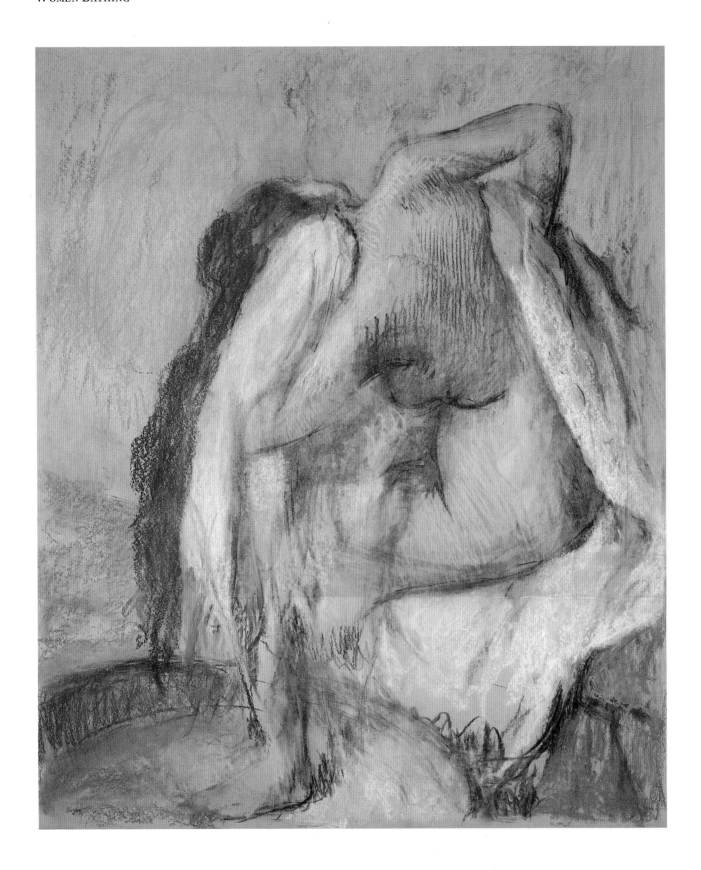

CAT. 53
After the bath, woman drying herself, c.1895–1905
Pastel and charcoal on tracing paper, 121 x 101 cm (47⅝ x 39¾ in.)
Stuttgart, Staatsgalerie

CAT. 54
Seated woman wiping her left side, c.1900–5
Bronze, 33 cm (13 in.) high
Detroit Institute of Arts

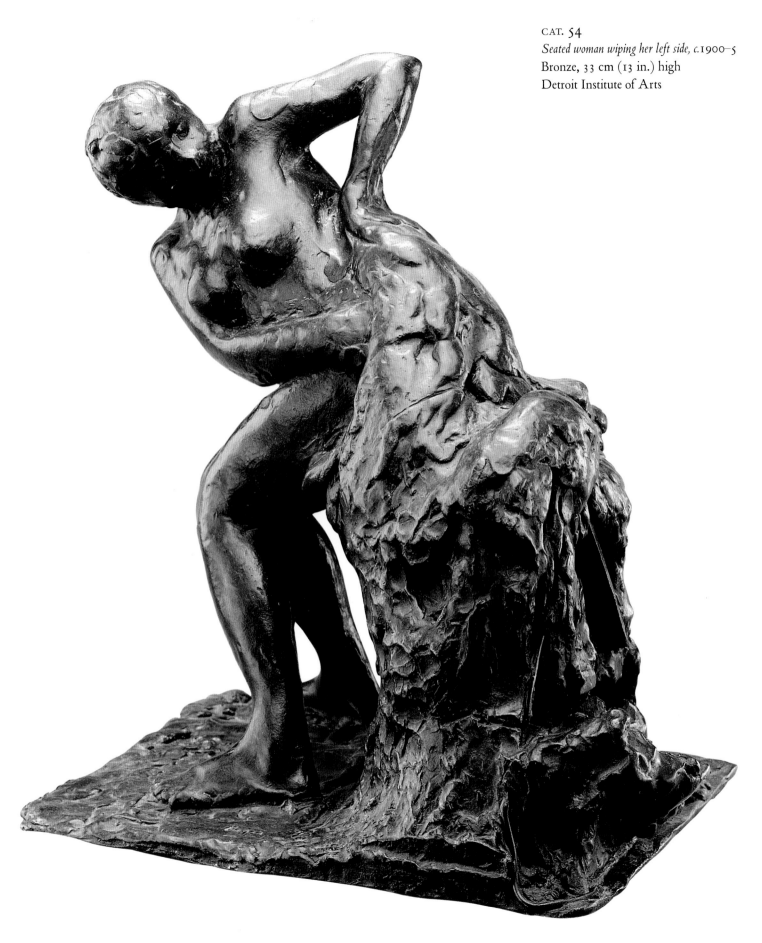

CAT. 55
*Seated woman wiping her left hip, c.*1900–10
Bronze, 45.4 cm (17⅞ in.) high
Washington, Hirshhorn Museum and
Sculpture Garden, Smithsonian Institution

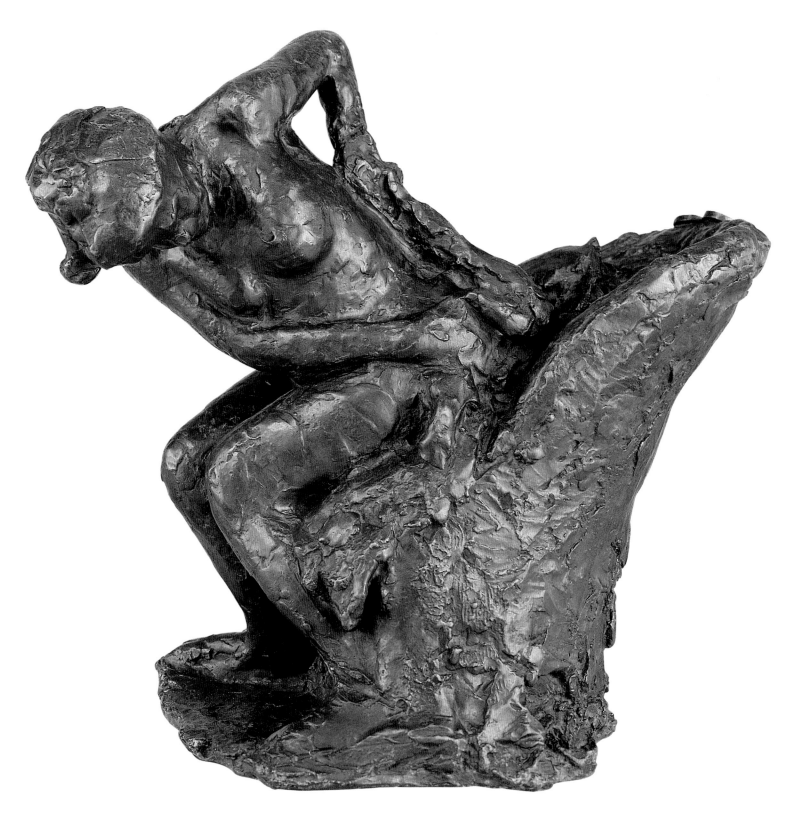

CAT. 56
*Woman seen from behind, drying her hair, c.*1905–10
Pastel on tracing paper, 57 x 67 cm (22½ x 26⅜ in.)
Paris, Private Collection

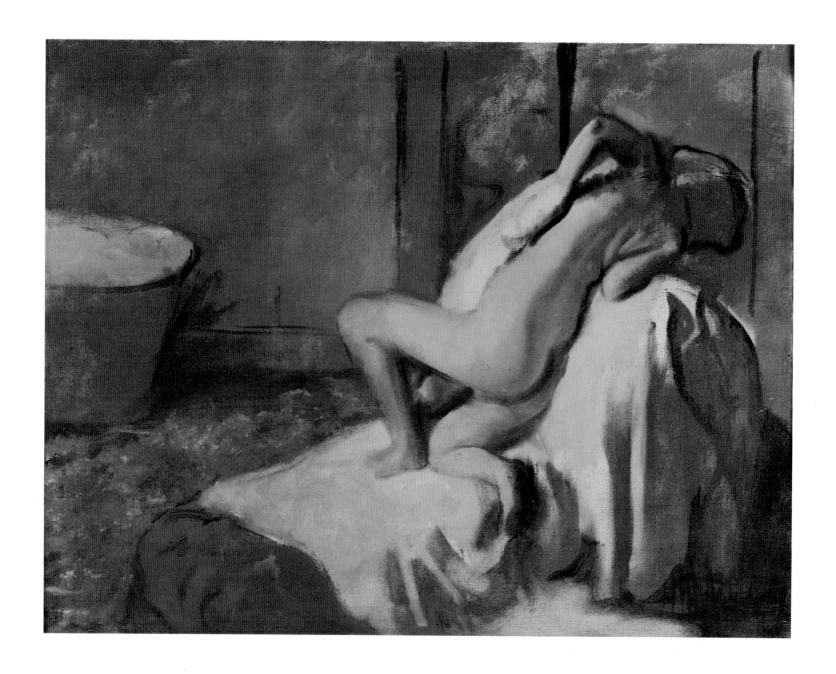

CAT. 57
*After the bath, woman drying herself, c.*1894–6
Oil, 89 x 116 cm (35 x 45⅝ in.)
Philadelphia Museum of Art

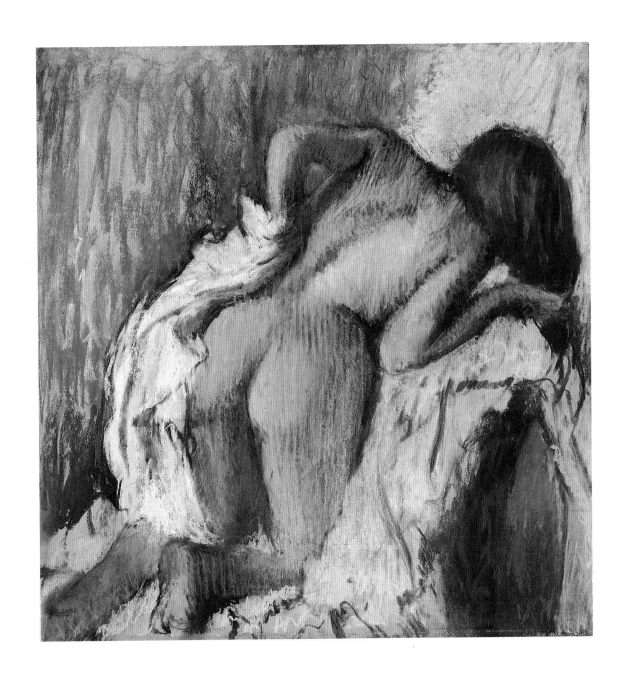

CAT. 58
*Woman drying herself, c.*1896–8
Pastel on tracing paper, 64.8 x 63.5 cm (25½ x 25 in.)
Edinburgh, National Gallery of Scotland

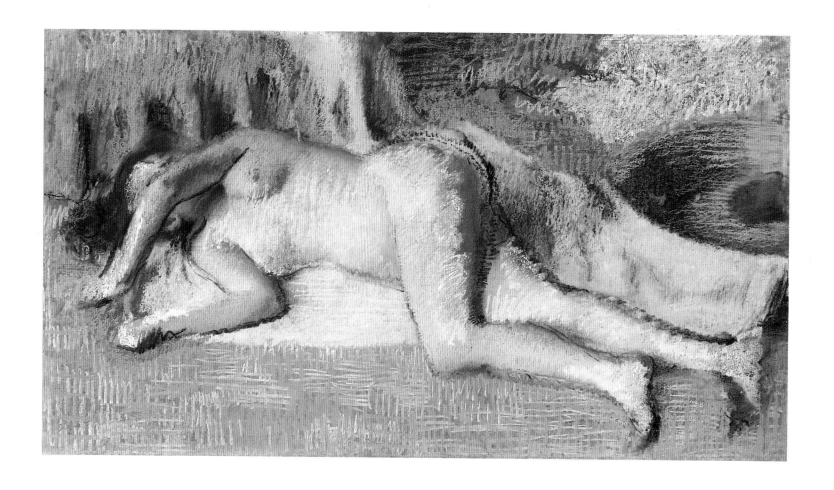

CAT. 59
After the bath, c.1893–5
Pastel on paper, 48.3 x 83.2 cm (19 x 32¼ in.)
Private Collection

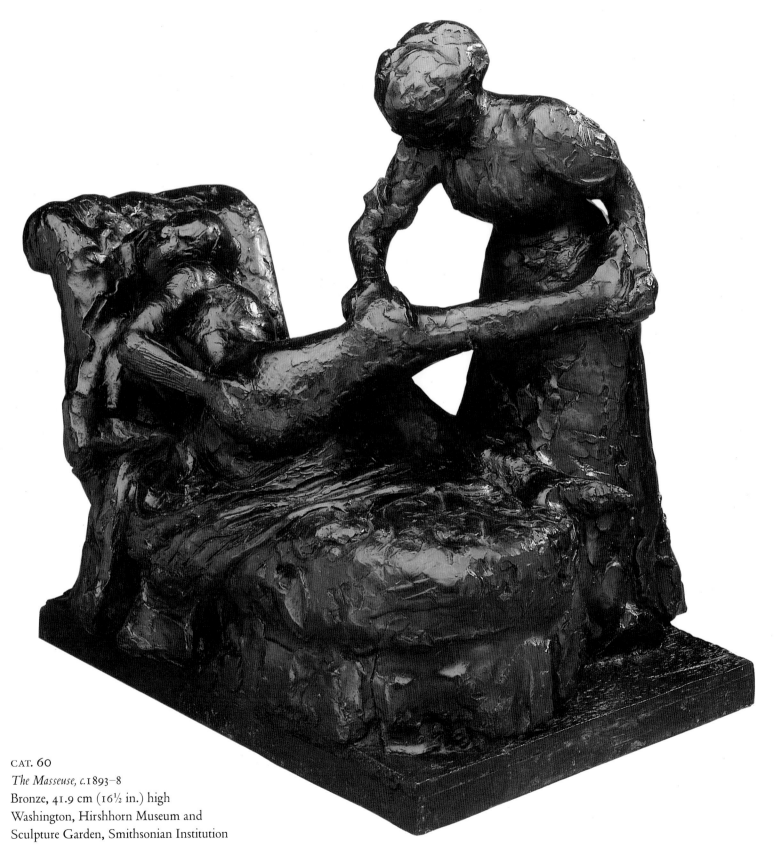

CAT. 60
*The Masseuse, c.*1893–8
Bronze, 41.9 cm (16½ in.) high
Washington, Hirshhorn Museum and
Sculpture Garden, Smithsonian Institution

CAT. 61
After the bath, woman drying herself, c.1895–1900
Pastel on tracing paper, 67.7 x 57.8 cm (26⅝ x 22¾ in.)
London, Courtauld Institute Galleries
(Samuel Courtauld Trust)

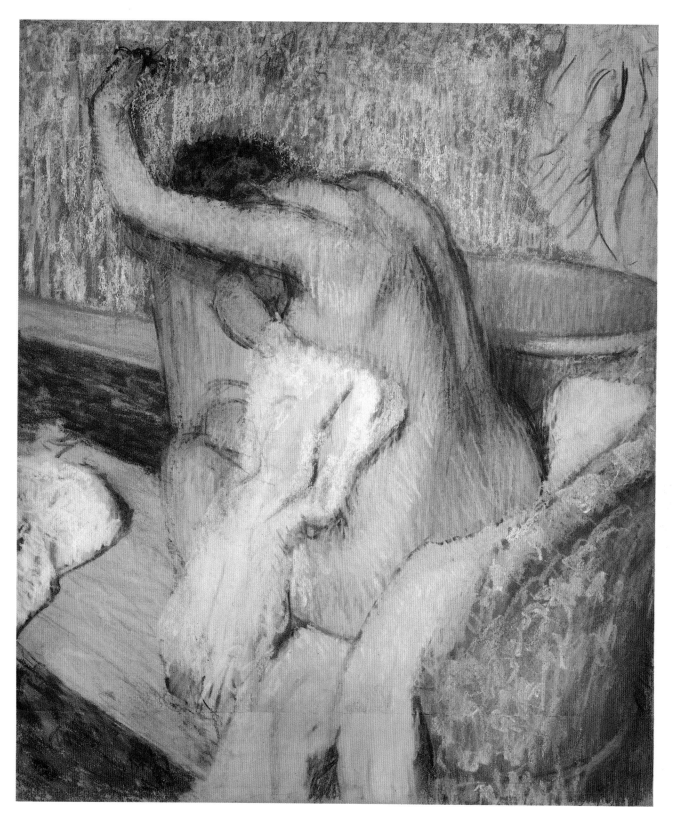

CAT. 62
Woman seated in an armchair wiping her left armpit, c.1895–1900
Bronze, 31.8 cm (12½ in.) high
The Art Institute of Chicago

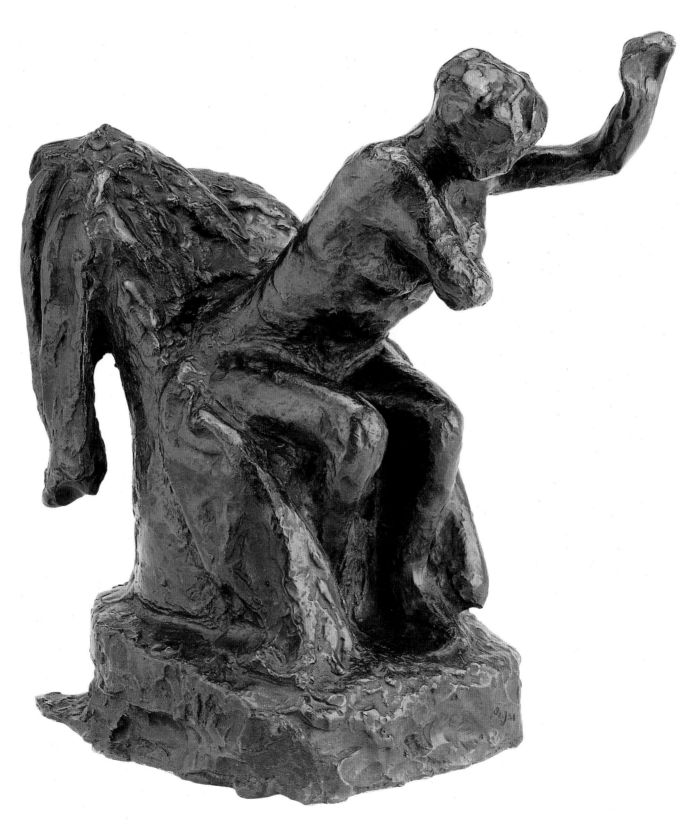

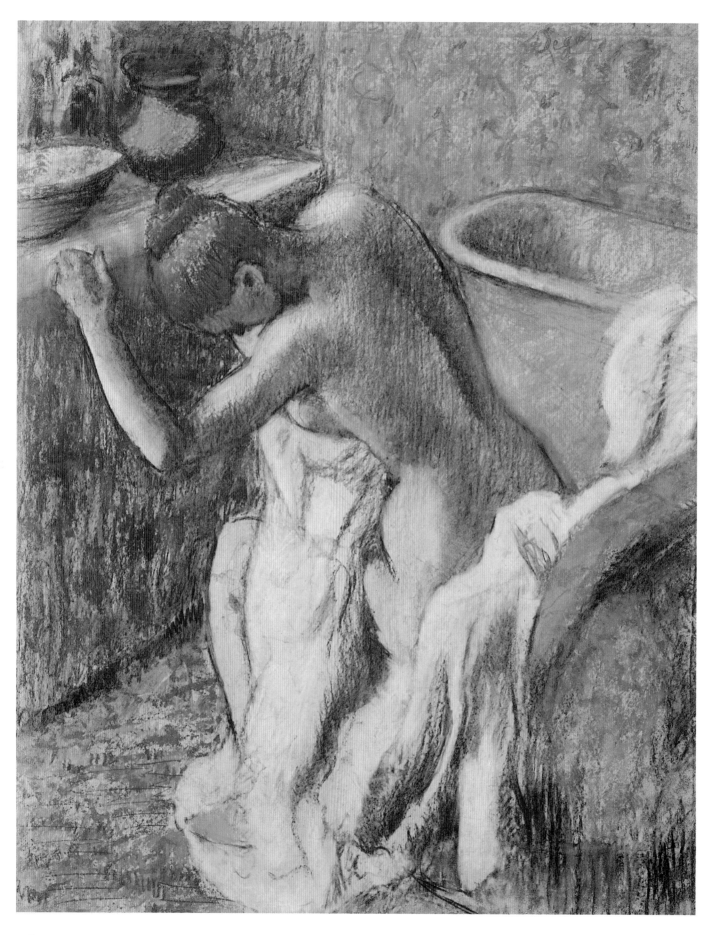

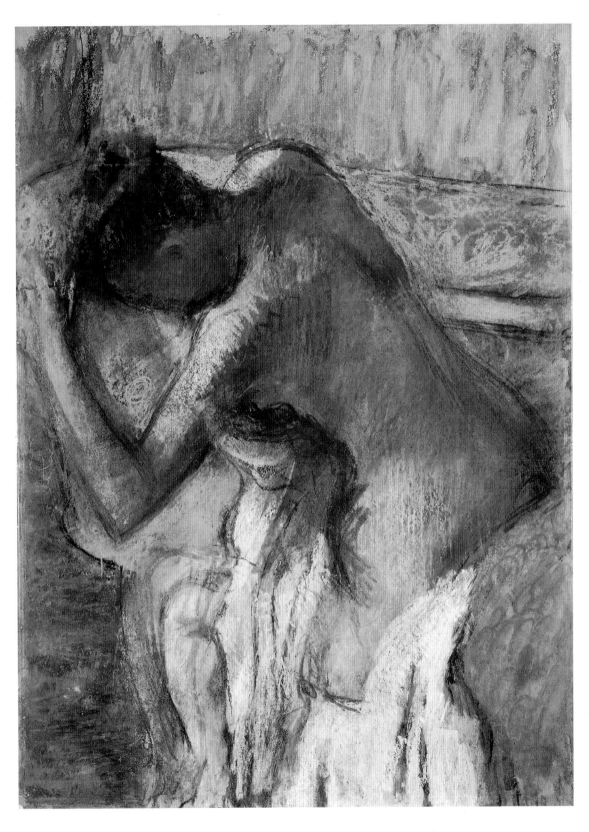

CAT. 63
Woman drying herself, c.1893–8
Pastel and charcoal on tracing paper
110.5 x 87.3 cm (43 ½ x 34 ⅜ in.)
Chicago, Private Collection

CAT. 64
After the bath, 1900–10
Pastel on tracing paper
80 x 58.4 cm (31 ½ x 23 in.)
Ohio, Columbus Museum of Art

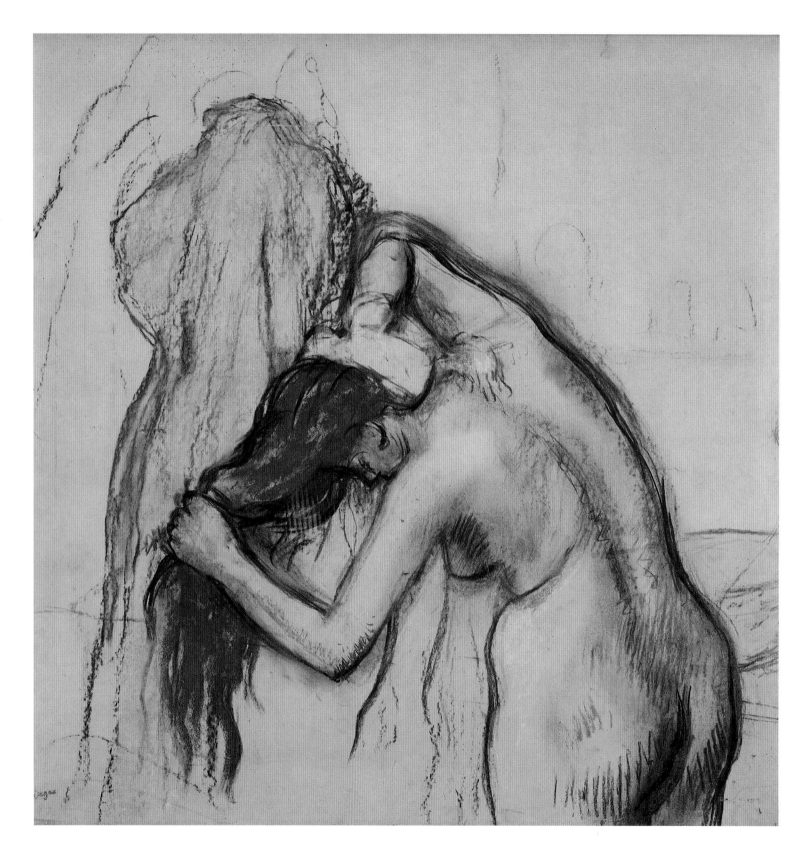

CAT. 65
Woman drying herself, c.1900–5
Charcoal and pastel on tracing paper, 78.7 x 78.7 cm (31 x 31 in.)
Houston, Museum of Fine Arts

CAT. 66
*Woman at her toilette, c.*1900–5
Pastel on tracing paper
75 x 72.5 cm (29½ x 28½ in.)
The Art Institute of Chicago

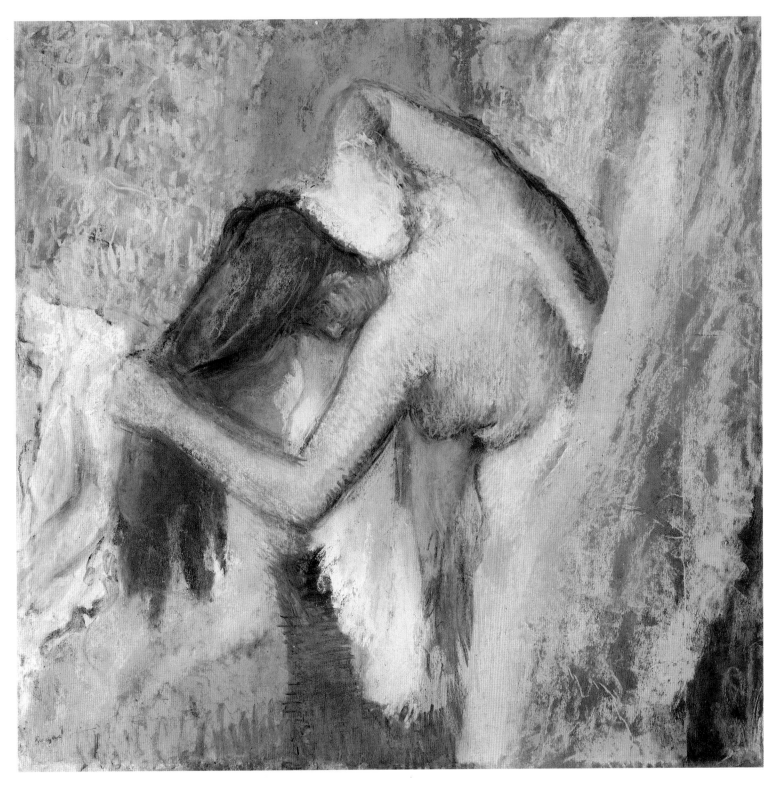

CAT. 67
After the bath, woman drying herself, c.1900–5
Charcoal and pastel on tracing paper, 77 x 72 cm (30¼ x 28⅜ in.)
Bremen/Berlin, Private Collection

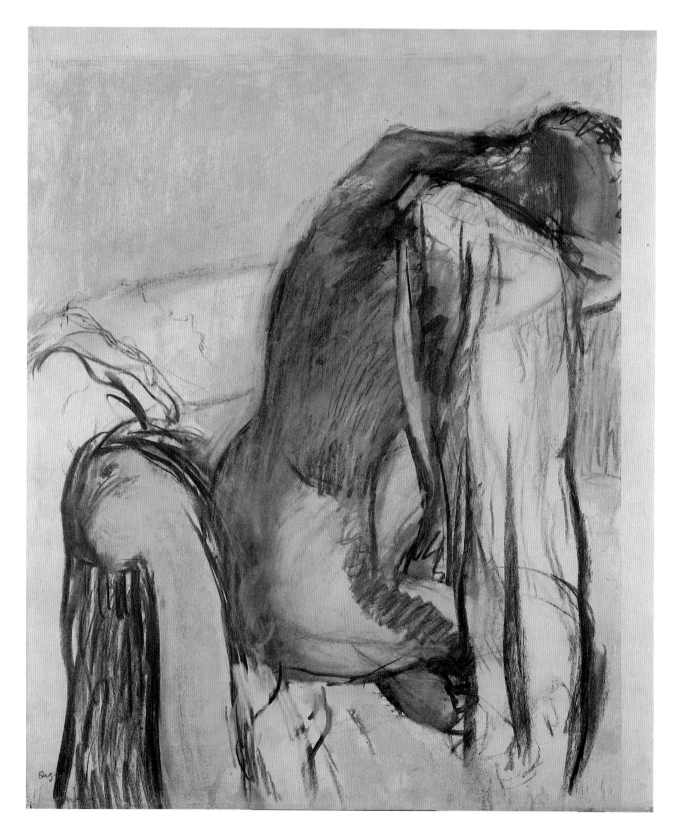

CAT. 68
*Woman seated in an armchair wiping her neck, c.*1900–10
Bronze, 31.8 cm (12½ in.) high
Richmond, Virginia Museum of Fine Arts

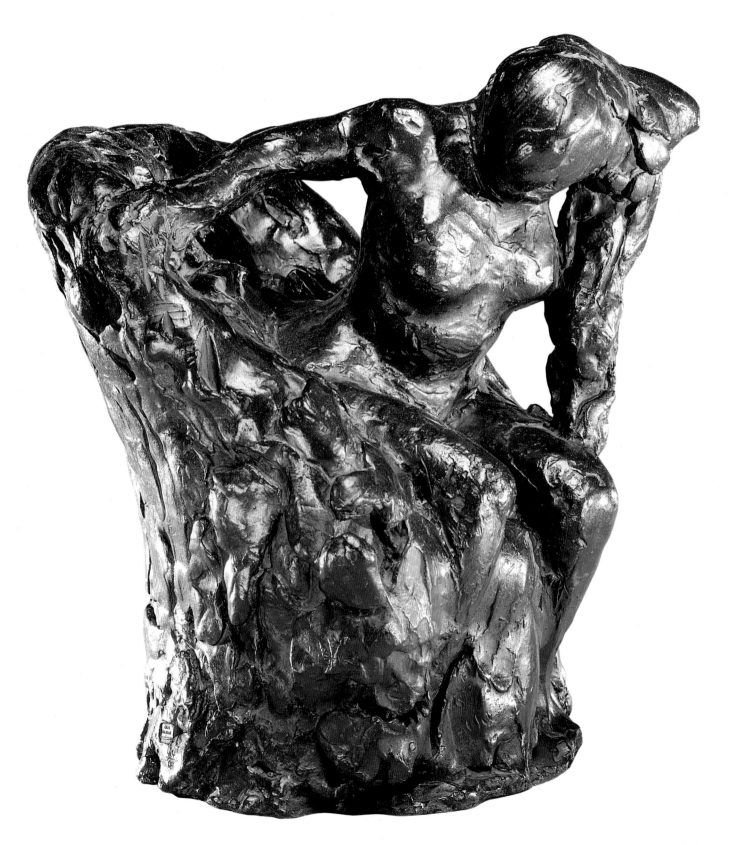

THE ROLE OF SCULPTURE

DEGAS WAS THE MOST IMPORTANT painter-sculptor of the nineteenth century, anticipating and perhaps stimulating the creative dialogue between the two media among his immediate successors, most notably Picasso and Matisse. Despite the high esteem in which his sculpture has been and continues to be held (Renoir called him 'the greatest living sculptor'), there are still remarkable gaps in our knowledge of the circumstances in which Degas's statuettes were made, the dates of individual pieces and the part they played in his technically diverse art. The little that is known about the subject tends to compound the mystery that surrounds it; it has often been noted, for example, that Degas chose to exhibit only one work, the *Little dancer of fourteen years* (fig. 23), in his lifetime; that he kept the remainder of the sculptures in his studio until his death; and that many of his figures of dancers, bathers and horses were left to crumble into dust in his later years. Whatever his ambitions for these sculptures, popular acclaim and an appeal to posterity were not prominent among them.[43]

Current research promises to illuminate much of the technical uncertainty that has dogged the history of these extraordinary objects.[44] Examination of many of the seventy-four surviving models has already shown that Degas worked principally in wax, though with excursions into plaster and clay, and that he habitually mixed extraneous and sometimes bizarre materials and objects into his medium.[45] Many of the figures show the evidence of their fabrication, in preserved fingerprints and roughly gouged surfaces, and in the toothed marks of modelling tools typically used by late nineteenth-century sculptors (fig. 204). Often poorly constructed in the first place, using home-made armatures and improvised extensions for further support, the figures were clustered on table-tops and sculpture-stands in Degas's Montmartre studio, where they were observed by friends and augmented until the end of his career. It was not until after Degas's death in 1917 that the waxes were rescued by friends and family, repaired where possible and prepared for casting into bronze. Using an ingenious variation of the *cire perdu* (or 'lost wax') process, some two dozen sets of bronzes were undertaken, while preserving most of Degas's original models.

A partial explanation of Degas's highly irregular sculptural project, as simple as it is provocative, has occasionally been hinted at but never frankly confronted. This is the possibility that the majority of his waxes were made to assist in the composition of Degas's pastels and oil paintings, either to increase his understanding of a three-dimensional form or to take the place, quite literally, of the living model. Support for this proposal comes from a variety of sources, not least an account of several conversations that took place between Degas and the critic François Thiébault-Sisson in 1897. As their discussion progressed, Degas told Thiébault-Sisson of 'his attempts at modelling which his

failing eyesight had led him to substitute for painting as a means of expression'.[46] Insisting that he had been practising sculpture for 'upwards of thirty years, not continuously but from time to time', Degas cited his earlier experiments with wax racehorses, when he had realised that 'to achieve exactitude so perfect in the representation of animals that a feeling of life is conveyed, one had to go into three dimensions'. Finally, the artist summarised his current practice, claiming that

> *the only reason that I made wax figure of animals and humans was for my own satisfaction, not to take time off from painting or drawing but in order to give my paintings and drawings greater expression, greater ardour and more life. They are exercises to get me going; documentary, preparatory motions, nothing more. None of this is intended for sale . . .*[47]

Even allowing for journalistic licence, the implications of this statement for Degas's sculpture are profound. In strictly historical terms,

however, such a relationship between modelling and picture-making is far from exceptional. Elsewhere in the interview, Degas acknowledges the use of miniature figures by his predecessors and he would certainly have been familiar with the mannequins, lay figures and wax studies exploited by painter contemporaries, such as Gustave Moreau and Ernest Meissonier, as well as the distinguished pedigree of this practice. Charles Blanc's widely read *Grammaire des arts du dessin* described the existence of comparable devices in antiquity, specifically as substitutes for the living model in the composition of paintings, and Poussin's reliance on small-scale modelled wax *tableaux*, incorporating rudimentary draped figures, would have been known to Degas through Poussin's letters, which he appears to have read as a young man.[48] Closer to home, he must have seen wax sculpture at first hand during his friendship in the 1860s with Joseph Cuvelier and become acquainted with the use of wax models in the development of Gustave Moreau's pictures at the same period.[49]

FIG. 204
Late nineteenth-century sculpture tools
Paris, Musée Bouchard

If we take Thiébault-Sisson at his word, we should expect to find the closest correspondence between Degas's own wax figurines and the two-dimensional images that were given 'greater expression, greater ardour and more life' with their help. Surprisingly, no comprehensive attempt has yet been made to put this to the test, though pioneering publications by John Rewald and Ettore Camesasca have bravely and plausibly attempted such juxtapositions on the printed page.[50] More recently, several exhibitions have installed individual sculptures beside a corresponding drawing or pastel, culminating in the imaginative efforts of the 1988–9 Degas retrospective to establish some new linkages.[51] What is still unclear, however, is the significance of such pairings; does the picture follow the sculpture, or vice versa? If there is a connection between the two forms, how precise is it? Did Degas use recent sculptures, or might they be many years old? And if he replaced his live models with waxes, what does this tell us about his understanding of realism?

At its simplest and most unarguable, Degas's reliance on a modelled wax figure in composing a picture can be seen in *Grand arabesque, second time* (cat. 69). Here the artist has chosen a sculpture made perhaps a decade earlier but still visible in his studio, *Grand arabesque, second time* (cat. 71), drawing it with charcoal on tracing paper from a dramatic, frontal position. Perhaps because it was derived from a small statuette, Degas has merely indicated the details – such as hands, feet and facial features – and concentrated his energies on the dramatic impact of the pose. A similarly simplified figure appears at the right of *Three dancers* (cat. 70), another charcoal drawing from the same sculpture, which carries the process a stage further. Arranging the wax in three successive positions, the artist has drawn it three times, suggesting both the movement of a single ballerina and the rhythmic sway of an ensemble. On this occasion, Degas has added the flimsiest of tutus and some elements of individuality in the dancers' heads, but the effect is that of vivid, almost weightless dynamism.

Working on tracing paper, Degas was able to duplicate such drawings, reverse them laterally and develop some sheets with pastel. Several variants of *Three dancers* have been catalogued, as well as a version in oil on canvas, set against a variety of backgrounds, but each one deriving ultimately from the same three-dimensional model.[52] Another direct response to one of his sculptures is evident in *Bather* (cat. 80), a faithful transposition of *Woman taken unawares* (cat. 81), though this time Degas also attempted to introduce the drawn figure into a large rural bathing composition.[53] In *Three dancers in purple skirts* (cat. 73) we see this progression from sculpture to drawing, from line to the pyrotechnic colours of pastel as it reaches sensuous fulfilment. Begun as a charcoal study from *Dancer moving forward, arms raised* (cat. 72), here studied in several positions as *Three dancers* had been, and finally enriched

with a near-tropical setting, *Three dancers in purple skirts* exemplifies both the versatility and the transforming alchemy of Degas's late craft.

Once established, the practice of restating a three-dimensional form in a two-dimensional composition was open to a number of curious variations. By turning over his traced sheet, Degas could produce a mirror-image of the original drawing, such as that which transposed *Dancer looking at the sole of her right foot* (cat. 82) into *The morning bath* (cat. 83). In this case, a superb sculptural invention has been metamorphosed into one of the most scintillating pastels of the early 1890s, in effect by relocating his substitute model in a fictive light-filled bedroom. Combining reversal and repeated poses, *Three dancers* (cat. 86) may well have been prompted by *Dancer with tambourine* (cat. 87), a wax study that suffered deterioration in the last years of Degas's life. As with a number of these configurations, the pose of the statuette seems to recall earlier subjects from Degas's career, proposing an even more complex transition from drawn forms to modelled ones, then back again. Such a history may account for the association of a second version of *Dancer looking at the sole of her right foot* (cat. 85) with the foreground figure in *Ballet dancers* (cat. 84), a rapidly improvised oil painting on canvas that looks back to a picture of Degas's middle years, such as *Ballet class* (fig. 17).

Habitually and randomly surrounded by his sculptures, drawings, pastels and paintings in the vast rue Victor Massé studio, Degas appears to have moved freely from one object and one image to another, borrowing a posture from a wax model or situating a familiar pose in a novel setting. Over the years, the commerce between living models and their wax replacements, between space-occupying reality and linear invention, must have been intense and we can only look forward to further research into their subtle exchanges. Indicative of the profusion of such examples is the remarkable family of pictures and sculptures based on a single ballerina with her hands on her hips, represented here by *Dancer at rest, her hands behind her back, right leg forward* (cat. 74). At some stage in its evolution, the drawing *Three nude dancers* (cat. 75) had a common link with this sculpture, another offshoot acquired delicately tinted costumes to evolve into *Two dancers* (cat. 77) and a third study, *Three dancers in the wings* (cat. 78), reflected the more austere manner of Degas's later years. A catalogue of varied stage scenery was introduced in a sub-series, one of which is *Group of dancers* (cat. 79) and at some point a unique clothed variant of the wax figure, *Dressed dancer at rest, hands behind her back, right leg forward* (cat. 76) was modelled to assist in their construction. Yet again echoing much earlier compositions and occasionally finding expression in oil paintings, such as *Dancers, pink and green* (cat. 31) and *Blue dancers* (cat. 32), this haunting subject pervades every medium, in every stage of dress and undress, and in every state of completion, in Degas's late oeuvre.

CAT. 69
Grand arabesque, second time, c.1900–5
Charcoal on tracing paper
46 x 36 cm (18 x 14 in.)
New York, Peter Findlay Gallery

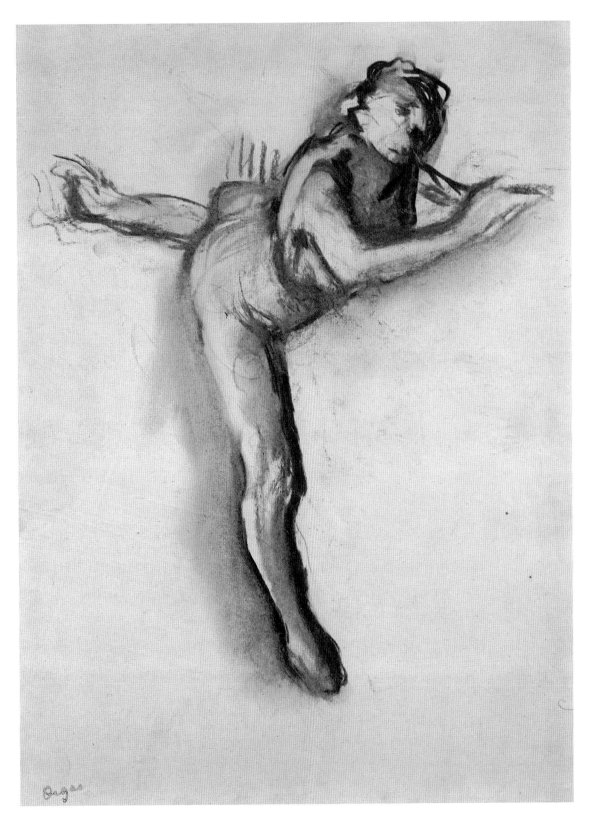

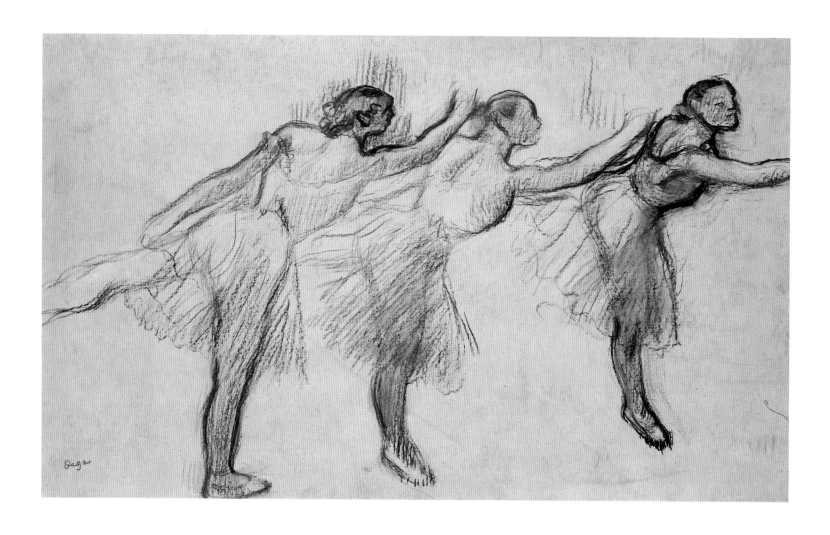

CAT. 70
*Three dancers, c.*1900–5
Charcoal and pastel on tracing paper
39 x 63.8 cm (15⅜ x 25⅛ in.)
Oxford, Ashmolean Museum

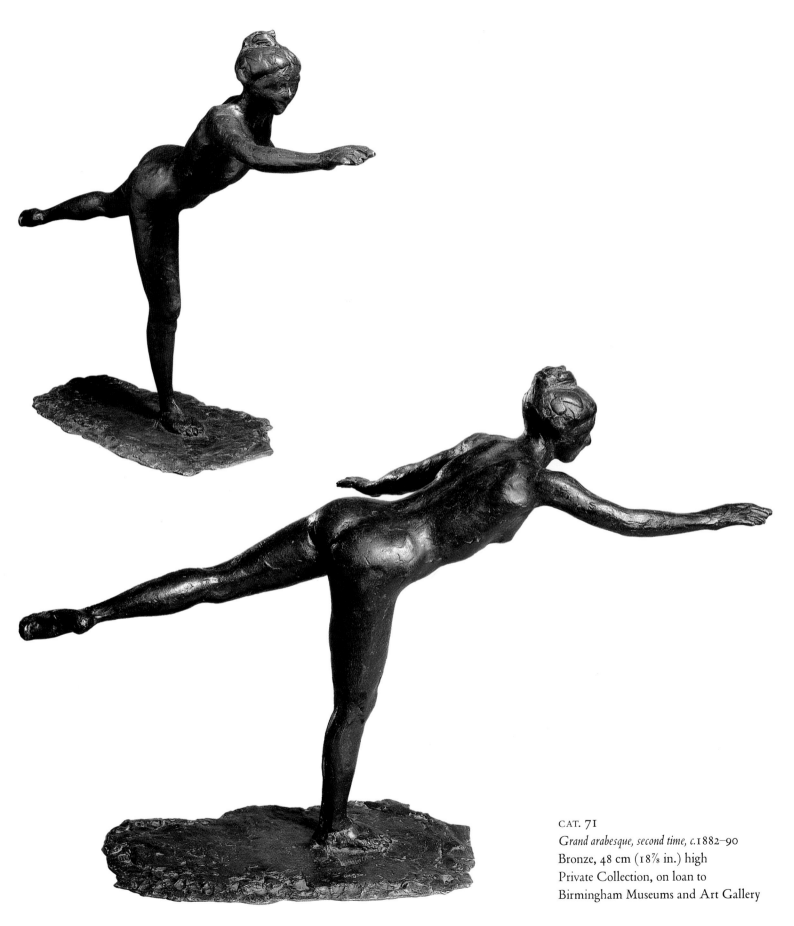

CAT. 71
*Grand arabesque, second time, c.*1882–90
Bronze, 48 cm (18⅞ in.) high
Private Collection, on loan to
Birmingham Museums and Art Gallery

259

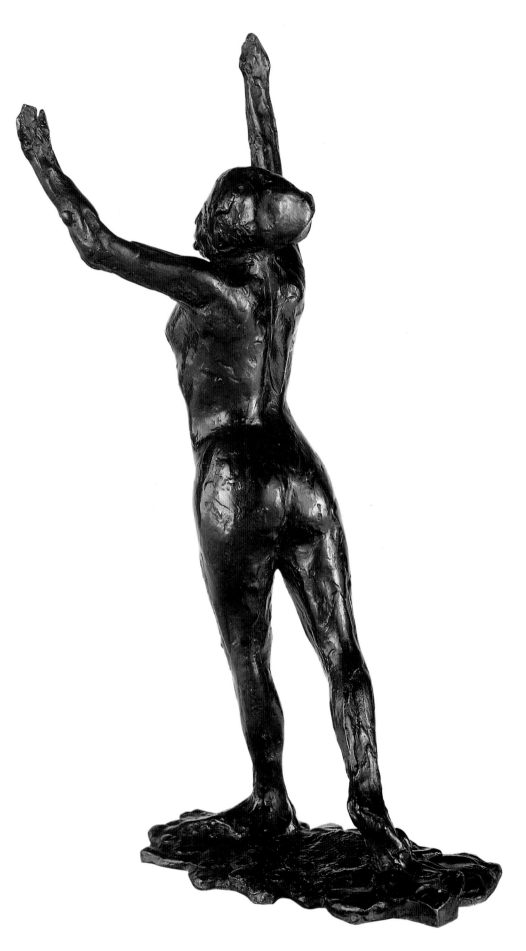

CAT. 72
Dancer moving forward, arms raised, c.1882–95
Bronze, 34.9 cm (13¾ in.) high
Washington, Hirshhorn Museum and
Sculpture Garden, Smithsonian Institution

CAT. 73
Three dancers in purple skirts, c.1895–8
Pastel on paper
73.5 x 48.9 cm (29 x 19¼ in.)
The Phillips Family Collection

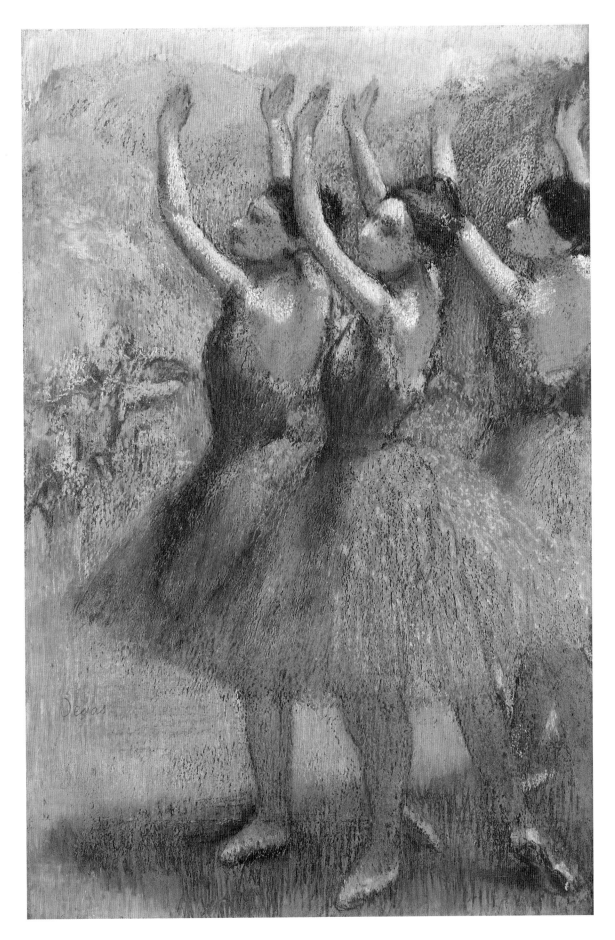

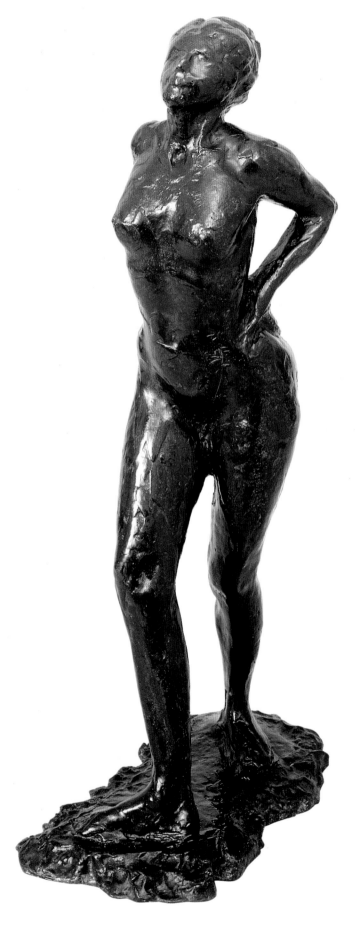

CAT. 74
Dancer at rest, hands behind her back, right leg forward, c.1885–95
Bronze, 44.5 cm (17½ in.) high
London, Tate Gallery

CAT. 75
Three nude dancers, c.1893–8
Charcoal on tracing paper, 63 x 53 cm (24¾ x 20⅞ in.)
Private Collection

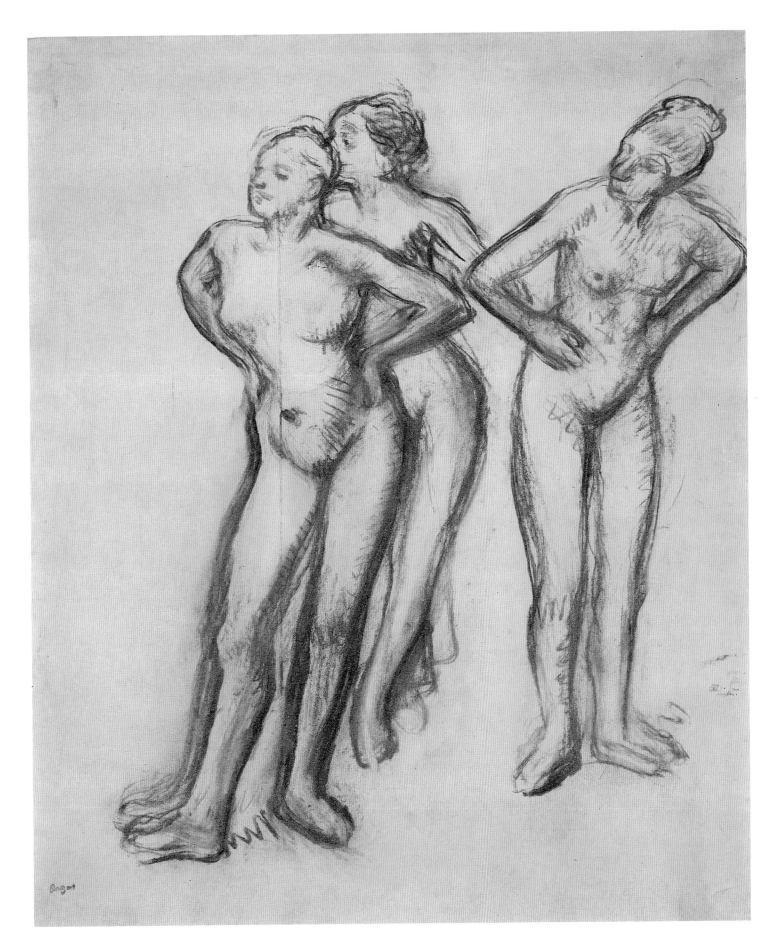

CAT. 76
Dressed dancer at rest, hands behind her back, right leg forward, c.1895–1905
Bronze, 42.5 cm (16¾ in.) high
Paris, Musée d'Orsay

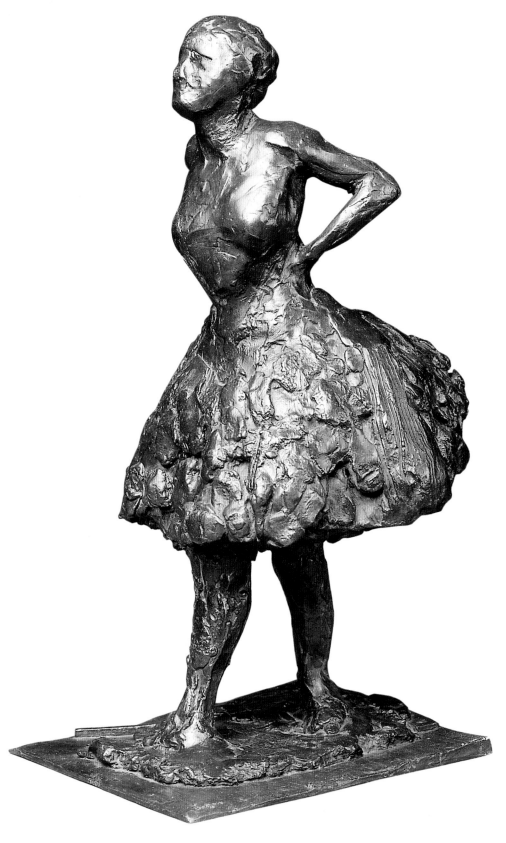

CAT. 77
Two dancers, c.1893–8
Pastel on wove paper,
70.5 x 53.6 cm (27¾ x 21⅛ in.)
The Art Institute of Chicago

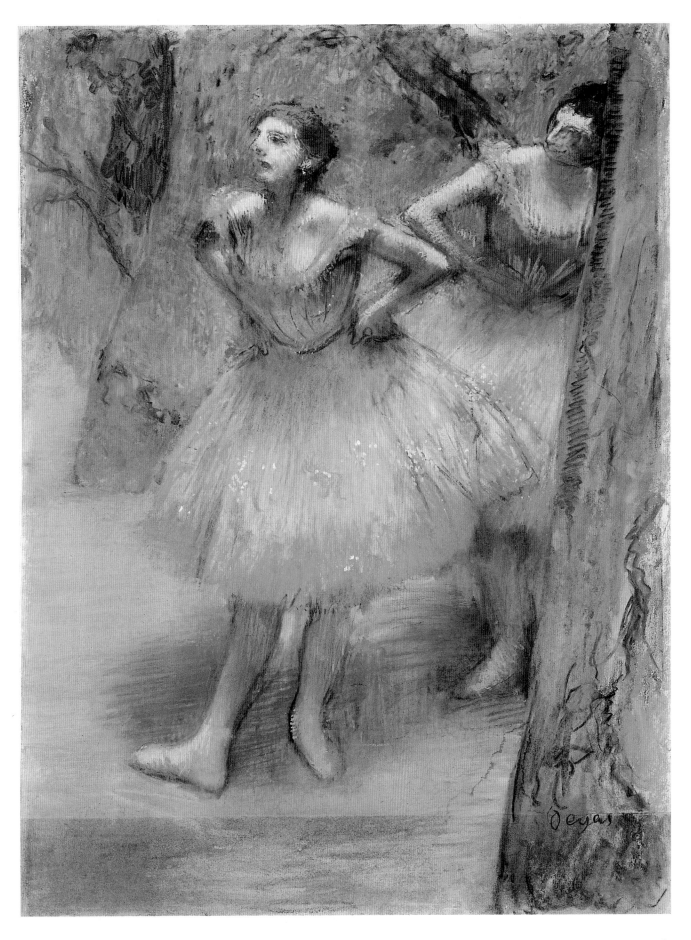

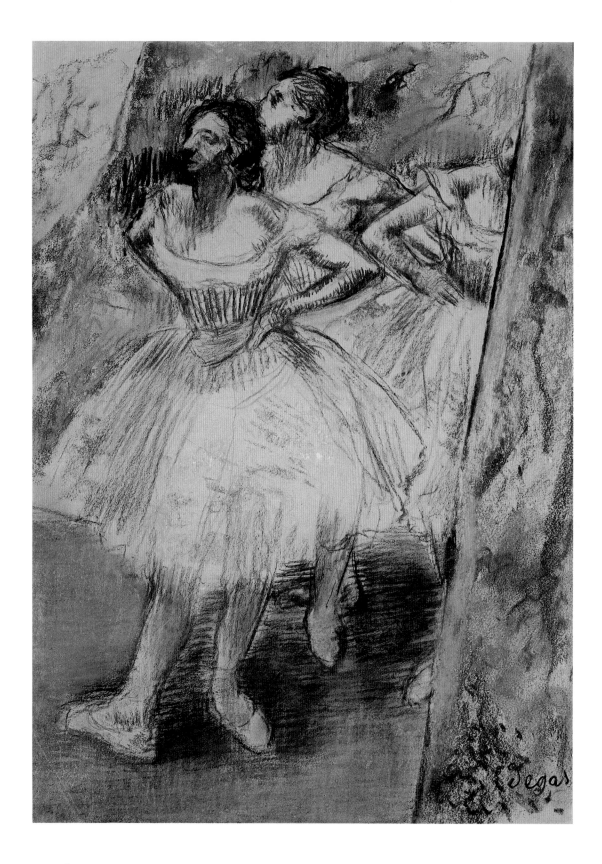

CAT. 78
*Three dancers in the wings, c.*1900–10
Charcoal and pastel on tracing paper, 60.6 x 44.4 cm (23⅞ x 17½ in.)
London, Private Collection

CAT. **79**
*Group of dancers, c.*1900–10
Pastel on paper, 57 x 45 cm (22½ x 17¾ in.)
Private Collection

CAT. 80
*Bather, c.*1896
Charcoal and pastel on paper, 47 x 32 cm (18½ x 12⅝ in.)
Princeton University, The Art Museum

CAT. 81
*Woman taken unawares, c.*1896
Bronze, 41cm (16⅛ in.) high
Philadelphia Museum of Art,
Louis E. Stern Collection

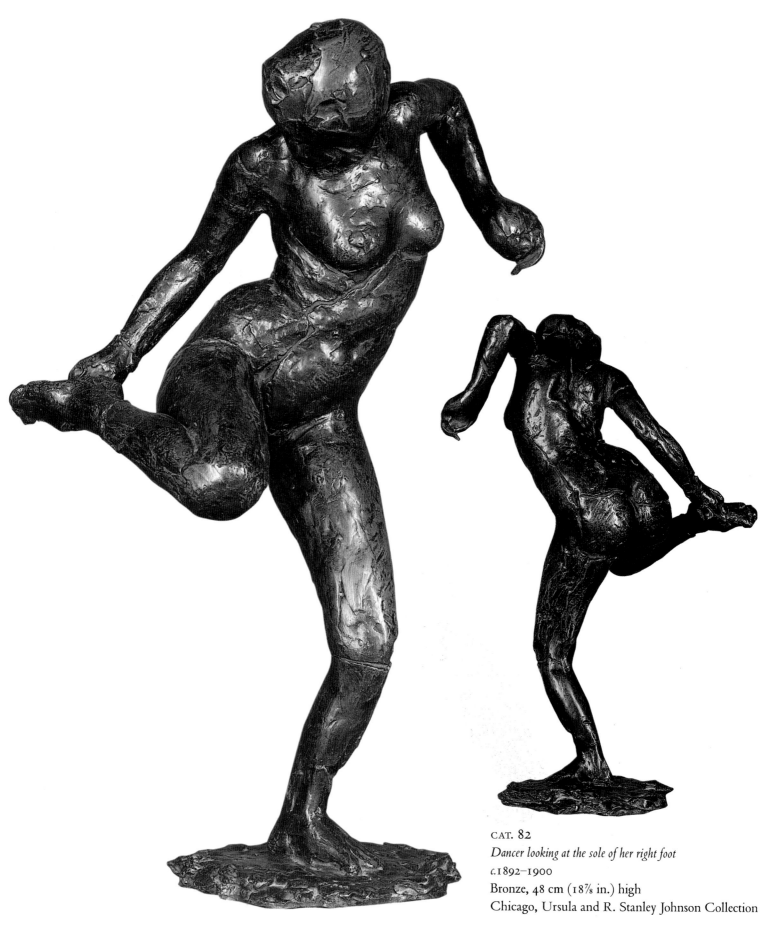

CAT. 82
Dancer looking at the sole of her right foot
*c.*1892–1900
Bronze, 48 cm (18⅞ in.) high
Chicago, Ursula and R. Stanley Johnson Collection

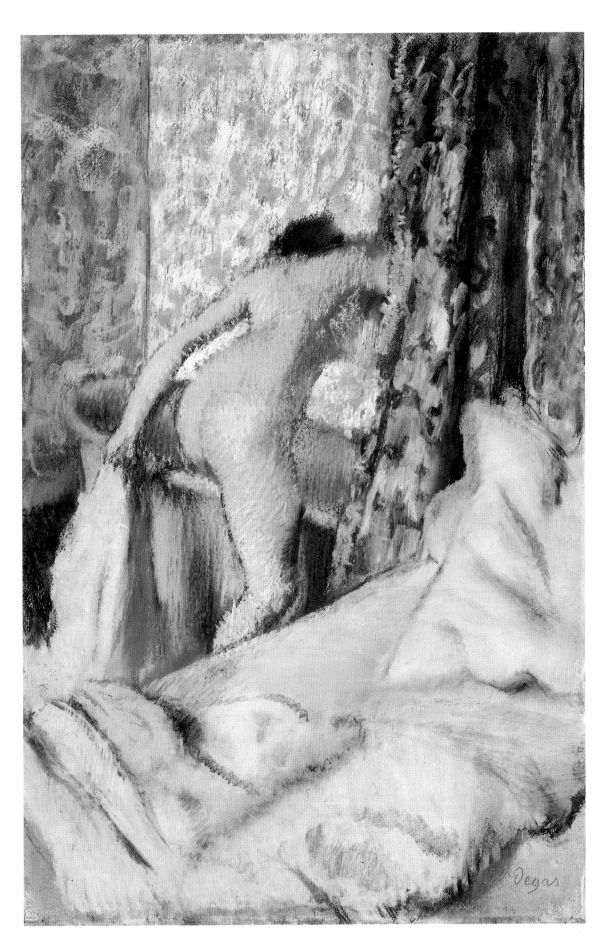

CAT. 83
The morning bath, c.1892–5
Pastel on wove paper
70.6 x 43.3 cm (27¾ x 17 in.)
The Art Institute of Chicago

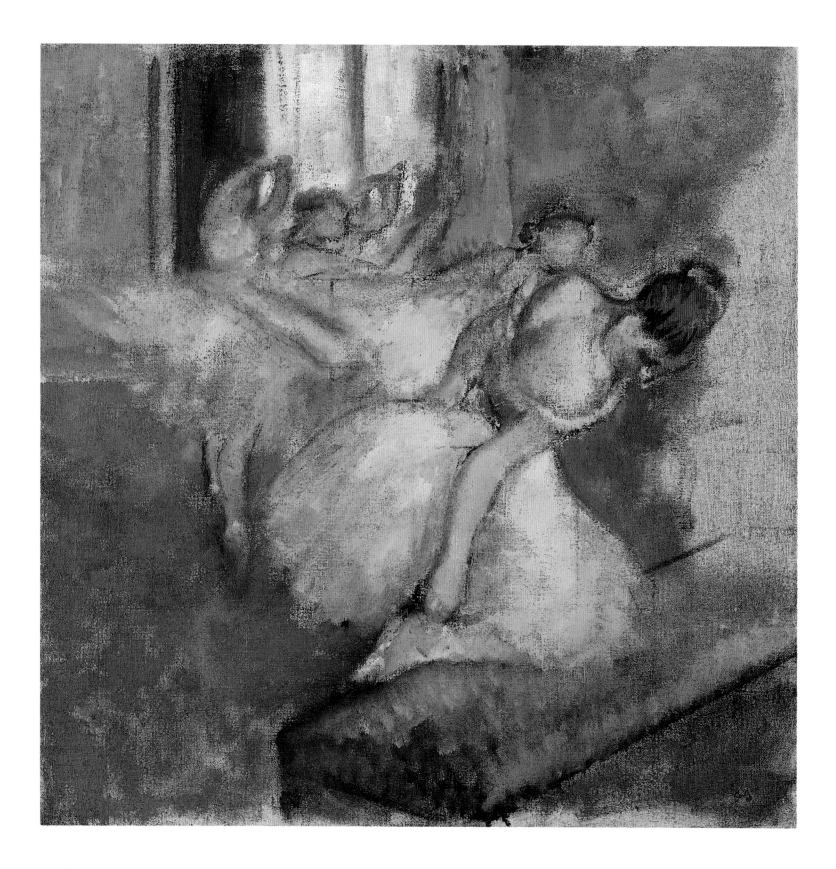

CAT. 84
*Ballet dancers, c.*1895–1900
Oil, 72.4 x 73 cm (28½ x 28¾ in.)
London, National Gallery

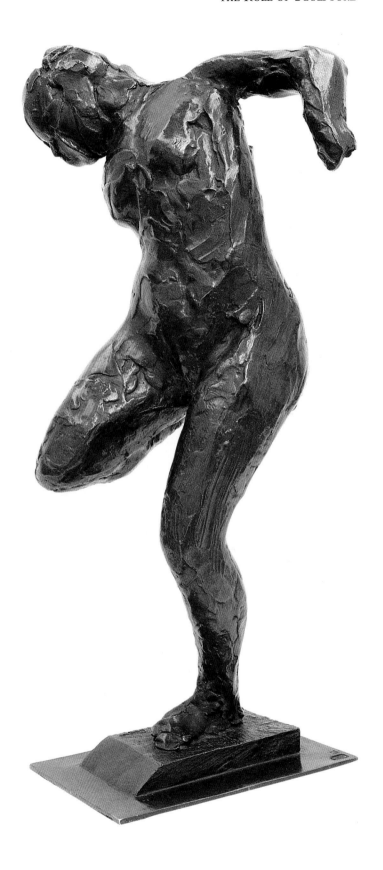

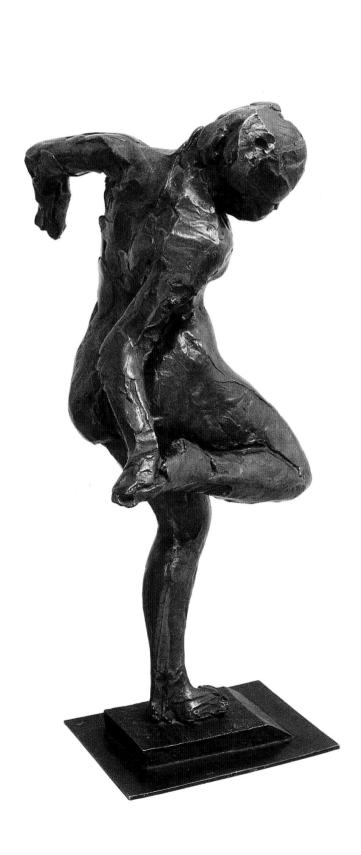

CAT. 85
Dancer looking at the sole of her right foot, c.1895–1905
Bronze, 46 cm (18⅛ in.) high
London, Private Collection

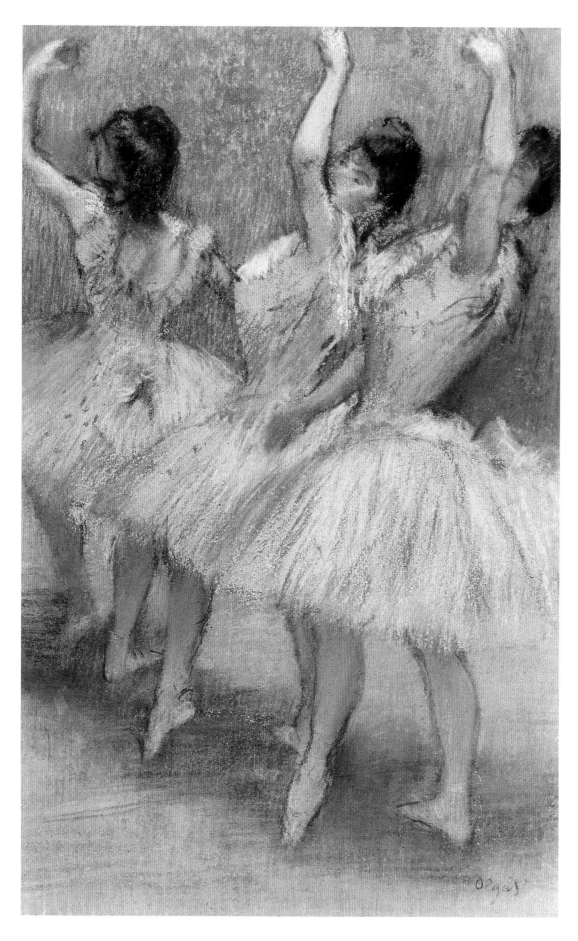

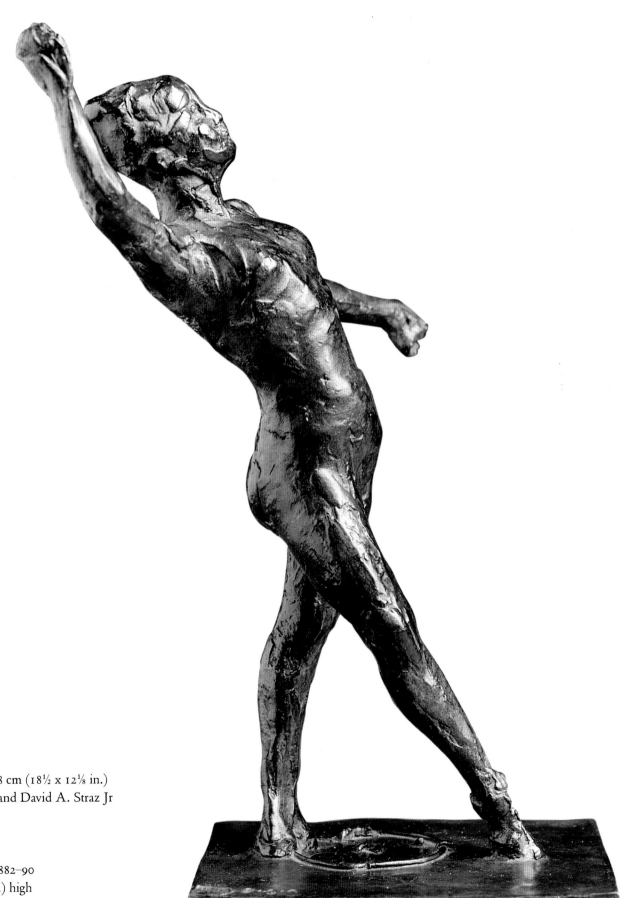

CAT. 86
*Three dancers, c.*1888–93
Pastel on paper, 47 x 30.8 cm (18½ x 12⅛ in.)
Collection of Catherine and David A. Straz Jr

CAT. 87
*Dancer with tambourine, c.*1882–90
Bronze, 27.5 cm (10⅞ in.) high
Paris, Musée d'Orsay

THE FIGURE
AND THE LANDSCAPE

THOSE CLOSE TO DEGAS knew him as an artist who thrived on challenge; his niece, Jeanne Fevre, recalled how 'Deep down, the painter loved nothing but difficulty', while Denis Rouart, the son of his pupil Ernest Rouart, said of Degas's technical problems that 'he loved to confront them and perhaps would have created them had they not existed'.[54] Something of this creative obstinacy, or perhaps a fascination with the limits of the visually possible, animated a number of Degas's later projects, resulting in quantities of half-finished paintings and pastels as well as dizzying moments of pictorial originality. His passion for photography and his excursions into sculpture, a bizarre plan to compile a book devoted to billiards and a determination to write poetry, all bear witness to the same phenomenon, to the combination of 'an almost tragic sense of the difficulty and strictness of his own art with a certain prankishness' described by Paul Valéry.[55] One of the greatest conundrums of his career, however, was Degas's involvement with landscape, with rural scenes in general and with open-air figure compositions in particular. Accounting for four of the most remarkable pictorial sequences of the late period – the colour monotypes, such as *Wheatfield and green hill* (fig. 34); the outdoors nudes, among them the Chicago *Bathers* (cat. 88); the suite of paintings of Saint-Valéry, such as *Houses at the foot of a cliff* (cat. 102); and the series of Russian dancers (cats. 89–96) – this obsession remains among the least known and least understood aspects of his final achievement.

Many factors in Degas's mature career seemed to militate against his engagement with landscape. During the years of Impressionism, he had acquired and assiduously cultivated a reputation as the enemy of *plein-air* art, mocking the pretensions of fellow-exhibitors such as Henri Rouart who scaled cliffs in search of their subjects: 'Painting is not a sport!', Degas protested.[56] Through obduracy or professional pride, Degas also distanced himself in public from the pretensions of the new landscape school, turning up his collar in front of excessively realistic canvases and dismissing Monet's light-filled *Waterlilies* as mere decoration.[57] As if to compound his problems, Degas had long suffered from damaged eyesight, resulting in an intolerance of bright sunshine and the need to wear dark glasses out of doors.[58] Proud of his studio-based art, where light could be controlled and the rituals of the Old Masters observed, he affected a dislike for the countryside and the 'pastures where it is like walking on sponges'.[59] A city-dweller throughout his life, Degas complained that the seaside was 'more Monet than my eyes can stand', and reminded a painter friend 'You love nature more than I do'.[60]

Characteristically, on closer inspection all these postures turn out to be exaggerated or whimsically contrived. Though Degas certainly preferred to paint indoors, evidence that he worked in the open air has emerged from several points in his career, crowned by a recently

FIG. 205
Huyot, *The khorovod and the trepak, Russian dances*
Illustration from Henri de Soria's *Histoire pittoresque de la danse*, 1897

discovered photograph of the artist at his easel in a field, datable to the early 1890s.[61] Drawings, watercolours, freshly observed pastels and a variety of inventive prints of outdoor subjects have also survived, some in substantial numbers, either executed on the spot or from very recent experience. Even his eyesight problems, severe though they undoubtedly were, proved not to be incapacitating, allowing the artist to work selectively on chosen subjects and perhaps to deepen his grasp of the perceptual process. In the course of hundreds of train and carriage rides, habitual holidays in the countryside, and longer journeys to Switzerland, Spain, Belgium and Italy, as well as far-flung parts of France, Degas learnt to enjoy the spectacle of landscape seen at speed, capturing its blurred colours in his monotypes and recording some of its details for later use in his paintings.

Degas's most dramatic intervention in the landscape culture of the period after Impressionism was, arguably, the first, when he showed some two dozen examples of recent work at the Durand-Ruel gallery in the autumn of 1892. Rather than the ballet scenes, portraits, genre subjects or bathers his audience undoubtedly expected, Degas devoted the entire exhibition to the landscape, including twenty or so colour monotypes, such as *Wheatfield and green hill* and a number of pure pastels, like *Steep coast* (cat. 98) and *Landscape* (cat. 97).[62] Having earlier announced to his friend Jeanniot an intention to make 'a series of landscapes', Degas pointedly displayed several linked pairs or variants of similar subjects, in the very gallery where Monet had shown his suite of *Poplars* only months before.[63] Tackling not only the 'difficulties' of the colour monotype process, a system he invented specifically for this project, Degas also took on his major rival at one of the most challenging moments of Monet's career. Here were issues of colour and perception, the operations of memory and the continuity of experience, all keenly embraced in the name of 'the strictness of his own art' and 'a certain prankishness'.

Even more provocative in the 1892 exhibition was a group of anthropomorphic images, in which monstrous human heads peered out of mountain peaks and giantesses loomed in hillsides and cliffs.[64] Prominent among these were the loosely paired *Steep coast* and *Landscape*; in the former, a recumbent female figure merges with a flower-strewn headland, as if to link their beauty or signify a shared fecundity; in the latter, a phallic monolith towers over a sunlit valley, its foundation half-human, half terrestrial. In both, there are analogies with contemporary Symbolist poetry and a long-standing tradition of punning popular imagery, as well as with current interests in archaeology and the standing stones of an area such as Burgundy, where the earliest of Degas's anthropomorphic pictures were begun. What is still extraordinary, however, is that Degas made these haunting pictures at all. Attracted

once again by the sheer strangeness of the enterprise, Degas abandoned his commitment to the modern spectacle and to precise observation in a rare moment of what he himself described as 'fantasy'.[65]

Three or four years after the Durand-Ruel show, Degas embarked on another suite of landscapes in equally paradoxical circumstances. Apparently forgetting his aversion to the countryside, he took the first of a series of annual holidays in the small seaside resort of Saint-Valéry-sur-Somme, on the Picardy coast, where he experimented with perspective and light, cloud-filled skies and the textures of stone and foliage. Staying with the young painter Louis Braquaval or with his own brother René, both of whom had houses at Saint-Valéry, Degas produced more than a dozen substantial canvases and large pastels, even conducting a number of outdoor painting lessons for Braquaval's benefit.[66] Once again, Degas seems to have had the technical and perceptual challenges of his contemporaries' recent work in mind as he chose his subjects in and around the medieval town. In *Village street* (cat. 101), for example, we find echoes of Pissarro's rooftop views of Rouen, exhibited at the Durand-Ruel gallery in 1896 and singled out by Degas for praise; the sombre yet curiously exotic hues of canvases such as *The return of the herd*

(cat. 100) remind us of Degas's active support for Gauguin during this decade; while the sensuous geometry of *Houses at the foot of a cliff* and *View of Saint-Valéry-sur-Somme* (cat. 99), compares with and perhaps exceeds in audacity the contemporary work of Cézanne.[67] These latter canvases are deceptively simple in appearance, yet extraordinarily complex in structure. Only recently yielding to analysis, they seem to be synthetic reformulations of observed elements, constructed by Degas from disparate views of the town in a collage-like process, which may depend on photography or conceptual verve but has few equals in the age before Cubism.[68]

A further challenge shared by Degas with these artists, as well as with a large number of their peers, was that of the monumental figure composition set in the open air, rivalling those of Titian and Poussin, Delacroix and Courbet, yet asserting its modernity. Almost all the prominent Impressionists tackled the theme at some stage in their careers, from Monet's early, gigantic picnic scenes to Renoir's later fresco-like bathers, though it is arguable that none entirely resolved the demands of the genre. One of Degas's first major canvases, the 1860 *Young Spartans* (fig. 108), was essentially a figure-in-the-landscape study, though still dependent on history and inevitably painted in the artificial surroundings of the studio. Later in that decade, at a time when she was much involved with Degas, Berthe Morisot admired a more contemporary effort by Bazille, noting that 'he has tried to do what we have so often attempted – a figure in the outdoor light', and drawing attention to the demands and contradictions of *plein-air* technique in this context.[69] Degas's *Beach scene* (London, National Gallery) of 1869 belongs to this evolution (though the artist insisted in later life that it was contrived indoors), as do numerous open-air portraits, horse-racing scenes and rural conversation pieces from the Impressionist years.

In the mid-1880s, in publicly exhibited pastels such as the defiantly rustic *Girl drying herself* (fig. 163), Degas again laid claim to the ambitious, insistently modern nude-in-a-landscape motif. Though the striking of postures against outdoor painting continued, he more frequently turned to rural settings for his female bathers than is generally recognised. Like Cézanne, who admitted that he had failed to persuade models to pose for him outdoors, Degas continued to arrange his riverbank scenes and countryside toilettes in the studio, adding rocks, trees and grassy thickets from his own earlier sketches or from those of friends.[70] Some nude subjects were developed with both indoor and outdoor backgrounds (figs. 172–3) and even certain of his sculptures were implicitly located in the open air, like the *Seated woman wiping her left side* (cat. 54) who sits on a tree stump. Again, the lure of posterity played its part, tempting Degas towards scenes of muscular nudity that recall

the *Diana at her bath* of Titian or Poussin's *Baptism*, if only to prompt his irreverence. Poussin's picture, known in nineteenth-century France in copies and engravings, provided Degas with a moment of private humour when he introduced a figure from the master's composition – the seated nude who struggles with her stocking – into his majestic but probably unfinished *Bathers* (cat. 88).[71] Quoting also from bath studies and reclining nudes that date back to his youth, Degas locked together four massively stated bodies in every state of activity and lassitude, summarising his past even as he reached forward to the bathing parties of the Fauves and the anxious seashore nudes of Matisse and Picasso.

The culmination of Degas's ambition, however, as well as one of the most unexpected departures of his late career, was surely the series of *Russian dancers* (cats. 89–96), begun in 1899.[72] Conspicuously situated in the open air, or against highly naturalistic backcloths that make no reference to their stage settings, these triumphant pastels belong to the great tradition of European figure art. Surprisingly, they are also evidence of Degas's participation in a wave of curiosity for folk art and the exotic that swept through European culture in the early twentieth century. Though it is still not known who his models were, troupes of foreign dancers performed regularly in cabarets near Degas's Montmartre studio, and a taste for all things Russian, such as the 'Brutal colouring of a . . . Russian toy' noted by Jacques-Émile Blanche, was much in evidence in Paris, perhaps encouraged by the state visit of the Tsar in 1896.[73] Even closer to Degas's imagery were accounts in contemporary books on the dance of the wild steps and brilliant costumes in Balkan and Russian festivities, illustrated in Henri de Soria's 1897 *Histoire pittoresque de la danse* by a scene analogous to Degas's pastels (fig. 205). In de Soria's wood engraving, the near frenzy of the performers is vividly captured, but the bright colours of their outfits necessarily left to our imaginations.

Individually and cumulatively, Degas's *Russian dancers* fuse together many of the distinctive practices and themes of his late career; the progression from traced drawings, such as *Three Russian dancers* (cat. 96), to a sequence of compositional successors; the restatement of a single figure, for example the Metropolitan Museum's *Russian dancer* (cat. 92), in more complex contexts, such as the Stockholm *Three Russian dancers* (cat. 89); the exploration of expressive colour, from the descriptive hues of the Sara Lee Corporation's *Russian dancer* (cat. 91) to the explosive tints of *Russian dancers* (cat. 94); the fascination with energy, whether the dignified rhythms of the pastel in the Lewyt Collection (cat. 90) or the near-hysteria of *Russian dancers* (cat. 95); and, above all, the obsessive, relentless inventiveness of the artist when confronted by the female form, his sticks of charcoal and his pastels, and the imperious demands of his picture.

CAT. **88**
*The Bathers, c.*1895–1905
Pastel and charcoal on tracing paper
113.4 x 115.7 cm (44⅝ x 45½ in.)
The Art Institute of Chicago

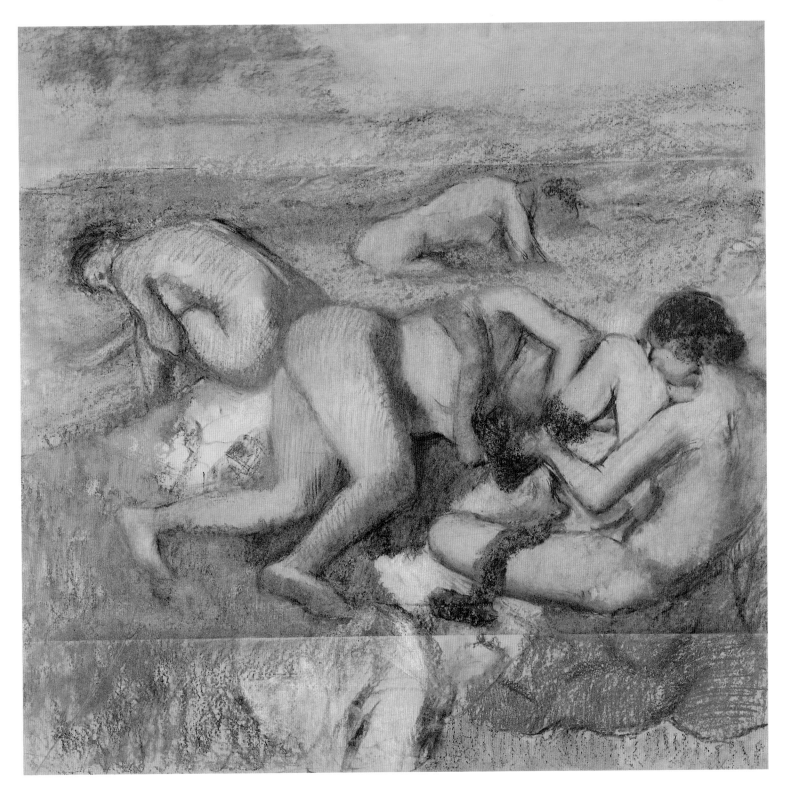

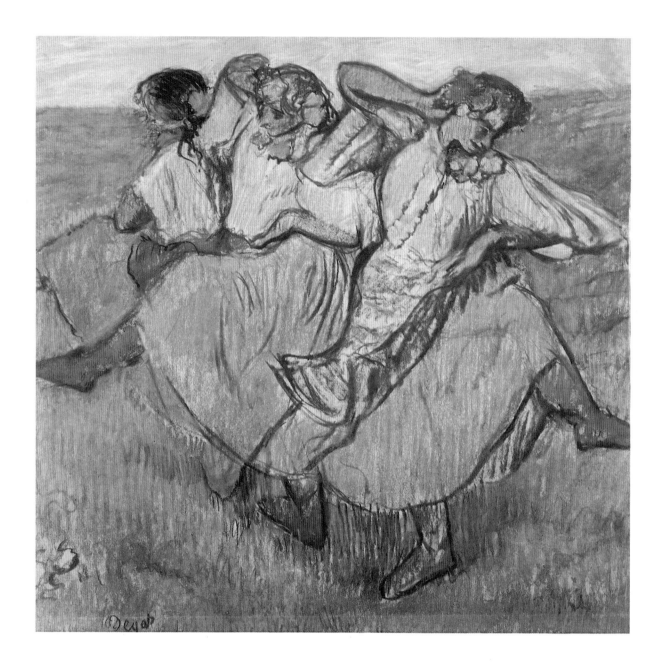

CAT. 89
*Three Russian dancers, c.*1899
Pastel and charcoal on tracing paper
62 x 67 cm (24⅜ x 26⅜ in.)
Stockholm, Nationalmuseum

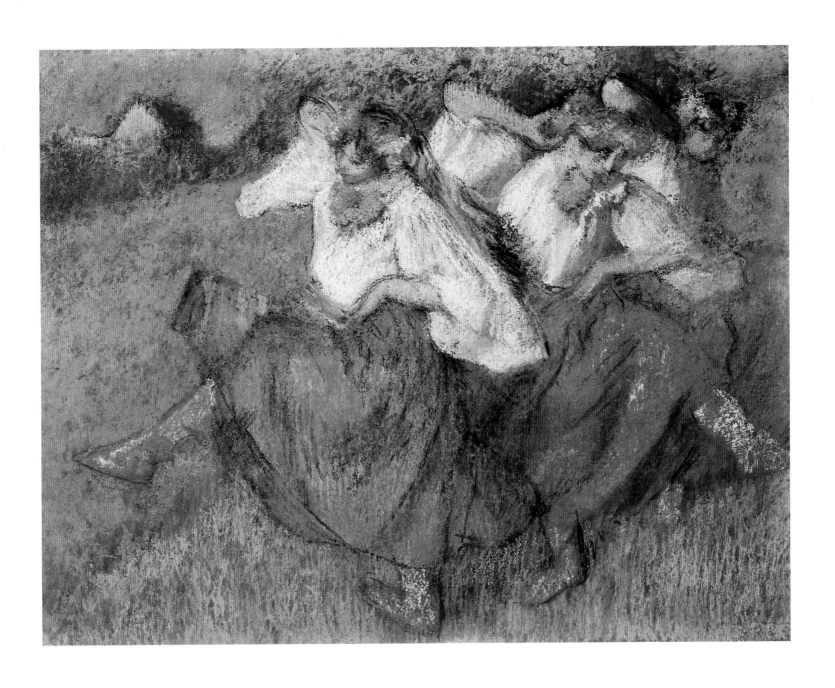

CAT. 90
Russian dancers, c.1899
Pastel on tracing paper
58 x 76 cm (22⅞ x 29⅞ in.)
Mrs Alex Lewyt

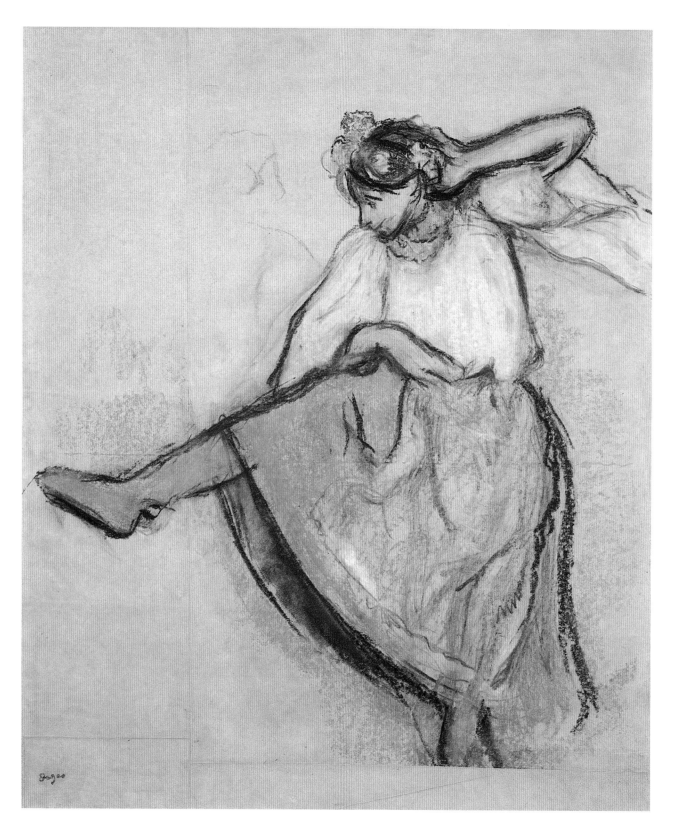

CAT. 91
*Russian dancer, c.*1899
Pastel and charcoal on tracing paper
63 x 54 cm (24¾ x 21¼ in.)
Chicago, Sara Lee Corporation

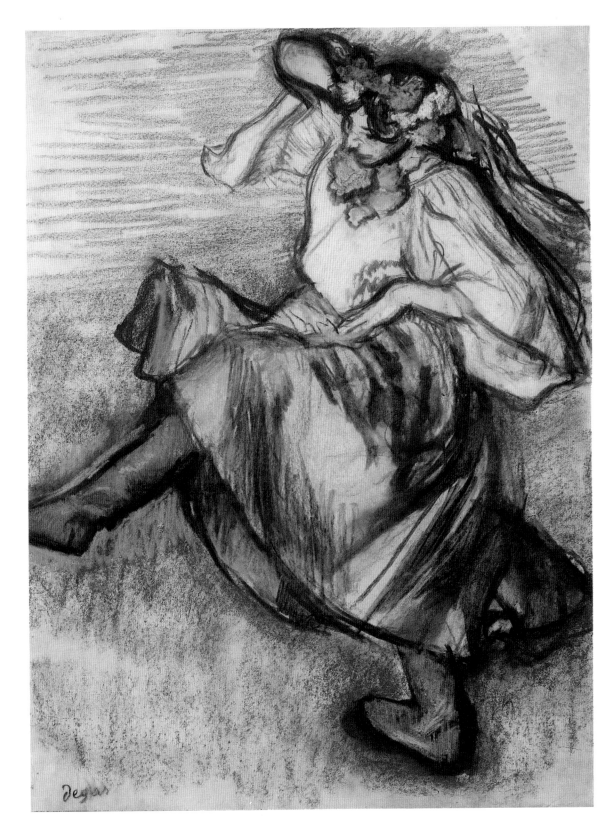

CAT. 92
*Russian dancer, c.*1899
Pastel and charcoal on tracing paper
61.9 x 45.8 cm (24⅜ x 18 in.)
New York, Metropolitan Museum of Art

283

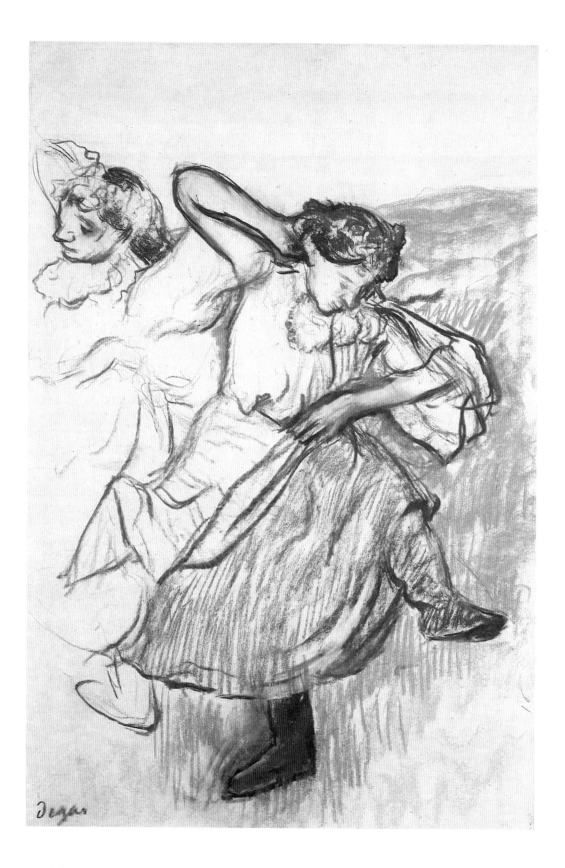

CAT. 93
Russian dancers, c.1899
Charcoal and pastel on tracing paper, 67 x 47 cm (26⅜ x 18½ in.)
Berwick-upon-Tweed, Borough Museum and Art Gallery

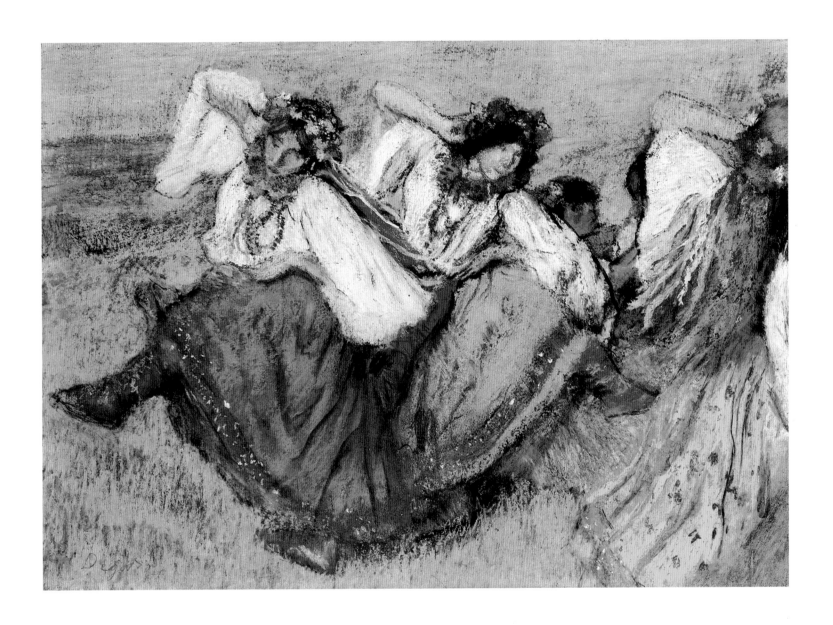

CAT. 94
*Russian dancers, c.*1899
Pastel on tracing paper, 48 x 67 cm (18⅞ x 26⅜ in.)
Canada, Private Collection

285

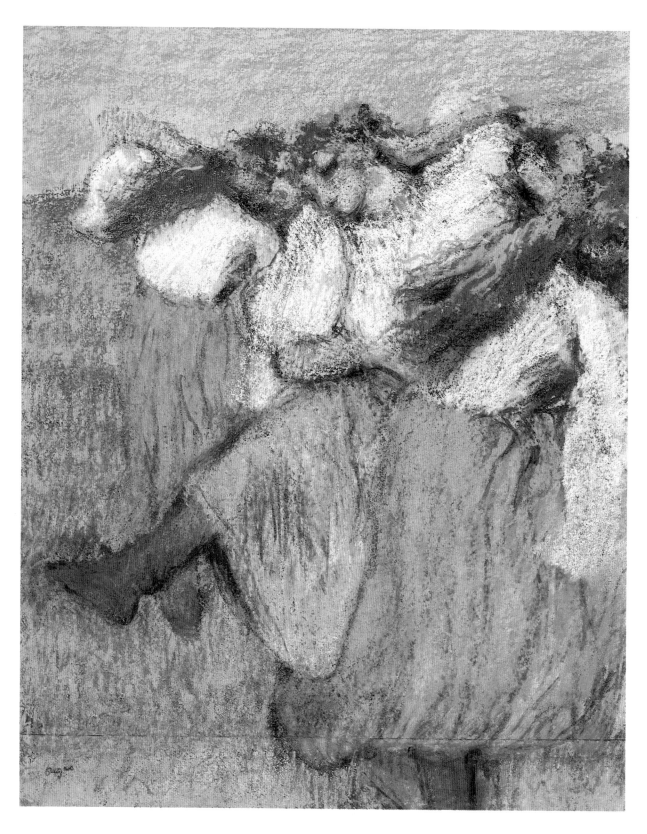

CAT. 95
Russian dancers, c.1899
Pastel on tracing paper
71 x 57 cm (28 x 22½ in.)
Chicago, Sara Lee Corporation

CAT. 96
Three Russian dancers, c.1899–1905
Charcoal and pastel on tracing paper
99 x 75 cm (39 x 29½ in.)
Mrs Alex Lewyt

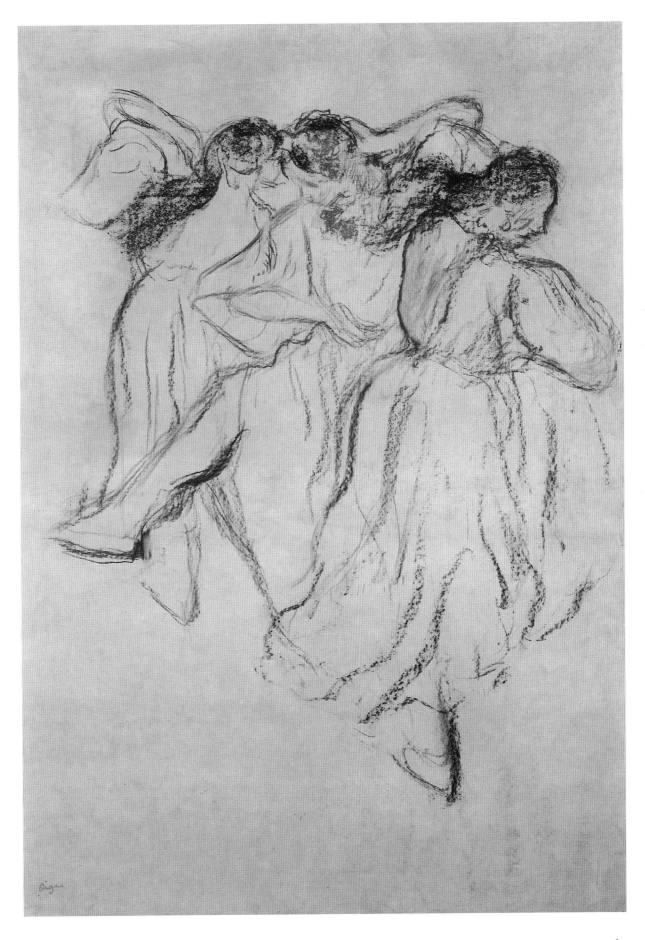

CAT. 97
*Landscape, c.*1890–2
Pastel on paper, 49.2 x 48.8 cm (19⅜ x 19¼ in.)
Houston, Museum of Fine Arts

CAT. 98
*Steep coast, c.*1890–2
Pastel on paper, 46 x 54.6 cm (18⅛ x 21½ in.)
Collection Jan and Marie-Anne Krugier

CAT. 99
*View of Saint-Valéry-sur-Somme, c.*1896–8
Oil, 51 x 61 cm (20⅛ x 24 in.)
New York, Metropolitan Museum of Art

CAT. 100
The return of the herd, c.1896–8
Oil, 71 x 92 cm (28 x 36¼ in.)
Leicestershire Museum and Art Gallery

CAT. 101
Village street, c.1896–8
Oil, 81.3 x 68.6 cm (32 x 27 in.)
Collection Dr and Mrs Julius H. Jacobson II

CAT. 102
Houses at the foot of a cliff (Saint-Valéry-sur-Somme), c.1896–8
Oil, 92 x 72.2 cm (36¼ x 28½ in.)
Ohio, Columbus Museum of Art

Summary Chronology of Degas's Late Career

1886

At the age of fifty-one, Degas contributes to the eighth and final Impressionist exhibition in Paris.

Degas travels to Geneva and Naples.

Durand-Ruel Impressionist exhibition in New York includes twenty-three works by Degas.

He frequently visits the Paris Opéra, to see operas and ballets.

1887

Théo van Gogh, acting for the Boussod et Valadon gallery, begins to buy work by Degas.

Two pastels by Degas shown in New York.

1888

Exhibition of at least nine pastels of bathers at Boussod et Valadon gallery.

Publication of William Thornley's lithographs after Degas's pictures.

Degas travels to Cauterets, near the Pyrenees, for a cure at the spa.

In a letter to Octave Maus, Degas declines to exhibit in Brussels.

Degas much involved in writing sonnets, which he discusses with Mallarmé.

1889

At the exhibition of *Peintres-graveurs* at Durand-Ruel's gallery, Degas shows two lithographs.

Degas is said to have declined the offer of a room for his pictures at the Exposition Universelle.

A selection of works on view at Boussod et Valadon.

Degas again visits Cauterets and later travels to Madrid, to see the Prado, with Giovanni Boldini.

Less frequent visits to the Opéra.

1890

Degas rents a new studio at 37 rue Victor Massé, in Montmartre, where he is to work for the next twenty-two years. At about this time, he also moves to a new apartment in the nearby rue de Boulogne (later rue Ballu), though by 1897 he had combined his living and working arrangements at 37 rue Victor Massé.

Travels to Brussels and Normandy. Journey to Cauterets, Pau and Geneva, returning to Paris via brief visit to Diénay in Burgundy.

Three-week excursion to Diénay with Bartholomé, in a horse-drawn tilbury. Staying at the house of Georges Jeanniot, Degas makes his first colour monotypes of the landscape.

1891

Degas has an appointment with the oculist Dr Landolt.

Several pictures on show in London.

A lithograph included in an exhibition at the Ecole des Beaux-Arts.

1892

Extensive travel, to Pau, Switzerland, Belgium, Normandy.

Exhibition devoted to his recent landscape pastels and monotypes at Durand-Ruel gallery.

Degas wearing special spectacles prescribed by Landolt.

Daniel Halévy records Degas's trips to the popular theatre with 'his young American niece', presumably the daughter of his brother René.

Attendances at the Opéra appear to have ceased.

1893

Travel to Switzerland, Carpentras, Diénay.

L'Absinthe shown in London. Works by Degas in Boussod et Valadon's London gallery.

Mixed exhibition at Camentron gallery includes several pictures by Degas.

1894

Works by Degas again feature in Camentron gallery, Paris.

Some of Degas's coloured landscape monotypes apparently redisplayed at Durand-Ruel.

Important articles on Degas by Duret and Geffroy.

Pictures by Degas included in loan exhibition at Cleveland.

Earliest surviving correspondence with Suzanne Valadon.

1895

During a rest-cure at Mont-Dore in the Auvergne, Degas experiments with photography.

Visits Saint-Valéry-sur-Somme.

Julie Manet finds Degas in his studio working at his sculpture.

Display of Degas's photographs at Tasset et Lhôte.

Mary Cassatt claims that 'Degas works as much as ever'.

1896

Substantial exhibition of works by Degas, in several media and from various periods (including a new 'series of nudes'), at Durand-Ruel.

With Monet and others, Degas helps to arrange memorial exhibition for Berthe Morisot.

Caillebotte bequest, including seven pictures by Degas, deposited at the Luxembourg.

Degas writes to Braquaval about projected trip to Saint-Valéry-sur-Somme.

1897

Travel to Montauban, to visit the Ingres Museum, and to Mont-Dore.

Supervises copy by Ernest Rouart of painting by Mantegna in Louvre.

Degas speaks at length to Thiébault-Sisson about his own sculpture.

Breaks with the Halévys over the Dreyfus affair.

Works shown in mixed exhibitions in Pittsburgh and Dresden.

Manzi's *Degas: vingt dessins, 1861–1896* published.

Article on Degas by Roger Marx.

1898

Visits Saint-Valéry-sur-Somme, works on landscape oils.

Pictures shown in London and Pittsburgh.

Signac refers to Degas's offensive behaviour towards Pissarro since the Dreyfus affair.

Exhibition at Cassirer gallery, Berlin, of *Liebermann, Meunier and Degas.*

Large exhibition of Impressionist art at Durand-Ruel, includes 'race-track scenes, landscapes, dancers' by Degas.

1899

Degas refuses to exhibit in the planned centennial exhibition.

Exhibition at Cassirer gallery, Berlin, of *Manet, Degas, Puvis de Chavannes and Slevogt.*

Works shown in London and Pittsburgh.

Julie Manet is shown the *Russian dancers* in progress.

1900

Despite Degas's objections, a small group of works shown in centennial exhibition.

Pictures included in Munich Secession and Pittsburgh shows.

1901

Degas refers in a letter to work on his 'little waxes', and describes a *Laundress* he has 'succeeded in finishing'.

Apparent date of retrospective exhibition of some twenty works, including several recent pastels, at Durand-Ruel gallery, New York.

Durand-Ruel insures Degas and his possessions.

First visit of Maurice Denis to Degas's apartment.

1902

Degas describes himself as 'working obstinately'.

Dinner engagements with Forain, the Rouarts, Cochin, General Mercier.

1903

In a letter to Alexis Rouart, Degas refers to himself
 'doing some wax figures'.
Degas meets Georges Rouault, who begins to visit him
 in the rue Victor Massé studio.
Long article on Degas by Camille Mauclair.
Works included in the Berlin Secession exhibition and
 the Bernheim *Impressionism* show.
On different occasions, Degas dines with Forain, Mme
 Braquaval, the Rouarts.
Louisine Havemeyer, with the help of Mary Cassatt. attempts
 to buy the wax *Little dancer of fourteen years* from Degas.

1904

Daniel Halévy records an encounter with Degas, who is
 recovering from illness.
Travels to Alsace, Besançon, Ornans and Pontarlier.
Exhibition of fifteen works by Degas at La Libre
 Esthétique, Brussels.
About this time, Degas is visited in his studio by
 Fernande Olivier, soon to be the mistress of Picasso.
Degas plans an excursion to Ménil-Hubert.

1905

Discussion with Paul Valéry, principally about Ingres.
Major exhibition of Impressionist and other painting
 organised by Durand-Ruel at Grafton Gallery,
 London, includes thirty-four works by Degas, among
 them several late pictures.
Degas visits the Salon d'Automne, where he is seen by
 the American painter Maurice Sterne.

1906

In a letter to Durand-Ruel, Degas writes of the need 'to
 get down to painting'.
Between 1906 and 1910, single items and groups of
 works shown in Stuttgart, Moscow, Brussels,
 London, Cincinnati, Budapest and elsewhere.

1907

Moreau-Nélaton watches Degas at work in his studio on
 a pastel of a female bather.
Degas travels alone to Naples on 'family affairs'.
Works by Degas shown in Manchester, at the *Modern
 French Paintings* exhibition, and in Strasbourg.
In a letter Degas claims, 'I trace and retrace', and in
 another that 'journeys do not tempt me any more'.
Degas at a meeting of the anti-Dreyfusard Action Française.
Paul Paulin works in Degas's studio on a portrait bust of
 the artist.

1908

Degas refers to his wish to 'do sculpture'.
Although his social engagements become less frequent, he
 arranges to dine with Bartholomé.
He writes to Alexis Rouart, 'soon one will be a blind
 man'.
Degas pays his respects at the Halévy household, on the
 death of Ludovic.
Exhibition of Impressionism at Cincinnati Museum
 includes three works by Degas.

1909

Mixed exhibition at Bernheim-Jeune includes pictures by
 Degas.
Tells Daniel Halévy he is 'a little in the air'.
George Grappe's illustrated *Degas* published in Leipzig
 and London.

1910

The model Pauline claims that she posed at this time for
 Degas's nude dancers.
Degas described as 'resigned, gentle, weary', by Daniel
 Halévy.
Works by Degas shown by International Society in
 London, in the first exhibition of Impressionism in
 Florence and in a display of pictures from the Potter
 Palmer collection in Chicago.
Degas writes to Louise Halévy, planning to visit her.

1911

Exhibition of twelve works by Degas at the Fogg Art
 Museum.
Degas visits an Ingres exhibition, where he feels the
 canvases with his fingers.
Daniel Halévy recounts Degas's first sight of an aeroplane.
He sends a brief note to Lafond, claiming, 'I can write no
 more'.

1912

At the Rouart sale, Degas sees his *Dancers at the barre* sell
 for nearly 500,000 francs.
Lemoisne publishes his first book on Degas.
Degas is obliged to move from his rue Victor Massé
 studio and apartment.

1913

Mary Cassatt describes Degas as 'a mere wreck'.
Degas deposits several large early pictures with Durand-
 Ruel.
Exhibition entitled *Degas/Cézanne*, with twenty-nine
 works by Degas, at Cassirer gallery in Berlin.
Works shown in Armory Show, New York, and mixed
 exhibition in Ghent.

1914

Publication of Vollard album of ninety-eight Degas
 pictures.
Works by Degas in Grosvenor House exhibition,
 London.
Russian dancer included in Berlin Secession show.
Note from René Degas describes Degas's long walks, his
 inability to work.

1915

Suffrage exhibition at Knoedler Gallery, New York
 organised by Louisine Havemeyer, includes twenty-
 six pictures by Degas.
Sacha Guitry briefly films Degas on the boulevard de
 Clichy.
René Degas writes of Degas's good appetite, failing
 memory and deafness.

1916

Daniel Halévy's first visit to Degas in his boulevard de
 Clichy apartment.
Exhibition of *Manet and Degas* at Durand-Ruel gallery in
 New York.
Degas's niece, Jeanne Fevre, moves in to nurse him.

1917

Works by Degas shown in Grosvenor Gallery, London,
 and in Zurich.
Paulin writes, 'he dreams, he eats, he sleeps'.
27 September, Degas dies.

Lenders to the Exhibition

The Arkansas Arts Center Foundation Collection: cat. 26
The Art Gallery of Ontario, Toronto: cat. 49
The Art Institute of Chicago: cats. 4, 15, 62, 66, 77, 83, 88
The Ashmolean Museum, Oxford: cat. 70
Birmingham Museums and Art Gallery: cat. 71 (Private Collection)
Borough Museum and Art Gallery, Berwick-upon-Tweed: cat. 93
The Brooklyn Museum: cat. 9
Mr Gregory Callimanopulos, New York: cat. 12
The Chrysler Museum, Norfolk, Virginia: cat. 6
Cincinnati Art Museum: cat. 18
The Cleveland Museum of Art, Ohio: cat. 16 *(Chicago only)*
Columbus Museum of Art, Ohio: cats. 64, 102
Corporate Art Collection, The Reader's Digest Association Inc.: cat. 23
The Courtauld Institute Galleries, London: cats. 22, 61
Dallas Museum of Art: cat. 7 *(Chicago only)*
The Detroit Institute of Arts: cat. 54
Fogg Art Museum, Harvard University Art Museums: cat. 50
Fondation Rau pour le Tiers-Monde, Zurich: cat. 1
Fujikawa Galleries Inc., Tokyo: cat. 37
Galerie Beyeler, Basel: cat. 25
Glasgow Museums, The Burrell Collection: cat. 17 *(London only)*
Graphische Sammlung der Staatsgalerie Stuttgart: cats. 11, 53
Hirshhorn Museum and Sculpture Garden, Smithsonian Institution: cats. 55, 60, 72
Dr and Mrs Julius H. Jacobson II: cat. 101
Ursula and R. Stanley Johnson Collection: cat. 82
Kasama Nichido Museum of Art Collection, Tokyo: cat. 19 *(Chicago only)*
Kimbell Art Museum, Fort Worth, Texas: cat. 51
Collection Jan and Marie-Anne Krugier: cat. 98
Kunsthalle, Bremen – Kupferstichkabinett: cat. 34 *(Chicago only)*
Kunstmuseum, Winterthur: cat. 52
Leicestershire Museums, Arts and Records Service: cat. 100
Mrs Alex Lewyt: cats. 90 and 96 *(Chicago only)*
Susan and Lewis Manilow: cat. 36
The Metropolitan Museum of Art: cats. 10 (Private Collection), 24, 31, 92, 99 *(Chicago only)*
Musée d'Orsay, Paris: cats. 32, 76, 87
The Museum of Fine Arts, Houston: cats. 65, 97
Nasjonalgalleriet, Oslo: cat. 40 *(London only)*
The National Gallery, London: cats. 2, 42, 47 *(London only)*, 84
The National Gallery of Art, Washington: cat. 8
The National Gallery of Scotland, Edinburgh: cat. 58
The National Museum of Western Art, Tokyo: cat. 46

The National Museums and Galleries on Merseyside (Walker Art Gallery, Liverpool): cat. 5 *(London only)*
Nationalmuseum, Stockholm: cat. 89
The Norton Simon Foundation, Pasadena, California: cat. 48
Ordrupgaard, Copenhagen: cats. 20, 39
Peter Findlay Gallery, New York: cat. 69 *(Chicago only)*
Philadelphia Museum of Art: cats. 57, 81
The Phillips Family Collection: cat. 73
Princeton University, The Art Museum: cat. 80
Private Collections: cats. 13, 14 *(London only)*, 28 *(Chicago only)*, 29 *(Chicago only)*, 30, 35 *(Chicago only)*, 38 *(Chicago only)*, 41, 43 *(London only)*, 44, 56, 59, 63 *(Chicago only)*, 67, 75, 78, 79, 85, 94
Santa Barbara Museum of Art: cat. 21
Sara Lee Corporation: cats. 91, 95
Scott M. Black Collection, Boston, Mass.: cat. 3
Solomon R. Guggenheim Museum, New York: cat. 27
Collection of Catherine and David A. Straz Jr: cat. 86
The Tate Gallery, London: cats. 45 *(London only)*, 74
Virginia Museum of Fine Arts: cat. 68
Wallraf-Richartz-Museum, Cologne: cat. 33 *(Chicago only)*

Works in the Exhibition

The Years of Transition

CAT. 1

*Self portrait, c.*1895–1900

Pastel on paper, 47.5 x 32.5 cm (18¾ x 12¾ in.)

Zurich, Fondation Rau pour le Tiers-Monde (Ex-L.)

CAT. 2

*Hélène Rouart in her father's study, c.*1886–95

Oil on canvas, 161 x 120 cm (63⅜ x 47¼ in.)

London, National Gallery (L. 869)

CAT. 3

*Pagans and Degas's father, c.*1895

Oil on canvas, 82 x 84 cm (42¾ x 44 in.)

Boston, Mass., Scott M. Black Collection (L. 345)

CAT. 4

*The millinery shop, c.*1879–84

Oil on canvas, 100 x 110.7 cm (39⅜ x 43⅝ in.)

The Art Institute of Chicago,

Mr and Mrs Lewis Larned Coburn Memorial Collection (L. 832)

CAT. 5

*Woman ironing, c.*1892–5

Oil in canvas, 80 x 63.5 cm (31½ x 25 in.)

Board of Trustees of the National Museums and Galleries on Merseyside

(Walker Art Gallery, Liverpool) (L. 846)

(London only)

CAT. 6

*Dancer with bouquets, c.*1890–5

Oil on canvas, 180 x 151 cm (71 x 60 in.)

Norfolk, Virginia, Chrysler Museum, Gift of Walter P. Chrysler Jr,

in memory of Della Viola Forker Chrysler (L. 1264)

CAT. 7

Ballet dancers on the stage, 1883

Pastel on paper, 62.2 x 47.3 cm (24½ x 18⅝ in.)

Dallas Museum of Art, Gift of Mr and Mrs Franklin B. Bartholow

(L. 720)

(Chicago only)

CAT. 8

*Before the ballet, c.*1890–2

Signed lower left

Oil on canvas, 40 x 88.9 cm (15¾ x 35 in.)

Washington, National Gallery of Art, Widener Collection (L. 941)

CAT. 9

*Nude woman drying herself, c.*1884–6

Oil on canvas, 150 x 214.5 cm (59 x 84⅜ in.)

New York, The Brooklyn Museum, Carll H. deSilver Fund (L. 951)

CAT. 10

*Woman having a bath, c.*1886–8

Signed lower right

Pastel on paper, 72 x 56 cm (28⅜ x 22 in.)

New York, Lent by the Metropolitan Museum of Art,

Private Collection (L. 883)

Drawing, Tracing and the Sequence

CAT. 11

Nude on the edge of the bath drying her legs, c.1900–5

Charcoal on tracing paper, 40 x 54 cm (15¾ x 21¼ in.)

Stuttgart, Graphische Sammlung der Staatsgalerie (Vente II, no. 315)

CAT. 12

After the bath, woman drying herself, c.1900–5

Charcoal and pastel on tracing paper, 80 x 72 cm (31½ x 28¼ in.)

New York, Mr Gregory Callimanopulos (L. 1380)

CAT. 13

After the bath, woman drying herself, c.1900–5

Charcoal on tracing paper, 63.1 x 38.1 cm (24⅞ x 15 in.)

Private Collection, Courtesy of Browse and Darby Ltd

(Vente II, no. 343)

CAT. 14

Bather drying her legs, c.1900–5

Charcoal and pastel on tracing paper, 69 x 36 cm (27⅛ x 14⅛ in.)

Switzerland, Private Collection,

Courtesy of Galerie Nathan, Zurich (L. 1383)

(London only)

CAT. 15

After the bath, woman drying her feet, c.1900–5

Charcoal and pastel on tracing paper, 57 x 40.8 cm (22½ x 16 in.)

The Art Institute of Chicago,

Gift of Mrs Potter Palmer (Vente II, no. 307)

CAT. 16

Frieze of dancers, c.1893–8

Signed lower right

Oil on canvas, 70 x 200.5 cm (27½ x 79 in.)

Ohio, Cleveland Museum of Art,

Gift of the Hanna Fund (L. 1144)

(Chicago only)

CAT. 17

Red ballet skirts, c.1897–1901

Pastel on tracing paper, 81.3 x 62.2 cm (32 x 24½ in.)

Glasgow Museums, The Burrell Collection (L. 1372)

(London only)

CAT. 18

Three dancers in yellow skirts, c.1899–1904

Charcoal and pastel on tracing paper, 64.5 x 49.8 cm (25⅜ x 19⅝ in.)

Cincinnati Art Museum, Gift of Vladimir Horowitz (L. 1376)

CAT. 19

Dancers in the wings, c.1897–1901

Charcoal and pastel on tracing paper, 80 x 110 cm (31½ x 43¼ in.)

Tokyo, Kasama Nichido Museum of Art Collection (BR. 159)

(Chicago only)

CAT. 20

Three dancers, c.1897–1901

Pastel on tracing paper, 90 x 85 cm (35½ x 33½ in.)

Copenhagen, Ordrupgaard (L. 1322)

CAT. 21

Ballet dancer resting, c.1897–1901

Charcoal on tracing paper, 49.8 x 31.1 cm (19⅝ x 12¼ in.)

Santa Barbara Museum of Art, Gift of Wright S. Ludington

(Vente II, no. 274)

CAT. 22

Two dancers at rest, c.1897–1901

Charcoal on tracing paper, 62 x 35 cm (24⅜ x 13¾ in.)

London, Courtauld Institute Galleries

(Lillian Browse Collection) (Vente III, no. 264)

CAT. 23

Dancers, c.1897–1901

Signed lower left

Pastel and charcoal on tracing paper, 65.4 x 77.5 cm (25¾ x 30½ in.)

New York, Corporate Art Collection,

The Reader's Digest Association Inc. (L. 1223)

CAT. 24

Dancer with a fan, c.1897–1901

Signed lower right

Pastel and charcoal on tracing paper, 55.6 x 48.9 cm (21⅞ x 19¼ in.)

New York, Lent by the Metropolitan Museum of Art,

H. O. Havemeyer Collection,

Bequest of Mrs H. O. Havemeyer, 1929 (L. 1068)

CAT. 25
Dancers, c.1897–1901
Pastel on tracing paper, 73.5 x 61 cm (29 x 24 in.)
Basel, Galerie Beyeler (L. 1304)

CAT. 26
Group of dancers, c.1897–1901
Charcoal on tracing paper, 77.2 x 63.2 cm (30⅜ x 24⅞ in.)
Little Rock, The Arkansas Arts Center Foundation Collection:
The Fred W. Allsopp Memorial Acquisition Fund, 1983
(Vente I, no. 322)

CAT. 27
Dancers in green and yellow, c.1899–1904
Pastel on tracing paper, 98.8 x 71.5 cm (38⅞ x 28⅛ in.)
New York, Solomon R. Guggenheim Museum,
Thannhauser Collection, Gift, Justin K. Thannhauser, 1978
(L. 1431)

CAT. 28
Four dancers, c.1899–1904
Pastel on paper, 64 x 42 cm (25¼ x 16½ in.)
Private Collection (L. 1417)
(Chicago only)

CAT. 29
Two nude dancers on a bench, c.1900–5
Charcoal on tracing paper, 80 x 106 cm (31½ x 41⅞ in.)
Chicago, Private Collection (Ex-L.)

CAT. 30
Two dancers on a bench, c.1900–5
Pastel on tracing paper, 83 x 107 cm (32⅝ x 42⅛ in.)
Private Collection (L. 1256)

CAT. 31
Dancers, pink and green, c.1885–95
Signed lower right
Oil on canvas, 82.2 x 75.6 cm (32⅜ x 29¾ in.)
New York, Lent by the Metropolitan Museum of Art, H. O.
Havemeyer Collection, Bequest of Mrs H. O. Havemeyer, 1929
(L. 1013)

CAT. 32
Blue dancers, c.1895
Oil on canvas, 85 x 75.5 cm (33½ x 29¾ in.)
Paris, Musée d'Orsay,
Gift of Docteur and Madame Albert Charpentier, 1951 (L. 1014)

CAT. 33
Dancers, c.1900–10
Signed lower right
Pastel and charcoal on tracing paper, 45 x 93 cm (17¾ x 36⅝ in.)
Cologne, Wallraf-Richartz-Museum (L. 998)
(Chicago only)

CAT. 34
Torso of a dancer, c.1899
Signed lower right
Charcoal and pastel on tracing paper, 47.5 x 37 cm (18¾ x 14½ in.)
Kunsthalle, Bremen – Kupferstichkabinett (Ex-L.)
(Chicago only)

CAT. 35
Dancers, nude study, c.1899
Signed lower right
Charcoal and pastel on wove paper, 78.1 x 58.1 cm (30¾ x 22⅞ in.)
Private Collection (L. 1355)
(Chicago only)

CAT. 36
Study of four nude dancers, c.1890–1900
Charcoal on tracing paper, 56 x 66 cm (22 x 26 in.)
Susan and Lewis Manilow (Vente III, no. 200)

CAT. 37
Dancers, c.1895
Signed lower left
Pastel on tracing paper, 51 x 40 cm (20⅛ x 15¾ in.)
Tokyo, Fujikawa Galleries Inc. (L. 1242)

COMBING THE HAIR

CAT. 38
*Woman combing her hair, c.*1896–9
Signed upper left
Charcoal and pastel on tracing paper, 108 x 75 cm (42½ x 29½ in.)
Private Collection (L. 933)
(Chicago only)

CAT. 39
*Woman combing her hair, c.*1894
Oil on canvas, 54 x 40 cm (21¼ x 15¾ in.)
Copenhagen, Ordrupgaard (L. 1147)

CAT. 40
*Combing the hair, c.*1896–1900
Oil on canvas, 82 x 87 cm (32¼ x 34¼ in.)
Oslo, Nasjonalgalleriet (L. 1127)
(London only)

CAT. 41
*Woman combing her hair, c.*1892–6
Signed lower left
Pastel on tracing paper, 56 x 56 cm (22 x 22 in.)
Private Collection (L. 1129)

CAT. 42
*Combing the hair, c.*1892–6
Oil on canvas, 114.3 x 146.1 cm (45 x 57½ in.)
London, National Gallery (L. 1128)

CAT. 43
*Woman combing her hair, c.*1896–9
Charcoal and pastel on tracing paper, 58.5 x 81 cm (23 x 31⅞ in.)
London/Geneva, Private Collection (L. 1164 bis)
(London only)

CAT. 44
*Woman combing her hair, c.*1896–9
Signed upper right
Charcoal and pastel on tracing paper, 89 x 89 cm (35 x 35 in.)
Private Collection (L. 1164)

CAT. 45
*Woman at her toilette, c.*1896–9
Pastel on tracing paper, 96 x 110 cm (37¾ x 43¼ in.)
London, Tate Gallery, presented by C. Frank Stoop, 1933 (L. 1161)
(London only)

CAT. 46
*After the bath, c.*1896–9
Charcoal and pastel on paper, 47.6 x 61.5 cm (18¾ x 24¼ in.)
Tokyo, The National Museum of Western Art, Matsukata Collection
(L. 1165)

WOMEN BATHING

CAT. 47
After the bath, woman drying herself, c.1890–5
Pastel on tracing paper, 103.8 x 98.4 cm (40⅞ x 38¾ in.)
London, National Gallery (L. 955)
(London only)

CAT. 48
After the bath, c.1890–3
Signed lower left: incorrectly dated by a later hand
Pastel on tracing paper, 66 x 52.7 cm (26 x 20¾ in.)
Pasadena, California, The Norton Simon Foundation (L. 815)

CAT. 49
Woman at her bath, c.1893–8
Oil on canvas, 71.1 x 88.9 cm (28 x 35 in.)
Toronto, Collection Art Gallery of Ontario,
Purchase, Frank P. Wood Endowment, 1956 (L. 1119)

CAT. 50
After the bath, c.1893–8
Charcoal on tracing paper, 49.7 x 64.4 cm (19½ x 25⅜ in.)
Cambridge, Mass., Fogg Art Museum, Harvard University Art
Museums, Bequest of Meta and Paul J. Sachs (Vente II, no. 289)

CAT. 51
After the bath, woman drying her hair, c.1893–8
Charcoal on tracing paper, 62 x 69.3 cm (24⅜ x 27¼ in.)
Fort Worth, Texas, Kimbell Art Museum (Vente I, no. 327)

CAT. 52
Breakfast after the bath, c.1893–8
Pastel on tracing paper, 119.5 x 105.5 cm (47 x 41½ in.)
Winterthur, Kunstmuseum,
Purchased with funds from the estate of Dr Henri Friedrich, 1979
(L. 979)

CAT. 53
After the bath, woman drying herself, c.1895–1905
Pastel and charcoal on tracing paper, 121 x 101 cm (47⅝ x 39¾ in.)
Stuttgart, Graphische Sammlung der Staatsgalerie (L. 981)

CAT. 54
Seated woman wiping her left side, c.1900–5
Bronze, 33 cm (13 in.) high
The Detroit Institute of Arts, Gift of Edward E. Rothman
(R. LXXII)

CAT. 55
Seated woman wiping her left hip, c.1900–10
Bronze, 45.4 cm (17⅞ in.) high
Washington, Hirshhorn Museum and Sculpture Garden, Smithsonian
Institution, Gift of Joseph H. Hirshhorn, 1966 (R. LXXI)

CAT. 56
Woman seen from behind, drying her hair, c.1905–10
Pastel on tracing paper, 57 x 67 cm (22½ x 26⅜ in.)
Paris, Private Collection (L. 1168)

CAT. 57
After the bath, woman drying herself, c.1894–6
Oil on canvas, 89 x 116 cm (35 x 45⅝ in.)
Philadelphia Museum of Art,
Purchased, Estate of the late George D. Widener (L. 1231)

CAT. 58
Woman drying herself, c.1896–8
Pastel on tracing paper, 64.8 x 63.5 cm (25½ x 25 in.)
Edinburgh, National Gallery of Scotland (L. 1113 bis)

CAT. 59
After the bath, c.1893–5
Pastel on paper, 48.3 x 83.2 cm (19 x 32¼ in.)
Private Collection (L. 855)

CAT. 60
The Masseuse, c.1893–8
Bronze, 41.9 cm (16½ in.) high
Washington, Hirshhorn Museum and Sculpture Garden, Smithsonian
Institution, Gift of Joseph H. Hirshhorn, 1966 (R. LXXIII)

CAT. 61
After the bath, woman drying herself, c.1895–1900
Pastel on tracing paper, 67.7 x 57.8 cm (26⅝ x 22¾ in.)
London, Courtauld Institute Galleries
(The Samuel Courtauld Trust) (L. 1011)

THE ROLE OF SCULPTURE

CAT. 62
Woman seated in an armchair wiping her left armpit, c.1895–1900
Bronze, 31.8 cm (12½ in.) high
The Art Institute of Chicago, Wirt D. Walker Fund (R. LXXII)

CAT. 63
Woman drying herself, c.1893–8
Pastel and charcoal on tracing paper, 110.5 x 87.3 cm (43½ x 34⅜ in.)
Chicago, Private Collection (L3142)
(Chicago only)

CAT. 64
After the bath, 1900–10
Pastel on tracing paper, 80 x 58.4 cm (31½ x 23 in.)
Ohio, Columbus Museum of Art,
Gift of Ferdinand Howald (L. 1343)

CAT. 65
Woman drying herself, c.1900–5
Charcoal and pastel on tracing paper, 78.7 x 78.7 cm (31 x 31 in.)
Houston, Museum of Fine Arts,
The Robert Lee Blaffer Memorial Collection,
Gift of Sarah Campbell Blaffer (L. 1423 bis)

CAT. 66
Woman at her toilette, c.1900–5
Pastel on tracing paper, 75 x 72.5 cm (29½ x 28½ in.)
The Art Institute of Chicago,
Mr and Mrs Martin A. Ryerson Collection (L. 1426)

CAT. 67
After the bath, woman drying herself, c.1900–5
Charcoal and pastel on tracing paper, 77 x 72 cm (30¼ x 28⅜ in.)
Bremen/Berlin, Private Collection,
Courtesy Kunsthandel Wolfgang Werner KG (L. 1458)

CAT. 68
Woman seated in an armchair wiping her neck, c.1900–10
Bronze, 31.8 cm (12½ in.) high
Richmond, Virginia Museum of Fine Arts,
Gift of Mr and Mrs Paul Mellon (R. LXX)

CAT. 69
Grand arabesque, second time, c.1900–5
Charcoal on tracing paper, 46 x 36 cm (18 x 14 in.)
New York, Peter Findlay Gallery (Vente III, no. 235)
(Chicago only)

CAT. 70
Three dancers, c.1900–5
Charcoal and pastel on tracing paper, 39 x 63.8 cm (15⅜ x 25⅛ in.)
Oxford, The Visitors of the Ashmolean Museum (Vente III, no. 198)

CAT. 71
Grand arabesque, second time, c.1882–90
Bronze, 48 cm (18⅞ in.) high
On loan to Birmingham Museums and Art Gallery,
Private Collection (R. XXXVI)

CAT. 72
Dancer moving forward, arms raised, c.1882–95
Bronze, 34.9 cm (13¾ in.) high
Washington, Hirshhorn Museum and Sculpture Garden, Smithsonian
Institution, Gift of Joseph H. Hirshhorn, 1966 (R. XXIV)

CAT. 73
Three dancers in purple skirts, c.1895–8
Signed lower left
Pastel on paper, 73.5 x 48.9 cm (29 x 19¼ in.)
The Phillips Family Collection (L. 1339)

CAT. 74
Dancer at rest, hands behind her back, right leg forward, c.1885–95
Bronze, 44.5 cm (17½ in.) high
London, Tate Gallery, Purchased 1949 (R. XXIII)

CAT. 75
Three nude dancers, c.1893–8
Charcoal on tracing paper, 63 x 53 cm (24¾ x 20⅞ in.)
Private Collection (Vente II, no. 284)

CAT. 76
Dressed dancer at rest, hands behind her back, right leg forward, c.1895–1905
Bronze, 42.5 cm (16¾ in.) high
Paris, Musée d'Orsay (R. LII)

CAT. 77
Two dancers, c.1893–8
Signed on lower right
Pastel on wove paper, 70.5 x 53.6 cm (27¾ x 21⅛ in.)
The Art Institute of Chicago,
Amy McCormick Memorial Collection (L. 1017)

CAT. 78
Three dancers in the wings, c.1900–10,
Signed lower right
Charcoal and pastel on tracing paper, 60.6 x 44.4 cm (23⅞ x 17½ in.)
Private Collection (BR. 161)

CAT. 79
Group of dancers, c.1900–10
Pastel on paper, 57 x 45 cm (22½ x 17¾ in.)
Private Collection, Courtesy of Stephen Mazoh and Co., Inc.
(L. 1252)

CAT. 80
Bather, c.1896
Charcoal and pastel on paper, 47 x 32 cm (18½ x 12⅝ in.)
Princeton University, The Art Museum,
Gift of Frank Jewett Mather, Jr (Vente III, no. 337a)

CAT. 81
Woman taken unawares, c.1896
Bronze, 41cm (16⅛ in.) high
Philadelphia Museum of Art, Louis E. Stern Collection (R. LIV)

CAT. 82
Dancer looking at the sole of her right foot, c.1892–1900
Bronze, 48 cm (18⅞ in.) high
Ursula and R. Stanley Johnson Collection (R. XLIX)

CAT. 83
The morning bath, c.1892–5
Signed lower right
Pastel on wove paper, 70.6 x 43.3 cm (27¾ x 17 in.)
The Art Institute of Chicago,
Mr and Mrs Potter Palmer Collection (L. 1028)

CAT. 84
Ballet dancers, c.1895–1900
Oil on canvas, 72.4 x 73 cm (28½ x 28¾ in.)
London, National Gallery (L. 588)

CAT. 85
Dancer looking at the sole of her right foot, c.1895–1905
Bronze, 46 cm (18⅛ in.) high
London, Private Collection (R. LX)

CAT. 86
Three dancers, c.1888–93
Signed lower right
Pastel on paper, 47 x 30.8 cm (18½ x 12⅛ in.)
Collection of Catherine and David A. Straz Jr (L. 1208)

CAT. 87
Dancer with tambourine, c.1882–90
Bronze, 27.5 cm (10⅞ in.) high
Paris, Musée d'Orsay (R. XXXIV)

THE FIGURE AND THE LANDSCAPE

CAT. 88
The Bathers, c.1895–1905
Pastel and charcoal on tracing paper, 113.4 x 115.7 cm (44⅝ x 45½ in.)
The Art Institute of Chicago, Gift of Nathan Cummings (L. 1079)

CAT. 89
Three Russian dancers, c.1899
Signed lower left
Pastel and charcoal on tracing paper, 62 x 67 cm (24⅜ x 26⅜ in.)
Stockholm, Nationalmuseum (L. 1181)

CAT. 90
Russian dancers, c.1899
Pastel on tracing paper, 58 x 76 cm (22⅞ x 29⅞ in.)
Mrs Alex Lewyt (L. 1187) *(Chicago only)*

CAT. 91
Russian dancer, c.1899
Pastel and charcoal on tracing paper, 63 x 54 cm (24¾ x 21¼ in.)
Sara Lee Corporation (L. 1193)

CAT. 92
Russian dancer, c.1899
Signed lower left
Pastel and charcoal on tracing paper, 61.9 x 45.8 cm (24⅜ x 18 in.)
New York, Lent by the Metropolitan Museum of Art, H. O.
Havemeyer Collection, Bequest of Mrs H. O. Havemeyer, 1929 (L. 1184)

CAT. 93
Russian dancers, c.1899
Signed lower left
Charcoal and pastel on tracing paper, 67 x 47 cm (26⅜ x 18½ in.)
Berwick-upon-Tweed, Borough Museum and Art Gallery (L. 1185)

CAT. 94
Russian dancers, c.1899
Signed lower left
Pastel on tracing paper, 48 x 67 cm (18⅞ x 26⅜ in.)
Canada, Private Collection (L. 1188)

CAT. 95
Russian dancers, c.1899
Pastel on tracing paper, 71 x 57 cm (28 x 22½ in.)
Sara Lee Corporation (L. 1190)

CAT. 96
Three Russian dancers, c.1899–1905
Charcoal and pastel on tracing paper, 99 x 75 cm (39 x 29½ in.)
Mrs Alex Lewyt (Vente III, no. 286)
(Chicago only)

CAT. 97
Landscape, c.1890–2
Signed lower left
Pastel on paper, 49.2 x 48.8 cm (19⅜ x 19¼ in.)
Houston, Museum of Fine Arts, Museum purchase with funds provided
by the Brown Foundation Accessions Endowment Fund (BR. 127)

CAT. 98
Steep coast, c.1890–2
Signed lower right
Pastel on paper, 46 x 54.6 cm (18⅛ x 21½ in.)
Collection Jan and Marie-Anne Krugier (BR. 134)

CAT. 99
View of Saint-Valéry-sur-Somme, c.1896–8
Oil on canvas, 51 x 61 cm (20⅛ x 24 in.)
New York, Lent by the Metropolitan Museum of Art, Robert
Lehman Collection, 1975 (BR. 150)
(Chicago only)

CAT. 100
The return of the herd, c.1896–8
Oil on canvas, 71 x 92 cm (28 x 36¼ in.)
Leicestershire Museums, Arts and Records Service (L. 1213)

CAT. 101
Village street, c.1896–8
Oil on canvas, 81.3 x 68.6 cm (32 x 27 in.)
Dr and Mrs Julius H. Jacobson II (L. 1212)

CAT. 102
Houses at the foot of a cliff (Saint-Valéry-sur-Somme), c.1896–8
Oil on canvas, 92 x 72.2 cm (36¼ x 28½ in.)
Ohio, Columbus Museum of Art,
Gift of Howard D. and Babette L. Sirak, the Donors to the
Campaign for Enduring Excellence, and the Derby Fund (L. 1219)

Notes

I 37 RUE VICTOR MASSÉ

The author gratefully acknowledges information from the following sources:
Archives Durand-Ruel, and Musée du Louvre, Bibliothèque Centrale et Archives des Musées Nationaux, Archives Vollard.

1. Fevre 1949, p. 132.
2. Blanche 1919, pp. 287–8.
3. Lemoisne 1912, pp. 5–6.
4. 'Bing' 1911, p. 678.
5. See Blanche 1919, p. 308, and Moore 1918, p. 22.
6. Valéry 1960, p. 100.
7. Ibid., p. 10.
8. Ibid., p. 57.
9. McMullen 1985; Loyrette 1991.
10. Boggs 1988.
11. For subsequent studies, see especially Paris 1989, Armstrong 1991, Kendall 1993 and *Apollo* 1995.
12. Geffroy 1894, p. 179.
13. Sickert 1917, p. 184; Halévy 1960, p. 104.
14. Lemoisne 1912, p. 6.
15. Michel 1919, p. 471; Fevre 1949, p. 14.
16. Moore 1918, p. 22.
17. See Vitali 1968.
18. See Jeanniot 1933, p. 168; Paris 1989, pp. 59–63; Guérin 1947, p. 107
19. See Guérin 1947, p. 133–5; Kendall 1989, p. 70; Paris 1989, p. 418.
20. Morisot 1986, p. 165; Fénéon 1970, pp. 140–41.
21. Guérin 1947, p. 146; Morisot 1986, p. 181.
22. Guérin 1947, p. 139.
23. Valéry 1960, p. 9; Blanche 1919, p. 257; Halévy 1960, p. 51.
24. See Lerolle 1932; Lyon 1994, p. 29 n. 8.
25. Halévy 1960, p. 51.
26. Guérin 1947, pp. 181–3.
27. Morisot 1986, p. 204.
28. Manet 1979, p. 30; Manet 1987, p. 73.
29. Halévy 1960, p. 101.
30. Rothenstein 1931, p. 318.
31. Boggs 1988, p. 494; Manet 1987, p. 183.
32. Baudot 1949, p. 79.
33. Jeanniot 1933, pp. 173, 301.
34. Mathews 1984, p. 246; Guérin 1947, pp. 171–2.
35. Guérin 1947, p. 176; Manet 1987, pp. 86–7.
36. Degas first refers to his camera in 1895; see Guérin 1947, p. 196.
37. Vollard (Degas) 1937 pp. 31–2.
38. Ibid., p. 30.
39. Halévy 1929, pp. 93–5; Halévy 1960, p. 94.
40. Vollard 1936, p. 68.
41. Sickert 1917, p. 191.
42. Valéry 1960, p. 18.
43. Ibid., p. 88.
44. Ibid., p. 58.
45. See Loyrette 1991, p. 543; Guérin 1947, pp. 187–8.
46. See Halévy 1960, p. 101; Halévy 1929, p. 71.
47. Michel 1919, p. 469.
48. See Halévy 1960, pp. 30, 46, 102; Baudot 1949, p. 103; Guérin 1947, p. 76.

49. Guérin 1947, p. 76.
50. Jeanniot 1933, p. 284.
51. See Manet 1987, p. 187; Halévy 1960, p. 128.
52. See Michel 1919, p. 468; Baudot 1949, p. 67; Loyrette 1991, p. 487; Vollard 1936, p. 179.
53. Guérin 1947, p. 197.
54. Morisot 1986, p. 165; Valéry 1960, pp. 61–3.
55. See Kendall 1993, chaps. 6 and 7.
56. His telegrams are in Paris 1989, pp. 355–509; his encounter with an aeroplane in Halévy 1960, p. 139–40.
57. Halévy 1960, p. 94.
58. Ibid., pp. 43–4, 127.
59. Michel 1919, p. 475; Silverman 1995; Manet 1987, p. 158; Vollard 1936, p. 269.
60. Vollard (Degas) 1937 p. 29; Daudet 1992, p. 663.
61. Nochlin 1988, p. 102.
62. Ibid., p. 108.
63. Halévy 1960, p. 155; Vollard 1936, p. 90; Bailly-Herzberg 1989, pp. 200, 455.
64. Halévy 1929, pp. 142–3; Rothenstein 1931, p. 341; Vollard 1936, p. 269.
65. Baudot 1949, p. 68.
66. Nochlin 1988, pp. 108–9.
67. Valéry 1960, p. 24.
68. Nochlin 1988, p. 109.
69. Guérin 1947, pp. 226, 229.
70. Previous studios had been on the nearby rue Frochot and rue Fontaine.
71. Valéry 1960, p. 19.
72. Degas's initial lease (preserved in the Archives de Paris, register D1–P4/1200) with his landlord M. Picot, for the studio only, is dated 9.1.1890, and a reference in Halévy 1960, p. 120, suggests that he took up residence on the lower floors in 1897. However, Theodore Reff has recently established that the *liste electorales* (Archives de Paris, series D1–M2) records 37 rue Victor Massé as Degas's residence from 1890.
A description of the building is in the *calepins cadastraux*, partially reproduced in Loyrette 1991, p. 800 n. 486). I am greatly indebted to Theodore Reff and Henri Loyrette for their help with this investigation.
73. Halévy 1929, p. 136.
74. My thanks to Robert McNab for locating this card.
75. For the description of the structure, see n. 72.
76. Boggs 1988, p. 53.
77. See Mathews 1984, p. 131; the link with Renoir was discovered in the *calepins cadastraux* (see n. 72) by Theodore Reff.
78. Bomford 1990, pp. 42–3; Kendall 1991, p. 98.
79. See Bomford 1990, pp. 42–3; Newhall 1956, p. 125; Fevre 1949, p. 140; Boggs 1988, p. 491.
80. Tanguy was in rue Clauzel (see Monneret 1987, p. 9340; Bomford 1990, p. 42; Milner 1988, pp. 145–6.

81. Monneret 1987, p. 250; Schimmel 1991, p. 165; the Moreau studio still exists.
82. Halévy 1929, p. 66.
83. From an advertisement preserved in the Cabinet des Estampes, Bibliothèque Nationale (no. H 67578).
84. Michel 1919, p. 470.
85. Severini's awareness of Degas is recorded in Severini 1996, p. 6.
86. Halévy 1929, p. 28.
87. Blanche 1919, p. 302; Jeanniot 1933, p. 287; Halévy 1960, pp. 54, 158.
88. Many such works can be found in Milner 1988.
89. See Sacha Guitry's film, *Ceux de chez nous*.
90. Michel 1919, p. 462.
91. Ibid., p. 637.
92. See description recorded in n. 72, and Michel 1919, p. 459.
93. Halévy 1960, p. 120.
94. Lafond 1919, p. 118.
95. Manet 1987, p. 176.
96. Lyon 1994, p. 271.
97. See Lafond 1919, p. 118; Moreau-Nélaton 1931, pp. 259–60.
98. Lafond 1919, p. 118; Guérin 1947, p. 203.
99. Degas's passion for photography occurred in the mid-1890s, the period when he moved apartments.
100. Guérin 1947, pp. 142–3, 145–6.
101. Terrasse 1983, nos. 59 and 51.
102. The Ingres was no.212 Vente Collection I.
103. See Terrasse 1983, nos 8, 36–9, 47, 50, 55, 58.
104. For his pictures, see Dumas 1996.
105. See Loyrette 1991, p. 37–8.
106. Jeanniot 1933, p. 284.
107. Michel 1919, p. 462.
108. Valéry 1960, p. 33.
109. Lafond 1919, p. 114; Halévy 1960, p. 183; Jeanniot 1933, p. 284.
110. Michel 1919, pp. 458–9.
111. Valéry 1960, p. 22.
112. See Michel 1919.
113. See Baudot 1949, p. 102 and Manet 1987, pp. 108, 177.
114. See Sickert 1917, p. 186; Sickert 1947, p. 134; Moreau-Nélaton, 1931 p. 259; Fevre 1949, p. 33; Valéry 1960, p. 19.
115. Halévy 1960, p. 62.
116. Ibid., p. 19.
117. Ibid., pp. 62–3.
118. See Kendall 1988, and Lanthony 1990.
119. Michel 1919, p. 470.
120. Degas is recorded looking at the model through his 'bonocles' in Michel 1919, p. 460.
121. Manet 1987, p. 177.
122. Valéry 1960, p. 19.

2 Degas and the Market-place

123. Havemeyer 1961, pp. 151–2.

124. Valéry 1960, p. 39.

125. For the dating of both works to 1906, see Lyon 1994, p. 271.

126. In *Portrait of Degas*, the pastel *Nude woman having her hair combed* (L.847) is clearly visible, though curiously reversed. At this date the pastel belonged to Roger Marx, an acquaintance of Denis's.

127. Lafond 1919, p. 114; Vollard 1937, p. 56; Valéry 1960, p. 19.

128. Lafond 1919, p. 114.

129. Valéry 1960, p. 19. *Bain*, *baignoire* and *tub* are used without clear distinction.

130. Zillhardt 1949, p. 5.

131. Originally executed *c*.1880, the canvas was reworked with Degas's fingertips in the mid-1890s; see Washington 1990, no. 33.

132. The Bibliothèque Nationale print lacks these areas; see Terrasse 1983, no.23

133. In Terrasse 1983, no. 63, perhaps also posed in the studio, similar drapes are visible.

134. Though the link with Degas is plausible, the sofa and tall jug are not characteristic of the artist's props and the pose is untypical of the mid-1890s.

135. See Buerger 1978, and Boggs 1988, pp. 568–74.

136. Moreau-Nélaton, 1931, p. 258.

137. Michel 1919, p. 459.

1. Jamot 1924, p. 4.

2. Rothenstein 1931, p. 71.

3. Fosca 1921, p. 373; Rewald 1944, p. 3.

4. See Fénéon 1886.

5. Moore 1890, p. 416.

6. Marx 1897, p. 324.

7. Vollard 1925, p. 39.

8. Havemeyer 1961, p. 255.

9. Moore's description probably refers to a studio of the 1880s, before his split with Degas.

10. Havemeyer 1961, p. 254.

11. See Loyrette 1991, p. 626; Sickert 1917, p. 184; Valéry 1960, p. 19; Jeanniot 1933, p. 302.

12. Rothenstein 1931, pp. 103–4; Flint 1984, p. 277.

13. Sickert 1917, p. 184; Jeanniot 1933, p. 302.

14. For example, in Valéry 1960, p. 19, the *Little dancer* is located in the studio, but in Havemeyer 1961, p. 254, in the apartment.

15. Michel 1919, p. 628.

16. For a photograph of the vitrine, see *Apollo* 1995, p. 72.

17. Lafond 1919, p. 114.

18. Michel 1919, p. 628.

19. I am most grateful to Anne Distel and Isabelle Cahn for arranging access to these photographs.

20. The works are dated 1881–5, 1888–92 and 1882–1900 respectively in Pingeot 1991.

21. See Michel 1919, pp. 464, 628; Lemoisne 1919, p. 115.

22. Lemoisne 1919, p. 115.

23. Vollard (Degas) 1937, p. 89.

24. Manet 1987, p. 76.

25. Ibid., p. 151.

26. Baudot 1949, p. 102.

27. Fevre 1949, p. 137; Vollard (Degas) 1937, p. 89.

28. Vollard 1925, p. 39.

29. Jeanniot 1933, p. 300.

30. Cited in Millard 1976, p. 25.

31. Zillhardt 1949, p. 5.

32. Halévy 1960, p. 183.

33. Blanche 1930, p. 154.

34. Raunay 1931, p. 279.

35. Sickert 1917, p. 191. The sculpture in question was R.XXXVI.

36. Thiébault-Sisson 1923, p. 3; Guérin 1947, pp. 219, 227, 229.

37. Lemoisne 1912, p. 111.

38. See chap. 6.

39. For Degas and Rosso, see Reff 1976b, and Lista 1994, pp. 17–8, where Rosso's cast of Hélène Rouart's hand is also mentioned.

40. Guérin 1947, p. 169; Jeanniot 1933, p. 171.

41. Paris 1989, pp. 403–8.

42. Paris 1989, p. 426, and Pingeot 1993.

43. Spies 1983, no. 7.

44. See Glimcher 1986, p. 68; Olivier 1988, p. 170.

45. Halévy 1960, p. 20.

46. Boggs 1988, p. 392.

47. Manet 1987, pp. 108, 177–8.

48. Jeanniot 1933, p. 157; Moreau-Nélaton 1931, p. 258.

49. Sickert 1947, p. 134.

50. Valéry 1960, p. 19.

51. Havemeyer 1961, pp. 251–2.

52. See nn. 46, 47, 51.

53. See Moffett 1986.

54. Huysmans 1975, p. 259.

55. Mathews 1984, p. 331.

56. See Kendall 1993, p. 183.

57. Guérin 1947, p. 183. The work in question was RS.54.

58. See Kendall 1993, chap. 7, especially n. 36 p. 288, and the photographs of some of these works at the 1901 Durand-Ruel New York exhibition, discussed below.

59. See Cahn 1989.

60. See cat. 97 and several works from the Art Institute of Chicago.

61. See, for example, the references to his working routines in chap. 1 and numerous late letters to Durand-Ruel asking for cash.

62. Michel 1919, pp. 462, 464, 628.

63. Paris 1989, pp. 449, 460, 473.

64. See, for example, Paris 1989, p. 482.

65. Halévy 1960, p. 20; Fevre 1949, p. 63.

66. Paris 1989, p. 482.

67. For the *Young Spartans*, see Halévy 1960, pp. 160, 183–4.

68. Rothenstein 1931, p. 336.

69. Sickert 1917, p. 186.

70. Halévy 1960, p. 106.

71. Sickert 1917, p. 186.

72. Huysmans 1975, p. 258.

73. Vollard (Degas) 1937 p. 83.

74. Michel 1919, p. 624.

75. Guérin 1947, p. 129.

76. Jeanniot 1933, p. 174.

77. Mathews 1984, p. 220.

78. See Jeanniot 1933, p. 174, and Guérin 1947, p. 212.

79. L.320 and L.400 were certainly shown.

80. His unease about the Luxembourg, where many of these pictures were shown, is noted in Halévy 1960, p. 112.

81. My thanks for access to these materials is due to Caroline Durand-Ruel Godfroy, Anne Distel, Isabelle Cahn, Walter Feilchenfeldt and Roland Dorn.

82. For Degas's dealings with some of these individuals, see Loyrette 1991 and Boggs 1988.

83. See Thomson 1988, p. 132.

84. Fénéon 1888, pp. 95–96; Morisot 1986, p. 152.
85. Guérin 1947, p. 133; Boggs 1988, p. 390–91; Fénéon 1970, pp. 140–41; Morisot 1986, p. 165.
86. Boggs 1988, p. 393.
87. Fénéon 1970, p. 191; Mathews 1984, p. 220.
88. See Kendall 1993, chap. 7.
89. The relevent pages of the Durand-Ruel ledger are reproduced in Kendall 1993, p. 232.
90. See Kendall 1993, chap. 8, and the 1901 New York exhibition discussed below.
91. See Kendall 1993, p. 231; Loyrette 1991, p. 590.
92. Loyrette 1991, p. 588.
93. See n. 66.
94. Rothenstein 1931, p. 71.
95. Paris 1989, p. 452.
96. New York 1993, p. 338, no. 260.
97. Boggs 1988, p. 527.
98. Paris 1989, pp. 462, 464.
99. Tavernier Sale, Galerie Georges Petit, 6 March 1900, no. 115 (reproduced); *Ballabile*. The price is written on the copy of the sale catalogue in the Witt Library. See also Drouot, 16 April 1907, no. 70 (reproduced); *Danseuses en jupes mauves*.
100. For the pastel, see Boggs 1988, pp. 468–9 and New York 1993, p. 336, no.243.
101. L.1129, L.1296, L.1321 and L.1148. Details from Durand-Ruel archives and New York 1993, p. 338.
102. L.1285, L.1288, L.1339 and L.1337. Details from Durand-Ruel Archives.
103. *The Toilette* L.946, Sisley Sale 1899; *Bathtime*, L.1031, Lacroix Sale 1902.
104. Bailly-Herzberg IV, p. 191.
105. Purchased 16 December 1995; see Boggs 1989, p. 527.
106. For example, *La Toilette,* bought on 29 January 1895 (see Paris 1989, p. 452) and *Leaving the bath,* L.1335, bought on 11 June 1895 (see Monnier 1985, p. 86).
107. Mellerio 1896.
108. See their letters in Paris 1989, pp. 461–6.
109. Rewald 1985, p. 203.
110. See Distel 1990, chaps. II and XX.
111. Details of many of these shows can be found in the Documentation at the Musée D'Orsay.
112. Though the photographs are clearly dated 1901 in the Durand-Ruel albums and unquestionably show the Fifth Avenue premises around the turn of the century, the most assiduous research by Deborah Bogle, intern at the Art Institute of Chicago, has failed to locate any reviews or responses to such an exhibition.
113. In addition to those mentioned below, L.113, L.258, L.295, L.334, L.387, L.485, L.614, L.645, L.652, L.1024 and L.1107 were shown.
114. L.1248, L.1278, L.1386.

115. L.1036, L.1037, L.1039, L.1047, L.1059, L.1129.
116. It should be noted that the photographs may not show the complete exhibition.
117. The Fogg assembled twelve works (see Boggs 1989, p. 497); the Armory Show included L.767 and an unidentified 'Femme sur lit'.
118. See Rebecca Rabinow, 'The Suffrage Exhibition of 1915', in New York 1993, pp. 89–95.
119. 5–29 April 1916, *Exposition Edouard Manet et Edgar Degas*.
120. 9–26 January 1918, *Exposition Degas*; 11–27 March 1920, *Exposition Degas*.
121. See n. 111.
122. I am most grateful to Roland Dorn for information on these exhibitions.
123. 'Dancer at the photographer's' was probably L.447 and 'Laundresses' may have been L.687.
124. Nos.28 and 30a in the 1899 catalogue.
125. Durand-Ruel archive.
126. Durand-Ruel archive.
127. L.1015 (sold 1905), L.942 (sold 1905), L.976 (sold 1909); information from Durand-Ruel archive.
128. Manet 1987, p. 76.
129. See R. Kendall, 'Degas et Cézanne' in Paris 1989, pp. 103–13, and Dumas 1996.
130. In the Vollard *Ventes* notebook for 29 November 1895, the entry originally included '1 tableau de Cézanne (Déjeuner sur l'herbe 80 ½ x 59 ½ [manière noir])', along with two other purchases, though this was subsequently struck out. The work in question was probably Venturi 107.
131. The picture was sold to Stchoukine on 16 November 1896.
132. Mathews 1984, p. 313.
133. A number of glass plates have been preserved, though they have yet to be integrated with the written records.
134. The entry for 4 May 1906, recording a sale to Havemeyer, appears to read '1 pastel de Degas – 9000'. For the later works, see New York 1993, p. 338, nos. 254, 258.
135. Entries for 27 April and 14 June 1909.
136. Entry for 16 January 1911.
137. Entries for 13 May and 19 September 1911.
138. Entry for 17 October 1913.
139. See entry for 17 October 1913.
140. My thanks to Roland Dorn for supplying me with a copy of this document.
141. The charcoal is L.837.
142. For example, the entries for 18 and 20 October 1913.
143. The pastel is L.545.
144. See Guérin 1947, pp. 146–7; the proof of *Young dancer with a fan* reproduced here, is signed by both Thornley and Degas.

145. Fénéon 1970, pp. 111,118; Laughton 1971, p. 47.
146. The volume was published by 'Goupil et Cie, Boussod, Manzi, Joyant et Cie', and seems to have appeared between October 1897 and January 1898 (Bailly-Herzberg IV, pp. 379,439).
147. Bailly-Herzberg, IV p. 439.
148. The drawings include notably Ingresque studies for such early works as *Semiramis building a city*, in both nude and clothed versions.
149. L.906, L.1232.
150. Many of the pictures sold to Cassirer, for example, came from this 'stock'.
151. Catalogue nos. 20, 23, 24, 30, 44, 92, 93 , 94.
152. BR. 146, L.1411, ex-L.
153. Accounts of the filming are in Fevre, 1949 p. 142; Vollard (Degas) 1937, p. 86; Loyrette 1991, pp. 667–9.
154. Halévy 1929, p. 224; Jeanniot 1933, p. 304; Halévy 1960, p. 152.
155. Halévy 1960, p. 149; Jeanniot 1933, p. 304.
156. For his travels, see Guérin 1947, pp. 217, 220, 222–3, 225; Paris 1989, pp. 414–5.
157. Paris 1989, p. 394.
158. Guérin 1947, pp. 219, 222.
159. Paris 1989, p. 494; Guérin 1947, p. 226.
160. See Moreau-Nélaton, 1931; Michel 1919, pp. 464.
161. L.1437 onwards.
162. L.1453–8.
163. See Boggs 1989; Brame and Reff 1984; Thompson 1985–6; Shackelford 1984.
164. L.1424, Boggs 1989, p. 597.
165. For example, the reworked canvases L.841–4.
166. Paris 1989, p. 422.
167. Guérin 1947, p. 229.
168. Thiébault-Sisson, 1923; translation from Kendall 1987, p. 244.
169. Guérin 1947, p. 184.
170. Paris 1989, p. 386.
171. Ibid., p. 396.
172. Ibid., pp. 387, 404.
173. For Paulin's activities as a painter, see also Fénéon 1970, p. 383.
174. See Guérin 1947, pp. 218–9.
175. Rouault 1971, p. 86.
176. Paris 1989, p. 414; Rewald 1989, p. 97.
177. Lyon 1994, p. 271.
178. Sickert 1917, p. 184; Mathews 1984, p. 313.
179. Paris 1989, pp. 328, 394–9; Jeanniot 1933, p. 301; Valéry 1960, p. 64.
180. Valéry 1960, pp. 26, 34–5.
181. Gide 1947, pp. 238–9.
182. Halévy 1960, p. 136.
183. Ibid., p. 131; Guérin 1947, p. 227.
184. See above, nn. 134–7.

3 THE METAPHOR OF CRAFT

185. Gimpel 1966, p. 416.
186. Halévy 1960, p. 138.
187. Ibid., p. 141.
188. Vollard (Degas) 1937, pp. 53,93; Halévy 1960, p. 81; Fevre 1949, p. 141.
189. Jeanniot 1933, p. 299.
190. Loyrette 1991, pp. 647–8; Halévy 1960, p. 138; Vollard (Degas) 1937, p. 93.
191. Fevre 1949, p. 142.
192. Halévy 1960, p. 145.
193. Ibid., p. 151.
194. Mathews 1984, pp. 327–8.
195. See n. 111 above.
196. Mathews 1984, p. 328.

1. See Wiggins 1985.
2. See, for example, the reception of Degas's 1892 landscape monotypes, in Kendall 1993, chap. 7, especially n. 37.
3. See Bailly-Herzberg, III, p. 262.
4. Sickert 1917, pp. 184–5.
5. Jeanniot 1933, p. 291.
6. Raunay 1931, pp. 472–3; Valéry 1960, pp. 91–8.
7. Halévy 1960, p. 67.
8. Rothenstein 1931, pp. 103, 104, 318.
9. Valéry 1960, p. 84.
10. Rouart 1945, p. 16.
11. Raunay 1931, pp. 472–3.
12. Rouault 1971, p. 37.
13. Vollard (Degas) 1937, pp. 63, 65.
14. Valéry 1960 p. 105.
15. For Degas's works in the Impressionist exhibitions, see Moffett 1986, and Paris 1989, pp. 289–351.
16. L.400; see Moore 1918, p. 64.
17. See Moffett 1986, p. 120 no. 59; p. 268 no.75; p. 311 no.14; p. 204 no.58.
18. Rewald XX.
19. Moore 1918, p. 64.
20. See Rouart 1945; Boggs 1988, pp. 324–8.
21. See Boggs 1988, pp. 411–21, 437–40.
22. For the identity of the works, see n. 15.
23. Rewald XXVII.
24. Vollard (Degas) 1937, p. 48.
25. Rouart 1945, p. 19.
26. Ibid., p. 19.
27. Fevre 1949, p. 123; Rouart 1945, p. 128.
28. Valéry 1960, pp. 6, 88.
29. See the account of purchases in Boggs 1988, nos. 246, 250–52, 264–6.
30. Guérin 1947, p. 39.
31. Reff 1976b, p. 270.
32. Notebook 19, p. 8; Notebook 22, p. 5.
33. Moore 1918, p. 65. For Degas's copies, see Reff 1963, 1964.
34. His 1879 copy from Menzel (L.190) is from a work by a contemporary.
35. See Thomson 1987, pp. 90, 97.
36. Vollard (Degas) 1937, p. 60.
37. Moore 1918, p. 64; Halévy 1960, p. 40.
38. Valéry 1960, p. 94; Halévy 1960, pp. 68, 85, 97, 147.
39. See chaps. 4 and 5; for Turner, see Kendall 1993, p. 208.
40. BR.83; J.158; BR.143; BR.144.
41. Moffett 1986, p. 44.
42. See Guérin 1947, pp. 137, 198–9; 203–4; Clarke 1991.
43. See Loyrette 1991, p. 620; Guérin 1947, pp. 203–4; Dumas 1996.
44. In a 1911 letter to Wilhem Holzmann.

45. Vollard (Degas) 1937, pp. 55, 70, 72. For his museum, see Blanche 1919, p. 252; Halévy 1960, p. 98; Rothenstein 1931, p. 102.
46. Reff 1976b, p. 294.
47. See Kendall 1993, p. 181 n. 103.
48. Guérin 1947, p. 183.
49. Rouart 1945, p. 16.
50. Moreau-Nélaton, 1931 p. 260; Valéry 1960, p. 85.
51. Vollard (Degas) 1937, pp. 69–70.
52. Rouault 1971, p. 37.
53. Reff 1976b, p. 272.
54. Gasquet 1926, p. 176.
55. Ibid., pp. 165, 207.
56. Vollard 1925, p. 17.
57. Vollard 1925, p. 56.
58. Ibid., pp. 110–1.
59. See Kendall 1993, pp. 88–108.
60. Moffett 1986, pp. 127, 179.
61. Bouillon 1990, p. 226.
62. Duret 1894, p. 205.
63. Sickert 1947, p. 196; Vollard 1925, p. 58; Kitaj 1988, p. 179.
64. Valéry 1960, p. 23.
65. See Sète 1974.
66. See Valéry 1960, pp. 7, 19.
67. Ibid., p. 8.
68. Manet 1987, pp. 147, 152; for Valéry's illustrations, see Sète 1974.
69. Valéry 1960, p. 34–5.
70. Ibid., pp. 19, 39.
71. Ibid., pp. 7, 64.
72..Ibid., p. 68
73. Ibid., p. 38.
74. Ibid., pp. 39, 57.
75. Ibid., p. 134.
76. Ibid., p. 83.
77. Ibid., p. 35.
78. Sickert 1917, p. 186; Jeanniot 1933, p. 293; Halévy 1960, p. 57; Vollard (Degas), 1937, p. 60.
79. Halévy 1960, pp. 58–9; Rothenstein 1931, p. 105.
80. See Dumas 1996; Vente Collection I; Vente Collection II.
81. Moreau-Nélaton 1931, p. 259.
82. Haverkamp-Begemann 1964, p. 104 no. 222.
83. For the significance of the nude dancer in Degas's oeuvre, see chapter 5.
84. Armstrong 1991, pp. 228–32.
85. Moreau-Nélaton 1931, p. 259; Guérin 1947, pp. 191–2; Rothenstein 1931, p. 106; Sickert 1947, p. 125.
86. Delaborde 1870, p. 123.
87. Ibid., p. 123.
88. Blanc 1897, p. 21–2.
89. Ibid., p. 22.

90. Ibid., p. 21–2.
91. Ibid., p. 22.
92. Huysmans 1975, p. 121.
93. See Burnell 1969.
94. The pastel variant has been variously dated, from 1876–7 in Boggs 1988, pp. 307–8, to 1880–83 in Thomson 1987, p. 108.
95. This parallels the sales of prints treated with pastel; see n. 29.
96. *Nude drying herself* was in Vente III, no. 347; Monet's acquisition of the print is noted in Boggs 1988, p. 308.
97. See chap. 2.
98. See, for example, illustrations XCIV, XCVI, XV in Vollard 1914.
99. For example, L.1223–5, L.1321.
100. See Pickvance 1963.
101. Lloyd and Thomson 1986, pp. 23–49.
102. One of the few references to Degas's use of charcoal is in Jirat-Wasintynski 1980.
103. Fevre 1949, p. 135; Rothenstein 1931, p. 104; Rouart 1945, pp. 120–3.
104. Plate XCCVIII.
105. Delaborde 1870, p. 124.
106. Ibid., pp. 124–7.
107. Lemoisne 1946–9, I, p. 31.
108. Fevre 1949, p. 26.
109. Reversal of imagery can be found in the work of Liotard and Ingres; for Daumier's practice, see Maison 1956.
110. Rouart 1945, p. 63.
111. A number of counterproofs are listed in Vente II, nos. 361–86; Vente III, nos. 409–10; Vente IV, nos. 302–384.
112. For repetiton and replication in Degas's lithographs, see Douglas Druick and Peter Zegers, 'Degas and the Printed Image', in Reed and Shapiro 1984, pp. lxv–lxix.
113. See, for example, Cennini 1933, pp. 13–14.
114. Rothenstein 1931, p. 104.
115. Examples of early drawings on tracing paper in the Louvre are nos. 45, 46, 69, 72, 103, in Paris 1969.
116. For the genesis of the painting, see Dumas 1988.
117. Chialiva 1932.
118. See, for example, L.1450 and Vente IV, no. 254.
119. See Marjorie Cohn, 'Technical Appendix', in Cambridge, Mass., 1967, pp. 241–9.
120. For example, *Nude study for mounted centurion* and studies for the *Death of Leonardo da Vinci* (Musée Ingres, Montauban).
121. A follower like Hippolyte Flandrin used the material in much the same way as Ingres; see Foucart 1984, nos. 32, 55, 62, 65.
122. See Bittler and Mathieu, 1983.
123. For example, Degas Notebook 8, p. 2.

124. *Les Sources* is one of several large-scale compositions on tracing paper in the Musée Gustave Moreau.
125. Moreau-Nélaton 1931, p. 258.
126. For example, the Art Institute of Chicago's *Bathers*, L.1079.
127. Many of Ingres's drawings are stuck to white paper.
128. Blanche 1919, p. 295; Lafond 1919, p. 20.
129. Rothenstein 1931, p. 104.
130. Vollard (Degas) 1937, p. 6; Fevre 1949, p. 133.
131. Michel 1919, p. 631.
132. Guérin 1947, p. 117.
133. Vollard (Degas) 1937, pp. 62–3.
134. Vollard may have been confused by Degas's practice of expanding his compositions by adding strips of tracing paper.
135. Rothenstein 1931, p. 104.
136. Valéry 1960, p. 39.
137. The precise sequence of drawing and tracing in such a 'family' is difficult to establish.
138. Slight variations may be accounted for by imprecision in the tracing process.
139. See n. 137.
140. For example, Vente II, no. 284; Vente III, nos. 204, 219, 222, 256–8, 261, 325, 381; BR.146; L.1016–9, L.1250–3, L.1445–9.
141. Havemeyer 1961, p. 252; Romanelli 1937, p. 6.
142. Compare, for example, the photograph of L.1457 with Vollard 1914, pl.XXII.
143. See Douglas Druick and Peter Zegers, 'Scientific Realism: 1874–1881', in Boggs 1988, pp. 197–211, especially fig. 97.
144. A similar sequence was followed in L.981 (cat. 53).
145. See Maheux 1988, pp. 44–5.
146. For L.1249 as an example of the former, see Robinson 1987, p. 100.
147. See L.1130, L.1415; Vente III, nos. 265, 290.
148. Vollard (Degas) 1937, pp. 65, 68; Halévy 1929, pp. 261–3.
149. Halévy 1929, p. 261; Moreau-Nélaton 1931, p. 258; L.1252 bis and a *Dancers* (ex-L.).
150. Moreau-Nélaton 1931, p. 260; the description fits works such as L.724 and L.979 (cat. 52), though both were begun many years before Moreau-Nélaton's 1907 visit.
151. Moreau-Nélaton 1931, p. 260.
152. I am grateful to Sally Ann Yates, Paper Conservator at Merseyside Maritime Museum, for explaining the difficulties of sticking tracing paper to such supports and avoiding visible brushmarks in the adhesive.
153. See, for example, the edges of L.1011 (cat. 61).
154. For Degas's papers, see Roy Perkinson, 'Degas's Printing Papers', in Reed and Shapiro 1984, pp. 255–61; David Chandler, "Edgar Degas in the

Collection of the Art Institute of Chicago. Examination of Selected Pastels', in Guillaud 1984, pp. 443–8; Maheux 1988, pp. 43–50.
155. The former is grey-blue, the latter cream.
156. See L.917, L.960, L.964, L.987, L.1008, L.1133, L.1031 bis, L.1073.
157. For example, L.1017 (cat. 77), L.1073.
158. Vollard (Degas) 1937, p. 68.
159. Moore 1893, p. 28; Valéry 1960, p. 64.

4 COLOUR

1. Guérin 1947, pp. 80–81.
2. Sickert 1917, p. 185.
3. Guérin 1947, p. 226.
4. For the use of pastel on canvas, see below n.72
5. Moore 1918, p. 64.
6. See nn. 9–11.
7. Lemoisne 1946–9.
8. Ephrussi 1880, p. 487; Moffett 1986, p. 453.
9. Vollard (Degas) 1937, p. 70.
10. Sickert 1947, p. 154; Lemoisne 1946–9, I, p. 111; Jeanniot 1933, p. 169.
11. Sickert 1947, p. 155.
12. Rouart 1945, pp. 16–33.
13. Ibid., pp. 26, 32, 34.
14. For Degas's pastels, see Cooper 1952; Werner 1969; Reff 1976b, pp. 270–303; Callen 1982; David Chandler, 'Edgar Degas in the Collection of the Art Institute of Chicago. An Examination of Selected Pastels', in Guillaud 1984, pp. 443–8; Maheux and Zegers 1986; Maheux 1988; Fletcher and Desantis 1989; Boggs and Maheux 1992.
15. Lemoisne 1946–9, I, p. 111; Boggs and Maheux 1992, p. 7.
16. Vente IV, 71b.
17. Notebook 19, pp. 8–8a.
18. Reff 1976b, pp. 113–5; in a personal communication, Jean Sutherland Boggs has used sales catalogues to link La Tour's pastel portraits of Gluck and Marie Joseph de Saxe with Auguste de Gas's collection.
19. L.255.
20. Vaillat and de Limay 1923, pp. 38, 213, 215.
21. See the catalogue in Vaillat and de Limay 1923.
22. See n. 18.
23. Fevre 1949, p. 70.
24. See Monnier 1984, pp. 13–43.
25. Delaborde 1870, p. 132.
26. Ibid., p. 165.
27. Jeanniot 1933, p. 158.
28. Blanc 1897, p. 587.
29. Ibid., pp. 586–8.
30. L.765, L.816, L.847, L.872, L.874–7.
31. Blanc 1897, p. 586.
32. Sickert 1917, pp. 184–5.
33. See Kendall 1993, pp. 142–3.
34. Maheux 1988, p. 18.
35. Lloyd and Thomson 1986, p. 43.
36. Fevre 1949, p. 70.
37. In the eighteenth century, this was due to the scarcity of large sheets of orthodox paper; Degas's production of tracing paper collages was self-imposed.
38. See Paris 1989, pp. 306–15.
39. For exhibited pastels by these artists, see Moffett 1986, and Paris 1989, pp. 289–351.

40. It is often asserted that Degas left the final layer of pastel unfixed, though there is no documentary evidence for this.
41. Maheux 1988, p. 87.
42. Boggs and Maheux 1992, p. 21.
43. Such tints can be seen, for example, in cat. 25.
44. Maheux 1988, pp. 85–93; Norville-Day 1993, pp. 51–3.
45. Boggs and Maheux 1992, pp. 19–20.
46. Vollard (Degas) 1937, p. 63; Vollard 1936, p. 178.
47. Boggs and Maheux 1992, pp. 19–21.
48. Vollard (Degas) 1937, p. 63.
49. Valéry 1960, pp. 6, 50.
50. The São Paolo drawing was sold to Vollard and included as plate LXIII in Vollard 1914.
51. A group of such red–brown pastels (L.1382, L.1458 [cat. 67]) may have followed Degas's experiments with russet oil paintings, such as cats. 42, 57.
52. For example, L.1424, L.1172.
53. Vollard (Degas) 1937, pp. 68–9.
54. Rouart 1945, p. 66.
55. Blanc 1867, p. 588.
56. Moreau-Nélaton 1931, p. 260.
57. Ibid.
58. Chialiva 1932; Rouart 1945, p. 67.
59. Vollard (Degas) 1937, p. 68.
60. Sickert 1947, p. 192.
61. Emmons 1941, p. 250.
62. Guillaud 1984, p. 444.
63. Fletcher and Desantis 1989, p. 262.
64. Maheux 1988, p. 88.
65. For example cats. 11, 17, 77.
66. Evident at first hand, especially on unworked areas of tracing paper, in such works as cats. 27, 61.
67. Fletcher and Desantis 1989, p. 265.
68. Examination of cat. 47, for example, suggests that much of the visible pastel is unfixed.
69. My thanks to Robert Bruce-Gardner, William Bradford and Caroline Villers for helping me to examine this work.
70. See also House 1994, p. 92.
71. Like many pastels of this period, this light card was then attached to heavier millboard at its edges using a distinctive dark blue tape, and the label of the framer Adam Dupré, rue Fontaine St Georges (close to Degas's studio) attached to the reverse.
72. See also L.1294, L.1307.
73. Maheux 1988, p. 15.
74. Huysmans 1975, pp. 120–1.
75. Riout 1989, p. 396.
76. Alexandre 1892; Hale 1892, p. 326; Geffroy 1894, pp. 176–7.
77. Gide-Valéry 1955, 1898, p. 314; Denis 1957, p. 108.
78. Valéry 1960, p. 96.

79. Sickert 1917, p. 185; Valéry 1960, p. 84.
80. The division of the wheel is irregular and the inclusion of both violet and indigo unconventional.
81. Degas was acquainted with at least three pupils; Gustave Moreau, Evariste de Valernes and Léon Riesener.
82. Huysmans 1970s, pp. 120–21.
83. See also Richard Kendall 'Degas's Colour', in Kendall 1985, pp. 19–31.
84. I am grateful to Marianne Frisch and Jill Devonyar-Zansky for arranging for the examination of this pastel.
85. See Kendall 1993, chaps. 6 and 7; the Musée d'Orsay pastel is L.1081.
86. Riout 1989, pp. 394–405.
87. Ibid., pp. 401–2.
88. Rewald 1943, p. 101.
89. See Moffett 1986.
90. Rewald 1943, p. 233.
91. See chap. 2; Vente Fénéon 1947, nos. 7, 8.
92. Kendall 1993, p. 179.
93. See n. 83.
94. Lemoisne 1912, p. 110.
95. Michel 1919, p. 631.
96. Ibid., p. 631.
97. For other variants and associated drawings, see L.1371–9.
98. L.1322 was signed and sold to Vollard; see Vollard 1914, XXVI.
99. L.942, L.1066, L.1223, L.1321, L.1452 bis.
100. L.942 and L.1321 went to Durand-Ruel, the rest to Vollard.
101. L.1181 was sold to Durand-Ruel, L.1184–6 and L.1188 to Vollard.
102. Valéry 1960, p. 39.
103. Jeanniot 1933, p. 170.
104. Lemoisne 1912, p. 14.
105. Jeanniot 1933, p. 280.
106. Kendall 1993, p. 226 and n. 176.
107. Chipp 1968, pp. 66, 75. See also Françoise Cachin, 'Degas et Gauguin', in Paris 1989, pp. 114–127.
108. See also Dumas 1996.
109. See Richard Kendall, 'Degas et Cézanne', in Paris 1989, pp. 102–113.
110. Chipp 1968, pp. 130–7.
111. Ibid., p. 134.
112. Ibid., p. 135.
113. Blanc 1897, p. 586.
114. Vollard (Degas) 1937, p. 69.
115. For the most complete account of Degas's early training, see Loyrette 1991, chaps. 1 and 2.
116. See Burnell 1969.
117. Degas's early painting technique still awaits study, but see Rouart 1945 and Reff 1976b, pp. 270–303.

118. Other surviving monochromes are L.71, L.132,
 L.187, L.193, L.309–10.
119. See Richard Kendall, 'Degas's Colour',
 in Kendall 1985, pp. 19–31.
120. See Kendall 1993, chap. 5.
121. See House 1986, chaps. 4 and 5.
122. Vollard (Cézanne) 1937, p. 86.
123. Vollard 1925, p. 56.
124. Ibid., pp. 47–8, 58, 60.
125. Manet 1987, p. 148; Baudot 1949, p. 12.
126. Rewald 1941, p. 243.
127. Vollard 1925, pp. 37–8.
128. Vollard 1936, p. 178.
129. Moffett 1986, pp. 43–5.
130. See Boggs 1988, pp. 395–401.
131. See Brettell and McCullagh 1984, pp. 131–4.
132. See Boggs 1962, pp. 67–9; Gordon 1984.
133. Brettell and McCullagh 1984, p. 132.
134. I have benefited greatly from David Bomford's
 guidance in examining this painting, before and
 during its recent cleaning.
135. Hélène was married in 1886; see Gordon 1984, p. 15.
136. Though remarkably like pastel in appearance,
 analysis has shown that these strokes were made
 with dry oil paint.
137. See, for example, L.893, L.1291, L.1334.
138. Sickert 1947, p. 47.
139. Ibid., p. 185.
140. My thanks are due to Ken Moser and his colleagues
 in the Brooklyn Museum Conservation Department
 for assisting my studies of this painting.
141. At least two different grid systems were used,
 neither of them consistently across the canvas.
142. See Boggs 1988, pp. 307–8, 423–4.
143. There is some evidence in this photograph that
 chalk or pastel lines, now lost, were also used to
 develop the composition.
144. L.872.
145. Once abandoned, the picture remained in the artist's
 studio until his death.
146. See also Notebook 36, pp. 31 and 32.
147. See Thomson 1988, pp. 170–71.
148. Halévy 1960, p. 67.
149. Valéry 1960, p. 91; Jeanniot 1933, p. 161.
150. Degas's awareness of Cennini is noted in Fevre
 1949, p. 26, and of Félibien in Notebook 1, p. 36a.
151. Valéry 1960, pp. 94–6; Manet 1987, p. 120.
152. Valéry 1960, p. 95.
153. Ibid., p. 94.
154. Ibid., p. 96.
155. The confident use of multicoloured fingerprints in
 the lower areas of the canvas coincides with Degas's
 known practice at this date.
156. Jeanniot 1933, p. 293–4; Kendall 1993, p. 181.

157. See Boggs 1988, pp. 551–4.
158. For the pigments used, see Philadelphia 1985, p. 32.
159. Rouart 1945, p. 85; Boggs 1988, p. 552.
160. This technique of painting fine, dark lines over
 earlier colour can also be seen in cats. 16, 31, 32,
 and in many other later canvases.
161. Delaborde 1870, p. 124.
162. Delacroix 1893.
163. Rouart 1946, p. 46.
164. BR.83, BR.143.
165. Marx 1897, p. 322.
166. Moreau-Nélaton 1931, p. 259.
167. Ibid., p. 257.
168. Delacroix 1979, p. 151.
169. Ibid., pp. 30, 137, 168.
170. Degas's Inventory.
171. Proust, II, p. 841.
172. Halévy 1960, p. 184; Fevre 1945, p. 41.
173. Duret 1984, p. 204.
174. For Degas's copy, see also Manet 1987,
 p. 126; Moore 1918, p. 65.
175. See chap. 5; 'The Role of Sculpture;
 The Figure and the Landscape'.
176. Degas noted Poussin's letters in Notebook 11,
 p. 105.
177. Blunt 1967, p. 256; Hours 1960, pp. 349–52.
178. Rouart 1945, p. 89.
179. Notebook 19, p. 8.
180. See Sickert 1917, p. 186; Richard Thomson, 'Notes
 on Degas's Sense of Humour', in Kendall 1985,
 p. 14; Kendall 1993, pp. 54–5.
181. Guérin 1947, pp. 134–9.
182. Ibid., p. 139.
183. Thomson 1981.
184. Blanc 1868. Following Blanc's introduction,
 the text is divided into studies of individual artists,
 their pages numbered separately.
185. Ibid., pp. 6–8.
186. Blanc 1868 (Titian), pp. 1, 3.
187. Merrifield 1849, p. ccc.
188. Blanc 1868, p. 6.
189. Conspicuous in such pictures as cats. 16, 39, 42,
 and in many other works in these pages.
190. Confirmed by David Bomford of the National
 Gallery's Conservation Department.
191. Sickert 1917, p. 185; Valéry 1960, p. 84.
192. L.785, L.951 (cat. 9)
193. Cats. 42, 57.
194. Paris 1989, p. 389. The letter was written on
 notepaper from Tasset et Lhôte, 31 rue Fontaine,
 close to Degas's studio and one of his principal
 suppliers of materials.
195. Vasari 1927, IV, p. 209.
196. Blanc 1868 (Titian), p. 3.

197. Kendall 1993, pp. 213–4.
198. Rouart 1945, p. 46.
199. Merrifield 1849, p. ccc.
200. Tietze 1950, pp. 52–3.
201. See n. 197.
202. Gasquet 1926, p. 166.
203. Bailly-Herzberg 1986, p. 77.
204. Boggs 1988, p. 568.
205. Both works are dominated by broad planes of
 earth red.
206. For the dating of these late canvases, see chap. 2.
207. My thanks to Mikael Wivel at Ordrupgaard for
 his kind co-operation with this project.
208. Shackelford 1984, pp. 93–7.
209. Boggs 1988, pp. 510–11.
210. William Robinson, Tom Hinton and Marcia Steele
 of the Cleveland Museum of Art were most helpful
 in arranging and assisting my study of this work.
211. The Durand-Ruel archives show that the picture
 was bought from the artist on 19.10.1904.
212. See, for example, L.500, L.512, L.544, L.783,
 L.853.
213. Boggs 1988, p. 475–6.
214. I am most grateful to Charlotte Hale of the
 Conservation Department at the Museum for
 supplying me with photographs and expert guidance.
215. Several of these adjustments can be seen with the
 naked eye.
216. See Lemoisne 1946–9, III, no. 1013.
217. See n. 42, chap. 2, above.
218. For the date of the picture and an associated
 drawing, see Philadelphia 1985, pp. 24–7.
 My thanks to Irene Konefal and Robert Boardingham
 of the Boston Museum of Fine Arts for their
 assistance in the study of this work.
219. Closely linked canvases, most of which appear to
 have been repainted, are L.839–43.
220. Douglas Druick and his colleagues at the
 Art Institute of Chicago kindly arranged for me
 to examine the painting.
221. See n. 219 and L.924.

5 AN ART OF RENUNCIATION

1. Riout 1989, p. 56.
2. Ibid., pp. 199, 270.
3. Zola 1970, p. 337; Riout 1989, p. 199.
4. Moore 1918, p. 65.
5. Moffett 1986, p. 323; Riout 1989, p. 270.
6. Riout 1989, pp. 270–71.
7. Ibid., pp. 270, 272.
8. Ibid., p. 273.
9. Moffet 1986, p. 361; Paris 1989, p. 339.
10. Riout 1989, p. 396.
11. For the dating and significance of the later nude monotypes, see Boggs 1988, p. 411–21; Kendall 1984.
12. Some were reworked with pastel in the 1880s; see Boggs 1988, pp. 437–40.
13. L.1318 is either a late reworking of an earlier composition, or a self-conscious *reprise*.
14. For *Portrait of Zacharian*, L.831, see Zurich 1994, p. 99.
15. Lemoisne 1946–9 and Brame and Reff 1984 have been used, but not the Ventes catalogues. If drawings, prints and sculpture were included, the pattern would be even more pronounced.
16. Shackelford 1984, p. 16.
17. See n. 15.
18. See Nepveu-Degas 1946; Terrasse 1983, nos. 26–34, 40–45.
19. See chap. 2, n. 99.
20. For Manzi, see Manson 1927 (frontispiece).
21. Browse 1949; Meuhlig 1979; Shackelford 1984.
22. In 1897 Degas claimed incorrectly that his dance images had preceded those of Manet; see Halévy 1960, p. 110.
23. L.491, L.340, L.400, L.498; see Boggs 1988, pp. 225–30, 274–6.
24. Morisot 1986, p. 181; Salon 1891.
25. Ibid., nos. 596, 2547.
26. Ibid., nos. 2614, 389, 347.
27. Ibid., no. 1023.
28. For Degas on Béraud, see Guérin 1947, p. 142.
29. Paris, 1983, no. 23.
30. Examples of several of these forms are found in Vuillier 1898 and de Soria 1897.
31. See Guérin 1947, pp. 76, 107, 109, 145; Vuillier 1898, pp. 358, 370; L.897; Boggs 1988, pp. 456–7.
32. See Jeanniot 1908, unpag.
33. Raunay 1931, p. 482.
34. For Forain, see Sickert 1917, p. 184.
35. Browse 1949, p. 59.
36. L.391, L.818.
37. For example, L.1261.
38. L.1459.
39. Riout 1989, p. 269.
40. Ibid., p. 350.
41. Geffroy 1894 pp. 148–9.

42. Ibid., p. 172.
43. Ibid., p. 173.
44. Geffroy 1894, p. 174.
45. Duret 1894, p. 206.
46. Ibid., p. 206.
47. Ibid., p. 205.
48. Degas's acquaintance with Geffroy, apparently in the 1880s, is recorded in Guérin 1947, pp. 85–6; his former friendship with Duret in Halévy 1960, p. 115.
49. Degas's painting and a group of related drawings (L.808–10) could only have been seen in his studio, where they remained until his death.
50. L.808.
51. See Henri Loyrette, 'Degas à l'Opéra', in Paris 1989, pp. 47–63.
52. Morisot 1986, p. 209; Baudot 1949, p. 103.
53. Guérin 1947, p. 185, seems to refer to Degas's bust of the dancer Mlle. Salle (R.XXX); the model Yvonne, a former dancer, is mentioned in Michel 1919, p. 476, and a 'young pupil of the dance' in Jeanniot 1933, p. 299.
54. Halévy 1960, p. 104.
55. See n. 53.
56. Sickert 1917, p. 185.
57. Vollard (Degas) 1937, p. 87; Moore 1918, p. 64.
58. Michel 1919, p. 627; Geffroy 1894, pp. 173–4.
59. Moffett 1986, p. 217.
60. Havemeyer 1961, p. 256.
61. Gimpel 1966, p. 164.
62. Rothenstein 1931, p. 104.
63. Hertz 1920, p. 37.
64. Valéry 1960, p. 135; Moreau-Nélaton 1931, p. 260.
65. See Notebooks 1–6.
66. See, for example, Notebook 8.
67. Millard 1976, p. 70.
68. Thomson 1988, pp. 147–50; L.1089.
69. See his reaction to Gérôme in n. 134
70. L.1303.
71. Vuillier 1898.
72. Ibid., pp. viii, 3.
73. Ibid., p. 22.
74. Ibid., pp. 6–7.
75. Ibid., pp. 18–9.
76. See Heuzey 1883, especially pls. 20, 30; Geffroy 1900; Higgins 1962.
77. Jeanniot 1933, p. 171; L.766 bis; Gordon 1984, pp. 7–8. An 1891 comparison between Degas's dancers and Tanagra figurines is in Flint 1984, p. 278.
78. Similar figures appear in Heuzey 1883, pl. 20.
79. Vuillier 1898, pp. 9, 18–9, 21.
80. De Soria 1897 p. 6.
81. Ibid., p. 70.
82. Ibid., p. 92; see also Thomson 1987, p. 39.

83. Vuillier 1898, p. 21.
84. See the review of Vuillier 1899 in *Magazine of Art*, 1899, pp. 170–72.
85. Vuillier 1898, p. 27.
86. Lightbown 1986, p. 443.
87. Carrière 1907, pp. 20–21.
88. Grunefeld 1989, p. 414.
89. Duncan 1928, pp. 30, 84.
90. See 'The Dance of the Greeks' and 'The Greek Theatre', in Duncan 1928.
91. Valéry 1964, p. 203.
92. Ackerman 1986, no. 411; the sculpture in question is S.21.
93. Michel 1919, p. 625.
94. Jeanniot 1933 pp. 158–9.
95. Moore 1918 p. 28.
96. Valéry 1964, p. 203.
97. Vuillier 1898, p. 24; de Soria 1897, pp. 83, 92.
98. Vuillier 1898, p. 207.
99. See Lampert 1986, no. 61: Washington 1988, pp. 94–6.
100. L.645, L.1303.
101. Vuillier 1898, pp. 199–210; de Soria 1897, pp. 253–5; and see below, 'The Figure and the Landscape'.
102. Both are now in the British Museum.
103. BR.157 and cats. 74–9.
104. For example, L.1202, L.1411; cats.35, 36.
105. Guérin 1947, p. 175; RS.59.
106. Vuillier 1898, p. 11; de Soria, p. 70.
107. RS.42, J.81.
108. Moffett 1986, p. 444.
109. Ibid., p. 453.
110. Flint 1984, pp. 278, 293.
111. Huysmans 1970, p. 262; Riout 1989, p. 350; Moore 1941, p. 39.
112. Moffett 1986, p. 454.
113. See Kendall 1994.
114. See Lemoisne 1946–9, vol. 3, no. 883; Loyrette 1991, p. 478.
115. L.738; White 1984, pp. 208–9.
116. L.717; Boggs 1988, pp. 421–2.
117. See New York 1993, pp. 335–8.
118. See Boggs 1988, pp. 526–7; L.849; Boggs 1988, pp. 465–8.
119. This total would be at least doubled if other media were included.
120. Notebook 1, p. 1.
121. Thomson 1988.
122. Chipp 1968, p. 293.
123. See Vente Collection I, 1918; Degas Inventory; Dumas 1996.
124. The Gauguin copy is noted in Moreau-Nélaton 1931, p. 259.

125. New York 1993, p. 92 and n. 30.

126. See n. 115.

127. Paris 1983, p. 86.

128. Grappe 1909, p. 18.

129. Michel 1919, p. 627.

130. Given the awkward poses his models were sometimes required to hold, these lines and blurrings may also record shifts of position.

131. Michel 1919, p. 627; Valéry 1960, p. 49; Mauclair 1903, p. 390.

132. L.1285–92. L.787 was bought before 1898 by Alexander Reid of Glasgow; information from Durand-Ruel archives.

133. L.1288 has a small picture on the wall, L.1292 a companion or maid.

134. See L.1422–7.

135. Notebook 2, p. 59.

136. See Thomson 1987, pp. 124–7.

137. See chap. 4; Thomson 1981; Millard 1976; Thomson 1987; Thomson 1988.

138. Morisot 1986, p. 152.

139. Fénéon 1888 and Fénéon 1970, p. 96.

140. Belinda Thomson 1993, p. 95.

141. Duret 1894, p. 206.

142. Ibid.

143. Geffroy 1894, pp. 167–9.

144. Bailly-Herzberg 1989, p. 191.

145. Mellerio 1896, p. 67.

146. Ibid., p. 70.

147. Marx 1897, p. 325.

148. Mauclair 1903, p. 390.

149. Ibid., pp. 391–4.

150. Marx 1897 p. 322.

151. L.848; Mauclair 1903 p. 397.

152. Ibid., p. 394.

153. Geffroy 1894, p. 163; Duret 1894, p. 204; Mauclair 1903, p. 394. For Delacroix, see chap. 4.

154. Alexandre 1901, p. 1.

155. Baudot 1949, p. 104.

156. Vollard (Degas) 1937, p. 48.

157. Jeanniot 1933, p. 172.

158. Geffroy 1894, pp. 162, 167.

159. Ibid., p. 169.

160. Salon 1887, nos. 82, 142, 245, 291.

161. For example, Salon 1887, no. 117.

162. For example, Salon 1887, nos. 232, 276.

163. Salon 1890.

164. Denis 1993, p. 16.

165. Saunders 1989, p. 25; Lesser 1991, p. 79.

166. From Jeanniot 1908, unpag.

167. Huysmans 1896, pp. 393–5.

168. L.717.

169. Duret 1894, p. 206.

170. Jeanniot 1933, p. 170.

171. Geffroy 1894, pp. 163, 168; Mauclair 1903, p. 392; Grappe 1909, p. 42.

172. Mauclair 1903, p. 393; Grappe 1909, p. 41.

173. Nead 1992, pp. 7, 18.

174. Jeanniot 1933, p. 172.

175. Mathews 1984, p. 328.

176. Mathews and Shapiro 1989, no. 14.

177. The links between *After the bath* and Degas's *After the bath, woman drying herself* (cat. 57), a work that remained in his studio, are compelling.

178. See Warnod 1981.

179. Higgonet 1992.

180. Ibid., p. 186.

181. Denis 1993, p. 101; Blanche 1919, p. 289; Huneker 1910, p. 77.

182. Grappe 1909, p. 49.

183. L.1077.

184. Michel 1919, p. 627.

185. Moore 1918, p. 64.

186. Sickert 1917, p. 185.

187. Michel 1919, pp. 467–70, 476.

188. Moore 1918, p. 64.

189. Lesser 1991, pp. 66, 74.

190. Berger 1972, p. 54.

1. Vollard 1936, p. 71.

2. See chap. 2.

3. Vollard 1936, p. 70.

4. Ibid., chap. 9.

5. Rouault 1971, p. 35.

6. See Ventes I–IV, 1918–9.

7. Mathews 1984, p. 321.

8. Cork 1987, p. 265.

9. Fevre 1949, p. 67.

10. For example, L.422–3, L.706, L.721, RS 42. An exception is L.1207.

11. Paris 1989, pp. 385–7; Valéry 1960, p. 73; Vollard (Degas) 1937, pp. 35,52; Jeanniot 1933, p. 294.

12. Fevre 1949, p. 144.

13. Jeanniot 1917.

14. Much of his graphic work is preserved in the Bibliothèque d'Art et d'Archéologie, Paris.

15. See Kendall 1993, chap.6; Jeanniot 1933.

16. Paris 1983, no.103.

17. The caption reads 'Chez nous, Maître, pas de grèves . . . , 'Non, mais c'est pis: vous pratiquez le sabotage'.

18. Halévy 1960, pp. 94, 109.

19. Ibid., p. 57.

20. See Halévy 1960, pp. 32, 56, 59, 67, 98.

21. See Blanche 1919, p. 308. The portrait, now destroyed, was reproduced in *Studio* in December 1903.

22. Halévy 1960, pp. 68–9.

23. Vollard (Degas) 1937, p. 36.

24. Paris 1990 (catalogue), I, p. 92 (RF.3094): for his landscapes, see I, pp. 93–105; Bantens 1990; Kendall 1993, p. 234.

25. Jeanniot 1933, p. 158; Halévy 1960, p. 135.

26. Jeanniot 1933, p. 173; Moore 1918, p. 63.

27. Rothenstein 1932, p. 66.

28. Schimmel 1991, p. 152 n. 3.

29. Ibid., pp. 152, 226.

30. Note, however, the currency of similar motifs at this time; see the introduction to 'Combing the hair'.

31. Rothenstein 1931 p. 106.

32. Wittrock 1985, p. 164; Blanche 1919, p. 285; Vollard 1925, p. 57.

33. L.1309; Grappe 1909, p. 54.

34. See Lehni and Martin 1993.

35. Lehni and Martin 1993, no. 39.

36. Carabin showed at Durand-Ruel in 1892, at the *Salon de la Rose+Croix*, and in 1894 at the *Exposition de peintres-graveurs*.

37. Denis 1993, pp. 99, 101.

38. See, for example, Lyon 1994, nos.,201–2, 214.

39. Jeanniot 1933, p. 281.

40. Denis 1993, pp. 27, 53, 68.

41. Ibid., p. 27.

42. Bailly-Herzberg 1989, p. 159; Sickert 1917, p. 186.

43. Vollard 1936, p. 43.

THE CATALOGUE

44. Degas is the figure at the extreme right.
45. Belinda Thomson 1988, pp. 40, 60; L.545 is visible in Belinda Thomson 1991, p. 28; the portrait is *Madame André Wormser and her children*, in the National Gallery, London.
46. BR,129; the drawing is in the Museum Boymans–van Beuningen, Rotterdam.
47. Vollard 1936, p. 90.
48. Valéry 1960, p. 12.
49. Lemoisne 1912, pp. 5, 16.
50. Pickvance 1963b.
51. Flint 1984, p. 283.
52. Ibid., pp. 288–96.
53. Ibid., p. 287.
54. Ibid., p. 283.
55. Ibid., p. 275.
56. Sickert 1917 and Sickert 1947.
57. Rothenstein 1931 and 1932; the image in question is cat. 42 (Vente I, no. 44).
58. *Frieze of dancers* was bought by Cassirer in 1904, then sold to the painter Max Liebermann.
59. Cork 1987, p. 15.
60. Rothenstein 1952, p. 54.
61. Ibid., p. 123.
62. For *The Bath*, see Hiesinger 1991, p. 112.
63. See Weinberg 1994.
64. Rewald 1989, p. 97.
65. Rutter 1933, p. 101.
66. L.1294. For the titles of works by Degas in this exhibition, see Flint 1984, pp. 369–70.
67. Bullen 1988, p. 231.
68. The other listed pictures were 'Chevaux de course' (probably L.767) and 'Femme sur lit' (unidentified).
69. Liebermann 1918.
70. Rewald 1989, p. 95.
71. Hergott and Whitfield 1993, p. 66.
72. Rouault 1971, p. 39; Crespelle 1978, p. 92 tells this story of a press now in the Musée du Vieux-Montmartre.
73. Low-Beer 1983, p. 75; Rouault 1971, p. 39.
74. Degas's alleged response to a Matisse still life ('une nature ivre morte') is in Loyrette 1991, p. 638.
75. Baudot 1949, p. 30.
76. Boggs 1988, p. 544.
77. Mathews 1984, p. 310.
78. See Moreau-Nélaton 1931, p. 259.
79. Guérin 1947, p. 206.
80. Warnod 1981, p. 65.
81. See Warnod 1981, p. 85; the Picasso 1901 portrait of Coquiot is in the Musée Picasso, Paris; Coquiot 1924.
82. See Crespelle 1978, pp. 32–3.
83. See Kendall 1991, p. 98.
84. For example, L.329, L.685–7, L.785–6.
85. Crespelle 1978, p. 40.
86. See Cabanne 1973.
87. Gimpel 1966, p. 416.

1. Guérin 1947, pp. 80–81.
2. Ibid., p. 100.
3. See chaps.3 and 4.
4. See Brettell and McCullagh 1984, no. 63; Boggs 1988, pp. 400–2.
5. L.756, L.1318.
6. Valéry 1960, p. 99.
7. See L.1176–8, L.1437–44, L.1450–2.
8. See chap.4.
9. Moffett 1986, p. 42; Riout 1989, pp. 271, 234.
10. See Shackelford 1984, pp. 94–7.
11. See Reff 1963; Reff 1964; Reff 1976a; Reed and Shapiro 1984.
12. Zola 1970, p. 337.
13. Guérin 1947, p. 117; Valéry 1960, p. 6.
14. Baudelaire 1955, p. 238.
15. See Thomson 1985, chaps.2 and 3.
16. Valéry 1960, p. 82.
17. See L.1304, L.1431–5.
18. Moreau-Nélaton 1931, p. 258.
19. Valéry 1960, p. 39.
20. See L.1371–9 and associated drawings listed by Lemoisne.
21. L.1294, L.1307, L.1368, L.1395–6.
22. Michel 1919, p. 631.
23. Mirbeau 1993, vol.2, p. 381.
24. Valéry 1960, p. 39; Armstrong 1991, p. 224.
25. Moffett 1986, p. 444; Kendall 1993, p. 146.
26. Bailly-Herzberg 1989, p. 191.
27. See chap.3.
28. L.1146.
29. L.376.
30. Boggs 1988, pp. 554–6.
31. See Notebook 28; Goncourt 1877, p. 137
32. For example, L.1003, L.1129, L.1146, L.1228.
33. See J.185; Boggs 1988, no.196.
34. Notebook 22 p. 4; Boggs 1988 p. 255.
35. See chap. 6.
36. The model's advancing pregnancy is suggested by her narrower waistline in early studies, even in the preliminary drafts on the canvas itself. Degas made a sculpture of a pregnant woman about this time (R.LXIII) and is said to have given employment to a model who Renoir dismissed when she became pregnant (Baudot 1949, p. 67).
37. See, for example, Francesco Albani's *Venus attended by nymphs*, a work Degas must have seen in the Prado, Madrid.
38. Manet 1987, p. 108; Sickert 1917, p. 191; Moore 1918, p. 64.
39. Grappe 1909, p. 4; Duret 1894, p. 206.
40. Kendall 1987, p. 318.
41. Jeanniot 1933, p. 172.
42. Halévy 1960, p. 159.

43. See chap.2.
44. Notably at the National Gallery of Art, Washington.
45. See *Apollo*, August 1995, especially pp. 49–63.
46. Kendall 1987, p. 244.
47. Ibid., p. 246.
48. Blanc 1897, p. 528–9; Notebook 11, p. 105.
49. For Cuvelier, see Morisot 1986, p. 56; several of Moreau's waxes are preserved in the Musée Gustave Moreau, Paris.
50. Rewald 1944; Camesasca 1986.
51. Boggs 1988.
52. L.1131, L.1131 bis and associated drawings.
53. See Boggs 1988, p. 558.
54. Fevre 1949, p. 123; Rouart 1945, p. 128.
55. Valéry 1960, p. 88.
56. Vollard (Degas) 1937, p. 56.
57. Mathews 1984, p. 331.
58. See Kendall 1988.
59. Guérin 1947 p. 84.
60. Ibid., p. 84.
61. Kendall 1993, p. 180.
62. Ibid., chap.7.
63. Jeanniot 1933, p. 291.
64. See Kendall 1993, pp. 214–23.
65. Kendall 1993, p. 213.
66. See Boggs 1988, pp. 566–8; Kendall 1993, ch.9.
67. See Kendall 1993, pp. 263–5.
68. Ibid., pp. 267–8.
69. Morisot 1986, p. 37.
70. For his use of a sketch by Braquaval, see Paris 1989, pp. 392–3.
71. Poussin's figure, in its turn, was based on Raphael's *Baptism*.
72. See Boggs 1988, pp. 581–6.
73. Blanche 1919, p. 264.

BIBLIOGRAPHY

Abbreviations for the standard catalogues of Degas's works used in the text are as follows:

L: Lemoisne 1946–9
BR: Brame and Reff 1984
J: Janis 1968
RS: Reed and Shapiro 1984
Notebook numbers are those used in Reff 1976a
Vente numbers are from Ventes I–IV, 1918–19

Gerald Ackermann, *La vie et l'oeuvre de Jean-Léon Gérôme*, Paris 1986

Jean Adhémar and Françoise Cachin, *Degas: The Complete Etchings, Lithographs and Monotypes*, London 1974

Kathleen Adler and Tamar Garb, *Berthe Morisot*, Oxford 1987

Gotz Adriani, *Degas: Pastels, Oil Sketches, Drawings*, London 1985

Arsène Alexandre, 'Chroniques d'aujourd'hui', *Paris*, 9 November 1892

Arsène Alexandre, 'Le marché aux toiles: comment on devient amateur', *Le Figaro*, 12 October 1901, p. 1

Apollo, Degas Sculpture Issue, August 1995

Carol Armstrong, *Odd Man Out: Readings of the Life and Work of Edgar Degas*, Chicago and London, 1991

Janine Bailly-Herzberg, ed., *Correspondance de Camille Pissarro. I: 1865–1885*, Paris 1980

Janine Bailly-Herzberg, ed., *Correspondance de Camille Pissarro. II: 1886–1890*, Paris 1986

Janine Bailly-Herzberg, ed., *Correspondance de Camille Pissarro. III: 1891–1894*, Paris 1988

Janine Bailly-Herzberg, ed., *Correspondance de Camille Pissarro. IV: 1895–1898*, Paris 1989

Janine Bailly-Herzberg, ed., *Correspondance de Camille Pissarro. V: 1898–1903*, Paris 1991

Robert Bantens, *Eugène Carrière: The Symbol of Creation*, New York 1990

M.-L. Bataille and G. Wildenstein, *Berthe Morisot*, Paris 1961

Charles Baudelaire, *The Mirror of Art*, Oxford 1955

Jeanne Baudot, *Renoir: ses amis, ses modèles*, Paris 1949

John Berger, *Ways of Seeing*, London 1972

'Bing', *Fantasio*, Paris 1911

Paul Bittler and Pierre-Louis Mathieu, *Catalogue des dessins de Gustave Moreau*, Paris 1983

Charles Blanc, *Histoire des peintres de toutes les écoles: école vénétienne*, Paris 1868

Charles Blanc, *Grammaire des arts du dessin*, Paris 1897

Jacques-Emile Blanche, *Propos de peintre: de David à Degas*, Paris 1919

Jacques-Emile Blanche, 'Bartholomé et Degas', *L'Art Vivant*, 15 February 1930, pp. 154–6

Anthony Blunt, *Nicolas Poussin*, 2 vols., New York and London 1967

Jean Sutherland Boggs, *Portraits by Degas*, Berkeley and Los Angeles 1962

Jean Sutherland Boggs, 'Edgar Degas in Old Age', *Oberlin College Bulletin*, 35, 1977–8, pp. 57–67

Jean Sutherland Boggs, 'Degas at the Museum: Works in the Philadelphia Museum of Art and John G. Johnson Collection', *Bulletin of the Philadelphia Museum of Art*, vol. 81, no. 346, Spring 1985

Jean Sutherland Boggs, Douglas Druick, Henri Loyrette, Michael Pantazzi and Gary Tinterow, *Degas*, Paris, Ottawa and New York 1988–9

Jean Sutherland Boggs and Anne Maheux, *Degas Pastels*, London 1992

Albert Boime, *The Academy and French Painting in the Nineteenth Century*, New Haven and London 1971

David Bomford, Jo Kirby, John Leighton and Ashok Roy, *Art in the Making: Impressionism*, London 1990

Jean-Paul Bouillon, *La promenade du critique influent*, Paris 1990

Philippe Brame and Theodore Reff, *Degas et son oeuvre: A Supplement*, New York 1984

Richard Brettell and Suzanne F. McCullagh, *Degas in the Art Institute of Chicago*, Chicago 1984

Richard Brettell and Joachim Pissarro, *The Impressionist in the City: Pissarro's Series Paintings*, London 1992

Lillian Browse, *Degas Dancers*, London 1949

Janet Buerger, 'Degas' Solarised and Negative Photographs. A Look at Unorthodox Classicism', *Image*, XXI, 2 June 1978, pp. 17–23

J.D. Bullen, *Post-Impressionists in England*, London and New York 1988

Devin Burnell, 'Degas and his "Young Spartans Exercising"', *Art Institute of Chicago Museum Studies*, 4, 1969, pp. 49–65

Pierre Cabanne, 'Degas chez Picasso', *Connaissance des Arts*, 262, December 1973, pp. 146–51

Isabelle Cahn, 'Degas's Frames', *Burlington Magazine*, April 1989, pp. 289–92

Anthea Callen, *Techniques of the Impressionists*, London 1982

Cambridge, Mass., Fogg Art Museum, *Ingres Centennial Exhibition, 1867–1967*, 1967

Ettore Camesasca, *Degas scultore*, Florence 1986

Eugène Carrière, *Ecrits et lettres choisies*, Paris 1907

Phillip Dennis Cate and Marianne Grivel, *From Pissarro to Picasso: Colour Etching in France*, Paris 1992

Cennino Cennini, *The Craftsman's Handbook*, New Haven and London 1933

Jules Chialiva, 'Comment Degas a changé sa technique du dessin', *Bulletin de la société de l'histoire de l'art français*, XXIV, 1932, pp. 44–5

Herschel Chipp, *Theories of Modern Art*, Berkeley and Los Angeles 1968

Michael Clarke, 'Degas and Corot', *Apollo*, July 1991, pp. 15–20

Douglas Cooper, *Pastels by Edgar Degas*, London 1952

Gustave Coquiot, *Degas*, Paris 1924

Richard Cork, *Bomberg*, London 1987

Jean-Paul Crespelle, *La Vie quotidienne à Montmartre au temps de Picasso, 1900–1910*, Paris 1978

Léon Daudet, *Souvenirs et polémiques*, Paris 1992

Degas's Inventory, Manuscript inventory of Degas's collection of paintings, private collection, Paris

Henri Delaborde, *Ingres: sa vie, ses travaux, sa doctrine*, Paris 1870

Eugène Delacroix, *The Journal of Eugène Delacroix*, Paris 1893; Eng. trans. London 1979

Loys Delteil, *Degas: le peintre-graveur illustré*, IX, Paris 1919

Maurice Denis, *Journal*, Paris 1957

Maurice Denis (ed. Jean-Paul Bouillon), *Le Ciel et l'Arcadie*, Paris 1993

Anne Distel, *Impressionism: The First Collectors*, New York 1990

Ann Dumas, 'Mlle. Fiocre' in Context: A Study of 'Portrait de Mlle. E.F...'; à propos du ballet "La Source"', Brooklyn 1988

Ann Dumas, *Degas as a Collector*, London 1996

Isadora Duncan, *The Art of the Dance*, New York 1928

Théodore Duret, 'Degas', *The Art Journal*, 1894, pp. 204–8

Robert Emmons, *The Life and Opinions of Walter Richard Sickert*, London 1941

Charles Ephrussi, 'Exposition des artistes indépendants', *Gazette des Beaux-Arts*, 1 May 1880, pp. 485–8

L'Ermitage [anon.], 'Galerie Durand-Ruel: paysages de M. Degas: oeuvres de Lépine', *L'Ermitage*, V, no. 12. December 1892, pp. 415–5

Félix Fénéon, *Petit Botin des lettres et des arts*, Paris 1886

Félix Fénéon, 'Calendrier de janvier', *La Revue Indépendante*, February 1888, pp. 95–6

Félix Fénéon, *Oeuvres plus que complètes*, 2 vols., Geneva and Paris 1970

Jeanne Fevre, *Mon Oncle Degas*, Geneva 1949

Armond Fields, *Henri Rivière*, Salt Lake City 1983

Shelley Fletcher and Pia Desantis, 'Degas: The Search for his Technique Continues', *Burlington Magazine*, April 1989, pp. 256–65

Kate Flint, ed., *Impressionists in England: The Critical Reception*, London 1984

François Fosca, 'Degas, sculpteur', *L'Art et les Artistes*, III, 1921, pp. 373–4

Jacques Foucart et al, *Hippolyte, Auguste et Paul Flandrin*, Paris 1984

Francis Fowle, 'Impressionism in Scotland: An Acquired Taste', *Apollo*, December 1992, pp. 374–9

Joachim Gasquet, *Cézanne*, Paris 1926

Gustave Geffroy, *La vie artistique*, 3rd ser., Paris 1894

Gustave Geffroy, *La sculpture au Louvre*, Paris 1900

Waldemar George, 'Oeuvres de vieillesse de Degas', *La Renaissance*, 19, January–February 1936, pp. 2–4

André Gide, *The Journals of André Gide*, I, London 1947

André Gide–Paul Valéry, *André Gide–Paul Valéry: correspondance (1890–1942)*, Paris 1955

René Gimpel, *Diary of an Art Dealer*, New York 1966

Arnold and Marc Glimcher, *Je suis le cahier: The Sketchbooks of Picasso*, London 1986

Edmond de Goncourt, *La Fille Elisa*, Paris 1877

Dillian Gordon, *Hélène Rouart in her Father's Study*, London 1984

Robert Gordon and Andrew Forge, *Degas*, London 1988

Georges Grappe, *E.M. Degas*, London and Leipzig 1909

Frederic Grunefeld, *Rodin: A Biography*, Oxford 1989

Marcel Guérin, ed., *Lettres de Degas*, Paris 1945

Marcel Guérin, ed., *Degas Letters*, trans. Marguerite Kay, Oxford 1947

Maurice Guillaud, ed., *Degas: Form and Space*, Paris 1984

Philip Hale, 'Art in Paris', *Arcadia*, I, no. 16, 15 December 1892, p. 326

Daniel Halévy, *Pays Parisiens*, Paris 1929

Daniel Halévy, *Degas parle*, Paris 1960; Eng. trans., *My Friend Degas*, Middletown 1964

Louisine Havemeyer, *Sixteen to Sixty: Memoirs of a Collector*, New York 1961

E. Haverkamp-Begemann, S.D. Lawder and C.W. Talbot, *Drawings from the Clark Art Institute*, 2 vols., New Haven 1964

Ulrich Hiesinger, *Impressionism in America*, Munich 1991

Fabrice Hergott and Sarah Whitfield, *George Rouault: The Early Years 1903–1920*, London 1993

Henri Hertz, *Degas*, Paris 1920

Léon Heuzey, *Les figurines antiques de terre cuite du Musée du Louvre*, Paris 1883

A.H. Higgins, 'The Discovery of Tanagra Statuettes', *Apollo*, October 1962, pp. 587–93

Anne Higgonet, *Berthe Morisot's Images of Women*, Cambridge and London 1992

Madeleine Hours, 'Documents de laboratoire', *Exposition Nicolas Poussin*, Paris 1960, pp. 329–54

John House, *Monet: Nature into Art*, New Haven and London 1986

John House, *Impressionism for England: Samuel Courtauld as Patron and Collector*, London 1994

James Huneker, *Promenades of an Impressionist*, New York 1910

Joris-Karl Huysmans, 'Félicien Rops', *La Plume*, 15 June 1896

Joris-Karl Huysmans, *L'art moderne/certains*, Paris 1975

Colta Ives, *The Great Wave: The Influence of Japanese Woodcuts on French Prints*, New York 1974

Paul Jamot, *Degas*, Paris 1924

Eugenia P. Janis, 'The Role of the Monotype in the Working Method of Degas', *Burlington Magazine*, CIX, no. 766, January 1967, pp. 20–27; CIX no. 767, February 1967, pp. 71–81

Eugenia P. Janis, *Degas Monotypes: Essay, Catalogue and Checklist*, Cambridge, Mass., 1968

Georges Jeanniot, *Les maîtres humoristes: Georges Jeanniot*, Paris 1908

Georges Jeanniot, *Crimes allemands*, Paris 1917

Georges Jeanniot, 'Souvenirs sur Degas', *Revue Universelle*, LV, no. 14, 15 October 1933, pp. 152–74; LV, no. 14, 1 November 1933

V. and T. Jirat-Wasintynski, 'The Uses of Charcoal in Drawing', *Arts Magazine*, October 1980, pp. 129–31

Lee Johnson, *The Paintings of Eugène Delacroix*, 6 vols., Oxford 1981–9

Maurice Joyant, *Henri de Toulouse-Lautrec: 1864–1901*, 2 vols., 1926–7

Richard Kendall, *Degas by Himself*, London 1987

Richard Kendall, 'Degas and the Contingency of Vision', *Burlington Magazine*, CXXX, no. 1020, March 1988, pp. 180–97

Richard Kendall, *Degas: Images of Women*, Liverpool 1989

Richard Kendall, *Van Gogh to Picasso: The Berggruen Collection at the National Gallery*, London 1991

Richard Kendall, *Degas Landscapes*, New Haven and London 1993

Richard Kendall, 'The Impromptu Print', *Degas Intime*, Copenhagen 1994, unpag.

Richard Kendall, ed., *Degas, 1834–1984*, Manchester 1985

Richard Kendall, ed., *Cézanne and Poussin: A Symposium*, Sheffield 1993

Richard Kendall and Griselda Pollock, eds., *Dealing with Degas*, London 1992

R.B. Kitaj, 'An uneasy participant in the tragicomedy of modern art, mad about drawing', *Burlington Magazine*, March 1988, p. 179

Mary Louise Krumrine, *Paul Cézanne: The Bathers*, London 1990

Paul Lafond, *Degas*, 2 vols., Paris 1918–19

Catherine Lampert, *Rodin: Sculpture and Drawings*, London 1986

Phillipe Lanthony, 'La malvision d'Edgar Degas: Pathographies 110', *Médécine et Hygiène*, 48, 1990, pp. 2382–2401

Bruce Laughton, *Philip Wilson Steer*, Oxford 1971

Bruce Laughton, *The Drawings of Daumier and Millet*, New Haven and London, 1991

Howard G. Lay, 'Degas at Durand-Ruel, 1892: the landscape monotypes', *The Print Collector's Newsletter*, IX, 5, November–December 1978, pp. 142–7

Frederic Lefèvre, ed., *Entretiens avec Paul Valéry*, Paris 1926

Nadine Lehni and Etienne Martin, *F.R. Carabin, 1862–1932*, Strasbourg 1993

Paul-André Lemoisne, *Degas*, Paris 1912

Paul-André Lemoisne, 'Les statuettes de Degas', *Art et Decoration*, September–October 1919, pp. 109–17

Paul-André Lemoisne, *Degas et son oeuvre*, 4 vols., Paris 1946–9

Henry Lerolle, *Henry Lerolle et ses amis*, Paris 1932

Wendy Lesser, *His Other Half: Men looking at Women through Art*, Cambridge and London 1991

Max Liebermann, *Degas*, Berlin 1902

Ronald Lightbown, *Mantegna*, Oxford 1986

Eunice Lipton, *Looking Into Degas: Uneasy Images of Women and Modern Life*, Berkeley 1987

Giovanni Lista, *Medardo Rosso: La sculpture impressioniste*, Paris 1994

Christopher Lloyd and Richard Thomson, *Impressionist Drawings*, Oxford 1986

Alice Low-Beer, *Georges Rouault–André Suarès: Correspondence, 1911–1939*, Ilfracombe 1983

Henri Loyrette, *Degas*, Paris 1991

Lyon, Musée des Beaux-Arts, *Maurice Denis, 1870–1943*, 1994

Anne Maheux and Peter Zeghers, 'Degas Pastel Research Project: A Progress Report', *American Institute for Conservation of Historic and Artistic Works: Preprints*, May 1986, pp. 66–76

Anne Maheux, *Degas Pastels*, Ottawa 1988

K. Maison, 'Daumier Studies', *Burlington Magazine*, May 1956, pp. 162–6

Julie Manet, *Journal (1893–9)*, Paris 1979

Julie Manet, *Growing up with the Impressionists: The Diary of Julie Manet*, London 1987

J.B. Manson, *The Life and Work of Edgar Degas*, London 1927

Michel Manzi, *Degas: Vingt Dessins 1861–1896*, Paris 1897

Roger Marx, 'Cartons d'artistes: Degas', *L'Image*, October 1897, pp. 320–5

Nancy Mowll Mathews, ed., *Cassatt and her Circle: Selected Letters*, New York 1984

Nancy Mowll Mathews and Barbara Stern Shapiro, *Mary Cassatt: The Color Prints*, New York 1989

Roy McMullen, *Degas: His Life, Times and Work*, London 1985

Camille Mauclair, 'Artistes contemporains: Degas', *La Revue de l'Art Ancien et Moderne*, 10 November 1903, pp. 381–98

André Mellerio, 'Degas', *La Revue Artistique*, April 1896, pp. 67–70

Mary Merrifield, *Original Treatises on the Arts of Painting*, 2 vols., London 1849

Alice Michel, 'Degas et son modèle', *Mercure de France*, 16 February 1919, pp. 457–78, 623–39

Charles Millard, *The Sculpture of Edgar Degas*, Princeton 1976

John Milner, *The Studios of Paris*, New Haven and London 1988.

Octave Mirbeau, *Combats esthétiques*, 2 vols., Paris 1993

Charles Moffett et al., *The New Painting: Impressionism 1874–1886*, Geneva 1986

Sophie Monneret, *L'Impressionisme et son époque*, 2 vols., Paris 1987

Geneviève Monnier, *Pastels from the 16th to the 20th Century*, Geneva 1984

Geneviève Monnier, *Musée du Louvre; Musée d'Orsay. Cabinet des dessins; pastels du XIXe siècle*, Paris 1985

George Moore, 'The Painter of Modern Life', *Magazine of Art*, XII, 1890, pp. 416–25

George Moore, *Modern Painting*, London 1893

George Moore, 'Memories of Degas', *Burlington Magazine*, January 1918, pp. 22–9; February 1918, pp. 63–5

George Moore, *Confessions of a Young Man*, London 1941

Etienne Moreau-Nélaton, 'Deux heures avec Degas', *L'Amour de l'Art*, XII, July 1931, pp. 267–70; reprinted in Lemoisne 1946–9, I, pp. 257–61

Berthe Morisot, *The Correspondance of Berthe Morisot*, ed. Denis Rouart, London 1986

Linda Muehlig, *Degas and the Dance*, Northampton 1979

Lynda Nead, *The Female Nude: Art, Obscenity and Sexuality*, London and New York 1992

Jean Nepveu-Degas, *Huit sonnets d'Edgar Degas*, Paris 1946

Beaumont Newhall, 'Degas, Amateur Photographer: Eight Unpublished Letters by the Famous Painter Written on a Photographic Vacation', *Image*, V, 6, June 1956, pp. 124–6

New York, Metropolitan Museum of Art, *The Painterly Print: Monotypes from the Seventeenth to the Twentieth Centuries*, 1980

New York, Metropolitan Museum of Art, *Splendid Legacy: The Havemeyer Collection*, 1993

Linda Nochlin, 'Degas and the Dreyfus Affair: A Portrait of the Artist as an Anti-Semite', in *The Dreyfus Affair: Art, Truth and Justice*, ed. N. Kleeblatt, New York 1988

Heather Norville-Day et al, 'Degas Pastels: Problems with Transport and Examination and Analysis of Materials', *The Conservator*, no. 17, 1993, pp. 46–55

Fernande Olivier, *Souvenirs intimes*, Paris 1988

Paris, Galeries Georges Petit, *Exposition Degas; au profit de la ligue franco-americaine contre le cancer*, 1924

Paris, Musée d'Orsay, *Degas inédit*, Paris 1989

Paris, Musée d'Orsay, *De Manet à Matisse: sept ans d'enrichissements au Musée d'Orsay*, 1990

Paris, Musée d'Orsay, *Catalogue sommaire illustré des peintures*, 2 vols., 1990

Paris, Musée du Petit-Palais, *Catalogue sommaire illustré des peintures*, 2 vols., 1981

Paris, Musée du Petit-Palais, *Catalogue sommaire illustré des pastels*, 1983

Paris, Orangerie des Tuileries, *Degas: oeuvres du Musée du Louvre*, 1969

Philadelphia, Museum of Art, 'Degas', *Bulletin of the Philadelphia Museum of Art*, vol. 81, no. 346, Spring 1985

Ronald Pickvance, 'Degas's Dancers: 1872–6', *Burlington Magazine*, June 1963, pp. 256–66 [a]

Ronald Pickvance, 'L'Absinthe in England', *Apollo*, May 1963, pp. 395–8 [b]

Anne Pingeot, *Degas Sculptures*, Paris 1991

Anne Pingeot, 'Rodin et Degas, sculpteur, face à la critique d'art', *Conferences du Musée d'Orsay*, 5, 1993, pp. 96–109

Marcel Proust, *Remembrance of Things Past*, 3 vols., trans. C.K. Scott Moncrieff and Terence Kilmartin, London 1981

Jeanne Raunay, 'Degas, souvenirs anecdotiques', *La Revue de France*, 15 March 1931, pp. 262–82; 1 April 1931, pp. 469–83; 15 April 1931, pp. 619–32

Sue Welsh Reed and Barbara Shapiro, *Edgar Degas: The Painter as Printmaker*, Boston, 1984

Theodore Reff, 'Degas's Copies of Older Art', *Burlington Magazine*, CV, 723, June 1963, pp. 241–51

Theodore Reff, 'New Light on Degas's Copies', *Burlington Magazine*, CVI, 735, June 1964, pp. 250–59

Theodore Reff, 'Some Unpublished Letters of Degas', *Art Bulletin*, L, no.1, March 1968, pp. 87–93

Theodore Reff, 'More Unpublished Letters of Degas', *Art Bulletin*, LI, no. 3, September 1969, pp. 281–9

Theodore Reff, 'Works by Degas in the Detroit Institute of Arts', *Bulletin of the Detroit Institute of Arts*, vol. 53, no. 1, 1974

Theodore Reff, *The Notebooks of Edgar Degas*, 2 vols., Oxford 1976 [a]

Theodore Reff, *Degas: The Artist's Mind*, New York 1976 [b]

Jean Renoir, *Renoir, My Father*, London 1962

John Rewald, *Paul Cézanne: Letters*, London 1941

John Rewald, *Degas, Works in Sculpture: A Complete Catalogue*, New York 1944

John Rewald, *The History of Impressionism*, New York 1946

John Rewald, *Studies in Impressionism*, London 1985

John Rewald, *Cézanne and America*, New York 1989

John Rewald, ed., *Camille Pissarro: Letters to his Son Lucien*, New York 1943

Denis Riout, ed., *Les écrivains devant l'impressionisme*, Paris 1989

Georges Rivière, *Monsieur Degas, bourgeois de Paris*, Paris 1935

William Robinson, 'Edgar Degas: Ballet Girls', *Creativity in Art and Science, 1860–1960*, Cleveland 1987, p. 100

Piero Romanelli, 'Comment j'ai connu Degas', *Le Figaro Littéraire*, 13 March 1937, p. 6

John Rothenstein, *Modern English Painters*, I, 1952

William Rothenstein, *Men and Memories*, 2 vols., London 1931–2

Denis Rouart, *Degas: à la récherche de sa technique*, Paris 1945

Georges Rouault, *Sur l'art et sur la vie*, Paris 1971

Frank Rutter, *Art in My Time*, London 1933

Salon 1887, *Salon de 1887, catalogue illustré*, Paris 1887

Salon 1890, *Salon de 1890, catalogue illustré*, Paris 1890

Salon 1891, *Salon de 1891, catalogue illustré*, Paris 1891

Gill Saunders, *The Nude: A New Perspective*, London 1989

Herbert Schimmel, *The Letters of Henri de Toulouse-Lautrec*, Oxford 1991

Sète, Musée Paul Valéry, *Paul Valéry: peintre, sculpteur*, Sète 1974

Gino Severini, *The Life of a Painter*, London 1996

George Shackelford, *Degas: The Dancers*, Washington 1984

Walter Sickert, 'Degas', *Burlington Magazine*, November 1917, pp. 183–91

Walter Sickert, *A Free House*, London 1947

Willa Z. Silverman, *The Notorious Life of Gyp*, Oxford 1995

Henri de Soria, *Histoire Pittoresque de la danse*, Paris 1897

Werner Spies, *Picasso: Das plastische Werk*, Stuttgart 1893

PHOTOGRAPHIC CREDITS

Denys Sutton and Jean Adhémar , 'Lettres inedites de Degas à Paul Lafond et autres documents', *Gazette des Beaux-Arts*, CIX, no.1419, April 1987, pp. 159–80

Joshua Taylor, *Nineteenth-Century Theories of Art*, Berkeley, Los Angeles and London, 1987

Antoine Terrasse, *Degas et la photographie*, Paris 1983

François Thiébault-Sisson, 'Degas sculpteur par lui-meme', *Le Temps*, 23 May 1923; repr. and trans. in Kendall 1987

Belinda Thomson, *Gauguin*, London 1987

Belinda Thomson, *Vuillard*, Oxford 1988

Belinda Thomson, *Vuillard*, London 1991

Belinda Thomson, *Gauguin by Himself*, London 1993

Richard Thomson, 'Degas's "Torse de Femme" and Titian', *Gazette des Beaux-Arts*, July 1981, pp. 45–8

Richard Thomson, 'Degas Literature: The Class of 1984', *Master Drawings*, vol. 23/4, 1985–6, pp. 551–63

Richard Thomson, *The Private Degas*, London 1987

Richard Thomson, *Degas: The Nudes*, London 1988

Richard Thomson, *Edgar Degas: Waiting*, Malibu 1995

Hans Tietze, *Titian: The Paintings and Drawings*, Oxford 1950

Paul Tucker, *Monet in the '90s: The Series Paintings*, New Haven and London 1989

Leandre Vaillat and Paul de Limay, *J.-B. Perroneau: sa vie et son oeuvre*, Paris 1923

Paul Valéry , 'Degas Dance Drawing', in *Degas, Manet, Morisot*, Princeton 1960

Paul Valéry, *Aesthetics*, London 1964

Giorgio Vasari, *The Lives of the Painters, Sculptors and Architects*, 4 vols., trans. A.B. Hinds, London 1927

Vente I, *Catalogue des tableaux, pastels et dessins par Edgar Degas...*, Paris, May 1918

Vente II, *Catalogue des tableaux, pastels et dessins par Edgar Degas...*, Paris, December 1918

Vente III, *Catalogue des tableaux, pastels et dessins par Edgar Degas...*, Paris, April 1919

Vente IV, *Catalogue des tableaux, pastels et dessins par Edgar Degas...*, Paris, July 1919

Vente Collection I, *Catalogue de tableaux modernes et anciens...composant la collection Edgar Degas...*, Paris, March 1918

Vente Collection II, *Catalogue des tableaux modernes... faisant partie de la collection Edgar Degas...*, Paris, November 1918

Vente Collection Estampes, *Catalogue des estampes anciennes et modernes...composant la collection Edgar Degas*, Paris, November 1918

Vente Estampes, *Catalogue des eaux-fortes, vernis-moux, aqua-tintes, lithographies et monotypes par Edgar Degas...*, Paris, November 1918

Vente Fénéon, *Vente Félix Fénéon*, Paris, May 1947

Lionello Venturi, *Cézanne: son art, son oeuvre*, 2 vols., Paris 1936

Lamberto Vitali, *Un fotografo fin de siècle, il conte Primoli*, Turin 1968

Ambroise Vollard, *Quatre-vingt-dix-huit reproductions signées par Degas*, Paris 1914

Ambroise Vollard, *Renoir: An Intimate Record*, New York 1925

Ambroise Vollard, *Recollections of a Picture Dealer*, Boston 1936

Ambroise Vollard, *Degas: An Intimate Portrait*, New York 1937

Ambroise Vollard, *Paul Cézanne: His Life and Art*, New York 1937

Gaston Vuillier, *La Danse*, Paris 1898; English edn, *A History of Dancing from the Earliest Ages to Our Own Times*, London 1899

Jeanine Warnod, *Suzanne Valadon*, Paris 1981

Washington, National Gallery of Art, *The Art of Paul Gauguin*, 1988

Washington, National Gallery of Art, *The Passionate Eye: Impressionist and other Master Paintings from the E.G. Bührle Collection*, 1990

Barbara Weinberg et al., *American Impressionism and Realism*, New York 1994

Frances Weitzenhoffer, *The Havemeyers: Impressionism comes to America*, New York 1986

Alfred Werner, *Degas Pastels*, London 1969

Barbara Ehrlich White, *Renoir: His Life, Art and Letters*, New York 1984

Colin Wiggins, *Frank Auerbach and the National Gallery: Working after the Masters*, London 1995

Daniel Wildenstein, *Claude Monet: biographie et catalogue raisonné*, 4 vols., Paris 1974–85

Wolfgang Wittrock, *Toulouse-Lautrec: The Complete Prints*, 2 vols., London 1985

Madeleine Zillhardt, 'Monsieur Degas . . . Mon Ami', *Arts*, 9 September 1949

Emile Zola, *Mon Salon: Manet: écrits sur l'art*, Paris 1970

Zurich, Kunsthaus, *Degas Portraits*, 1994

Index

Illustration numbers refer to the page on which the work is illustrated.